The Hajj:
Collected Essays
Edited by Venetia Porter
and Liana Saif

Cardiff Libraries
www.cardiff.gov.uk/libraries
Llyfrgelloedd Caerd
...ydd.gov.uk/llyfrgell

D1556581

The British

Arts & Humanities
Research Council

ACC. No: 03183459

297.352
HAJ

**Published with the kind assistance of the
Arts and Humanities Research Council
and Professor David Khalili**

Publishers

The British Museum
Great Russell Street
London WC1B 3DG

Series editor

Sarah Faulks

Distributors

The British Museum Press
38 Russell Square
London WC1B 3QQ

The Hajj: Collected Essays
Edited by Venetia Porter and Liana Saif

ISBN 978 086159 193 0
ISSN 1747 3640

© The Trustees of the British Museum 2013

Front cover: 'Crossing the Sea of Oman', from *Anis al-hujjaj*
(The Pilgrim's Companion) by Safi ibn Vali (fol. 3b).
The Nasser D. Khalili Collection of Islamic Art
(© Nour Foundation. Courtesy of the Khalili Family Trust)

Printed and bound in the UK by 4edge Ltd, Hockley

Papers used by The British Museum Press are recyclable
products made from wood grown in well-managed forests
and other controlled sources. The manufacturing processes
conform to the environmental regulations of the country of
origin.

All British Museum images illustrated in this book are
© The Trustees of the British Museum.

Further information about the Museum and its collection can
be found at britishmuseum.org

Contents

Preface

Nasser D. Khalili

Mecca, during the month of Dhu al-Hijja, sees the largest annual congregation of people at any given place and time in the world. Towards it some three million Muslims converge from the four corners of the earth in order to fulfil their religious duty of Hajj. Dressed in their white ritual garments, the pilgrims stand shoulder to shoulder equal before God, regardless of race, gender, wealth or rank. I am always deeply moved by the sight of the mass of pilgrims circumambulating the noble Ka'ba chanting their prayers in a timeless ritual; one might as well be reading an account by a medieval traveller. The physical journey has obviously changed over the centuries: the camel has now been replaced by motorized transport and the pilgrim caravans by chartered flights. The spiritual journey, however, remains – in essence – unchanged.

It is curious that the subject of Hajj, the fifth pillar of Islam and the one that lends itself most readily to artistic expression, had not been seriously addressed in an exhibition before the British Museum's recent *Hajj: journey to the heart of Islam*. The huge success of this exhibition is a tribute to the foresight and imagination of the Director, Neil MacGregor, in his enthusiastic promotion of world cultures, as well as the vision and tireless efforts of its curator, Venetia Porter. In so eloquently relating this fascinating story from its beginnings to the present day, the exhibition made the subject of Hajj accessible to all, not least among those who are unable to take part. For Muslims and non-Muslims alike, it presented a way of exploring what is common to all faiths and shared by all. One should not forget that many of the rites of Hajj revolve around the central figure of Abraham who is equally venerated by Jews, Christians and Muslims. There is, after all, far more that is common to these religions than separates them.

Since 1970, The Khalili Family Trust has been actively involved in assembling a comprehensive collection of Islamic art. Simultaneously, we have focused our attention on putting together a notable collection of objects relating to Mecca and Medina and the arts of pilgrimage in general. We were therefore extremely proud to have been involved so closely with the British Museum, and pleased that we could play a significant role in the presentation of this landmark exhibition.

I am also delighted that we have been able to support this publication which is the fruit of the multidisciplinary conference associated with the exhibition. The 29 essays included in this book cover many aspects of Hajj. They demonstrate the depth and richness of the subject, from the religious and social importance of Hajj to the ancient remains of its routes; from the personal accounts of pilgrims to the experience of Hajj today; and from the remarkable gifts of textiles for the holy cities to the material and contemporary culture of Hajj. I am certain that the publication will be a vital source of information and inspiration for years to come.

Nasser D. Khalili
Founder
The Khalili Collections

Introduction

Venetia Porter

This volume of 29 essays comes out of a conference sponsored by the Arts and Humanities Research Council that accompanied the exhibition *Hajj: journey to the heart of Islam*.[1] The exhibition was sponsored by HSBC Amanah with the King Abdulaziz Public Library as organizational partner. The intention of the conference, as with the exhibition, was to try to tell the story of the Hajj from different perspectives, from its early history to the present day. This multidisciplinary approach is reflected in the widely diverging subject areas that are represented by these essays: history, archaeology, Islamic art, linguistics, religious and social studies. The contributors evoke the lives of the pilgrims, the routes they took, the objects they left behind, the dangers of the journey and the strong sense of belief that impelled them to undertake the journey to Mecca. Also highlighted are the many objects associated with the Hajj: the lavish textiles, the beautifully painted tiles, the richly illuminated manuscripts and the everyday objects made for or to bring to mind the holy cities and the Hajj.

The volume opens with an exposition of the rituals of the Hajj expressing clearly what Hajj represents for Muslims and closes with the experiences of the Hajj today by Muslims from the United Kingdom. In between, the essays fall into several groups. In the section 'Religion, Early History and Politics', the contributors examine pre-Islamic Hajj and its early politicization under the Umayyad caliphs. The next group of essays, under the heading 'By Land and Sea: Archaeology, Hajj Routes and Ships', concentrates on different aspects of the routes. An Arabic text on Damascene crafts sheds light on objects traded on Hajj; there are new discoveries about the Hajj route from Basra; the rediscovery of an Ottoman fort at Mafraq along the Syrian route and the reinterpretation of Ottoman royal inscriptions. A survey of the Sinai route looks at the extensive network of fort-*khans*, while a discussion of the Trans-Saharan route focuses on the fascinating city of Tadmekka. The all important role and history of the Hajj ports on the Red Sea and Indian Ocean is examined along with an analysis of the different types of ships used to make these journeys.

The third group of essays fall under the title 'Travellers' Tales and Colonial Histories'. We start with pilgrims' accounts: one told in Mehri of a journey from Oman by camel; and the second of *hajjis* who travelled on the Trans-Siberian railway. We then look at how colonialism affected the Hajj, under the French in Algeria with the strictures they imposed on pilgrims and in India during the Raj with a focus on the role played by Thomas Cook. The last two articles in this section highlight Britons who went on Hajj – some as genuine believers, others as imposters.

The essays in the last section are grouped under the loose heading 'The Material and Contemporary Culture of Hajj'. Here the contributors look mainly at objects, and there is a deep analysis of the depictions of the holy sites on tiles, a discussion of the inscriptions on the Hajj textiles and keys to the Ka'ba, an examination of the making of the Hajj textiles in Cairo, a description of the textiles of Medina and, that supreme political symbol of the Hajj, the *mahmal*, is considered from a number of different perspectives. The role that the Hajj has played in the transmission of architectural ideas is also highlighted, as are the literary and manuscript traditions of the

Ottomans and southeast Asia. We conclude with the modern-day souvenirs that are brought back by pilgrims today.

The articles in this book develop and deal in depth with many of the ideas that were touched upon in the exhibition and the accompanying multiauthored publications *Hajj: journey to the heart of Islam* and *The Art of Hajj*. They further demonstrate how multifaceted and what a fruitful area of research the study of the Hajj is. My thanks therefore go first and foremost to the contributors of the excellent articles in this volume. They have provided us with thought provoking new material on a wide range of subjects and have truly confirmed that a new subject area called 'Hajj studies' has been created.

My other main thanks go to my co-editor Liana Saif who worked tirelessly with the contributors and translated the two articles by Sami Saleh 'Abd al-Malik and Muhammad al-Mojan. I would also like to thank Sarah Faulks, our editor at the British Museum Press, for all her work, kindness and professionalism. Without Professor David Khalili this book is unlikely to have seen the light of day, and to him and to Nahla Nassar, curator of the Khalili Collection of Islamic Art, whose enthusiasm for the subject of Hajj knows no bounds, I am extremely grateful. Nahla helped us with some of the texts, provided photographs and regularly offered much needed support. Others who have provided assistance and guidance in several ways are James Allan, Colin Baker, William Facey, Annabel Gallop, Tim Insoll, Selin Ipek, Hugh Kennedy, James Piscatori, Tim Stanley, Arnoud Vrolijk and Rahul Qaisar.

As far as the production of the book is concerned, I would like to thank Matt Bigg at Surface 3 and Martin Brown for the maps, and at the British Museum Press, our picture researcher Katie Anderson, Susan Walby, Head of Production, and Rosemary Bradley, Director of Publishing. I would also like to thank all those who generously allowed us to use their photographs: Professor David Khalili, Nurhan Atasoy, Newsha Tavakolian, Andrew Petersen, Sami Saleh 'Abd al-Malik, Sam Nixon, Marcus Milwright, Ann Parker, Sotheby's, David Collection, Mehmet Tütüncü, Laurence Hapiot, Diana Danke, Bruce Wannell and Qaisra Khan. Thanks also to British Museum photographer Dudley Hubbard for his beautiful photographs.

Finally I would like to express my deepest thanks to Qaisra Khan and John Slight who organized the conference upon which this book is based and to the Arts and Humanities Research Council who sponsored it and helped us in other ways. I would also like to thank my colleague Jeremy Hill for all his help and advice throughout this project and to the Keeper of the Middle East department, Jonathan Tubb, for his ongoing support of the project.

Practical notes on the text

All the dates are AD unless a Hijra date is included in which case they are presented as: 580/1184–5. We decided to keep the transliteration to a minimum and therefore diacritical marks are only included where essential, as in Janet Watson's article. We apologize to those who may find this irritating. All non-Western words are italicized unless they have formed part of English vocabulary such as imam or sheikh. Turkish spellings have been used for the names of the Ottoman sultans and other Turkish words. The references for each article are treated as endnotes and an integrated bibliography is at the end of the book, alongside a basic glossary and an index. The translations of the Qur'an that have been principally used are by Alan Jones (2007) and M. Abdel Haleem (2005).

Notes
1 The essays by William Facey and Qaisra Khan are based on lectures given at different times during the course of the exhibition.

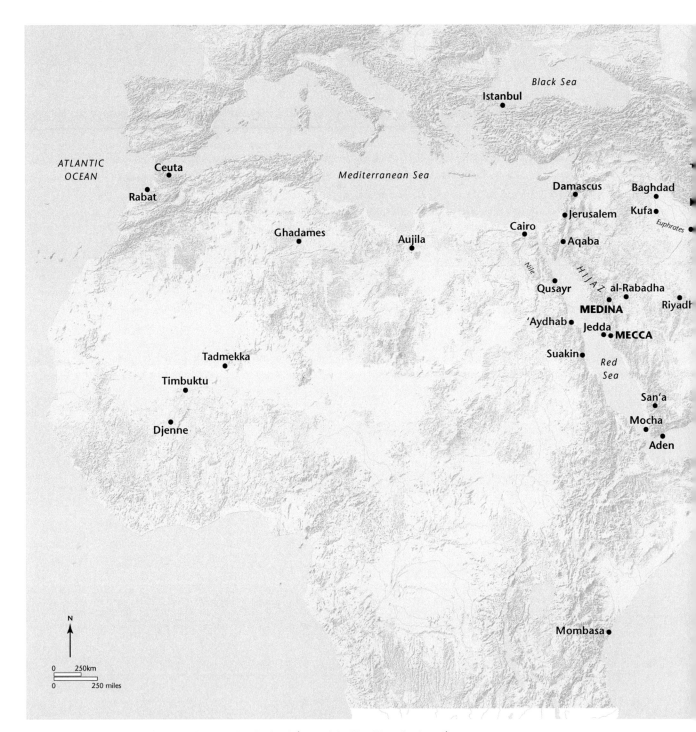

Map showing a number of the sites discussed in the book (artwork by Matt Bigg, Surface 3)

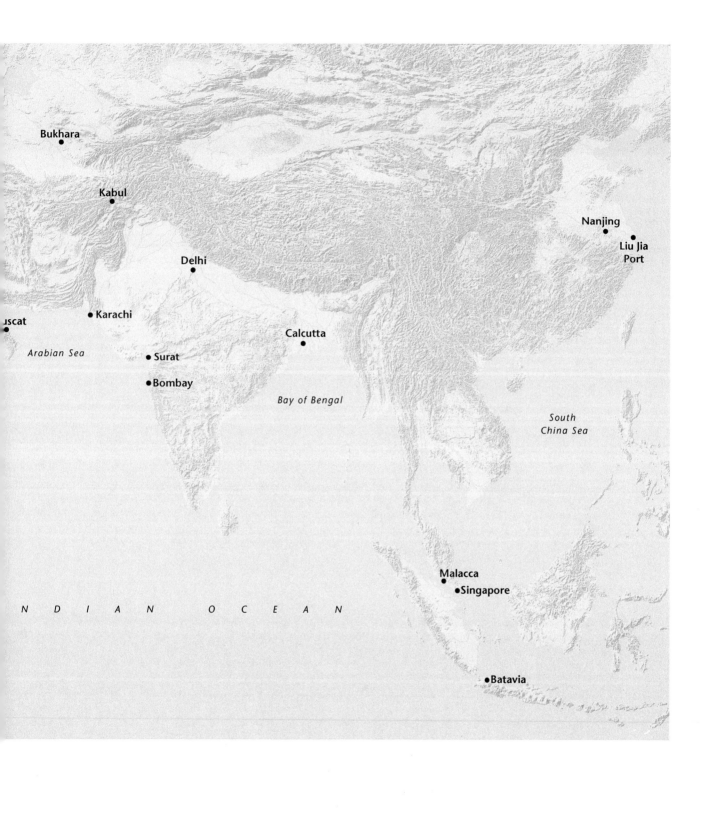

Bukhara

Kabul

Nanjing

Liu Jia
Port

Delhi

uscat

Karachi

Calcutta

Arabian Sea

Surat

Bombay

Bay of Bengal

*South
China Sea*

Malacca

Singapore

N D I A N O C E A N

Batavia

Chapter 1
The Religious and Social Importance of Hajj

M. Abdel Haleem

Undertaking the Hajj is really and truly making a journey to the heart of Islam, to the Ka'ba, 'the first house' set up for the worship of the One God, the heart of the Islamic faith.[1]

The pilgrimage to the Ka'ba in Mecca is the fifth pillar of Islam, after the declaration of faith (*shahada*), ritual prayer (*salat*), obligatory alms (*zakat*) and the fast (*sawm*) of Ramadan. Although it comes fifth, it is very special in its impact. Prayer is familiar to Muslims every day, but the Hajj is required only once in a lifetime. It also involves an unforgettable journey which adds to its mystique and appeal. No one acquires a title for praying or fasting, but you do after taking that journey to the heart of Islam.

The Hajj rites are, moreover, an obligation on all Muslims, attested by the Qur'an, the supreme authority in Islam; the *Hadith* (traditions of the Prophet), the second authority; the consensus of Muslim scholars, and the continued practice ever since the time of the Prophet Muhammad. From its institution as a pillar of Islam, the word 'Hajj' has applied only to the pilgrimage to Mecca; no pilgrimage to any other place is called Hajj.

The Hajj rites are fixed and have been handed down through the ages, and all Muslim pilgrims must fulfil the required acts. In this way the Hajj connects Muslims historically through the generations, as well as geographically to other Muslims around the world at any particular time. It is one of the most important unifying elements in the Muslim community (*umma*), and it is a journey that marks a huge change in the spiritual and social life of the pilgrims.

The origin of Hajj

According to the Qur'an, the Hajj did not start with the Prophet Muhammad but thousands of years before, with the Prophet Ibrahim (Abraham), the supreme example in the Qur'an of dedication to the One God and submission (*islam*) to His will.[2] Most of the Hajj rituals are actually based on the actions of Ibrahim and his family, as stated in the Qur'an:

> The first House [of worship] to be established for people was the one at Bakka.[3] It is a blessed place; a source of guidance for all people; there are clear signs in it; it is the place where Ibrahim stood to pray; whoever enters it is safe. Pilgrimage to the House is a duty owed to God by people who are able to undertake it. If anyone denies this, God has no need of anyone (Q.3:96–7).

God says in the Qur'an: 'We showed Ibrahim the site of the House' (Q.22:26), relating how Ibrahim and Isma'il (Ishmael) built up the foundations of the Ka'ba and the beautiful prayers they recited, and how God commanded Ibrahim:

> Do not assign partners to Me. Purify My House for those who circle round it. Proclaim the Pilgrimage to all people and they will come to you on foot and on every kind of lean camel, emerging from every deep mountain pass to obtain benefits and mention God's name on specified days. (Q. 22:26–8)

When these verses are heard or recited by Muslims, when they repeat the prayers of Ibrahim, with their sentiments, their words and the rhythm they have in Arabic, it moves them to tears and deepens their longing to respond to that call made thousands of years ago and undertake the journey.

Performing the Hajj

The Qur'an states that Hajj should take place 'in the specified months'.[4] These are the last three months of the Muslim calendar and this period is known as *miqat zamani* (fixed time). In the past, pilgrims would start their journey to Mecca early within this period, but the main acts of the Hajj itself take place in five days during the third (and last) of these months, 8th–13th Dhu al-Hijja.

Hajj rituals start with consecration (*ihram*) for Hajj, which must be made by the time pilgrims reach the specified fixed places, each known as *miqat makani* (the fixed place), on the roads to Mecca from the various directions. The closest *miqat* to Mecca (Yalamlam) is the one on the road from the Yemen, 50km (31 miles) away. The furthest one (Dhu al-Hulayfa) is only a few kilometres from Medina, which is over 300km (185 miles) from Mecca.[5] In the days before modern transport this meant lengthening the period of consecration to include this arduous journey, but also to provide further spiritual feelings and blessings.

When pilgrims enter into *ihram*, it is recommended that they have a full body wash and perfume themselves, and men must change into the *ihram* clothing, consisting of two pieces of seamless white cloth (such as towels), one fixed round the waist and the other covering the top of the body.[6] These can be secured with pins or a belt. Footwear should also be simple and not sewn. Women's clothing for Hajj is normal and can be of any colour, although usually they choose white, but they should not cover their faces.

Once the pilgrims are in *ihram* they must not use perfume, shave, cut their hair or nails, or have sexual intercourse. Entering into *ihram* is a high spiritual moment, one the pilgrims have long anticipated. They leave behind any luxury living, any social distinction and dedicate themselves to worship. They begin the *talbiya*, chanting in Arabic '*Labbayk allahumma labbayk*', 'Here I am, Lord, responding to Your call [to perform the Hajj]. Praise belongs to You, all good things come from You and sovereignty is yours alone.' This is constantly repeated during the Hajj, especially when meeting other pilgrims, moving from place to place, and after the daily prayers. The pilgrims are unified by chanting in the same language and also by their simple clothing, worn by people of every status, colour, language and background.

It is interesting to note here that although the Hajj ritual takes only five days, within a 25km distance from Mecca, the consecration and consequent sense of security and peace spread much further afield in time and place. Ibrahim prayed that God would make Mecca peaceful and secure. Pilgrims must not hunt, kill animals or cut any plant – peace to all. They must also refrain from indecent speech, misbehaviour and quarrelling,[7] jostling or rushing: all very fitting, considering the huge crowds in the limited spaces. The Prophet emphasized that those who performed the Hajj without committing these forbidden acts would return home as free from sin as on the day their mother gave birth to them.[8] These restrictions apply not only when the pilgrim is in Mecca and its surroundings but also in the entire area between the *miqat makani* and Mecca. Such is the effect of the Hajj in establishing peace and good behaviour in that land.

Throughout the Hajj period and during the various rituals, there are special *du'a* prayers for pilgrims to say, many of which were spoken and recommended by the Prophet Muhammad. There are handbooks of these prayers, written in Arabic, and also transliterated with translations for non-Arabs. Pilgrims prefer to recite them in Arabic, in the words uttered by the Prophet himself, and consider them more effective than any other prayer in any language. Each group, large or small, normally has a guide (*mutawwaf*) who chants, and they repeat the prayers after him, interspersed with the *talbiya*. All this intensifies the spirituality of the Hajj season and enhances the unity of the pilgrims.

When pilgrims arrive in Mecca they make their first visit to the Haram, the sacred precinct, with its grand mosque. The first glimpse of the minarets and mosque is an unforgettable experience shared with huge numbers of people from all over the world, most of whom are seeing it in person for the first time. It is recommended that as they go in through the Gate of Peace (Bab al-Salam) they recite in Arabic,[9] 'Lord, open the gates of Your mercy for me. You are peace, from You comes peace, give us Your greeting of peace and admit us to Paradise, the land of peace. Glory be to You, Lord of Majesty and Honouring.'

On entering the mosque, it is the Ka'ba that attracts the pilgrims' eyes. There they will glorify Allah and repeat:

> There is no god but Allah, alone with no partner. Dominion and praise belong to Him, and He has power over all things. Peace be upon our Prophet Muhammad and on his family and companions. Lord, increase this House in honour, glory, reverence and respect and increase those who glorify it and visit it, make pilgrimage to it and increase their respect and goodness.[10]

Pilgrims approach the Ka'ba, happy to be at the actual building that Muslims face in their daily prayers all their lives and after death when they are buried. They go as near as possible to the Ka'ba and do the *tawaf* (circumambulation) seven times, anti-clockwise, starting from the eastern corner in which the Black Stone is embedded, thus re-enacting the actions of the Prophets Ibrahim, Isma'il and Muhammad and all succeeding generations of Muslims. Every time they pass the Black Stone, if possible they should kiss, touch or at least point to it, saying '*Allahu akbar*', 'God is greater'. While walking round the Ka'ba, pilgrims continually recite prayers as mentioned above, particularly: 'Lord, give us good in this life and good in the hereafter and protect us from the torment of the Fire'.[11]

Those near the Ka'ba often lay their hands on the wall or reach for the velvet cover, praying most earnestly for the heartfelt needs of themselves, members of their families and the many who have asked the pilgrims to pray for them. Later at home, when someone wants to ask the *hajji* earnestly for something, they may say, 'I beg you by the Ka'ba on which you placed your hand'.

The pilgrims do the *tawaf* together, men, women and children from all nations. The infirm are carried on litters by strong men. This ritual continues night and day and a considerable number do it as many times as they can. Following this it is recommended to do two *rak'as* (prayer cycles) at the Maqam Ibrahim (the place where Ibrahim

stood in prayer, now protected by a glass and gold case) near the Ka'ba.[12]

Near the Ka'ba too is the well of Zamzam, now underground. Drinking from this is a special ritual which reminds the pilgrims of Hagar's search for water for herself and her baby Isma'il, and their relief when the well gushed out of that barren spot. This is commemorated further by *sa'i* (hurrying) in the *mas'a* (the place of hurrying), now covered like a massive corridor, three storeys high, to help accommodate more pilgrims. This runs between the two hillocks of Safa and Marwa, about 410m (1,350ft) long. The pilgrims walk along this corridor from Safa to Marwa and back seven times in total, continuously repeating traditional or individual prayers. Part of the corridor is marked with green lights as a place for trotting rather than walking, again in commemoration of what Hagar did. For people unable to walk, there is a special track fenced off for wheelchairs. When I did *sa'i* myself, I recalled that my parents took these very steps years ago, so did their parents and many ancestors back to the time of the Prophet himself and earlier. My skin quivered as I felt, 'Now I am connected, I am fulfilled'. I had joined my ancestors. My children do the same. The call Ibrahim made still resounds for more to follow and always will.

On the 8th of Dhu al-Hijja, pilgrims go to Mina, a valley about five kilometres (three miles) from the Ka'ba, to spend the night there. On the morning of the ninth, they proceed towards 'Arafat,[13] a plain 14.5km (nine miles) from Mina, where the central rite of the Hajj, *wuquf* (standing) on 'Arafat, takes place between noon and sunset, during which time many heartfelt prayers are offered. The scene reminds Muslims of the gathering on the Day of Judgement. If any pilgrim misses this event, his/her Hajj is not valid and has to be done again another year. This does not apply to any other rite, all of which can be done over a longer period or compensated for with an offering. This is the time for the pilgrims to read the Qur'an, glorify God and pray most earnestly for forgiveness and everything else they wish for. Particularly recommended for glorification and repetition is this prayer, 'There is no God but Allah alone, with no partner. Dominion and praise belong to Him, who gives life and death. Goodness is in His hands and He has power over everything.' This just gives a succinct summary of the Islamic faith and connects the individual pilgrim to what Ibrahim and Muhammad brought and uttered. Pilgrims normally face towards the Ka'ba while reciting these prayers, as they do for the five daily prayers, believing that, by doing this, their prayers are more likely to be accepted.

After sunset, the pilgrims pour away from the plain of 'Arafat and go to Muzdalifa, another plain nine km (5.5 miles) from 'Arafat on the way back to Mina, a tremendous migration that continues throughout the night. In Muzdalifa they pray, read the Qur'an, talk to others from different parts of the world and exchange food, or sleep under the stars. There they collect the pebbles they will need in the morning and the following days to throw at the *jamarat* (place of stoning the devil): each individual throws at least 49 pebbles, and those who spend an extra day in Mina throw a further 21. In the morning they go to Mina to stone the biggest pillar (*jamarat al-'Aqaba*) using seven pebbles, in

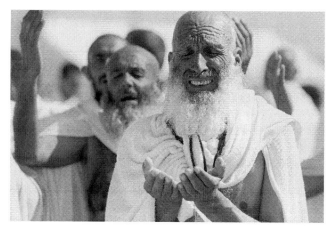

Plate 1 Photograph by Newsha Tavakolian, Hajj 2009 (reproduced in Tavakolian 2011, p. 11)

commemoration of what Ibrahim did when Satan tried to tempt him to disobey God. What the pilgrims do here is affirm God, saying *'Allahu akbar'* (God is greater), and reject Satan. Then the sacrifice of animals takes place, again in memory of Ibrahim and the substitution of a ram for his son, whom he set out to sacrifice in obedience to God, fulfilling a vision he had experienced. The Qur'an states, 'Eat some of [the meat] and feed the poor . . . It is neither their meat nor their blood that reaches God, but your piety'.[14] That day (10th Dhu al-Hijja) is Eid al-Adha, a great feast of sacrifice throughout the Muslim world, uniting the Muslims in their homelands with the pilgrims in Mecca.

Thus, the occasion of performing the rituals of Hajj is not just a matter that concerns the pilgrims who are actually engaged in Hajj. Muslim countries throughout the world are involved in many ways, particularly during the five central days of Hajj, as lectures, talks and sermons about Hajj are given in mosques. This is further facilitated now with the spread of satellite television. The day of 'Arafat is usually relayed in full in most Arab countries – a unifying aspect of Hajj. This reflects the Prophet's instructions during his last pilgrimage in 10/632, when he gave his Farewell Sermon emphasizing the unity of all believers. Pilgrims at that time came from all over Arabia, which marked the extent of the land of Islam. At the end of his speech he said, 'I have delivered the message. God is my witness. Let those of you present here deliver it to those who are not present.'[15]

Following the sacrifice in Mina, pilgrims shave or cut their hair to mark the end of the consecrated (*ihram*) state.[16] Then pilgrims go to Mecca to do the obligatory *tawaf al-ifada*, the *tawaf* marking the departure from 'Arafat, and go to their accommodation in Mina to rest. They spend the night there, and from midday on the 11th of Dhu al-Hijja they cast more stones at the three *jamarat* pillars: seven pebbles each. This is another very congested place, and great efforts are made to facilitate the ritual, most recently by replacing the pillars with large walls. There are now five levels of walkways to accommodate the large numbers of pilgrims.[17] The stoning is repeated on the 12th of Dhu al-Hijja and some pilgrims stay for a further stoning on the 13th of Dhu al-Hijja.[18] During their time in Mina, pilgrims have more free time and opportunity to mix and talk, get to know each other and the countries from where they come.

The pilgrims finally return to Mecca where they perform the *tawaf al-wada'* (the farewell *tawaf*), the last rite of Hajj, and they are then free to go home.

In the intervals between the rituals, pilgrims are allowed to trade, 'seeking some bounty from [their] Lord'.[19] A vast indoor *suq* (market) surrounds the sanctuary. Pilgrims are expected by their families and friends to bring something back as a blessing: prayer beads, prayer mats, clothing, perfume or Zamzam water. Zamzam water is celebrated as providing healing and great blessing. It is also drunk with others when pilgrims return home. Many pilgrims make a point of bringing back sealed containers of Zamzam water to be kept to sprinkle on their shroud when they die, and into their grave. Other kinds of souvenirs are also available, and even a head cap or a scarf from Mecca has great significance for the recipient. All of these objects augment people's desire and dreams to undertake the journey to the heart of Islam.

After the Hajj (or sometimes before it, according to dictates of time) the pilgrims prepare to visit the burial place of Muhammad usually expressed as 'visiting the Prophet' in Medina rather than 'visiting his tomb'. Once again, their yearning reaches its height when they approach the mosque and glimpse the green dome over the sacred spot. It is very moving to face the gate to the Prophet's tomb and greet him as if he were alive and could respond to the greeting (part of the normal daily prayers), 'Peace be to you Prophet and the mercy and blessing of God'. Visitors are recommended to add, 'I bear witness that you are the servant and messenger of God, that you have delivered the message and discharged the trust and advised the community'. They then pray to God for whatever they need. As this is a very special opportunity for spiritual recharging, pilgrims make a point while in Medina of performing as many of the daily prayers as they can in the Prophet's Mosque. Many also visit the adjacent cemetery which contains the remains of the Prophet's companions and relatives.

Having done the Hajj and visited the Prophet, pilgrims have fulfilled all that they came for; they have now completed all the pillars of Islam and can go home, hopefully as free from sin as the day they were born, full of blessing and spiritually charged. They hope to have achieved the merits of the accepted Hajj and 'the reward of Hajj Mabrur (the one accepted by Allah) is nothing except Paradise'.[20] On completing the Hajj, pilgrims acquire a new title: *hajji* for a man, *hajja* for a woman. Especially in the rural areas of Muslim countries where the aspiration to perform the Hajj, the preparations for it and the follow-up is greater than in the cities, it becomes a mark of the greatest honour. Even dignitaries, such as the Sultan of Brunei, include the name Hajj among their official titles.

The return of a pilgrim is an occasion for great celebration. He or she will normally relate in detail what they did on Hajj. Accounts can also add to the ever-growing genre of Hajj travel books or songs by local bards who perform ballads that emphasize the importance of Hajj and stir up the desire to go on that remarkable journey.

The prospect of having one's Hajj accepted, and being cleansed of sins, makes the Hajj more important to someone who, having sinned for a long time, decides at last to turn a new leaf, like some characters in modern Arabic novels.[21]

Ahmad 'Abd al-Jawwad, proverbial for being dictatorial at home, was a respectable merchant in society but dissolute in private. However he was overcome by high blood pressure and in bed ill for a period of time. His friends came to visit him when he had recovered slightly, the majority of whom, like him, had double lives: drinking, taking drugs and womanizing in private. Now Ahmad realized that the time for this was over and he had to listen to the doctor's orders to change his life or else become paralyzed. Many were saying, 'No, no, we still have a long life ahead of us and we must keep on enjoying it. There is nothing wrong with having fun. Our ancestors used to live long lives and would remarry in their seventies.' At this point an old religious man, Sheikh Mitwalli, to whom Ahmad had been kind and in whose blessing he believed, came and said to him, 'You must now decide to go on Hajj and take me with you'. Ahmad agreed to this. Sheikh Mitwalli, who lamented that such people had come to visit Ahmad and were still persisting in their way of life, exclaimed, 'Can anyone tell me whether we are sitting in the house of Ahmed or in a den of vice?' Then he said, 'I call upon you all to give up this life, repent and go on Hajj'.[22] Sheikh Ridwan al-Husseini sought repentance for himself and the people of his alley by going to the land of repentance and returning with a pure heart.[23]

The journey to the heart of Islam is arduous, but this in itself makes it special and mysteriously more desirable. Those who experienced it long to do it again when the season returns and may do it several times. Hajj connects pilgrims historically and geographically, enhancing the sense of one community and one God. In fact, the Hajj is the only gathering open to all Muslims from all over the world, where they can pray, talk and have cultural and commercial exchange.

The Hajj has grown from only two people, Ibrahim and Isma'il, going round the Ka'ba, to the present age with about 3 million pilgrims every year. The fact that it is done at one fixed time, in a fixed small area, according to a fixed order of rituals, and with an ever increasing numbers of pilgrims, creates perhaps the greatest logistical challenge of the present time, taxing the ingenuity of successive Saudi governments, as can be witnessed just in the last few decades. They clearly consider it the peak of their glory and responsibility to enable pilgrims to perform this fifth pillar of Islam and hence the official title of the King is 'Custodian of the Two Holy Sanctuaries'.

Whatever the numbers, the faith that drives the believers guarantees that the Hajj will continue, even within the restrictions of space and time, as long as there are Muslims. It is this faith that underpins the Hajj and gives rise to all its other aspects: archaeological, architectural, artistic, cultural and so forth, as shown in the 2012 British Museum exhibition. The phenomenon provides fertile ground for the continued proliferation of religio-historical, cultural and political studies as exemplified in the present volume.

Notes

1 Q.3:96. See Peter Webb in this volume.
2 Q.16:110–13.
3 There is an agreement among Muslim exegetes that this Bakka is an old name for Mecca. See Webb in this volume, esp. n. 6.
4 Q.2:197.

5 Pilgrims arriving by plane are alerted by the airline staff when they pass over these places if they have not done it earlier.

6 Pilgrims travelling by air should have this wash before boarding the plane.

7 Q.2:197.

8 'Narrated by Abu Huraira: The Prophet said, "Whoever performs Hajj for Allah's pleasure and does not have sexual relations with his wife, and does not do evil or sins then he will return (after Hajj free from all sins) as if he were born anew."' Sahih Bukhari, vol. 2, book 26, *Hadith* number 596. Accessed online (1 August 2013), http://www.hadithcollection.com/sahihbukhari.html.

9 Only two gates are mentioned in the *Hadith* literature: the Bab al-Salam and the Bab Bani Shayba. More gates have been added in successive expansions of the mosque. In the King Fahd development (1988–2005) many more gates were added, including the King Fahd gate to the new extension.

10 Sabiq al-Sayyid 1987.

11 Q.2:201.

12 Many pray especially inside *Hijr* Isma'il, a low semi-circular wall adjacent to the side of the Ka'ba following its door anti-clockwise. This is said to have been part of the area of the original Ka'ba.

13 A legend says that Adam and Eve, after expulsion from the garden and separation, met each other at 'Arafat, and the name means that they knew (recognized) each other there. Ibrahim is said to have gone to 'Arafat and stayed there. The Prophet Muhammad also stayed there during his Farewell Pilgrimage and this is where he gave his Farewell Sermon, standing on the small hill, Jabal al-Rahma.

14 Q.22:28, 37. Since the late 20th century, abattoir facilities have been provided where the meat is frozen or canned and sent later to the poor in different countries. Before this, the excess meat would have been preserved by drying it in the sun.

15 For a discussion of the Farewell Pilgrimage see Munt in this volume esp. n. 10.

16 Only marital relations remain off limits, until after *Tawaf al-'ifada*.

17 One of the many ways of facilitating Hajj rituals for ever increasing numbers of pilgrims, enabled by stronger economies and faster modes of travel.

18 Q.2:203.

19 Q.2:198. See Qaisra Khan in this volume.

20 Sahih Bukhari, volume 3, book, *Hadith* number 1. Accessed online (1 August 2013), http://www.hadithcollection.com/sahihbukhari.html.

21 For example, the character of Sheikh Ridwan al-Hussaini in *Ziqaq Midaq Alley* by Najib Mahfouz and that of Ahmad 'Abd al-Jawwad in *Qasr al-Shawq* by the same author.

22 *Qasr al-Shawq*: 448–52.

23 *Ziqaq al-Midaq*: 298.

Chapter 2
The Hajj before Muhammad
Journeys to Mecca in Muslim Narratives of Pre-Islamic History

Peter Webb

The Hajj poses intriguing historical questions to students of Islam. Most quintessential Islamic icons, such as the Qur'an, ritual prayer and the Ramadan fast are closely associated with Muhammad's prophetic mission, but the Hajj is explicitly ascribed a much more ancient history. Although Muslim and non-Muslim scholars disagree over its precise antiquity, there is consensus that Muhammad embraced a pre-existing Hajj ritual. Several western scholars have studied this 'pre-Islamic Hajj' to explore what they believe to be Islam's syncretism, and they contend that Muhammad's Hajj incorporated rituals from Arabian paganism, litholatry (stone worship) and even Judaism.[1] Muslims, on the other hand, maintain that the Hajj was originally a divinely inspired monotheistic practice for the worship of Allah, which was gradually corrupted by Arabian polytheists, but then restored by Muhammad to its original intention and correct monotheistic significance.

The two camps of scholars make divergent arguments, but they are united by a common objective of proving the 'true history' of the 'actual' pre-Islamic Hajj. Their work, however, is confronted by evidential problems. The Muslim account relies on an oral tradition purportedly explaining all details of the ancient origin of Hajj, but this tradition only survives in sources from the Islamic era and lacks both corroboration from pre-Islamic texts and archaeological substantiation. Western academic theories for their part pose interesting questions and highlight inconsistencies in the Muslim tradition, but they too lack the textual and archaeological evidence necessary to establish cogent alternatives.

The debate continues, but the factual origins of Hajj are buried deep in time, and as a practical matter, the only ready evidence of the early history of Hajj are Arabic narratives written in the Islamic period. These texts cannot take us back to the primordial origins of the Hajj, but they can be dated with some precision, and they do provide a record of how early generations of Muslims understood the origins of Hajj.

In this essay, I shall analyse the Arabic accounts as narratives to decipher the layers of discourses in the early Islamic period which contributed to the development of a canonical account of the history of Hajj. I shall then apply the results of this analysis to explore how the Hajj stories affected the ways in which Muslim writers narrated the pre-Islamic history of Arabia.

My exploration of the Muslim portrayal of the history of Hajj starts at first principles with two related questions: first, when does the Muslim 'tradition' believe the first Hajj was performed; and second, precisely what texts constitute this 'tradition'? Identifying texts is relatively straightforward, but they reveal complex discourses surrounding the history of Hajj.

Chronologically, the relevant texts fall into two groups: the first consists of texts from the very first generations of Islam, namely the Qur'an and, to varying degrees, the *Hadith* (most attributed to the Prophet himself and at first primarily transmitted orally and then increasingly recorded in writing from the eighth century);[2] and the second group consists of histories, Qur'anic commentaries, geographies and other scholarly books written some 200 to 350 years

after Muhammad's death by Arabic writers in Iraq.[3] The later texts interpreted and expanded upon the older material and produced the canonical version of the Muslim tradition, but they do not always dovetail neatly with the narratives of the Qur'an and *Hadith*. There are fissures and discrepancies between the two, and these are fruitful sites for investigating how Muslim scholars in the first centuries of Islam developed variant interpretations and even new accounts of history. The story of the Hajj is one such example.

Regarding the question of the first Hajj in history, the later texts, particularly those written since the tenth century, assert that Adam, the first man, was the first *hajji*.[4] This has become well established in the Muslim tradition; however, early texts make a very different claim. We shall begin with the earliest sources and chronologically trace the evolving history of the first Hajj.

The first Hajj (1): the Qur'an and the *Hadith*

Our earliest source is the Qur'an. It makes several references to the Hajj and the Ka'ba's construction in verses which invariably revolve around the figure of the prophet Ibrahim (Abraham) and his community of monotheists identified by the adjective *hanif* (of pure faith/upright religion). The Qur'an portrays Ibrahim as the prophet whom God guided to the holy site of Mecca (Q.22:26); the builder of *al-bayt* (the house i.e. the Ka'ba) (Q.2:127);[5] the first to call mankind to perform the Hajj (Q.22:27); and the earliest figure to bless Mecca as a holy place (Q.2:126) (**Pls 1, 2**). Ibrahim is also described as a God-appointed imam (Q.2:124), and in the following verse, the Qur'an specifies the sanctity of *al-bayt* and Maqam Ibrahim (the 'standing place' of Ibrahim) which Muslims are instructed to take as a place of prayer.

The Qur'an also describes Mecca as the 'first house [*bayt*] [of worship] to be established for people (Q.3:96).[6] In isolation, this verse could appear to bestow deep primordial roots on Mecca, but in the verse's context (Q.3:95–7), the connection with the Hajj and Ibrahim is palpable. Verse 95 urges readers to 'follow Ibrahim's religion' (described as *hanif*), and verse 97 orders mankind to perform the Hajj, here mentioning Maqam Ibrahim (Q.3:95–7). The Qur'an's historical horizon of the Hajj is firmly fixed on Ibrahim with no reference to Adam (**Pl. 1**).

The second group of extant early texts are the Prophetic *Hadith*, the corpus of reported sayings and acts of Muhammad. Against the background of controversy surrounding the *Hadith*'s authenticity,[7] I survey those individual *hadith*s which the Muslim tradition cherishes as the most authentic: the *hadith*s preserved in the six canonical collections (*al-Kutub al-sitta*) and in Ahmad ibn Hanbal's more voluminous *Musnad*. As a group, these *hadith*s plainly corroborate the Qur'an's discourse, which evidences their coherence and likely antiquity. Taken together with the Qur'an, they elaborate upon what appears to be a genuinely early conception of the origins of Hajj.

The Hajj, its rituals (*manasik*) and holy places (*masha'ir*) are described as *irth Ibrahim* (the legacy of Ibrahim),[8] mirroring the Qur'anic depiction of Ibrahim as the original imam of the Hajj. The foundations of the Ka'ba are described in the *Hadith* as *qawa'id Ibrahim* (the foundations of Ibrahim),[9] again echoing the Qur'anic description of Ibrahim's construction

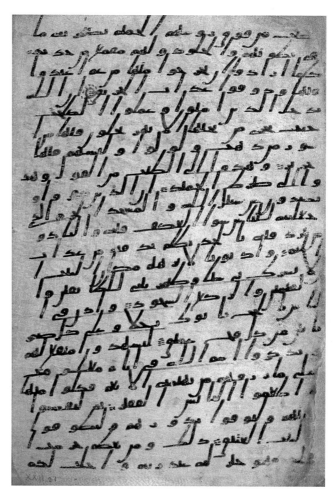

Plate 1 Qur'an, Arabia, c. 8th century. British Library, London (Or 2156, f.59b). Lines 13–17 record Qur'an 22:26–7, describing God's command to Ibrahim to inaugurate the Hajj. This may be the oldest surviving document referring to the Abrahamic narratives of Hajj origins (© The British Library Board)

of *al-bayt*. The *Hadith* cites ritual locations such as the well of Zamzam, Safa and Marwa and the original construction of the Ka'ba in narratives about Ibrahim's original settlement of Mecca with his son Isma'il (Ishmael).[10] Some *hadith*s even report that pictures of Ibrahim and Isma'il were painted on the walls of the Ka'ba in pre-Islamic times.[11] The special connection between Mecca and Ibrahim is also reinforced through the notion that Mecca's status as a holy sanctuary (*haram*) was ordained by God 'via the tongue of Ibrahim'.[12] The importance of Hajj as an act of monotheistic worship is thus portrayed in both the Qur'an and *Hadith* as being inspired by God, but mediated through the person of the prophet Ibrahim (**Pl. 2**).

We here encounter a model in which the early Muslim community portrays holy sanctuaries as connected with the founding person of their prophets. This model, and further emphasis on the Abrahamic origins of Mecca, appears in *hadith*s regarding Muhammad's settlement of Medina after the *Hijra*. Muhammad is said to have declared that 'each prophet has a sanctuary (*haram*), and my *haram* is Medina'.[13] The *hadith*s describing Muhammad's settlement of Medina also expressly compare the two prophets' establishment of holy sanctuaries; Muhammad was reported to say, 'I sanctify (*uharrimu*) that which lies between [Medina's] two stony plains (*labatayha*), just as Ibrahim sanctified (*harrama*)

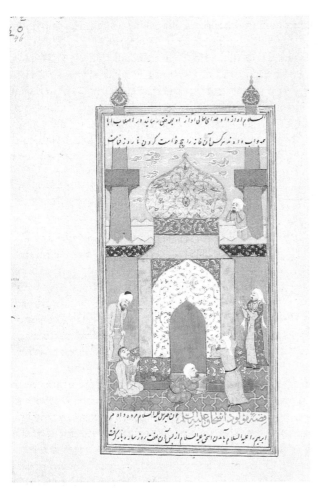

Plate 2 Ishmael and his father Abraham pray after building the Ka'ba. Staatsbibliothek, Berlin (Diez A fol. 3, f. 46r)

Mecca'.[14] The specifically Abrahamic connection of Mecca's holy sites and the Hajj ritual are thus embedded in a construction whereby Ibrahim, divinely inspired, represents the foundation of Mecca's sanctity.

The model in which sacred geography and ritual sites are perceived as the personal property of holy men was noted in southern Arabia during the early 20th century.[15] Whether the desert sanctuaries encountered by European researchers are the distant descendants of the belief in the prophetic origins of both Mecca and Medina is a matter for separate consideration, but for our purposes, the specific emphasis placed on Ibrahim's connection to Mecca and the Hajj in both the Qur'an and the *Hadith* and the continuation of the Hajj in Islam with its distinctly Abrahamic connections are readily explainable if we understand that, around Muhammad's time, shrines were perceived as the holy space of specific prophets. The narratives support an interpretation that Mecca was perceived as Ibrahim's special sanctum and the Hajj as his personal legacy to monotheism. Muhammad accepted Ibrahim as a major prophet,[16] and upon triumphing in Mecca, Muhammad was in a position to restore Ibrahim's rites and resurrect monotheism in the sanctuary of Ibrahim.

Mecca's sanctity is occasionally described without reference to Ibrahim, whereby some *hadith*s state 'Mecca was sanctified by God',[17] and call the Ka'ba the 'House of God' (*bayt Allah*).[18] With one exception, these statements do not appear in *hadith*s concerned with the history of Mecca, but

rather its quality as a hallowed space. And the exception, a reference to the Ka'ba as 'the House of God', occurs in an account of Ibrahim's construction of the sanctuary.[19] The assertion that Mecca's sacredness ultimately derives from God does not affect Ibrahim's historical role as the prophet who invoked this status. These *hadith*s thus indicate that the early Muslims believed Ibrahim to have been intimately involved with the establishment of a ritual site in Mecca, and they provide no evidence that early Muslims believed Adam or any other person made a pilgrimage to Holy Mecca before Ibrahim. As for Adam, the canonical collections of *hadith*s portray him, uncontroversially, as the first man, but are silent on his life after the fall from Paradise. Ahmad ibn Hanbal does record a *hadith* describing the purported burial of Adam (which is posited as the origin of several Islamic burial practices), but there is no intimation that this occurred in Mecca;[20] and the Qur'an and *Hadith*, read on their own, consistently provide an Abrahamic focus for Mecca's blessedness and the ritual significance of the Hajj.

The first Hajj (2): ninth- and tenth-century texts

The Abrahamic aspects of the Hajj remain a fixture in the tradition to the present day, but from the third/mid-ninth century, history books and Qur'an commentaries begin to report the story of the Hajj of Adam. There are some minor variations, but the story's framework according to historians such as al-Azraqi (d. 864), Ibn Qutayba (d. 885), al-Ya'qubi (d. 897–8) and al-Tabari (d. 923) is as follows.[21] After his fall from Paradise, Adam is said to have landed in the mountains in India. Dejected, Adam despaired his separation from God and the angels who circumambulate God's throne in worship. To console Adam, God instructed him to leave the mountains and journey to Mecca.

Why Mecca? Here, the historians explain that in their cosmology, Mecca is directly aligned under the throne of God, and the path around the Ka'ba is thus, spatially, the terrestrial equivalent of the angels' heavenly circumambulation of God's throne, and, spiritually, the centre of the world.

Upon arriving in Mecca, Adam, in imitation of the angels, performed the *tawaf* (circumambulation) and completed a Hajj under the direction of an angel who instructed him in some of its rituals. According to some texts, Mecca is also where Adam was reunited with Eve (she had landed near Jedda).[22] The historians continue the narrative, stating that Adam established a tent where the Ka'ba currently stands, and there he placed a heavenly ruby (foreshadowing Ibrahim's later placement of the Black Stone currently *in situ*).[23] Adam treated this space as an inviolable sanctuary (*haram*) in which the historians tell us only he could dwell and, where, in most versions, he spent the rest of his life. According to these sources, the first permanent *bayt* of the Ka'ba was erected by Adam's sons after his death.

In light of this story, ninth-century historians began to reinterpret Ibrahim's role in the Hajj. He was now cast as the rebuilder of Adam's Ka'ba which was said to have been washed away in the Great Flood.[24] The history of the Hajj was thus shifted backwards. Whereas the Qur'an portrays Muhammad as restorer of Ibrahim's Hajj and the *hadith*s call the foundations of the Ka'ba *qawa'id Ibrahim* (Ibrahim's

foundations), from the mid-ninth century, histories portray Ibrahim as merely a restorer and Adam assumed the mantle of the first *hajji* and the sanctuary's first inhabitant. Mecca's historical and theological significance was thus tracked backwards to the beginning of time, but this is manifestly at odds with the earlier Qur'anic and *Hadith* narratives.

The Hajj of Adam: sources and controversies

While extant texts referring to Adam's Hajj date only from the ninth century, the historians who recorded the story indicated through its *isnad* (chain of authorities) that it was told originally by early scholars such as Ibn 'Abbas (d. 687) and Mujahid (d. *c.* 718). If such attributions are correct, the story is almost as old as the Qur'an and *Hadith*, and its appearance in ninth-century texts would not indicate such a stark division in the community's conception of the first Hajj. Close examination of the historians' accounts of Adam's Hajj, however, reveals that the narrative style is markedly different from accounts of Ibrahim's Hajj. Specifically, the Ibrahim stories, even in later histories such as that of al-Tabari's,[25] are invariably cross-referenced with quotations from the Qur'an and *Hadith* whereas Adam's have no external corroboration – we read them as pure narration of the historians. Is it possible therefore that Adam's Hajj was inserted sometime between Muhammad's death and the mid-ninth century, and so indicates changing opinions on the early Hajj? The fact that the historians marshalled neither Qur'anic nor *Hadith* texts to corroborate the Adam story suggests this, and a survey of citations of Mecca and the first Hajj in ninth- and tenth-century literature indicate this may indeed have been the case.

Geographical considerations

In a celestial cosmology, the claim that Mecca lies on a blessed trajectory directly beneath the throne of God is a logical and undoubtedly convenient means to explain why God directed Adam to Mecca, to highlight the parallels between the *hajji*'s circumambulation of the Ka'ba and the angels' worship of God in the Highest Heaven, and also to underscore the significance of Mecca and the Hajj for contemporary pilgrims. In terms of the Muslim tradition, however, the imputing of such spatial significance to Mecca appears to originate from historians and exegetes, the tellers of *akhbar* (reports) who narrated stories of the Hajj of Adam. Early Muslim geographers, on the other hand, were slower to adopt this paradigm.

Of the early geographers, Ibn Khurdadhbih's (d. *c.* 912) *Al-Masalik wa-l-Mamalik* plots a description of the world whereby Baghdad and the *Sawad* of Iraq (the arable land between the Tigris and Euphrates) are the central reference point. By Ibn Khurdadhbih's time, historians commonly cited the narrative of Adam's Hajj,[26] and Ibn Khurdadhbih briefly mentions it himself in his description of Mecca.[27] But Mecca is merely part of the 'Land of the South' (*Tayman*) in Ibn Khurdadhbih's worldview, whereas all regions of the world converge on Iraq: the lands of the east, west, south and north all seem to commence from the gates of the Abbasid imperial metropolis of Baghdad.[28] Not only is Iraq narrated as the centre of the world; it is also the first region Ibn

Khurdadhbih describes. Politically, he identifies it as the heart of the Sasanian Persian Empire which justifies its elevated importance,[29] and 'scientifically', by using his contemporary technical terminology of the four elements (fire, earth, water and air) and states (hot, dry, cold and wet), Ibn Khurdadhbih explains that Iraq sits comfortably in the middle, the ideal, balanced location for habitation.[30] Al-Ya'qubi's geographical text *Kitab al-buldan* of the late ninth century also commences with Baghdad for reasons similar to those adduced by Ibn Khurdadhbih,[31] and another mathematical, neo-Ptolemaic approach to world mapping laid out by Sohrab in *'Aja'ib al-aqalim* also provides for Baghdad to fall in the precise centre.[32]

By the tenth century, however, in the geographies of al-Istakhri (d. 961), al-Muqaddasi (d. 988) and Ibn Hawqal (d. 990), we find Mecca and the Arabian Peninsula taking pole position. The presence of Mecca and the *qibla* (direction of prayer) in Arabia are cited as justification for its status as the world's most prestigious region,[33] and al-Muqaddasi adds that Mecca was the node from which the world 'protruded into shape' (*duhiyat*).[34] The geographical privilege of Arabia on account of Mecca's religious significance, and particularly the concept of Mecca's spatial importance as the nodal point of the world since Creation marries well with the cosmological and historical privilege of Mecca asserted by Muslim historians who portray it in the Adam stories as the first place of terrestrial worship, aligned underneath the throne of God. But geographical texts seem to have adopted this position relatively late – i.e. by the mid-tenth century, by which time historical texts had been narrating Mecca's centrality for about a century. Did the geographers take their lead from the historians? As a survey of a broader range of Arabic writings will reveal, the geographers do appear to have been responding to a wider-scale phenomenon in Muslim intellectual circles in which the Hajj of Adam suddenly emerges in the mid-ninth century and rapidly asserted its primacy, generating wide-scale ramifications for the position of Arabia in the Muslim consciousness.

Pre-Islamic Arabian history: ninth-century narratives

In terms of the history of the Hajj, the earliest extant books of pre-Islamic Arabian history, written in the first half of the ninth century, follow the Hajj narrative from the Qur'an and *Hadith*. Ibn Hisham's (d. 833) biography of the Prophet details Muhammad's genealogy from Adam and explores the religious history of pre-Islamic Mecca without making any mention of Adam's Hajj. Ibn Hisham also closely echoes the Abrahamic emphasis of the Hajj, referring to the foundations of the Ka'ba as *asas Ibrahim* (the foundation of Ibrahim; compare with *qawa'id Ibrahim* from the *Hadith*),[35] and he even calls the sanctuary itself *bayt Ibrahim*.[36]

Adam is similarly absent in Ibn Habib's (d. 859–60) *al-Munammaq* (a history of Mecca and the Quraysh tribe) and *al-Muhabbar* (a compendium of anecdotes largely about pre-Islamic Arabia). Ibn Habib's narratives are focused on reconstructing the history of Arabia and his discussion of the Hajj is centred on portraying it as the key pre-Islamic Arabian ritual. Hence, Ibn Habib relates various memories of the 'pagan' Hajj and even an account of a soothsayer who

inhabited the Ka'ba.[37] He mentions Arabian ritual sites which appear as 'pseudo-Ka'bas' to which Hajj-like pilgrimages were reportedly made,[38] but to highlight the primacy of Mecca's Ka'ba, Ibn Habib calls it *bayt Allah* (God's [sacred] House).[39] He also relates an anecdote in which the Ka'ba is called *bayt al-'Arab* (the [sacred] House of the Arabs). This unusual name may be explainable in light of Ibn Habib's emphasis on portraying the Hajj as the primary festival of the pre-Islamic Arabs.[40]

Given his focus on Mecca's pagan Arab history immediately before the Islamic period, Ibn Habib rarely comments on the more ancient origins of the Hajj, but when he does, he returns to the Abrahamic narrative. For example, when listing the ritual locations of the pre-Islamic Hajj, Ibn Habib notes that they were ordained by Ibrahim, and that Quraysh – the powerful Meccan tribe from which Muhammad hailed – acknowledged their Abrahamic origins.[41] Ibn Habib, in short, narrates the pre-Islamic Hajj as an Abrahamic ritual partially corrupted by paganism and in need of restoration, once again paralleling the Qur'anic conception of the history of Hajj.[42]

Ibn Hisham's and Ibn Habib's works with their Abrahamic conception of the origins of the Hajj are curiously silent on the Hajj of Adam which appears in the histories of al-Ya'qubi and al-Tabari written only a generation or two later. In accounting for this silence, two relevant factors are immediately apparent to distinguish Ibn Hisham and Ibn Habib from the later historians. The earlier writers date from the first half of the ninth century, and their histories revolved around Arabia and Muhammad's prophethood. The later historians, on the other hand, wrote after the mid-ninth century and their books set out to narrate universal histories of the world. Adam's Hajj thus appears to have become in vogue some fifty years after Ibn Hisham and was endorsed by writers whose horizons of historical enquiry expanded beyond Arabia and Muhammad's lifetime, engaging broader visions of world history. We shall consider the ramifications of these differing motivations below, but first we shall explore the source material from which the later historians constructed Adam's Hajj.

Adam's Hajj: first stories, weak *isnads*

We cannot determine for how long anecdotes of Adam's Hajj circulated before al-Tabari and likeminded historians recorded them, but even if they did exist in the early ninth century, the stories provoke questions of authenticity which may have negatively impinged upon their initial scholarly reception. These issues emerge at the point of the narrative's first iterations in two histories of Mecca written by al-Azraqi and al-Fakihi in the mid-ninth century.

Al-Azraqi provides a historical survey of Mecca's history from Creation to the early Umayyad period in which Adam's Hajj and details of his life in Mecca are reported on the authority of the seventh-century Muslim narrators Ibn 'Abbas and Wahb ibn Munabbih,[43] with additional anecdotes from their contemporary Ka'b al-Ahbar.[44] All three narrators are frequently associated with fanciful or unusual historical anecdotes doubted by modern scholars who argue that later Muslim historians concocted such anecdotes and

falsely attributed them to the earlier narrators in an attempt to bestow 'ancient authority' on their forgeries. But not all stories attributed to Ibn 'Abbas and others are later counterfeits: genuinely old narratives are mixed with false attributions and the extant texts attributed to these ancient historians are a perplexing jumble. From our perspective of textual analysis, we can infer that al-Azraqi, by narrating the stories of Adam's Hajj at the outset of his book, and by expressly attributing the stories to old narrators, intended to make the case for their authenticity to persuade his readers to accept them. Whether his readers were initially convinced of the historicity of Adam's Hajj, however, is another matter, and evidence from al-Fakihi's contemporary text about Mecca demonstrates that competing narratives existed with apparently better authority.

Parts of al-Fakihi's text have been lost, including the narrative chapters on Mecca's history, but notwithstanding the losses, his book is still larger than al-Azraqi's and his tastes appear more catholic: al-Fakihi records an encyclopaedic array of sometimes contradictory anecdotes which paint a varied picture of how Muslims in the ninth century remembered the history of the Hajj.

Amongst the thousands of preserved anecdotes, Adam's Hajj is mentioned by al-Fakihi, although the nature of its recording requires close analysis. In a chapter dedicated to 'the first occurrences' of events in Mecca, Adam is mentioned six times: he was the first resident of Mecca and the first to be buried there.[45] This list also includes curious claims: al-Fakihi relates anecdotes describing Adam as the first man to mint coins in Mecca and also the first to call for a doctor there.[46] The *isnad*s for these latter anecdotes are extremely weak according to the standards of critical analysis developed by Muslim scholars to ascertain the quality of historical reports.[47] This introduces a pattern in al-Fakihi's work: the anecdotes he cites which mention Adam are either expressly doubted by al-Fakihi himself or related with questionable *isnad*s. This contrasts other accounts in al-Fakihi's text which stand up to the most rigorous *isnad* criticism.

Hence, al-Fakihi reports that '[t]he first to make the *tawaf* was Adam (peace be upon him); but contrarily, it is said the angels [were]',[48] and so through his editorial comment, he casts doubt on the precise origins of the Hajj. Furthermore, in discussing the first Hajj, al-Fakihi relates one anecdote in which it is linked to Adam, though its *isnad* is *matruk* (reprobate),[49] whereas in the next anecdote he reports that the Hajj was started by Ibrahim and interprets the term Maqam Ibrahim from the Qur'an to mean 'the whole Hajj'.[50] The *isnad* of this 'Abrahamic' anecdote is rated *sahih*, the highest standard of authority amongst Muslim scholars. In the succeeding pages, al-Fakihi relates more anecdotes suggestive of the Abrahamic origins of Hajj, including the statement, 'Everyone who makes the Hajj is responding to the call of Ibrahim'.[51] Similarly, when reporting the origin of the Black Stone, only three anecdotes (out of 34 in this section) report Adam's placement of the stone (or ruby) in the Ka'ba, and two of them are *da'if* (weak).

Al-Fakihi's writing style is common in ninth-century Arabic literature. Authors related an encyclopaedic array of anecdotes, both authentic and dubious, to produce a

'warts and all' version of history that expresses sometimes contradictory opinions. Authors generally leave the reader free to interpret the evidence, and when authors do guide their readers, they employ subtle methods. To help readers discern the truthful from the doubtful, authors rarely express their own opinion outright, but they commonly repeat their 'preferred version' more times and with 'stronger' isnads – in other words, anecdotes that would stand up better to the contemporary standards of anecdotal criticism. In the case of al-Fakihi's Hajj anecdotes, the repetition and authenticity are with the Ibrahim stories. Al-Fakihi would, thus, seemingly suggest that the Abrahamic perception of the origin of Hajj was more accurate and more commonly held by authoritative scholars than the 'Adamic' perception which was evidently present, but was supported by what would have been recognized as weaker authority according to contemporary standards.

Additionally, al-Fakihi gives an interesting insight into the traditions surrounding the origin of the names 'Arafa and al-Muzdalifa, two ritual locations of the Hajj, which in later literature are usually associated with Adam's Hajj and his reunion with Eve in Mecca.[52] Al-Fakihi does not relate anecdotes connecting Adam to 'Arafa and instead offers four stories with strong or even sahih isnads that unambiguously demonstrate its Abrahamic ritual origins.[53] Regarding al-Muzdalifa, al-Fakihi writes what may be his own opinion that 'al-Muzdalifa only received its name on account of the gathering (muzdalif) of people around it', effectively casting doubt on the subsequent anecdote he relates that links al-Muzdalifa to Adam which additionally has a weak isnad.[54] Thus, contrary to later accounts, the material and structure of al-Fakihi's sections on 'Arafa and al-Muzdalifa mitigate against the opinion that Adam visited them.

Al-Fakihi's compendium therefore illuminates an array of varied opinions surrounding Mecca's early history, mentioning both Adam and Ibrahim, though the manner in which al-Fakihi relates his material seems to favour the Abrahamic connections. His text does, however, shed light on the early genesis of the Adam anecdotes which, from their roots with seemingly weak authority, would over the next two generations vie with the Abrahamic version to settle a 'canonical' account of the origin of Hajj.

Ninth-century debate: 'Ibrahimists' versus 'Eternalists'?
If the stories of Adam's Hajj represented an inauthentic explanation for the origin of the Hajj, we should expect that mid-ninth century scholars would object and argue for the Abrahamic narrative. Luckily, surviving texts from the period preserve traces of debate over the historicity of Adam's Hajj as opposed to Ibrahim's, but the weight of opinion and the eventual outcome of the debate at the outset of the tenth century turned in favour of Adam.

Al-Jahiz (d. 869) informs us that scholars had become partisan to one of two camps: those who believed Mecca's sacred status began with Ibrahim, and those who asserted that Mecca's sanctity was eternal, even predating Adam. The 'Eternalists', with whom al-Jahiz sided, argued that the sacrosanctity of Mecca's Haram was a miraculous natural phenomenon that transcended any human agency. Animals

cease hunting in the Haram, birds will not fly over it and the relative fecundity of rains in Syria and Iraq can be predicted by observing rain over the Ka'ba.[55] Al-Jahiz accepted that Muhammad's decree rendered Medina a sanctuary (which resulted in the formerly foul-smelling location miraculously adopting a sweet scent),[56] but he considered the sacredness of Mecca of a different order, not commensurate with the mere human act of Ibrahim's blessing. Hence, al-Jahiz argued that Mecca must have been a sanctuary since the beginning of time. According to al-Jahiz's text, the arguments about Mecca's eternal sanctity referred to the Qur'an's description of Mecca as 'al-bayt al-'atiq'.[57] 'Atiq can mean 'ancient' but also 'free/autonomous', and al-Jahiz argues that the verse describes the sanctuary (al-bayt) as divinely protected from earthly authority – an eternal sanctity from God not inaugurated by Ibrahim.[58] Al-Jahiz mentions the opposing group of scholars would treat ''atiq' differently to maintain that Mecca's Haram began with Ibrahim.[59]

Moving ahead to the very end of the ninth century, al-Tabari's commentary on the Qur'an reports the same debate between 'Ibrahimists' and 'Eternalists' over the meaning of 'al-bayt al-'atiq'.[60] He also relates a similar debate over the interpretation of the Qur'anic phrase 'Maqam Ibrahim'.[61] According to al-Tabari, one group of scholars interpreted the 'Maqam' as meaning the whole Hajj.[62] These were the 'Ibrahimists' – they maintained that Ibrahim was the original hajji and that the verse implies the entire Hajj originated with Ibrahim's action in Mecca. On the other hand, al-Tabari and a group of scholars he cites in support argued that the 'Maqam' should only be read to mean one specific place of prayer in Mecca and not the entire Hajj ritual.[63] Their interpretation portrays the Hajj as something greater which predates Ibrahim.

Al-Tabari's evidence to support the 'Eternalist camp' included Adam's Hajj. According to al-Tabari, the fact that Adam made a Hajj proves that Mecca's holiness was older than Ibrahim. Remarkably, and demonstrating an apparent change in the tenor of the debate since al-Jahiz's day, al-Tabari even went so far as to call the 'Ibrahimists' juhhal (ignorants), extremely strong censure from the usually sober scholar, and demonstrating his avid partisanship to the 'Eternalist' argument in what had apparently become an acerbic debate.[64] The contempt al-Tabari expresses for the Ibrahimists may harbinger the eclipse of this discourse in later writings as the Eternalist narratives of Adam's Hajj became dominant from the tenth century onwards.

The shift from Abrahamic to Eternalist conceptions of Mecca was significant. Breaking through the Qur'anic historical horizon of the Hajj, later Muslim historians rendered Mecca a timeless sanctuary. As witness to this, al-Jahiz's inference of timeless holiness became a fact asserted with empirical statements: al-Tabari reports the rock of the Ka'ba floated on the primordial soup before the world was created.[65] The story of Adam's Hajj clearly reinforces the Eternalist discourse by unequivocally demonstrating that the first act of human history on earth was a Hajj. Mecca is no longer portrayed as the House of Ibrahim, but rather bayt Allah, the House of God alone (a sobriquet noted, but not dominant in earlier narratives),[66]

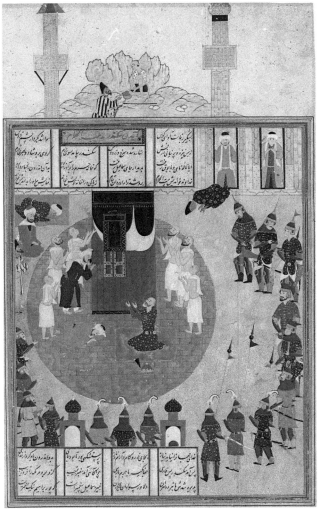

Plate 3 Alexander visits the Ka'ba, from the *Shahnama* of Firdausi, mid-16th century. The Nasser D. Khalili Collection of Islamic Art (MSS 771) (© Nour Foundation. Courtesy of the Khalili Family Trust)

narratives of Adam's Hajj as they bestowed timelessness to the Hajj and affirm Mecca's global importance, and so cogently answer the question 'why do we make the Hajj?' for a wider audience.

Hajj before Muhammad and the 'rise' of Mecca

The establishment of Mecca's timeless sanctity paved the way for a proliferation of Hajj narratives. Firstly, historians began to ascribe the performance of Hajj to most if not all prophets,[67] even Noah is said to have performed a kind of Hajj during the Flood when his Ark circumambulated the waters over the Ka'ba seven times.[68] The ancient 'Arab' prophets Hud and Salih are also said to have sought refuge in Mecca after their communities, which did not heed their warnings of God's punishment, were destroyed.[69] Secondly, and more profoundly, this conception of Mecca fundamentally coloured Muslim accounts of pre-Islamic history. Mecca became an eternal beacon of virtue in the mental map of Arabia in the *jahiliyya* (pre-Islamic times), and the journey to Mecca became an act *de rigueur* for praiseworthy figures in narratives of pre-Islamic history.[70]

Hence many communities in the Muslim Empire incorporated Mecca and the Hajj into their own pre-Islamic history. Sasan, ancestor of the Sasanian Persian dynasty, was said to have sent gifts to the Ka'ba,[71] and the Muslim portrayal of Alexander the Great reportedly included him performing a Hajj (**Pl. 3**).[72] Yemeni historians ascribed Hajj performances and other interactions with Mecca to their mythical kings, the *Tababi'a*, and one was even credited with inaugurating the now traditional rituals of adorning the Ka'ba in cloth (*kiswa*) and making a feast for the pilgrims.[73] The Hajj also became a regular activity in the stories of pre-Islamic Arabian folkloric heroes.[74]

A factually minded critic may question the widespread reference to the Hajj before Muhammad, but for our purposes, as students of the stories of Muslim historiography, the pre-Islamic Hajj is a prominent and very real phenomenon in our source texts. Somewhat analogous to Mecca's spatial position as the focal point of prayer and pilgrimage, Mecca acquired a similar literary gravitational pull, attracting the limelight in stories of pre-Islamic history. 'Literary Mecca' became the symbolic centre of both monotheism *and* the Arab world, as narratives of pre-Islamic prophets and pre-Islamic Arabian history came to revolve around it. Mecca thereby provided a link between Arabs and the worship of Allah long pre-dating Muhammad and the Qur'an. The narrative that the Arabs spread over all of Arabia and thence, via the Islamic conquests, into the Near East was also portrayed as starting from Mecca.

Stories of pre-Islamic Mecca thus come to serve a dual purpose for Muslim narrators: on the one hand, Mecca's role as a spiritual centre provided a means for different communities to establish praiseworthy credentials for indigenous heroes such as the Persian Sasan. And secondly, Mecca's role as a central Arab homeland permitted narrators to assert 'authentic' Arab credentials for their past heroes via Hajj stories, for instance the frequent interaction between pre-Islamic Yemeni kings and Mecca allowed Yemeni historians to fully integrate their pre-Islamic history in an Arabian guise.

possessing eternal sanctity and cosmological spatial holiness lying directly under God's throne. God's order that Adam perform the Hajj is an integral part in establishing a portrayal of the Hajj as a universal expression of monotheism.

Therefore, we have seen that whilst the origin of the stories of Adam's Hajj, according to the traditional methods of *isnad* criticism, lies on weaker premises, within fifty years of al-Fakihi's compendium Muslim scholars had come to embrace it and even chastise those who would deny it. The veritable paradigm shift can perhaps be understood in the context of changing audiences in the Muslim world. Muhammad led a community where guidance was expressed through the person of the Prophet. The close association of the Hajj with Ibrahim, a prophet himself, would emphasize and justify the ritual's importance: the Hajj was portrayed as Ibrahim's personal guidance to monotheists. But over the succeeding 150 years, Islam expanded and large numbers of new peoples in far-flung places entered the community. At this time, the historical horizons of Muslim writers commensurately broadened, and by the ninth century, they began to write universal histories of the world. No longer strictly a prophetic community, and possessing a much broader historical consciousness, the more diverse audiences of later historians would appreciate

Adam's Hajj thus did much more than posit a starting point for the pilgrimage and justify the ritual in Islam. It facilitated a major orientation of pre-Islamic history portraying Mecca as the nodal point of the Arab people, and indeed world history, channelling the attention of Muslim scholars of pre-Islamic history to Mecca. Muhammad's origin was thus spatially aligned with the origin of the world, and temporally aligned with world history: in the Muslim narratives Mecca became the site of the first act of history (Adam's Hajj) and also the most important act of history (the beginning of Muhammad's mission). Accordingly, Mecca's footprint in the memory of pre-Islamic times was vastly increased to provide a bedrock upon which Muslim historians would reconstruct the history of the Arabs. From *asas Ibrahim* (the foundation of Ibrahim), Mecca became *asas al-'Arab* (the foundation of the Arabs) and profoundly coloured the telling of Arabian history.

Notes

1 Research on this topic is vast and varied; some even deny that Mecca was Islam's original cult centre (originally in Crone 1987, and repeated very recently in Holland 2012: 328–31). Hawting 2004: xvii, xxi–xxiii; Lazarus-Yafeh 1981; Peters 1994a: 10–54, 1994b: 5–19 summarize the panoply of scholarship on the Hajj's origins and precedents.

2 The *Hadith*'s authenticity is hotly debated. Schacht's classic deconstruction in *The Origins of Muhammadan Jurisprudence* is counterbalanced by Azami's defence in *On Schacht's Origins of Muhammadan Jurisprudence*. It is perhaps imprudent to assert that a given *hadith* records the Prophet's speech verbatim, but many are of considerable antiquity and do represent some of the earliest records of the Muslim community, if not from the time of the Prophet, at least from the first few generations (Motzki 1991).

3 Pre-Islamic poetry includes references to Mecca and the Hajj primarily preserved in the ninth-century histories of Mecca and the Quraysh tribe. The authenticity of these is doubtful, and my preliminary survey of the better established 'canonical' collections of pre-Islamic verse compiled in the eighth to ninth centuries (al-Mufaddaliyyat, al-Asma'iyyat, al-Hamasa) revealed no citations of the Hajj. The complex question of poetry and Hajj history requires lengthy analysis outside the scope of this essay.

4 Adam's Hajj is thoroughly endorsed by al-Tabari (1990, I: 745–56, *Tarikh* [n. d.], I: 121–36), and repeated thereafter. See al-Qurtubi 2000, II: 81; Ibn Kathir [n.d.], I: 85; Ibn al-Jawzi 1995, I: 105.

5 It has been suggested that '*al-bayt*' does not mean the Ka'ba as assumed by later Muslim exegetes (Hawting 2001, III: 79), but the clusters of verses describing *al-bayt* do have a lexical unity with words associated with Hajj and Mecca such as *Hajj, Maqam Ibrahim, Bakka, Masjid al-Haram* and *Bayt al-Haram* (Q.2:124–8, 3:95–7, 5:97, 7:34–5, 22:25–9). Even without recourse to later exegesis, an application of the verses to interpret each other strongly suggests that pilgrimage to Mecca is intended.

6 The text reads 'Bakka' instead of 'Mecca'. All Muslim exegetes affirm that the Qur'an's Bakka is one and the same as Mecca, explaining that Bakka is a nickname for Mecca derived from a verb connoting a crush (caused by pilgrims gathering). The letters 'b' and 'm' also can be interchangeable in Arabic speech, for instance '*bayda anna*' and '*mayda anna*', both connoting 'however'; or *lazib* and *lazim* meaning 'necessary' (see Ibn Manzur 1990, I: 738).

7 See note 2.

8 Al-Tirmidhi 1999: *al-hajj* 53; Sulayman 1999: *al-manasik* 62.

9 Al-Bukhari 1999: *al-hajj* 42.

10 Al-Bukhari 1999: *al-anbiya'* 9; Muslim ibn al-Hajjaj 1999: *al-hajj* 398.

11 The reports describe the pictures as being of either Ibrahim and Isma'il or Ibrahim and Maryam (Mary), see Sulayman 1999: *al-Manaqib* 92; al-Bukhari 1999: *al-hajj* 54, and Ibn Hanbal 1993, I: 362.

12 Ibn Majah 1999: *Manasik* 104.

13 Ibn Hanbal 1993, I: 414.

14 This *hadith* is frequently cited, see al-Bukhari 1999: *al-Madina* 1, *al-anbiya'* 10; Muslim ibn al-Hajjaj 1999: *al-hajj* 445–6, 458; Sulayman 1999: *al-manasik* 96; al-Nasa'i 1999: *al-hajj* 11, 111, 120.

15 Sergeant 1962: 42, 52–3.

16 The close parallels between Ibrahim and Muhammad are reflected in many aspects of Muslim ritual texts and practices, for instance, in prayer Muslims invoke blessing on both prophets together.

17 Al-Bukhari 1999: *al-hajj* 43, al-Tirmidhi 1999: *al-hajj* 1; Ibn Majah 1999: *al-manasik* 103.

18 Al-Bukhari 1999: *al-anbiya'* 9, *Jaza' al-Sayd* 27.

19 Al-Bukhari 1999: *al-anbiya'* 9.

20 Ibn Hanbal 1993, V: 136.

21 The following account is based on al-Azraqi 1983, I: 43–51, al-Ya'qubi [n.d.], I: 5–7 and al-Tabari [n.d.], I: 121–36. Their narratives are remarkably consistent, differing only in minor details, such as the precise mountain upon which Adam landed (al-Tabari [n.d.], I: 121–2), the exact nature of the Hajj rituals he performed (al-Azraqi 1983, I: 43–6) and the number of pilgrimages he performed (al-Tabari [n.d.], I: 124–5).

22 Al-Tabari [n.d.], I: 121–2.

23 Some sources omit mention of the ruby and state that Adam himself placed the Black Stone (which shone white at the time) in the sacred precinct (al-Azraqi 1983, I: 328).

24 For the flood, see, for example al-Azraqi 1983, I: 50–2 and al-Tabari 1999, I: 752.

25 Al-Tabari [n.d.], I: 251–62.

26 Among the writers of history during the late ninth century, it appears that only al-Dinawari's *Akhbar al-tiwal* omits narration of the Hajj of Adam.

27 Ibn Khurdadhbih [n.d.]: 133.

28 Ibn Khurdadhbih [n.d.]: 18, 72, where each of the Lands of the East and West are traced via a route from Baghdad.

29 Ibn Khurdadhbih [n.d.]: 5.

30 Ibn Khurdadhbih [n.d.]: 158.

31 Al-Ya'qubi 1892: 233–4.

32 Sohrab 1930: 30.

33 Ibn Hawqal [n.d.]: 18.

34 Al-Muqaddasi 1906: 67. A view earlier noted in al-Azraqi's history of Mecca (I: 31–2).

35 Ibn Hisham 1936, I: 195.

36 Ibn Hisham 1936, I: 28, 48, 199. The term '*Bayt Allah*' (The House of God) which conjures images of more eternal sanctity does occur, but less frequently, see Ibn Hisham 1936, I: 196.

37 Ibn Habib 1942: 156–7, 178–81, 311–15.

38 Ibn Habib 1942: 315–19.

39 Ibn Habib 1985: 25–6.

40 Ibn Habib 1985: 74.

41 Ibn Habib 1985: 126.

42 The Qur'an expressly chastises the corrupted Hajj of the pagan Meccans (Q.8:35).

43 Al-Azraqi 1983, I: 36–47.

44 Al-Azraqi 1983, I: 40.

45 Al-Fakihi 1994, III: 208, 223.

46 Al-Fakihi 1994, III: 208, 227–8.

47 The coins anecdote is described as '*da'if jiddan*' (very weak), while the doctor story is described as '*mursal*' – an anecdote with gaps in the chain of transmission (al-Fakihi 1994, III: 227–8).

48 Al-Fakihi 1994, III: 219.

49 Al-Fakihi 1994, II: 444.

50 Al-Fakihi 1994, II: 445.

51 Al-Fakihi 1994, II: 446–7.

52 Al-Tabari [n.d.], I: 121–2. He relates 'Arafa was so named as Adam found Eve there, associating the name with the verb '*arafa* (to know) and al-Muzdalifa was named because both Adam and Eve went there, an association with the verb *izdalafa* (to gather).

53 Al-Fakihi 1994, V: 9–10.

54 Al-Fakihi 1994, IV: 312.

55 Al-Jahiz 1998, II: 72–4.

56 Al-Jahiz 1998, II: 74.

57 Q.22:29.

58 He argues linguistically that the Qur'an's placement of the definite article on '*al-bayt*' demands the 'Eternalist' interpretation (al-Jahiz 1963–79, IV: 119).

59 Al-Jahiz 1963–79, IV: 120.
60 Al-Tabari 1999, XVII: 199–200.
61 Q.1:125. Al-Tabari 1999, I: 745–8.
62 Al-Tabari 1999, I: 745–6, a view which al-Fakihi reported along
 with robust *isnad*s (1994, 2: 445).
63 Al-Tabari 1999, I: 747–8.
64 Al-Tabari 1999, I: 756. For his argument leading to this statement,
 see I: 754–6.
65 Al-Tabari 1999, I: 761.
66 For instance, it is only cited twice in al-Bukhari. See notes 19 and
 40.
67 Al-Tabari 1999, I: 760. Al-Azraqi notes that 70 prophets have
 performed the Hajj, and records different prophets' *talbiyya* (the
 saying Pilgrims make on Hajj) (al-Azraqi 1983, I: 73). See also
 al-Azraqi 1983, I: 53 for the Hajj of Angels before even the
 Prophets.
68 Al-Tabari [n.d.], I: 185.
69 For Hud, see Ibn Qutayba 1958: 28; for Salih, see al-Tabari [n.d.], I:
 232.
70 See the story of the sage Luqman and the 'Delegation of 'Ad' who
 reportedly journeyed to Mecca many centuries before Muhammad
 to pray for rain (al-Tabari [n.d.], I: 219–22). The Ghassanids and
 Lakhmids, pre-Islamic Arab kings of Syria and Iraq respectively,
 were also ascribed the performing of Hajj (al-Jahiz 1963–79, IV:
 120).
71 Al-Mas'udi 1966: §575.
72 Al-Dinawari 2001: 75. Alexander's Hajj was often reported and
 even illustrated in subsequent centuries.
73 Al-Khuza'i (d. *c.* 760) may be the earliest reference to King Tubba'
 al-Akbar's Hajj, his seven-time circumambulation of the Ka'ba
 and slaughter of the *budn* (fat animals for feeding the poor) (53). For
 variations in later Yemeni histories see the pseudo Wahb ibn
 Munabbih's *al-Tijan* (1997, 139, 142) and Nashwan al-Himyari 1985:
 161. For narratives of three Yemeni 'Tubba'' kings and the Hajj, see
 also al-Azraqi 1983, I: 132–4.
74 E.g. the many examples of 'Arab kings' performing Hajj in al-'Absi,
 Sirat 'Antara [n.d.], I: 64, 91.

Chapter 3
The Official Announcement of an Umayyad Caliph's Successful Pilgrimage to Mecca[1]

Harry Munt

In the year 725, the Umayyad Hisham ibn 'Abd al-Malik (r. 724–43) set out from Syria on a journey to the Hijaz, only a year after his accession as caliph. In Medina, he led the funeral prayers for a recently deceased local scholar, Salim ibn 'Abd Allah ibn 'Umar, who was the grandson of an earlier caliph and the Prophet's second successor, 'Umar ibn al-Khattab (r. 634–44).[2] Noticing that there was quite a considerable number of people in the town, Hisham levied four thousand men from Medina for military service. On his approach to Medina he had also written to another local scholar, Abu al-Zinad 'Abd Allah ibn Dhakwan (d. *c.* 747–8), asking the latter to provide him with some notes on the proper customs and rites to be observed while undertaking the Hajj.[3] This request underlines the main reason for Hisham's journey to the Hijaz, which was, of course, both to perform the Hajj rites in and around Mecca and probably to lead the other pilgrims in theirs.[4] After his stay in Medina,[5] Hisham moved on to Mecca where he carried out both the Hajj rites and a number of other duties. As in Medina, in Mecca he led the funeral prayers for another scholar, Ta'us ibn Kaysan.[6] He also had to deal with a local troublemaker from the Umayyad family who insisted that Hisham curse the original enemy of their family, 'Ali ibn Abi Talib; Hisham refused to do so and merely stated: 'We did not come [here] to vilify or curse anyone, but as pilgrims'. Shortly after he had finished praying in the *Hijr* – eventually understood as the semi-circular area next to the Ka'ba – Hisham was petitioned by another notable Meccan to redress a wrong that had occurred during a property dispute.

These are the main features of Hisham's pilgrimage of 725 to which attention was drawn by the famous Muslim jurist and historian Abu Ja'far Muhammad ibn Jarir al-Tabari (d. 923).[7] According to the worldview of this and other scholars of the Abbasid period, a caliphal Hajj was rarely undertaken simply as an act of personal piety, but was rather on many levels an extremely important political act.[8] When Hisham acceded to the caliphate, it had already been a considerable time since a reigning caliph had actually resided anywhere in the Hijaz, in either Mecca or Medina; it was nearly 70 years since the murder of 'Uthman ibn 'Affan in 656, and more than 30 years since the defeat of 'Abd Allah ibn al-Zubayr in 692. Since Hisham was the first reigning caliph even to visit the Hijaz for nine years, it should come as no surprise that there were a number of petitions to deal with and ceremonial requirements to fulfil.[9] Leadership of the Hajj was a symbolic demonstration of the caliph's role as leader and guide of the Muslim community, and it is this aspect of Hisham ibn 'Abd al-Malik's pilgrimage to Mecca that will be the focus of the present chapter.

In many respects, Hisham's journey to Mecca for the Hajj was unremarkable. He was neither the first caliph to lead the rites, nor was he the last. Muhammad himself is often believed to have set the precedent for official leadership of the pilgrimage when in 632 he guided the pilgrims during the Farewell Pilgrimage (*hijjat al-wada'*), something that we will return to below.[10] The earliest caliphs had themselves resided in Medina, and so it is not surprising that they too are reported as having led the pilgrims at Mecca fairly frequently.[11] As the centre of the caliphate moved away from

the Hijaz to Syria and Damascus, caliphal leadership of the Hajj became much less frequent, although when they did not go in person, caliphs remained eager to delegate the responsibility to men whom they could completely trust, usually, although not always, a close relative. It is relatively clear that the Umayyads considered their leadership of the Hajj – be it in person or through the appointment of a subordinate – as an integral part of their office as leaders of the Muslim community. Margaret McMillan has suggested in a recent study of the Umayyad caliphs and the Hajj that, circumstances being appropriate, Marwanid caliphs liked to be seen leading the pilgrimage at least once during their reigns.[12] Since, however, neither 'Umar ibn 'Abd al-'Aziz (r. 717–20) nor Yazid ibn 'Abd al-Malik (r. 720–4), nor any Umayyad caliph after Hisham, led the Hajj as reigning caliphs, this was probably not a firm and fast rule (at least not for those who only had short reigns).

Likewise, others who wished to challenge the Umayyad family's entitlement to the caliphal office would, if possible, seek to undermine their authority by leading the Hajj themselves. This threat to Umayyad legitimacy was made particularly clear at the famous Hajj of 688. At this time the Umayyads were being seriously challenged on several fronts, and there were no fewer than four rival parties undertaking the Hajj rites behind separate banners: alongside the followers of the Umayyads were the supporters of Muhammad ibn al-Hanafiyya, 'Abd Allah ibn al-Zubayr and the Kharijite Najda ibn 'Amir.[13] The last Umayyad caliph, Marwan ibn Muhammad (r. 744–50), also suffered great political embarrassment when his governor of Mecca and Medina, 'Abd al-Wahid ibn Sulayman ibn 'Abd al-Malik, lost control of Mecca during the Hajj season in 747 to the Kharijite rebel Abu Hamza al-Mukhtar ibn 'Awf.[14] In the ninth century, one historian could claim that the caliphate truly belonged to whoever controlled the holy sites of Arabia and the Hajj, so we should understand the threat posed by these rebels to the Umayyads as a very real one.[15]

It was not simply that by leading the Hajj in person caliphs could demonstrate their suitability for office; by leading the pilgrimage rites in and around Mecca the caliphs could also attempt to control and determine which precise rites were followed.[16] It has already been noted that Hisham ibn 'Abd al-Malik was said to have asked Abu al-Zinad how best to perform the Hajj, and there is no indication that the caliph did not defer to the latter's recommendations. Hisham's brother Sulayman (r. 715–17), however, who as caliph led the Hajj in 716, was not so deferential. It is also reported that he asked leading local scholars in the Hijaz how to perform the pilgrimage rites correctly, but when they all disagreed he simply asked how his father 'Abd al-Malik (r. 685–705) had done it and declared that he would do it that way too.[17] 'Abd al-Malik himself while caliph had written to his infamous subordinate, al-Hajjaj ibn Yusuf, to give him orders concerning the proper fulfilment of the pilgrimage rites (manasik), which in this case entailed following the precedent set by the famous Hijazi scholar 'Abd Allah ibn 'Umar ibn al-Khattab.[18] As late as the tenth century, the geographer and traveller al-Muqaddasi could still suggest that in the very early Abbasid period the inhabitants and pilgrims at

Mecca were in need of a caliph – in this case Abu Ja'far al-Mansur (r. 754–75) – to remind them of the true sanctity of the Ka'ba and mosque there.[19] All of this suggests that the Umayyad caliphs tried to use their leadership of the annual pilgrimage both to advertise their own right to rule and – albeit perhaps in vain – to control how their subjects carried out that important religious and ritual act.

The caliph, the secretary and the Hajj

So why is Hisham ibn 'Abd al-Malik's Hajj of particular interest? Put simply, because of the survival of a remarkable page-and-a-half of text which purports to offer a copy of a proclamation written on behalf of an Umayyad caliph announcing that he had successfully completed the Hajj and its rituals.[20] The original does not survive, and nor does anything particularly close in date to an apparent original. The only copy of the text survives within a manuscript of al-'Ata' al-jazil fi kashf ghita' al-tarsil by one Ahmad ibn Muhammad al-Balawi, apparently copied in 580/1184–5.[21] This work is essentially an adab (literary) compilation which includes numerous exemplars of good Arabic prose. Among those exemplars are 15 letters, including one on a caliphal Hajj, attributed to the famous Umayyad court secretary 'Abd al-Hamid ibn Yahya (d. 750), who spent a little less than a decade working for Hisham's chancellery before he moved into the service of Marwan ibn Muhammad. A relatively large number – over 40 – of letters attributed to 'Abd al-Hamid are extant today within a variety of medieval compilations, a survival rate which can be attributed to his later reputation as one of founding pioneers of Arabic literary prose; they have been helpfully collected and edited by Ihsan 'Abbas and studied in some detail by Wadad al-Qadi.[22]

There is much to be debated concerning the authenticity of all these letters ascribed to 'Abd al-Hamid, especially as not a single one of them survives in any work written earlier than the mid-to-late ninth century, at least a century after 'Abd al-Hamid's death.[23] It is unlikely that this question of authenticity will ever be definitively resolved, but 20 years ago Wadad al-Qadi published a very thorough study of the entire extant corpus of 'Abd al-Hamid's letters in which she argued that the attribution of many of these letters (if not quite all of them) to 'Abd al-Hamid is likely to be correct.[24] The Hajj proclamation was among those she considered authentic, and it is also worth emphasising here that this particular text does not include any of the obvious signs of later forgery and/or misattribution identified in other studies of early Arabic epistles.[25] Since there is an almost total lack of extant documentary material relating to the Hajj in the Umayyad period, this proclamation is certainly worth examining in more detail.[26]

Here is a translation based on 'Abbas' edition of the Arabic text:[27]

> §1 God,[28] with His blessings and grace, did not cease to guide the Commander of the Faithful during the pilgrimage to His house which he undertook, and his presence at His/its sites and places, and during his completion of His/its rites and covenants; and in closeness to God, desiring means to him, and the virtue of nearness to him which he hoped to gain through that; [and in fact] in all of that which he desired [would bring

him] to God, and [in what] he entrusted to God that would bring him to it and to complete it. [This included] the greatest ease and company, the removal of repugnant things, and protection against what is cautioned against, until he approached God's Haram and His sanctuary (*amn*). There he found a group of pilgrims from distant lands and towns the likes of which he had never seen, neither regarding their huge number and quantity nor their effort [to attend] and crowding as they came into his view from every ravine. Among [them] were those fulfilling the Islamic pilgrimage (*hijjat al-Islam*) that God had ordained for them, those seeking to come closer to God hoping for reward for supererogatory work and accumulated merit, and those desiring [to be brought closer] to God through the doubling of good deeds and reduction of bad deeds that comes with that. God gave great joy to the Commander of the Faithful through what of this he saw, and he increased his praises of God for this and for what had inspired his subjects to send forth their bodies and spend of their wealth in obedience to God, performing the pilgrimage to His house, and following the custom (*sunna*) of His Prophet, may God bless him and grant him peace, as he had laid out for them.

§2 Then the Commander of the Faithful set out for 'Arafat, and he spared himself with you neither effort nor goodness in beseeching God and imploring Him; nor in venerating that which He made venerable at that station, what goodness, blessing and distinction He placed there, and the pardon, mercy and divine approval which He divided among those who deserved it.

§3 Then the Commander of the Faithful performed the *ifada* from 'Arafat and the sacred place (*al-mash'ar al-haram*) to Mina in the best way possible, with great meekness, tranquillity and dignity, and taking what direction[29] is known and all of what one comes close to God through [doing]. God showed the Commander of the Faithful and those who witnessed the festival (*mawsim*) with him the very best good health and well-being for which he had hoped and wished, after [their] longing, effort, and utmost exertion in that which was owed to God by the Commander of the Faithful.

§4 The Commander of the Faithful, and those whose presence on the pilgrimage God provided for, had never heard of [a pilgrimage that was] safer for those riding and walking, or with a greater crowd, or [carried out] with greater exertion. May God be praised and thanked!

§5 The Commander of the Faithful wrote this proclamation (*kitab*) of his to you when he had completed his pilgrimage and fully accomplished its rites, as the Commander of the Faithful has described them to you. He has informed you of the great trial that God set him, what He showed to him and those Muslims who attended the festival, how they hoped that God would answer his prayers, and the well-being and good health that he made known for himself and the elite and non-elite among his subjects. The Commander of the Faithful asks God – Who bestowed upon him the pilgrimage to His house which He granted him and encouraged him through a desire to do that – to grant him a true pilgrimage, an accepted act, and a striving gratefully received, and to answer the Commander of the Faithful's supplication on behalf of his elites and non-elites, to grant him success in all that is good, to protect him against those affairs that might concern him, and to return him to the goodness of pardon, mercy, forgiveness, good health, and well-being with which he who comes to God returns, in this world and the next. Peace.

This fairly short text follows the general form of an Arabic letter of the eighth century and seems to be more or less complete, since it starts with '*amma ba'd*', the usual

introductory phrase in early Arabic letters after opening blessings and addresses, and ends with a common concluding greeting, '*wa-al-salam*' (and peace).[30] Any original would presumably have had a *basmala* (In the name of God, the Compassionate the Merciful) and maybe a short *tahmid* (praise of God) section at the beginning before the '*amma ba'd*', and the extant text may be missing some concluding information at the end, such as the name of the scribe. Neither the addressee nor the person on whose behalf it was written are named, although the latter is regularly identified as the Commander of the Faithful (*Amir al-Mu'minin*), the standard title in official protocol of the period for the reigning caliph.[31] As 'Abbas and al-Qadi have already noted, that caliph is almost certainly Hisham ibn 'Abd al-Malik, since he was the only reigning caliph for whom 'Abd al-Hamid worked and who undertook the Hajj.[32] As for the recipient(s), al-Qadi has suggested that the text was probably a proclamation intended to be read out in the mosques by local governors across the caliphate; this seems a very reasonable suggestion, but it cannot be proven.[33] It would certainly fit very well with the later Marwanid trend towards the production of official documents as public texts, especially related to the official designation of the reigning caliph's heir (*wali al-'ahd*).[34] It should be said in support of this idea that it reads much more like an official pronouncement than a private correspondence.[35]

The proclamation has been divided here into five sections, but these do not reflect any comparable sections in the original. The language throughout is highly stylized and, typically for 'Abd al-Hamid, it is full of synonyms and Qur'anic coinages and paraphrasing. Wadad al-Qadi has published a very thorough study of 'Abd al-Hamid's use of the Qur'an and Qur'anic language in his epistolary prose;[36] this text is full of such features, although two examples may suffice. In §1, within the description of the caliph's delight at seeing so many fellow pilgrims, it is noted that those pilgrims approached 'from every ravine' (*min kull fajj*), a phrase which instantly reminds the reader/listener of Q.22:27, 'Proclaim the Pilgrimage to the people. Let them come to you on foot and on every lean camel, which will come from every deep ravine (*min kull fajj 'amiq*).'[37] As a second example, in §5 when the caliph asks God to accept his Hajj as a 'striving gratefully received' (*sa'yan mashkuran*), this intentionally invokes Q.17:19, 'Those who desire the world to come and strive for it as they should and are believers, those – their striving is gratefully received' (*fa-ula'ika kana sa'yuhum mashkuran*).[38]

Perhaps more interesting, however, is the fact that the heavy Qur'anic influence on this proclamation is not simply stylistic; many of the completed rites which the caliph is announcing are also to be found in the Qur'an. The Hajj is described (§1) as a 'pilgrimage to His house' (*hajj baytihi*), which has clear Qur'anic parallels. For example, Q.3:97 states, 'It is the people's duty to God to make pilgrimage to [that] house'. The *ifada* (dispersing) from 'Arafat and the 'sacred place' (*al-mash'ar al-haram*), both of which are referred to in this text (§3), are also in the Qur'an (Q.2:198). There are, of course, Qur'anic rites which are not mentioned here – most notably the circumambulation (*tawaf*) of the house (Q.2:125; 22:26; 22:29) and the rituals performed at Safa and

Plate 1 The plain of 'Arafat, from the *Futuh al-haramayn* by Muhyi al-Din Lari. Iran, 16th century, British Library, London (OR 1153, fol. 27b) (© The British Library Board)

that if a proper methodology was applied then a single, correct narrative could be constructed.[41]

Ibn Ishaq's (d. *c.* 767) account of the *hijjat al-wada'* and the Prophet's instructions concerning the Hajj, transmitted from 'Abd Allah ibn Abi Najih (d. *c.* 748–50),[42] mentions the following locations and rites:[43] 'Arafa and the *wuquf* (standing) there; Quzah at al-Muzdalifa and 'the morning of al-Muzdalifa' (*sabihat al-Muzdalifa*); the sacrifice at Mina; throwing the stones (*ramy al-jimar*); and the circumambulation of the house (*al-tawaf bi-al-bayt*). In the middle of Ibn Abi Najih's account comes the statement, 'The Messenger of God, may God bless him and grant him peace, completed the Hajj having shown them their rites (*manasik*), and he informed them of what God had ordained for them during their Hajj'. Within al-Waqidi's (d. 822) much more detailed account, the following rites and locations can be found:[44] entry into *ihram* (rites of purification) at Dhu al-Hulayfa; 'Arafat; Mina and the sacrifice there; circumambulation of the house and kissing of the stone; the Maqam Ibrahim; the *sa'i* between Safa and Marwa; prayer inside the Ka'ba (although according to some the Prophet expressed remorse for doing so);[45] al-Muzdalifa and Quzah; al-'Aqaba and the throwing of stones; shaving after the sacrifice at Mina. The match between these rites and locations mentioned in early narratives of the *hijjat al-wada'* and those referred or alluded to in the proclamation is not a particularly close one. This is all the more curious since the latter explicitly mentions (§1) that the caliph and his fellow pilgrims were 'following the custom of His Prophet, may God bless him and grant him peace, as he had laid out for them'. This would appear to be a relatively clear case of a phenomenon that is already well attested elsewhere and has been investigated by several modern scholars: the later Umayyad caliphs' appeal to the custom and tradition of the Prophet but in a generic rather than a specific fashion.[46] It was simply by performing the Hajj that the caliph was following the custom (*sunna*) of the Prophet, not necessarily by adhering to any specific regulations outlined elsewhere in the *Hadith*, *fiqh* and *sira* literature.[47]

There is a further point worth making here regarding the fact that the main specific locations connected to the Hajj which this proclamation emphasizes are 'Arafat (**Pl. 1**) and the *ifada* on to Mina, and that the *tawaf* of the Ka'ba and the *sa'i* at Safa and Marwa are not mentioned at all. The most immediately striking point is that both of these latter rites take place in Mecca itself, whereas most of the other Hajj rituals are centred around sites outside of Mecca. This reminds us of the possible pre-Islamic distinction, stressed over a century ago now by Julius Wellhausen, between the Hajj rites, which were centred around 'Arafat and other sites outside of Mecca, and other rites, particularly connected to the 'Umra, which involved the Ka'ba and other places within Mecca. As Wellhausen succinctly put it, 'The Hajj to 'Arafat originally had nothing to do with the 'Umra in Mecca'.[48] Now our caliph certainly visited God's house, which may well have been immediately identifiable to all contemporary readers/listeners as the Ka'ba in Mecca (although those two toponyms are not mentioned in the proclamation), but the rites specifically emphasized are

Marwa (Q2.158)[39] – and there is one location, Mina (§3), which is not mentioned in the Qur'an. On the whole, however, the Hajj envisaged within this proclamation fits comfortably with that which can be found in the Qur'an.

In light of the clear Qur'anic influence on the literary style of the proclamation this may not be particularly surprising, but it does lead the way to a further observation. It is striking that, excluding the one reference to Mina, the author of the text shows no interest in referring to any of the Hajj rites which were said to have been outlined by Muhammad for his followers but which are not in the Qur'an itself. It is in accounts of the so-called Farewell Pilgrimage (*hijjat al-wada'*), discussed briefly above, that Muhammad usually clarifies, among other matters, the correct Hajj rites. There are many surviving accounts of this *hijjat al-wada'*, some much more detailed than others, and, as many medieval Muslim scholars themselves noted, there are several contradictions between the various narratives on offer.[40] The 11th-century Andalusi scholar Ibn Hazm (d. 1064) even dedicated an entire treatise to sort out the various conflicting accounts of the *hijjat al-wada'* and to demonstrate

among those of Wellhausen's pre-Islamic Hajj, outside of Mecca.[49] More recently, Gerald Hawting has argued quite convincingly that throughout the seventh century the *wuquf* at 'Arafat had a much more direct association with religio-political leadership than any of the rites within Mecca itself. He also suggested, albeit a little more tentatively, that references to the Hajj in Arabic accounts of the civil war (*fitna*) during the late 680s and early 690s 'seem to be consistent with Wellhausen's view and do not positively indicate that the association of the Hajj with Mecca had yet been established'.[50] 'Abd al-Hamid's description of the caliph's activities in and around Mecca during the Hajj season, albeit now from the early eighth century, supports these ideas.

Conclusion

We return at the end to an important outstanding question: why would an Umayyad caliph such as Hisham want his chancellery officials to pen an official proclamation announcing his successful completion of the Hajj? Part of the answer probably lies in the ever-increasing association of the Hajj and its leadership with the issue of caliphal succession and legitimacy.[51] If leadership of the annual pilgrimage rites in and around Mecca was considered to play no small part in determining who was the rightful guide of the Muslim community (and the evidence seems more and more to point this way), then it is natural enough that those caliphs and heirs apparent who did carry out this duty in person would want that to be known as widely as possible. It is worth remembering that three of the Marwanid caliphs who led the Hajj in person – al-Walid, Sulayman and Hisham – were the sons of 'Abd al-Malik, whose greatest rival for the caliphal office had derived much of his legitimacy from being based in Mecca. A public announcement that the caliph had fulfilled the Hajj rites also demonstrated that the Hijaz was now fully under the control of the Umayyads of Syria.

Furthermore, we have already seen that Marwanid caliphs such as Sulayman and Hisham were perhaps more concerned than their predecessors with establishing the 'correct' way for their subjects to perform the Hajj – McMillan suggestively subtitled the section of her book on Hisham's Hajj of 725 'Restoring Precedent' – and the promulgation of a text explaining how exactly the caliph himself had acted while undertaking the rites would no doubt have aided such an endeavour.[52] Steven Judd has suggested that the later Marwanid period, including in particular the reign of Hisham, witnessed a narrowing of the boundaries of 'orthodoxy' (as defined by the Umayyads) as caliphs increasingly strove to prescribe how their subjects could and could not worship God.[53] How Muslims were to perform the Hajj would have been one obvious area for such-minded caliphs to attempt to regulate.

In any case, the proclamation analysed here offers a unique testimony to the increasing emphasis that Umayyad caliphs by the time of Hisham ibn 'Abd al-Malik were placing on the public promotion of their leadership of the Hajj, be that leadership in person or through the appointment of a trusted official. It therefore provides important background for the evidence of massive caliphal investment in the Hajj and the holy sites of the Hijaz that were witnessed throughout the eighth century. This personal caliphal involvement in the Hajj culminated in the early Abbasid period, during the reigns of Abu Ja'far al-Mansur (r. 754–75), Muhammad al-Mahdi (r. 775–85), and Harun al-Rashid (r. 786–809); the latter personally led the Hajj no fewer than nine times during his 23-year reign.[54] This era of the Marwanid Umayyad caliphs and the first half century or so of Abbasid rule was the major period for caliphal leadership of the Hajj and patronage of the holy cities and the pilgrim routes that led to them. 'Abd al-Hamid's proclamation, written for Hisham ibn 'Abd al-Malik, is one of the most remarkable extant texts testifying to that.

Notes

1 I would like to thank both Andrew Marsham and Chase Robinson for their helpful comments on an earlier draft of this article. My research has been generously funded by the British Academy, to whom I am very grateful.
2 On Salim, see al-Mizzi 1982–93, X: 145–53.
3 For Abu al-Zinad 'Abd Allah ibn Dhakwan, and for more on his relationship with Hisham ibn 'Abd al-Malik, see al-Mizzi 1982–93, XIV: 476–83.
4 That this should be how we understand the standard phrase '*hajja* [*fulan*] *bi-al-nas*', see Hawting 1993: 39. It is not fully clear what exact duties leadership of the Hajj would have entailed in the Umayyad period, although by the 11th century at least we have a better idea thanks to al-Mawardi 1909: 93–8.
5 Since several authorities believe Salim ibn 'Abd Allah ibn 'Umar to have died in 724, it is possible that Hisham ibn 'Abd al-Malik's stay in Medina was a rather long one, but it seems most sensible to assume that Hisham only visited Medina immediately before his performance of the Hajj rites in 725.
6 See further al-Mizzi 1982–93, XIII: 357–74.
7 Al-Tabari 1879–1901, II: 1472, 1482–4 (quotation from 1483). For other versions of parts of this story, see for example Ibn Sa'd 1904–40, V: 395; al-Zubayri 1953: 283–4; Ibn Khayyat 1985: 336–7; al-Baladhuri 1993: 43–4 (§83). For a recent discussion, see McMillan 2011: 130–4. On the period of Hisham's caliphate in general, see Blankinship 1994.
8 The literature on the significance of the Hajj in the Umayyad and early Abbasid periods is continuously growing, but see especially Elad 1992; Hawting 1993; Crone 2004: 41–2, 97, n. 37; McMillan 2011.
9 For the Hajj leaders in the Umayyad period, see now conveniently the various tables in McMillan 2011: 45–7, 63–5, 77–9, 95–7, 115–16, 127–30, 143–5.
10 For some of the earliest accounts of the Farewell Pilgrimage, which is sometimes known as the 'pilgrimage of completion' (*hijjat al-tamam*), the 'pilgrimage of delivery' (*hijjat al-balagh*), or the 'pilgrimage of Islam' (*hijjat al-Islam*), see al-Waqidi 1966, III: 1088–1115; Ibn Hisham (1936), IV: 248–53; Ibn Sa'd 1904–40, II/ii: 124–36; al-Tabari 1879–1901, I: 1751–6, 1793–4. For a discussion, see Rubin 1982.
11 See the table in McMillan 2011: 29–32.
12 McMillan 2011: 133–4.
13 Al-Ya'qubi 1883, II: 314, 320; al-Tabari 1879–1901, II: 781–3; McMillan 2011: 75–6. Cf. Ibn Khayyat 1985: 263, where three of these parties (the Umayyads are missing) conduct separate *wuquf*s at the Hajj of 686.
14 Ibn Khayyat 1985: 385–7; al-Baladhuri 1997–2004, VII: 624–9; al-Ya'qubi 1883, II: 405–6; al-Tabari 1879–1901, II: 1981–3; McMillan 2011: 155–8.
15 Al-Ya'qubi 1883, II: 321; Robinson 2005: 34.
16 See, for example, Calder 1993: 221; Hawting 1993; Donner 2010: 199–201.
17 Al-Ya'qubi 1883, II: 358; Hawting 1993: 36–7; McMillan 2011: 109.
18 Al-Dhahabi 1981–8, v: 327; Ibn Hajar 1907–10, IX: 451; Donner 2010: 200.
19 Al-Muqaddasi 1906: 75: the reasons why al-Mansur undertook

renovation work on the Sacred Mosque in Mecca was that he 'went on pilgrimage and he saw the smallness of the Sacred Mosque, its dishevelled state, and [the Meccans'] lack of respect for its sanctity. He even saw a Bedouin circumambulate the house on his camel.'

20 Texts such as this are usually referred to as 'letters' but, for reasons outlined further below, in this particular case 'proclamation' seems more appropriate.

21 The manuscript is held in the Husayniyya library in Rabat, no. 6148. The precise identity of this Ahmad ibn Muhammad al-Balawi is not currently clear; cf. the conflicting ideas in al-Qadi 1992: 233, and Binbin *et al.* 2001, I: 348–9.

22 'Abbas 1988. al-Qadi 1992; 1993; 1994. Wadad al-Qadi's studies should be consulted for further information and bibliography on 'Abd al-Hamid and his letters.

23 This earliest work to preserve any of 'Abd al-Hamid's letters is the *Kitab al-manzum wa-al-manthur* by Ibn Abi Tahir Tayfur (d.893). The three surviving manuscripts of part of this work are all much later still, dating to the 16th century and later; see Toorawa 2005: 180.

24 Al-Qadi 1992.

25 For example in Cook 1981. There is a growing corpus of literature on supposedly early 'documents' preserved in later Arabic sources; for the most recent contribution, see Marsham 2012.

26 There is one late seventh- or early eighth-century papyrus now in the Oriental Institute in Chicago (Papyrus OI 17653) which refers to a caliphal announcement of the Hajj; see Sijpesteijn (forthcoming). I am very grateful to the author for providing me with a draft of her forthcoming article.

27 'Abbas 1988: 205–6, no. 11. The translation here offers little testimony to the eloquence of the Arabic original.

28 It seems unnecessary to translate the initial *amma ba'd*.

29 The Arabic word here can be read either as *huda*, 'guidance; direction', or as *hady*, which is used in the Qur'an (see 2:196, 5:2 and 5:97) to refer to the animals taken for sacrifice during the Hajj.

30 Diem 1993; Khan 1993: 63–6; Grob 2010: 39–42, 72–7, 82–3.

31 Hoyland 2006: 399, 405–6; Marsham 2009.

32 'Abbas 1988: 67; al-Qadi 1992: 230; al-Qadi 1994: 238, 258–9. Hisham's pilgrimage is also alluded to outside of the usual Arabic historical sources in a couple of verses of poetry attributed to al-Farazdaq (d. *c.* 728–9); see Nadler 1990: 257.

33 Al-Qadi 1994: 259.

34 Marsham 2009: 155–9. The famous succession letter of Hisham's successor, al-Walid ibn Yazid (r. 743–4), was sent to all of the major Muslim cities (*amsar*) seemingly to be read out in public; see al-Tabari 1879–1901, II: 1755; Crone and Hinds 1986: 26.

35 For reference, the 'you' at the start of §5 is plural, but the 'you' in §2 is singular.

36 Al-Qadi 1993; see also Marsham 2011: 113–16.

37 Unless otherwise stated, all translations from the Qur'an are taken from Jones 2007. Significantly, Q.22:27 is also clearly invoked in lines 6–7 of Papyrus OI 17653; see Sijpesteijn (forthcoming).

38 I have slightly adapted Jones's translation here.

39 Interestingly, at a much later date, the *tawaf* and the *sa'i* at Safa and Marwa are precisely the two Hajj rites emphasized within the text on the surviving *mahmal* of the Mamluk Sultan Qansawh al-Ghawri (r. 1501–16); Jomier 1972.

40 For some of the earliest accounts of the *hijjat al-wada'*, see above, note 10.

41 Ibn Hazm 1998; Adang 2005.

42 Al-Mizzi 1982–93, XVI: 215–19.

43 Principally in Ibn Hisham 1936, IV: 253; al-Tabari 1879–1901, I: 1755–6.

44 Within al-Waqidi 1966, III: 1089–1116.

45 On the evidence for an early debate over the permissibility of prayer inside the Ka'ba, see Hawting 1984.

46 Crone and Hinds 1986: 59–80; al-Qadi 1994: 263–5; Marsham 2011: esp. 125.

47 The proclamation does refer at one point (§1) to the 'Islamic pilgrimage' (*hijjat al-Islam*), which is one variant name offered for the *hijjat al-wada'*: al-Waqidi 1966, III: 1089; Ibn Sa'd 1904–40, II/i: 124. This is not, however, an obvious reference to Muhammad's Farewell Pilgrimage.

48 Wellhausen 1897: 68–84 (quotation from 79).

49 See Webb in this volume.

50 Hawting 1993: 37–9 (quotation from 39).

51 As well as the various references above, see Marsham 2009: 90–1, 124–5; McMillan 2011: 100–2, 134–8.

52 McMillan 2011: 130.

53 Judd 2011.

54 For a useful overview of eighth-century caliphal involvement in the Hajj, see Kennedy 2012: 92–107.

Chapter 4
The Lost Fort of Mafraq and the Syrian Hajj Route in the 16th Century

Andrew Petersen

The Syrian Hajj route which runs from Damascus is the most ancient and significant of all the Hajj routes, having been used by the Prophet Muhammad on his journeys from Mecca to Bosra. However, unlike the Darb Zubayda route from Baghdad, which was furnished with stopping places and facilities from as early as the eighth century, the Syrian route was not systematically provided with facilities until the Ottoman period in the 16th century. The route continued to develop throughout the Ottoman era, and in the early 1900s it was further improved with the introduction of the Hijaz Railway. The Ottoman participation in the development of this route was therefore significant and decisive. The actual route taken by pilgrims through Jordan from the 16th century onwards is generally well known following that of the modern Desert Highway. Prior to the 16th century, the pilgrims appear to have used a number of routes, most of which ran further west, following the ancient King's Highway or *Via Nova Traiana*. According to Jordanian tribal history, the change of route occurred in the 16th century when the daughter of the sultan complained of the bandits and hilly nature of the route. In response to this complaint, the sultan ordered that the Hajj take a new route further east which not only avoided the precipitous valleys at the edge of the Jordanian plateau, but was also much quicker.[1] There is no other historical evidence for the change of the route and it is tempting to regard the story as apocryphal. However, a reassessment of some of the forts and their dates provides a basis of support for this story.

Before discussing the fort at Mafraq and possible implications for the dating of the 16th-century route, it is worth briefly reviewing the development of the Hajj route during the medieval and Ottoman periods (**Pls 1, 2**).

Medieval and Ottoman Hajj route

The Syrian Hajj route continued more or less uninterrupted until the 12th century when it became unusable because of the establishment of Crusader castles to the east of Jordan at Karak, Shawbak and possibly 'Aqaba. This meant that Muslims travelling to Mecca from Syria often had to take an alternative route, travelling either via Arabia or via Egypt.[2] With the return to Muslim rule in the 13th century, the Syrian route was gradually re-established. The exact route taken probably varied from year to year and medieval authors give few details of the actual route followed. However, the route taken by Ibn Battuta (1304–77) is fairly representative and shows that the pilgrims followed the *Via Nova Traiana* through Bosra and Karak.[3] There were few facilities built specifically for the medieval pilgrims and most of the large cisterns, such as that at Bosra and Zizia, had pre-Islamic origins. However, a few facilities were built; a bathhouse and a mosque were established at Bosra, whilst forts were built at Zerka and Zizia.[4] In general, however, the medieval route was ill defined and did not provide much security for the pilgrims.

This situation changed following the Ottoman victory over the Mamluks at Marj Dabiq in 1516. Following this victory, all of Greater Syria (including Syria, Jordan, Palestine and Lebanon) was absorbed into the Ottoman domain. Egypt was added soon afterwards and the whole focus of the empire shifted south. The incorporation of the

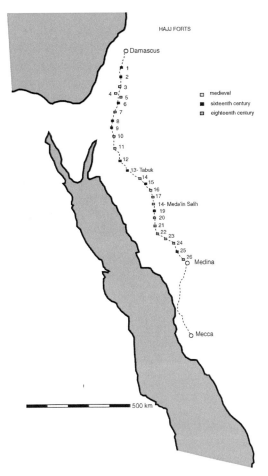

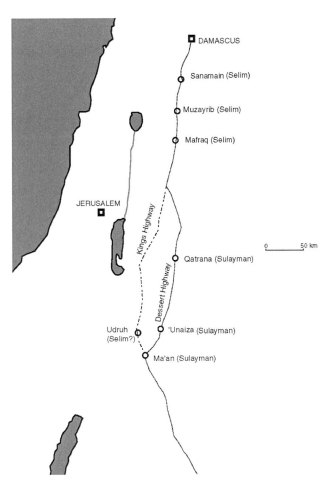

Plate 1 Map of the Syrian Hajj route showing all of the fortresses built between the 16th and 18th centuries

Plate 2 Map of Jordan showing the King's Highway used by the Hajj until the time of Selim I and the Desert Highway route adopted during the reign of Sultan Süleyman I

region into the Ottoman Empire was significant both in terms of trade and religion. Before this period, the Ottomans had had little direct contact with Arabia and, more pertinently, they were not well acquainted with the Hajj. As the largest Muslim power in the world, the Ottomans felt they had a duty to promote Muslim institutions and in the process legitimize their own claims to power. The enhancement of the Syrian Hajj route was one of a number of initiatives to support their Muslim credentials.

The significance which the Ottomans placed on the Hajj can be seen in the construction of the *Takiyya* in Damascus which was a large complex combining a mosque, religious school and facilities for pilgrims. The complex was built between 1554 and 1560 according to the design of Mimar Sinan (*c.*1489–1588), and it is the only building in the country designed by this famous architect. Pilgrimage facilities included a soup kitchen, an enclosed camping ground, as well as a mosque and market.[5]

Further south on the route to Mecca, a number of forts were built to protect the water resources; in addition, they functioned as postal stations and provided regional security. Initially the forts were only built at strategic locations; however, by the end of the 18th century, forts were built at regular intervals along the entire route.

Although it is probable that further archive research will reveal more about the construction of the forts, for now the principal source for the history of construction of forts along the whole route is the account of the 18th-century pilgrim Mehmed Edib who made the Hajj in 1779. Individual forts were also recorded by travellers and are referred to in occasional Ottoman imperial or local orders. In addition to the historical accounts, the forts themselves contain significant information about their construction. For example, the fort at Ma'an has an inscription above the entrance which records its construction in 971/1563 under the orders of Süleyman the Magnificent (r. 1520–66). Also, the architecture of the forts allows a sequence of construction which can be used to date individual forts. For example, the 18th-century forts have projecting corner towers and numerous small gun slits whilst earlier forts have neither of these features. Using these techniques, it was possible to provide dates for the entire sequence of forts from Damascus to Medina. It is noticeable that the forts fall into two main categories: those built in the 16th century and those built in the 18th century.[6]

The lost fort of Mafraq

The fort at Mafraq was built during the reign of Sultan Selim I sometime before his death in 1520.[7] It later appears in the itinerary of Mustafa Pasha in 1563, although no details are provided. The earliest description of the fort is given by the Turkish traveller Evliya Çelebi (1611–82) who describes it as a square fort in the middle of the desert. In the immediate vicinity of the fort, there was a green meadow and a number of acacia trees. Çelebi further notes

Plate 3 The fort at Mafraq with graves in foreground (courtesy of the Israel Antiquities Authority)

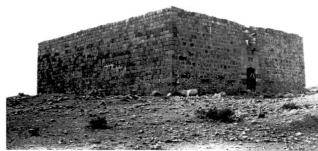

Plate 4 Exterior of the fort at Mafraq showing the entrance with machicolation above (courtesy of the Israel Antiquities Authority)

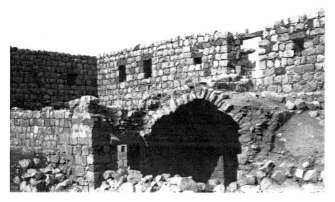

Plate 5 Interior of the fort at Mafraq looking north-west (courtesy of the Israel Antiquities Authority)

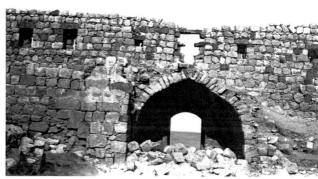

Plate 6 Interior of the fort at Mafraq with entrance *iwan* in centre (courtesy of the Israel Antiquities Authority)

that the fort was deserted at the time of his visit and that it was used by the local Bedouins to house sheep and goats.[8] When Murtada ibn 'Alawan travelled on the Hajj route in 1709, the pilgrims pitched their tents outside the fort.[9] Mehmed Edib also passed by Mafraq and noted that the fort was garrisoned by troops from the fortress at Muzayrib. Edib also made the rather unlikely assertion that the name *Mafraq* (meaning 'crossroads') was derived from the fact that on the return journey, some of the pilgrims would break free at this point and race back to Damascus.[10] The first European description of the fort is by the Swiss traveller John Lewis Burckhardt, who visited it whilst accompanying the Hajj caravan in 1812. Interestingly, Burckhardt noted that a small garrison was based in the fort which was also used to store grain for use by the pilgrims.[11] By the latter part of the 19th century, the fort seems to have been no longer in use and Charles Doughty described it as ruined and abandoned.[12]

Research on the Ottoman Hajj forts in Jordan was carried out over a number of years involving fieldwork and archival research, and formed the basis for a recent monograph by the author.[13] Although some of the forts were in a derelict or endangered condition, the majority were still standing with the exception of the fort at Mafraq, of which there appeared to be no trace. However, it soon became apparent that the Hajj fort at Mafraq was still standing in the early 20th century, although by the 1960s it seems to have been destroyed. In 1998, undated photographs of the

fort were located in the archives of the Palestine Antiquities Department in the Rockefeller Museum in Jerusalem (**Pls 3–6**). The photographs show that the fort was located on or near the top of a low hill, and like many of the other forts, was a square building with a single entrance protected by a box machicolation. The small gateway led into a small courtyard although the interior of the fort appeared to be in ruins at the time of the photographs.

The question of when the fort was destroyed, and by whom, has not been resolved. During the 1930s, the Iraq Petroleum Company established one of their main bases at Mafraq. At approximately the same time, the British forces established an RAF (later Jordanian Air Force) airbase near Mafraq. Christina Grant claims that the fort was destroyed in 1957 by the Iraqi army, though others have suggested it was the Iraq Petroleum company.[14] An attempt to resolve the question by appealing to former RAF personnel who had been based in Jordan during the 1950s and 1960s was made on BBC Radio 4's *Making History* programme (27/9/2011). Although there was considerable interest in the fort, no one was able to confirm when and by whom the fort was destroyed. However, the RAF Museum was able to provide some detailed information on the location of the site which demonstrated that it was identical with the important archaeological site of al-Fudayn.[15] The excavation had been concerned with the Umayyad palace on the site which comprised two large buildings (70 x 47m and 40 x 40m) as well as the foundation of the Ottoman fort.[16]

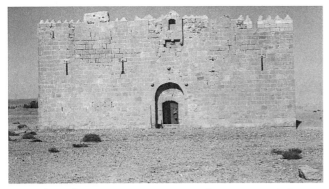

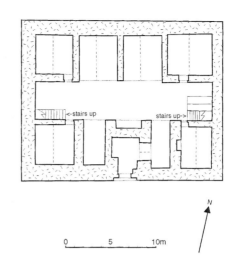

Plate 7 (above) South facade of the fort at Qatrana in 1986 following restorations financed by the Turkish government in the 1970s

Plate 8 (right) Plan of the fort at Qatrana built in 1559

The connection between the two sites had also been recognized by a Jordanian architect and an archaeologist who examined the site of the Ottoman fort and were able to publish a ground plan of the fort and some historical photographs, one of which shows the fort from a distance in 1925.[17] Unfortunately, their reconstruction of the fort did not have the benefit of the early photographs from the Rockefeller Museum, instead it was based mostly on a comparison with the late 16th-century fort at Qatrana over a 100km further south. Although both the Qatrana fort and the Mafraq fort were probably built in the 16th century, there are significant differences in details and design. For example, the Qatrana fort has a rectangular plan and decorative arrow slits, whilst the Mafraq fort had neither of these features (**Pls 7, 8**).[18]

The following description is based on the four photographs from the Rockefeller Museum in Jerusalem (**Pls 3–6**), RAF aerial photographs supplied by the Royal Air Force Museum, satellite images provided by Google and the excavation report from al-Fudayn. The fort at Mafraq is built of roughly squared reused limestone blocks with the occasional use of basalt. The entire structure is almost exactly square measuring 19m per side (**Pl. 9**). The entrance was set into the north side of the building and comprised a panel faced with dressed limestone and basalt blocks. Directly above the gateway was a small recessed panel which originally must have contained an inscription. Further up at first floor level, there was a projecting box machicolation. Apart from the gateway, the exterior of the fort appears to have been very plain, though the upper portion was pierced by a series of gun-slits one course high. The entrance led via an *iwan* (vaulted room with open arch) into a square courtyard with a square opening into a well or cistern in the centre. A series of doorways (three on the south, two each on the west and east sides, and two on the north side, not including the entrance *iwan*) led into nine rooms. The internal walls were not bonded to the outer wall of the fort, which gives the impression of a fairly rapid construction. To the left (east) of the entrance, a staircase led up to the first floor which does not appear to have had any rooms or structures.

Early 16th-century forts on the Syrian Hajj route
Very few buildings within the new Ottoman province of Syria are known to have been built by Sultan Selim I (r. 1512–20), who only lived another four years after his conquest of Syria and Egypt. With the exception of the tomb of Ibn 'Arabi in Damascus,[19] the only buildings known to have been built during his reign are all associated with the Syrian Hajj route. These include forts at Sanamayn, Muzayrib and Mafraq, as well as a bridge near Sanamayn.[20] In addition, it may be possible to date the fort at Udruh in southern Jordan to this period on the basis of comparisons with the vanished fort at Mafraq. Unfortunately, none of these structures has been studied in great detail and they are now in ruins or completely destroyed.

Sanamayn
Although there are Roman remains at Sanamayn (meaning 'two idols'), it does not appear to have been a major settlement in pre-Islamic times.[21] In the ninth century, al-Harbi lists it as a staging post on the Hajj route, and in the medieval period, it is mentioned by Yaqut (1179–1229).[22] Ibn Battuta (1304–77) passed through Sanamayn on his pilgrimage in 1336 and described it as a large settlement, but offers no further details.[23] Following the construction of a fort in the 16th century, there are

Plate 9 Plan of the fort at Mafraq based on aerial and satellite photographs as well as published plans of the complex at al-Fudyan

increasing references to Sanamayn. The fullest description is given by Çelebi, who describes a large settlement (population 2,600) next to a lake with three mosques, a bath house and a *khan*. In addition, Çelebi takes note of the fort which is a square building made of black stones located on the eastern side of the town next to the lake.[24] To the south of the town, there was a bridge which, according to Edib, was also built by Sultan Selim.[25] Unfortunately, there have been no archaeological surveys of the fort which appears to have been demolished.

Muzayrib

It is probable that Muzayrib began to replace Bosra as a stopping place on the Hajj in the 15th century following the Timurid invasions.[26] In any case, Muzayrib is first mentioned as part of the route in 1503 when Ludovico di Varthema (1470–1517) stayed there for three days employed as one of the guards on the Hajj. Di Varthema describes a large market at the site which, amongst other things, sold horses. However, he makes no mention of a fort or any other buildings at the site.[27] The fort, which was built at some point between 1516 and 1520, was surveyed in the 1980s although large parts were already destroyed. A reconstruction shows that it was a large rectangular building with a mosque in the middle of a central courtyard (**Pl. 10**). It was defended by corner towers and interval towers as well as a bent entrance.[28] Official records state that in 1563 the fortress had a garrison of 51 men and was used as a centre for financial transactions.[29] Travellers' accounts indicate that there was an annual Hajj market which lasted for seven days. The first detailed description of the fortress is given by Çelebi who visited in 1670 and wrote:

> This castle was built by Hatem Tay in the time of Hazret-i Ebu Bekir. It is built in the form of a square, situated on a stony plateau and measures 8,000 paces in circumference. There is a fortress commander and 80 soldiers in the garrison. One of the Ağas of the Pasha sits here with 300 men, as does the kadi of the Hauran. Its Nahiye comprises 270 villages. Inside the castle is a mosque, a small hammam and stores where the treasures of state as well as the merchants are kept.[30]

The fort was also visited by Edib who gives few details beyond the fact that it was built by Sultan Selim. In 1812, Burckhardt gave a more detailed description of the fort, as well as mentioning its construction by Sultan Selim, presumably derived from a foundation inscription above the gateway. In the 1880s, Gottlieb Schumacher made the first archaeological plan of the fortress and its immediate surroundings.[31] By the time K.A.C. Creswell visited the site in 1919, the fort was in a ruinous condition and by the late 1990s there was little left.[32]

Mafraq

Although the building in Mafraq is clearly on the Hajj route, its architecture is different from the forts built during the reign of Sultan Süleyman in the late 16th century (e.g. Ma'an or Qatrana) and those built during the 18th century (e.g. Hasa or Mudawwara). The building specifically does not have the projecting corner towers visible on the 18th-century forts, nor does it have the tall arrow slits found on the late 16th-century forts. Instead, the Mafraq fort has a very plain

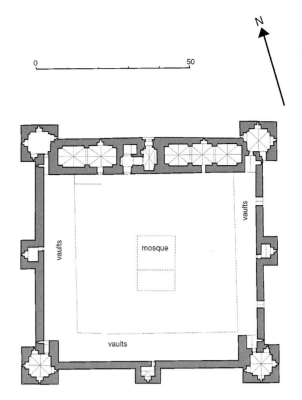

Plate 10 Reconstructed plan of the fort at Muzayrib after Norbert Hagen and Emad Terkawi

appearance with decoration limited to a small panel with an inscription above the doorway. A series of gun slits are found at first floor level which on the exterior appear as narrow slits, and on the interior are set into small square niches covered with stone lintels.

Udruh: another fort built by Selim?

The fort at Mafraq may also hold the key to understanding the Ottoman fort which lies in the midst of earlier remains. Udruh is a major Roman site which was built as a legionary fortress sometime between AD 293 and 305, though it later became a civilian settlement and does not feature in the *Notitia Dignatatum*.[33] In the early Islamic period, Udruh was the site of a number of meetings between the Caliph 'Ali and Mu'awiya, the governor of Syria. Later under the Umayyads, the fortress was converted into an official residence, although by the ninth century the site seems to have been abandoned. The fort located at the northern edge of the fortress, is generally regarded as an Ottoman building although its date of construction and function are unknown (**Pls 11–13**).

Certainly the rectangular plan of the fort built around a small central courtyard with a box machicolation over the gateway is strikingly similar to the Ottoman forts on the Hajj route. The interior of the fort is badly damaged and has obviously been rebuilt on more than one occasion. More detailed examination indicates a striking similarity to the fort at Mafraq – both forts comprise a single storey building with the roof area used as a parapet and numerous gun-slits around the upper wall. Internally the gun-slits appear as rectangular niches covered with stone lintels. In view of these similarities it is possible that this building also dates to the reign of Selim I and became redundant once the nearby

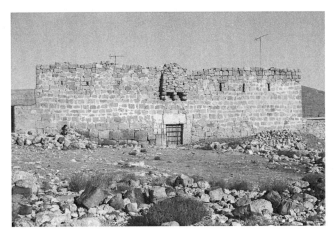

Plate 11 (above) Ottoman fort at Udruh, entrance facade from south

Plate 12 (right) Ottoman fort at Udruh, detail of machicolation

fort of Ma'an was constructed in 1559 which may explain why it is not mentioned in later sources.

Architectural origins and significance

Based on this brief review of Selim's forts on the Darb al-Hajj, two important conclusions can be drawn: one is based on the acceptance of Udruh as one of Selim's constructions, and the other relates to the introduction of Ottoman architecture into the region.

If it is accepted that Udruh pre-dates the fort at Ma'an, then its location conforms to a position in the 13th to 14th centuries on the Hajj route where it crossed from the King's Highway towards Ma'an. However, the architecture of the fort at Udruh has nothing in common with Mamluk or Ayyubid fortifications, strengthening the case for an attribution to Sultan Selim, who we know built a fort of similar design at Mafraq. If this building is added to the small corpus of structures built by Selim in the first four years of Ottoman rule, it may also provide support for the story that the Hajj route was changed from the King's Highway to the Desert Highway during the reign of Sultan Süleyman.[34] In any case the construction of forts on the Darb al-Hajj indicates a very early commitment on the part of the Ottomans to the protection and promotion of the Syrian Hajj route.

The second conclusion concerns the design of these early forts, which was one of the earliest expressions of Ottoman architecture outside Anatolia and the Balkans. The forts built by Selim can be divided into two distinct but closely related types. The first type, represented by the fortress at Muzayrib, is a form which is later seen in fortifications throughout the Ottoman Empire. The design is based on a series of strongly built towers linked by a wall which encloses a rectangular space.

Examples include the fortresses of Ras al-'Ayn and Qal'at Burak in Palestine,[35] the fortress of Cefala in Mani (Greece),[36] the fortress of Qusair on the Red Sea in Egypt[37] and Qal'at al-Sai on the Nile in Sudan.[38] The plan of these buildings comprises a large rectangular courtyard with a single gateway, four corner towers (usually square or rectangular) and a mosque in the centre. In most of these structures, there is a bent entrance and a barracks block along one or more of the sides. There is some variation in the interpretation of the plan, and in some cases the overall shape is non-orthogonal, though there is an approximation to a rectangular plan (e.g. Qal'at al-Sai). The origin of the plan is not known, although it is likely to be related to

Plate 14 Ground plan of the Mamluk fort of Qasr Shebib which dates to the medieval period (12th to 14th century)

Plate 13 Interior of Ottoman fort at Udruh. Note the gun slits which can be compared with those at Mafraq in Pl. 5

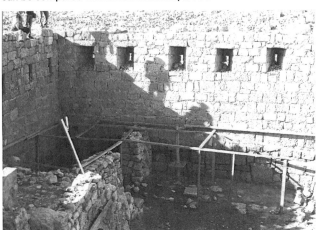

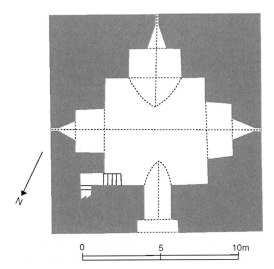

Byzantine prototypes. However, the fort at Muzayrib appears to be one of the earliest Ottoman examples and is certainly the earliest in the Bilad al-Sham (Greater Syria).

Before the Ottoman conquest, fortifications in the region comprised large fortresses or citadels often located on strategic hill tops which dominated the landscape. There were few smaller scale fortifications, although, where these were built, they often comprised single towers. Examples include Qasr Shebib and Zizia in Jordan,[39] the fort at al-Braij in Palestine – built by the Mamluk Sultan Baybars (r. 1260–77) in 1266[40] – and the coastal towers that protect Tripoli (**Pl. 10**).[41] The architecture of these towers comprises a series of two or more square chambers built one above the other with extremely thick walls pierced by arrow loops contained within arched niches (**Pl. 14**). By comparison, the Ottoman Hajj forts, of which Mafraq is the first example, are significantly lighter in terms of construction and provide considerably more room inside as a proportion of their volume. It is clear that the Ottoman forts were a significant departure from their medieval predecessors; however, the origin of their design is not clear. Superficially, the Hajj forts are similar to medieval *khans* or caravanserais with their central courtyard design and plain appearance accentuated by their isolated locations. However, there are significant differences in terms of size and internal arrangement of rooms. Firstly, *khans* are generally much larger. For example, all of the 23 Mamluk *khans* investigated by Cytryn-Silverman are significantly larger (typically more than 30m per side) than the Hajj forts, only one of which exceeds 20m per side. Secondly, although there is some variation in the internal arrangement of *khans*, the majority of the space comprises long vaulted halls which typically take up most of each of the sides. However, in the Hajj forts, the internal space is divided up into a series of small rooms clearly indicating different functional requirements.

Leaving aside the obvious differences, it is possible that the design of the Hajj forts was based on that of the Mamluk *khans*, although another possibility is that the Hajj forts were modelled on wooden *palanka* forts used by the Ottomans while on campaign in the Balkans. Unfortunately, none of these wooden structures has survived; however, descriptions and some contemporary illustrations give some idea of their appearance. Although they could be of any size, the *palanka* forts were generally small square enclosures surrounded by a palisade with a gateway below a watchtower. Whilst the details of the architecture are difficult to discern, the way the forts were built as networks lining the road system is clearly identical with the Hajj forts. In this case, the fort at Mafraq may be the first attempt to build a *palanka* type fort in stone using local craftsmen and materials.

Conclusion

This examination of the early 16th-century Hajj forts demonstrates that the Hajj route was one of the priorities of the Ottoman sultans as soon as they gained control of Syria and Egypt. Despite the fact that Egypt was more populous than Syria and that the Egyptian route nearly always carried more pilgrims, the Syrian route was of more significance to the Ottomans because it provided a physical link between Mecca and Constantinople. Although none of the Ottoman sultans managed to participate personally in the Hajj, the early and continued patronage of the route to Mecca demonstrated their commitment to the Muslim faith and their leadership in the Islamic world. Additionally, the development of new architectural designs (the Hajj fort and the rectangular fortress) specifically for this route demonstrates the unique and prestigious nature of the Hajj. There are occasions when the Syrian Hajj route was neglected for one reason or another, but the general pattern over four centuries is one of continuing commitment which reached its culmination with the construction of the Hijaz Railway.

Notes

1 Peake Pasha 1958: 85.
2 Ibn Jubayr 1949–51: 81–3.
3 Ibn Battuta 1958: 158–60.
4 Meinecke 1996: 31–49; Petersen 2012: 58–68.
5 Petersen 2012: 49–54.
6 Petersen 2012: 22–3.
7 Barbir 1980: 197.
8 Çelebi 1996, IX: 292.
9 'Alawan 1860 fol. 104a.
10 Bianchi 1825: 23.
11 Burckhardt 1822.
12 Doughty 1979: 47.
13 Petersen 2012.
14 Grant 2003.
15 Renwick 29.11.11.
16 Humbert 1986: 354–8.
17 Al-Rajub and al-Husan 2010: 45–68.
18 For a plan and discussion of the fort at Qatrana see Petersen 2012: 76–84.
19 Kafesçioğlu 1999.
20 Barbir 1980: 134.
21 Freyberger 1989 and 1990.
22 LeStrange 1890: 530–1.
23 Ibn Battuta 1981: 77.
24 Çelebi 1996, IX: 287.
25 Bianchi 1825: 122.
26 Meinecke 1996: 48.
27 Varthema 1863: 16..
28 Meinecke 1996: 47, 53.
29 Bakhit 1982: 113.
30 Kiel 2001: 104; Çelebi 1996, IX: 201.
31 Schumacher 1886.
32 Kiel 2001: 104.
33 Kennedy and Falhat 2008.
34 Peake Pasha 1958: 85.
35 Petersen 2012: 38–50.
36 Wagstaff 2009.
37 Le Quesne 2007.
38 Alexander 1997.
39 Petersen 2012: 58–68.
40 Meinecke 1992: 22, 87.
41 Piana 2010: 319–20.

Chapter 5
Trade and the Syrian Hajj between the 12th and the early 20th Centuries
Historical and Archaeological Perspectives[1]

Marcus Milwright

In the novel *Zorba the Greek* by Nikos Kazantzakis (d. 1957), there is an intriguing description of the aftermath of a pilgrimage. On the night before his wedding the eponymous hero relates a story about his father who was alive at the time of the Greek war of independence in the 1820s. Zorba describes him as a scoundrel, but then says that his father had made the pilgrimage to the Church of the Holy Sepulchre in Jerusalem. On returning home, one of his friends, a goat thief, asks whether the pilgrim had brought back a piece of the True Cross from the Holy Sepulchre. Zorba's father claimed that he had and told his friend to return with a suckling pig and some wine so that they could celebrate the handover of this precious item. While his friend was away collecting these items, Zorba's father cut a sliver of wood from a doorpost, wrapped it in soft cloth, and poured a little oil over it. A priest was then called to give blessings upon the wooden fragment before it was presented. This deception had an unexpected result, and the life of the goat thief was transformed. He joined the Klephts (literally 'brigands', but referring here to anti-Ottoman insurgents) in the mountains and fought fearlessly against the Turks. With the relic of the True Cross around his neck, the man ran through showers of bullets, believing himself to be immune to danger. Zorba concludes his story with this observation, 'The idea's everything, have you faith? Then a splinter from an old door becomes a sacred relic. Have you no faith? Then the whole Holy Cross becomes an old doorpost to you.'[2]

Zorba's narrative contains within it an economic transaction: a piece of wood exchanged for a meal and some wine. For different reasons each partner in this transaction probably believed himself to have received the more valuable gift. My reason for highlighting this example is that it illustrates the complexity of what can be broadly be termed 'trade', and particularly those economic activities associated with acts of faith. Some aspects of trade can be defined in the conventional sense as the sale of commodities by merchants or artisans, but many other types of exchange can be identified, including redistribution of wealth by the state, charitable bequests, barter, gift-giving, bribes, extortion, theft and tipping for services rendered.[3] We should also be aware that commodities are accorded value for reasons other than their intrinsic characteristics; for example, belief can transform a fragment of wood or a vessel of oil into something more valuable than gold. Even clay from the vicinity of holy sites can be transformed into a token of pilgrimage. This is a widespread practice, prevalent in Jerusalem and other sites of Christian pilgrimage in the Middle East.[4] In his *Manners and Customs of Modern Egyptians*, Edward Lane (d. 1876) records that *hajjis*, those who completed the Hajj, would return with small leather cases containing amulets made from dust of Mecca mixed with the saliva of pilgrims (**Pl. 1**).[5] Pressed clay tablets (sing. *mohr*) impressed with inscriptions and schematic designs (typically representations of the Dome of the Rock, the Ka'ba and the 'hand of Fatima') are sold today at sites of Shi'a pilgrimage (*ziyara*) such as Karbala and Mashhad (**Pl. 2**). Pilgrims tend to deposit these tablets in their local mosque when they return from the *ziyara*.

For archaeologists, the diversity of forms of exchange presents a problem because we are seldom in a position to

Plate 1 (far left) Amulet made from dust/earth gathered in Mecca, 19th century. Ashmolean Museum, Oxford

Plate 2 (left) Pressed clay tablets (Persian: *mohr*) in the Pa Minar mosque in Zavareh, Iran (photo: Marcus Milwright, 2000)

reconstruct the processes that led to the deposition of an artefact at a given location. That said, the excavation of sites in Jerusalem, and other places associated with Christian pilgrimage has revealed immensely varied assemblages of ceramic shards, and one would expect to find such variety in much larger and more economically significant cities in Greater Syria like Damascus, Aleppo and Hama. Archaeologists working in Jerusalem, Nazareth and Bethany ('Ayzariyya) have reported medieval glazed pottery from as far afield as China, but more notable is the wealth of ceramics from the west, including Italian maiolica, lustrewares from Spain and sgraffito from the Aegean, Cyprus, North Africa and the Veneto.[6] We can envisage that some of this was brought by medieval pilgrims themselves, while others came in the cargoes of merchants eager to benefit from the constant traffic of believers to the Holy Land. In the 18th and 19th centuries new ceramics make their appearance at these and other sites, including Meissen porcelain, faience from southern France and stonewares from the Staffordshire potteries.[7]

A last point to make about Zorba's story is the word he used to describe his father; having made his trip to Jerusalem, Zorba confers upon him the title of *Hadji* (χατζη). This epithet was often added to one's personal name, and it is not uncommon today to encounter Greek family names such as Hadjicostas, Hadjigiorgiou, and Hadjivassiliou. That Greek Christians should have adopted this explicitly Muslim epithet can be attributed in part to the acculturation that resulted from centuries of Ottoman rule, but one should also consider the sheer scale of the Muslim pilgrimage; every year tens of thousands of *hajji*s made their way from all parts of the Islamic world to the holy cities of the Hijaz. Not even Jerusalem could compete with this massive migration by sea and land to Mecca and Medina.

This chapter offers a preliminary assessment of the ways in which archaeological evidence and primary written sources can be correlated in the reconstruction of the diverse forms of economic activity associated with the Hajj. The first part draws together archaeological and textual sources relating to the Syrian Hajj prior to the 19th century. The second half of the chapter looks at the 19th century and the early years of the 20th century. In particular, I address the range of crafts and trades operating in Damascus that

were wholly or partly reliant upon the annual Hajj. The main source for this evidence is an Arabic text entitled *Qamus al-Sina'at al-Shamiyya* (Dictionary of Damascene Crafts) written by three authors, Muhammad Sa'id al-Qasimi (d. 1900), Jamal al-Din al-Qasimi (d. 1914) and Khalil al-'Azm (d. 1926).[8] Published in two volumes in 1960, this substantial work records all the 'crafts' (sing. *hirfa* or *sina'a*)[9] of the Syrian capital and the immediate vicinity. The text was started by Muhammad Sa'id and continued after 1900 by the other two authors. The dictionary was completed somewhere between 1905 and 1908, and contains 435 chapters, each devoted to a single craft, trade or skill.[10]

Trade and the Hajj prior to the 19th century

As already noted, some of the economic dimensions of pilgrimage to Jerusalem and other sites in the Holy Land can be recovered through archaeology. The prohibition upon archaeological work in the holy cities of Mecca and Medina means that one must look elsewhere for evidence of trade relating to the annual Hajj. Where archaeology can make a greater contribution, however, is in the study of the major land and sea routes of the Hajj. Two of these, the Syrian Hajj route from Damascus and the Darb Zubayda that ran from southern Iraq through the Arabian desert to Medina, have been subjected to detailed archaeological study,[11] while recent research at the port of Qusair has illuminated aspects of the route across the Red Sea and the related trade between Egypt and the Hijaz.[12] In the following paragraphs I draw together some of the archaeological and textual evidence for trade and other economic activity along the routes from Damascus to the holy cities of Mecca and Medina prior to the 19th century.

Mehmed Edib, who left his record of the itinerary of the Syrian caravan in the late 17th century, pays much attention to the stopping places and the availability of fruit, vegetables and water. In most cases the produce was probably local to the area, though he does note that the fruit sold at the Hajj fort of Qatrana, east of Karak, was actually brought from the fertile lands surrounding the castle of Shawbak in southern Jordan.[13] He particularly commends Ma'an in the south of modern Jordan for its supplies, and also the area around Mada'in Salih in northern Arabia (**Pl. 3**).[14] Prior to the 16th century, the Jordanian portion of the Hajj route was

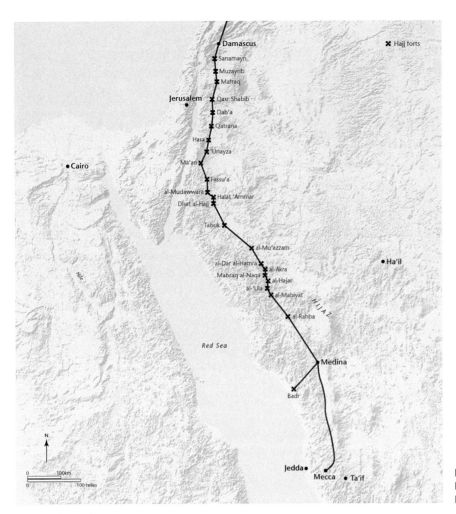

Plate 3 Map showing the route of the Syrian Hajj in the Ottoman period (artwork by Matt Bigg, Surface 3)

located further to the west, and passed over the fertile plains (al-Balqaʾ, Ard al-Karak and al-Sharat) before heading to Maʿan. The famous Maghribi traveller, Ibn Battuta (1304–77), mentions stopping to buy supplies at al-Thaniyya in the central zone of the Karak plateau. From this hill of Marj al-Thaniyya he had a fine view of the castle and walled town of Karak, and he gives a description that tallies well with what can be seen today (**Pl. 4**).[15]

Money and resources flowed into the local economies of southern Syria, Jordan and north-western Arabia in a variety of means ranging from trade with pilgrims to redistribution by the state. Archaeology provides some insights into the long-term impact of such processes. The extensive record of excavations and field surveys on the Karak plateau in Jordan has provided a detailed picture of the fluctuating patterns of occupation and land use from the earliest periods of human history to the present (**Pl. 5**). From the 12th to the early 16th century, the main north–south route through the plateau was most extensively used, both by Muslim pilgrims and merchant caravans passing between Cairo and Damascus. In an area with roughly equivalent annual rainfall and soil quality, one would expect to find an even distribution of villages across this area. What transforms this picture, however, is the presence of the town of Karak in the centre of the plateau and the main road, known in ancient sources as Darb al-Malik (the King's Highway), as well as Darb al-Sultan or Tariq al-Rasif. Villages remote from the road seem to have made almost exclusive use of locally produced handmade pottery,

whereas the villages and small towns along the central north–south spine report considerably higher percentages of glazed and decorated pottery (**Pl. 6**).[16]

Al-Thaniyya, the village visited by Ibn Battuta, is one of these, and the pottery assemblage from this area also contained another rare find: shards from large storage jars that merchants would have used for the storage of such products as olive oil, molasses and date syrup (*dibs*).[17] Another site in the vicinity that was associated with the annual Hajj is al-Lajjun. Excavations at this former Roman garrison encampment revealed an assemblage of Islamic ceramics and coins. The latter group was recovered from the area of the north gate and comprised an unworn Ayyubid coin dateable to 592–615/1196–1218 and a hoard of Mamluk coins

Plate 4 Karak seen from Marj al-Thaniyya, Jordan (photo: Marcus Milwright, 2005)

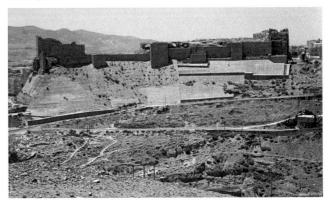

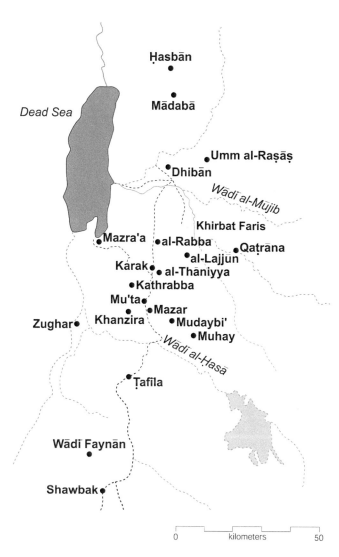

Plate 5 (left) Map showing the principal settlements of the Karak Plateau (© Chris Mundigler)

Plate 6 (above) Glazed and unglazed pottery of the 12–14th centuries found in Karak castle, Jordan (drawn by Marcus Milwright)

(the latest dating to 886–8/1481–3). The Ayyubid phase is most interesting in the present context because of the relative abundance of glazed and decorated wares, including underglaze-painted stonepaste bowls. Al-Lajjun is consistently mentioned as a stopping place for the Hajj in the written sources of the 13th to 15th century, and continued to be used for this purpose periodically even when the Ottoman sultanate constructed the forts and other resources along the Hajj route (from the 16th century). The site was also employed for a banquet by the Ayyubid Sultan al-Malik al-Kamil (r. 1218–38).[18]

Pottery remains an important indicator of economic activity along the Syrian Hajj route in the Ottoman period (1516–1918). Two ceramic items, the coffee cup and the tobacco pipe, are also evidence of the adoption of new leisure pastimes for the inhabitants of the Middle East. Cups and other equipment associated with the brewing and serving of coffee are mentioned in the inventories made of the personal effects of pilgrims who died on the outward or return journey. Inventories of the 17th and 18th centuries mention the types and prices of coffee cups (sing. *finjan* or *filjan*), as well as *zuruf* (sing. *zarf*), decorative cup holders, which were commonly made of silver. What becomes apparent is that cups could come from many locations including China, Iran and Turkey, as well as the porcelain factories of Europe. This diversity is also reflected in excavations of urban sites such as the citadel in Damascus.[19]

The inventories have been analysed by Colette Establet and Jean-Paul Pascual who have noted another significant detail about these documents: it is the returning pilgrims who possessed the larger quantities of goods designated with terms such as 'Chinese' (*farfuri*), 'Syrian' (*shami*) and 'Indian' (*hindi*).[20] In other words, pilgrims tended not to buy these goods in Damascus prior to their journey, but rather from merchants in Mecca and Medina or from markets held on the way back to the Syrian capital (the famous market held near Mada'in Salih is discussed in the following section).

As noted above, the route of the Syrian Hajj was changed in the 16th century by order of Sultan Süleyman I (r. 1520–66). In Jordan the road was moved east of the fertile plains and necessitated the construction of a new line of forts and associated structures between the 16th and 18th centuries.[21] This impressive phase of architectural patronage has been extensively studied, although until recently there were no significant publications of finds excavated within or around the fortified sites. Fortunately, there are now the results of excavations in Qal'at 'Unaiza (built in 1576) and surveys conducted in Qal'at al-Hasa (**Pl. 7**), Dab'a and

Plate 7 Ottoman-period bridge and paved road with Qal'at al-Hasa in the background, Jordan (photo: Marcus Milwright, 2005)

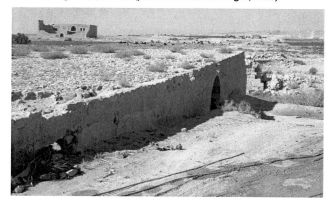

Plate 8 Metal pilgrim flask containing Zamzam water. Brought back from Mecca by Sir Richard Burton in 1853. British Museum, London (OA+3740)

Qal'at al-Mudawwara. The excavations at Qal'at 'Unaiza revealed the richest finds in an area outside the fort (trench F). This was probably a refuse site, and included ceramics, glass (particularly bracelets/bangles and beads), coins, metalwork, textiles and tobacco pipes. The 18th- and 19th-century imported pottery is noteworthy for its diversity, including Chinese porcelain, Batavian ware, stonepaste from Kütahya, Çanakkale ware and perhaps English pearl ware. Chinese porcelain and Kütahya ware were recovered from surveys of the other three Ottoman forts.[22] The prevalence of imported pottery certainly correlates well with the inventories of contemporary pilgrims (see above), and attests to the degree of mercantile activity along the Darb al-Hajj.

The Syrian Hajj in the latter part of Ottoman rule

It is difficult to assess with any accuracy the size of the Hajj caravan that departed annually from Damascus in the last decades of the 19th century. The threat of disease, especially outbreaks of cholera in the Hijaz, probably reduced numbers in some years. One estimate is provided by Nu'man Qasatili (d. 1920) who, writing in the 1870s, gave a figure of 8,500 pilgrims leaving the Syrian capital per year. He also claimed that each pilgrim spent the sum of 50 *lira* on the supplies, transport and services needed for the return journey to the holy cities.[23] Even if Qasatili's figures give no more than order of magnitude, they still help to illustrate the potential economic opportunity that the annual Hajj brought to the people of Damascus and inhabitants living along the route through the southern regions of Bilad al-Sham (Greater Syria) and northern Arabia.

Qasatili gives the personal expenses incurred by pilgrims, and to this should be added the very substantial sums spent by the Ottoman state. The economy of the Hijaz also benefited from the largesse of the Ottoman state. A British Foreign Office report of 1903 details the finances of the Syrian Hajj caravan of that year.[24] The total sum of £136,000–140,000 came from a variety of sources, and was divided into two parts: first, that controlled by the *Sürre-Emini* (keeper of state funds) and, second, the *Kiler* (Commissariat fund), controlled by the *muhafiz* (or the Amir al-Hajj: the man charged with leading the annual caravan). The first of these was the larger – about £100,000. Surprisingly, the report claims that £93,500 of this sum was distributed as 'gifts'. Comprising money and fine robes, these gifts were allocated to as many as 5,000 individuals ranging from members of Bedouin tribes along the Hajj route to descendants of the Prophet and employees of the sanctuaries of Mecca and Medina.[25] The author remarks: 'there are a considerable number of religious and possibly other functionaries whose salaries are paid out of this fund, and who, it may be said, depend upon its yearly arrival for their means of subsistence'.[26] This was particularly important because of the meagre revenues of the *Vilayet* (administrative region) of the Hijaz.

Mecca was a centre of some economic activity, though not on the scale of Damascus. Trade in Medina appears to have been much less developed.[27] Written sources provide abundant evidence concerning the markets and trades operating in Mecca however, with particularly detailed accounts appearing in the writings of European observers such as John Lewis Burckhardt (d. 1817), Ali Bey Abbasi (pseudonym of Domingo Badia y Leblich, d. 1818), and Christiaan Snouck Hurgronje (d. 1936).[28] Although none appear to have admired the quality of the native crafts of Mecca, they do mention some thriving trades. These included butchers, barbers, guides (sing. *mutawwaf*) and the sellers of water from the well of Zamzam (sing. *zamzami*). Renting of rooms to pilgrims was a profitable business in the 19th century, as were other more surprising activities within the holy city such as the selling of liquor (a drink made from fermented raisins was popular), prostitution and begging.[29] Among the manufacturers one of the most economically significant activities was the fashioning of bottles and flasks used by pilgrims to carry Zamzam water (**Pl. 8**).[30] Examples of such containers exist in museum collections along with other valued souvenirs of the Hajj, including clothing and furnishings made from the interior lining of the *kiswa*.[31]

Returning to the 1903 Foreign Office report, it is stated that between £22,000 and £26,000 was spent in Damascus from the treasury.[32] These monies were divided between the bulk of the sum which was spent on supplies and smaller portion allocated for the salaries and rations of the *muhafiz* and his two assistants. Clearly the practitioners of the crafts and trades of Damascus were well placed to take advantage of the annual economic opportunity provided by the treasury and the monies spent by individual pilgrims. Many activities directly or indirectly related to the provisioning of the Hajj are recorded in the *Qamus al-sina'at al-shamiyya* (from now on referred to as the *Qamus*). These comprise: the assessor of the caravan (*muqawwim*); the tent maker (*khaymi*); the tent raiser (*muhattar*); the maker of camel litters/palanquins (*muhayiri*); the camel driver/broker (*shayyal*); the camel driver (*jammal*); and the porter (*'akkam*). Merchants too benefited from trade with the pilgrimage caravan as well as the purchasing of goods in the markets of Mecca. These traders are discussed at the end of this section.

The *muqawwim*'s role as a facilitator was one of the most important activities associated with the Syrian Hajj.[33] He was responsible for amassing the animals, supplies and manpower required for the journey. Each year he made contracts with the masters (sing. *sahib*) of the other crafts and trades, paying some money up front and handing out payment vouchers (sing. *wusul*) to cover the remainder. Aside from ensuring adequate supplies and equipment (such as tents and bedding), he would locate and hire the very large number of riding and baggage camels required for the caravan. The authors of the *Qamus* record that the specialists he commissioned included the *'akkam*, the *shayyal*, the *muhattar*, the *tabbakh* (cook), and the *siqaya* (water provider). He also found the other servants (*ghulam*, pl. *ghilman*) who would be employed by pilgrims. There were evidently considerable profits to be made from this position, though there were also risks; in years when the numbers of pilgrims were low, the *muqawwim* might incur losses on camels, litters, tents, bedding and other supplies that remained unused. The charge for the rental of bedding ranged from 30 to 100 *lira* per person while a high quality litter (*mahara*) cost between 25 and 40 *lira*.

Tents for the annual pilgrimage were manufactured by the *khaymi*.[34] The tents were made up of strips of woven fabric, often decorated with bands of colour or *naqsh* (in this context probably referring to embroidery). Also required were the ropes, wooden poles and tent pegs. The *khaymi* produced a range of tents from relatively simple structures like the *qubba* (i.e. shaped like a domed building) to the elaborate *siwana* (marquee). The latter type was employed by the Amir al-Hajj during the journey. The most popular type of tent for *hajjis*, however, was one called *al-tazlaqa* (the precise vowelling for this word is unclear). Unfortunately, the authors of the *Qamus* do not give a description of the appearance of this type of tent. Another specialist, the *muhattar*, is responsible for erecting and taking down tents on each day of the trip to and from Mecca.[35] These men would travel ahead of the main caravan in order to prepare the tents at each of the appointed halting places.[36] They would dismantle the tents following the traditional morning call of *halluma jarran* ('let's go!') that heralded the beginning of the next leg of the journey. Many Syrian men were evidently employed as tent-raisers during the season of the Hajj.

The litters or palanquins on which pilgrims made their long journeys to and from Mecca were made by the *muhayiri*.[37] These artisans produced two types of camel litter, the *mahara* (pl. *maha'ir*) and the *shibriyya* (**Pl. 9**).[38] The former was the more expensive, and allowed pilgrims to travel in greater comfort. The authors of the *Qamus* do not describe the appearance of these types, but Charles Doughty (d. 1926) remarks that the 'Damascus litter' was 'commonly a cradle-like frame with its tilt for one person, two such being laid in balance upon a beast's back; others are in pairs housed together like a bedstead under one gay awning'.[39] The former is likely to be the *mahara* and the latter the *shibriyya* (a description of a *shibriyya* is also given by Ali Bey Abbasi[40]). This was a major craft in Damascus, and the makers of litters had their own *suq*. According to the *Qamus*, the *muhayiri* generally sold his litters to the *muqawwim*, rather than directly to pilgrims. Other craftsmen were responsible

Plate 9 Illustration of a *shibriyya,* or camel palanquin (centre of plate). The lower section depicts another type of litter known as a *takhtrawan.* After Ali Bey Abbasi, *The Travels of Ali Bey Abbasi* (1816), vol. 2, pl. LXIII

for supplying the *muhayiri* with the fabrics, particularly the tent maker (see above). These textile elements could be removed from the wooden frame each evening to provide the bedding for the two travellers riding on each camel. One of the challenges for the *muhayiri* was the seasonal nature of his work. In order to combat this, he would at other times of the year manufacture packing cases (*sahhara*, pl. *sahir* or *sahahir*) used for the export of two Damascene specialities, dried apricots and *qamr al-din* (thin sheets made by rolling dried apricots).

The *shayyal* hired out the camels used by Hajj pilgrims (presumably for a price fixed in advance by the *muqawwim*).[41] There were camels both for riding and for the transport of baggage,[42] and the *shayyal* also provided fodder for the animals. According to the *Qamus*, many were employed in this activity during the season of the Hajj. A related craft was that of the *jammal*, who sold camels in the camel market (*suq al-Jimal*) of the Syrian capital.[43] Again, different prices would be charged for riding and load-bearing camels (the former were more prized). The base language and foul manners of these men were apparently a notorious aspect of the Syrian Hajj, and the authors of the *Qamus* remark that the masters of this craft came from the lowest strata in society (*min adani 'l-nas*). The *'akkam* (porter) would guide the camel and its two passengers along the arid and sometimes treacherous tracks of southern Bilad al-Sham and the Hijaz.[44] These men were admired for their physical endurance and strength. Each *'akkam* was responsible for the protection of two pilgrims, their camel, and their litter. In addition to leading the camel he would provide other

services such as the cooking of meals at the stopping places of the journey. The price for his work was agreed in advance, and the authors of the *Qamus* note that it was possible to make a good living from this activity.

Syrian merchants were certainly active in Mecca in the early part of the 19th century. Burckhardt records that there was a *suq* devoted to them in Mecca known as al-Shamiyya (the Syrian), and located within the commercial area of al-Suwayqa (the little market). As might be expected, their busiest time was during the Hajj, and at this time they kept open numerous shops selling manufactured goods from Syria and elsewhere. Burckhardt wrote:

> In these shops are found silk stuffs from Damascus and Aleppo; cambric manufactured in the district of Nablus; gold and silver thread from Aleppo; bedouin handkerchiefs, called kafiyya, of Damascus and Baghdad fabric; silk from Lebanon; fine carpets from Anatolia and the Turkman bedouin; abbas from Hama.[45]

Reports from the 1830s also note the presence of merchants in Damascus who specialized in long-distance trade with the Hijaz, though these men boasted fewer financial resources than those engaged in commercial contact with Baghdad and European ports.[46]

The *Qamus* too gives information regarding the merchants with connections to Mecca. Some of this takes the form of anecdotal detail; for instance, the chapter devoted to the ʾantakji (dealer in art and antiquities) relates the story of the acquisition and subsequent resale of a copper bowl bought by a pilgrim in Mecca. In this case, the ʾantakji (based in Beirut) is able to secure, much to the chagrin of the pilgrim, a handsome profit for himself by selling the vessel to a European or North American collector.[47] Of more economic significance, however, were the activities of the ʾalajati (cloth merchant).[48] Damascene textiles and clothing were much in demand – as noted by Burckhardt in his description of the Syrian market in Mecca – and the ʾalajati profited from this trade with the Hijaz. Mecca was also an important source for imported fabric, including the Indian (hindiyya) cottons sold by this merchant in Damascus.

Other merchants dealt specifically with the Hajj caravan, and particularly the two major markets: at Muzayrib on the journey to Mecca and near Madaʾin Salih on the return journey to Damascus. The authors of the *Qamus* record that a merchant known as the ramihati operated at the market held at Muzayrib.[49] Traditionally, these merchants specialized in the sale of different types of spears (rumh, pl. rimah) to the Bedouin of Syria. Such weaponry was largely outmoded by the late 19th century (handheld firearms being freely available to those with sufficient funds to purchase them), and was probably bought as much for display as actual use. It is probable that the ramihati had diversified his operations to include the sale of other items, and this is implied in the *Qamus*. The authors state that Bedouin and villagers flocked to the Muzayrib market in order to purchase a wide range of goods including clothing, floor coverings and weapons. This had been a flourishing market long before the writing of the *Qamus*, and a detailed description of it appears in the writings of the Turkish traveller, Evliya Çelebi (d. 1682).[50]

The *jarrad* attended the gathering at Muzayrib and the large market that took place at al-Hijr near Madaʾin Salih.[51]

Doughty describes this as the 'Jurdy market', a name that presumably derives from the jirda, a garrison sent from Damascus in order to escort the returning caravan on the last stage of the journey from northern Arabia to Syria.[52] The name of the jarrad probably has the same origin. These men sold a wide range of merchandise – the *Qamus* mentions cloth, finished clothing, skins and foodstuffs – to pilgrims as well as inhabitants of the countryside. This was a profitable activity and the authors of the *Qamus* note that, outside of the Hajj season, the jarrad would roam widely buying and selling goods in remote towns and villages. Doughty records the Damascene merchants at the Jurdy market opening bales in order to reveal, 'coffee-cups, iron ware, precious carpets (like gardens of fresh colours and soft as the spring meadows,) – fairings for great sheykhs! And clothing stuffs for the poor Beduw'.[53] Among the items sold by those returning from Mecca were coffee from Yemen, spices from the Malay islands, perfumes from India and Mecca as well as Chinese porcelain. Food on sale at the Jurdy market included Syrian olives, leeks, cheese, biscuits, sour lemons and sweet dates. (Doughty makes clear that one reason for the profitability of this event was the inflated prices charged to pilgrims for fresh produce.) Bread was baked in clay ovens (sing. tannur) set up on site, and there were itinerant cobblers who used the skins of camels (from those that had died on the journey) to repair the shoes of pilgrims. Local Bedouin moved among the stalls trying to sell clarified butter (samn) and the money gained from this would be used to buy Damascene shirt cloth and other products.

Conclusion

This brief survey only presents a fraction of the available textual and archaeological evidence on this topic. More research is needed to gain a fuller impression of the ways in which the annual movement of the Syrian Hajj shaped the economies of Damascus, the rural areas of southern Greater Syria and north-western Arabia. Money, manufactured goods, foodstuffs, beasts of burden and services all formed part of the economy of the Hajj, while modes of exchange ranged from trade to the redistribution of wealth by the state. Prices were evidently volatile with merchants keen on the opportunities presented by captive markets (such as the sale of fresh produce to pilgrims on the return journey to Damascus). The written sources hint at the co-existence of different mercantile networks – local, regional and international – and this picture is borne out by the archaeological evidence from the Karak plateau and from the Ottoman forts along the Darb al-Hajj. This topic would be a fruitful avenue for future archaeological research.

The evidence from the *Qamus* illustrates the ways in which the economic opportunity presented by the Hajj led to considerable diversification of craft specialisms in the city of Damascus. Each craft sought ways of benefiting from the presence of thousands of pilgrims passing from the Syrian capital to the Hijaz and back again. The *Qamus* frequently notes that many are employed in a given activity during the season of the Hajj, but this also means that these same people had to find gainful employment elsewhere for the remainder of the year. In the case of the muhayiri this meant shifting to the manufacture of wooden packing cases in the

slack periods, while the *jarrad* looked for other clientele in the rural areas of Greater Syria when he was not selling his wares at the Muzayrib and 'Jurdy' markets. All of these crafts were, of course, designed to supply a population of pilgrims who made the long trek to the holy cities Medina and Mecca by camel or on foot (a journey of thirty seven days each way), but the first decade of the 20th century brought with it a massive change. The completion of the last stage of the southern section of the Hijaz railway in 1908 finally connected Damascus to Medina, reducing the travelling time between the two cities to four days.[54] The entry devoted to the *muqawwim* notes that with 'the arrival of the railway line (*khatt al-hadidi*) to the two Noble Sanctuaries' this craft was no longer operating.[55] The same must have been true of many of the other Hajj-related crafts in Damascus. The Syrian Hajj, and the economic activity associated with it, had entered a new phase of mechanized transportation.

Notes

1 I am most grateful to Venetia Porter for inviting me to participate in the Hajj conference at the British Museum. My thanks also to Andrew Petersen for allowing me to read the final proofs of his book on the forts of the Syrian Hajj route.
2 Kazantzakis 1961: 225–6.
3 On different forms of exchange during the Hajj, see Faroqhi 1994: 66, 74–91, 146–73. Sir Richard Burton (d. 1890) also provides numerous examples of payments for goods and services from his journey from Egypt to Mecca, Burton 1937: 119, 126, 135, 139–40, 142, 154–5, 202–3, 241 and 257.
4 For example, see the late antique ceramic plaques from Jerusalem and other Palestinian sites in Buckton 1994: 114–15, cat. 130.
5 Lane 1836, I: 323. Tawfiq Canaan records that Palestinian pilgrims would bring back from Mecca pear-shaped artefacts made from dried earth from around the Ka'ba mixed with blood from sacrificial animals; see Canaan 1927: 99, 106, 110.
6 Saller 1957; Bagatti 1984; Pringle 1984; Tushingham 1985.
7 François 2002; Milwright 2008a: 127–30, 146.
8 Al-Qasimi, al-Qasimi and al-'Azm 1960. For the biographies of the three authors, see the introductions by Louis Massignon and the editor Zafir al-Qasimi (I, 7–23 [French text], II, 5–23 [French text], 208 [Arabic text]). Also Commins 1990: 42–6.
9 The semantic range of these terms is rather broader than would normally be connoted by the English term 'craft'. *Hirfa* and *sina'a* can be understood as referring to skilled activities that will earn a wage.
10 On the date at which the text was completed, see Commins 1990: 86; Milwright 2011a: 61.
11 Archaeological work on the Darb Zubayda is summarized in Creswell 1989: 280–4; Milwright 2010: 162–4.
12 For the analysis of the mercantile documents in the building called the 'Sheikh's House' at Qusair, see Guo: 2004. On the diverse material culture of this site, see Peacock and Blue 2011.
13 Edib 1840: 45. Milwright 2008b: 113–17.
14 Edib 1840: 47–8, 54–5.
15 Ibn Battuta 2005, I: 72.
16 Brown 2000.
17 Milwright 2008b: 111–12.
18 Brown 2006: 374–5, 382–4.
19 François 2002.
20 Establet and Pascual 1996: 145–6; 2001: 147–50.
21 Petersen 2012.
22 See chapters by Andrew Petersen, Tony Grey and St John Simpson in Petersen 2012: 164–208.
23 Qasatili 1876: 124–5.
24 Reproduced in Issawi 1988: 236–9. The document (FO 195/2144) was from Richards to O'Connor, and is dated 10 February 1903.
25 On the distribution of such gifts in earlier periods, see Faroqhi 1994: 55–8, 66.

26 Issawi 1988: 237. On the impact of the payment of the *Sürre* upon the economy of the Bedouin tribes of northern Arabia, see Doughty 1936: 239, 323, 338.
27 Issawi 1966: 303.
28 These sources are conveniently collected in Peters 1994b: 246–85.
29 Burckhardt 1829: 116–17, 128, 260; Al-Abbasi 1816, II 105–6; Hurgronje 1931: 37–8. On begging in the holy cities, see also Burton 1937: 190–1, 202–3, 241.
30 On the activities of the *zamzamis*, see Hurgronje 1931: 21–2. Burckhardt (1829: 123–4) mentions about twelve kilns operating in the pottery district of Mu'amala. These concentrated upon the production of jars for the well of Zamzam. Al-Abbasi (1816, II: 100) notes that tinners made vessels for Zamzam water. Quoted in Peters 1994b: 252, 262, 282–3.
31 Porter 2012a: 72–5, figs 39–45, 262–4, fig. 208.
32 Issawi 1988: 238.
33 Al-Qasimi, al-Qasimi and al-'Azm 1960: 465–6.
34 Al-Qasimi, al-Qasimi and al-'Azm 1960: 129.
35 Al-Qasimi, al-Qasimi and al-'Azm 1960: 474.
36 Doughty 1936: 246; This is described at the stopping place of the *Hijr*. For an illustration of the work of the *muhattar*, see Porter 2012a: 125, fig. 86 (a 19th-century Viennese toy theatre set depicting the Hajj caravan halting in the desert).
37 Al-Qasimi, al-Qasimi and al-'Azm 1960: 420–2.
38 On the definitions of these terms, see Lane 1863–93: 667; Dozy 1881, I: 334, 719. The *mahara* may derive its name from having originated in the ancient Iraqi city of Hira.
39 Doughty 1936: 100. The author also claims that the awnings of one litter were embroidered with a Greek cross, perhaps having some apotropaic value for the occupants.
40 Al-Abbasi 1816, II: 47. He wrote: 'I travelled on a machine made of sticks, and covered with cushions in the form of a sofa or cabriolet, roofed with boughs upon arches, which they placed upon the back of a camel, and called a Schevria. It was very convenient, and I was enabled to sit up or lie down upon it ...' See also Burton 1937: 142, 256 (he mentions two other types, the 'Haml Musattah' and 'Takhtrawan').
41 Al-Qasimi, al-Qasimi and al-'Azm 1960: 263.
42 On the different prices for load camels and riding camels, see Issawi 1966: 320 (citing British diplomatic and consular reports from 1898 and 1912–13).
43 Al-Qasimi, al-Qasimi and al-'Azm 1960: 83.
44 Al-Qasimi, al-Qasimi and al-'Azm 1960: 318–19.
45 Burckhardt 1829, 120–1. Quoted in Peters 1994b: 251–2.
46 The assets of the different importing merchants of Damascus are discussed by Sir John Bowring (d. 1872). See Bowring 1840: 94.
47 Al-Qasimi, al-Qasimi and al-'Azm 1960: 40–1. Partially translated in Issawi 1988: 388. This chapter is discussed in greater detail in Milwright 2011b.
48 Al-Qasimi, al-Qasimi and al-'Azm 1960: 39–40.
49 Al-Qasimi, al-Qasimi and al-'Azm 1960: 158–60.
50 Çelebi's comments on the market are discussed in Irwin 2012: 178–9. Another account of the market appears in a text about the Hijaz railway by Muhammad 'Arif. See Irwin 2012: 211.
51 Al-Qasimi, al-Qasimi and al-'Azm 1960: 79.
52 Doughty 1936: 243–50, 632.
53 Doughty 1936: 246.
54 Irwin 2012: 211.
55 Al-Qasimi, al-Qasimi and al-'Azm 1960: 466.

Chapter 6
Royal Ottoman Inscriptions on the Istanbul to Mecca Pilgrimage Route (*Darb al-Hajj al-Shami*)

Mehmet Tütüncü

Introduction

After the defeat of the Mamluk sultanate in 1517, almost all the lands of the Middle East and Northern Africa were unified under the Ottoman Empire. Subsequently, the holy places – Mecca, Medina and Jerusalem – became part of the Ottoman state. Ottoman sultans, now carrying the honorific title of *Khadim al-Haramayn* (Custodian of the Two Holy Sanctuaries) were also considered to be the only legitimate caliphs and became the protectors of the Hajj routes. The maintenance and the security of these routes were imperial tasks that underlined their religious leadership. Therefore, Ottoman sultans ordered the rebuilding and restoration of the old Hajj route from Damascus to Mecca and extended it to Istanbul. This route was also a part of an old Christian pilgrimage route leading to Jerusalem and was used for the purposes of trade and commerce.

In the northern part of the route from Istanbul to Damascus, the Ottoman sultans ordered the construction of many amenities and large complexes for commercial activities.[1] In the southern parts, they built other facilities with forts and water reservoirs for the travellers and the pilgrims heading to Mecca.[2] In the 20th century, the Ottoman sultan Abdülhamid II (r. 1876–1909) ordered the building of the Hijaz Railroad, which would connect Istanbul with the holy cities of Mecca and Medina.

Many inscriptions are found along the Ottoman Hajj route and on its buildings.[3] Although it is likely that all the forts on the Hajj route had inscriptions detailing when and by whom they were built, as well as any subsequent restoration or re-building, unfortunately only a few of these have survived. Currently there are only 19 Ottoman inscriptions to have been discovered on the Hajj route south of Damascus (**Table 1**). The earliest surviving inscriptions are from the year 1531 (at al-Akhdar) some 15 years after the Turkish victory over the Mamluks. The latest inscriptions are from Haifa from the year 1319/1901–2.

In this contribution I will focus on the inscriptions of Ma'an in Jordan, of Tabuk and Qal'at Mu'azzam in Saudi Arabia, and those found near the Hijaz Railway station at Haifa in Palestine. The versions I present here are based on recent photos taken during a trip to Saudi Arabia.

Ma'an

Ma'an in Jordan was one of the last Hajj stations before entering the Arabian Peninsula. The Ottomans built a fort and a water reservoir there. An inscription describing this is preserved in the fort. This inscription was discovered in the 'Darb al-Hajj' survey'[4] by Andrew Petersen and it has been a source of great interest ever since. It was recently published in Arabic,[5] and in 2012 by the present author.[6] The 2011 publication by Rashdan and Sha'ban is useful as it provides a historical background and contains many illuminating images and drawings. However, the reading of the inscription is incorrect in parts and in this article, I would like to present a revised and, in my opinion, more accurate reading.

The famous Ottoman traveller Evliya Çelebi (1611–82) visited Ma'an in 1681. In his *Seyahatname*, he mentions an inscription that gives the date of construction, but he says with regret that he could not copy its content. He wrote:

Table 1 List of inscriptions from the Damascus Hajj Route (Jaussen 1907 and Ghabban 2012)

Number	Place	Date	Size = lines	Current status	Language used
1	Al-Akhdar – Saudi Arabia	938/1531	40 x 55 = 4	National Museum, Riyadh	Turkish
2	Al-Akhdar	938/1531	1.15 x 53	National Museum, Riyadh	Arabic
3	Ma'an – Jordan	971/1563	4	*in situ*	Turkish
4	Dhat al-Hajj – Saudi Arabia	971/1563	40 x 50 =5	*in situ*	Arabic
5	Mu'azzam – Saudi Arabia	1031/1622	?	*in situ*	Turkish?
6	Mu'azzam	1031/1622	4	*in situ*	Turkish
7	Mu'azzam	1031/1622	4	*in situ*	Turkish
8	Mu'azzam	1031?/1622	6	*in situ*	Turkish
9	Tabuk – Saudi Arabia	1064/1653	8	*in situ*	Arabic
10	Tabuk	1064/1615	3	Destroyed	Arabic
11	Al-Akhdar	1115/1703	7	*in situ*	Arabic
12	Hasa – Jordan	1174/1760	3	Destroyed	Arabic
13	Dab'a – Jordan	1189/1766–7	3	Destroyed	Arabic
14	Fassu'a – Jordan			Destroyed	? Arabic
15	Al-Akhdar	Unknown	4	National Museum, Riyadh	Arabic
16	Tabuk	1260/1844	8	Destroyed	Arabic
17	Dhat al-Hajj	1266/1850	54 x 58 = 9	National Museum, Riyadh	Arabic
18	Tabuk	1319/1901	6	Destroyed	Turkish
19	Haifa – Palestine	1319/1901	6	*in situ*	Arabic/ Turkish

'Above the door, there is a date, but because we were in a hurry, we could not write it down'.[7]

The inscription (**Pl. 1**) is expertly carved onto a marble panel and is divided into eight cartouches in four horizontal bands. The second and third lines are partly destroyed, but from the visible letters we can fill in the blanks. It is inscribed in Turkish and forms one of the most beautiful Ottoman inscriptions in Arabia:

جهانك شاه هفت اقليمي عثمان اوغلينك

ضمير خير انديشينه الهام ايلدى رحمان

[...]قباد باشا قوليله عسكر شامه.

معانده ايلدى بر برج و بركه يابمغي فرمان

تعمير بحمدالله ادوب معمورك يت(ب)ريقن(ط.)

اولب حجاج ابد داعي زهي خير و زهي احسان

بو احقير بنده سي كاتب سكوني ديدى تاريخن

معانده يابدى برج بركهء سلطان سليمان

Turkish transcription of the inscription

Cihânın şâh-ı heft-iklîmi Osmânoğlu'nun
Zamîr-i hayr-endîşine ilhâm eyledi Rahmân
… Kubad Paşa kuluyla asker-i Şam'a
Ma'an'da eyledi bir burc u birke yapmağı ferman
Tarîkin beyt-i ma'mûrun edüp ta'mîr bi-hamdillâh
Olup huccâc ebed dâ'î zihî hayr u zihî ihsân
Bu ahkar bendesi kâtib Sukûnî dedi tarîhin
Ma'an'da yapdı burc [u] birkeyi Sultân Süleyman (971)

English translation

The Lord of the world and seven climes, the Ottoman
The merciful ordered them to do beneficence.
[Through] … Kubad Pasha his officer in Syria;

He ordered the building of a fort and a water reservoir in Ma'an.
He repaired – praise to God – the road to the holy site,
The pilgrims prayed: what charity and what benevolence.
Humble slave scribe Sükuni composed its chronogram:
In Ma'an Sultan Süleyman built a fort and a water reservoir (971)

The date is written in the last line in figures but also in the numerical value of the letters. The chronogram reads as follows:

معانده يابدى برج بركهء سلطان سليمان
191 150 1 227 205 27 170 = 971/1563

The inscription clearly draws attention to the Ottoman's imperial force by describing Sultan Süleyman as the 'ruler of the seven climes and as the one who ordered the construction of the fort and water reservoir. It also gives a

Plate 1 Ottoman Turkish inscription from the fort at Ma'an above the entrance (photo: Andrew Petersen)

Plate 2 Fort in Tabuk (photo: Sami Saleh 'Abd al-Malik)

good insight into the reasons why the Ottoman sultans decided to carry out these construction developments along the route, namely to do beneficence and receive blessings from the prayers of pilgrims. The people mentioned in the inscription are the scribe Sükuni and the Qubad Pasha the governor of Damascus who was from the Ramazanid dynasty in southern Turkey.

Tabuk

Ottoman inscriptions also appear at the Hajj station of Tabuk which was one of the most important stations on the Hajj route (**Pl. 2**). Here the Ottomans built a fort, which dates back to the rule of Sultan Süleyman I (r. 1520–66). The fort consisted of two storeys: the ground floor contained an open courtyard, a number of rooms, a mosque and a well, with stairs that led to the first floor which in turn contained an open courtyard, a mosque, a number of rooms and stairs leading to the adjoining watchtowers. This fort is one of the most important monuments in the area.

There are four imperial inscriptions in Tabuk. One of them is the inscription of Sultan Mehmed IV (r. 1648–87), which will be described below. Three more inscriptions at Tabuk highlight the importance of the city along the Hajj

route. One of these inscriptions is from the rule of Sultan Abdülmecid (r. 1839–61), dating specifically to 1260/1845. It records the repair of the mosque inside the fort. Another dates to 1319/1901 from the rule of Sultan Abdülhamid II (r. 1876–1909) and it records the repair of a water reservoir. These royal inscriptions referring to different sultans clearly indicate the importance of Tabuk to the Ottoman sultans as guardians and servants of the pilgrimage route. For discussion in this article, I selected the inscription of Sultan Mehmed IV.

This Arabic inscription at Tabuk is unique as it is inscribed on a series of ceramic tiles set within a rectangular recessed panel above the entrance to the fort. With the exception of this example, all inscriptions were inscribed on stone along the Damascus Hajj route.

Evliya Çelebi mentions this inscription in 1672 in his *Seyahatname*.[8] In Book 9 he transcribes it as follows:

> Simâle nâzır bir demir kapusu vardır. Atebe-i ulyâsı üzre kâsî-i Çîn içre bu târîh (düsürme) tahrîr olunmusdur: (Târîh)
> Fî eyyâmi Mevlânâ es-Sultân Mehemmed Hân ibn İbrâhîm Hân medde zillahu bi-sebebi tamîri Emîn-i Defteri Dimaşk Nâşifzade Mehemmed el Fakîr sene 1062.[9]

Translation

> There is a metal door in the north side of the building. Above this door is written a date with an inscription on tiles. The date is as follows:
> During the times of our Master\Sultan Mehmed Khan son of Ibrahim Khan may Allah prolong his reign till the end of time, the person involved was the treasurer from Damascus Nasifzade poor Mehmed year 1062.

The sultan in question is Sultan Mehmed IV (r. 1648–87). Evliya notes the year as 1062/1651 but this is incorrect as I have read the inscription and it shows the year as 1064/1653. Such an error is easy to make because the digit 4 is written in a way that makes it appear as a 2. Nonetheless, from Evliya's description, we can also figure out the destroyed part of the name in line 7 as follows: *Nâşifzade defterci* (the treasurer or secretary from the Nashifzade family).

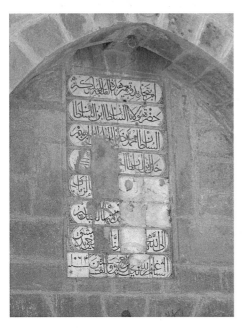

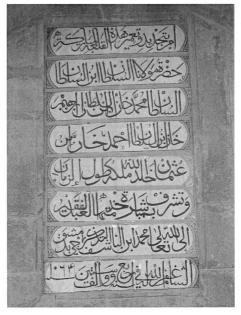

Plate 3 (far left) Inscription in front of the fort at Tabuk in 2001 (photo: Mehmet Tütüncü)

Plate 4 (left) Replica inscription in front of the fort at Tabuk in 2012 (photo: Sami Saleh 'Abd al-Malik)

The Turkish writer Söylemezoğlu Süleyman Şefik bin 'Ali Kemâlî who performed the Hajj in 1890 together with his father wrote an extensive description of his travels.[10] He noted in his book that the fort of Tabuk was built by Selim I and later restored by Sultan Mehmed Khan. He described an inscription on its doorway which was installed on green ceramics and dates to 1064/1653. He mentioned with regret that the Arabs had destroyed many parts of this inscription with their bullets and so as a result he had great difficulties in reading the content. There is a picture from 2001 of this inscription (**Pl. 3**) although it is very difficult to read.

A recent photograph of the inscription shows that the original was removed and replaced with a replica. It reads:

أمر بتجديد وتعمير هذه القلعة المباركة

حضرة مولانا السلطان ابن السلطان

السلطان محمد خان ابن السلطان ابراهيم

خان ابن السلطان احمد خان ابن

عثمان خلد الله ملكه الى اخر الزمان

وتشرف بمباشره خدمتها العبد الفقير

الى الله محمد ابن الناشف زاده دفترجي بدمشق

الشام غفر الله له في سنة أربع و ستمين و الف

English translation

The reconstruction and renewal of this blessed fort was ordered by
Our present lord Sultan son of the Sultan
Sultan Mehmed I Khan son of the Sultan Ibrahim
Khan son of the Sultan Ah[med]
Osman, may Allah prolong his reign till the end of times
And this poor servant was honoured for his service to the service of Allah Mehmed ibn al-Nashshifzade Defteri of Damascus
in Syria may Allah pardon him in the year 1064 [1654 AD]

Al-Mu'azzam

Al-Mu'azzam fort is located half way between Tabuk and Mada'in Saleh (**Pl. 5**). It was built to guard the water reservoir of al-Mu'azzam.[11] Three inscriptions are found on the fort, all in Ottoman Turkish. Although Jaussen and Savignac saw the inscriptions, they were, unfortunately, unable to make copies at the time. They published

translations based on copies that had been made and sent to them at the École Biblique in Jerusalem made by one of the telegraph operators at al-Mu'azzam.[12] Ghabban has republished all the inscriptions, with photos.[13] Relying on the photos of Ghabban, I published these inscriptions in 2012.[14] However, due to the poor quality of the photos, my assessment was not conclusive. During a trip in 2013, I was able to visit the fort and take pictures of the inscriptions *in situ*. The following readings are based on these new pictures:

Inscription A (Pl. 6)

شهنشا هي جهانة سلطان عثمان بحق كعبة وحنان ومنان

معظم بركة سي نامنه عثمان منزيل قلعة يابدي راه حجده

حبيبك حرمتي هم جار ياران الهي سلطانلره يرقرار ايت

ديدي هاتيف كمالي خير احسان ولي فكر ايلر ايكن تاريخي

سنة ١٠٣١ كتبه يوسف

Turkish transliteration

Bi-hakk-ı Ka'be ve ve Hannân ve Mennân Şehinşâh-ı cihân Sultan 'Othman
Menzil-i kal'a yapdı râh-ı hacda Muazzam birkesi nâmına 'Othman
İlahi sultanları ber-karâr et Habîbin hürmetine hem câr-ı yârân
Veli fikri eyler iken tarihi Dedi hâtif kemâl-i hayr u ihsân
Ketebehû Yusuf, sene 1031.

English translation

By the Ka'ba, by the Ever Yearning One (*hannan*) and the Benefactor (*mannan*), Sultan of the sultans of the world Sultan Osman,
He built the fortress and resting place of al-Mu'azzam and excavated this vast cistern fitting for the name of Osman,
May God guard the ruler in his majesty by the intercession of the beloved (Prophet) and his neighbours and family;
The poor Veli Fikri has said its date, the author of this verse states that the benefaction will be complete. Written by Yusuf in 1031.

The last line is an *abjad* date which, when calculated, gives exactly 1031 the same year that is given in numerals:

كمالي خير احسان

130+ 810+101= 1031

Plate 6 Inscription A from al-Mu'azzam (photo: Laurence Hapiot)

Plate 7 Inscription B from al-Mu'azzam (photo: Laurence Hapiot)

Plate 8 Inscription C from al-Mu'azzam (photo: Laurence Hapiot)

Inscription B (Pl. 7)

This consists of four lines (4 x 2 distiches) of Turkish verse written above the entrance gate of the fortress.

سليمان أغه اير كور مراده	خدايا باعث أولا بو باسايه ن
كه أنك أرى در خير ايشه مايه	دخي شام حافظى وزير سليمان
كركدر أو ستلرينه صالح سايه	عنايت ايلسون انلارده سلطان
أو قيوب فاتخة دوره دعاية	غريقى رحمت ايده انى يزدان

Turkish transliteration

Hudâ'ya bâ'is ola bu besayan Süleyman Ağa er gör murâda
Dahi Şam Hâfızı Vezir Süleyman Ki anın eridir hayr işe mâye
İnâyet eylesin anlara Sultân Gerekdir üstlerine sâlih-sâye
Garîk-i rahmet ede anı Yezdân Okuyup Fatiha dura duâya.

English translation

To the Almighty God this shadowy place, and it fulfills the wishes of Süleyman Agha,
The guardian of Damascus, vizier Süleyman who has done many good works to establish the foundations:
And the Sultan, who came to help, for the master mason needed this rescue,
Let God grant them grace in abundance and for whom one recites the *Fatiha* and pray for him.

Inscription C (Pl. 8)

A seven line inscription on the left wall of the entrance gate, the first five lines is a Turkish poem, while the last two lines contain the names and signatures of the people involved in the renovation of the fort:

خسين أغا درا وسته ناظر	مبارك قلعة ديارى بولدي حاضر
مرادينه ايره بطان وظاهر	بياله بر يلوك سر معتمدر
الهى غل غشدن ايله طاهر	محافظ عثمان أغا شيخ مرشيدي
أو له رلر رحمتك أمر كه	كه كاتب يوسف ولي وقولكدر
كوجيه أيمان أيله دنيان اخر	بيره دروب دعا أيدن عزيز لر

امل المعلم علي ابن محمد المعمار باشي بدمشق الشام

المعلم قلعة نقولا ابن الياس

نقشه هلال

Turkish transliteration

Mübârek kal'a diyarı buldu hâzır Hüseyin Ağa'dır usta [vü] nâzır
Piyale bir bölük ser-i mu'temeddir Murâdına ere bâtın u zâhir
Muhâfiz 'Othman Ağa Şeyh mürşidi İlahî gıll ü gişten eyle Tâhir
Ki kâtip Yusuf veli ve kulundur Olurlar rahmetin emrine hâzır
Bize durup duâ eden azîzler Göçe imân ile dünyâdan âhir
Amelü'l-Muallim Ali ibni Mehmed el-Mimârbaşı bi-Dımaşk eş-Şam
El-malûm kal'a-i Nikola ibni İlyas
Nakkaşahû Hilal.

English translation

This blessed fortress has found the rest, the chief Hüseyin Agha is the master and caretaker.
He is the head of the protector of this (holy) road. That God will grant both their inner and outer wishes.
Muhafiz [Qur'an reciter] Osman Agha, is the guide of the Sheikhs, May God make clean from all the bad things;
The writer Yusuf Wali is your servant, and is ready to execute the orders that are given to him.
The true pilgrims, who pass on this route pray, let them pass with faith from this world to the other
Made by the famous 'Ali ibn Yahya, the master mason from Damascus of Syria sent to the known fortress Nikola the son of Ilyas and scribe Hilal.

According to the Ottoman writer Hibri who made the pilgrimage in 1632 and left us a pilgrimage route guide, Sultan Osman II intended to visit the Ka'ba and made preparations for his visit giving orders to build and repair the Hajj route fortresses and water reservoirs. The reparation of the Mu'azzam water reservoir and the building of the fortress with orders to his soldiers to guard the fortress and water reservoirs seems to have been a part of his pilgrimage plans.[15] However, before Sultan Osman II could realize his plans, he was murdered by a mutiny of the Yenicheri soldiers in 1622. Another fortress and water reservoir that Osman II had built and repaired is the famous Solomon's Pool (Qal'at Burka) between Hebron and Jerusalem.

Plate 9 (far left) The Hijaz railway monument in Haifa (photo: Mehmet Tütüncü)

Plate 10 (left) Detail of Haifa's Hijaz Railway monument (photo: Mehmet Tütüncü)

Only Inscription B is dated. The other two are not but based on their style and content they probably date to 1031/1622. All three inscriptions are hierarchically composed and they mention all the individuals who were involved in the construction of the fortress.

Inscription A is an ode to the governor and commander of Damascus, vizier Süleyman, who oversaw the development of the Hajj route. Inscription B is dedicated to the ruling Sultan Osman II, the patron of the fortress. It was inscribed in 1622, the last year of his rule. Inscription C mentions the names of 6 people who were involved in the construction and decoration of the fortress:

1. Hüseyin Agha in his capacity as a caretaker.
2. Muhafiz Osman (the religious person, Qur'an reciter).
3. Katib Yusuf is probably the same person as in inscription B.
4. The architect named is 'Ali Ibn Muhammed Mimarbashi (chief architect) from Damascus. It is notable that, as in the case of the fort at Tabuk, the architect was from Damascus.
5. Nikola son of Ilyas – caretaker or contractor for the construction of the fort. The name is remarkable because this is the first time that a non-Muslim is mentioned in connection with the construction of the forts.
6. A new name is the scribe, Hilal.

Hamidiya Hijaz Railway monument

In 1900, Sultan Abdülhamid II started the construction of a railway that would run from Istanbul to Mecca.[16] Modern railway transport for pilgrimage was used and financed completely by contributions from Muslims all over the world. This was a pan-Islamic project stressing the unity of the Muslim *umma* (community). The construction of the railroad route would also augment the sultan's prestige as it increased the speed of the journey but decreased the cost of pilgrimage. Construction started in May 1900 and was finished by September 1908 when the transportation of pilgrims from Istanbul via Damascus to Medina began.

This was a landmark of achievement by the Ottomans in the modern period. The use of the railway lasted until the year 1917 when parts of the railway were bombed in World War I at the time of the Arab revolt, which marked the end of Ottoman domination of the Hijaz. The railway had several branches and it was intended that it would be used by the pilgrims coming from the Mediterranean. The most important branch was that in Haifa, from where passengers could take the train to Dera which would connect them to the main railroad.

The only surviving commemorative monument to the railway is actually not in Istanbul, Damascus or Medina, but in Haifa (**Pl. 9**). Sultan Abdülhamid built a monument with an inscription by Haifa train station. This inscription, which I will look at closely here, gives an excellent insight into the intentions of Sultan Abdülhamid.

Haifa's imposing *Sûtun-u âli* or imperial monument is of great significance. It is decorated with an Ottoman coat of arms, *tughras* and railway symbols all of which have been cut into the marble. It also contains two inscriptions in Arabic and Turkish (**Pl. 10**).

The monument is constructed as a group of four fluted Ionian columns with a square entablature on top, which is an architrave supported by the four columns. Four stone balls crown the entablature; a fifth stone ball is wreathed

Plate 11 Inscription on the Hijaz Railway monument in Haifa (photo: Mehmet Tütüncü)

Plate 12 Telegraph monument of Damascus (photo Mehmet Tütüncü)

long life, as he ordered the construction of a railway line from Damascus [in] al-Sham, to facilitate the pilgrimage of the community of Muhammad to the House of God and to humbly pray on the tomb of the Prophet of God. The Sultan then gave his grand command (may God lengthen his rule) that a railway line should be laid from the city of Haifa to connect with the Hijaz line. Therefore it is the duty of every Muslim who made the pilgrimage to the House of God and visited the grave of the Prophet to pray to God to strengthen and enforce the Sultan's great caliphate and to raise his high hand over the heads of the people. Inscribed in 1319 (1901/1902).

The Turkish inscription (dated 1319/1901)

بسم الله الرحمن الرحيم الحمد لله وحده والصلاة والسلام على من لا نبي بعده

امير المؤمنين وخليفة روي زمين سلطان البرين وحاقان البحرين السلطان ابن السلطان السلطان

الغازي عبد الحميد خان ابن السلطان عبد المجيد خان افندمز حضر تلرينك حجاج مسلمين فريضيا

حجى ادى و روضى عاطري رسالت بناهي زيارت ايله سدى سنيه خلافت كبرانك نصرو ايله تيدنه

دعا ايتملرنه واسطى خيري اولماق اوزره شام شريف شهرندن مكيي مكرميه قدار انشاسنه امر وفرما

بيوردقلرى حميدية حجاز تيمور يولونا شعبه اولماق اوزره تمديدي اردى سنيه جنابى خلافتي بناهي

حوكمى منيفندن اولا (ن) حيفا تمور يوانك خاطيرى بركز اريدر سنة ١٣١٩

Turkish transliteration:

Bismillâhi'r-Rahmâni'r-Rahîm el-hamdü lillâhi vahdehû ve's-salâtü ve's-selâmü alâ-men lâ-nebiyye ba'dehû) Emiru'l-müminin ve halife-i ruy-i zemin sultanü'l-berreyn ve hakanü'l-bahreyn es-Sultan ibnü's-sultan es-Sultan el-Gazi Abdülhamid Han ibni's-Sultan Abdülmecid Han Efendimiz hazretlerinin hüccâc-ı Müslimînin farîza-i haccı edâ ve ravza-i mutahhara-i risâlet-penâhîyi ziyaret ile südde-i seniyye-i hilafet-i kübrânın nasr u te'yîdine duâ etmelerine vâsıta-i hayriyye olmak üzere Şam-ı şerif şehrinden Mekke-i Mükerreme'ye kadar inşasını emr u ferman buyurdukları Hamidiyye Hicaz demiryoluna şube olmak üzere temdîdi irâde-i seniyye-i cenâb-ı hilâfet-penâhî hükm-i münîfinden olan Hayfa demiryolunun hâtıra-i ber-güzârıdır sene 1319. (Miladi 1901/1902)

English translation

In the name of the most Merciful and Compassionate God, praise be to God alone and prayers and peace to the last of the prophets.

Commander of the faithful and the caliph of the earth, the Sultan of two continents, and the king of the two seas, the Sultan, son of the Sultan, the warrior Abdülhamid Khan, son of the Sultan Abdülmecid Khan, as he ordered the construction of a railway from Damascus, to facilitate the pilgrimage of the community of Muhammed to the House of God and to humbly pray on the tomb of the Messenger of God. The Sultan then gave his grand command (may God lengthen his rule) that a railway line should be laid from Haifa to connect with the Hamidiya Hijaz line. This is a monument for remembrance of this works.

Inscribed in 1319 (1901/1902).

with flowers and supports the crescent. The pedestal has a bas-relief of a steam locomotive with a tender and a flying wheel drive with wings and signs of steam and thunderstorms. On the base of the monument, two inscriptions are carved: one on the southern side is in Arabic and the other on the northern side is in Turkish.[17] The inscriptions tell their own history of how the Haifa Damascus railway road was built as a supply route of the Hijaz Railway from Damascus to Medina. Moreover, it reports that Sultan Abdülhamid ordered the construction of a railway line to be built from Damascus to Medina in order to facilitate the act of pilgrimage (**Pl. 11**).

The Arabic inscription (dated to 1319/1901)

بسم الله الرحمن الرحيم الحمد لله وحده والصلاة والسلام على من لا نبي بعده

ان سيدنا ومولانا امير المؤمنين خليفة سيد المرسلين سلطان البرين وحاقان البحرين السلطان

ابن السلطان السلطان الغازي عبد الحميد خان ابن السلطان الغازي عبد المجيد خان ايد الله ملكه وا،

حياته وعمره قد امر ان بنشا من دمشق الشام سكة حديدية تسهل على امة محمد (صلعم) الحج الى

الجباه على روضة رسول الله (صلعم) ثم صدر امره المعظم ادام الله ملكه المفخم ان تمد سكة حديد

حيفا تتصل في السكة الحميدية الحجازية فعلى كل مسلمين حج بيت الله وام روضة رسول الله ان يد

اليه عز شأنه بان يؤيد خلافته الكبرى وان يرفع على هام العالمين يده حرر سنة ١٣١٩

English translation

In the name of the Most Merciful and Compassionate. Praise be to God alone; and prayers and greetings upon the last of the prophets. Our lord and master the Commander of the Faithful and the Sultan of the two continents, and the king of the two seas, the Sultan, son of the Sultan, the warrior, Abdülhamid Khan, son of the Sultan, the warrior, Abdülmecid Khan, may God support his reign and lengthen his life and bless him with

The monument at Haifa is an expression of Sultan Abdülhamid II's efforts to modernize the Ottoman Empire by developing transport and communication lines from the Ottoman capital to the Arab provinces. So why did the sultan build this monument in Haifa and not in Istanbul or in Damascus which were more appropriate locations for a monument to the railway? The answer is motivated by

geopolitics. Palestine was at a junction where many Western foreigners were present. Jaffa was the main gateway for the Christians and Jews who came to Palestine. By making Haifa a gateway for Muslims, Abdülhamid was hoping to make Palestine a hub along the pilgrimage route. He also wanted to display the presence of the Ottoman Empire in Palestine with this modern monument and to convey the message of pan-Islamism and Muslim unity.

A monument comparable to the Haifa is the Damascus telegraph monument, which commemorates the laying of telegraph lines from Istanbul to Damascus (**Pl. 12**).[18] On the top of the monument is a carved miniature of the mosque of Yildiz Hamidiye in Istanbul. This was the principal mosque in Istanbul where the sultan carried out his Friday prayers and receptions. Under the miniature mosque on the column, there are telegraph lines and cables that connect the capital Istanbul with distant Arab provinces.

The Hijaz railway shortened the duration of travel from 40 days to 3 days. Consequently, the more conservative Muslims who took the long route with camels named it the 'women's route' as an indication of the ease of the journey. We wonder then what they would have called the 'airplane' route nowadays, which is the most common way to visit the holy cities in modern times.

Conclusion

The range and content of the inscriptions in Arabic and Ottoman Turkish discussed in this chapter demonstrate the significance of the buildings on which these texts were placed. As imperial buildings, they illustrated and asserted the sultan's authority over the annual pan-Islamic event of Hajj, while at the same time being expressions of piety that connected the authority of the sultan in the major centres of the administration of the Ottoman empire to Mecca, the heart of Islam itself. As we have seen, these inscriptions are not only of documentary and historical value providing the names of patrons and scribes but they often also contain evocative texts in which they implore pilgrims as they journey to the holy cities to remember those involved in the building. The arrival of the railway certainly made things easier for travellers; it shortened the length of the journey and connected the various regions of the empire more effectively. But World War I and the Arab Revolt marked the end of an era in the history of Hajj when the narrative of Hajj-going was grander and more epic, and when the stopping places were more conducive to contemplating the journey, its hardships and the spiritual reward in Mecca and thereafter. And it may be argued that the inscriptions in Maʿan, al-Muʿazzam and other locations mark points of remembrance.

Notes

1 For an overview of Ottoman *khans* and road constructions in Turkey see Müderrisoğlu 1993; for Greater Syria see Sauvaget 1937 and Cytryn-Silverman 2010.
2 For Ottoman activities south of Damascus see Petersen 2012.
3 Arabic inscriptions are mainly published by Sauvaget 1937. Cytryn-Silverman 2010 provides a compilation of the published material. Arabic and Turkish inscriptions are found in Petersen 2012: 155–63.
4 Petersen 2012: 156.
5 Rashdan and Shaʿban 2011.
6 Petersen 2012: 156.
7 Çelebi, 1996, IX: 295–6.
8 Çelebi, 1996, IX: 297.
9 Çelebi 1996, IX: 296–7.
10 Söylemezoğlu 2013.
11 Petersen 2012: 141–2, 160–2.
12 Jaussen and Sauvignac 1997, I: 296–8.
13 Ghabban 2011: 574–80.
14 Petersen 2012: 155–62.
15 See al-Hibri 1975, 126.
16 Nicholson 2005: 188–9.
17 First published by Tütüncü 2006: 230–3, and figures 135–7.
18 The monument and its inscription have not been published before.

Chapter 7

From Iraq to the Hijaz in the Early Islamic Period

History and Archaeology of the Basran Hajj Road and the Way(s) through Kuwait

Andrew Blair and Brian Ulrich[1]

'*Who has not seen with his own eyes this Iraqi caravan has not experienced one of the genuine marvels of the world....*'[2]

Introduction

When the Andalusian Ibn Jubayr was leaving Mecca for Medina on the Hajj of 1183, he was clearly awestruck by the sheer size of the pilgrimage from Iraq. To a traveller from the remote west of the *Dar al-Islam* (the regions of Islam), the number of pilgrims making the comparatively short Hajj from Iraq must have seemed out of this world. Indeed, for Ibn Jubayr the 'immensity of the desert was too narrow' to contain the mass of people whom he described no longer as a crowd but as a 'sea swollen with waves, whose waters were the mirages and whose ships were the camels, their sails the lofty litters and round tents'.[3] As the caravan travelled by night, the numbers of hand-born torches were so vast that they seemed to be 'wandering stars which illuminate the depths of the darkness and enable the earth to compete in brightness with the stars of heaven'.[4]

Among Ibn Jubayr's vivid metaphors we find aspects of the pre-modern Hajj which are very different to those of today. It is of particular significance that the considerable distances and treacherous landscapes between Iraq and the Hijaz were covered by vast numbers of pack animals and pedestrians on foot, making the journey much longer and more arduous than that undertaken by today's pilgrim. Indeed the duration and dangers of travel, the corresponding scale of the logistical operation in providing shelter, food and water, as well as the pilgrims' shared life experiences – such as the mode of travel, sights witnessed and the places visited – would have made the journey itself a much larger aspect of Hajj than it is today. It follows that to understand the nature of the early Islamic Hajj one must look beyond the performance of the rites around the Haramayn (The two Sanctuaries in Mecca and Medina) to the roads and the journeys which brought pilgrims there from all over the Islamic world.

Perhaps a more immediate point to take from Ibn Jubayr's description is of the sheer size of the Iraqi Hajj. Ibn Jubayr performed his pilgrimage in the 12th century when the Muslim conversion of Iraq would have been well under way and the annual pilgrimage in full flow. While Iraq began to be incorporated as part of the Islamic caliphate within a decade of the death of the Prophet Muhammad (d. 632), popular uptake of Islam took time to follow suit and the Iraqi Hajj in the Umayyad period was likely to have been a minor affair compared to the Syrian and Hijazi pilgrimages.[5] The defeat of the Umayyad caliphs in the Abbasid revolution of 750, however, heralded a new significance for the Iraqi Hajj. The new ruling Abbasid family shifted the centre of power in the Islamic world from Damascus to central Iraq, establishing subsequent capitals at Kufa, Baghdad and Samarra. The implication was that the roads from Iraq to the Hijaz would now host the flagship pilgrimage led by the caliph.[6]

The most famous of the Iraqi routes and perhaps the most celebrated Hajj route of all is the so-called Darb Zubayda, which ran from Kufa to the Hijaz. The name derived from its patron, Queen Zubayda (762/3–831), wife of the Abbasid Caliph Harun al-Rashid, in respect of her sponsorship of

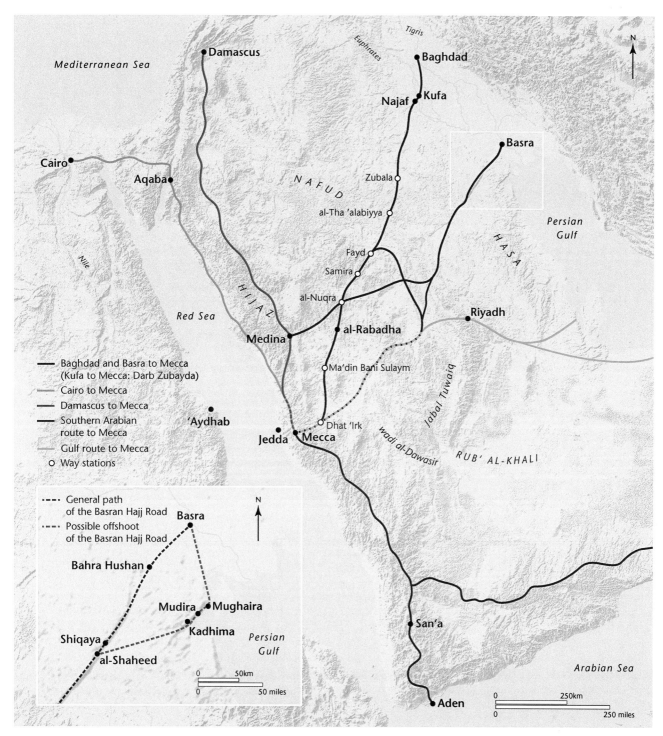

Plate 1 The Arabian Hajj roads as well as the northern portion of the Basran Hajj road with the archaeological sites mentioned in the text (inset) (artwork by Matt Bigg, Surface 3)

shelter and water installations for the benefit of pilgrims.[7] This road has seen extensive historical and archaeological research, whether on the history of caliphal investment, the development of official stations along the route, its water facilities or its milestones.[8] The Abbasids, however, also developed a route from the southern Iraqi city of Basra, apparently to facilitate the needs of pilgrims from southern Iraq and south-west Iran. This road followed a natural valley called the Wadi al-Batin, which today separates Iraq from Kuwait (**Pl. 1**). The Basran Hajj road is sometimes considered a secondary or subsidiary road;[9] however, although the shortest route from Baghdad to Mecca went through Kufa, the Abbasid caliphs and their extensive

official caravans often took the Basra road as well, sometimes going to Mecca via the Darb Zubayda and returning by way of Basra.[10]

The Basran Hajj and the Wadi al-Batin
The Basran road has received far less scholarly attention than its more famous counterpart. While often mentioned alongside the Darb Zubayda, the first work which dealt with it in detail was Salih ibn Sulayman al-Washmi's *Al-Athar al-ijtima'iya wa al-iqtisadiya li-tariq al-hajj al-'iraqi 'ala mintaqat qasim* (Social and Economic Remains of the Iraqi Hajj Road in the Region of Qasim), published in 1994, and based primarily on research conducted during the 1970s.[11] More

Plate 2 The large building at Shiqaya. The outlines of the plastered walls can be seen in white

recently, Sa'id ibn Dabis al-'Utaybi published *Tariq al-hajj al-basri: dirasa tarikhiya lil-tariq wa-athariya li-manazilihi min dariya ila awtas* (The Basran Hajj Road: Studies on the History of the Road and the Archaeology of the Stations from Dariyah to Awtas).[12] Like al-Washmi, al-'Utaybi focused mainly on archaeological sites in the Qasim province in north-central Saudi Arabia. Information on the route stations along the Iraq-Kuwait border was included in Ya'qub Yusuf al-Ghunaym's *Al-Sayyidan: qabs min madi al-kuwayt* (Al-Sayyidan: Glimpse of Kuwait's Past).[13] Finally, 'Awad ibn Salih al-Surur published his own study of the stations between al-Qasim and south-western Kuwait in *Tariq al-hajj al-basri bayna al-nabaj wa-al-ruqa'i* (The Basran Hajj Road between al-Nabaj and al-Ruqa'i).[14]

The route of the Basran Hajj road covered around 1200km, running from southern Iraq across the northern Arabian Peninsula. Once the road had departed from Basra, it entered the Wadi al-Batin – a broad palaeo-channel which extends from the west of the city at the head of the Persian Gulf – and continued along the northern border between Iraq and Kuwait, eventually leading into Saudi Arabia and reaching Hafar al-Batin. The road then cut across a northern stretch of the Dahna Sands before entering al-Qasim province north of the city of Burayda. From there, the road curved south towards Dariya, where it was joined by the road from al-Yamama, then headed south-west across parts of Riyadh province west of 'Afif and towards Mecca. The two Iraqi routes eventually met around 100km north-east of the holy city, recorded in some versions to be at a place called Dhat 'Irq, or in others at Umm Khurman or Awtas.[15]

The origins of this route are a matter of debate. Al-Rashid has stated that unlike the Darb Zubayda, the road between Mecca and Basra had no pre-Islamic heritage and was a 'purely Muslim innovation'.[16] Al-Washmi and al-'Utaybi, however, note that several of its stations were inhabited in pre-Islamic times, and parts of the route may

have been in use to travel between these settlements as well as to reach Basra's predecessor port of al-Ubulla. Al-'Utaybi also notes accounts from the lifetime of Muhammad which describe people travelling along the route, although the only evidence he gives of use north of al-Qasim is from Sayf ibn 'Umar's account of the Battle of Dhat al-Salasil, which Ulrich has argued elsewhere to be unreliable.[17] Although it is certainly true that pre-Islamic settlements along the route would have used sections of it, it is probable that in the absence of investment in the upkeep of its infrastructure, most commercial traffic from the Hijaz turned towards al-Yamama at Dariya and then up the coast, as happened after the road's decline.[18]

Use of the route is more certain from the earliest years of the Islamic period. With the founding of Basra in 637 the route began to be used for administrative traffic, and we have the first report of an improvement to the northern section when the Basran governor Abu Musa al-Ash'ari dug a well to provide water for the place that would bear his name, Hafar Abu Musa, the modern Hafar al-Batin. Under the rightly guided caliphs, 'Umar and 'Uthman, governors were actually required to perform the Hajj each year and report to the caliph, who almost always led it. Improvements to the road's infrastructure continued into the Umayyad period, and in 675 al-Tabari reports that there were Hajj pilgrims travelling to Mecca along the Wadi al-Batin. Al-Washmi also mentions the likelihood that it would have seen traffic communicating between those living in the garrison towns of lower Iraq and their fellow tribesmen who remained in central and north-eastern Arabia.[19]

When the Abbasids came to power in 750 they not only continued supporting the Hajj as one of their most important duties as leaders of the Islamic community, but even lead it in person far more frequently.[20] Development of the road was again led by the governors of Basra, and was particularly undertaken during the reigns of al-Mahdi (r. 775–85) and al-Rashid (r. 786–809). Al-Mahdi's governor,

his cousin Muhammad ibn Sulayman, not only provided route stations with fresh water and fruit trees, but brought ice to the caliph on the Hajj in 777. Route development continued under Muhammad's brother and successor Ja'far ibn Sulayman in al-Rashid's reign.[21] The reigns of al-Mahdi and al-Rashid were also the most important for development of the Darb Zubayda.[22]

Recent survey and recording work conducted within the Kuwaiti portion of the Wadi al-Batin has begun to produce archaeological data illustrative of the development of the Basran Hajj route. Since 2009, the Kadhima Project (Durham University and Kuwait National Museum) has been tasked with exploring Kuwait's early Islamic heritage.[23] Within that remit, the project has conducted surveys of parts of the Kuwaiti portion of the Wadi al-Batin and identified several previously understudied archaeological sites with a proposed link to the Abbasid development of the Basran Hajj road. The data collected is unfortunately only a summary due to the fact that the Wadi al-Batin currently functions as a demilitarized border zone between Iraq and Kuwait, with access severely restricted and possible only under the presence of a police guard. Freedom to survey the Wadi was further constrained by the presence of unexploded ordnance residual from the 1991 war.

The first site of interest, located in the northern portion of the border area, is that of Bahra Hushan (**Pl. 1**), which is possibly the al-Hufayr of the ninth-century Hajj route guides.[24] Three broad mounds, best considered as low tells, lie in close proximity to one another. The easternmost and westernmost mounds measured approximately 80 x 95m and 50 x 80m respectively, and both possessed traces of multiple structures composed partly of stone. The central mound, 60 x 70m in size, had a large central depression such as would be consistent, perhaps, with a large well. A tarmac track which cuts through the edge of the central mound revealed part of a fired brick construction in the section. All the mounds were densely littered with building debris, large quantities of ceramics, and glass; while a small scattering of human bone was found on the surface of the western mound. A preliminary analysis of the ceramic assemblage places the site firmly within the early Islamic period, and indeed the settlement can be assigned with some confidence to the eighth century based on the presence of torpedo jars (TORP) and turquoise glazed wares (TURQ), alongside an absence of the so-called 'Samarra Horizon' wares which were produced from the early ninth century.[25] This assemblage of fine wares and imports is typical of eighth-century sites in the region of Iraq and eastern Arabia, and is repeated locally at a number of settlements along the northern coastline of Kuwait Bay as well as the site of al-Qusur on Failaka Island.[26] The black gritty coarseware and fired brick at Bahra Hushan are not, however, found in Kuwait Bay, and the use of fired bricks in general is a phenomenon hardly known in eastern Arabia, suggesting that the cultural affinities of the site might be more closely tied to Iraq.

A second site was later identified at Shiqaya in the southern end of the Kuwaiti portion of the Wadi, near to the border with Saudi Arabia (**Pl. 1**), and the probable site

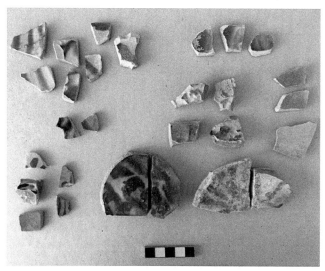

Plate 3 Polychrome splash wares from Shiqaya, indicating the first substantial ninth-century settlement discovered in modern Kuwait

of medieval al-Shajiya.[27] The central part of the site consisted of a large building over 30m long and 15m wide, which was surrounded by a number of small single or double-roomed structures with stone foundations. The large building survives as a series of plastered walls exposed to surface level, and a low-level kite photograph has revealed that it was rectangular in plan with a tripartite internal organization perpendicular to the long axis of the building (**Pl. 2**). In the immediate region, the most comparable buildings in architectural style, scale and method of construction are the churches at al-Qusur and Akkaz Island;[28] however, the Shiqaya structure's plan and orientation is almost certainly not that of a church. More appropriate parallels may be found in the Abbasid building complexes erected at the stations along the Darb Zubayda.[29] While no exact parallel can be found between the Shiqaya structure and those examples published by Donald Whitcomb, the buildings are reconcilable in thematic plan and scale, although the Shiqaya building is smaller. Certainly the architecture is more characteristic of Iraq than eastern Arabia. In the case of the Darb Zubayda, Whitcomb interprets the buildings as 'elaborate caravanserai' having been constructed according to a structural template,[30] and it is tempting to see the Shiqaya building as the Basran equivalent of this.

Around 200m south of the settlement area can be found a broad mound with a central depression, 20m in diameter, which almost certainly represents a large well. To the north of the settlement, the survey identified what appears to have been an industrial complex, 15 x 15m in extent, with large amounts of heavily vitrified kiln or furnace lining. The settlement and industrial areas are littered with material culture, with the ceramic assemblage providing clear evidence that the site was occupied during the ninth century. This conclusion is based on the presence of polychrome splash wares which began to circulate widely in Iraq from around 835 – the so-called 'Samarra Horizon' wares (**Pl. 3**).[31] A large portion of the ceramic assemblage consists of the ubiquitous turquoise glazed wares which have a long chronology, dating back to the pre-Islamic period.[32] Without stratigraphic excavation it is impossible in this case to either

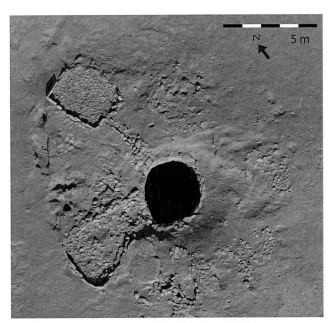

Plate 4 The well and cisterns at Kadhima Area ABC

reject or confirm an earlier (eighth century) occupation. One can be more certain, however, that the settlement at Shiqaya did not continue long into the tenth century, based on the absence of lustre and sgraffiato wares. Shiqaya currently represents the only substantial ninth-century occupation yet to have been discovered within the modern state of Kuwait, in spite of plentiful evidence for eighth-century settlement at Bahra Hushan, numerous small settlements along the Kuwait Bay coastline,[33] Akkaz Island, as well as the extensive site at al-Qusur on Failaka Island.[34]

Further south, the survey identified a large well at al-Shaheed close to the border with Saudi Arabia. The well survives as a ring mound with a central depression, 25 x 25m in size. While impossible to assign a date, the well appears similar in plan and size to that at Shiqaya and would have required significant levels of investment far beyond the more common smaller-scale wells. A sense of considerable antiquity is enhanced through the presence on the surface of several simple oval arrangements of stone such as denote the type of Islamic graves used prior to the late 19th and early 20th centuries.

Through these preliminary historical and archaeological studies an impression of the nature of the Basran Hajj road is beginning to emerge which repeats a signature pattern identified for other Hajj routes, specifically the Darb Zubayda and Syrian Road. Andrew Petersen has identified settlements as a key feature of the Syrian Hajj route and the Darb Zubayda,[35] growing up organically around deliberately planned infrastructure in a similar fashion to a *vicus* next to a Roman fort, with Whitcomb going further to describe the Darb Zubayda itself as a linear settlement network.[36] As regards to the Basran Road, within the Kuwaiti section of the Wadi al-Batin we have identified above what appears to be substantial settlements at Bahra Hushan and Shiqaya. The settlement at Shiqaya gives the clearest indication of development, where the presence of a large structure and a well suggest the involvement of the Abbasid government through the governors of Basra,

around which a settlement grew, as suggested by the presence of a large number of smaller structures with simple stone foundations. The repetition of the pattern elsewhere is suggested by the growth of Hafar al-Batin (Saudi Arabia) as a settlement following the aforementioned installation of wells on behalf of the Basran governor Abu Musa al-Ash'ari (r. 639–50).

Hajj roads, however, were more than routes demarcated by a series of consecutive settlements. Among those archaeological sites that have so far been identified in the Wadi al-Batin, a range of functions and needs that needed to be fulfilled have been identified. The presence of wells (or possible wells) at each settlement demonstrates that providing the large numbers of travellers and their animals with adequate quantities of water was high among the logistical concerns of the Hajj, particularly given the heat and aridity of the region. Indeed the provision of water facilities is one of the best studied elements of the Darb Zubayda and the Syrian road.[37] Furthermore, the size of the caravans and length of the journey would have necessitated frequent repairs and replenishment of material provisions. Undoubtedly, the settlements themselves thrived on this kind of business and it is likely that the aforementioned industrial complex at Shiqaya served this passing demand as much as the needs of the permanent inhabitants of the settlement. The link between Hajj and mercantile trade has been demonstrated elsewhere in the context of the Syrian road and the Darb Zubayda,[38] and it is also likely that similar activities characterized exchange along the Basran Road – whether the purchase of goods to take to the famed markets at Mecca, or the sale of items procured there. Religious provision in the form of mosques – another important need for pilgrims – is also a common element of the Darb Zubayda. Petersen suggests these were quite small and served the officials as opposed to the mass body of pilgrims themselves.[39] There is however, as of yet, no definite evidence for such a structure at any of the Kuwaiti sites mentioned above. We can also see facilities appropriate to fulfilling an administrative and political function. The large 'palatial' building at Shiqaya is the type of structure that might have played a role in the logistical organization of all aspects of that section of the road, and would have been appropriate for housing important officials whether as part of the caliph's official caravan or the messengers on administrative business travelling between Basra and the Hijaz. In a more subtle way, the Abbasid government's investment in such infrastructure would have served to impose their authority on the route network and emphasize in a physical way their presence and control of the landscape. The impact of this would not only have been to fulfil their obligation to protect the Hajj and to ensure it took place, but also to make clear to passing travellers, pilgrims and Bedouin alike exactly who was in charge.

The settlement of northern Kuwait Bay: Kuwait's other road?

In addition to the aforementioned route, there is potential archaeological and literary evidence of a less developed road along Kuwait Bay's northern coast. The proposed route is similar to that described by John Gordon Lorimer in his

Gazetteer of the Persian Gulf,[40] where upon departing Basra travellers would head through Safwan and Um Qasr towards Subiya on Kuwait Bay's northern coastline. From here, they would follow the coastal plain as it turned south-west towards the town of Jahra, and then continue in a westerly direction through al-Dawwa and al-Sayyidan, eventually joining the Wadi al-Batin near al-Shajiya.

Literary support for such an early Islamic route is a complicated matter. The early Islamic archaeological remains of northern Kuwait Bay are often associated with the historic toponym 'Kadhima' due to the location of the modern version of that name in this area, and in turn this toponym is mentioned by a number of authors in discussions of roads (including Hajj routes). However, the meaning of the toponym 'Kadhima' is somewhat ambiguous, or more accurately varies according to author. In some cases it appears to refer to a specific settlement(s), while in others it is better understood as a larger region which probably encompasses most of the Kuwait Bay area and not just the narrow strip along the northern coastline.[41]

As far as the literary evidence is concerned, Kadhima is mentioned in relation to roads by several authors, although unfortunately none are in complete agreement.[42] Al-Bakri locates Kadhima on the Tariq al-Munkadir, a Hajj road connecting central Iraq with Arabia via Basra,[43] yet in a separate work he is somewhat contradictory, saying that only a road to eastern Arabia or al-Yamama passed through Kadhima.[44] Lughdah al-Isfahani identifies two routes from Mecca to Basra – one that followed the Wadi al-Batin, as well as 'an easier one through Kadhima, al-Samman and al-Dawwa' which he calls the Tariq al-Munkadir.[45] Al-Harbi however disagrees, suggesting that the road from Iraq forked at Safwan, with one branch heading to Mecca while the other passed through Kadhima whence it forked again, into branches leading towards al-Yamama and the Yemen respectively.[46]

It seems that there are at least some historical grounds for placing Kadhima on a road linking Basra with Mecca, specifically the Tariq al-Munkadir. However, we return to the problem that Kadhima cannot be unproblematically identified with the northern coastline of Kuwait Bay, and thus we must turn to the archaeological evidence to determine whether the north coast was used as a route during the early Islamic period as indeed it was at Lorimer's time of writing. In examining this evidence, we can identify many of the same archaeological indicators evidenced for better known routes, particularly the aforementioned Basran Hajj road along the Wadi al-Batin, the Syrian road and the Darb Zubaydah.

Foremost among these is the presence of a number of seemingly contemporary settlements stretching along the coastal plain, with three settlements at Mughaira, Mudira and Kadhima areas A, B, C, E and F possessing material assemblages dated to the eighth century (**Pl. 1**).[47] Both within and between these settlements there appears to have been a hierarchy expressed in architecture, with large multiroomed rectangular buildings contrasting with small sub-rectangular single-roomed structures. In this hierarchy we may find archaeological traces of a distinction between the elite/administrative and domestic aspects of the sites,

mirroring in a much smaller way the picture emerging from deliberately planned Hajj stations elsewhere.

In addition to the linear arrangement of contemporary settlements, it is certainly the case that the Kuwait Bay coastline met the practical requirements of a route. The region has been long known for the availability of water, with both al-Bakri and Yaqut noting the presence of wells and brackish water at Kadhima in medieval times.[48] Recently, solid archaeological evidence has emerged for an investment in water installations which were likely to have been in use during the eighth century. The region around Mughaira has an abundance of water wells that were used from prehistory until the mid-20th century; however, it is uncertain which wells served the large eighth-century population (wells being notoriously difficult to date). The best evidence for water provision is found at site Kadhima ABC, where a large stone-built well, between 3.5 and 4.5m in diameter and around 5.5m deep, is surrounded by up to six cisterns (**Pl. 4**). Each cistern was lined with stone, made watertight with an underlying layer of clay, and connected to the central well via a drainage sluice. This water installation would have allowed for the watering of large numbers of pack animals relatively quickly. The well is located in close proximity to a large multiroomed rectilinear building with a material assemblage which suggests it was occupied during the eighth century. This substantial structure may have fulfilled an administrative function related to access to the well water, as well as a suitable residence for passing officials.

In terms of religious provision, no buildings which were obviously mosques have yet been identified along the coast; however, two cemeteries (one at Kadhima Areas ABC, E and F, the other at Mughaira) are composed of simple stone outlines roughly oriented with their sides on the *qibla* (direction of Mecca) for the most part.[49] These cemeteries are indicative of a Muslim population, an important point given the fact that the contemporary settlement of al-Qusur on nearby Failaka Island appears to have been largely Christian in denomination.

As well as allowing for the dating of the settlement network, the eighth-century material assemblage excavated from the sites offers evidence that the coastline was linked to the exchange networks of the wider Islamic world, perhaps even the Hijaz. The ceramic assemblage is characterized by the presence of turquoise glazed ware, as has been reported above for the sites in the Wadi al-Batin and indeed seen all over the Islamic world at this time. Links to the outside world are further supported by large quantities of glass, with basic forms of globular bottles and bowls paralleled throughout Iraq and eastern Arabia. It is, however, the assemblage of chlorite which offers the potential link to the Hijaz, with chlorite quarries known from several locations within that region and near to al-Rabadha on the Darb Zubayda.[50]

The coastal settlements were somewhat rapidly abandoned by the early ninth century, as indicated by the almost total absence of 'Samarra Horizon' wares. One possible explanation for such a rapid decline was that the ongoing investment in the Wadi al-Batin eventually diverted enough pilgrim and merchant traffic away from Kuwait Bay that the coastal settlements lost their crucial

sustenance and ceased to be viable. This argument is not entirely convincing however as investment and use of the Wadi al-Batin is already known from the seventh and eighth centuries, and it is not clear what crucial difference would see the abandonment of the coast in the early ninth century. Rather, the abandonment of the Kuwait Bay settlements appears to be part of a wider trend negatively affecting eighth-century settlements in the Persian Gulf region. There is little continuity between the eighth and ninth centuries across the region, with a large number of eighth-century settlements in eastern Arabia abandoned, such as the nearby al-Qusur on Failaka Island, as well as a discontinuity between eighth- and ninth-century sites witnessed in Andrew Williamson's surveys of south-western Iran.[51] It is, therefore, unlikely that a loss of pilgrim traffic alone could account for the abandonment of the coastal settlements; instead a broad regional explanation relating to political, economic or population trends appears more likely.

If pilgrim (or other) traffic was not the main source of income for the Kuwait Bay settlements, for what other reason did the sites grow and thrive during the eighth century? As a precursor to the eighth-century settlements, activity along Kuwait Bay's mainland coastline is evident from the fifth to the seventh century based on the presence of a large number of dense scattering of torpedo jars in association with a small number of yellow glazed sherds with notched rims which have been dated elsewhere to the Sasanian period.[52] These ephemeral sites probably represents signs of fishing activity, as suggested by the discovery of a number of net weights. It is possible that prosperity from this industry provoked the growth of more substantial settlements, albeit with diversified incomes from activities such as controlling camel grazing lands and water sources, and trade of secondary animal products in return for manufactured items of material culture such as ceramics, chlorite and glass.

In summary, it is still unclear whether the Kuwait Bay settlements which were occupied during the late seventh and eighth century were part of a route used by pilgrims, merchants or other travellers. On the one hand, the sparse documentary evidence that we have for this area suggests that a place known as Kadhima was located along a route connecting southern Iraq with the Arabian Peninsula, while archaeologically we witness on Kuwait Bay's northern coastline the same components of the Darb Zubayda, Syrian road, and now the Basran Hajj road, though albeit on a smaller scale. However, on the contrary, there is little archaeological evidence that the emergence and abandonment of the coastal settlements had much to do with fluctuating prosperity associated with an Iraq–Arabia road. In other words, if the northern coastline was indeed used by travellers or pilgrims, this was likely to have been short lived – confined to the late seventh and eighth centuries, and of relatively minor impact. Research on these settlements is still ongoing, and at present a compromise conclusion would perhaps be that while it is entirely possible that travellers including pilgrims used a route along the Kuwait Bay coast, this was unlikely to have been the *raison d'être* for the coastal settlements themselves.

Decline of the Iraqi roads

The decline of the upkeep of the Iraqi Hajj roads is generally considered to have begun in the ninth century. The chronology of the settlement at Shiqaya supports such a date for the demise of the Basran road, as monochrome lustrewares and polychrome sgraffiato – chronological markers of the tenth century and later periods – are strikingly absent. To explain this, historians have focused on growing insecurity in the Arabian Peninsula, with Bedouin raids in particular rendering performance of the pilgrimage unsafe. One explanation for this insecurity, emphasized by al-Rashid and mentioned by al-'Utaybi, is that disenfranchised Arab Bedouins were responding to a loss of power within the caliphate to Persians and Turks.[53] This, however, is simply anachronistic, attributing a sense of ethnic solidarity to the Bedouins where none existed. Al-'Utaybi, however, primarily focuses on the general weakness of the Abbasid caliphate, with the decay in its economic foundations preventing it from projecting adequate military power into Arabia to preserve road security and maintain the infrastructure developed along the Hajj routes. What investments they did make were along the Darb Zubayda, which was the direct route from Baghdad.[54] As Abbasid officials often recruited local Bedouins to assist with the administration of the routes, the raids could also have been an attempt to reclaim from the pilgrims income previously acquired from more official sources.[55] With this in mind, it is striking that the military campaigns against Arabian Bedouins belong primarily to the period when the caliphs were in Samarra, a few decades after the major development projects along the pilgrim roads.

Disturbances affecting the Hajj routes came to a head at the end of the ninth century, with the Zanj revolt in southern Iraq, and the Qarmatians in the Gulf region raiding across the peninsula. These factors would undoubtedly have negatively influenced the upkeep of the Basran road to a greater degree than the more westerly Darb Zubayda, and thus it is likely that the infrastructure associated with the former road declined much earlier than the latter as central control of southern Iraq became more difficult to assert. Ultimately however the decline of the upkeep of both of the Iraqi roads was unavoidable; and, rather than being the result of a single death-blow, their gradual demise appears to have been a consequence of an economically and politically troubled central administration which by the tenth century was long in retreat. That said, the decline of central government investment in the Darb Zubayda and the Basran Hajj road was not the end of the Iraqi pilgrimage by any means. Every year until perhaps the early 20th century many thousands would assemble in the cities of Iraq, forming huge caravans as they embarked for the Hijaz. The golden age of the Iraqi roads may have passed, but the magnificence of the Iraqi caravan remained: a point which was so beautifully made by the 12th-century writer Ibn Jubayr.

Notes

1 This chapter emerged from research undertaken as part of the Kadhima project, which is a collaboration between Durham University and the Kuwaiti National Council for Culture Arts and Letters (NCCAL) directed by Derek Kennet. The authors would like to express their thanks to NCCAL Secretary General, Ali

Hussein Alyouha, Assistant Secretary General Shehab A. Shehab and Director of the Department of Antiquities and Museums, Sultan al-Duwish. The authors would also like to thank Shippensburg University interlibrary loan staff, as well as Derek Kennet for his comments on an earlier draft of this chapter.

2 Ibn Jubayr 1949–51: 213–15/Ar. 184–6, quoted in Peters 1994a: 75.
3 Ibn Jubayr 1949–51: 213–15/Ar. 184–6, quoted in Peters 1994a: 75.
4 Ibn Jubayr 1949–51: 213–15/Ar. 184–6, quoted in Peters 1994a: 75.
5 Hourani 2005: 46–7; Bulliet 1979.
6 Kennedy 2012: 92–4.
7 Abbot 1946; al-Rashid 1978: 35; al-Rashid 1980; Peters 1994a: 73–4.
8 Knudstad 1977; al-Dayel and al-Helwa 1978; al-Dayel *et al.* 1979; MacKenzie and al-Helwa 1980; Wilkinson 1980; Morgan 1981; al-Rashid 1978, 1979, 1980; al-Helwa *et al.* 1982; Whitcomb 1996; Petersen 1994.
9 Petersen 1994: 48–9.
10 Al-'Utaybi 2005: 52–6.
11 Al-Washmi 1994.
12 Al-'Utaybi 2005.
13 Al-Ghunaym 1998.
14 Al-Surur 2007.
15 Al-'Utaybi 2005: 25–6; al-Rashid 1980: 4. For a list of all 29 stations and the sources mentioning them, see al-'Utaybi 2005: 32–3. An English list of most of the stations is in al-Muqaddasi 2001: 91–2.
16 Al-Rashid 1980: 329.
17 Al-Washmi 1994: 103; al-'Utaybi 2005: 42–5; Ulrich 2012: 404.
18 Nasir-i Khusraw 2001: 108–10.
19 Al-Rashid 1980: 14–15; al-Washmi 1994: 104–7; al-'Utaybi 1994: 46–51; McMillan 2011: 35–6.
20 McMillan 2011: 158–60.
21 Al-'Utaybi 2005: 52–6; Kennedy 2012: 101–4.
22 Al-Rashid 1980: 18–20, 31–5.
23 Kennet *et al.* 2011; Blair *et al.* 2012.
24 Ulrich 2012: 403; al-Ghunaym 1998: 91.
25 Kennet 2004: TURQ (p. 35–8), TORP (p. 85), Samarra Horizon wares (pp. 38–42).
26 Al-Duwish 2005; Kennet *et al.* 2011; Blair *et al.* 2012.
27 Al-Ghunaym 1998: 130.
28 Bernard *et al.* 1991; Gachet 1998; for Sir Bani Yas, see also King 1997.
29 Whitcomb 1996; Petersen 1994.
30 Whitcomb 1996: 31.
31 Kennet 2004: 38–42.
32 Kennet 2004: 35–8.
33 Al-Duwish 2005; Kennet *et al.* 2011; Blair *et al.* 2012.
34 Bernard *et al.* 1991; Kennet 1991; Pieta *et al.* 2009.
35 Petersen 1994.
36 Whitcomb 1996.
37 Al-Rashid 1979; Wilkinson 1980.
38 See Milwright in this volume.
39 Petersen 1994: 52.
40 Lorimer 1908.
41 Kennet *et al.* 2011; Ulrich 2012.
42 See Ulrich 2012: 403.
43 Al-Bakri 1945–51, iv: 1109.
44 Al-Bakri 1977: 50–1.
45 Lughdah al-Isfahani 1968: 338.
46 Al-Harbi 1969: 573–8.
47 Al-Duwish 2005; Kennet *et al.* 2011; Blair *et al.* 2012.
48 Abu 'Ubayd al-Bakri 1983: 1110; Yaqut [n.d.], IV: 489.
49 Blair *et al.* 2012: 20–1.
50 Al-Rashid 1986: 77.
51 Kennet 2012: 193.
52 Blair *et al.* 2012: 16–17; Kennet 2004: 35–7, table 15, fig. 5/64.
53 Al-Rashid 1980: 47–8; Al-'Utaybi 2005: 59–60.
54 Al-'Utaybi 2005: 70.
55 Al-Washmi 1994: 96–7.

Chapter 8
The *Khans* of the Egyptian Hajj Route in the Mamluk and Ottoman Periods

Sami Saleh 'Abd al-Malik

Introduction

Studies dealing with fortified buildings on the Hajj route tend to focus on their military functions, overlooking their roles as places where pilgrims could rest and store their belongings. Furthermore, current research on the Egyptian Hajj route has not sufficiently explored the emergence and development of *khans* on this route and the services they provided for pilgrims and other travellers. This article aims to address these gaps using archaeological evidence and the historical accounts of those who visited the *khans* or witnessed their construction.

Most constructions on the Egyptian Hajj route that were built between the period of the Islamic conquest of Egypt and the end of Fatimid rule (1171) were places for the storage of water in the form of wells and reservoirs, or were the sites of religious buildings such as mosques, and were linked to the fort towns that rose on the route itself. Most important among such towns were Qulzum, the recently discovered Ayla, al-Hawra' and the town and port of al-Jar. During this period, the first *khan* was built in 'Ushaira on the shore opposite the town of Yanbu' al-Nakhl. Mentioned by al-Muqaddasi (d. 990), this is the oldest *khan* to my knowledge. I believe that further excavations at the locations of the ports and early towns along the Egyptian Hajj route and its various paths are likely to uncover more *khans* not mentioned by geographers and historians.

As a result of the presence of the *firanj* (Europeans) in Bilad al-Sham (Greater Syria) during the Ayyubid period and the expansion of the kingdom of Jerusalem as far as the town of Ayla ('Aqaba), the overland Hajj route moved from Sinai to the south of Egypt, through Qus and 'Aidhab, and from there by sea to the port of Jedda. The Egyptian Hajj route, particularly the first quarter between Birkat al-Hajj and Ayla, became a military route upon which the armies of Saladin (r. 1169–93) marched between Cairo and Damascus, and it became known as the route of Sadr and Ayla.

During the Mamluk period (1250–1517), the overland Egyptian Hajj route was redirected to the north through Sinai and flourished both culturally and architecturally. The most significant buildings constructed on this route were forts and towers that served as security points in addition to acting as *khans* which were centres of hospitality for travellers and pilgrims. These were built at the major stations on the route, namely 'Ajroud, Suez, al-Tur, Nakhl, Abyar al-'Ala'i, 'Aqaba, al-Aznam and Yanbu'.

During the Ottoman period, the Mamluk towers and forts were expanded to incorporate *khans*, such as the fort-*khan* at Nakhl. New *khans* and towers were built which also functioned as security and military facilities. Some *khans* were rebuilt to include warehouses for storing the belongings of pilgrims and to accommodate state officials. These include the *khan* of Dawud that lies in the desert between Cairo and Birkat al-Hajj, and the fort-*khans* of al-Muwailih in the valley of al-Zurayb al-Wajh.

These towers, forts and *khans* functioned as places where traders and pilgrims could keep their money safe and where grain that was transferred by the Hajj caravan could be stored. Use of these *khans* was free since most were established as *waqf* (pious endowments). They were guarded

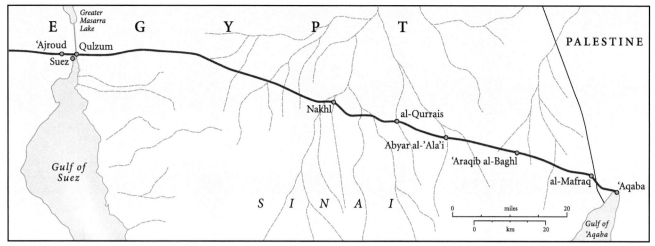

Plate 1 The map of the Egyptian Hajj route between Birkat al-Hajj and the fort-*khan* of 'Ajroud (map by Martin Brown)

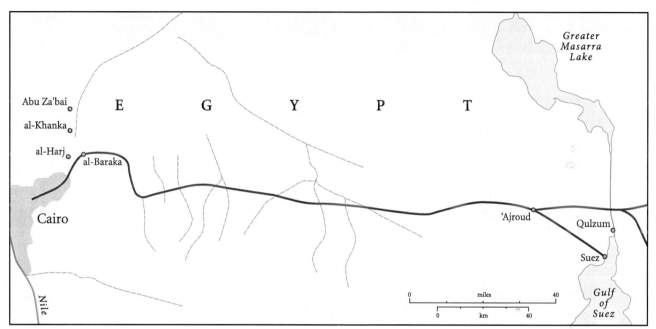

Plate 2 The map of the Egyptian Hajj route between 'Ajroud and 'Aqaba, showing the *khans* in 'Ajroud, Nakhl, Abyar al-'Ala'i and 'Aqaba (map by Martin Brown)

all year round by *mamluks* who shared a rota with guards from Cairo, a system that was sustained throughout the Ottoman period.

The layout of these buildings followed a standard plan. They were either square or rectangular with fortified gates and towers of varying design at the four corners, and in the centre was an open-air courtyard that provided light and ventilation. They were built on one or two levels to include essential facilities such as mosques, accommodation and warehouses. Wells, waterwheels and reservoirs were also generally attached.

From the Islamic conquest to the Fatimid period

As noted above, from the Islamic conquest to the end of Fatimid rule in 1171, the constructions on the Egyptian Hajj route were mostly reservoirs or religious buildings. As for the *khans*, they were built within the fortified cities along the route. Ibn Qudama al-Baghdadi (d. 948) mentions a stop known as al-Hisn (modern day al-Qurrais) between the station of al-Kursi (modern day Nakhl) and Ayla.[1] Al-Hisn must have provided the pilgrims with services similar to

those offered by the later *khans* and is likely therefore to have included accommodation and warehouses within the building. In this period, a *khan* was built in 'Ushaira on the coast opposite Yanbu' al-Nakhl,[2] which was described by al-Muqaddasi as 'unparalleled'.[3]

It can be said that during this period the small fortified cities along the Egyptian Hajj route provided the basic services that pilgrims and their caravans required on their way to Mecca.

The *khans* and towers on the route during the Mamluk period

The Egyptian Hajj route flourished during the Mamluk period when it was officially redirected overland through Sinai. In the year 1267 Sultan Baybars al-Bunduqdari (r. 1260–77) ordered the preparation of a *mahmal* that accompanied the *kiswa* and a new key to the door of the Ka'ba, all made in Egypt.[4] Al-Maqrizi observed that 'Aidhab remained a passage for pilgrims … until al-Zahir Baybars al-Bunduqdari placed a *kiswa* on the Ka'ba, made a key for it, and then redirected a pilgrim caravan overland in

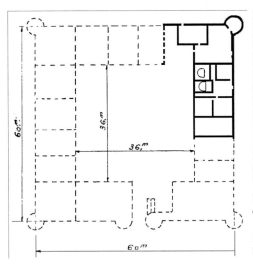

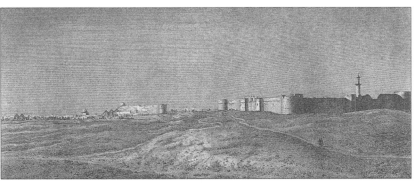

Plate 3 (left) Ground plan of the remains of the *khan* of al-Malik Jokendar in 'Ajroud based o excavations conducted between 2005 and 2006 (Jomier 1951, fig. 2)

Plate 4 (above) Drawing of the *khan* and the tower *khan* of 'Ajroud as they would have looke like at the end of the 18th century (by André Dutertre from *Description de l'Égypte*, pl. 12/2)

the year 666 [AH], and so the activity of pilgrims was reduced in this desert ['Aidhab]'.[5]

The tower in Ayla ('Aqaba) which was mentioned by Abu al-Fida' (d. 1331) is the first to be constructed on the route for purposes other than water storage. It was built at the beginning of Mamluk rule under the orders of Sultan Baybars in Ayla ('Aqaba).[6] Abu al-Fida' wrote, 'In Ayla [passes] a route for Egyptian pilgrims, and in our time it [Ayla] has a tower in which a governor from Egypt [stays] … and it [Ayla] had a fort on the sea but was deserted and the governor then moved to a tower on the coast'.[7]

Muhib al-Din ibn al-'Attar (d. 1476) in his *Manazil*, written in 1461, confirms that the tower was built by Sultan Baybars 'and he found there [Ayla] … a derelict tower of Zahir Baybars'.[8]

The khan and tower at 'Ajroud

Ibn al-'Attar discusses the stops of 'Ajroud and Suez together as constituting the fifth stop on the Egyptian Hajj route.[9] 'Ajroud is located 122km east of Cairo, and 20km north-west of Suez (**Pls 1, 2**).[10] The *khan* at 'Ajroud is the first and largest of the fort-*khans*. It was built during the reign of Sultan al-Nasir Muhammad ibn Qalawun (r. 1293–4) and its construction was supervised by the Amir al-Hajj Saif al-Din Al Malik al-Jokendar who headed the first and most extensive project to develop the route in the Mamluk period. The *khan* of 'Ajroud was built to keep safe the possessions of the traders and pilgrims – especially the Maghribis[11] – free of charge until their return from Mecca. This was reported by al-Suyuti (d. 1505) and confirmed by al-Jaziri (d. 1570) who was an expert on the state of the route and its buildings from the late Mamluk period to the beginning of the Ottoman era.[12]

In the later years of the Mamluk period, Sultan al-Ashraf Qansawh al-Ghawri (r. 1500–16) was also keen on developing the Egyptian Hajj route. He ordered Amir Khayir Bak al-Mi'mar (the architect) to build a tower at 'Ajroud as part of the second largest development project after the one undertaken by al-Jokendar.[13] The erection of this tower was reported by Ibn Iyas (d. 1522) and the traveller Ibn al-Shamma' al-Halabi (d. 1529). Ibn Iyas noted that the construction took place during Muharram 915/April–May 1529.[14] An important inscription on the building at 'Ajroud indeed attributes its construction to Khayir Bak al-Mi'mar

but the date is omitted.[15] However, according to the reports of contemporary historians who witnessed the architectural development of 'Ajroud at the time of Qansawh al-Ghawri, it was constructed in 914/1509.[16] Ibn al-Shamma', for example, passed by the site in 1509 and reports: 'we arrived in 'Ajroud after four stages, and we found there a great tower, four pools of water, a waterwheel out of which water is lifted by a camel, and this is called in our land *al-dulab*.[17] All this was built by al-Ashraf Qansawh al-Ghawri, king of Egypt, as I saw inscribed on the stone dated 914 (1509).'[18]

This tower was also described as a *khan*. Al-Jaziri explains: 'in 'Ajroud a new *khan* [was ordered to be] built by the late Sultan Abu al-Nasr Qansawh al-Ghawri, under the supervision of the great Amir Khayir Bak al-Mi'mar who headed a thousand *mamluks* in the year 915, after the old *khan* which was built by al-Hajj Malik Jokendar [had fallen into disrepair]. [The new *khan*] was maintained by the people thereafter. It contains a well and a waterwheel.'[19] This report confirms that the construction of the new *khan* of al-Ghawri was not the first in the area and that the sultan ordered the building to replace an older one.

The two *khans* built in 'Ajroud during the Mamluk period continued to provide services for pilgrims and other travellers long after 1509. The Maghribi traveller al-'Ayashi who journeyed to Hajj three times in 1649, 1654 and 1662,[20] wrote: 'in this resting place – 'Ajroud – are two forts … in which people leave their provisions and luggage until [they] return'.[21] Similarly, Ibn 'Abd al-Salam al-Dar'i writing 124 years after al-'Ayashi says: 'we stayed in 'Ajroud a day to rest and to shop, where there are two forts in which a pilgrim may unburden himself of the provisions he has carried until he returns'.[22]

The large *khan* of 'Ajroud lies 150m north of the al-Ghawri tower, separated now by a train line. These days, the visible remains of the *khan* still hint at its design, and excavations on this site began in 2001. It had a square layout (6,000m × 6,000m (3,500m²))[23] and cylindrical corner towers. They overlooked a central courtyard which is 3,600m² surrounded by a mosque with a minaret in addition to a series of rooms for guards and travellers, warehouses for the belongings of pilgrims, as well as mills and ovens for the preparation of food (**Pls 3, 4**). As for the tower of al-Ghawri, it was rectangular (3,700m × 1,500m), with two cylindrical towers at opposite corners (**Pls 5, 6**).

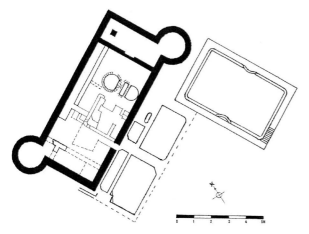

Plate 5 Ground plan of the tower and water reservoir of 'Ajroud (drawn by Muhammad Rushdi)

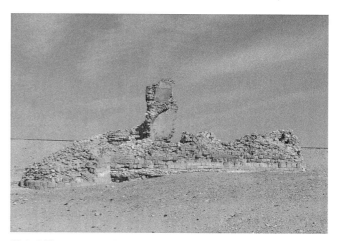

Plate 6 The remains of the tower *khan* built by Qansawh al-Ghawri in 'Ajroud (photo: author)

The tower and khan at Suez

Suez has long been an important centre at the head of the Gulf of Suez 20km east of 'Ajroud.[24] In medieval times, it was a flourishing port alongside the three others on the Red Sea coast, 'Aidhab, Qusair and al-Tur.[25] In the Mamluk period, Sultan Baybars was interested in developing Suez; he had the Egyptian Hajj route redirected through the Sinai desert and in 1260 built a small fort there.[26]

Sultan Husam al-Din Lajin (r. 1296–9) built four fountains which were mentioned by Ibn al-'Attar who wrote: 'Suez … has four fountains for al-Mansur Lajin, a water tank and two wells with a waterwheel in the yard'.[27] Sultan Qansawh al-Ghawri also fortified the ports and harbours of the Red Sea which also resulted in the establishment of buildings that served both travellers and traders. Ibn Iyas reports the visit of Sultan Qansawh al-Ghawri to Suez in 1514 to mark the completion of the series of building projects that he had ordered. He reported: 'the sultan stayed in Suez for three days, and he constructed a *khan*, shops and some houses'.[28] Al-Jaziri also mentions that 'Suez … has in addition a *khan*, and it is now a large port'.[29]

The tower-*khan* in Suez was rectangular (3,500m × 1,400m).[30] The north-eastern and south-western corners were supported by two angular towers, and it was provided with rooms and a well,[31] perhaps the same well dug by al-Jokendar in the days of Sultan al-Nasir Muhammad ibn Qalawun (**Pl. 7**).[32]

The tower-khan at al-Tur

During the Mamluk period, al-Tur was well known as a port for foreign trade ships as well as for pilgrims and their caravans. After Suez the road bifurcated; the first branch went eastwards to 'Aqaba and from there overland to Mecca; the second went south to the port of al-Tur and from there to the ports of the Hijaz by sea.[33] After 1378 it superseded the port of 'Aidhab[34] which was abandoned during the reign of Barsbay (r. 1422–37) and was officially replaced by al-Tur in 1426.[35] Al-Tur was connected to several overland and sea trade routes specifically to Jedda, Yanbu', al-Teena, Suez and Cairo.[36] The tower-*khan* of al-Tur lies in the south of the city in an area between the city centre and a quarantine hospital near the coast.[37]

Some speculate that this tower-*khan* was built by the Ottoman Sultan Selim I (r. 1465–1520),[38] but I remain doubtful about this attribution. During the reign of Baybars a pavilion had been constructed in al-Tur as a charitable foundation to provide shade and rest to travellers,[39] which leads me to consider that the construction of the tower-*khan* of al-Tur may in fact have taken place in the Mamluk period, probably during the reign of Barsbay who, as mentioned above, made al-Tur the official Egyptian port on the Red Sea. This accords with the conclusions of 'Abd al-Latif Ibrahim who stated: 'in those days before the discovery of the Cape of Good Hope, the city of al-Tur was a port suitable for receiving ships and it seems that the Mamluks built a watchtower there'.[40]

Before its destruction, the fort of al-Tur was rectangular (6,700m × 5,500m) with four cylindrical corner towers. There was a mosque next to the main gate and an internal courtyard surrounded by rooms, a warehouse and a well (**Pl. 8**).

The tower-khan at Nakhl

Nakhl lies in the heart of Sinai, 135km from the *khan* and tower of 'Ajroud. It is also 130km from 'Aqaba,[41] and 56km from Abyar al-'Ala'i (**Pl. 2**). At the end of the Mamluk period, several historians, such as Ibn Iyas and Ibn al-Shamma' followed by al-Jaziri, reported that Sultan

Plate 7 Ground plan of the tower of Suez from the Mamluk period (after Clédat 1921, 186, fig. 1)

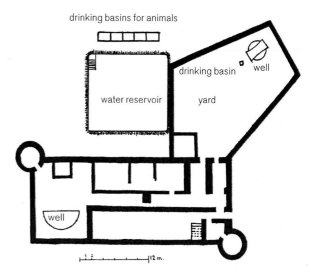

drinking basins for animals

water reservoir

drinking basin

well

yard

well

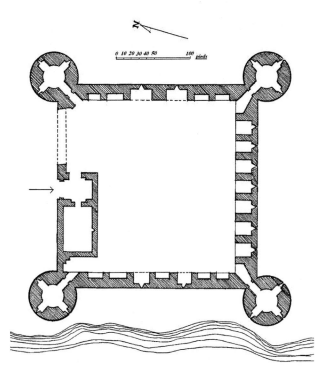

Plate 8 Ground plan of the fort-*khan* of al-Tur in the first quarter of the 19th century

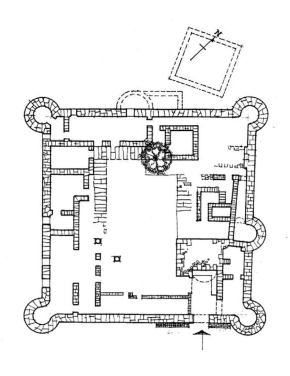

Plate 9 Ground plan of the fort-*khan* in Nakhl

Qansawh al-Ghawri ordered Khayir Bak al-Mi'mar to build a tower in Nakhl which was completed in 1509 and came to function as a *khan* for pilgrims and traders. The tower itself protected the wells, reservoirs and the surrounding area. Ibn Iyas who reports the news of its construction in the month of Muharram in the year 915/April–May 1509 wrote: 'a tower was built in 'Ajroud and Nakhl'.[42] Ibn al-Shamma' also tells us that in Shawwal of 915/February 1510 he 'reached Nakhl after sunrise, and there was a tower, three reservoirs and a waterwheel'.[43] This is the same date he gives for the building projects in 'Ajroud during the reign of Sultan Qansawh al-Ghawri.[44]

Nakhl contained several security or military bases and the tower later grew into a fort-*khan*. It began essentially as a single construction that was expanded over time and was used for various purposes: accommodation for the guards' who protected the water supplies, as well as a *khan* where travellers could stay and store their belongings.

The layout of this fort-*khan* was rectangular (2,850m × 1,425m), thus occupying an area 406,125m² stretching from the south-east to the north-west. It may have had two corner cylindrical towers (**Pl. 9**).

The fort-khan at Abyar al-'Ala'i, al-Qurrais

Abyar al-'Ala'i was the twelfth stop on the Egyptian Hajj route from Cairo,[45] and it is located east of Nakhl 56m into the valley of Qurrais ('Aqaba) and 1km north of the road of Nafaq (Nuwaibi' al-Duwali) (**Pl. 2**).

There is little information about this tower in the historical narratives, as the area simply consisted at the beginning of an enclosure that contained a well. Ibn al-'Attar wrote: 'the twelfth [stop] in Abyar al-'Ala'i ... in it a well for Baydra and another for 'Ala'i inside an enclosure with a waterwheel'.[46] Al-Khiyari al-Madani (d. 1672) mentions the destruction of the fort of Abyar al-'Ala'i by the

Bedouins of the area.[47] Al-Nabulsi describes it as 'a fort old in structure, its corners ruined, with a destroyed well'.[48] This is the same fort whose existence I confirmed in my preliminary research in this area before it was confirmed through excavations.[49] In my opinion, this tower, which had been attributed to Sultan Baybars, was actually founded later by Sultan al-Nasir Muhammad ibn Qalawun (r. 1294–1309) who built numerous structures along the Egyptian Hajj route before the building activities by Sultan Qansawh al-Ghawri. A fragmentary inscription was found on the site that refers to the building: '... and a factory', and another piece that indicates the century only, '... seven hundred'.[50]

The tower-*khan* of Abyar al-'Ala'i was discovered and excavated in 2002, and like the rest of the towers on the route, it served as a *khan* as well. It comprised two sets of buildings on the eastern bank of the valley of Qurrais ('Aqaba), 350m apart. The newly discovered tower-*khan* is to the south.[51] It was rectangular (2,000m × 1,300m), with two cylindrical towers in two opposite corners, east and west. There was a well in the centre of the courtyard which was surrounded by rooms and warehouses, making its layout identical to that of the tower of Suez (**Pls 10, 11**).[52]

The tower, fort and khans of 'Aqaba

'Aqaba was the fifteenth stop according to Ibn al-'Attar and the sixteenth according to al-Jaziri,[53] and it marks the end of the first quarter of the Egyptian Hajj route, reached on the ninth day after setting off from Birkat al-Hajj.[54] It is 300km from Suez overland, 130km from the fort of Nakhl, and 26km before al-Haql on the route (**Pl. 2**).[55]

Interest in constructing service buildings in 'Aqaba began in the Mamluk period from the time Sultan Baybars lead the *mahmal* caravan on the overland route and he was the first to construct a fort-*khan* there. Abu al-Fida' confirms that the sultan transferred the garrison of Saladin's fort that had

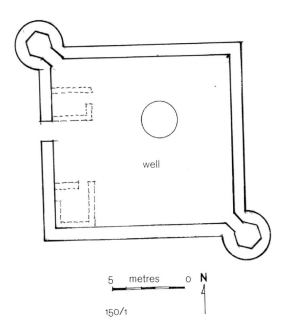

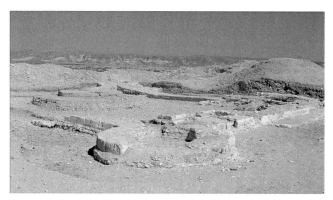

5 metres 0 N

150/1

Plate 10 (left) Ground plan of the tower-*khan* in Abyar al-'Ala'i

Plate 11 (above) The remains of the tower-*khan* of Abyar al-'Ala'i in Sinai discovered in 2002 (photo: author)

been stationed in Pharaoh's Island to this fort-*khan*.[56] 'In Ayla', he wrote, '[passes] a route for Egyptian pilgrims, and in our time it [Ayla] has a tower in which a governor from Egypt [stays]… and it [Ayla] had a fort on the sea but was deserted and the governor then moved to a tower on the coast'.[57] This tower functioned as a *khan* and al-Jaziri confirms that it was built by Sultan Baybars.[58] But by the time Ibn al-'Attar passed by on his way to Mecca in the year 1461, this fort-*khan* was described as 'a derelict tower of al-Zahir Baybars'.[59] He also mentions that he found in it, two ruined fountains, an abandoned mosque, a disused *khan* with 36 warehouses, which was the site of a big market supplied from Gaza by the Gazan caravan.[60] I estimate that one of them was built in the 14th century as part of the first construction project on the Egyptian Hajj route during the reign of Sultan al-Nasir Muhammad ibn Qalawun and supervised by al-Jokendar.[61]

At the beginning of the 16th century during the reign of Sultan Qansawh al-Ghawri (r. 1501–17), the *khan* constructed some 200 years earlier during the reign of al-Nasir Muhammad ibn Qalawun was rebuilt as a fort according to an inscription that dates its construction.[62] An order was given by the sultan to Khayir Bak al-Mi'mar to supervise its construction at the beginning of Rabi' II 914/August 1508.[63] This is also confirmed by Ibn Iyas who wrote: 'the sultan ordered Khayir Bak al-Mi'mar to head towards 'Aqaba Ayla and to take with him a group of builders and architects, and authorized the construction of a *khan* in 'Aqaba, including towers and fountains anticipating the arrival of pilgrims. He also set up a wharf on the sea at 'Aqaba.'[64] In the month of Muharram 915/April–May 1509 the construction of the *khan* was completed as Ibn Iyas reported: 'there a *khan* was constructed in which there were many warehouses for depositing belongings, as well as towers'.[65] And in Rajab 915/October–November 1509, Khayir Bak al-Mi'mar returned after the completion of the *khan* and the towers of 'Aqaba.[66] Ibn Iyas mentions this building project elsewhere: 'he built there a *khan* with towers on its gate, and he placed in it warehouses for the belongings of pilgrims'.[67] Ibn al-Shamma' also mentions this *khan* when he passed by 'Aqaba

in 1509. He wrote: 'we stayed in 'Aqaba … and went to a *khan* that was built by the ruler of Egypt, al-Ashraf Qansawh al-Ghawri. It is a great *khan*, and a troop of soldiers were deployed to guard the belongings of pilgrims, this way the pilgrim is guaranteed thorough security'.[68]

This is the same *khan* mentioned by al-Jaziri when he discusses the guards that come from the tribes of al-Masa'id, namely al-Wuhaidat who made up one of the tribal groups of the Bani 'Atiyya. He wrote, 'Arabs of al-Masa'id: … receive for guarding the gate of the *khan* of 'Aqaba Ayla 74 dinars and a half',[69] and adds that the Arabs of al-Wuhaidat were assigned to guard an old *khan* built for Baybars which was demolished at the time of al-Ghawri.[70]

The building commissioned by Qansawh al-Ghawri at 'Aqaba is also mentioned in a memorial inscription discovered on the Egyptian Hajj route in Sinai in an area called 'Araqib al-Baghl (also known as Dubbat al-Baghla).[71] Discussing the achievements of Sultan Qansawh al-Ghawri, al-Bakri (d. 1650) mentions that the sultan 'fixed the 'Aqaba road and the circle of al-Haql, built there a *khan* with towers on its gate, placed warehouses in it, and established the *khan* which is at 'Aqaba'.[72] Elsewhere he describes it as 'a high well-protected fort … where belongings are stored and given back upon the return [of travellers]'.[73]

The fort-*khan* of 'Aqaba is an extensive structure containing warehouses and towers at various points around its walls. Its construction took place in the period between Rabi' I 914/July 1508 – when Khayir Bak al-Mi'mar arrived to prepare for building the *khan* and the wharf – and Rajab 915/October–November 1509 which is the date of al-Mi'mar's return and completion of the task he was charged with by the sultan; so it is likely to have been fully completed in 1509.[74]

The building is rectangular (5,800m × 5,650m) with four corner towers, two of which, the north-western and the south-western, are polygonal on the outside; the other two are round. The fort has a principal gate with a rectangular tower at each side with a semi-circular top. The entrance opens onto a passage that leads into the courtyard surrounded by warehouses and accommodation on two levels. There were other facilities such as a mosque, a well and an oven (**Pls 12, 13**).

In summary, 'Aqaba under the Mamluks had four *khans*. Historical accounts mention a tower that functioned as a

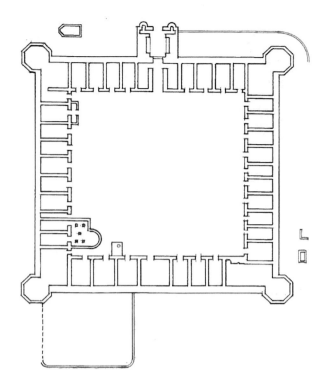

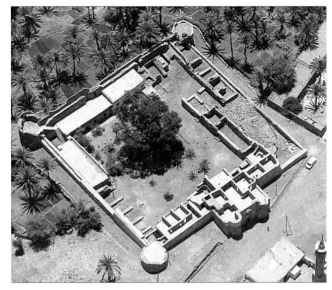

Plate 12 (left) Ground plan of the tower-*khan* at 'Aqaba at the beginning of the 19th century

Plate 13 (above) An aerial view of the fort-*khan* at 'Aqaba (courtesy of the Jordanian Directorate of Antiquities and Museums)

khan which was built by the orders of Baybars.[75] Also, recent excavations revealed the remains of two other *khans*, one of which was built by Qalawun in the 14th century. And finally, there is the 16th-century *khan* built by Qansawh. This last *khan* was constructed using the stones of Qalawun's building.[76]

The khan and tower at al-Aznam (al-Azlam)

The *khan* at al-Aznam is located between Birkat al-Hajj and Mecca, 100km north of the city of al-Wajh, 40km south of the city of Duba' and 10km east of the Red Sea coast into al-Aznam valley (**Pl. 14**).[77] It was rectangular (4,590m × 4,400m), had four octagonal corners and a memorial gate. The central courtyard was surrounded by warehouses roofed with cross vaults, accommodation rooms, a well near the main gate and another outside the *khan* (**Pls 15–17**).[78]

It was established by al-Jokendar during the third reign of Sultan al-Nasir Muhammad ibn Qalawun (1309–40). It was mentioned by al-Jaziri who, quoting al-'Umari, wrote that in al-Azlam 'the pilgrim deposits some of his provisions and camel feed for his return in a *khan* built by Amir al-Muqaddam al-Kabir al-Hajj al Malik al-Jokendar'.[79]

Eventually, however, the *khan* fell into ruin. Ibn al-'Attar wrote: 'near the eastern mountain lies a derelict *khan* built by al-Nasir Muhammad ibn Qalawun, containing seven warehouses'.[80] It was levelled and a tower was built there in its place during the reign of Sultan Qansawh al-Ghawri. Its construction began in 915/1508–9 and was completed in 916/1509–10 by Amir Khushqadam as indicated by an inscription found on the building.[81] Ibn Iyas mentions this tower and the role of its garrison in Muharram 915/April–May 1509. He wrote: 'When the pilgrims returned, they told of the many good things Sultan al-Ghawri did.… He also built a tower in al-Aznam and placed a group of *mamluks* to stay there, and every year they come and others depart.'[82] This is corroborated by the traveller Kabrit who recorded:

'al-Azlam … is a valley containing a fort where pilgrims leave their belongings for their return [there is also] a derelict *khan* built by al-Nasir and torn down by al-Ghawri'.[83]

As seen from the accounts cited above, there is clear evidence therefore that al-Aznam had a *khan* built during the reign of al-Nasir Muhammad ibn Qalawun, supervised by al-Jokendar which, having fallen into disrepair, was demolished during the reign of Sultan Qansawh al-Ghawri, and was replaced by a tower whose construction was supervised by Amir Khushqadam. This tower then functioned as a *khan* on the Egyptian Hajj route.

The khans of Yanbu'

Yanbu' was three quarters of the way along the Egyptian Hajj route.[84] It was divided into two regions: the first, which lies on the shore, acted as a sea port and was called Yanbu' al-Bandar; the second is the internal region known as Yanbu' al-Nakhl which was a supply point on the route (**Pl. 14**).[85] In 1460, Ibn al-'Attar described the *khans* of Yanbu', its markets and port: 'the town of Yanbu' … in the town centre [there are] gold, fabric and animal feed markets, outside it [there is] a food market …, it has *khans*, houses, ovens, [it is abundant with] vegetables, meat, gee and flour … its port [can be reached] by a westbound journey'.[86] A *khan* was built in Yanbu' al-Nakhl even though many travellers left their belongings in the houses of relatives and friends.[87]

This concludes our list of *khans* which were built on the Egyptian Hajj route during the Mamluk period, from the first *khans* in Suez and 'Aqaba under the rule of Sultan al-Zahir Baybars al-Bunduqdari, to the tower-*khans* of the late Mamluk period in the reign of Sultan Qansawh al-Ghawri.

The khans during the Ottoman period

During the Ottoman period, some Mamluk towers, especially those at Nakhl, were enlarged. Others were renovated such as the ones in 'Ajroud and 'Aqaba, and new

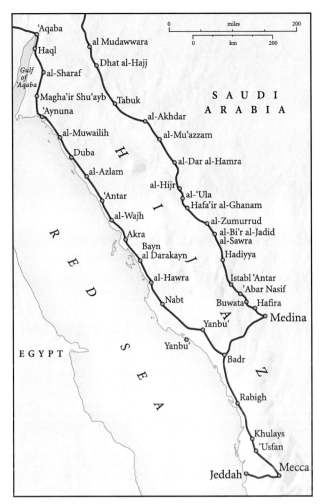

Plate 14 The map of the Egyptian Hajj route between ʿAqaba, Mecca and Medina (map by Martin Brown, after Al-Ghabban, *Les deux routes syrienne et égyptienne du pèlerinage*, vol. 2, carte no. VI)

forts were also built. These functioned as security centres and provided accommodation for guards. In addition they were also used as *khans* and warehouses for pilgrims such as the *khan* of Dawud that was constructed in the desert between Cairo and Birkat al-Hajj, and the *khans* of al-Muwailih and al-Wajh. These constituted the most important *khans* of the Egyptian Hajj route during the Ottoman period.

The khan at Dawud Pasha in the Cairo desert
As mentioned by al-Jaziri, the governor of Egypt, Dawud Pasha, constructed a *khan* for pilgrims in the desert outside

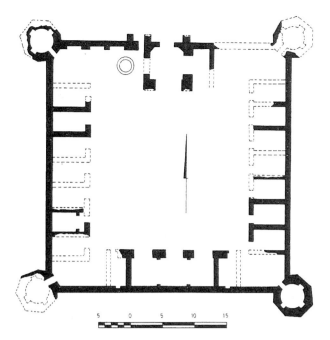

Plate 15 Ground plan of the *khan* in al-Aznam (after Angraham *et al.* 1981: fig. 79d)

Cairo on the route to Birkat al-Hajj.[88] Elsewhere al-Jaziri relates that the area between the Cairo desert and the *khan* of Dawud stretching to the coast of ʿAqaba fell under the guardianship of the chief of the Arabs of al-ʿAyed and his tribe who resided east of the Nile Delta.[89]

The fort-khan in Nakhl
The Mamluk fort-*khan* of Nakhl was the model upon which the Ottoman project of refurbishing and expanding other *khans* was established. Its dimensions were doubled during the reign of Sultan Süleyman the Magnificent (r. 1520–66) when the word *khan* was first explicitly used.[90] Certainly, the original Mamluk tower in Nakhl was now too small which led Amir Zain al-Din ibn Shahab, who was responsible for maintaining the waterwheels in ʿAjroud and Nakhl on the route, to propose to the governor of Egypt ʿAli Pasha the expansion of the *khan* which then took place in the year 959/1551–2. It was granted and funded by the treasury.[91] This project was witnessed by al-Jaziri who wrote: 'the *khan* was narrow and so … our Zain al-Din, the caretaker of the sultanate's waterwheels, presented his proposal to the guardian of the Egyptian kingdom ʿAli Pasha in the year 959 [AH], who then ordered the expansion [funded] by the

Plate 16 Al-Aznam *khan* in north-west Saudi Arabia (view from the north-west) (photo: author)

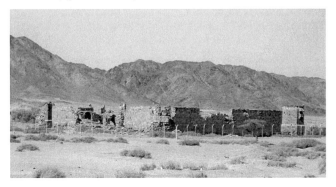

Plate 17 Al-Aznam *khan* in north-west Saudi Arabia (view from the south-east) (photo: author)

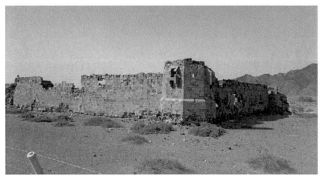

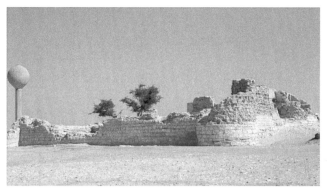

Plate 18 The western side of the fort-*khan* at al-Nakhl (photo: author)

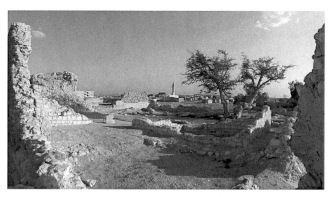

Plate 19 The remains of the fort-*khan* at Nakhl (photo: author)

sultan's money; the expense of everything needed was to be taken from the treasury. And so with a group of architects and a generous amount of supplies, he diligently undertook its expansion in the shortest time, and he increased it in height.'[92]

The fort-*khan* in Nakhl was rectangular with four cylindrical corner towers. The length of each side between the towers measured 2,850m and a fifth semi-circular tower was on the outer eastern wall. There was a main gate on the south-eastern side which lead to the courtyard around which the fort's main facilities, the mosque, the well, the accommodation rooms for the guards and travellers, and warehouses were distributed (**Pls 9, 18–19**).

The fort-khan of al-Muwailih

Al-Muwailih was known in the past as al-Nabak. It is mentioned by al-Jaziri who, citing al-'Umari, wrote: 'al-Nabak and it is called al-Muwailiha'.[93] It lies north-west of the border with Saudi Arabia, 230km south of the fort of 'Aqaba and 50km north of the port of Duba. It is on a hill at the estuary of the valley of al-Muwailih. Sultan Süleyman the Magnificent ordered the construction of the fort-*khan* at the suggestion of the governor of Egypt Pasha Agha al-Khadim, and it was supervised by Amir Qayit ibn 'Abd

Plate 20 Ground plan of the fort-*khan* in al-Muwailih (after Angraham *et al.* 1981: fig. 77)

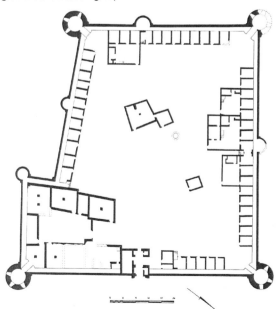

Allah al-Dawudi who began building wells and the fort at the end of 967/1559–60. This is according to an inscription that dates the construction of the well near the fort to the end of the month of Dhu al-Hijja 967/21 September 1560.[94] It was completed at the end of the year 967/1559–60 according to another inscription found over the arched gate.[95]

The fort-*khan* of al-Muwailih is considered one of the most important Ottoman buildings along the route. Before its construction, it was thoroughly planned and carefully designed. Al-Jaziri reported:

> Among the news about the supply points of the Hajj route was that [project] proposed to and ordered by the grand Pasha 'Ali Agha during his government of the Egyptian land in the year 967. Our master Amir Qayit ibn 'Abd Allah al-Dawudi prepared the chief of a group of Circassian soldiers and one of the notable princes known for his horsemanship, courage, and enthusiasm – who is also one of the *mamluks* of the late Sultan Qansawh al-Ghawri – to build a big *hisar* or fort and a momentous bastion in al-Muwailih as a harbour and also to protect the money of traders and the subjects [of the sultanate], and [also] to guard them from the evil and the corrupt. It is to be square, 500 square *'amal* cubit,[96] each side being 125 cubits long. And so he went in the aforementioned year, and his company [comprised] a class of victorious soldiers, from all sects, prepared with architects, machines, canons and all the food and conveniences needed for land and sea. *Aghriba* vessels were assigned for it at the shore of al-Muwailih to transport what was needed to and fro, in addition to police chiefs and the most prominent among them to protect and support this goal.[97] [The amir] began laying the foundations according to the measurements. The gate was arched, four round towers [were erected] on each side, and there were installations in which 47 canons were positioned. Inside it [there were] depositories and convenient facilities.[98]

The dimensions of this fort-*khan* were measured by the unit known as *thira' al-'amal* which according to Walter Hantscho equals 66.5cm,[99] therefore the *khan* was 8,300m². The current state of the *khan* does not provide a clear understanding of its original dimensions; however, the northern wall is 109m long, the western 107,90m, the eastern wall is not straight and is 107,60m long, and the southern is 8,190m.[100] The main gate is set in the middle of the northern side, next to which a minaret was built which also functioned as a lighthouse. It had four round corner towers in addition to interval towers. There was a courtyard at the centre of the building around which numerous facilities were provided

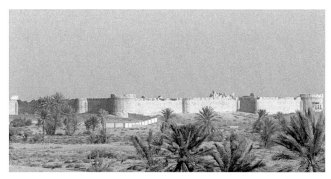

Plate 21 The fort-*khan* Muwailih in north-west Saudi Arabia (view from the south-east) (photo: author)

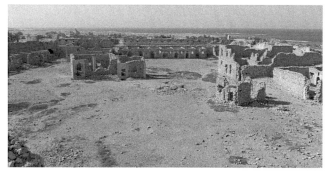

Plate 22 The fort-*khan* Muwailih in north-west Saudi Arabia (photo: author)

which included a mosque, a well, and a water reservoir. There were accommodation rooms, one and two storeys high, for guards, employees and travellers, as well as warehouses for pilgrims' belongings and provisions (**Pls 20–2**).

Thus in addition to being used as a watchtower and a security point, this fort was also clearly used as a *khan*,[101] as confirmed by al-Jaziri who informs us that, after completing the construction of the fort, Amir Qayit considered building a separate *khan* for depositing pilgrims' belongings but decided against it as the fort was big enough to be used as a *khan* as well. Al-Jaziri actually met Amir Qayit in al-Muwailih. The former wrote: 'Qayit the architect told me that after the completion of the fort he wanted to build a nice *khan*, like the ones in Nakhl and 'Ajroud, for [the storing of] travellers' belongings. Al-Muwailih became one of the most important centres of the Hijaz, but he did not build the second nice *khan*, and confined himself to the first as there was in it enough [space] since it was a huge fort useful for protection and storage, and there was a *khan* in it [already].'[102]

The fort-khan of Wadi al-Zuraib

The fort of al-Wajh lies in al-Wajh valley at a location known as Wadi al-Zuraib, 10km east of the port and town of al-Wajh (**Pl. 14**).[103] It was built on the orders of Sultan Ahmed I in

Plate 23 Ground plan of the *khan* of Wadi al-Zuraib in al-Wajh (after Angraham *et al.* 1981: 79c)

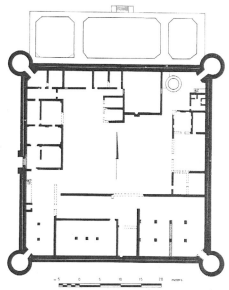

1617, as stated in an inscription above the arch of its main gate,[104] for the protection of Hajj caravans and for storing the belongings and provisions of pilgrims. It was rectangular (5,530m × 5,130m), with four cylindrical corner towers. A minaret stood on the western side whose gates opened onto a courtyard around which were built a mosque, a prayer hall, a well, accommodation and warehouses for the storage of travellers' belongings and grain supplies. Three reservoirs were attached to the northern wall,[105] and a number of wells were found near the fort and the valley from which the caravans benefited during their journey to and from Mecca (**Pls 23–5**).[106]

Architectural analysis

After the historical outline of the construction of the Mamluk and Ottoman *khans* on the Egyptian Hajj route, I will now discuss their design and how they functioned as well as the garrisons located there.

Plate 24 The fort-*khan* of Wadi al-Zuraib in al-Wajh, north-west Saudi Arabia (view from the south and west) (photo: author)

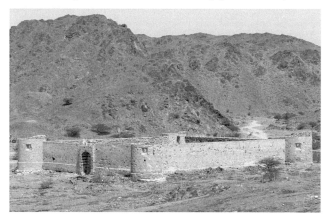

Plate 25 The fort-*khan* of Wadi al-Zuraib in al-Wajh, north-west Saudi Arabia (view from the south and east) (photo: author)

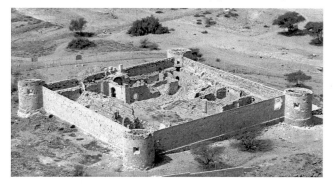

The *khans* were built in the largest centres on the route and became flourishing cities in the seasons when markets were set up as at Birkat al-Hajj, 'Ajroud, Nakhl, 'Aqaba, al-Muwailih, al-Aznam and Yanbu'.[107] Hajj caravans would stay for a day or more for rest and to obtain provisions for the journey. They were also used, as we have seen, as storage depots and for overnight accommodation. Some *khans* such as those of 'Aqaba and al-Aznam also acted as prisons where wrongdoers could be incarcerated.[108]

The earliest instance of regulated protection of the *khans* took place during the reign of Muhammad ibn Qalawun when al-Jokendar constructed the fort-*khan* in al-Aznam and, as al-Jaziri testifies, assigned to it a permanent ranked live-in garrison.[109] After this, regulated garrisons were installed in the major centres on the route: Birkat al-Hajj, 'Ajroud, al-Tur, Nakhl, Abyar al-'Ala'i, 'Aqaba, al-Aznam, al-Muwailih, Duba, al-Wahj and Yanbu'. The guards were replaced every year following a well-organized system which was known before the Mamluk period as *nizam badal* (the system of alternation).[110] This system was applied in the *khan* of al-Aznam and the fort-*khan* of 'Aqaba.[111] It is mentioned by Ibn Iyas who wrote:

> When the pilgrims returned, they told of the many good things Sultan al-Ghawri did in [regards to] construction in 'Aqaba, having built a *khan* with many garrisons for [the protection of] the belongings and towers. He placed in it a group of Turks who lived there and stay in it [the *khan*] for a year then they returned to Egypt and replaced by others.... He also built a tower in al-Aznam and placed a group of *mamluks* to stay there, and every year they come and others depart.[112]

Al-Jaziri also mentioned the garrison of the *khans* of 'Aqaba and al-Aznam in the Ottoman period and reported: 'as for the Circassians … in the *khan* of 'Aqaba there were ten, the rotating guards in the *khan* of al-Azlam [were also] ten'.[113] This system is also seen at 'Ajroud; al-'Ayashi wrote, 'in the aforementioned *khans*, and in other seaports, there were soldiers.… Every year a group comes and the ones who were there before go, and they receive an allowance for this from the treasury.'[114]

The *khans* were *waqf*s (pious endowments), providing free services for pilgrims. Al-Jaziri tells of an event that took place in al-Aznam in which some pilgrims confronted the head of the caravan for demanding something in return for looking after their belongings. They complained 'that this *khan* and the ones before it – 'Ajroud, Nakhl and 'Aqaba – were established by Sultan al-Ghawri as *waqf* for the benefit of visitors and for storing their belongings. And he supplied them with flour [to be prepared] as food for the lonely and destitute all year long, and he neither assigned a fee for it nor allowed the taking of one'.[115]

In terms of the design of the *khans*, we can observe two principal architectural features which unite them. The *khans* on the Egyptian Hajj route between Cairo and 'Aqaba have a generally uniform plan with towers as the main feature. More specifically, some appear to be rectangular and fortified with two opposite towers, as seen at 'Ajroud, Suez, Nakhl and Abyar al-'Ala'i. It is possible that the *khan* of Baybars in 'Aqaba was also structured in this way. A second group of *khans* are square or rectangular with towers in the four corners with fortified gates often with semicircular

interval towers as found at 'Ajroud, Nakhl, 'Aqaba, al-Muwailih and al-Aznam. We find parallels for such design structures in the *khans* of Bilad al-Sham (Greater Syria), especially those that were constructed in the Mamluk period,[116] for example the *khan* at al-Sabil on the road between Homs and Aleppo built during the reign of Sultan al-Ashraf Sha'ban (r. 1371–2) and supervised by Amir Manjak.[117] To this category we can add the *khan* at Danun near al-Keswa that lies on the Syrian Hajj route also constructed during the reign of Sultan al-Ashraf Sha'ban in Jumada I 778/September–October 1376 and supervised by 'Ali ibn al-Badri. The *khan* at Danun was square, with four round corner towers with a courtyard in the centre surrounded by different facilities and a mosque near the main gate.[118]

Conclusion

Although the towers and forts built at the major centres on the Egyptian Hajj route indeed functioned as such according to the inscriptions marking their foundations, that they also functioned as *khans* is made clear by the reports and statements of the contemporary writers cited in this essay. It can also be confirmed that the rebuilt *khans* and the newly constructed towers of Sultan Qansawh al-Ghawri at 'Ajroud, Nakhl, 'Aqaba and al-Aznam were *khans* established as part of the *waqf*s along the route, providing free services for pilgrims.

In the Ottoman period, the Mamluk towers were adapted as forts and *khans*, and many more were also constructed as watchtowers such as those of Dawud, 'Ajroud, Nakhl, 'Aqaba, al-Muwalilih and al-Wajh. The enthusiasm of the Ottoman rulers for building and developing the *khans* as integral parts of forts and towers is demonstrated by al-Jaziri's encounter with Qayit al-Mi'mar, the architect of al-Muwailih fort who expressed his keen interest in building independent *khans* in Nakhl and 'Ajroud, a project that never materialized simply because the existing towered fort also functioned efficiently as a *khan*.[119] The effort and expense invested in the *khans* indicates that the development of pilgrim services was important to the Ottoman sultans, facilitating an arduous but spiritual endeavour central to the religion of Islam and its followers throughout the Islamic world.

Notes

1 Al-Baghdadi 1988: 90; al-Baghdadi 1987: 300.
2 Al-Hamawi 1977, IV: 127.
3 Al-Muqaddasi 1877: 83.
4 Ibn Shaddad 1983: 137, 186; al-Fasi 1999 I: 237; al-Maqrizi [u.d.], I: 202. Al-Maqrizi 1955: 85–9; Ibn Fahd 1984, III: 87, 91, 94–6; Suroor 1960: 115–16; 51; Jomier 1953: 3, 27; El-Hawary 1985: 128–33.
5 Al-Maqrizi [u.d.], I: 202; Ibn Iyas 1982, I: 20.
6 Abu al-Fida' 1840: 87; al-Qalaqashandi [u.d.] III: 388; al-Maqrizi 1934–73, III: 285; Ibn al-'Attar, University of King Sa'ud' MS. 5602: 5, Pl. 3; Ibn al-'Attar, Dar al-Kutub al-Masriya, MS 1008: 10–1, Pl. 6.; al-Jaziri 1983, II: 1337; Ghawanma 1982: 18, 232. Mouton 2000: 89, 96.
7 Abu al-Fida' 1840: 87.
8 Ibn al-'Attar, MS. 5602: 5, Pl. 3; al-Jaziri 1983, II: 1344.
9 Ibn al-'Attar, MS. 5602: 3, Pl. 2.
10 Al-Batnuni 1995: 109–10; Mubarak 2006, XIV: 8; Ahmad 1977: 210; Bakr 1981: 106; Jalal 2006: 37–8; Jomier 1951: 33, 34; Jomier 1953: 180.

11 Al-Jaziri 1983, II: 1320; al-Sulayman 1973: 73–4; 'Ujaimi 2001:
 17–18; Bakr 1981: 10; Ghabban 1991: 75–6, 79; Ghabban 1988: 74;
 Ghabban 2011, I: 41.

12 Al-Suyuti [u.d.], II: 185; al-Jaziri 1983 II: 1320.

13 Ibn Iyas 1982, IV: 133, 163; Kabrit 1966: 22; Sabri Basha 1999: 247;
 Ibrahim 1972, II: 254; 'Ujaimi 2001: 19; al-Fi'r 1986: 282.

14 Ibn Iyas 1982 IV: 152.

15 Moritz 1911: 100–1.

16 Ibn Iyas 1982, IV: 152; al-Jaziri 1983, II: 1320; Ibn al-Shamma', Dar
 al-Kutub al-Masria MS. 5705, I: 81.

17 For more in al-dulab, see Amin 1990: 61–2; Ghalib 1988: 192; Rizq
 2000: 137.

18 Ibn al-Shamma', MS. 5705, I: 81.

19 Al-Jaziri 1983, II: 1320; Raslan 1401/1980–1: 370–1.

20 Al-Jasir 1990: 18–27; Nawab 1999.

21 Al-'Ayashi 1977, I: 160; al-'Ayashi 1971: 191; al-Jasir 1984: 16.

22 Al-Dar'i 1983: 52–3.

23 Burton 1994, I: 131–2.

24 Al-Idrisi [u.d.], I: 348; al-Muqaddasi 1877: 196; al-Hamawi 1977,
 III: 325; Ramzi 1953: 99; al-Shami 1981: 18.

25 Al-Qalqashandi [u.d.], III: 465.

26 Ibn al-Furat 1940–2, VII: 83; Ibn Shaddad 1983: 327–47; Ibn
 Taghribirdi 1992, VII: 192, 194; al-Yunayni 1960, III: 257;
 al-Batnuni 1995: 108; al-Sulayman 1973: 201; Ahmad 1977: 18, 204;
 Rabi' 1977: 406; Ashqar 1999: 69–70. Jomier 1951: 43.

27 Ibn al-'Attar: 3, Pl. 2, 7–8, Pl. 5.

28 Ibn Iyas 1982, IV: 308–10; al-Jaziri 1983, II: 1320; Jomier 1953: 181.

29 Al-Jaziri 1983, II: 1320.

30 Al-Hamawi 1977 III: 325, IV: 439–41; Ibn Shaddad 1983: 347;
 al-Maqrizi 1934–72, I: 72; Kabrit 1966: 23; al-Shami 1981: 18, 49;
 'Umar 2001: 249, 291.

31 Clédat 1921: 186, fig. 1.

32 Al-'Umari 1988: 331; al-Suyuti [u.d.], II: 185; al-Jaziri 1983, II: 1249.

33 Abu al-Fida' 1840: 110–11, 121; al-Qalqashandi [u.d.], III: 464–5;
 al-Maqrizi 1934–72, III: 980; al-Sakhawi 2001: 224; Ibn Fahd,
 1984, III: 415, 472. Ibn Fahd 2005, III: 1729; al-Jaziri 1983, I: 289,
 II: 798, 840; Zaki 1960: 132; Zain 2000: 126–7; 'Abd al-Malik 2002:
 39–41. Ibn Iyas, Dar al-Kutub al-Masriya MS 439: 241.

34 Ibn al-Mujawir 1951, I: 138; al-Qalqashandi [u.d.], III: 465;
 al-Maqrizi 1934–73, IV: 707, 823, 824.

35 Darrag 1975: 63.

36 Ibrahim 1963: 110.

37 Shuqair 1985: 135–8, fig. 33; Zaki 1960: 132.

38 Zaki 1960: 132.

39 Al-Maqrizi 1934–72, I: 555; Ibn Fahd 1984, II: 965, f. 2.

40 Ibrahim 1963: 110.

41 Shuqair 1985: 150; Zaki 1960: 133; Ibrahim 1956: 103–4; al-Fi'r
 1986: 282; Al-Jaziri 1983, II: 1327–8; al-Jawhari 1964: 86.

42 Ibn Iyas 1982, IV: 152.

43 Ibn al-Shamma', MS 5705, I: 82.

44 Ibn al-Shamma', MS 5705, I: 81.

45 Ibn al-'Attar, MS. 5602: 8–9, Pl. 6.

46 Ibn al-'Attar, MS. 5602: 8–9, Pl. 6.

47 Al-Khayyari 1980, III: 183.

48 Al-Nabulsi 1986: 304.

49 'Abd al-Malik 2007: 16, 24.

50 'Abd al-Malik 2010: 126.

51 'Abd al-Malik 2005: 250–70, figs 4 and 18, Pls 40–51; 'Abd al-Malik
 2007: 1–44; 'Abd al-Malik 2005: 1–144; 'Abd al-Malik 2009:
 257–66, figs 16–18, Pls 41–60; 'Abd al-Malik 2001: 51–8, figs 104.

52 'Abd al-Malik 2005: 122–4, fig. 11; Clédat 1921: 186, fig. 1.

53 Ibn al-'Attar, MS. 5602: 4–5, Pl. 3; Ibn al-'Attar, MS 1008: 10–11,
 Pl. 6; al-Jaziri 1983, II: 1305.

54 Al-Jaziri 1983, II: 1117, 1153.1249, 1307, 1327–8.

55 Shuqair 1985: 16, 150; Zaki 1960: 133, 136; al-Kurdi 1974: 30;
 Ibrahim 1956: 103–4; al-Fi'r 1986: 282; al-Rashdan 2010: 50, Map 1.

56 'Abd al-Malik 2002: 248; 'Abd al-Malik 2005: 317; Petersen 2005:
 49; al-Shqour 2005–6: 99, 108–9, figs 103–6.

57 Abu al-Fida' 1840: 87; al-Qalqashandi [u.d.], III: 388; al-Maqrizi
 1934–72, III: 285; al-Jaziri 1983, II: 1337, 1344; Ghawanma 1982: 18,
 232; Mouton 2000: 89, 96; Pringle 2005–6: 333.

58 Al-Jaziri 1983, II: 1344.

59 Ibn al-'Attar, MS. 5602: 5, Pl. 3; Ibn al-'Attar, MS. 1008: 10–11, Pl. 6.

60 Ibn al-'Attar, MS. 5602: 4–5, Pl. 3; Ibn al-'Attar, MS. 1008: 10–11,
 Pl. 6.

61 Ibn al-'Attar, MS. 5602: 4–5, Pl. 3; Ibn al-'Attar, MS. 1008: 10–11,
 Pl. 6; al-Shqour 2005–6: 108–9, figs 103–12.

62 Zaki 1960: 136; Zaki 1970, II: 44; Ghali 1976, II: 177; al-Rashdan
 2010: 54, Pls 32–3; Glidden 1952: 117–18; Cytryn-Silverman 2004, I:
 47–8; Tütüncü 2008: 20, fig. 3.

63 Ibn Iyas 1982, IV: 133, 144, 151–2, 163, V: 95; al-Shqour 2005–6:
 110, figs 114–16.

64 Ibn Iyas 1982, IV: 133, 144.

65 Ibn Iyas 1982, IV: 151–2.

66 Ibn Iyas 1982, IV, 163.

67 Ibn Iyas 1982, V: 95.

68 Ibn al-Shamma', MS. 5705, I: 81–2.

69 Al-Jaziri, 1983, II: 1345.

70 Al-Jaziri 1983, II: 1344.

71 Shuqair 1985: 160; Ahmad 1977: 165–6; Bakr 1981: 114; Ghabban
 1991: 1–115, Pls 1–2; 'Abd al-Malik 2005: 277, fig. 20, Pl. 53; 'Abd
 al-Malik 2006: 91–138, figs 1–4, Pls 1–9; Tamari 1975: 274; Tamari
 1982: 505–16, Pls XIIb, XIII, XIV; Ghabban 1988: 616–17;
 Ghabban 2011, I: 42, II: 546.

72 Al-Bakri, Library of Alexandria, MS. 235: 39a, 77a.

73 Al-'Ayashi 1977, I: 164; al-Dar'i 1902, I: 161–2; Al-Jasir 1978: 842.

74 Al-Suyuti [u.d], II: 156; Ibn Iyas 1982, IV: 133; al-Jaziri 1983, II:
 1344; al-Rammal 1980: 132; Ghawanma 1984: 131; Glidden 1952:
 118.

75 Al-Suyuti [u.d.], II: 156; Ibn Iyas 1982, IV: 133, 151–2; al-Jaziri,
 1983, II: 1344; Kabrit 1966: 20; Al-Diyarbakri, Al-Azhariya
 Library 941: 296z; Al-Diyarbakri [u.d.], II: 390; Mubarak 2006,
 XIII: 27; Shuqair 1985: 67, 262; Ibrahim 1956: 117; Ibrahim 1972:
 254; Raslan 1401/1980–1: 371.

76 Kurdi 1974: 32; Ghawanma 1982: 234; al-Momani 1988: 294–317;
 Ribat 2001: 6.

77 Al-Jaziri 1983, II: 1388–91, 1393; al-'Ayashi 1977, I: 173; al-Dar'i
 1902, I: 167; al-Dar'i 1983: 77; Al-Diyarbakri [u.d.], II: 389–90;
 Sadiq 1880: 18; Sadiq 1896: 16; Sadiq 1999: 277; al-Jasir 1976:
 934–45; Angraham et al. 1981: 73, Pl. 76, 95b; Bakr 1981: 131; Raslan
 1401/1980–1: 368, fig. 1; Muhammad 1985, II: 351–62; al-Fi'r 1986:
 282, 289–90, Pl.60; 'Ujaimi 2001: 36; Ghabban 1991: 91; Ghabban
 1993a: 241; al-Ansari et. al. 1999: 31; al-Rashid et. al. 2003: 178, 179.

78 Raslan 1401/1980–1: 375–86, figs 1–8, Pls 1–21; Ghabban 1993a:
 241–4, figs 108 a–b, 109 a–b; 'Ujaimi 2001: 35–54, 165–70, figs 1–13,
 Pls 1–48; al-Resseeni 1992: 250–250a.

79 Al-Jaziri 1983, II: 1251.

80 Ibn al-'Attar, MS. 5602: 8, Pl. 5; Ibn al-'Attar, MS. 1008: 17, Pl. 9

81 Ibn Iyas 1982, IV: 152; al-Jaziri 1983, II: 1251; Raslan 1401/1980–1:
 371, 373. Angraham et al. 1981: 73, Pl. 76.95B; Raslan 1401/1980–1:
 367, 381–2, Pl. 21; Muhammad 1985, II: 351, 362; al-Fi'r 1986: 282,
 289–90, Pl. 60; 'Ujaimi 2001: 35–54; Ghabban 1991: 91; Ghabban
 1993a: 241; al-Ansari et. al. 1999: 31; al-Rashid et. al. 2003: 178, 179;
 Ghabban 1988: 211, 565–71, 616, Pls 91a–b, 92, 271; Ghabban 2011,
 I: 42, II: 545, 554–7, 641, fig 271.

82 Ibn Iyas 1982, IV: 152; Salim [u.d.]: 95; al-Fi'r 1986: 282, 289–90;
 'Abd al-Malik 2002: 249.

83 Kabrit 1966: 16.

84 Ibn al-'Attar, MS. 5602: 10–11, Pl. 6; Ibn al-'Attar, MS. 1008: 21–2,
 Pl. 11; al-Jaziri 1983, II: 1414.

85 Al-Zahiri 1997: 16.

86 Ibn al-'Attar, MS. 5602: 10–11, Pl. 6; Ibn al-'Attar, MS. 1008: 21–2,
 Pl. 11; al-Jaziri 1983, II: 1414.

87 Al-Jaziri 1983, II: 535–6; Raslan 1401/1980–1: 371.

88 Al-Jaziri 1983, II: 1251.

89 Al-Jaziri 1983, II: 1309, 1313; Hilmi 1993: 133; 'Abd al-Malik 2005:
 78.

90 Al-Jaziri 1983, II: 1327–8; Zaki 1941: 89.

91 Al-Jaziri 1983, II: 1327–28; Kabrit 1966: 22; Sabri Basha 1966, V:
 266; al-Fi'r 1986: 326–7; Ghabban 1991: 80; 'Umar 2001: 251.

92 Al-Jaziri 1983, II: 1327–8; Shuqair 1985: 157; Raslan 1401/1980–1:
 371.

93 Al-Jaziri 1983, II: 1251.

94 Ghabban 1992: 305–30; Ghabban 1993b: 99–136, figs 1–9;
 al-Resseeni 1992a: 246–8.

95 'Ujaimi 1983: 29, 106–13. fig. 16, Pls 109, 110; al-Fi'r 1986: 332;

Ghabban 1993b: 133–4, figs 10, 11; Ghabban 2011: 562–70, Insc n°, 5, 647, figs 277 a,b.

96 Islamic measuring systems included many types of cubit units such as the Hashimi cubit and 'Amal cubit. For more see Hantscho 2001: 84–91; al-Tayyar 2001: 150, 157.

97 Aghriba (sg. *ghurab* meaning crow) refers to the hexareme which is a type of Roman military vessel that was steered with 180 oars. It was adopted by Muslims and used until the Ottoman period. It is given this name either because of the dark coloured materials used to paint it or because of the vessel's resemblance to the head of a crow.

98 Al-Jaziri 1983, II: 1379–81.

99 Hantscho 2001: 89.

100 Kabrit 1966: 17; Sadiq 1880: 18; Sadiq 1896: 16; Sadiq 1999: 277; 'Ujaimi 1983: 29–53; al-Rashid et. al. 2003: 184–5; Ghabban 2011, I: 184–6, 300–2, figs 85 a–b, 86, 87 a–b, II: 545, 562–70, 647, figs 277 a, 277 b.

101 Al-Jaziri 1983, II: 1298.

102 Al-Jaziri 1983, II: 1381.

103 Kabrit 1966: 14; Ghabban 1993: 28–9, 246, fig. 92; Euting 1999: 198; Ghabban 1988: 308, 595–8; Ghabban 2001, I: 191–3, figs 96a–99b, II: 545, figs 279–80. Euting 2007: 130.

104 Ghabban 1993c: 305–30; Ghabban 1993a: 246–9, figs 112, 113; Ghabban 1992: 222–3; al-Ghabban 1988: 308, 595–8; al-Ghabban 2011, II: 545, figs 279, 280.

105 Kabrit 1966: 14; Ghabban 1993a: 246–50, figs 111a–b, 114; Ghabban 1988: 308, 595–8; Ghabban 2011: 191–3, figs 96a–99b.

106 Kabrit 1966: 14; Ghabban 1990: 257–83; al-Resseeni 1992: 253–5a.

107 Al-Jaziri 1983, II: 1320.

108 Al-Jaziri 1983, II: 1327, Shuqair 1985: 157; Raslan 1401/1980–1: 370.

109 Al-Jaziri 1983, II: 1251.

110 Al-Jaziri 1983, II: 1251. Ibn 'Abd al-Hakam 1999: 191–2; Gibb 1952: 44–50.

111 Al-Jaziri 1983, II, 1251.

112 Ibn Iyas 1982, IV: 152.

113 Al-Jaziri 1983, II: 241.

114 Al-'Ayashi 1977, I: 160.

115 Al-Jaziri 1983, II: 1390–1.

116 Sauvaget 1937: 48–55; Sauvaget 1940: 1–19; Suavaget 1968: 3–19; Lee et. al. 1992: 55–94, figs 1–63; Cytryn-Silverman 2004 I: 1–268, II: 1–260.

117 *Khan* Sabil lies 15km north of Ma'zet al-Nu'man, see Sauvaget 1940: 11–12, fig. 20; Sauvaget 1968: 90–1; Comb, Sauvaget and Wiet 1931–91, XVII: 179; Cytryn-Silverman 2004, I: 34–5, 139, 199–201.

118 Sauvaget 1935a: 45; Sauvaget 1940: 13; Sauvaget 1935b: 41–8, Pls I–II; Cytryn-Silverman 2004, I: 35–7.

119 Al-Jaziri 1983, II: 1381.

Chapter 9
'A Longing for Mecca'
The Trans-Saharan Hajj and the Caravan Towns of West Africa

Sam Nixon

Introduction

During the 19th century when Europeans first encountered the Hajj in West Africa, it was most closely associated with routes running across the Sahel, skirting the southern edge of the Sahara to the Horn of Africa (**Pl. 1**).[1] However, before the 19th century, this route was significantly less important and pilgrimage was principally associated with routes across the Sahara. Islam first came to West Africa by means of the Saharan routes through the commencement of trade with the Islamic world and it was by way of these routes that the first pilgrims made their way on the Hajj.[2] What originally brought Muslim traders and Islam to West Africa was the wealth of gold, slaves and ivory found there. Throughout the medieval era the Saharan routes were frequented by massive camel caravans shipping these precious raw materials from West to North Africa, and bringing in return such commodities as copper, cloth and horses. These camel caravans therefore were the natural means of passage for pilgrims to the central Islamic world, providing infrastructure and security. Even with the end of the grand era of Saharan trade caravans from the 16th century onwards – a result of the rise of European coastal trade with West Africa, as well as the decline in power of North and West African states controlling trans-Saharan trade – these desert routes continued to see trade and organized pilgrimage caravans up to the modern era.

The trans-Saharan Hajj is most commonly discussed in relation to its most famous *hajji*s, namely the rulers of the medieval West African states and empires.[3] These rulers were instrumental in expanding Islam and the Hajj beyond clerics and traders to a wider populace, and their Hajj journeys played an important role in this process. Their Hajj journeys were not only historically important, but they were also spectacular, involving retinues of thousands of followers, as well as a wealth of products for exchange, including gold and slaves. While these journeys will be briefly reviewed below, this essay focuses instead on the locations within the West African landscape that were important to the Hajj, the towns which served as gathering points for pilgrims, and as launching points for the journey across the Sahara. Located at the southern edge of the desert (**Pl. 1**), the primary function of these places was as commercial centres of trans-Saharan trade, where camel caravans arrived and departed and where rich and varied markets could be found. They were also host to some of the strongest Muslim communities in West Africa. While there has been much historical and archaeological debate concerning the commercial function of these towns,[4] their role within the Hajj has been little discussed.

This chapter is organized in two sections. Firstly, it contains an overview of the trans-Saharan trade and the Hajj from West Africa. The second part of the chapter then focuses on the towns which served the Hajj, looking at three towns which had a particularly strong relationship to the pilgrimage and which together span the pre-20th century era of Islam in West Africa: Tadmekka, Timbuktu and Chinguetti. What I wish to show is that these places were not only physical points in the landscape to aid Hajj pilgrims, they were also highly symbolic places within the conceptual landscape of Islam, connected in no small part to their role

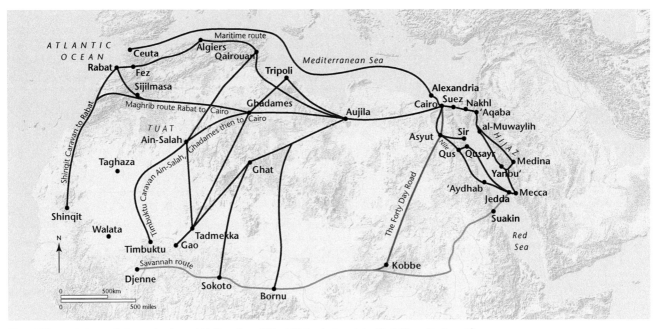

Plate 1 The early trans-Saharan trade and Hajj routes of West Africa (artwork by Matt Bigg, Surface 3)

in the Hajj. What is also important about these places, which I wish to bring out here, is that in addition to their strong relationship to the Hajj, these towns also functioned as sites of local pilgrimage in themselves.

Trade and Hajj across the Sahara

Clear historical records of Islamic trade across the Sahara are recorded from the tenth century onwards, although archaeology suggests that this goes back to at least the eighth century.[5] Islamic trade was itself also likely based on a pre-Islamic trade,[6] but it was certainly during the Islamic era that trans-Saharan commerce expanded hugely. Islamic traders identified West Africa as a rich source of gold, slaves and ivory and it was essentially these three products which drove the trade. Over the course of the medieval era, trade in these precious resources was controlled by a succession of West African states or 'Empires', most importantly Ghana (8th/9th–11th centuries), Mali (12th–14th centuries) and Songhay (15th–16th centuries).[7] From early on, a network of trade routes and trade centres were developed to facilitate this trade, and by the 16th century flourishing Islamic trading communities were found throughout West Africa.[8]

Essential to the expansion of trade was the spread of Islam, as the common cultural network this provided was a significant aid to commerce. In the first centuries of trade, Islam was largely restricted to the desert fringe trading towns and elsewhere to isolated communities of traders and clerics, initially just expatriates but very soon new converts appeared as well.[9] The historical records certainly suggest that Ghana, the pre-eminent kingdom up until the 11th century, was only very superficially Muslim, and the rulers themselves seemingly adhered to their indigenous beliefs.[10] From the 11th century, however, we appear to see significant changes. At this time, the Almoravids, a militant Islamic Berber group from the southern Saharan region of modern Mauritania, waged a campaign of holy war, actively enforcing the rule of Islam throughout the southern Sahara, as well as into the territories of the West African states

further south, including that of Ghana.[11] This process of Islamicization certainly facilitated a greater phase of openness in trade, most notably leading to a surge in the gold trade.

By at least the 13th century it appears that even prominent rulers of West African kingdoms further away from the desert were converting to Islam. During the 12th and 13th centuries, the Empire of Mali rose to prominence, assuming and expanding the power previously enjoyed by Ghana.[12] In the 14th century, Mali's most famous ruler, Mansa Musa (**Pl. 2**), was responsible for a further concerted effort at Islamicization. This went hand in hand with what is widely regarded as the start of the 'Golden Age' of trans-Saharan commerce, an era associated with the rise of the famous trade entrepôt of Timbuktu. In the 15th century, Mali's power was itself usurped by Songhay, which would become the last of the great medieval West African empires. Songhay spread the word of Islam even further, almost to the boundaries it has today. By the time of direct European contact with West Africa along the coast in the late 15th century,[13] West African Islam was some 700 years old and the region was thoroughly connected to the wider Muslim world.

As with other parts of the Islamic world, West African Muslims were required to undertake Hajj provided they had the means to do so. However, the trans-Saharan Hajj journey they needed to take to achieve this goal was an arduous one. The passage itself from one side of the Sahara to the other would have taken in the region of six to eight weeks, but for certain pilgrims the Hajj journey as a whole, there and back, sometimes lasted up to two years as they profited from the opportunity to visit other parts of the Muslim world. There was never one set route for the trans-Saharan Hajj as the great size of West Africa allowed for and required different departure points. On the whole, these followed the routes taken by commercial caravans (**Pl. 1**).[14] In the earliest era of the Islamic trade (i.e. up to the 12th century), perhaps the two most important routes were

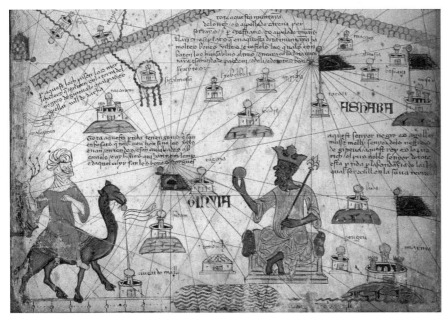

Plate 2 Section of the Catalan Atlas (Abraham Cresques, AD 1375) showing Mansa Musa of Mali holding out a gold nugget to a Saharan merchant. Bibliothèque Nationale, Paris

the route running from Morocco to western Mauritania, and the central Saharan route running through Ghadames to the Niger Bend. Later in the 'Golden Era' of trans-Saharan commerce (14th to 16th century), the most important route was certainly that which runs through 'Ain Salah to Timbuktu. Following the conquest and destruction of Timbuktu in the late 16th century by Moroccan forces, the most important Saharan Hajj route then shifted further west, operating through towns such as Chinguetti and Wadan. Regardless of the different routes across the Sahara, all of the routes across these periods met up with the Maghribi Hajj caravan and passed on the way to Mecca with it.

Any route taken was a dangerous one due to the hazards of the desert. Despite this, until the rise of organized Sahelian caravans, this was still the most secure way to Mecca as the large Saharan camel caravans provided fundamental security and infrastructure for pilgrims. We must not forget also that unlike the Sahelian route, the Saharan route passed through some of the great Islamic centres of North Africa, enabling the pilgrim to visit not only the Hijaz, but also important places such as Kairouan and Cairo. While the desert crossing must surely have made for one of the harshest Hajj journeys in the world, this harshness perhaps only added to the weight attached to this pilgrimage and the status allotted to the returning *hajji*.

The first clear historical references to the cross-Saharan Hajj journey that we hear of are from the 11th century, describing the pilgrimages of southern Saharan nomad rulers.[15] By the 12th century, there were clearly significant numbers of pilgrims making their way from West Africa,[16] and indeed in this century we hear of a *madrasa* being created in Cairo by West African pilgrims on the way to Mecca.[17] Before the 14th century, it is unclear whether a particular caravan was designated for pilgrims or whether they simply attached themselves individually to available trade caravans. Also, it is unclear if journeying for Hajj across the Sahara was a yearly phenomenon. It is likely that it was more piecemeal, fitting with the vagaries of Saharan trading patterns. Certainly though, in the 14th and 15th centuries we

have clear records of organized pilgrim caravans from West Africa and an expectation of their annual arrival in the Hijaz.[18] By the 14th century we hear of West African pilgrim caravans of up to 5,000 arriving in the Maghreb.[19] In the late medieval era the Saharan Hajj caravan became known as the 'Takrur caravan',[20] this being a generic name applied to people from West Africa in the Middle East.[21] The later period of the Hajj is perhaps less widely discussed, but the cross-Saharan Hajj continued as a flourishing tradition right up to the European colonial era. In the 18th and 19th centuries the large West African Hajj caravans arriving in Mecca were known as the 'Shinqit caravan' due to their association with the important Saharan spiritual centre of Chinguetti (see more below).

The most famous associations of the West African Hajj are with specific *hajji*s, namely the rulers. The Hajj of one ruler in particular stands out: that of Mansa Musa of Mali in the early 14th century.[22] Mansa Musa set out from West Africa with a retinue of thousands, including slaves and courtiers. He also took with him an enormous wealth of gold. Such was the value of this gold wealth it was said that when the Malians began spending it in Cairo, it resulted in the devaluation of the local gold standard which would last for years to come. Mansa Musa's Hajj brought West Africa to world attention like never before, symbolized most famously by the prominent inclusion of Mansa Musa in the Catalan Atlas (**Pl. 2**). While Mansa Musa is the most well known of the West African Hajj monarchs, there were a number of rulers (of both Ghana and Mali) who travelled before him but who appear to have made less of a sensational arrival in North Africa and Mecca.[23] Various rulers also undertook the Hajj after Mansa Musa, including Askia Mohammed of Songhay who led a similarly grand caravan to that of Mansa Musa and received the honorary title of 'Caliph of the Western Sudan'.[24] Beyond being colourful historical figures, these rulers were important for the development of the Hajj as not only did their Hajj journeys spur more existing Muslims to undertake the journey, they also appear to have used their Hajj status for wider programs of Islamicization.

Plate 3 (above) View across the valley containing the ruins of the town of Tadmekka, noted for its supposed 'resemblance' to Mecca

Plate 4 (right) Excavations at Tadmekka

While Hajj journeys started for many people from various places in West Africa, the West African towns most strongly associated with the Hajj were those at the desert's edge. As the last permanently inhabitable place where water and pasture could be found before the long desert journey, these towns were located to serve the trading caravans arriving and launching off into the desert. It was here that Muslims from all over West Africa congregated to set off on the pilgrimage and where one waited to join the caravan. The Hajj journey from West Africa proper started here, not only in the sense of launching into the Sahara, but also in the sense of joining a great caravan of fellow pilgrims. It was also here that one began to feel a greater sense of the central Islamic world awaiting, as since the arrival of Islam in West Africa these desert edge towns were home to the strongest Islamic communities, and there was a sense of the deep heritage of Islam here.[25] In particular, there would have been an awareness that innumerable pilgrims before them had waited at that point to undertake the same journey. It is no wonder therefore that these places became not only congregating and provisioning places for the Hajj, but highly symbolic centres of Islam, with traditions connected to the Hajj, and a focus for pilgrimage in their own right.

Case studies

Tadmekka

From Bughrat you go to Tiraqqa and from there across the desert plain to Tadmakka, which of all the towns in the world is the one that resembles Mecca the most. Its name means 'the Mecca like'. It is a large town amidst mountains and ravines and is better built than Ghana or Kawkaw.... Their king wears a red turban, yellow shirt, and blue trousers. Their dinars are called 'bald' because they are of pure gold without any stamp. Al-Bakri 1068.[26]

The town of Tadmekka is widely recognized as one of the first important trading places of the Islamic trans-Saharan trade.[27] Al-Bakri's 11th-century description (see above) is the most glowing account of its status, in particular referring to its well-built nature and its gold wealth. Historical records for this town span the 10th to 14th centuries, indicating its status as a commercial centre of great importance for a long

period. Recent excavations by the author at the ruins of Tadmekka (**Pls 3, 4**) confirmed this picture, as well as providing evidence of a town that predates historical records. They revealed a deep occupation at the site (5 metres) dating from the 8th to the 14th centuries, with clear evidence of well-built structures, as well as numerous and varied trade goods, including proof of the production of its famed gold coinage.[28]

Tadmekka was equally recognized as an important centre of Islam as it was for its trading role, due to the fact that it was here that Islam was first significantly adopted by the Berber nomads of this southern Saharan region, and indeed this was one of the first urban centres in the wider region.[29] The Muslim scholars who came to be associated with this town spread the word of Islam far and wide, contributing to the association of the place as an origin point of Islam in the region. Surface archaeology at the site confirms its strong Muslim character, with mosques, a *musalla* (an open air prayer hall) (**Pl. 5**), and large Muslim cemeteries clearly evident. Tadmekka would therefore not only have provided pilgrims with the necessary physical infrastructure, including accommodation and markets for provisions, it would also have provided the religious

Plate 5 *Musalla* outside the ruins of Tadmekka where traders and pilgrims would have stopped to pray on departure and arrival

structure and apparatus necessary to prepare for such a spiritual journey.

The most obviously intriguing aspect of Tadmekka in the context of this volume is certainly the meaning of its name, translated broadly as either 'resembling Mecca', or 'the Mecca like'. This explicit comparison with Mecca was first made in the 11th century by al-Bakri but the name 'Tadmekka' was known at least a century before this.[30] This usage continued until the 14th century when the town was abandoned. While the comparison of towns with Mecca is not unique to this town,[31] what is special in the case of Tadmekka is that this comparison with Mecca was actually adopted for the town's name itself. In the local Berber language, Tamasheq, this name can be broken down to 'Tad' = 'resemblance' and 'Mekka' = the town of Mecca. Local variations of the meaning of 'Tadmekka' given today include the less direct French translation, 'ça, c'est la Mecque!'

While the translations of the name 'Tadmekka' given by the medieval Arabic geographers and by oral traditions are fascinating, in the 1980s the epigrapher Paulo F. de Moraes Farias made a spectacular discovery at Tadmekka's ruins offering new insight, namely an inscription reading 'and there shall remain a market in conformity to (or with a longing for) Mecca (or Bakka)' (**Pl. 6**). This is one of a series of inscriptions carved in the cliffs overlooking the town. The inscription is undated but it is surrounded by inscriptions dated to the 11th century (a range of other inscriptions dot the cliffs and are also found in the town's cemeteries), the time when al-Bakri was writing.[32]

Trying to understand the sense in which this town was seen to be 'in conformity to Mecca' can start with the geography alluded to by al-Bakri, namely its location between two hills. We can also add to this its desert location. It is not difficult to see how this place would have captivated visitors arriving there from across the desert (**Pl. 3**), thus leading them to draw such a parallel with Mecca. Beyond this, the town was obviously a flourishing market centre like Mecca, with a strong Islamic community, including scholars. However, to not only make this connection to Mecca, but to then use this as the basis for the town's name, and for an individual to have made a rock inscription at the site evoking this connection, clearly indicates an extremely strong local sense of an identity linked to the idea of Mecca.

To evoke the name of Mecca in this manner was to create a continual link between this distant post of Islam and the central Islamic world. There was obviously a deep desire to feel connected here, and in this sense the translation 'a longing for Mecca' makes sense. It gave the place an identity which created an extremely strong mental image of being tied into the network of the Islamic world. Moraes Farias has spoken of this more broadly in terms of there being a continual preoccupation also with the Islamic calendar in this town.[33] It is perhaps, then, this idea of 'longing for Mecca' rather than a belief in the actual resemblance of this place to the most holy city of Islam which is closest to the original meaning of the name. Regardless of the specific motivations for creating this conceptual connection – which are indeed difficult to reconstruct with certitude – what we can confidently say is that this conceptually brought the Hajj into the identity of the town as a continual presence, a

Plate 6 Drawing of an inscription found in the cliffs overlooking the ruins of Tadmekka which reads 'and there shall remain a market in conformity to (or 'with a longing for') Mecca (or Bakka)' (courtesy P.F. de Moraes Farias; see Moraes Farias, 2003, pl. 28, n. 104 and photo on same page)

continual evocation of Mecca and a signal across the desert towards it. This functioned to mentally reiterate the obligation on all Muslims who were able to make the pilgrimage, and it helped to make Tadmekka a compelling place for pilgrims to start their journey.

In addition to this inscription discussed above, there are a range of other inscriptions at the site, both in Arabic and in the local Berber script, Tifinagh. The funerary inscriptions in the cemeteries simply document the identity of the individual and the date of their death. There are, however, a range of other non-funerary inscriptions. A particularly fascinating inscription placed at one of the entrances to the town instructs the reader to recite the following phrase twenty times, 'Muhammad is His [God] messenger'.[34] There is for instance another inscription which names a local sultan and the date of his presence at the site.[35] The majority of the inscriptions are however simple graffiti-like works giving the name of the person and the date of their presence at the location.[36] This varied landscape of inscriptions testifying to the past presence of individuals – both in life and death – would have further added to the symbolic landscape of this place.

Many people would have been drawn to Tadmekka as the first point of their Hajj journey, but for most to go on the Hajj was an unrealistic prospect. For these people, Tadmekka would certainly have offered another possibility, as a site of importance in itself worthy of pilgrimage. In later times, Tadmekka was clearly identified as a pilgrimage centre, principally by the Sufis,[37] and it seems extremely likely that it would have functioned in this way in earlier times. Tadmekka had a strong Muslim clerical population who could be visited and consulted, and it had a whole symbolic landscape including important old mosques and cemeteries, its varied inscriptions and its famously described resemblance to Mecca. In this sense, it seems likely that Tadmekka began to gain an alternative connotation, not simply of being a place 'longing for Mecca', but a place in some way 'resembling' Mecca, albeit merely always a substitute for the central Muslim city.

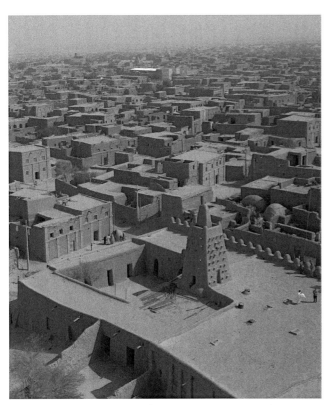

Plate 7 View across Timbuktu (© UNESCO/Serge Nègre)

more detailed accounts of rulers and notable individuals embarking on the Hajj. The most famous of these was Mansa Musa (see above). While most of the stories related to these rulers recount their activities in Mecca and elsewhere in the central Islamic world, an equally important part of their Hajj journeys was the activities they carried out on their return to West Africa. One of these was their increased efforts to spread Islam. While this is a diffuse process which leaves only a partial trace, one trace this did leave was the mosques which they built on their return, clear expressions of their greater faith and reminders of their journey and all it represented. Timbuktu is not only the main place where these monuments were created, but also where they still survive in the most complete form.

The first mosque of note to comment on, the Djinguereber mosque (**Pl. 8**), was supposedly commissioned in the course of Mansa Musa's return from the Hajj in 1324–7.[42] This is a very large mosque, as the name Djingeureber, meaning 'grand mosque', suggests. The building has a strong rectilinear arrangement in which parallels can be seen with mosques in North Africa and the Middle East. Much discussion has related to the influence of the architect al-Saheli who is said to have come back from the Hajj with Mansa Musa. While the building has certainly seen significant renovation over the centuries – a natural process due to it being constructed in mud brick and rammed earth – there is evidence for the use of certain architectural elements out of keeping with the West African architectural tradition which appear to date to the building's earliest phase, most obviously limestone arches.[43] Limestone as a building material is not widely abundant in West Africa and arches are an architectural form largely alien to this part of the world. It is interesting to observe also that the Djinguereber quarter of the town surrounding the mosque is still today inhabited by Muslim populations who claim to be descendants of the followers of Mansa Musa.[44] Therefore since the 14th century, the mosque and its surroundings have been fundamentally linked with the Hajj and West Africa's most famous *hajji*, Mansa Musa.

Another striking example of the connection between Timbuktu's mosque architecture and the Hajj is the Sankoré mosque (**Pl. 9**).[45] The exact origins of this mosque are not known, but it is reputed to be older than the Djinguereber mosque. Over time it was significantly remodelled. The most important piece of remodelling within the context of the Hajj is that which was said to have been undertaken by the Cadi el-Aqib after returning from the Hajj in 1581.[46] Upon preparing to leave Mecca at the end of his Hajj he asked permission to measure the Kaʿba using a length of rope. Upon his return to Timbuktu he is then said to have used this to remodel the Sankoré mosque, laying this out with pickets to plan a new interior courtyard (*sahn*) for the Sankoré mosque. Fascinatingly, the measurements of the Sankoré *sahn* do indeed correspond precisely to the exterior dimensions of the Kaʿba.[47]

Certainly these were amongst the most splendid examples of mosques known in West Africa in the medieval era. It is clear that they were designed in no small part to celebrate and confirm the power of the monarchs who built them, but also it seems they were borne of a genuine desire to

In the early Islamic era therefore, Tadmekka stood as a hugely important point in the West African landscape for Muslims, as a logical point of departure for the Hajj, but almost certainly also as a site of local pilgrimage. From the 14th century, Tadmekka's importance seemingly began to decline and this must have impacted on its status for Hajj pilgrims. Importantly, oral traditions speak of declining Islamic standards at this time and a departure of scholars.[38] Whatever local pilgrimage significance it once had would undoubtedly have altered too. While an explanation of its decline is difficult to pinpoint, a contributing factor was certainly the rise of another centre which assumed the trade and religious function of Tadmekka: Timbuktu.

Timbuktu

The earliest known reference to Timbuktu in Arabic historical records is from the 14th century.[39] Timbuktu rose to become perhaps the greatest of all the Saharan trading towns, in no small part due to it being the main trading town of the Empire of Mali. It is due to its connection with the Malian gold trade that Timbuktu gained such a legendary reputation amongst Europeans, one that continues still today. The majority of medieval Timbuktu is buried deep below the contemporary town (**Pl. 7**). Excavations have been conducted within the town but these only attained post-medieval levels due to difficulties of excavating at depth.[40] From historical sources though it is clear that cross-Saharan trade attained new heights with the rise of Timbuktu, and likewise that it gained a renowned reputation as a centre of Islam.[41] It is not an overstatement to say it became the greatest centre of medieval trade and Islam in West Africa.

The rise of the town of Timbuktu coincided with the commencement of the era when Arabic authors provided

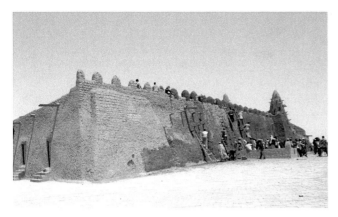

Plate 8 (above) Djinguereber mosque during the festival connected to its annual renovation (© Issouf Sanogo – AFP/Getty images)

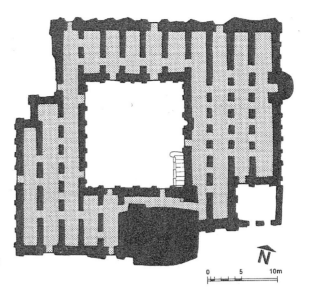

Plate 9 (right) Plan of the Sankoré mosque with interior courtyard matching the dimensions of the Ka'ba (Prussin 1986, after Raymond Mauny)

celebrate the Islamic faith and to inspire others to convert. Whether the buildings were designed to directly inspire Hajj is not clear. Certainly though, as extremely prominent monuments in the town which were understood to have been built in direct association with the most famous Hajj journeys, they acted as signifiers of the pilgrimage and all that this represented. In particular, the *sahn* of Sankoré was one of the greatest evocations and inspirations to the Hajj. There could be no clearer evocation of Mecca than standing in a courtyard planned using a rope which had been laid around the Ka'ba. One would be able to go inside this building, to hear about the traditions of its construction and almost visualize the Ka'ba itself. Inevitably, there were other traditions and symbolisms created around these buildings in Timbuktu linking them to the Hajj but these are now lost to us.

Just as these buildings acted as an inspiration to Hajj, they also stood as objects of Islamic pilgrimage in their own right. As with Tadmekka, by visiting places which were so obviously linked to the Hajj tradition, one was genuinely visiting a place touched by and connected to the Muslim central places. When we look at Timbuktu today, we actually see living traditions of pilgrimage based around these very mosques. An important ceremony to highlight is one connected with the renovation of the mud walls of these buildings (**Pl. 8**). Mud architecture by its very nature requires continual renovation to prevent its erosion. Festivals have developed where Muslims participate in this process. As well as locals, people journey from great distance to take part in this festival. Participation in this renovation is said to bring the participant *baraka* (blessing). The accumulation of this *baraka* through a variety of pious acts is said to be in some ways equivalent to making the journey to Mecca, or at least to be a significant substitute. It is unclear how far back in time this festival goes but this gives us a sense of how these Hajj-related buildings have been integrated into patterns of local pilgrimage. Again, it is clear to see how attractive it would be for people who could not visit Mecca to take part in the renovation of buildings which were directly linked to the Hajj and primarily inspired by Mecca.

In 1592, Timbuktu was partially destroyed by Moroccan forces attempting to occupy the town which was now at the heart of the Songhay trading network. The ultimate aim was to gain access to the gold sources further south upon which Timbuktu's wealth was based, an aim which was ultimately unsuccessful. Following this event, the Saharan trade was never the same again, compounded by the fact that Europeans were now trading on the West African coast for gold and slaves, which offered new, more competitive markets for these core trade items.[48] This event also led to immediate and radical change for Timbuktu as a central place for Islam in the region. Many of its religious communities and scholars were displaced and a number of its famous libraries of Islamic manuscripts were moved to Morocco. Timbuktu as a holy place did not completely disappear, but it was significantly diminished as a thriving point of the Hajj network. However, the need for Hajj continued and this led to the rise of other centres, the most important of which was Chinguetti.

Chinguetti (Shinqit)

From Arabic sources it is clear that Chinguetti was associated with caravan routes from at least the 15th century,[49] but its trading history undoubtedly precedes this. The wider region around Chinguetti certainly profited as a focus for trade and the Hajj after the 16th century, following the reduced role that Timbuktu played from this time, as well as other towns such as Wadan and Tichitt.[50] While its

Plate 10 View of Chinguetti showing the Friday Mosque and the surrounding old town (© Mark DeLancey)

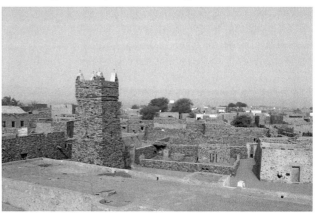

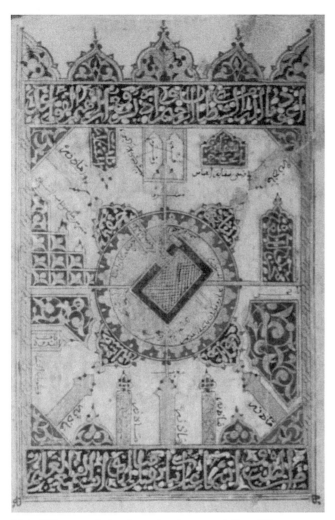

Plate 11 Manuscript showing a visual representation of Mecca, Habbot Library, Chinguetti (courtesy Ghislaine Lydon)

In addition to its pilgrims, Chinguetti is also famous for its manuscript libraries. While Timbuktu's manuscripts are world famous, those of Chinguetti are less well known, despite being seen to be as significant as, if not more so, those of Timbuktu. Following the demise of many of Timbuktu's libraries and manuscript traditions after the Moroccan conquest, Chinguetti was one of the most important places to inherit this role in the Western Sudan.[56] It was reputed that almost every house in the town possessed a library of some form. Many of these libraries still exist today but they have been diminishing in importance since the end of the 19th century following changes in Saharan networks caused by the colonial presence in the region.[57] Amongst the manuscripts still in Chinguetti today can be found those dealing with subjects such as the life of the Prophet, the *Hadith* of the Prophet, and Qur'anic sciences, as well as a variety of Qur'an copies. Certain manuscripts even contain visual representations of Mecca (**Pl. 11**).

It is particularly important to draw attention to Chinguetti's libraries for their close connection to the Hajj. These libraries actually came into existence to a significant extent through the Hajj, as returning pilgrims began to bring back books with them, and this developed into a strong tradition.[58] Also, due to the perceived 'spirituality' of the pilgrims of 'Shinqit', when they went on Hajj they were often given books and even whole libraries to take home with them to supplement their 'outpost' of Islam.[59] Along with the commercial trade in books across the Sahara, this is one of the important ways in which the numerous libraries of the town came into existence.[60] In effect, Chinguetti was acting as a conduit through the Hajj for bringing the word of God, in the form of the book, from the Hijaz into West Africa.

The attraction of Chinguetti as a gathering place for pilgrims was huge. It was home to a very important scholarly community from whom one could seek advice and be sure of one's spiritual passage to Mecca and Medina. Also, as the fame of its pilgrims in the holy land was extremely important, to join the 'Shinqit' caravan would have held a great prestige. Its libraries and manuscript traditions also led to it having an additional importance. Not only would one feel closer to the centre of the Muslim world through being in a town noted for its collection of manuscripts which had in large part arrived there as a result of the Hajj, pilgrims would also be able to themselves purchase and commission copies of Islamic texts to take with them, or for those less versed in the Arabic script to buy such things as amulets containing elements featuring the Arabic script.[61] It is important, therefore, to stress that Chinguetti was not just a 'library town', but a location with a living tradition of copyists who provided hugely important functions for pilgrims setting out to Mecca.

For those who could not make the Hajj, 'Shinqit' itself was a worthy alternative destination for the same reasons that Hajj pilgrims were attracted there. Indeed, the importance of Chinguetti as a centre of Islam worthy of pilgrimage is still seen today, most clearly expressed perhaps by the fact that it is also known locally as 'the seventh city of Islam'.

trade and Hajj caravans are best documented from the 19th century onwards, oral traditions and manuscripts provide some insights into a comparable trade and pilgrimage function in the 17th and 18th centuries. In the same way as Tadmekka and Timbuktu before it, Chinguetti functioned as a gathering centre for traders and pilgrims, although it seemingly never attained the scale of Timbuktu as a commercial centre. Chinguetti is now a semi-abandoned town, but signs of its past prosperity can still be seen in its old quarter (**Pl. 10**).[51]

Chinguetti became particularly famous within the Islamic world for the great spirituality of its population.[52] This was partly related to the consistency of the presence of people from Chinguetti on the Hajj, but also for their comportment in the holy land of Mecca and their great knowledge of Islamic traditions. Due to the perceived importance of this town, the whole western Saharan region became known throughout the Islamic world as '*Bilad al-Shinqit*', the 'land of Chinguetti'. The earliest reference we have to this is from the late 18th century.[53] Various traditions related to Chinguetti suggest that an annual caravan was organized from this town, and that often a significant percentage of the town went on pilgrimage.[54] There are also traditions suggesting that citizens of Shinqit were noted for sponsoring others to go on the Hajj who were not themselves able to meet the expenses of the journey.[55]

Conclusion

The trading towns where early West African pilgrims left for and returned from Mecca are central places for understanding the Islamic pilgrimage tradition in West Africa. Firstly, they enable us to understand the nature of the urban environments that formed the true departure point for the trans-Saharan Hajj. Secondly, as well as providing the essential infrastructure to support and organize the Hajj caravan, it is not surprising that Hajj traditions developed at these locations and as a result physical and symbolic traces of the Hajj have been left there.

What I have highlighted here are the clearest examples of this process. At Tadmekka we saw the development of a very strong identity explicitly linking this place with Mecca, leading to the naming of the town after the holy city, which was commemorated physically at the site in at least one place with an inscription. At Timbuktu we have shown how this place became famous for the various monumental mosques constructed by returning *hajjis* in commemoration of their journey, and how these gained a certain inspiration from the buildings of Mecca, including most notably the *sahn* of Sankoré which was supposedly planned using measurements taken directly from the Ka'ba. At Chinguetti we have seen how the *hajjis* of this town became known throughout the Islamic world for their great spirituality and how the Hajj was closely connected with the development of manuscript libraries in the town, formed from individual books and even whole libraries which were bequeathed to *hajjis* on their return journey.

These traditions and material traces of the Hajj certainly acted to inspire the pursuit of Mecca for new generations of pilgrims, in the sense that they acted to focus the visitor on the central Islamic world. Moreover, these traditions confirmed the status of these locations as rightful places of departure for the Hajj caravans, where the correct first step on the Hajj could be taken in line with pilgrims before them. Beyond their Hajj-related function and symbolism, these towns also acted as pilgrimage centres for people who could not perform the Hajj. This in no small part derived from their role within the Hajj, as visits to them enabled one to connect with Hajj traditions and their spiritual and material symbolism. In this sense, they enabled people to get as near to the ideal of Hajj as was possible without actually leaving West Africa. Therefore, not only did these towns foster a 'longing for Mecca', over time they also began in some ways to 'resemble Mecca'.

Notes

1 Al-Naqar 1972: 92–113; Birks 1978: 12–14.
2 Levtzion and Hopkins 2000; Insoll 2003; Mitchell 2005.
3 Al-Naqar 1972: 3–33.
4 Devisse 1988; Insoll 2003: ch. 5; Nixon 2009.
5 Levtzion and Hopkins 2000; Mitchell 2005; Insoll 2003: ch. 5; Nixon 2009.
6 Liverani 2003; Magnavita 2009.
7 Levtzion 1980.
8 Levtzion and Hopkins 2000: xxii.
9 Insoll 2003: ch. 5.
10 Levtzion 1980.
11 Hrbek and Devisse 1988.
12 Levtzion 1980.
13 Mitchell 2005: ch. 6.
14 Levtzion and Hopkins 2000: xxii.
15 Levtzion and Hopkins 2000: 70–1.
16 Levtzion and Hopkins 2000: 133.
17 Levtzion and Hopkins 2000: 353.
18 Levtzion and Hopkins 2000: 355–6.
19 Levtzion and Hopkins 2000: 355.
20 Levtzion and Hopkins 2000: 356.
21 Al-Naqar 1972: 3–5.
22 Al-Naqar 1972: 11–17; Levtzion and Hopkins 2000: 269–71.
23 Levtzion and Hopkins 2000: 133; Al-Naqar 1972: 6–17.
24 Al-Naqar 1972: 18–25.
25 Devisse 1988; Insoll 2003: ch. 5; Mitchell 2005: ch. 5.
26 Levtzion and Hopkins 2000: 85.
27 Insoll 2003: ch, 5; Mitchell 2005: ch, 5; Nixon 2009.
28 Nixon 2009; Nixon 2010; Nixon *et al.* 2011.
29 Norris 1975.
30 Levtzion and Hopkins 2000: 50–1; indeed al-Bakri is widely recognized as having copied from earlier authors, see Levtzion and Hopkins 2000: 62–3.
31 For a description of the town of Audaghoust in Mauritania, see Levtzion and Hopkins 2000: 46.
32 Various aspects of this inscription are discussed in detail in Moraes Farias 2003: xxxvi, xliii, cxxxiv–cxxxv, cxlii, clxxxix, cxc–cxcii, cxcv, cxcviii, cci, ccxvi, ccxxxi–ccxxxv, and its text is transcribed and translated on 87–8.
33 Moraes Farias 2003.
34 Moraes Farias, 2003: 88–9.
35 Nixon 2010: 44.
36 Moraes Farias 2003: ch. 7.
37 Norris 1975.
38 Nixon 2009; Norris 1975.
39 Levtzion and Hopkins 2000: 279–304.
40 Insoll 2002; for other settlements around Timbuktu, see Park 2010.
41 Insoll 2003: ch. 5.
42 Prussin 1986: 150–1.
43 Prussin 1986: 150–2.
44 Prussin 1986: 140–3.
45 Prussin 1986: 148–50.
46 Prussin 1986: 148–50.
47 Prussin 1986: 148–50.
48 Mitchell 2005.
49 Norris 1962.
50 Lydon 2009: 81–4.
51 Prussin 1986: 114–15.
52 Norris 1962; al-Naqar 1972: 95–7.
53 Lydon 2009: 82.
54 Al-Naqar 1972: 95–7.
55 Al-Naqar 1972: 95–7.
56 Lydon 2004; Krätli and Lydon 2011.
57 Lydon 2004; Krätli and Lydon 2011.
58 Meyine 2009; Lydon 2004.
59 Lydon 2004: 53; Meyine 2009: 4.
60 Lydon 2004.
61 Lydon 2004.

Chapter 10
Hajj Ports of the Red Sea
A Historical and Archaeological Overview

Charles Le Quesne

Introduction

This chapter sets out to consider the role played by the ports along the Red Sea coast of Egypt and Sudan in enabling African pilgrims to reach the holy cities of Islam (**Pl. 1**). It also examines their function in supplying the Hijaz with staples (notably wheat) to sustain the annual influx of ever-growing numbers of people into an environment with very limited agricultural resources. While these are themes that have been dealt with in many period and site-specific studies, this overview provides an opportunity to highlight wider patterns in the available evidence, as well as to identify some conservation and research priorities for the future.

The history (and archaeology) of the Hajj is deeply and inextricably intertwined with the geopolitics and economics of the Red Sea region. The pilgrimage routes were also used for trade, and, in times of war, for military mobilization. Only the official overland Hajj routes from Baghdad, Damascus and Cairo can easily be distinguished as being primarily religious in nature. In travelling by boat via Qulzum/Suez, Qusair, 'Aidhab and Suakin, pilgrims in the Middle Ages were following established routes of politically endorsed commerce in a period when the Red Sea was a key terminus of international maritime trade. With the passage of time the political significance of the pilgrimage grew under Mamluk and Ottoman sultans and ultimately became a determining factor in economic and political strategy in the region.

This chapter relies largely on evidence of historical analysis, archaeological survey and excavations, much of it carried out over the past 35 years. Satellite imagery is a secondary but important source in locating and interpreting sites that the author has not had the opportunity to visit. A distinction has been drawn as much as possible between ports used for the Hajj from north-east Africa and those where pilgrimage was not a major part of their function. The latter (for example Badi and 'Aqaba) have not been discussed in any detail for this reason.

Plate 1 Early medieval Hajj ports of the Red Sea

Port	African coast						Hijaz		
	Qulzum/ Suez	Al-Tur	Qusair al-Qadim	Qusair	'Aidhab	Suakin	Jedda	Al-Jar	Yanbu'
Period occupied									
7th century	■						■		
8th century	■						■		
9th century	■						■		
10th century	■				■		■		
11th century	▨				■		■	▨	
12th century	▨				■	▨	▨		▨
13th century	▨		■		■	■	■		■
14th century	▨	■			■	■	■		■
15th century	▨	■			■	■	■		■
16th century	■			■		■	■	■	■
17th century	■			■		■	■		■
18th century	■			■		■	■		■
19th century	■			■		■	■		■

Table 1 Summary of the main periods of pilgrimage traffic through the Red Sea ports (dark grey = in regular use for the Hajj; light grey = in occasional use for the Hajj; white = out of use)

Early medieval period (639–868)

In the early centuries of Islam, Egypt occupied a place on the periphery of power, with the centre of the caliphate moving from the Hijaz to Damascus under the Umayyads in 661 and to Baghdad in 750 under the Abbasids. It was a period during which the traditional economic powerhouses of the Red Sea – Egypt and Yemen – were exploited for their resources while suffering from relative political neglect.[1] This underlies the lack of investment in Egyptian/African Hajj infrastructure while the Umayyads and Abbasids were developing wells, cisterns and caravanserais along the Syrian and Iraqi routes. It should also be noted that the majority of Egypt remained Christian until the ninth century. There are therefore few historical references to the use of Red Sea ports for pilgrimage at this time. It appears that the Hijazi coastal route was not in regular use by pilgrims travelling overland until the ninth century.[2] Nonetheless it is clear that both Qulzum and, from at least the ninth century, 'Aidhab were essential gateways between Egypt and the Hijaz (**Pl. 1**). Those passing through them undoubtedly included many Muslim pilgrims as well as soldiers, administrators and merchants.

Qulzum

Qulzum – the modern terminus of the Suez canal, medieval predecessor of the port of Suez and successor of ancient Clysma – lies at one of the key historic crossroads of the northern hemisphere (**Pl. 2**). From the medieval period to this day it has controlled trade and traffic passing from the Mediterranean to the Indian Ocean and from north-east Africa to Asia. The city was connected by canal to the Nile since the fifth century BC. Of particular interest is a recent study of the evidence of the ancient Red Sea Canal connecting Babylon/Fustat and the ancient and medieval harbour of Qulzum which was dredged in 23/643–4 on the orders of Caliph 'Umar after a period of disuse in late antiquity. The canal, originating in the fifth century BC, had

seen successive renovations under the Ptolemies, and the emperors Trajan and Diocletian before becoming silted up once again in the later sixth century AD.[3]

Early Arabic sources such as the writings of Ibn 'Abd al-Hakam clearly state that the canal was opened up in order to boost grain supplies to the Hijaz during a period of famine.[4] Among the key features of Fustat (Old Cairo) evident until at least the 18th century were the massive granaries between the river and the Roman fortress at the entrance to the canal; they were monuments that testified to the historic importance of this key transport node which controlled the distribution of resources. Until the 19th century Egypt continued to be the key source of cereals to the Hijaz, encompassing other key supply points along the

Plate 2 Plan of the head of the Gulf of Suez showing the old harbour and the location of Tell al-Qulzum

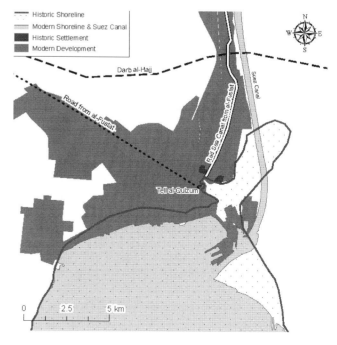

Historic Shoreline
Modern Shoreline & Suez Canal
Historic Settlement
Modern Development

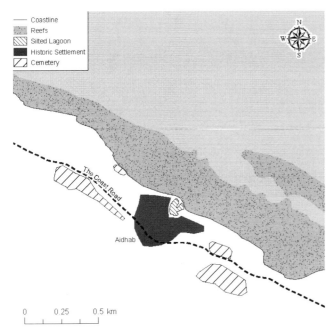

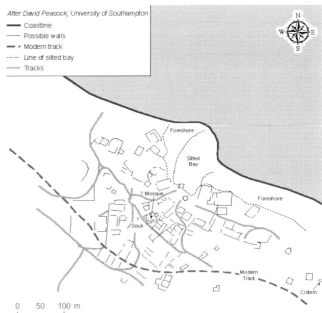

Plate 3 Annotated satellite image of 'Aidhab

Plate 4 Plan of remains at 'Aidhab based on satellite imagery

pilgrimage route and the holy cities. This was, of course, only a continuation of its role as breadbasket of the Roman and Byzantine empires. The final closure of the Red Sea Canal came around 767 by the orders of Caliph al-Mansur to prevent wheat reaching rebels in Medina.[5]

Qulzum therefore offered a key transport link between the new occupying forces based in Fustat – the western terminus of the canal – and the Hijaz. For any Muslim living in Lower Egypt it was the only real option for seaborne travel to the holy cities. Before the construction of reliable infrastructure across the Sinai, it must have seen substantial pilgrimage traffic. Unfortunately, the outcomes of the only significant excavations on the site have never been fully published.[6]

'Aidhab
Like Badi to the south, established as a bulwark against Ethiopia, 'Aidhab was founded in the seventh century as a point of access from the Hijaz to the Nile Valley. The site lies in what is today a profoundly inaccessible position on the borders of Sudan and Egypt. Only looked at from a wider maritime perspective can its historical context be understood. Far closer than any other Egyptian port, it lies roughly equidistant (just over 250km) from al-Jar and Jedda, the medieval Hijazi ports serving Medina and Mecca (**Pls 1, 3–4**).

There are reasons to believe that 'Aidhab – like al-Jar – may have been established as early as the Islamic conquest of Egypt in 641. This is based on the fact that the better-known campaign of 'Amr ibn al-'As, who established the capital at Fustat after taking the Byzantine stronghold of Babylon in 641, was matched by a southern thrust led by 'Abd Allah ibn Abi Sarh that led to the capture of Aswan. Ibn Hawqal stated that his forces crossed the Red Sea by ship.[7] Given that the only practical route to Aswan from the coast runs from 'Aidhab through the Wadi Allaqi, a foundation for the port at this time seems entirely reasonable.[8]

It has been suggested that the town's reputation as a major medieval pilgrimage port relies on Fatimid and Ayyubid accounts and therefore cannot be applied to earlier periods. However, there is evidence that its rise to prominence in the ninth-century was specifically connected with the Hajj. In 819 a chief of Qift asked for the protection of the Beja in crossing the desert in order to make the pilgrimage. His betrayal and death led to the Abbasid state instigating a series of substantial military campaigns against the Beja in the context of which there are references to a naval squadron being sent from Qulzum to 'Aidhab.[9] Provision for Hajj pilgrims travelling by sea was also included in the treaty of 831 between the Abbasids and the Beja, leaving little doubt that, as the only Red Sea port connecting Upper Egypt with the Hijaz, 'Aidhab served pilgrims from the earliest period of the Muslim administration of Egypt.[10]

Hijazi ports
The two Hijazi ports described most often in the early centuries of Islam in the context of trade and pilgrimage from Egypt are al-Jar serving Medina, and Jedda serving Mecca. Written in 846, Ibn Khurradadhbih's description of the trade networks of the Jewish Rhadhanite merchants speaks of ships bringing cargoes from western ports via Pelusium, Qulzum, al-Jar and Jedda and then into the Indian Ocean and China.[11]

The site of al-Jar, which has produced some limited archaeological evidence of Nabatean and Roman use, is referred to as an important port from the earliest years of Islam. This is not surprising given that it has a superb natural harbour: a double lagoon accessed through a break in the reef at the end of the shortest route from Medina to the Red Sea (**Pls 5, 6**). Unlike Jedda, it has been abandoned since the middle ages making it accessible to archaeological investigation. Sondages dug within and outside the defensive walls have identified ceramic evidence of occupation in the seventh to ninth centuries.[12] The extensive remains of

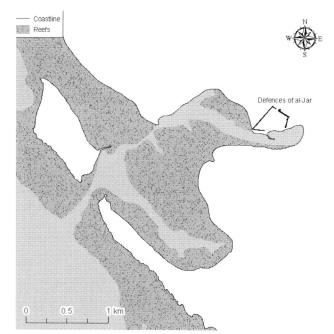

Plate 5 Annotated satellite image of al-Jar

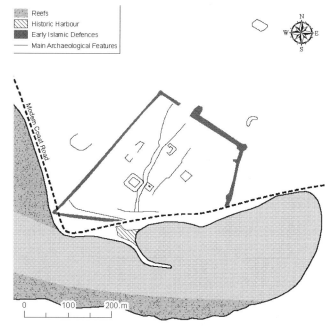

Plate 6 Plan of remains at al-Jar based on satellite imagery

structures visible on the surface as wall footings and mounds are probably largely Fatimid.

Historical sources suggest that al-Jar was the main terminus for the receipt of wheat shipments from Qulzum. Caliph 'Umar built large granaries there in the seventh century to contain and protect imported Egyptian grain.[13] It is possible to infer with some confidence that Egyptian and Maghribi pilgrims coming via Qulzum and 'Aidhab would have used al-Jar in the early years of the caliphate.

The same can be said of Jedda, also established by Caliph 'Uthman in the mid-seventh century. The location of the old town forms a close parallel with that of al-Jar, lying on the inner lagoon of a natural harbour (**Pl. 7**). Jedda's continuing importance as the main port of Mecca – and therefore of the pilgrimage – has meant that the port has seen constant renewal and redevelopment since this time, accelerated massively since World War II. However, there is little archaeological material published relating to the early development of the port, although the potential for important urban archaeology beneath the old town is clear. Certainly, its location has made it a key port for Hajj pilgrims since the earliest days of Islam.

High medieval period (868–1171)

With the removal of Abbasid rule and the establishment of the Tulunids in Cairo in 868, the Egyptian government began to focus on growing its own economy.[14] The Tulunids and then the Fatimids encouraged international trade and specifically Indian Ocean trade via the Red Sea, creating a boom in Egypt which is captured in the documents of the Geniza archive.[15] Fustat lay at the heart of the new trading system and was the principal terminal of the new Red Sea trade, while Qus became the chief city of Upper Egypt, replacing Aswan.[16]

While Egypt continued to supply the Hijaz with many staples via Qulzum, the political imperative to do so was much reduced in the high medieval period. Nevertheless, it continued to be a port of major regional and international

significance until its prosperity began to dwindle in the later tenth century, although its significance for the pilgrimage remained high. Nasir-i Khusraw sailed from Qulzum to al-Jar when he journeyed to the Hajj in both 1048 and 1049.[17] While inscriptional evidence indicates Tulunid and Fatimid development of pilgrimage infrastructure in Sinai and along the Hijazi coast,[18] it appears that it remained only partially effective. When the Fatimid sultan cancelled the overland Hajj in 1048, it was because of drought and famine in the Hijaz, a reflection of the relatively rudimentary nature of the supply system during this period.[19]

It was a severe blow to Qulzum in 1058 when the Sinai pilgrimage caravan was stopped as the result of regional conflict between the Fatimids and Seljuks.[20] The accessibility of the overland Sinai route was made yet more perilous with the establishment of the Crusader kingdoms to the north in

Plate 7 Annotated satellite image of Jedda

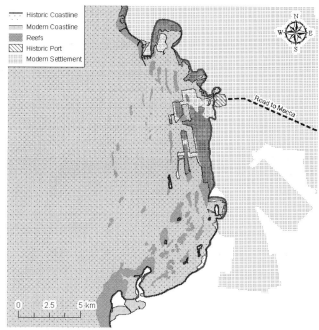

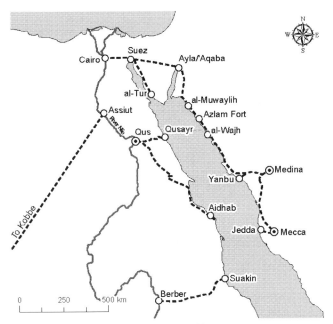

Plate 8 Ayyubid-Mamluk sites discussed in text

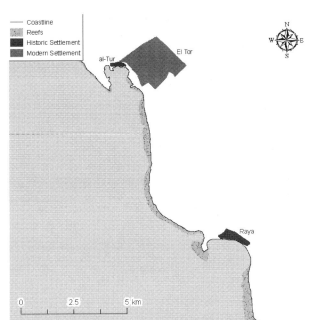

Plate 9 Annotated satellite image of al-Tur and al-Raya

the 12th century, compromising the Muslim control of the Gulf of ʿAqaba and the key ports in the Hijaz. The 200-year hiatus that resulted was a major watershed in the history of the Red Sea, permanently changing patterns of commerce and pilgrimage (**Table 1**). It was the beginning of a major period of decline for Qulzum, which would only end with the development of Suez under the Ottomans.

ʿAidhab

The first specific reference to pilgrims passing through ʿAidhab comes from al-Muqaddasi in the later tenth century. During the Fatimid hiatus, the cross-desert route to ʿAidhab followed by a crossing of the Red Sea to Jedda became the only reliable and relatively safe method for African pilgrims to reach the holy cities. It is telling that Nasir-i Khusraw chose to sail from ʿAidhab, reached via Aswan, to Jedda on his final Hajj in 1050.[21] He described ʿAidhab as comprising mostly of mud-huts with increasing numbers of masonry buildings. He complained severely of the conditions and the exploitation by the locals of the pilgrim traffic, advising travellers to avoid the port at all costs.[22] There are many references and descriptions of the pilgrimage via ʿAidhab from the 11th and 12th centuries, but perhaps the best-known, most informative and colourful account is that of Ibn Jubayr in 579/1183. Like Nasir-i Khusraw, he described ʿAidhab as a place where pilgrimage had become a key source of income as pilgrims were crowded onto dangerous boats which often never reached their destinations.[23]

Owing to its remote location, only superficial investigations have ever been carried out on the site generally identified as ʿAidhab which lies some 20km north-west of its modern successor Halaib (**Pl. 4**). These investigations have identified surface finds from the 8th to 14th centuries,[24] which is in accord with what we know of ʿAidhab, its size and general location. The core of the site comprises a series of mounds, a total of approximately 400m (north–south) x 350m across, marking the locations of former buildings. Some large individual buildings can be

identified within the settlement including a possible mosque (**Pl. 4**). The buildings are centred round a silted up former bay which opens out onto the sea but satellite imagery does not reveal any break in the reef. This has led to suggestions that the actual historic harbour of ʿAidhab may be at modern Halaib, although the layout of the town strongly indicates that it was a functioning port.[25] Cemeteries were discovered beyond the remains of the settlement as might be expected given the large numbers of pilgrims – not always in the prime of life – who passed through over the centuries. Noticeably absent is any indication of a fortification, a feature of contemporary ports and settlements on the Hijaz coast such as ʿAqaba, al-Hawr and al-Jar.

Al-Jar

Surveys and sondage excavations at al-Jar have revealed substantial traces of occupation from the Fatimid period, including substantial two-storey stone buildings with plastered walls and internal drainage, extending some 600m from the north shore of the inner lagoon (**Pl. 6**).[26] These observations can be supplemented by features visible on satellite imagery. At the centre of the site, beside the shore, is a fortified quadrilateral enclosure, approximately 260m x 290m, oriented south-west to north-east, reminiscent of the early Islamic fortifications of ʿAqaba to the north, which may date from the eighth century.[27] As at ʿAidhab, there are indications of a substantial monumental building, possibly the main mosque or a municipal granary, in the centre of this fortified area. ʿAli al-Ghabban noted traces of coral-built quay structures on the shoreline to the south of the defences with others seemingly visible on satellite imagery.

Ayyubid and Mamluk eras (1171–1517)

In Egypt under the Ayyubids, control over the Red Sea was definitively re-established with the capture of Jerusalem in 1186, permitting the overland pilgrimage to recommence.[28] Saladin established *awqaf* (sing. *waqf*, meaning 'endowment') in Upper Egypt to supply the holy cities with wheat consignments via ʿAidhab, requiring the Sharifs of the holy

cities to end their levies on pilgrims.[29] Critically, the Ayyubid and Mamluk eras saw the concentration of power in the Islamic world in Cairo, meaning that the Egyptian caravan received a level of political and economic support that it enjoyed at no other point in history.

When the Mamluk Sultan Baybars visited Mecca on the Hajj in 1268, it marked the fact that for the first time in 400 years the northern Red Sea and the holy cities were again under a single political administration (**Pl. 5**). As with the Umayyads and Abbasids, the Mamluks demonstrated their piety and authority through effective management of the pilgrimage. This included the establishment of the overland Hajj from Cairo in 1266 in a form which largely survived until the mid-19th century, supported by large subsidies of money and food supplies to the Sharif of Mecca as well as Bedouin tribes of the region. New stations, wells and cisterns were built along the pilgrimage routes at sites such as 'Ajroud, north-west of Suez, Nakhl, 'Aqaba and al-Azlam, near al-Wajh.[30]

The effect of these changes was slowly to reduce the numbers of pilgrims passing through 'Aidhab, although Ibn Battuta travelled along this route as late as 1348. His journey across the eastern desert started at Edfu, to the south of Qus, the Fatimid terminus of the desert route. It was only 10 years later that, according to al-Maqrizi, Indian and Yemeni ships stopped calling at 'Aidhab altogether, using Aden, Jedda or al-Tur instead.[31] The long cross-desert route had also become increasingly insecure owing to attacks from the Beja. The last reliable reference to 'Aidhab as an active port dates to 1390.[32]

Qusair increasingly took on 'Aidhab's regional role during the 13th and 14th centuries, both as a Hajj port and a conduit for the produce of Upper Egypt into the holy cities and the caravan stations. Indeed the Hajj via Qusair and Yanbu' seems to have become an institution in itself for many Upper Egyptians by the later 14th century, with descriptions of an annual caravan with its own *mahmal* setting out from Asyut.[33] Ultimately, however, Mamluk Qusair was also abandoned, because of insecurity along the desert routes. When Alfonso d'Alberquerque's Portuguese fleet reached the town in 1513 he described it as being in ruins.[34]

Al-Tur

In the late 14th century the port of al-Tur on the west side of the Sinai peninsula saw a sudden rise in trade, and inevitably in pilgrimage too, as merchants moved away from the increasingly expensive and dangerous eastern desert routes (**Pl. 9**).[35] The site is located three-quarters of the way down the western side of the Sinai. From the 6th until the 12th century the settlement was centred at the site of al-Raya. Excavations there by the Middle Eastern Culture Centre in Japan have revealed extensive remains of a fortified settlement and courtyard buildings similar in character to those of Ayyubid/Mamluk Qusair al-Qadim. Investigations at al-Tur to the north have revealed an extensive settlement dating from the 14th century.[36] Among many other discoveries, this work has identified significant numbers of *zamzamiyya*s, pilgrim flasks containing water from the well of Zamzam at Mecca, demonstrating the presence of pilgrims passing through the port.[37]

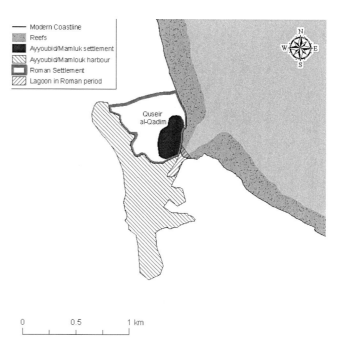

Plate 10 Annotated satellite image of Qusair al-Qadim

Qusair al-Qadim

The easing of the political threat from the north is likely to have had something to do with the founding of a medieval port at Qusair al-Qadim on the site of an earlier Roman port.[38] The site lies at the eastern end of the Wadi Hammamat, leading from Qus on the Luxor bend of the Nile to the Red Sea coast: the point in Upper Egypt where the river is closest to the sea. The Roman settlement lay on a ridge separating the lagoon, which served as its harbour, from the sea. By the time the port was re-established 1,000 years later, the lagoon had largely silted up, leaving a protected bay in which ships could moor or be drawn up on the beach (**Pl. 10**). Critically, the new port offered an outlet for the produce of Upper Egypt to the Hijaz. It seems likely that the consignments of wheat were destined not only for the holy cities but increasingly for the Hajj stations along the long overland trek.

Qusair lies well north of the ports of the holy cities. The shortest crossings were to ports and caravan stations such as al-Wajh, al-Azlam and al-Muwailih, which are located in the central part of the overland route and were key points of reprovisioning for the Hajj caravan. A fort was built during the reign of Sultan Qalawun at al-Azlam, which lay approximately half way along the Egyptian overland Hajj route in a particularly vulnerable and poorly watered section. It was rebuilt subsequently under al-Ghawri in 1511, who established a *waqf* to support it and specifically to ensure that pilgrims and the needy were provided with supplies, specifically flour.[39] The produce for this *waqf* is likely to have come from Upper Egypt and in all probability was transported via Qusair.

The excavations of the Islamic settlement at Qusair al-Qadim carried out by the University of Chicago and the University of Southampton identified few substantial structures on the site, where the unrelenting salt-laden north winds had reduced the largely mud-brick architecture to footings only. Most of the buildings identified were modest courtyard houses, many of which contained traces of craft

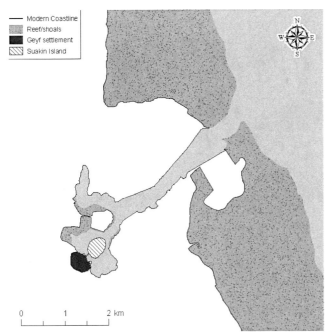

— Modern Coastline
░ Reef/shoals
■ Geyf settlement
▨ Suakin Island

0 1 2 km

Plate 11 Annotated satellite image of Suakin

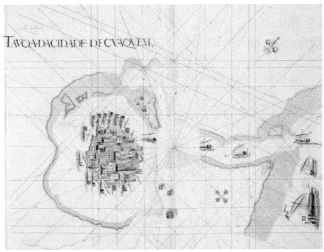

TAVOADACIDADE DE CVAQVEM.

Plate 12 Portuguese map of Suakin from the *Roteiro of Juan de Castro*, 1543, British Library, London (Cotton MS. Tiberius d.IX) (© The British Library Board)

activities of various kinds, although a possible caravanserai was identified to the west of the harbour.[40] This aside, no mosques or civic buildings (such as grain stores) have been identified yet. The exceptional preservation of organic remains on the site has meant that textiles and basketry as well as pottery and glass has been preserved, revealing much about trading patterns in the Red Sea at this time. Many hundreds of Arabic texts from the 'Sheikh's House' excavated by the American team in the 1970s have revealed a detailed picture of the life and business of a local trading family in the early 13th century under its patriarch, Sheikh Abu Mufarrij. The documents indicate that a substantial portion of the sheikh's trade related to the sale of Egyptian wheat to the Hijaz. They have also provided evidence for pilgrims undertaking the Hajj via Qusair in the early 13th century, documenting their attempts to buy grain, weapons and mounts to carry them back to the Nile.[41]

Suakin

As with the other ports and harbours described in this chapter, Suakin lies in a magnificent natural position: an island inside a large natural lagoon on the northern Sudanese coast (**Pl. 11**). Like Qusair, it is located adjacent to an eastward bend in the Nile from where, at Berber, routes run eastwards across the desert. It lies 375km south of 'Aidhab (approximately seven days sailing) and approximately 330km south-west of Jedda. Recent excavations on the island have revealed evidence of settlement dating back to at least the 11th century, while documentary evidence indicates that it was a significant trading port by the 12th century.[42] From the later 15th century onwards, as the Muslim population of Sudan and sub-Saharan Africa grew, Suakin increasingly became the pilgrim port of choice for large numbers of Hajj pilgrims.

One of the few descriptions of the early town is provided by Ibn Battuta who visited in 1332 and wrote that it had 'neither water nor cereal crops nor trees. Water is brought to it in boats, and it has large reservoirs for collecting

rainwater. The flesh of ostriches, gazelles and wild asses is to be had in it, and it has many goats together with milk and butter, which is exported to Mecca'.[43] This account of an informal settlement with relatively ephemeral architecture is supported by results from recent excavations in the centre of the island which have revealed evidence for what appears to be a *suq* with light wooden structures and extensive remains of food preparation. The first use of masonry architecture there does not occur until the 16th century.[44]

When Juan de Castro's Portuguese fleet reached Suakin in 1541, just after the end of Mamluk rule in Egypt, his description suggests that the port had developed considerably. He wrote: 'In this space there is not a foot of ground but what is taken up with houses; as that all the island is a city, and all the city an island…. The road for ships lies round about the city to the distance of a great crossbow-shot; having everywhere six or seven fathom of water, so that ships may cast anchor at pleasure, in a mud bottom.'[45] De Castro goes on to describe the arrangements for loading and unloading ships cargoes stating that they 'come up close to the shore quite around the city and may be laden by laying a plank from them to the merchant's warehouses to the doors of which the Galleys are fastened with their beaks stretching over the streets which serve as bridges'.[46] The Portuguese made a map during their visit which depicts a town comprising tightly packed stone, coral or mud-brick buildings, including at least one substantial mosque (**Pl. 12**). There is no suggestion, however, of the coral-limestone buildings with their projecting *rawshan*, wooden carved windows, that came to characterize the town in later years, marking it out as effectively a colonial offshoot of Jedda.

Hijazi ports

The first evidence for an active port at Yanbu' al-Bahr, to the north of the early medieval port of al-Jar, dates from the period when the Ayyubids were battling with the Rasulids of Yemen for control of the Hijaz. Al-Maqrizi records the existence of an Egyptian military garrison at Yanbu' between 1224 and 1233.[47] It is probably no coincidence that the earliest references to a port at Yanbu' are contemporary with the establishment of Ayyubid Qusair. It was a more

convenient destination for ships sailing from northern ports, such as Qusair, trying to reach the holy cities, than the early medieval port at al-Jar – an additional day's sailing to the south – whose prosperity and destiny seems to have been strongly connected to that of 'Aidhab. The historical town, which has yet to be studied or documented in any detail, lies on the north side of a lagoon 435km from Qusair and 175km in a direct line west of Medina (**Pl. 13**).

Yanbu' appears to have been the main point of disembarkation for pilgrims travelling from Qusair. The town's development as a significant pilgrimage port continued under the Mamluks as the destination of the annual Upper Egyptian Hajj caravan coming from Asyut via Qusair. The rise of Yanbu' ran parallel with the decline and abandonment of al-Jar which was no longer mentioned as a destination from this period onwards. Jedda continued to be the most important destination for pilgrims and was provided with a substantial fortification wall in the early 16th century to protect the city from Portuguese attacks.

Ottoman era (1517–1798)

The attempts by Portuguese fleets to gain control of the Red Sea in the early 16th century – including an assault on Jedda – were an important stimulus for a programme of militarization of many ports and coastal settlements in the Ottoman period. One result of this was a major project of fortification along the Egyptian and Syrian Hajj overland routes. The Egyptian Treasury's salary book lists pilgrim fortresses whose garrisons it funded from the later 16th century onwards, including al-Tur, 'Aqaba, al-Muwailih, al-Azlam, al-Wajh, Yanbu' and Jedda (**Pl. 8**).[48]

Qusair

A letter of permission (*firman*) issued by Selim II in 1571 ordered the construction of a fort at Ottoman Qusair, as distinct from Ayyubid/Mamluk Qusair al-Qadim 6.5km to the north (**Pls 14, 15**). It states that the port supplied the annual provision to the holy cities but the population had fled owing to raids by local Bedouin tribesmen. It adds 'that it would be impossible to bring back one person unless a fort for defence against disorder makers will be built'.[49] The commitment of substantial resources to the building of a fortress in such a remote location demonstrates above all the importance of delivering Egyptian wheat to the Hijaz in a time when the number of pilgrims was growing ever larger. At times during the Ottoman period, Qusair was the designated port of departure for the *dashir*: the food consignments to the holy cities and the Hajj stations provided by Egypt's rulers as part of their annual tribute to the Porte (Ottoman government). In the early 19th century this amounted to 180,000 *ardeb* (approximately 38,000 metric tons) of supplies, predominantly wheat, barley, lentils, oil and biscuits.[50]

The seeming isolation of the fort at Qusair may be illusory given that a Red Sea crossing was often quicker than a desert crossing to the Nile. Two substantial new forts were built on the Hijazi coast at approximately the same time as that in Qusair: a large fort at al-Muwailih completed in 1560, and a smaller fort at Zurayb 10km inland from al-Wajh completed in 1603 (**Pl. 8**). The latter, in particular, bears a

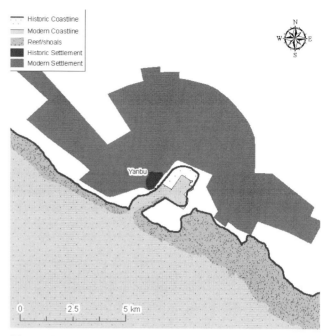

Plate 13 Annotated satellite image of Yanbu'

striking resemblance to the fort at Qusair from its ground plan to its architectural detail.[51] It is clear that these two substantial new military bases and the one on Qusair were part of a single strategic vision related to the protection and supply of the pilgrimage across the Red Sea.

C.B. Klunzinger, writing in the mid-19th century, notes that the insecurity of the region meant that in the first century or so after the fort was built the harbour was still too dangerous to allow permanent settlement with large pilgrim caravans being the main traffic. Merchants apparently attached themselves to these caravans for security, demonstrating that trade could follow pilgrimage as well as the other way round.[52] The wide diaspora represented by the pilgrims of the Ottoman period is reflected in the dedications of the historic mosques especially the one in Qusair

Plate 14 1:2,500 Survey of Egypt map of Qusair, 1931

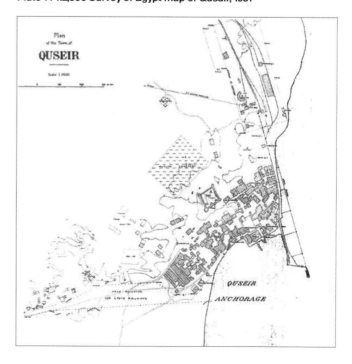

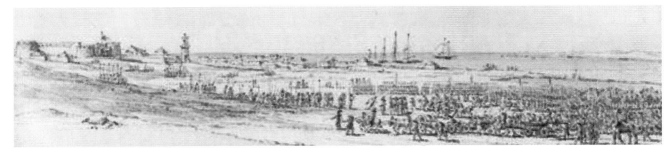

Plate 15 View of Qusair from the *Description de l'Egypte*

dedicated to holy men from Saudi Arabia, Somalia, Yemen, Tikrur (a term covering Darfur, Kordofan, west and central Africa), Morocco and India.[53] John Lewis Burckhardt, describing a voyage along the Sudanese Hajj route in 1814, described its frequent use by 'Takruri' pilgrims from Darfur and points west of the Darb al-Arbain across the western desert to Asyut and thence via Qusair to Mecca.[54]

By the early 19th century, in the final decades before steam and the railways brought an end to the traditional Hajj journeys, 30,000 pilgrims per year were passing through the port. More returned through Qusair than departed from it, presumably a reflection of the fact that a significant number of pilgrims who had taken the overland route from Cairo chose to take the quicker maritime route when returning home. In describing the significant numbers of pilgrims in the mid-19th century, Klunzinger evoked the international character of Red Sea Hajj ports through the ages. The greater number comprised Upper Egyptians, travelling with their families, as well as Takruri and Maghribis. Smaller numbers from more distant places are also listed including Turks, Daghestanis, Bukharans, Persians, Syrians, Iraqis and Indians. He describes large numbers of destitute pilgrims, dependent on government handouts of bread, packed into small boats carrying 80–120 people. Many traded small items they had acquired in the Hijaz to fund their journeys including 'weapons, books, perfumed woods, pieces of black coral, and rosaries made of it or aloes wood, leathern and metal vessels filled with water from the famous Zemzem well, sheets of pictures giving views of the holy places, packets of sacred earth from Meccah or Medinah, dates from the tomb of the Prophet, toothpicks and other relics'.[55]

Suez

Suez rose to prominence during Ottoman rule once more after a long period of semi-abandonment during much of the Mamluk period. It formed the main base for the Ottoman navy tasked with preventing Portuguese incursions into the Red Sea. Increasingly it became Egypt's principal Red Sea port, taking this role over from Qusair, encouraged by customs regulations which required many of the most important categories of imported goods to pass through Suez.[56] In the 17th century it took over the role as the designated port of departure of wheat for the holy cities, although this did briefly revert to Qusair in the early 19th century.[57] Large numbers of pilgrims also opted to take the increasingly secure sea route via Suez and al-Tur. Karsten Niebuhr provides a vivid account of this journey in 1761, describing the crowded conditions and uncertain sea

journeys. His ship's first stop was at al-Tur, where the pilot for the journey to Jedda was collected, then Yanbu' and finally Jedda.[58] The arrival of steamships and then the railway connecting it to Cairo in the 1860s made Suez the key Red Sea port of departure for the great majority of Egyptian and North African pilgrims.

Suakin

The late 15th and early 16th centuries saw the conquest of the remaining Christian kingdoms of central Sudan which were replaced by Islamic sultanates such as the Funj, who briefly annexed Suakin in the early 16th century only to be ejected by the Ottomans in 1517, although control of the port continued to be disputed until the 17th century. Under the Ottomans, Suakin became an important administrative and military base, as well as a major commercial port. Recent excavations on the island have identified widespread evidence of building activity from the 16th century onwards, although many of the famous coral limestone buildings on the island date to the 19th century.[59]

Like Ottoman Qusair, Suakin gradually declined as a commercial port in the 17th and 18th centuries. On the other hand its significance as a pilgrimage port steadily increased throughout the Ottoman period, given that it was the gateway to the holy cities for northern and central Sudan as well as many of the Muslims of sub-Saharan Africa. The port was governed from Jedda for much of this period, reflecting its strong historical and cultural connections with the Hijaz.[60] When Burckhardt visited in 1814, he described the island town as being 'built in the same manner as Jedda', a reflection of its strong political, social and economic ties with that port. This is contrasted with the indigenous straw huts of the 'Gayf', the mainland settlement beside Suakin. He also described substantial numbers of Takruri pilgrims, largely without possessions, gathering in the port for months before the Hajj.[61]

Hijazi ports

The motivation of defeating the Portuguese in the first half of the 16th century and an absolute commitment to the protection of the pilgrimage led to the construction of town walls and forts/citadels protecting the major ports of al-Wajh, Yanbu' and Jedda in the 16th and 17th centuries.[62] These destinations continued to be the key ports of arrival for pilgrims taking the sea route from the western side of the Red Sea via al-Tur, Qusair and Suakin until the later 19th century. The surviving old towns of these ports show in their layouts and architecture strong similarities to western Red Sea ports such as Qusair and Suakin. This reflects the strong

cultural as well as economic and political bonds that connected these ports during the Ottoman administration, when this style of distinctive 'Red Sea architecture' appears to have developed.[63]

Conclusion

A number of broader themes stand out from this survey of maritime Hajj routes in the Red Sea. A basic division can be distinguished between the Hajj ports of the Hijaz and those on the African coast. The Hijazi ports, serving the fixed points of Mecca and Medina, became much more substantial than those on the opposite shore, having more developed political administrations, fortification and harbour infrastructure. By contrast, the ports of the western shore were always subject to the winds of political change in their hinterlands and were therefore neither as deeply rooted nor as well provided with infrastructure as their Hijazi counterparts. Neither 'Aidhab nor Qusair al-Qadim were provided with town walls or, as far as we know, formal quays or harbour facilities. This is perhaps a reflection of the fact that, in terms of the pilgrimage at least, the western Red Sea ports were essentially subsidiary, servicing the ports of the Hijaz.

The role of the strong prevailing north winds, which blow with particular strength in the summer, has also played an important factor in relationships between the two coasts.[64] The pilgrimage destinations of the east coast – al-Jar, Yanbu' and Jedda – formed a relatively quick journey from both Qulzum and Qusair. Similarly, Suakin was an easy journey from Jedda, surely an important factor in its development as effectively a colonial offshoot from the Hijaz.

A key aspect of this relationship between the two sides of the Red Sea under Islam until the later 19th century was Egypt's role as the key provider of food to the holy cities of Mecca and Medina and the lesser settlements of the Hijaz. As described above, this was evident from the earliest period of Islamic rule, with accounts of large consignments of wheat being transported across the sea via Qulzum and al-Jar. However, the link of these supplies to the pilgrimage is not explicit at this stage. The cancellation of the overland Hajj under the Fatimids in 1048 as a result of a lack of supplies suggests that the arrangements remained largely ad hoc up until as late as the 11th century. The development of the infrastructure of the Egyptian pilgrimage – and of the regular *dachir* subsidies to the holy cities to back it up – took a step change with the concentration of power in Cairo under Saladin and the Mamluk sultans after him. These arrangements largely survived the shift of power to Istanbul under the Ottomans, who made significant investments in order to assure the annual delivery of the *dachir* through the construction of fortifications on both sides of Red Sea.[65]

Thus it can be seen that the ports of the Red Sea were crucial in providing logistical support for the pilgrimage, as well as for the journey itself. It has undoubtedly left a trace in the archaeological record that has still only been partially explored or documented. This potentially comprises mosques, warehouses, customs facilities, texts, caravanserai, shops, merchants' houses and workshops, not to mention the rich artefact records. The cemeteries perhaps offer the greatest potential for understanding the development of the pilgrimage and its effect on the wider world; aided by the desert conditions of preservations, modern techniques have the possibility to tell us about the origin, age, gender, diet and medical histories of pilgrims from all periods.

Notes

1 Power 2010: 331–6.
2 Ghabban 2011: 29.
3 Cooper 2009: 197–8; Sheehan 2010: 35–54.
4 Torrey 1922: 162–3.
5 Cooper 2009: 198.
6 Bruyère 1966.
7 Ibn Hawqal 1975: 152.
8 Power 2010: 154–5.
9 Power 2010: 215.
10 Cooper 2010: 178.
11 Power 2010: 341.
12 Ghabban 2011: 231–41.
13 Power 2010: 160–1.
14 Power 2010: 345–7.
15 Goitein 1967.
16 Garcin 1976.
17 Thackston 1986: 77.
18 Ghabban 2011: 30–3.
19 Peters 1994a: 89.
20 Cooper 2008: 181.
21 Thackston 1986: 87.
22 Peters 1994a: 92.
23 Vantini 1975: 296–7.
24 Harden 1955; Kawatoko 1993.
25 Peacock and Peacock 2008: 39–42.
26 Whalen *et al.* 1981: 52; Ghabban 2011: 219–31.
27 Power 2010: 167–8.
28 Mouton *et al.* 1996: 42; Garcin 1976: 136.
29 Garcin 1976: 134.
30 Ghabban 2011: 41–2. See Sami Saleh 'Abd al-Malik in this volume.
31 Cooper 2008: 183.
32 Garcin 1976: 420.
33 Garcin 1976, 418
34 Le Quesne 2007: 30–1.
35 Garcin 1976: 400.
36 Kawatoko 1995, 1996, 1998, 2003 and 2005.
37 Kawatoko 2005: 854.
38 Whitcomb and Johnson 1979, 1980; Peacock and Blue 2006, 2011.
39 Ghabban 2011: 187–8.
40 Peacock and Blue 2006: 103.
41 Burke 2007: 235; Guo 2004: 28.
42 Breen *et al.* 2011: 207.
43 Gibb 1929: 104.
44 Breen *et al.* 2011: 215.
45 Bloss 1936: 290.
46 Bloss 1936: 290.
47 Garcin 1976: 135.
48 Shaw 1962: 250.
49 Le Quesne 2007: 33.
50 Klunzinger 1878: 272.
51 Ghabban 2011: 191.
52 Klunzinger 1878: 271.
53 Al-Zeini 1982.
54 Peters 1994a: 97.
55 Klunzinger 1878: 273, 318–27.
56 Shaw 1962: 104.
57 Tuscherer 1994; Shaw 1962: 258–71.
58 Peters 1994a: 184.
59 Breen *et al.* 2011.
60 Greenlaw 1995; Mallinson *et al.* 2009; Um 2012.
61 Peters 1994a: 192–3.
62 Ghabban 2011.
63 Um 2012.
64 Facey 2004.
65 Tuscherer 1994.

Chapter 11
Ships that Sailed the Red Sea in Medieval and Early Modern Islam
Perception and Reception

Dionisius A. Agius

'Guide us O Allah, and deliver us from the hands of the evildoers, and grant us a fair wind'.[1]

Introduction

Knowledge on sea transport in medieval Islam comes from different genres of written Arabic sources, notably history, geography and travel literature, with a number of authors themselves eyewitnesses to such events. These sources were written primarily for the use of the Islamic caliphate and governors, but they would also have been received by the educated few. Much of this information was memorized and subsequently conveyed to the mass of the people through oral recounts in *suq*s (markets), stopping places and at caravanserais.

This chapter investigates how much information can be extracted from primary Arabic sources as to the types of watercraft which merchants and pilgrims embarked upon, their stability and seaworthiness. What can we deduce about sea voyages from the sparse evidence we can glean from the medieval texts? A key focus of the present inquiry is to establish the way in which medieval Muslim authors and artists perceived the maritime space, the sea pilgrimage and related mercantile activity; who their perceived audience were; and how they obtained their information.

At the outset of this chapter, it needs to be said that the subject of medieval Red Sea watercraft and those connected with trade and pilgrimage in the western Indian Ocean in Arabic primary sources has not hitherto been covered, and it is the intention here to fill that gap in spite of the fact that medieval Arabic narratives are only too often wanting in clarity and detail.

I will not be dealing with pilgrim ships as such because they performed this function only once every lunar year and so for most of the year ships had many functions, including the transportation of people, merchandise, ammunition and animals, while others were used for fishing, pearl diving and piracy. There were ships that ferried pilgrims and therefore it is correct to call them 'pilgrim ships', but this was not their sole function, which was that of cargo vessels.

The Red Sea was for many centuries an important commercial corridor that linked the western Indian Ocean with the Mediterranean, and hence the coastal towns of both the African and Arabian Red Sea played a significant role in the trade that went across the seas and the countries adjacent to them.

Jedda, at the advent of Islam, was to become an important Islamic port for the many pilgrims sailing to it from the east or west. It was one of the most important port towns in medieval Islam for merchants and pilgrims from the African coast, India and Southeast Asia, and was first and foremost a trading port. Although Jedda is often referred to as being the gateway to Mecca, it could never have claimed to be a pilgrim port as this was only during the Hajj season, and this moved every year according to the lunar calendar while trade followed the solar calendar and was all year round.

In this chapter, I will argue that although the narratives are frustratingly short on detail concerning maritime and nautical matters, they were perfectly understood by some of the receptive audience who were familiar with the landscape

and seascape of the time and did not require such information. This does not mean that they are not rewarding; for the modern reader, the interpretation of these texts is a challenge, but, taken together with other supporting archaeological and iconographical evidence, we can gain a better perspective and understanding from them of the maritime past.

The Red Sea

The Red Sea was known by its medieval name as *Bahr al-Qulzum* (The Sea of Qulzum). Other names given to it by Arabic authors were *Bahr al-Hijaz* (The Sea of the Hijaz) and *al-Khalij al-'Arabi* (The Arabian Gulf) (**Pl. 1**).[2] There are several inlets (*sherms*) leading to its harbours (*khors*): a survey conducted by British Naval Intelligence in the early 1940s recorded 60 inlets which were identified as 'true sherm-formation',[3] many of which had a deep channel. The sea is hazardous because of the numerous rocks, corals and submerged islands, and a sailing craft taking advantage of the land breeze risked being dashed to pieces. Because of these perils, one way of avoiding them was for the sea captain to sit in the crow's nest, according to the geographer al-Muqaddasi (*fl.* second half of the tenth century), guiding the helmsman to navigate right or left by pulling the two ropes of the steering rudder.[4] Another method mentioned by medieval and early modern authors was for a mariner to stand at the stem post to assist the helmsman in avoiding the submerged rocks and corals. Because of these difficulties of navigating into shallow waters, ships operated by day only and at night were anchored at a safe shelter.

But the principal danger in the northern region is the prevalence of the north wind: 'This sea … is subject to very thick fogs, and to violent gales of wind',[5] reports Abu Zayd, a Sirafi merchant in the tenth century, and his contemporary al-Muqaddasi describes the northern winds as 'overpowering', causing many ships to founder.[6]

The north–south direction was safer and shorter. The pilot would in all probability sail close to the shore and anchor at night, while sailing up the Red Sea against the prevailing wind was difficult and longer. The downwards journey from Suez to Jedda, starting at the end of February, would have taken ships 10 to 20 days, depending on favourable winds and stops. But the journey from Jedda to Suez, which would have begun around mid-March, took up to three months,[7] allowing for the time these ships had to remain anchored in the harbour because of strong winds. Progress would have been slow because of the buffeting the vessels would endure to reach their destination. The larger ships, if caught in these winds, could have encountered difficulties in finding a safe anchorage.

The journey to Mecca (which could take from three months to a year) for the majority of medieval and post-medieval pilgrims was a once in a lifetime experience, and a memory that was cherished for many years in spite of the difficulties they might have encountered. Caravan pilgrims travelled through the desert under scorching sun and desert winds, and were very often subjected to the raiding Bedouin who looted their possessions or demanded 'protection money' in return for water and safe passage.[8] As for the sea pilgrims, they experienced discomfort in the form of

Plate 1 A tenth-century map by Ibn Hawqal showing the Red Sea and the names of the main ports (depicted as a tail connected to the wider Indian Ocean) (after Ibn Hawqal 1992, 50)

exposure to sun, damp nights, winds and high waves, as well as pirates who took away their money and precious belongings. The long-distance seafarers coming from Southeast Asia or India would have had to pay tax (as *zakat* 'almsgiving') at the port of call.[9]

Comfort depended on the pilgrim's wealth: the rich rode the camel and the poor walked; the rich seafaring pilgrim had the luxury of being in the company of the sea captain or ship owner, and boatswain, sleeping on the poop deck, while the poor would sleep on top of the merchandise or, if they were unlucky, would lie somewhere in the hold of the ship sharing space with sheep, goats or camels. Many pilgrims, whether travelling on land or sea, died en route; the caravan pilgrim was at risk from thirst or sunstroke while the seafaring pilgrim could also suffer from lack of water, but there was also the threat of dysentery or other disease due to poor sanitation. The latter, together with the smell of vomit and rats running all over the place, must have made the sea experience unpleasant to say the least. But the most feared catastrophe was the threat of shipwreck, which few would survive, as many did not know how to swim.

Pilgrims travelling from the Maghrib, sub-Sahara and Egypt combined the caravan route with a sea crossing, whereas those from the Levant and Asia traversed the desert, meeting in Baghdad and hence travelled across the desert to Mecca. Those who gathered in Damascus proceeded either through 'Aqaba (formerly Ayla) or down the Hijaz to a sea port or across the desert to their final destination. From India, Java, Sumatra and beyond, they would have voyaged by sea to Jedda. Their *junks* would put

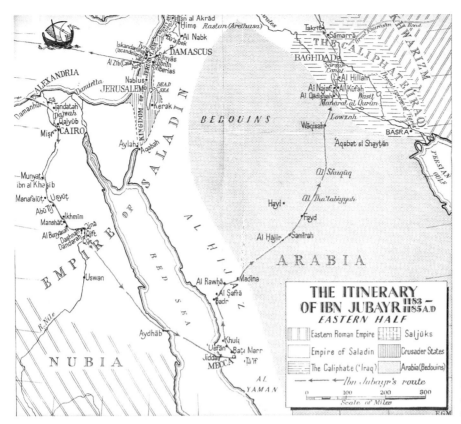

Plate 2 Ibn Jubayr's journey showing the Alexandria–Qus–'Aidhab route (after Ibn Jubayr 1952: 30)

in at Calicut (Malabar), Surat and Diu (Gujarat), the chief pilgrim ports. Only during the sailing season, when the winds are south-easterly, did the merchant-pilgrim ships go directly to Jedda, otherwise they stopped at Aden to be guided by able pilots to Jedda. We have a full-scale description of this route by Safi ibn Vali (*fl.* 17th century) in a treatise entitled *Anis al-hujjaj* (A Pilgrim's Companion), who records his sea pilgrim voyage, which lasted about twenty-five days, from Surat or Diu to Mocha and Jedda *c.* 1677–80.[10]

Alexandria was the port for seafarers from al-Andalus, Sicily and North Africa. The Andalusian traveller Ibn Jubayr (d. 1217) came via this route in 1183, giving a detailed report of his journey with his companion Abu Ja'far Ahmad ibn Hasan, a physician from Granada.[11] They sailed up the River Nile from Alexandria to Cairo and from there they went to Qus on the River Nile, and then through the desert to 'Aidhab,[12] a journey which took them almost four months (**Pl. 2**). There was an alternative land and river-lake route from Alexandria to the Red Sea via Tinnis, from where the pilgrims travelled to Suez and then sailed close to the Hijazi coast to Yanbu' al-Bahr.[13] The Persian traveller Nasir-i Khusraw (d. *c.* 1077) took this route in 1048, from Suez to al-Jar, not far from Yanbu' al-Bahr and it took him 15 days.[14] When he performed the second pilgrimage the following year he went via the 'Aidhab route which Ibn Jubayr and his companion followed.[15]

The Arabian coast had several anchorages.[16] Al-Jar was a well-known pre-Islamic harbour which was used by 'ships from Qulzum and Yemen',[17] a reference which implied that these might be ships of the Red Sea. They carried pilgrims to al-Jar, from where these pilgrims followed the caravan route to Mecca or Medina.[18] Al-Ya'qubi (d. *c.* 278/891–2) notes that among the ships that

anchored at al-Jar were those that transported food (probably corn) from Egypt.[19]

The new Qus–'Aidhab route mentioned earlier, which Ibn Jubayr and his companion undertook, first came into use in the ninth century and was a distinct improvement on those that entailed a longer period at sea where the north-westerly winds made the voyage difficult. As noted above Abu Zayd had remarked on the frequent storms experienced in the northern region,[20] while his contemporary, al-Muqaddasi, warned of the dangers of this sea where ships were tossed by the waves or sunk to the bottom of the sea.[21] A second reason for the change of route could have been because of piracy,[22] as Abu Zayd's narrative tells that 'merchants and ships … are often plundered [in this sea]'.[23]

For the Maghribi or Mediterranean merchants, this new Qus–'Aidhab route brought in more financial gains. They could sell and buy merchandise at Fustat – Old Cairo, Qus, 'Aidhab and Jedda. With the Fatimid conquest of Egypt in July 909, trade flourished in Egypt as a result of a demand for oriental exports that came from India via the Red Sea. Al-Ya'qubi reported how 'Aidhab was ideally placed to take advantage of the exchange of spice and luxury goods from the Yemen (that came from India), as well as African gold and ivory.[24] Egypt was also well positioned in this transit trade as many of the oriental goods were taxed and shipped from there to the Mediterranean and Europe, thus contributing to the country's prosperity.[25]

The 'Aidhab desert-crossing would have been safer than being at sea but not free from the dangers of Bedouin raids or lack of water. And when water was available, Ibn Jubayr writes from his experience, it was 'brackish'; moreover, the traveller had to endure the intense heat and the unbearable 'flaming air'.[26] In these conditions many pilgrims perished in the desert and died of thirst.[27] But the desert-crossing was not

the end of the pilgrim journey, the ferry ride from 'Aidhab to Jedda had its calamities as the ferry-*jalbas* that carried pilgrims were often overcrowded and, therefore, were prone to capsize in rough weather, so many lost their lives.[28] These calamities, together with the high taxation of pilgrims,[29] could have brought an end to the 'Aidhab route in the 13th century, which was replaced by a newer port in the north, Qusair al-Qadim, on the Egyptian coast which was to be used during the late Ayyubid and early Mamluk period. A thousand years earlier this was the Roman port of Myos Hormos.[30] For the Egyptian and Maghribi medieval travellers, Qusair al-Qadim became the preferred merchant-pilgrim port because it was a five-day journey through the desert to Qus, approximately 100km, and, in spite of the north winds, it entailed a short sea crossing to al-Wajh or Yanbu' al-Bahr on the Arabian coast (**Pl. 3**).[31]

Ships that sailed the Red Sea

The Red Sea, as we have seen, was never a safe sea. So the question is how far did the hazardous coastal landscape affect the design of the watercraft built in this region? And did weather conditions dictate the size and the design of the ships that sailed the Red Sea?

A word on the terminology applied by the primary Arabic sources for types of ships and boats would be useful here. Broadly speaking, the term *markab* (plural *marakib*), is used as a generic word that signifies 'something that one embarks upon', from the verb *rakiba*,[32] the trilateral radicals being traced to an old Semitic root, ultimately to the Ugaritic-Canaanite *markabu*.[33] The term is a common application, and one finds, though uncommon, *markab* compounded with an adjective to mean an ocean-going ship, such as *markab bahri* or *markab safari*.[34] It is in this context that the tenth-century sea captain Buzurg ibn Shahriyar (d. 1009) applies this term to describe a ship that sailed as far as the seas of China.[35] The word is also compounded with a noun or adjective to describe different functions related to trade, pilgrimage, transport and war: *marakib hammala* (cargo ships), *marakib al-tujjar* (merchant ships), *marakib al-hujjaj* (pilgrim ships), *marakib harbiyya* (war ships) and *marakib mu'tadda* (equipment ships).[36] All these compounds imply how widely the term was spread, as is the generic term *safina*, although it was only remotely used in the Red Sea context.[37]

Furthermore, the plural term *marakib* is compounded with the name of a region: *marakib Qulzum* (ships of Qulzum), *marakib al-Hijaz* (ships of Hijaz), *marakib al-Yaman* (ships of Yemen), *marakib Siraf* (ships of Siraf) and *marakib al-Hind* (ships of India). The question arises: what significance is there in referring to ships of a particular region? For example, what is the difference between 'ships of Qulzum', or 'ships of the Hijaz' and so forth? Is this a reference to the size and design of the ship? Or did ships, affiliated to a region, signify an identity for commercial and pilgrimage reasons, thus implying that they operated in such and such an area? To the modern reader this labelling is not understood, but it would have been clearly identified by a medieval audience.

First, it must be said that large vessels in the Red Sea could only anchor far out from the coral reef. Consider the channel leading to Jedda harbour; both sides are full of reefs,[38] and the entrance was negotiated by coastal boats

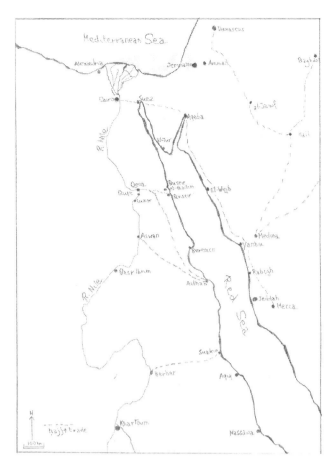

Plate 3 Hajj routes by sea (drawing D.A. Agius)

operated by skilful mariners who could steer them in shallow waters in and around the coral reef and rocks, through the narrow channels, transferring passengers and their goods to and from larger ships anchored out at sea. This was common practice at all Red Sea ports and it was the function of the *jawniyya*, light vessels at 'Aidhab,[39] and the small *sanbuqs* which guided the Portuguese *caravels*.[40]

But there was another danger that large ships faced in the form of the northerly prevailing winds. The 'ships of Siraf', wrote the Persian merchant Abu Zayd, had to 'put into Jedda' where they stayed,[41] because, he asserts, they 'dare not attempt' to sail the north of the Red Sea.[42] What he is saying here is that these ships, being large, could not cope with the coastal landscape let alone the treacherous winds of the north. So when sources refer to the 'ships of India' or the 'ships of Siraf', the medieval audience would understand that they were large ocean-going vessels. On the other hand, when there was mention of the 'ships of Qulzum' or the 'ships of the Hijaz' the audience would know that these were small or medium ships of the Red Sea, designed to cope with the corals and rocks, and find their way between the wide cracks or canals that existed between the reefs.

Exposed to northerly winds, Red Sea vessels had their hulls designed to perform well windward and they would have had a shallow draft; the *jalba* described by Ibn Jubayr at 'Aidhab would have been of this design. One other vessel, the *sanbuq*, of similar type, was mentioned by Ibn Battuta (d. 1377) and the Egyptian historian al-Maqrizi (d. 1442).[43] As noted by the Italian traveller Ludovico di Varthema (*fl.* 16th century), it was 'flat-bottomed',[44] an interesting feature not mentioned elsewhere; though it is possible that, unlike the

term *jalba*, the name *sanbuq* had more of a generic usage, and it could, therefore, apply to different designs and functions in the region, and more broadly in the western Indian Ocean.

The hold of these ships, we are told, was deep enough to accommodate camels as well as cargo. There must have been sufficient space for these camels but undoubtedly their presence would have been resented by some people. To this effect, Ibn Battuta recounts that he was invited by the Sharif of Mecca, Mansur ibn Abi Numayy (r. 1254–1301), to accompany him on a trip from Jedda bound for the East African coast, but seeing the camels on board ship, he said, 'I was frightened of this'. There was another reason, however, for his fear; he had never embarked on a ship before.[45] There must have been many such people who had taken to the sea for the first time in their life, and just the thought of sailing on a ship, must have worried them for weeks or months beforehand. Transport of camels by sea was common during the Hajj season, as it was until recent times. One of my Qusairi sources from al-Jabbara remembered his father telling him that some pilgrims preferred to take their camels on board ships rather than hiring them on the other side of the crossing as this could be more expensive.[46]

When it comes to accounts from European sources they also sometimes refer to the ships of Yemen, India and Siraf as being large. As explained earlier, some of them could only anchor at a distance outside the Red Sea ports because of the coral reef, and also the danger of being exposed to strong and violent winds made it difficult to find a safe haven. The Portuguese historian Fernão Lopes De Castanheda (d. 1559) describes these vessels in one word: 'huge'.[47] One English source, Samuel Purchas (d. 1626) reported in 1613 that an Indian 'pilgrim' ship bound for Jedda was 153 feet long, a second pilgrim ship was 136 feet long, 41 feet wide and 29.5 feet deep while the main mast measured 132 feet.[48] Another Englishman, William Daniel (*fl.* late 17th and early 18th century), embarked on a Yemeni sewn ship, and he remarked that it was 'one of the largest vessels (1400 bails)', he had ever seen.[49]

Many of these Indian ships were carrying merchants and pilgrims during the Hajj season. There would have been those who voyaged on Sumatran and Javanese *junk*s from Banda Aceh in Indonesia and other South Asian ports before boarding an Indian ship bound for the Red Sea.

Building the Red Sea craft

The medieval Arabic sources are vague about the size of watercraft, though some information is available about their function and what material they were constructed with. These sources, however, tell us very little about ship-building activity in the western Indian Ocean let alone in the Red Sea. Interestingly, there is mention of ships being built in Old Cairo or Asqalon in Syria, then dismantled and carried on camelback, and finally reassembled at a Red Sea anchorage.[50]

It is possible that some of the so-called 'ships of Yemen' were not built on the Yemeni Tihama coast, as it would be expected, but on the western Indian coast. One reason for coming to this conclusion was that Calicut had ship building

yards, and boat builders from the Yemen or Aden (and for that matter those of the African Red Sea coast) would in all probability have preferred to construct their ships there as timber and building material were not available in the Red Sea.[51] This may well have been the case, as even in recent times, boat builders in the Gulf and Oman, and the Red Sea have found importing timber difficult because of enormous costs imposed by the suppliers on the western Indian coast.[52] As for smaller craft, boat building would have taken place in sites such as 'Aidhab, as Ibn Jubayr informs us, although he claims that timber – probably teak – was imported from India.[53]

These craft were sewn-planked,[54] and while information in the classical and medieval Arabic literature is sparse concerning this subject, we are told that the material used for fastening planks was coir. This method is well known in the Indian Ocean, and coir was available in great quantities from the Maldives or the Indian coast. Iron nails must have been used in the Indian Ocean, and the Islamic sources report that this was practised in the Mediterranean too.[55] As for the Red Sea, Ibn Jubayr writes that no nailed-ships 'sail through',[56] and there was a very good reason for this, as Ibn Battuta asserts a century and a half later, 'if a ship is nailed with iron nails, it breaks on striking the rocks, whereas if it is sewn together with cords, it is given a certain resilience and does not fall to pieces'.[57] This was the belief at the time and such was its success that the practice lasted for many centuries right up to recent times, particularly in India.[58]

Ibn Jubayr gives a description of a sewn-planked boat called *jalba*; although a cargo ship, it functioned as a pilgrim ferry boat between 'Aidhab and Jedda. The planks of this boat were sewn with a coconut cord called *qinbar*; boat makers 'thrash [the fibre] until it takes the form of thread, which then they twist into a cord, and caulking is applied by using the shavings of the palm-tree. Then the ships' sewn planks were smeared with shark's (liver) oil (in his words the 'best'), and this was essential because it helped 'to soften and supple it against the many reefs that are met with in that sea (i.e. the Red Sea)'.[59] He also tells us that the sails were made from (date) palm-leaves.[60]

Evidence of sewn-planking of Arabian, Persian and Indian ships is shown in a 13th-century depiction from the *Maqamat* (The Assemblies) of Hariri (d. 1122) painted by al-Wasiti in 1237. A large amount of cord would have been used on these craft, and for a western observer, who was not used to this technique, seeing one such ship would have appeared extraordinary.

Sewn ships were obviously suited to the coastal conditions of the Red Sea, but what was the situation in the Indian Ocean? Archaeological evidence shows iron fastenings were already in place probably as early as the 13th century, but definitely by the 15th. Consider the discovery of the Kadakkarappally flat-bottomed iron-fastened boat on the Malabarian coast (**Pl. 4**).[61]

The Portuguese sources comment about the use of nails on Indian ships in the 16th century. Gaspar Correia (d. 1563), the chronicler of Vasco de Gama's (d. 1524) voyages, claims to have seen broad-headed nails used on Indian ships at the East African port of Melinde, and at Cannanore, north-west

of India.[62] At the ship building site in Calicut, Ludovico di Varthema, in the same century, witnessed quantities of nails ready for use on ships' planks.[63] This gives the impression that India was producing only iron-fastened planked vessels, but this would be wrong. It is a mixed picture of sewn-fastened ships being built simultaneously with iron-planked craft. Fernão Lopes de Castanheda (d. 1559) says that shipwrights in Goa were using cords; in fact, in the Goan storehouses, the chronicler reports that there were heaps of cordage as well as a large number of nails.[64] Other reports by European travellers in the 16th and early 17th century mention the use of cord. The French physician Charles Poncet (d. 1706) relates how the planks of a Surat ship from Gujarat were 'fastened with pitiful cords'.[65]

Earlier, I gave the reasons why sewn fastenings were preferred to iron fastenings in the Red Sea, but for the western Indian Ocean there were other reasons. Firstly, in any sea condition, nails rust and corrupt timber; secondly, the availability of material was at hand; cordage from coconut fibre came from the western Indian coast and the Maldive Islands, making it cheaper than using iron which had to be smelted to make nails; and thirdly, it was considered a safer option, for there was a cultural belief that ships sank to the bottom of the sea because rocks there attracted iron nails like a magnet. Such legends prevailed for many centuries, many of which go back to pre-Roman times.[66]

The hazards of the sea

For the ship builder, what counted was whether the hull of a ship or boat was seaworthy and able to cope with the physical rigours of the sea and the weather. It was also the responsibility of the sea captain to ensure that the ship had the right balance of passengers and merchandise. If a ship lost its stability, tons of water could enter the hull and break it to pieces.

What passengers feared most were the enormous waves which were created by the winds and currents that rose unexpectedly. When ships of India and Siraf hugged the coast of the Arabian Sea, they encountered, in al-Muqaddasi's words, 'waves like towering and immovable mountains'.[67] These mountainous waves were much feared by the Omani and Sirafi seafarers on approaching the Sea of Berbera.[68] As mariners entered this sea, Buzurg ibn Shahriyar warned sea captains that they would be about to face 'one of the most dangerous seas'.[69]

Prayers were said to ward off evil; it was customary in the 14th century for merchants and pilgrims to recite every day the Litany of the Sea (*Hizb al-bahr*) with devotees while crossing the Red Sea.[70] This devotional prayer was recited by the holy man 'Abd al-Hasan al-Shadhili (d. 1258) while performing the same voyage; and disciples of the al-Shadhili Sufi order have continued to recite his litany for a calm sea up to modern times. Richard Burton (d. 1890) reported such a prayer being recited by the devotees onboard the pilgrim *sanbuq* named *Silk al-dhahab* (The Golden Route).[71] One line is a supplication for God's assistance, 'Guide us O Allah, and deliver us from the hands of the evildoers, and grant us a fair wind'.

There was, noted al-Nuwayri l-Iskandarani (*fl.* 14th century), a ritual performed by sailors when their cargo-

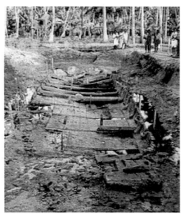

Plate 4 The Thaikkal-Kadakkarappally boat, Kerala

pilgrim ship approached 'Aidhab; they would hail the rocky hills for guidance and safe anchorage: 'O mountain, the captain of the ship sails from here and there, your favour is with him'.[72] Mariners also wore charms as a protection against pirates and to sail in good wind.[73] Sea genies (*jinn*) were mischievous; they dwelt in mountains and at the bottom of the sea, and in order to ward off evil, merchants would throw their rice or other food into the sea.

One of the major hazards mentioned by the Muslim sources was piracy. Safety of cargo and passengers was of prime concern to ship owners and sea captains as pirates raided for booty and slaves. In the ninth century, the Persian merchant Abu Zayd stresses the point that ocean-going ships were 'often plundered'.[74] The experience must have been terrifying for both passengers and crew, robbed of all possessions while there would have been costs for the owner and sea captain as a result of the damage caused to the ship. It was, therefore, customary in long-distance voyages to sail in a convoy of two or three ships, some carried armed men, and some were equipped with Greek Fire (incendiary Byzantine weapon) to use on the enemy ship.[75] Convoys of ships were the safest way to travel, both as a protection against piracy, but also to give help when a ship ran into difficulties. However, there are anecdotes which suggest that this was not always the case. Buzurg ibn Shahriyar has a story from a ship captain, who, in 936, sailed from Oman to Jedda, alongside other cargo vessels from the southern Red Sea coast, and in spite of being in a convoy, one of them tragically foundered with its cargo.[76]

Naval protection for pilgrims was necessary during the Fatimid period (909–1171) in the Red Sea because of the threat from Crusaders in the area. It is known that in the reign of Reynald de Châtillon (r. 1153–63 and 1177–87), the Lord Prince of Karak instructed his fighters to 'harass [Muslim] pilgrims'.[77] Thus it is reported that in 578/1182–3, 16 Muslim ships left Jedda and were burnt down; two other ships from the Yemen laden with merchandise heading for Jedda were captured and all the food destined for Mecca and Medina was destroyed. The attempt by the Crusaders to occupy Red Sea ports in the 12th century did not last for long as the Ayyubids (1169–1252), fearful of the danger from the Christian assaults on the ports, closed the Red Sea after a devastating effect on Muslim ships and the loss of merchant and pilgrim lives.[78] To this effect, Ibn al-Athir reports how the admiral of the fleet Husam al-Din Lu'lu', under the command of al-Malik al-'Adil Sayf al-Din (r. 1200–18) 'set

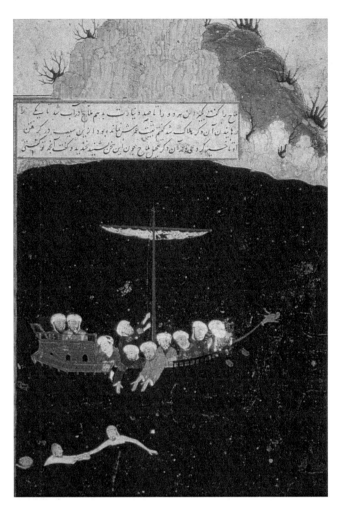

Plate 5 Saving a man at sea from Sa'di's *Gulistan*, Herat 1426. Chester Beatty Library, Dublin

Wrecks were many and survivals few. We have a story from Buzurg ibn Shahriyar of a brand new cargo *jalba* heading from Oman to Jedda in 936 when a gale struck the vessel and all passengers lost their lives.[83] There are many areas of the western Indian Ocean, such as the Gulf of Sarandib (modern Sri Lanka), which were considered dangerous and from where 'men rarely return safe and sound;' an area considered 'among the most difficult of all seas'.[84] Sri Lanka was the gateway to the eastern Indian Ocean and pilgrims boarding ships from Southeast Asia would not be aware of what was in store for them.

Stories about shipwrecks are many. One account informs us that a Hijazi merchant in the 12th century had lost 11 of 12 ships in one day.[85] These narratives, unlike the reports by Muslim geographers and historians, are full of emotion and contain descriptions of the horrors the passengers experienced as they themselves had endured them as well. Ibn Jubayr almost drowned three times. Ibn Battuta recounts the story of a ship he was travelling on which was caught in a storm south of the island of Sri Lanka; his ship was not wrecked but the experience was a harrowing one that he felt he had to document, he reports, 'We were face to face with death, and people jettisoned all that they had, and bade farewell to one another'.[86]

Mariners took risks as did pilgrims whose religious piety made them psychologically resilient in the face of what storms and gales could do. In a treatise written by Safi ibn Vali around 1677–80, he appeals to this piety as he is made 'aware of the dangers of the sea', giving instructions how 'to complete the journey [to Jedda] fearlessly, remembering the boundless mercy and kindness of the most generous and merciful Allah'.[87] Saving the lives of the crew and passengers could all depend on the mariner's nautical skills. Thus, Ibn Jubayr narrates a story of how the rigging gear of his ship when crossing from 'Aidhab to Jedda was not strong enough and kept breaking. He gave credit to the sailors whose competence at working the sails in the sudden storms and gales was remarkable.[88]

All stories have heroes. In Buzurg's narratives the heroes are the sea captains, mariners and the passengers who had to endure so much. Of the route to China he said: 'No one has done it without an accident. If a man reached China without dying on the way, it was already a miracle. Returning safe and sound was unheard of.'[89] One such hero was 'Abhara, a skilful sea captain, who had 'made the two voyages [to China] and back without mishap'.[90] In Ibn Battuta's stories, the hero is himself. He is critical of others, and behind each story he recounts one may detect an underlying message of mistrust in the person or persons he is talking about. One story retells his experience of a ship which was to sail from Jedda to Qusair but, on embarkation, he noticed that the ship was built by incompetent carpenters and he decided to abandon the idea of sailing on it. The story ended with him telling the reader how lucky (and wise) he was; 'This was an act of providence of God Most High' because the ship sank in the deep sea near a place called Ras Abu Muhammad, and with the exception of a few, including the sea captain and some merchants, all drowned. There were on the ship 70 pilgrims.[91]

out in pursuit of them (the Crusaders) ... swooping on them like an eagle on its prey'.[79]

The two Mediterranean travellers, Ibn Jubayr and Ibn Battuta, and the Persian sea captain Buzurg ibn Shahriyar of the tenth century, narrate stories from their experience or retell stories of people about their lives and ships at sea. These narratives are a unique insight into the past and the stories are powerful and engaging. 'Aidhab, the crossing-point to Jedda, was 'one of the most frequented ports of the world', claimed Ibn Jubayr, because here 'ships of India and the Yemen sail to and from it'.[80] Its profits were drawn not only from the port's activity but from pilgrims during the annual Hajj season. The most profitable income came from the hiring out of pilgrim ships. Four to five ferry boats were built every year; they were usually overcrowded and prone to capsizing when hit by huge waves and many pilgrims lost their lives.[81] He describes these pilgrims being packed 'like a chicken coop' on the ferry boat.

This loss of ships and pilgrims was costly and tragic but the owners or boat builders seem to have been largely indifferent to the human suffering. Ibn Jubayr cites a proverb which, he says, was known to locals in 'Aidhab, 'We [builders] produce the ships and they the pilgrims protect their lives'.[82] The gist of this proverb is that the owners are responsible for making boats (*alwah*) while pilgrims protect their lives (*arwah*), the underlying message being: if the pilgrims drowned, it was not the boat owners' fault (**Pl. 5**).

This anecdote raises some interesting points: Ibn Battuta offers details on: (a) the ship whose owner was a Tunisian 'Abd Allah; b) the poor workmanship of the ship; c) the location mentioned where the ship sank; d) the number of pilgrims who lost their lives. North Africans were well known at the time as navigators and mariners and many would have owned cargo-pilgrim ships or been hired to man them. Ibn Battuta, himself a Maghribi, knew them well, and from his experiences knew not to trust them. A number of these Maghribis had, over the centuries, settled on African or Arabian soil. This information was gathered during my fieldwork in Quft in 2004, where I was told then that there were many Maghribis, who after they had performed Hajj, would have settled in towns on the River Nile or on the Red Sea, engaging in trade, shipbuilding and facilitating caravan crossings and sea pilgrim voyages. Those that stayed behind in Quft married local women.[92]

The trade route between Qusair to Jedda and further south was well known at the time as evidenced by Arabic paper fragments discovered recently at Qusair al-Qadim.[93] The area where the ship foundered is untraceable; Ibn Battuta may have heard the story and got the name wrong or could not remember the name. As for the unfortunate 70 pilgrims, they would have most probably been placed in the hold of the deckless ship and would have had very little chance of survival.

Written and archaeological evidence

Does written and archaeological evidence offer sufficient insight into the understanding of sea pilgrimage? Sea pilgrimage was a never-to-be-forgotten experience which, while being a high point in the life of a pious Muslim, was a journey fraught with danger and terror. One of the possible problems, as noted, was that the Hajj month, being part of the lunar calendar, could have occurred at a time when the sea was subject to violent storms and other bad weather conditions leading to disaster. By contrast, travellers by land caravan could set off to perform Hajj at any time of the solar calendar.[94]

Texts about land caravan pilgrimage are numerous throughout the Islamic period, and even in modern times cultural and religious historians have given much more attention to the cross-desert Egyptian or Hijazi pilgrimage routes than those based on sea activity. The reason for this is the sparse information that exists on sea voyages of merchant-pilgrims in general, so that reconstructing the past could often mean hypothetical statements with unsubstantiated sources to support the argument. I have attempted in this study to show that although the primary Arabic sources taken individually appear to say little about sea transport, in particular the sea pilgrimage, if one looks at these sources together, and then compares their information, a clearer picture starts to emerge of the coastal landscape, the seascape and the maritime activity of the region investigated. However, there are many pitfalls in attempting to interpret this information, First, there are the linguistic issues as some of these sources are purely factual but written in a dense and impenetrable style which often confuses the reader as to whom or what is being referred to. Related to this, there is the issue of an *adab* (literary) style to which some

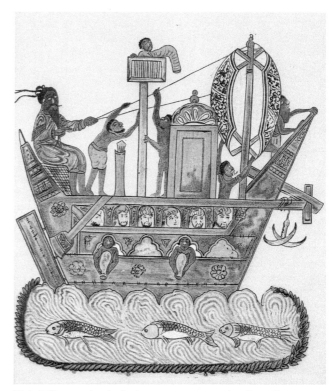

Plate 6 The merchant-pilgrim passengers peeping through portholes on a Perso-Arabian or Indian vessel (*Maqamat* of al-Hariri after al-Rumhurmuzi 1883–6: 90)

authors adhere, they write to instruct but also to entertain, and their flowery, embellished style can obscure the received information. Secondly, there is the question of the medieval audience for whom these accounts were written and recounted. Some of the information that the modern reader would expect to obtain is simply not there because it was common knowledge at the time and did not need further elaboration. For example, the description of storms and gales may have been a reference to the cyclical monsoonal winds blowing seasonally, the south-west from April to August, and the north-east from October to March, the workings of which were familiar to the reader or listener and therefore did not need further explanation.

Medieval pilgrims must have been well aware of the sea hazards, but their overriding goal was to perform the Hajj. Whatever happened on the journey, whether in the desert or at sea, they were resigned to their fate and there was just as much heavenly reward for the pilgrim who died on the journey as there was for those who reached Mecca.

The references made to the 'ships of Qulzum and Yemen' or 'ships of India' were for the same reason well understood by the medieval audience. Most people knew their type, the size and the function they performed and their mental picture of these craft and their background knowledge of them sufficed. All of this means that for the modern reader, the lack of information is frustrating and some informed guesswork is necessary to come close to the intended meaning.

Archaeology is an important source but it does not come with full answers unless the finds are compared with the written texts and iconography, and even then, there may be more questions than answers. One of the drawbacks in Islamic archaeology is the dearth of medieval shipwrecks.

Plates 7–8 Hajj wall paintings in Luxor, Egypt (courtesy of TMP photographer Francis J. Dzikowski © Theban Mapping Project, Egypt)

The ninth-century ship excavated off the Indonesian Island of Belitung is a good example of a sewn-planked construction which supports the written and iconographic evidence, but so far this is the only one there is to corroborate information from written and iconographic evidence.[95] It was described as an 'Arab' ship but this is not necessarily so. Why not Persian or Indian? Arabic and Persian literary texts give clear evidence of the involvement undertaken by the three major ethnic communities, Arabian, Persian and Indian, and of the overlap in ship building techniques, navigational methods and trade from the China seas to the East African coast. There is no doubt that the Belitung shipwreck is a significant find for it also confirms the mercantile trade running between the eastern and western Indian Ocean as our Chinese and Arabic sources reveal; Chinese *junk*s were anchored at the ports of Basra, Siraf and Aden to load goods for shipment to China.[96]

The place of iconography

How far do images offer a real or symbolic representation of sea pilgrimage? The 13th-century *Maqamat* images discussed earlier offer some striking insights into life at sea. So far these medieval drawings have been interpreted as being representative of cargo ships. It has been argued that the passengers peeping through the portholes represent wealthy merchants but they could well be wealthy pilgrims on their way to Jedda (**Pl. 6**). The stylized image of passengers peeping through portholes was a common theme as one sees it in Persian miniatures (see below). Moreover these crafts could be what the medieval authors described as 'ships of Yemen, Siraf or India'.

One important feature of the *Maqamat* ships is that the planks were fastened by rope. However, there is written and archaeological evidence of ships being fastened with iron nails from the 11th century. Interestingly, the Qusair al-Qadim timber finds point to the existence of both techniques from the 12th to the 15th century,[97] though nail planking found at the site does not necessarily indicate that it took place at Qusair. The timber might have come from

elsewhere, perhaps from an Indian vessel as the Kadakkarapally finds demonstrate.

Iconography perhaps needs more attention than we have given it in the past. Of course the artist's intention may be perceived differently today in comparison to what was understood then, and there are pitfalls for the modern viewer attempting to interpret them. However, the *Maqamat* images do show details of its construction and the materials used which suggest that the artist had direct knowledge of ocean-going ships. Just as I have noted references to sea transport or sea pilgrim activity in the Red Sea, the Persian Gulf and the western Indian Ocean occur rarely in Arabic and Persian literary works. Similarly the question arises as to why images of land merchant-pilgrim activity far exceed the number of those depicting seascape? Consider the number of drawings found of Hajj trade activity showing travellers on their way to Mecca or resting at the caravanserai; it is not until we come to modern times that the balance seems to be partially restored. Nowadays we see drawings of ships on the walls of mud brick houses decorated with pilgrimage scenes such as those found in Egypt (**Pls 7, 8**). Hajj paintings on walls are a longstanding tradition, the practice of which goes back to medieval times and, in the case of Egypt, to Pharaonic times. Lack of sea imagery in comparison to that of the land is probably due to the unfamiliarity on the part of the artist just as it was for the literary works. Of course, there is a general lack of image representation due to the prohibition of this by Islam; nonetheless, figurative art is found but 'only tolerated at its periphery with the proviso that it must not represent a sacred personage'.[98]

So far, the only images we have of Red Sea vessels from the medieval period are a paper fragment of a ship drawing at Qusair al-Qadim[99] and a rock carving showing a ship with a lateen-rigged sail.[100] The latter is difficult to date, and could well be a drawing from modern times.

One striking image, although dated 1835, is most likely derived from a much earlier period, probably 16th or 17th century. This native Indian chart drawn by a Gujarati showing the Arabian and African coasts at the Horn of

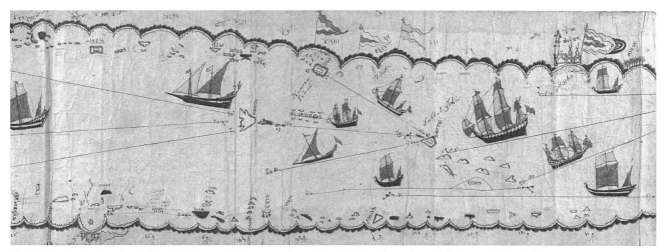

Plate 9 A native Indian chart of the Arabian and African coasts and the Red Sea drawn by an inhabitant of Cutch, Gujarat, c. 1835. Royal Geographical Society, London (mr Asia S.4)

Africa represents active sea traffic, showing among other ports, Mocha on the right and Jedda on the left (**Pl. 9**). The ships would be carrying merchants and pilgrims to Aden, Mocha and Jedda. Two things may be observed in this chart, namely the different types of ships, possibly from India, the Persian Gulf and East Africa, and the simultaneous use of square and lateen or settee sails. Also, there are names of local features in Gujarati-Cutchi, indicating reefs and shoals. As noted earlier, sailing outside the trading season (October to March) would have meant that the large ships used smaller boats guided by local pilots who were knowledgeable of the winds as well as the reefs and submerged rocks.

The 17th-century guide of *Anis al-hujjaj* (The Pilgrim's Companion) by Safi ibn Vali has some impressive images of pilgrim ships (c. 1677–80); one of which depicts vessels setting off from the city of Surat. Normally the Surat ships would have left the port in March or April, as they would follow the solar calendar,[101] though it is not clear which month or year Safi ibn Vali set off on board *Salamat Ras* from Surat to Jedda; all we know is that the ship (a *baghla* or *ghanja*) carried some 512 passengers, and that twice they encountered severe storms.[102] Two other images portray the ports of Mocha and Jedda, and another one of Jedda shows small boats which would have transported the pilgrims from the ships to the port. The larger craft show Indian and possibly South Asian pilgrims at the portholes in the style of the *Maqamat*. In other details one finds the mariner in charge of the sails, the sea captain, the look-out man and the sailor sounding the depth of the sea, as the ship was approaching Jedda (**Pl. 10**).

Depictions such as these, including the many Persian miniatures produced in various copies of Firdawsi's (d. c. 1020) *Shahnama* (The Book of Kings) such as the symbolic representation of the prophet Muhammad, his son-in-law 'Ali and followers at sea entitled 'the ship of faith', are very obviously stylized, and may at first glance appear to give us no real information. But this would be incorrect as there are different angles to the way a viewer sees an image; for the Shi'i devotee, the *Shahnama*'s image is a Shi'i symbol and its message is that of a 'journey of salvation' (**Pl. 11**).[103] For the boat researcher, they do offer a glimpse of the overall hull design which must have been prevalent at the time of

the illustration and can reward close study. For the art historian, the passengers peeping through the hole is a recurrent image, as we have seen in the *Maqamat* and the *Anis al-hujjaj* works. As Talbot Rice commented about the

Plate 10 Crossing the sea of Oman, folio 3b from the *Anis al-hujjaj* (The Pilgrim's Companion), India, possibly Gujarat, c. 1677–80. Nasser D. Khalili Collection of Islamic Art (MSS 1025, fol. 3b) (© Nour Foundation. Courtesy of the Khalili Family Trust)

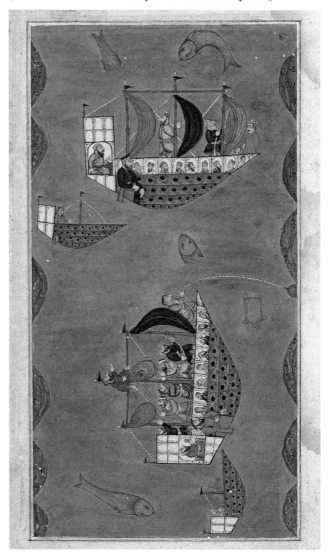

Plate 11 Firdawsi's parable of the 'ship of faith', *Shahnama,* Tabriz 1536. British Library, London (Ms Add. 15531, f. 12r) (© The British Library Board)

13th-century *Maqamat* images, one finds in such paintings 'the compositions are often very beautiful in themselves, and the colours are gay, brilliant, and remarkably effective'.[104]

For the devotee, the image of the ship signifies spiritually not only the pilgrimage to Mecca but also the journey of life, in which man struggles with the vagaries of existence and must learn that destiny lies in God's divine will. For the sea pilgrim, the ship and the dangers of the sea are to be faced 'fearlessly', in full trust of Allah.[105] The *safina* that appears in the Qur'an three times,[106] is the archetypal ship that safely carries devotees on their spiritual journey; one of the allusions in the Qur'an is to Noah's Ark (*safinat Nuh*). While the artists' intention here in such images was to create a symbolic representation, and would have been understood as such by their contemporary audience, they must have drawn upon their knowledge, whether direct or indirect, of ships of their time and the nautical and maritime traditions associated with them, which gives the modern researcher valuable information about boats. The information may be more like gold dust than solid gold but, in combination with the other sources I have attempted to discuss, they are a significant contribution to our understanding of the seascape in medieval and post-medieval Islam.

Notes

1 These words are recited by seafaring pilgrims, followers of the Sufi saint, Sheikh Abu al-Hasan al-Shadhili who founded a tradition which continues till this very day. His tomb, located at Hamthirah, some 150km from Marsa Alam on the Egyptian Red Sea coast, is visited today by hundreds of land and sea pilgrims.
2 See al-Ya'qubi 1892: 340; Ibn Khurradadhbih 1889: 81, 153–5; al-Istakhri 1927: 48; al-Muqaddasi 1906: 194–6.
3 Scott *et al.* 1946: 584.
4 Al-Muqaddasi 2001: 11.
5 Renaudot 1733: 93.
6 Al-Muqaddasi 2001: 11.
7 Pires 1944, I: 9.
8 Kennedy 2012: 114.
9 Pearson 1994: 154; Yusuf 1996: 247.
10 There are two illustrated copies of this manuscript; one is in the CSMUV Mumbai and the other in the Nasser D. Khalili Collection of Islamic Art MSS 1025, see Rogers 2010: 284–7; Leach 1998; Porter 2012a: 51, 153, 166–7. The text was translated by Ahsan Jan Qaisar whose family kindly made available the handwritten copy of his translation for use in the British Museum Hajj exhibition. There are extracts from it in Qaisar 1987. A project to publish the translation is in the planning stage.
11 Ibn Jubayr 1952: 15.
12 Ibn Jubayr 2004: 31–69. See also Le Quesne in this volume.
13 Al-Mas'udi 1983, II: 255.
14 Kennedy 2012: 114.
15 Kennedy 2012: 114.
16 Ibn Hawqal 1992: 50–1; al-Muqaddasi 1906: 9–11.
17 Renaudot 1733: 93; Yaqut [n.d.], II: 107; see also al-Zahrani 1994: 241.
18 Ibn Hawqal 1992: 48.
19 Al-Ya'qubi 1892: 313.
20 Renaudot 1733: 8.
21 Al-Muqaddasi 1906: 11–12; al-Muqaddasi 2001: 11.
22 See for example Renaudot 1773: 7.
23 Renaudot 1773: 7.
24 Al-Ya'qubi 1937: 190.
25 Abulafia 1997: 10, 12, 19, 28, 37; see also Peacock and Peacock 2007: 2–3, 6–8.
26 Ibn Jubayr 2004: 67.
27 Ibn Jubayr 2004: 64–5.
28 Ibn Jubayr 2004: 64–5.
29 Ibn Jubayr 1952: 47–8.
30 Peacock 2006: 3.
31 Al-Qalqashandi 1987, III: 536. On archaeological surveys and finds in Qusair al-Qadim, see Whitcomb and Johnson 1979 and 1982; Peacock and Blue 2006.
32 Lane 1984, I: 1142.
33 Soden 1958–81, II: 612.
34 Al-Idrisi 1866: 112.
35 Al-Ramhurmuzi 1883–6: 8–20, 25, 28, 33, 71, 103, 165–8, 177.
36 Several Arabic sources cited in Agius 2008: 273.
37 Agius 2008: 67, 153, 173, 175, 418.
38 Ibn Jubayr 1952: 69.
39 Margariti 2007: 151, 280, n. 51.
40 Birch 1875–84, IV: 206.
41 Renaudot 1733: 93.
42 Renaudot 1733: 93.
43 Ibn Battuta 1995, II: 413; al-Maqrizi 1853, II: 180.
44 Varthema 1863: 154.
45 Ibn Battuta 1995, II: 361–2.
46 Interviewed Jumaa Hamdan Muhamed Ahmed, 61 years old on 23 March 2003.
47 De Castanheda 1924–33, II: lxxv.
48 Purchas 1625, III: 396.
49 Foster 1967: 75.
50 Al-Maqrizi 2002–4, I: 504; Ibn Jubayr 1952: 52.
51 Margariti 2002: 256; Margariti 2007: 56–60, 154, 158–60.
52 Agius 2005: 65.
53 Ibn Jubayr 1952: 65.
54 Ibn Jubayr 1952: 65; Birch 1875–84, IV: 206.
55 I have discussed the Mediterranean nail-planked ships from a number of Islamic sources, Agius 2008: 163.

56 Ibn Jubayr 1952: 65.
57 Ibn Battuta 1994, IV: 827.
58 Only recently visited Punnani port in Kerala where *thoni* sewn boats lied anchor close to fishing boats (30 April 2013).
59 Ibn Jubayr 1952: 65.
60 Ibn Jubayr 1952: 65.
61 Tomalin *et al.* 2004: 253.
62 Stanley 1869: 239, 240–1.
63 Varthema 1863: 152.
64 De Castanheda 1833, III: 30.
65 Foster 1967: 156.
66 Al-Nuwayri l-Iskandarani 1968–76, II: 232; see also Agius 2008: 161.
67 Al-Muqaddasi 2001: 11.
68 Al-Mas'udi 1983, I: 123.
69 Al-Ramhurmuzi 1883–6: 113–14.
70 Ibn Battuta 1958, I: 24, nn. 62, 65.
71 Burton 1964, I: 211.
72 Al-Nuwayri l-Iskandarani 1968–73, II: 247.
73 Ibn Battuta 1968, II: 89–92; Ibn Battuta 1995, II: 320.
74 Renaudot 1733: 7.
75 Al-Muqaddasi 2001: 11.
76 Al-Ramhurmuzi 1883–6: 93.
77 Ibn Jubayr 1952: 52; see also Ibn al-Athir 1978, IX: 159; Ibn al-Athir 2010, II: 289.
78 See Hamilton 2006, IV: 1022.
79 Ibn al-Athir 1978, IX: 159; Ibn al-Athir 2010, II: 289.
80 Ibn Jubayr 2004: 63.
81 Ibn Jubayr 2004: 65; al-Maqrizi 2002, I: 551.
82 Ibn Jubayr nd: 65; Ibn Jubayr 2004: 65.
83 Al-Ramhurmuzi, 1883–6: 93.
84 Al-Ramhurmuzi, 1883–6: 113–14.

85 Labib 1970: 68.
86 Ibn Battuta 1994, IV: 857.
87 From the unpublished translation of the *Anis al-hujjaj* by Ahsan Jan Qaisar. See n. 10 above.
88 Ibn Jubayr 1952: 70.
89 Al-Ramhurmuzi 1883–6: 85; Al-Ramhurmuzi 1981: 50.
90 Al-Ramhurmuzi 1981: 50.
91 Ibn Battuta 1995, II: 413.
92 Interviewed Sayyid 'Abd al-Rahman in Quft on 23 February 2004.
93 Guo 2004; Regourd 2004: 277–92; 2011: 339–44.
94 Pearson 1994: 150.
95 Flecker 2000: 211–16.
96 Renaudot 1733: 8; Ibn Rusta 1892: 94; Ferrand 1922: 39; al-Ya'qubi 1982: 360; al-Tabari 1879–1901, IV: 2023; al-Mas'udi 1983, I: 123, 125; for the Chinese sources see Tampoe 1989: 120; and Agius 2008: 77.
97 Blue, Whitewright and Thomas 2011: 182–4.
98 Burckhardt 1976: 32.
99 Nicolle 1989: 180–1.
100 Blue, Whitewright and Thomas 2011: 203.
101 Pearson 1994: 150.
102 Ibn Vali *c.* 1677–80: 2, 6, 33; Rogers 2010: 284–7; Porter 2012a: 51, 153, 166–7.
103 A famous *hadith* in reference to the *ahl al-bayt* (people of the household), commonly known as the *safinat al-najat* (The Ship of Salvation) reads: *inna l-Husayn misbah wa l-huda wa safinat al-najat* (Indeed Husayn is the light and way and the ship is the salvation) (personal communication Sajjad Rizvi 8 July 2012).
104 Rice 1965: 107.
105 Ibn Vali 1677–80: 9.
106 Q.18: 71, 79; Q.29:15.

Chapter 12
Travel to Mecca from Southern Oman in the Pre-motorized Period

Janet C.E. Watson[1]

Introduction

Until the 1970s, almost all land travel from southern Oman was non-motorized. Members of the Mehri community in southern Oman regularly travelled to Mecca for the pilgrimage by foot or camel. In many cases, pilgrims travelled in groups. In some cases, however, they travelled as individuals. The older generation today is unique in having experienced both the pre-motorized past and the motorized, industrialized present. For this chapter, we gathered stories from members of the pilgrims' tribes, and discuss the collection of travel stories within the context of the documentation of Mehri as a Modern South Arabian language. We begin with a brief background to the Modern South Arabian languages, and discuss the importance of documenting cultural descriptions and narratives at this time. We then discuss the types of narratives collected, and finally present two sample travel narratives in romanized transcription and translation.

Mehri as a Modern South Arabian language

Tales of pre-motorized travel to Mecca from Dhofar have been collected as part of a larger project involving the documentation of the Modern South Arabian languages, a three-year project funded by the Leverhulme Trust, and one that involves Janet Watson, Miranda Morris and Domenyk Eades as investigators. Mehri is one of six unwritten Modern South Arabian languages (MSAL) spoken today by minority populations in southern and eastern Yemen, western Oman and the fringes of southern Saudi Arabia. The other MSAL are Soqoṭri, Baṭḥari, Hobyōt, Ḥarsūsi and Śḥerēt. The MSAL belong to the South Semitic branch of the Semitic language family, which also includes Ethiopian Semitic, and share a number of common linguistic features with Ethiopian Semitic. The South Semitic branch is distinguished from the Central Semitic branch, which includes Arabic, Aramaic and Hebrew.

In recent decades, the spread of Arabic as a result of rapid economic and socio-political changes has resulted in the MSAL languages increasingly falling into disuse. Consequently the MSAL are in varying stages of endangerment: Soqoṭri, spoken exclusively on the island of Soqoṭra, has around 50,000 speakers; Śḥerēt, also known as Jibbāli, spoken within the Dhofar region of Oman, has around 10,000 speakers; Ḥarsūsi, spoken in the Jiddat al-Ḥarāsīs of Oman, and Hobyōt, spoken in far eastern Yemen and far western Oman, each have under 1,000 speakers; Baṭḥari, spoken in a small region on the coast in eastern Dhofar, has well under 100 speakers. Mehri, spoken in Oman, Yemen and southern Saudi Arabia, has the largest number of speakers, estimated at around 100,000, although the actual number of speakers is extremely difficult to estimate for a number of reasons: firstly, the language is spoken across three state boundaries; secondly, many ethnic Mehris no longer speak Mehri, particularly in the western areas of Mahra in Yemen; and thirdly, where younger Mehris do speak Mehri, they no longer have command of all basic semantic fields in the language. Nowadays almost all speakers of MSAL are also speakers of Arabic.

Linguistically, the MSAL are noted for their retention of ancient Semitic phonological and grammatical features that

have disappeared from other Semitic languages, and for innovations not attested in other branches of Semitic. Recent research on the consonant system of MSAL indicates strongly that the MSAL occupy a developmental stage between Ethiopian Semitic and the central Semitic languages of Arabic and Hebrew.[2] The MSAL are the only vernacular Semitic languages to maintain the three plain sibilants of Proto-Semitic – /s/, /š/ (English 'sh') and /ś/, a lateral sibilant similar to Welsh 'll' – and to exhibit dual pronouns and verb inflections: for example, Omani Mehri *akay* 'I and one other', *atay* 'you and one other' and *hay* 's/he and one other' contrast with *hōh* 'I', *hēt* 'you (singular)', *hēh* 'he' and *sēh* 'she'. Recent research on negation suggests that Soqotri is the most conservative MSAL, and that dialects of Mehri and other MSAL exhibit degrees of innovation.[3] The MSAL lexis shows links between both Ethiopian Semitic and extremely conservative Arabic dialects of northern Yemen and south-western Saudi Arabia, suggesting early population movement, contact and shared cultural practices. Thus the documentation and synchronic and diachronic description of the MSAL is of crucial importance to understanding the historical development of the Semitic language family as a whole and population contact.

Alongside their importance to Semitic linguistics, the documentation of the MSAL is crucial in documenting the disappearing cultural traditions and socio-economic practices of the speakers. Language documentation is of significance not only to linguists, ethnographers and historians, but also to the MSAL language communities themselves, who wish to maintain a record of their heritage and traditions in a world undergoing rapid change. One of the most important aspects of the disappearing traditional culture relates to pre-motorized travel, navigation, communication and general mobility.

The documentation of travel narratives

Dhofar remained one of the least developed regions of the Arabian Peninsula well into the 1970s. Until the accession of Sultan Qaboos in 1970, the region lacked proper schools, hospitals, roads and telephones. Land travel was limited to non-motorized transport – either on foot or by camel. In embarking on the pilgrimage, foot pilgrims would travel either west along the Yemeni coast and up through the western Yemeni mountain range, or east heading firstly to the Gulf. In travelling east, pilgrims frequently travelled by boat from Sharjah or Abu Dhabi to Qatar and then continued overland. In many cases, the final stages of travel – either from San'a' north or from Qatar west – involved joining a caravan. Some travel by camel involved crossing the Empty Quarter – moving along Wadi Nadhur and the old frankincense route from oasis to oasis, travelling mainly at night navigating by the stars. The lack of electronic or telegraphic communication meant that pilgrims often arrived unexpectedly at way-stations; and where they took far longer than anticipated to complete the return journey to and from Mecca, the tribe and family back home often thought they had died on route, the effects of which is seen in Text 2 below.

Due to weight restrictions, pilgrims would take minimal provisions in goat leather saddle bags, waterskins and shoulder bags: sufficient water to reach the next oasis or town, a single change of clothing, and a small amount of high-calorific food – such as dates, dried shark, beans, or sorghum flour. The sorghum flour would be mixed with water and baked on red-hot stones to make an unleavened bread known as *xabz ḏa-mṭabalūt*. In returning from the pilgrimage, pilgrims would not bring back Zamzam water due to its weight. Many pilgrims took several months to return home, going back via the Gulf where they would buy headscarves for women or blankets. These would be either sent back via travelling merchants or brought back with the pilgrim. Blankets were considered particularly important, as we shall see in Text 1 below: Dhofaris did not have blankets unless they were imported; any native covers and floor coverings were made of tanned cattle or goat hide. The geographical position of Dhofar in Oman and Mahra in Yemen means that this region attracts the monsoon rains between June and September, making the climate cold and damp at this time. In the pre-motorized period, the monsoon period was a time of high infant mortality. Blankets often meant the difference between survival and death.

Non-motorized land travel is practically non-existent today. Similarly travel without the comforts of a mobile phone and GPS system is rare, and it is extremely difficult to find Dhofaris today who understand the stars sufficiently to navigate by them. This is but one significant loss in knowledge: Ahmed Bakheit al-Mahri, who died in Ramadan 2011, was renowned throughout Dhofar for travelling huge distances on his own by foot or by camel, travelling mainly by night and navigating exclusively by the stars. Today none of his sons are able to name the main stars and constellations, let alone navigate by the stars. During the documentation of Modern South Arabian, we hope to be able to find older speakers who still recognize and are able to provide local names for the stars and constellations.

The set of travel narratives collected so far includes descriptions of sightings of cars for the first time, tales of independent travel by camel, tales of stowaways on ships to distant places, and tales of people arriving unannounced in the Gulf and confronted by electric lights, fans and air conditioning for the first time. Several of these texts are included in Watson (2012) and a selection of the original oral recordings can be accessed at the Semitic Sound Archive in Heidelberg at http://www.semarch.uni-hd.de/index.php43?LD_ID=1&RG_ID=6&lang=de.

Tales of travel to Mecca

I recorded the following two narratives in Dhofar in 2011, and transcribed them with the help of Mohammed and Ali Ahmed Bakheit al-Mahri in Salalah in 2011 and 2012. The transcription and translation of the texts have also appeared with linguistic annotations in Watson (2012). Both texts present second-hand accounts of independent travel to Mecca from Dhofar in the pre-motorized age. As second-hand accounts of travel during an age when many places were not known by the names they have today, I found it difficult to collect a set of approximate way-stations. In the future documentation of MSAL, we hope to be able to locate elderly pilgrims and their families and to mark the main basic routes.

Text 1 was recorded in a house in the main town of Salalah, and Text 2 was recorded in an evening shelter in the desert village of Rabkūt on the edge of the Najd. The speaker of the first text is a member of the Bīt Samōdah tribe; the speaker of the second text a member of the Bīt Thuwār tribe. Both texts were recorded using a Marantz PMD661 solid state recorder with a dynamic Shure PG58 microphone. Since the publication of Watson (2012), the oral texts have been archived at the Heidelberg Semitic Sound Archive and can be accessed and downloaded on the following links: Text 1: http://www.semarch.unihd.de/tondokumente.php43?&GR_ID=4&ORT_ID=220&DOK_ID=1966&lang=de; Text 2: http://www.semarch.unihd.de/tondokumente.php43?&GR_ID=4&ORT_ID=223&DOK_ID=1968&lang=de.

In the transcription, words of Arabic origin are surrounded by superscript ^, as in ^zamān^ 'time'. The forward slashes indicate pauses in the speech. Elongated vowels and consonants are indicated by a following colon, as in ta::: 'until'. Additions in the translation are given in square brackets, as in [and they went together], and omissions from the oral text noted as ellipsis within square brackets [...].

Text 1: the Hajj by foot

Male speaker, aged 46 years at the time of recording. He was born in the mountain village of Gabgabt, and moved down to the town of Salalah in the mid-1980s. The story relates his maternal uncle's travel to Mecca in the 1950s.

1. kūtōna bi-kassēt da-xatarāt ġayg / ^zamān^ / ād awakt hāwalay /

2. amwāṣalāt al-śī / w-^aṭayyārāt^ al-śī / ^assayyārāt^ al-śī / ḏik awaktan ār rīkōb /

3. w-aġayg / daʿīh ḥagg / wa-l-ād ṣbūr lā yiśxawwal lā / āmūr sīrūn ḥagg bark xaṭrah /

4. hiss bi-ḥagg bār hēh wakt āmūr d-ihsūs bih / wa-l-šānūs lā yaklēt al-hibha / da-hēh sīrōna / la-hāsan hibha xazyēytah / wa-l-hawayśah lā /

5. wa-ḥābū ḏik awaktan / amsēr / w-hēt am-bawmah amsēr ^ṣāb^ / tsēr man bawmah tā baʿtī makkah /

6. amtalēh āmūr hīham kafdōn arḥabēt / wa-da-hatūgak wa-nkōna / hīs wiṣal arḥabēt / śītam kiswēt / śītam kawt aḥ-ḥibha^ wa-xṣawb bīham wadīham / w-āmūr xṣawb ka-ġayg / da-baʿtī karmōś āmūr amēr aḥ-ḥibya mrīd ūdīham / hōh hijjōna / wa-l-yiktalīb bay lā wa-l-yiṣayṣ lay lā /

7. aġayg syūr la-faʿmha ma bawmah / mnays m-bawmah atta ḏ-kamīr / man ad-kamīr tā baʿtī jōdab wa-ḥawf / wa-ḥlakmah tā baʿtī ġayṣat / wa-simm tā hāl hōram da-mkallah / amtalēh ād ātraṣ bi-ḥad tā::: / wiṣal makkah /

8. ār habṭāʿ mxaṭṭar yakāʿ bark warx warx ū-fakḥ / hām da-l-axayr / wiṣal ḥlakmah w-abēlī wafḳah / aġayg anīyatah gidat wa-kāśīyan astōmaḥ hēh /

9. wa-hēh ġayg kat akrawš d-aḥḥagg al-śēh krawš lā / hīs syūr ma-bawmah / akrawš xawr / hān šēh hān yasdūd akath / lākan hām hēt anyatk la-hāl xayr kāśīyan ^yatyassar^ hūk / yinakak ār taww abēlī ykadran kāśīyan ār taww /

10. man dār hajj ridd hlakmah / ridd attā baʿtī šārigah / wa-xdūm / wa-habṭāʿ / wḳōna bark itīt ībayt wūrax /

11. hīs habōr kat wiṣal hēh wa-xadamēt hāwalyēt / axṣawb maxṣayb la-hāl hibha / w-axṣawb bi-krawš yaśtīm aḥ-ḥanfāyham kawt / w-axṣawb līham bi-kanābal / slamdat / barānīs / slamdat / hād y'ōmar hīham slamdat wahād y'ōmar barānīs / abarnaws ār b-ārabayyat krayb lākan slamdat axayr / śīniš /

12. wa-dik awaktan / hām šūk / ^kanbal^ / salmōd dakmah / xahēt šūk adanyā wa-l-ād mtōn lā l-hāsan – hbūr lā⁵ / śetū yaś yēʿan hābū / w-axxarf ^kadālik^ tawran hābū kiswēt al-śī / tkūs amnādēm⁶ šēh mkāṭāb⁷ / darg / walā śikkāt yiśafkə bīs / akswēt aġahrīt śī lā /

13. wa-jād dik awaktan anīśāf takūs ār rēkū⁸ / anīśāf yhanśayf ār arēkū / arēkū agīlēd ḏ-abkār / yidabgam tēham / wa-:yatbītham yāmīlam gīlēd wayhanśayfham / tkūsa hābū ār kall ahad da-šēh arēkū ʿār bass xahēh ār / abith ^ʿamarah^ amkōn ār gīd /

14. hɨs nakam lēham slamdat lyakmah / xahēm āmawr flān / xṣawb / wanūka maxṣayb mn asfɨr / wa-d-yabśīran hābū kall da-hēh aġayg ādah ṣahh / wa-firham hābū /

15. ġayg amtalēh mġōran akōmal snētī trayt / yā śahlīt / wa-ridd / ridd ū-nūka b-xayr / wa-nūka l-hāl harbātha / wa-hābū da-yishayt wa-d-yabśīran kall bih /

16. dōmah kat ār l-amnādam / ham āzūm al-śī / wa-hēh fnōhan al-hēh šīh śī lā / abēlī ywafkan tah wa-yasthīlan hēh kāśīyan / tā ^tyassarih^ hajjah / asthūl hēh hajjah /

17. w-amtalēh xdūm / amtalēh nūka bi-xayr w-axṣawb la-hibha / wa-hēh ībōl baysah lā yallāh yallāh ār karśāyēn ād / ḏ-amṣaraf / ḏ-akath / man fnōhan ma-bawmah / wa-^slamtī^ /

Text 1: the Hajj by foot (translation)

1. I'm going to tell a story about a man once, a long time ago, in the old days.

2. There were no means of transport, no planes and no cars. At that time, it was just camels.

3. The man was called by the Hajj. He couldn't wait any longer. He said to himself, 'I'm going on the Hajj'.

4. He kept thinking about the Hajj. He'd been thinking about it for a while, he said. And he didn't dare tell his parents that he was going because his parents would refuse him and wouldn't trust him on his own.

5. People at that time, travelling, if you travelled from here it was difficult for you to go from here to Mecca.

6. Then he told them, 'I'm going down to the town. I need [something], then I'll come [back].' When he got to the town, he bought clothes; he bought food for his parents and sent it to them. He said, he sent [it] with a man, someone [to deliver] the things. He said, 'Tell my parents, send them the message that I am going on the Hajj and they shouldn't worry about me or be afraid for me.'

7. The man went from here by foot. He took [the road] from here to the region of Jabal Qamar, and from Jabal Qamar to Jōdab and Ḥawf, and [from] there to al-Ghaydhah. He continued on the road to Mukallah. He met up with someone [and they went together] until he arrived in Mecca.

8. He probably took around a month or a month and a half, if not longer. He arrived there and God granted him success. The man had good intentions and everything worked out for him.

9. He was a man, indeed in terms of money for the Hajj, he had no money [to speak of] when he left from here. Very little money. What he had was enough for his food, but if you have good intentions then everything is facilitated for you, things turn out well, God can make everything turn out well.

10. After the Hajj, he returned there. He returned to the region of Sharjah and worked. He spent around six or seven months there.

11. The moment he arrived, from his first work he sent parcels to his parents. He sent money so they could buy food for themselves, and he sent them blankets. Some call them *slamdat* and some call them *barānīs*, [but] *barnaws* is just close to Arabic, but *slamdat* is better. Do you (feminine singular) see?

12. At that time, if you had a blanket, that blanket, it's as if you have the [whole] world and you won't die, why – the cold of winter used to make people sick, and in the monsoon period too. People didn't have [many] clothes. You would find someone had a short waistcloth of unbleached, coarse cotton or unbleached calico or a loose body wrap they would sleep in. There weren't any other clothes.

13. And leather at that time the only mat you could find was from cow hide. They would just put down a cattle hide as a mat. *Rēkū* is the hide of cattle. They would tan it and prepare it well and make leather to put down. You would find anyone who had this *rēkū* it was as if his house was a good house, the place was [considered] good.

14. When these blankets came, they would say, 'So-and-so sent [something] and a parcel came from abroad'. And the people would tell each other that the man was still alive and they would be really happy.

15. The man then spent two or three years [there] and [then] returned. He came back and brought good things. He came [back] to his tribe. People slaughtered and told everyone that he was well.

16. That is just [what happens] to someone when he is determined to do something, and before he has nothing. God grants him success and makes everything easy for him, makes it easy for him to do the Hajj.

17. Then he worked. Then he brought good things [back] and sent [parcels] to his parents. [Before] he didn't have a penny, just a very little money for his food earlier from here. [God] bless you (feminine singular).

Text 2: Hajj story

Male speaker, aged 25 at the time of recording. He was born and raised in Rabkūt and educated to secondary level. The story relates to his maternal uncle's travel to Mecca in the 1960s.

1. āmawr hayš / ā tamīmah / āmawr āṣamīham ḥābū / yisyawr ār ḏār hībēr tā ḥagg / wa-tōlī ġayg ṭād āmūr sīrōn ḥagg / wa-ḥigg ḏār ḥaybith /

2. wa-syūr ḏār ḥarmah ḏār ḥaybith tā / wa-ḥabṭā ḏār hōram / attā wīṣal tā wīṣal makkah / amkōn d-aḥḥagg / kūsa ḥābū bār xāṣam ḥagg / w-aḥḥagg ʿarafah / wa-ʿarafah sēh ḥagg /

3. w-ād kūsa šī lā kūsa ḥābū bār ḥaggam / wa-ttōlī ḳaṭ amūr maśxawwal / wa-śxawalūl halakma:h / tā:: / tā ḥawl /

4. wa-ḥābū ḥarbātha bōh šāṣaywah / wa-ykībah bār mōt / wa-nḥāram lih / wa-ḥēh ġayg ūṭoh wa-tōlī śxawalūl ḥlakmah tā ḥagg hīs ḥawl nūka wa-ḥigg ka-ḥābū /

5. w-aḥḥagg yikūn bi-snēt ār ṭawr / hamaš / wa-man ḥlakmah syūr ḥagg [...] ridd / ridd tōlī ḥarbātha wa-ridd tōlī ḥabinha /

6. attā wīṣal amkōnah mn hāl yaḥlōl / āmūr / kūsa ġaganaʿōt ḳannitt / ksīs bars nōb bars nōb / wa-l-ād ġarbatha lā ḥēh ḥaybis /

7. āmūr hēt mōn / amurt hōh bart flān āmūr hīs ār ḥaybiš ḫõ / amurt ḥaybī bār mōt / āmūr xayban ḏōm hōh ḥaybiš / wa-bikyōh ād ḥlakm hay / anḥūrhī / wa-tā riddam ḥēh ād w-aḏānah wa-kall barham faxra /

8. wa-ḏīmah sēh ūḳōt aḳassēt / aḳassēt ḏ-aḥḥagg / ḏa-tmīmah ṭhams /

Text 2: Hajj story (translation)

1. They told you, Tamīmah. They said, people used to go on the Hajj by camel. And then one man said, 'I'm going on the Hajj'. And he went on the Hajj on his camel.

2. He went on his way on his camel until, and he took a long time on the way, until he arrived. When he reached Mecca, the place of the Hajj, he found people had already finished the Hajj, and the Hajj is during ʿArafa, and ʿArafa is [the time of] the Hajj.

3. He found nothing left; he found people had already done the Hajj. And then he said, 'I'll stay'. And he stayed there for a year.

4. And people, his tribe here, missed him and thought he had died. They slaughtered for him, but he, the man, was there and then he stayed there until the Hajj. After a year, he did the Hajj with other people.

5. The Hajj is only once a year, do you (feminine singular) hear? And from there he went on the Hajj [...], he returned. He went back to his tribe and returned to his children.

6. When he arrived at his place where he lived he said, he found a young girl. He found her and she was already grown up, she was grown up. She no longer knew that he was her father.

7. He said, 'Who are you?' She said, 'I am so-and-so's daughter'. He said, 'Where is your father?' She said, 'My father is dead'. He said, 'Okay, I am your father'. And they cried there all day until they returned [home], and he and his family were all together.

8. And this is the story, the story of the Hajj that Tamīmah wanted.

Notes

1 In collaboration with Mohammed Ahmed Bakheit al-Mahri and Ali Ahmed Bakheit al-Mahri.
2 Sima 2009; Watson and Bellem 2010, 2011.
3 Lucas and Lash 2010; Watson 2012; Watson and Rowlett 2012.
4 < *ha-ḥibha* 'for his parents'.
5 Better: *ḥabūr ḏa-śētū* 'the cold of winter'.
6 Diminutive of *mnādam* 'person'.
7 Diminutive of *maḳṭab* 'sarong; waist-wrap'.
8 Cattle hide used as a floor mat.

Chapter 13
The Rail *Hajjis*
The Trans-Siberian Railway and the Long Way to Mecca

Nile Green

Introduction

Between 1850 and 1915, the global expansion of steam travel triggered unprecedented mobility among Muslims from all corners of the world. The creation of a global network of rail and steamship routes was inseparable from the process of European expansion, both commercial and colonial. The movement of mail across oceans and soldiers across continents provided various colonial governments with important motives for investment in this new infrastructure. The close connection between industrial communications and imperial expansion meant that many of the key nodal points on these steam networks were located in relatively new port cities in far-flung reaches of the world: Mombasa, Bombay, Singapore, Batavia, Hong Kong and Vladivostok. For Muslims, this had important and unforeseen consequences. In the vast majority of cases, these nodal points were new kinds of cosmopolitan cities located far away from the traditional nodal points of pre-industrial Muslim travel.

One major consequence was that Muslims from the former 'peripheries' of the old *Dar al-Islam* (the territories of Islam) in India, Southeast Asia, East Africa and even Siberia found themselves more efficiently plugged into these new transport networks than Muslims from the former 'central' Islamic lands in places like the Ottoman Empire. While a few old and esteemed Muslim cities were connected with the steam network – most notably Istanbul – most of the Middle Eastern cities were either entirely new or previously minor ports, such as Isma'ilia, Port Said and Beirut. Moreover, the sheer number of passengers and the cheap cost of steerage and third class tickets enabled not only travellers from the Muslim 'peripheries' but also Muslims from all social classes to move from one corner of the planet to another. The age of steam was an age of mass Muslim labour migration as well as the cultivated itineraries of well-heeled *hajjis* and studious Young Turks. What these new steam routes brought, therefore, was a shuffling of the pack of Muslim interactions as far greater numbers and far more socially and ethnically diverse Muslims from increasingly more regions of the world were able to interact with one another, and, no less, interact with non-Muslims in Europe, Russia or even the Americas.

These new forms of transport, and the new kinds of Muslim travellers they brought with them, were to transform the Hajj in innumerable ways. As the European steamship companies that dominated global maritime traffic took an interest in the Hajj traffic, the Muslim pilgrimage became incorporated into this new industrial infrastructure of human transport. The Hajj became one itinerary among many and *hajjis* merely passengers (often poor and overcrowded ones) among others. In material and logistical terms, the Hajj lost whatever autonomy it had formerly had, as its organization – by travel agents, ticket touts and rail and shipping companies – was handled with the same techniques used for other large scale transport tasks. As Michael Miller explained, for those who oversaw its logistics at least, the 'business of the Hajj' became just another part of the larger mass transportation business: 'European companies introduced to the pilgrim trade the same business logic and structures that governed their other markets'.[1] And as the Hajj was recreated on an industrial scale, its more

efficient mechanisms served to mass produce far larger numbers of pilgrims. When by 1911 as many as 7,600 pilgrims might arrive in Mecca from far-flung Java alone, to be a *hajji* was no longer the rare and exclusive emblem of the unusually wealthy or pious few.[2]

Drawing on memoirs written in the midst of these mass pilgrimages, Mary Byrne McDonnell has noted how 'pilgrims seem to have become concerned with the prestige they would gain from the journey'.[3] And while the journey had always carried its risks, the sheer scale of human movement it now involved saw the Hajj become the major global vector for the spread of plague and cholera, prompting health authorities worldwide to enmesh it with a *cordon sanitaire* of checkpoint and quarantine stations.[4] Ironically, the pilgrim's path to salvation was in some years a path to statistically probable death. At the very least, the dangers, regulations and observation of others' sickness rendered the journey a trying and often terrifying one. In a common paradox of globalization, the industrialized Hajj became at once easier and more difficult than before, as the very ease of mass movement afforded by new technologies created new kinds of dangers (cholera epidemics) and obstacles (quarantine stations).

These were by no means the only ways in which the Hajj was transformed through the infrastructure of steam travel. For if the destination remained the same – uncannily so, given that by 1900 the underdeveloped Haramayn of Mecca and Medina looked strangely out of step with the changing world around them – then the route thither often involved a completely new itinerary. As we have already noted, the nodal points on the steam networks were new ports such as Bombay and Isma'ilia, while railtrack routes took pilgrims on long but now quicker detours through cities and entire countries that pilgrims, leaving the same regions a generation or two earlier, would never have seen. It was now common for *hajji*s to pass through such cities as Port Said and Port Sudan, Batumi and Odessa, Mombasa and Calcutta, Singapore and Batavia, even as we shall see, Port Arthur and San Francisco. For twelve centuries, the annual passage of pilgrims along the broadly stable overland and maritime routes of the pre-industrial era had led to the emergence of a whole series of subsidiary pilgrim centres along the way to Mecca.

The pre-industrial Hajj had typically been not one pilgrimage but many: a whole sequence of shrines culminating in the primordial shrine of Ibrahim (Abraham) at the Ka'ba. The quicker and cheaper alternative offered by train and steamship thus came at a symbolic price: the old shrines of the saints had to be sacrificed for a speedier and timelier arrival in Mecca. This is not to say that the saints lost out entirely in the new pilgrim business, for pilgrim demand for such subsidiary pilgrimages saw new saintly shrines appear in such steam nodes as Bombay.[5] Indeed, such was the terror of being crowded onto a steamer in steerage class at the height of a cholera epidemic that these shrines to the saints attracted a regular traffic of pilgrims seeking miraculous protection on their steam-powered Hajj. The steam age was not, then, inimical to the saints and the latter did find new outposts in the steam ports, at Singapore, Durban and Aden, as well as Bombay.[6] But the fact remained that even if the saints were still at hand, their shrines were now found beside P&O dockyards or train stations, such as those of Bismillah Shah inside the Victoria Terminus train station in Bombay or Sheikh Ahmad ibn 'Ali beside the Steamer Point quayside in Aden. The same continuities between the pre-industrial and industrial Hajj were surrounded by vivid reminders of the new era.

If the new steamship ports and railheads were not the old *manazil* (stages) of former times, then this had its own ramifications in turn. As global port and rail cities, these new Hajj nodes were by definition cosmopolitan sites filled with many different peoples. Even when these cities were located in 'Muslim' regions – as in the case of Beirut, Port Said or Istanbul – their Muslim populations lived alongside the many different peoples who migrated there in the 19th century. Pilgrims reaching Alexandria, for example, often remarked on the number of French and Italians whom they were surprised to find residing there in Egypt, while even Mecca's own port of Jedda attracted non-Muslim residents from Greece, Italy and Holland.[7] When the female Iranian pilgrim 'Alaviya Kirmani reached Bombay during her Hajj journey of 1893–5, she was shocked by both its pluralism and modernity. From her ship in the port, the sound of thirty steamships from one side and the city traffic from the other prevented her from sleeping and when she did venture onto dry land she found herself in a bewildering market hemmed between seven storey buildings with Hindus, Zoroastrians and Europeans rushing all around her.[8]

It was not only the ports and railheads that were pluralistic global sites. For by their very nature as forms of mass transportation, the steamships and trains themselves formed mobile microcosms in which people from all corners of the world might mingle. Indeed, the trains and ships were more cosmopolitan than their ports of call. For while on dry land, different groups were able to resort to their own social spaces such as their own clubs, hotels and places of worship, and train compartments and ship lounges were shared with whoever else had paid for the same class of ticket. Even as they traversed imperial spaces, trains and steamships were commercialized undoers of colonial boundaries. It was, therefore, not just in a geographical sense, but also in social terms that the Hajj was remade by industrialization as Muslim pilgrims found themselves mixing with an unparalleled array of different people. It was not only the vast numbers of Muslims who were mobilized by the new advances in transport, but other peoples of every religion and ethnicity on earth as well. Here again was one of the paradoxes of globalization, for if industrial transport allowed more Muslims to fulfil a pilgrimage that was the fifth pillar of their faith, by the very act of doing so they were exposed to a bewildering medley of non-Muslim peoples and practices. And when pilgrims did meet fellow Muslims, they were as likely to be unfamiliar Africans or Malays. If the Muslims encountered appeared to be outwardly different, then further enquiry often revealed them to be inwardly even more different as interaction revealed the multiplicity of Muslim communities, creeds and theologies. Once again, we see a paradox of globalization as a motor of apparent unity (the collective pilgrimage) serves to lay bare the many fractures of disunity (various kinds of Muslim and types of

Plate 1 Exploring non-Muslim religions in Japan (from Mehdi Quli Hedayat's Hajj diary, 1903–4)

Islam). As a socio-cultural experience, the Hajj was wholly transformed by the industrialization of travel. While the experience of meeting non-Muslims was by no means unique to the industrial era, as with many aspects of globalization, we are dealing with a question of scale and intensity. Whether through extensive railroad detours across Europe and even America, or stayovers in increasingly cosmopolitan ports such as Bombay or Alexandria, pilgrims were more exposed than ever to non-Muslim ideas, customs and technologies. Whether through visiting different places along the way or meeting an unprecedented range of Muslim and non-Muslim people, the steam Hajj was a quite different entity to its pre-industrial forebear.

If so far we have laid out a grand general picture of transformation, then in the following pages we will turn to two case studies to capture something of the detail of this new kind of pilgrimage. In order to capture the variety of pilgrims 'produced' by the new technologies, the examples selected are from different ends of the social spectrum. The first, Mehdi Quli Hedayat (1864–1955), was a well-connected official, modernist intellectual and future statesman who made his pilgrimage in the company of the former prime minister, 'Ali Asghar Khan Atabak. The second, 'Abd al-Rashid Ibrahim (1857–1944), was an impoverished provincial Sufi and hapless promoter of pan-Islamist politics. In reflection of the ethnic variety of Muslims who made the steam Hajj, the first of these pilgrims was a sceptical Persian Shi'i from the Iranian capital of Tehran and the second was a pious Tatar Sunni from the small Siberian town of Tara. What unites these quite distinct figures is the fact that they both made their pilgrimages to Mecca by means of the Trans-Siberian Railway. While as part of their globetrotting pilgrimages that saw them travel as far as the United States and Japan (**Pl. 1**), they both also sailed on many steamships. The remainder of this chapter focuses on their experiences along the Trans-Siberian Railway to illustrate the further and unexpected reaches of the globe that the steam *hajjis* reached.

The Trans-Siberian Railway

Construction on the network of railways known in English as the Trans-Siberian Railway began in 1890 and continued until 1916, the date usually given for the railway's

completion.[9] Even by the time its construction began, the Russian Empire possessed an extensive rail network that had begun in 1839 with the construction of the Warsaw–Vienna line, followed by the Saint Petersburg–Moscow line in 1851.[10] The opportunities brought by rail travel reached the empire's different Muslim communities – concentrated in the Caucasus, Crimea, Volga Basin and Central Asia – considerably prior to the building of the Trans-Siberian Railway. Rail lines were extending into the Caucasus by the early 1860s, where they would subsequently form a means of transport for many Iranians travelling north. As we will see below, this awkward overland exit route also shaped the pilgrimage of the Iranian rail *hajji*, Mehdi Quli Hedayat.

It was not only to the north-west of Iran that the Russian rail network was expanding, but also to the north-east. After the conquest of Tashkent in 1865, from 1879 the Trans-Caspian Railway began to extend across Central Asia, reaching Samarqand in 1888 and Tashkent in 1899.[11] Putting the inland towns of Turkestan into easy reach of the sea, the Trans-Caspian Railway allowed Central Asia's Muslims to take steamships across the Caspian Sea, Black Sea and Mediterranean, from where the Suez Canal took them to Jedda within a few days' camel journey to Mecca. As Daniel Brower confirms, 'the unexpected consequence of the railroad construction was to make available to Turkestan's Muslim population the least expensive, most rapid route of pilgrimage to Mecca via Russia's Black Sea ports'.[12] As early as the 1880s, the Black Sea port of Odessa was emerging as a major steam hub for the Hajj because, like its counterpart Bombay in British India, it formed a point of connection between rail and steamship routes.[13] Railway building effected the same transformations of the Hajj in Russia's other Muslim regions. The Volga Tatar Muslim centre of Kazan – which under Russian auspices had seen some of the earliest Muslims, from as early as 1797, adopt the other transformative technology of the era: printing – was connected to Moscow in 1893.[14] And further east in Siberia, such longstanding Tatar Muslim towns as Omsk were connected into the network in the 1890s. Subsequent lines – such as the Trans-Aral Railway built in 1906 to connect Orenburg and Tashkent and the Turkestan–Siberian Railway opened in 1931 – served to place Muslim population areas in direct contact. As early as 1893 and within a few years of the opening of the early lines, the Russian consul at Jedda estimated that Muslims from the Russian Empire constituted the third largest contingent of pilgrims after *hajjis* from India and Iran with up to 25,000 already arriving each year by this time.[15]

However, while the Russian Empire's rail system – and the Trans-Siberian Railway as part of it – did enable new levels of Muslim mobility, it was also instrumental in the mass migration of the colonists from European Russia who in some cases came to rapidly outnumber Muslims in their own homelands.[16] If it was the steamship that signalled the great age of migration in the last decades of the 19th century for the Americas, for the Eurasian continent it was the railway and the Russian rail age that was the great age of population transfer. Railheads such as Tashkent in Central Asia were transformed into entirely new urban entities as Europeans from across the Russian Empire rushed to settle

there.[17] In Siberia, whose Tatar Muslim populations had been relatively prosperous until the coming of the Russian settlers, the demographic shifts were especially massive.[18] For example the railhead town of Tomsk – one of the main centres of Siberian Tatar intellectual and spiritual life – saw its population rise from 24,000 inhabitants in 1869 to 104,000 by 1909.[19] The effect was to make Siberian Muslims a small minority in their own homeland; by the end of the 19th century Muslims constituted only 3% of Tomsk's population.[20]

This was the background of 'Abd al-Rashid Ibrahim, the second of the rail *hajji*s we will discuss. A set of developments saw him follow the Trans-Siberian Railway to Japan and spread from there the anti-Russian message of Muslim unity before departing from Yokohama for Mecca.[21]

Therefore, it is important to recognize that the rail *hajji*s who left travelogues of their journeys along the Trans-Siberian Railway were just a tiny part of the considerably larger number of Muslims and non-Muslims who travelled along these routes as part of the steam-powered population transfers of the period. The writings examined below in this way shed rare light into much more widespread encounters and experiences. Once again, the railway emerges as part of the larger process of human movement and interaction which was brought about by industrialization. This was as true for the commercial as it was for the mechanical dimensions of the Hajj, for just as in the British Empire of the 1880s the great travel impresario Thomas Cook attempted to use the same techniques of mass tourist management to oversee the Hajj from India, so in the early 1900s the Russified Muslim entrepreneur Sa'id Gani Saidazimbaev attempted to create a package tour Hajj for the Muslims of the Russian Empire.[22] While both of these ventures were failures in commercial terms, they were nonetheless part of the far larger and more successful mechanization of the overland Hajj from a journey that until as late as the 1880s (and for parts of the journey thereafter) had been carried out on camels and mules. But there was no looking back as Russian officials quickly recognized that 'the pilgrims, once accustomed to certain tsarist facilities, would bitterly resent a return to the past'.[23] The Hajj was transformed for good.

A Persian rail *hajji*: Mehdi Quli Hedayat

The son of a distinguished literary historian and courtier who was also the director of Iran's Telegraph and Post Office, Mehdi Quli Hedayat received a modern education that saw him being sent to study in Berlin.[24] On returning to Iran, he followed in his father's footsteps to work first in the Telegraph Office and then at the Qajar court, where he translated German books for Nasir al-Din Shah (r. 1848–96). Later in life he would serve as a minister under Reza Shah (r. 1925–41). Already well travelled and well connected by the time he commenced his Hajj in 1903, Hedayat made his journey as part of the small party that comprised the company of Mirza 'Ali Asghar Khan Atabak (1858–1907), Iran's recently deposed prime minister. Indeed, for Mehdi Quli Hedayat and his party, their Hajj was a pious excuse for Atabak to gain official permission to leave the country and make a wider journey around the world. Powered by

Plate 2 The Young Hotel in Hawaii (from Mehdi Quli Hedayat's Hajj diary, 1903–4)

train and steamship, a true world journey it was, taking them from Tehran to Moscow, across Siberia to Mukden (Shenyang) in Manchuria, down into China to visit Beijing, east to Japan, from there by steamship across the Pacific (**Pl. 2**) to San Francisco, across the continental United States by train, before taking another ship from New York to Cherbourg, crossing France by train, boarding another steamer to Alexandria, and then boarding the Khedive's railway to Cairo and finally across to Jedda and Mecca.

While Iran had no railways until the late 1920s, by the late 19th century Iranian travellers were able to enter steamship and rail networks as soon as they reached the frontiers of their country. Indeed, it often took them longer to cross Iran by pack animal than it might then take them to travel by steamship to Mecca or by train to Moscow. Hedayat's Hajj began with the journey from Tehran to the Iranian port of Bandar-e Anzali on the Caspian Sea.[25] From there, the party sailed into Russian territory at Baku. Already they were linked into imperial Russia's rail network, which had reached the Caucasian port of Baku as early as 1883. For many Iranian *hajji*s, Baku's train station formed a stepping stone to the Russian port of Batumi on the Black Sea, from where they could easily sail for Istanbul and thence Jedda. But Hedayat and his party had different ideas, and from Baku they took the train north to Moscow, where they arrived at 8.15 pm. Hedayat was very impressed by the 'National Hotel' where his party lodged in Moscow, describing it as one of the city's finest hotels. Only opened the previous summer, it was fronted by a large and impressive square.[26] It was, in fact, an important thing to remark on, for the coming of the railway had not only involved the laying of track and the building of stations, but also involved the creation of a larger infrastructure and market for accommodation. This was, after all, the era of the great railway hotels. While for most *hajji*s travelling across the Russian Empire the best accommodation they could hope for was one of the crowded but at least cheap and sanitary official Russian *khadzhikhana* (*hajji* houses), we should remember that in the company of the former prime minister Hedayat was able to travel in a luxury unknown to most pilgrims. It is a contrast we will see below with the pilgrimage of 'Abd al-Rashid Ibrahim.

Throughout his Persian travelogue, Hedayat recorded the stages of his journey with immense precision, recording

the times of his arrival in different cities down to the very minute. It was a travelogue written in 'rail time', the precise new timings of the age of the train timetable. Having visited the Kremlin (whose history he described for his readers), the party set off again at 9.40 pm on the night train from Moscow. They were heading east on the Trans-Siberian Railway. During the night, the train passed through the steppe which Hedayat referred to by its old Persian name of *dasht-e Qipchaq*, a name still redolent in this period with slave-raiding tribesmen of the kind that, until the Russian conquest of Central Asia in the late 19th century, remained a problem on Iran's own steppe frontier.[27] Hedayat recorded the stages of the train journey in his travelogue. Remarking on their easy passage through the Urals he remarked that they had now reached the border (*hadd*) of Europe and Asia. On reaching Chelyabinsk, the main city of the Urals, he described how the railway had made possible the mass migration of peasants, adding that no fewer than 600,000 settlers had passed through Chelyabinsk since the opening of its station ten years earlier in 1893.[28]

From the Urals, the Iranian party continued their journey into Siberia. Hedayat described the towns of Omsk and Tomsk. As a former medical student in Berlin and instructor at Iran's own pioneering Dar al-Funun polytechnic, he noted that Tomsk possessed its own *dar al-funun* (house of sciences) where it was possible to study law, natural science and medicine. This was in fact the University of Tomsk that had been founded in 1888.[29] But what is perhaps most interesting about Hedayat's account of Tomsk and the other towns in Siberia is the complete absence of any reference to its Muslim population. Tomsk was after all emerging as the centre of Siberian Tatar intellectual life in this period and, even if its first Muslim periodical, *Sibiriya*, would not be founded until 1912, its Tatar population was very much connected to the wider Muslim world, as we will see below.[30] But in fact, the absence of Muslims in Hedayat's Hajj diary was not unique to his account of Siberia and was typical of his interest in other non-Muslim peoples and their ideas and technologies. The industrialized Hajj formed a means of access to a wider, non-Muslim world.

Noting the impressive feat of bridge-building along the next leg of the train journey – comprising some 23 large and small bridges – the next section of Hedayat's travelogue described their arrival three hours before dawn in the Siberian town of Irkutsk.[31] Here the Iranians made a stopover to inspect the available hotels, finding that despite being managed by a German the station hotel was far from good, although there was another, cleaner one. While Hedayat did not elaborate on the unacceptable condition of the station hotel, much may be surmised from Stéphane Dudoignon's observation that many travellers of the period were appalled by 'the deplorable sanitary conditions, the ravages of alcoholism and of the *mal français* (*francuzskaja bolezn'* [i.e. syphilis]) in the towns of Siberia'.[32] But what did attract the high-minded Iranian *hajji* was Irkutsk's museum, where he inspected a collection of some five hundred statues of gods made of wood, stone, iron and porcelain and perused a display of stuffed animals. (Five years later, the American visitor Marcus Taft described these as 'specimens of

rhinoceroses, elephants and other ancient mammoths found in the frozen regions … not many miles north'.)[33] With a nod to his long-abandoned medical studies, he inspected a two thousand year old skeleton on display and (lest readers think this a frivolous curiosity) noted that the second floor of the museum housed a library and scientific society. Moreover, the town of Irkutsk had no fewer than 45 schools, including fourteen for the poor and orphaned and one for girls.

Far from being a means of immersion into a state of Muslim piety, the Hajj formed a means of inspecting and praising the moral accomplishments of non-Muslims and their alternative modes of government. This interest in non-Islamic matters even extended to the religious dimensions of Hedayat's travelogue, for in describing the Orthodox and Lutheran churches that stood opposite one another in Irkutsk, he took the opportunity to explain to his readers the doctrinal differences between Russian Orthodoxy and German Lutheranism. The industrial Hajj, then, was a cosmopolitan pilgrimage that initiated its participants into the mysteries of comparative religion.

With their ears freezing on the way from their hotel to the station as the temperature dropped to 21° below zero, the Iranian party once again set off along the Trans-Siberian Railway in the direction of Manchuria. At this point in his travelogue – perhaps the literary reflection of his readings on this longest leg of the train route – Hedayat distilled into his diary various facts about the recent history of Siberia and its railway.[34] He pointed out Siberia's vast natural resources of water, forest and minerals which provided great wealth to the Russians. He then described the Trans-Siberian Railway's foundation by Tsar Nicholas II in 1891, perhaps making an implicit contrast to the lack of interest in rail or other infrastructural developments by the Qajar rulers of Iran, for directly after his return home Hedayat was to play an important role in Iran's constitutional revolution. The railway was clearly an object of fascination and admiration, and Hedayat noted down many details and statistics concerning its construction.

Having previously worked in the Iranian telegraph service, Hedayat was keen to make use of all aspects of the new global communications facilities, which most affordably meant sending postcards from each of his destinations. Borrowing the French term as a loanword into Persian as *kart pustal*, he described himself dispatching many such postcards from Irkutsk and other stopping-places all the way to Beijing.[35] Affordable and efficient postal communication was also part of the communications revolution brought about by the global railway construction of the late 19th century. Since train stations often doubled as telegraph stations, he also occasionally took the opportunity to send telegraphs back to Tehran, a possibility of contact that would have been unimaginable to the pre-industrial *hajjis* of a generation or so earlier.[36]

In the far east of Siberia, the Trans-Siberian Railway joined the South Manchuria Railway that Russia constructed for the Chinese between 1898 and 1903. Hedayat's party was therefore among the earliest to make use of the new line which connected a whole series of Chinese destinations to Eurasia's rail network. Following his fascination with these new railways, Hedayat penned a

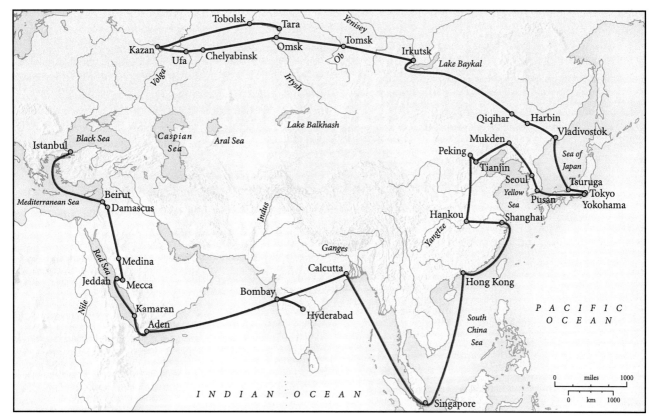

Plate 3 Map showing the route taken by 'Abd al-Rashid Ibrahim in his Hajj of 1908–9 (map by Martin Brown)

summary of the South Manchuria Railway's construction: how much it had cost the Chinese, how the Russians had built it, how long it would take China to pay for it and gain full rights over the railway.[37] Once again, the Hajj was prompting reflections less on Muslim religious matters than comparative lessons on how an underdeveloped Muslim country might learn from non-Muslim examples. When the Trans-Iranian Railway – Iran's first railway – was finally constructed between 1927 and 1938, it was indeed undertaken with the foreign help of German and American companies.[38]

The journey of Mehdi Quli Hedayat's party of pilgrims along the Trans-Siberian Railway was only one part of the globetrotting Hajj they accomplished through the power of steam. The next section of their trip took them to Mukden (Shenyang), Port Arthur (Lüshunkou), Che-fu (Yantai), Shanghai, T'ien-tsin (Tianjin) and from there finally to Beijing.[39] On this next leg of the journey, the Iranian hajjis interacted with many more non-Muslims, from the two young Russian graduates they shared a compartment with on the train to Mukden and with whom they communicated in French, to the multilingual English woman they met on the steamship from Port Arthur whose endless photographing convinced Hedayat she was a spy.[40] The Iranian party had, after all, taken the train straight into the opening salvos of the Russo-Japanese War at Port Arthur. While they made good their escape, their adventure was far from over and they would go on to tour Japan, the United States and France before finally returning to the old *Dar al-Islam* with a train ride across Egypt before their eventual arrival in Mecca. For when all was said and done, their journey was still a Hajj. But carried out on the steam ships

and trains of the industrial era, it was a Hajj like none that had come before.

A Siberian rail *hajji*: 'Abd al-Rashid Ibrahim

The second train *hajji* to whom we will turn was quite a different character from the privileged and scientifically minded Mehdi Quli Hedayat. Born in 1857 in the Siberian town of Tara, the Sufi scholar 'Abd al-Rashid Ibrahim was descended from an Uzbek family who had migrated to Siberia from Bukhara. While descended from the Siberian Uzbeks known as *Buharlık* after their Bukharan origins, 'Abd al-Rashid always referred to himself as either a 'Russian Turk' or, more often, a 'Tatar', assimilating himself to the Volga Tatars who were more established and better known within the Russian Empire.[41] Initiated as a Sufi, 'Abd al-Rashid was part of a much older legacy of Siberian Sufi '*ulama*' who in the late 19th century came into increasing contact with the new printed journals being circulated from the Ottoman Empire.[42] He was also highly mobile and prior to his long Hajj via the Trans-Siberian Railway had already lived in Kazan, Orenburg, Istanbul and Medina and in later years would travel to Egypt, Germany and finally Japan where he died in 1944. Described in the Turkish travelogue he published in Istanbul, the long and meandering journey that culminated in his Hajj of December 1909 commenced in his home town of Tara in the summer of 1908 (**Pl. 3**).[43]

After a short visit to the Tatar spiritual centre of Kazan, 'Abd al-Rashid boarded a steamship for Ufa belonging to the Iakimski Company. Here on this first leg of his steam travels, he was in Muslim company and described how after his sadness at leaving the mosques and minarets of Kazan he

was heartened to find a Tatar imam leading the evening prayer aboard the steamship.[44] While on the steamship, he had paid for a first class cabin, by the time he boarded a train from Ufa to Chelyabinsk on the next leg of his journey, he was already moving down the transportational social ladder and bought a second class ticket. But at least he was now aboard the Trans-Siberian Railway and all along its tracks 'Abd al-Rashid's travelogue described a whole series of encounters with non-Muslim peoples. Sharing the carriage from Ufa was a passenger whom 'Abd al-Rashid first greeted in Russian and, when there was no response, he tried French, to which his fellow passenger responded.[45] Since 'Abd al-Rashid didn't know French, the other passenger pulled out a Russian-French dictionary, with the aid of which they made their way through long conversations to pass the time. Later along the way a third passenger joined them, who turned out to be an Austrian who knew neither French nor Russian, but somehow the three of them managed a trilingual conversation that took them all the way to Chelyabinsk.

On the next leg along the Trans-Siberian Railway from Omsk to Tomsk, 'Abd al-Rashid found himself at a loose end after finishing all of his newspapers and so decided to pass the time by loudly chanting the Qur'an from memory.[46] Naturally, this attracted the attention of the other passengers and soon 'Abd al-Rashid fell into conversation with a Polish commercial traveller from Lodz. Echoing the comparative religious encounters of Mehdi Quli Hedayat, the conversation turned towards a comparison between Christian and Muslim doctrines with 'Abd al-Rashid making a case for the irrationality of the Trinity. Somewhat later, an Asian passenger entered their second class compartment. While he introduced himself with the Russian name of Mihailoff, on further discussion he revealed himself to be a member of the Siberian aboriginal ethnic group, the Yakout. This in turn led to a conversation about the Shamanistic and Buddhist beliefs of his ancestors before they had eventually converted to Russian Orthodoxy.[47] Once again, the rail Hajj enabled close encounters with the various non-Muslims with whom pilgrims spent long periods confined together in the cosmopolitan train compartments in the middle of Eurasia. On reaching the end of the line at Vladivostok, 'Abd al-Rashid found himself in the company of the impoverished Koreans who worked as railway porters. Sympathizing with their plight, he overpaid one of them for carrying his bag and had a long conversation with him in Russian about the causes of their poverty.[48] As though he had not met enough different people, wandering from the station at Vladivostok, he met a Romanian called Haralambu with whom he had once shared a prison cell in Odessa.[49] The different workers and travellers whom 'Abd al-Rashid encountered were just a tiny fraction of the cosmopolitan characters who travelled the Trans-Siberian Railway, the carriages of which brought together travellers from the far corners of the world, including such figures as Peter Copeland (1868–1930), a Scotland-born locomotive engineer from St Paul, Minnesota.[50] As the rail *hajjis* learned, one could meet literally anybody on the line between Moscow and Vladivostok.

The end of the Trans-Siberian Railway was of course not the end of 'Abd al-Rashid's Hajj. Before reaching Mecca, he would sail on Japanese steamships and Japanese trains, which he carefully compared with Russian trains and where he shared compartments with European as well as Japanese travellers.[51] From Japan he would sail to Korea, spend a month in Beijing teaching Arabic, and at Shanghai board the British steamship *Asia* for Hong Kong, Singapore and Bombay. Along this pan-Asian steam passage, he not only met non-Muslims, but unusual kinds of Muslims: an Iranian on board ship from Hong Kong with whom he debated the Shi'i–Sunni divide and an Indian Bohra in Singapore with whom he discussed heresy and Muslim unity.[52] When 'Abd al-Rashid finally reached Mecca, it was in the company of the Japanese convert, Yamaoka 'Umar Effendi.[53] After seeing so many regions of the world, and witnessing Asia's independent modernization in Japan, his final destination was a disappointment. Mecca had too many pilgrims and an inadequate infrastructure: there were not even enough toilets which meant that the pilgrims were constantly walking in excrement.[54] The new steam routes that took Muslim pilgrims to so many non-Muslim places on the railroad to Mecca fed comparison, criticism and occasionally disillusionment. When Yamaoka 'Umar fell seriously ill, the pair escaped the holy cities on the new Hijaz Railway.

Conclusion

In the previous pages, we have traced how as part of the larger industrialization of travel during the late 19th and early 20th centuries, the Hajj was transformed in a range of different ways. The steam network structured the itineraries of Muslim pilgrims in new ways, forcing them to travel to the new port cities and railheads that had not been part of the pre-industrial Hajj. Such steamship hubs as Bombay, Singapore and Odessa were now major pilgrim stopping points, as were the railway cities spread across British India and Russian Eurasia. With the exception of the short-lived Hijaz Railway, which as a pious Ottoman prestige project was deliberately designed to aid the Hajj, the steam network instead served newer geographies of commerce and empire that had little in common with the memory spaces of the old *Dar al-Islam*.[55] As a result, from the mid-1800s vast numbers of *hajjis* found their pilgrimages taking them to the hotbeds of capitalism and empire. Since *hajjis* comprised only one of the many different kinds of traveller who used these steam routes, the pilgrimage was also transformed into a far more cosmopolitan journey than the days of Hajj caravans comprised entirely of pilgrims. As we have seen with the evidence of just two such train *hajjis*, the pilgrim was now as likely to meet a Pole, Yakut or Korean as a fellow Muslim. And when 'fellow' Muslims were encountered, the global reach of the steam networks meant that they often held very different notions of what Islam was.

As much as the Hajj was a vehicle of Muslim unity, it was also a revealer of Muslim diversity. In this way, the Hajj in the steam age served to relativize Islam and Islamic ways of life. For no longer did the majority of pilgrims pass through Muslim majority or even Muslim-ruled lands, but through new kinds of cities ruled by non-Muslims and ideas,

technologies and political forms that made no reference to Islam. And as the travelogue of 'Abd al-Rashid made clear, the contrast of the disease-ridden and under-developed holy city at the end of the journey with the modern and orderly cities visited along the way must have been a painful one. Inevitably, for some pilgrims the result was disillusionment, whether with their own community or with the non-Muslims who 'held them back'. If in physical terms the steamship and train Hajj was easier than at any point in history, then in psychological and spiritual terms it placed new challenges before the pilgrims. For pilgrims like Mehdi Quli Hedayat, the Hajj was a means to discover a world beyond Islam.

Notes

1 Miller 2006: 209.
2 See the statistical table of Javanese-speaking pilgrims in Ricklefs 2009: 119.
3 McDonnell 1990: 121.
4 Roff 1982.
5 Green 2011: 49–89.
6 Green 2012: 196–7.
7 Tabrizi 2007: 128–30; Freitag 2011.
8 Kirmani 2007: 51. Thanks to Kathryn Babayan for providing access to this book.
9 Note that the term 'Trans-Siberian Railway' exists only in foreign sources, since in Russia there was never any such single entity, with the railway divided into multiple administrative units as part of the larger Tsarist and later Soviet rail network. For an anti-triumphalist account of the railway's construction, with a focus on the bureaucratic and governmental debates that surrounded it, see Marks 1991.
10 Ames 1947: 57–74.
11 Ames 1947: 73.
12 Brower 1996: 567–84, quotation at 579.
13 Kane 2012.
14 Kemper 1998: 43–50.
15 Brower 1996: 571.
16 Remnev 2011: 120–2.
17 Sahadeo 2007.
18 Treadgold 1957. On the effect of Russian settlement on the Siberian Tatars, see Dudoignon 2000: 297–339, especially 328–37.
19 Dudoignon 2000: 331.
20 Dudoignon 2000: 301.
21 On Japan's role as a locus of Muslim activity in this period, see Green 2013.
22 Brower 1996: 581–3; Kane 2012.
23 Brower 1996: 581.
24 For a summary of his life, see Bamdad 1984: II: 455–9, IV: 184–7, VI: 196–8. Also Kasheff 1987: 55–76.
25 Hedayat [n.d.]: 5–6.
26 Hedayat [n.d.]: 8.
27 Hedayat [n.d.]: 12.
28 Hedayat [n.d.]: 13.
29 Dudoignon 2000: 332.
30 Dudoignon 2000: 300–1.
31 Hedayat [n.d.]: 13–16.
32 Dudoignon 2000: 329, my translation.
33 Taft 1911: 113.
34 Hedayat [n.d.]: 17–18.
35 Hedayat [n.d.]: 14, 21, 26.
36 Hedayat [n.d.]: 21, 26, 28–9, 92.
37 Hedayat [n.d.]: 20.
38 Clawson 1993: 235–50.
39 Hedayat [n.d.]: 21–91.
40 Hedayat [n.d.]: 20, 24.
41 On his community, see Noack 2000: 263–78.
42 Zarcone 2000: 279–329; Dudoignon 2000: 304–5.
43 Ibrahim 2004.
44 Ibrahim 2004: 56–9.
45 Ibrahim 2004: 62–5.
46 Ibrahim 2004: 65–9.
47 Ibrahim 2004: 70–2.
48 Ibrahim 2004: 88–93.
49 Ibrahim 2004: 91–3.
50 Grenier 1963: 310–32.
51 Ibrahim 2004: 93–4, 104–5.
52 Ibrahim 2004: 199–207.
53 Georgeon 2004: 235–48. On Yamaoka 'Umar, see Nakamura 1986: 47–57.
54 Georgeon 2004: 238–9.
55 Landau 1971.

Chapter 14
The Colonial Hajj
France and Algeria,
1830–1962

Benjamin Claude Brower

Hajj and political power

As the contributions to this volume attest, the Hajj encompasses many distinct fields. A religious undertaking and spiritual event, the great pilgrimage has political, economic and social elements. It is also a global movement, one that touches not only the people and states of the Muslim world but also those outside of it. This chapter will centre on a specific case, that of Algeria, a predominantly Muslim country ruled by France between 1830 and 1962. This particular context, a colonial one, shows the political stakes of the Hajj and the way states have approached the pilgrimage as part of their larger strategies for power. A classic study in this respect is Suraiya Faroqhi's book, which shows how Ottoman sultans in Istanbul contributed to the organization and infrastructure of the Hajj to firmly link themselves to the religious sphere and thereby legitimate their authority over a far-flung empire.[1] Such considerations also include states that do not root their political culture in Islam, such as France. French leaders could not call themselves the *Khadim al-Haramayn* (Custodian of the Two Holy Sanctuaries) as the Ottomans did, but like other non-Muslim countries that have counted Muslims among their subjects, France saw the annual pilgrimage as a moment when it might assert its control over territories and populations.

In Algeria, violence was the main tool used by France to establish itself. As I have shown elsewhere, this violence followed multiple logics, from the terror and famine used to destroy Algeria's social fabric to the spectacular displays of extreme violence designed to inaugurate the social inequalities of the colonial order.[2] The costs were high and borne mainly by Algerians. Demographic historians have calculated that Algeria lost up to half of its pre-colonial population (people who were killed outright, succumbed to subsistence crises and disease, or who emigrated) in the first four decades of the occupation.[3] But violence also cost France heavily. Nearly 90,000 French soldiers died from wounds or illness during the first 20 years of the conquest and it cost the French state a sizable portion of its annual budget. These expenses combined with the negative publicity surrounding the violence of the conquest to produce politically dangerous crises at home.[4]

Thus, France sought political strategies to complement military force. General Thomas-Robert Bugeaud, who served as the Governor General from 1840–7, is emblematic of this thinking. While he privileged the force of arms to defeat Algerians, Bugeaud also thought that it was 'necessary to use the arms of seduction'.[5] The goal was to redeploy the military force and moral authority wielded by Algerian notables towards common enemies, or to 'use the Arabs themselves to defeat the Arabs' as another officer explained it.[6] Among the many ways that the French sought to produce these sorts of relations, religion was an important tool. French leaders looked within Islam to find arguments which might deflate the claims of those like the Amir 'Abd al-Qadir ibn Muhyi al-Din (*c.* 1807–83) who famously rallied Algerians against the French with the call to *jihad* in the 1830s and 40s. To counteract notables like the amir, officers became amateur Orientalists.[7] This meant that they would 'show the natives … that we know better than them the

morals and religion' of Islam.[8] Even before the arrival of troops in 1830, French planners sought elements within Islam that could be scaffolded into an ideological structure favourable to non-Muslim authority over Muslims. In the spring of 1830, the Minister of War insisted that his soldiers be seen as *ahl al-kitab* or fellow monotheists. He wrote: 'It can be read in the Koran that the Mohammedans [Mahométans] must see brothers and friends in the Christians; [and] it is especially towards the French that must be applied the words of the Prophet'.[9] The fact that they were poorly informed (here conflating the 'words of the Prophet' with the Qur'an) did not halt such condescending reminders to Algerians, who throughout the occupation were warned that behaviour which did not bend to French will was somehow against the principles of Islam.[10]

Bonaparte in Egypt

The main example for this approach was Napoleon Bonaparte and the French occupation of Egypt (1798–1801). These three years proved seminal for France's later colonial projects in the Muslim Mediterranean.[11] Bonaparte, who was immortalized by Victor Hugo as the 'Mohammed of the West', presented himself as a sincere admirer of Islam in documents such as the 1798 proclamation to the Egyptians, wherein he announced 'I worship God more than the Mamluks do; and that I respect His prophet Mohammed and the admirable Koran'.[12] On the subject of the Hajj, it is worth recalling that the returning Egyptian *mahmal* arrived at 'Aqaba just after the Mamluk defeat at the Battle of the Pyramids (21 July 1798).[13] Bonaparte, eager to claim the role of a benevolent sovereign of Muslims, offered an escort back to Cairo, an offer that was refused by the caravan's leader, Salih Bey, the Amir al-Hajj.[14] Bonaparte also wrote to the Sharif of Mecca, Ghalib ibn Musa'id, assuring him that France would take up Egypt's time-honoured duties to protect the pilgrimage, distribute the gifts and subsidies of the treasury and provide foodstuffs.[15] 'Muslims do not have better friends that us', Bonaparte wrote to the Sharif.[16] This offer fell on favourable ears. While many volunteer units formed in the Hijaz to join the Mamluk resistance that had assembled in Upper Egypt, Ghalib, threatened by the expanding Saudi-Wahhabi state, found it expedient to keep good relations with France in that year.[17] Bonaparte's embrace of Islam was selective, however. When Cairo erupted in revolt on 21–3 October 1798, the French army attacked the al-Azhar mosque, which was shelled and systematically sacked by French soldiers in a way that exceeded any military logic (desecration of Qur'ans, the smashing of wine bottles and urination in the central court, and the tethering of horses towards the *qibla* direction of Mecca).[18] Likewise, Bonaparte's support of the pilgrimage soon waned. In 1799, a new Amir al-Hajj, Mustapha Bey, who was handpicked by the French, followed his predecessor in revolt during the month of Ramadan, just as preparations began for the departure of the pilgrimage caravan. The French then cancelled the caravan.[19]

The most important legacy of 1798 was a conceptual model that configured a specific relationship between Islam and politics. Following a trend in 18th-century Orientalist texts which broke down the distinction between Islam as a religion and Islam as a society (marked in French with the word's capitalization in the latter usage), Bonaparte marked out Muslims as *homo religiosus*.[20] This meant that he saw Muslims' political actions as being fully determined by dogma. Such understandings presupposed that Islam had a fixed essence, one that scholars could study and map, and thus define Muslims' political being. This essence was generally construed in negative terms, as the lengthy history of European Orientalism explored by Edward Said and others amply demonstrates. But French planners also thought that Islam could be a positive force for colonial rule: there have long been 'Good Muslims' and 'Bad Muslims' in the minds of imperialists.[21] Leading up to the Egyptian occupation, for example, were the writings of the Comte de Volney, *Travels through Egypt and Syria*, which emphasized the political possibilities of Islam.[22] While the Qur'an was in Volney words, 'a chaos of unmeaning phrases', it also established what he called 'the blindest devotion in him who obeys'.[23] In other words, Volney saw Islam producing blind devotion in some moments, fatalism and resignation in others. In either case, governments that did not want to 'enlighten men, but to rule over them' as Volney put it, would find this trait useful.[24]

The 'Good Muslim'/'Bad Muslim'

The result of the above was that both coercion and pacification would be used in the politico-religious field: coercion to control the 'Bad Muslims' and pacification to interpolate the 'Good Muslims'.

The military men who decided policy in Algeria were adept at coercion. They underscored the dissymmetry of colonial power in symbolic acts of violence targeting Islam. These included both the desecration of mosques as well as the confiscation of them. The most infamous example of the latter is the Ketchaoua mosque, the most prominent mosque of pre-colonial Algiers, which in the 1830s was seized and transformed into a Catholic church.[25] Many other mosques were simply destroyed. By 1862, Algiers had only 21 mosques and *zawiya*s (Islamic study groups) remaining of the 176 that had stood when the French first arrived.[26] In some cases, spectacular displays of French violence could be used with the idea that they would shake Algerians' conviction in the omnipotence of God. In the aftermath of the routing of a Saharan mission in 1881, one administrator declared, 'we must show [to all] that we have force on our side ... before which every sectarian of Islam bows down, because it is the emanation of God'.[27] This thinking produced notable colonial atrocities. These include the asphyxiations at Dahra in 1845, an especially gratuitous act that claimed the lives of more than 1,000 Algerians who had taken refuge in a mountain cave. The officer responsible calculated that the deaths of these people, killed by the smoke from the fires that soldiers had built at the cave's entrance, would send a stark message. The massacre seemed to say that this was not the time of the Prophet and his Companions, when God offered miraculous protection to Muhammad and Abu Bakr, who also had sought safety in a cave (in the Jabal Thawr).[28] Pacification, or the attempt to interpellate 'Good Muslims', followed various tactics. Much effort focused on the development of a French-sponsored Islam that would stress

Plate 1 'Abd al Qadir, Cairo, 1860–3 (Library of Congress LC-USZ62-104871)

dimensions thought useful to French rule. As an influential colonial theorist put it in 1860, 'nothing is easier than to make law or religion … speak in our interests'.[29] In this understanding, France should take the lead to establish a new orthodoxy in Islam. This idea led to efforts to transfer control of the religious field to the colonial state, a task that began in 1851, when the outlines of state-controlled institutions were established.[30]

The colonial Hajj

The Hajj became part of this effort. At first France forbade the pilgrimage from Algeria, a policy that had little impact in as much as borders remained open long after 1830. Soon enough, however, policy makers saw its value. For example, in 1836 the civil intendant of Algiers called for the government to extend hospitality to pilgrims travelling through Algeria. He wrote, 'It needs to be said among the inhabitants of these savage countries … [that] in the north of Africa there is a people, who although Christians, are still allies of all Muslims and give their religion the respect it is due'.[31] The same year came a proposal to sponsor free travel.[32] In 1837, the Minister of War offered free transportation from Algeria to Alexandria. Most pilgrims were from the 'rich classes' and this gesture would help 'turn this influence to the benefit of our cause'.[33]

The 1840s were marked by the war between France and the Amir 'Abd al-Qadir, but a readiness to facilitate the Hajj continued. Thus, in September 1842, the French vessel *Le Caméléon* took 128 Algerians on a free voyage to Alexandria, and in 1843 *Le Cerbère* performed the same function.[34] The free tickets were given 'with the greatest discernment to those natives with influence that might be useful to our policy and for those whose service merits such an award'.[35] Although this responded to Bugeaud's call for 'seduction' mentioned above, security concerns informed it as much as the goal of rapprochement. Pilgrims in transit were guests of a colonial authority that controlled them. They could be kept away from foreign influence en route, especially British agents in Malta, and then could be watched over by French consuls in Egypt and the newly established consulate at Jedda.

The Hajj paid high dividends. In 1841, Algerian pilgrims dissatisfied with 'Abd al-Qadir's war brought home a *fatwa* excusing them from his call to *jihad*.[36] Later in 1892, an Algerian doctor, 'Abd al-Qadir Benzahra, returned from Mecca with another *fatwa* specifying that non-Muslim political authority over Muslims was permissible, a *fatwa* that was reproduced with 800 copies distributed throughout Algeria and the Sahara.[37] Finally, 'Abd al-Qadir himself was persuaded to surrender in 1847 with an offer to perform Hajj in the company of his mother, Lalla Zohra (d. 1861), who was about 76 years old.[38] He recounted, 'I have fulfilled my duty to God. And now … I want to rest from the fatigue of the war. And the only remedy for that is to leave for Mecca and Medina for the Hajj.'[39] 'Abd al-Qadir had previously made the Hajj twice in 1827 and 1828.[40] But he would not make it in the upcoming 1848 pilgrimage season, when the French violated the surrender terms, and he was sent to prison. Upon release some five years later, 'Abd al-Qadir emigrated to Ottoman Bursa, where he tried to leave for the Hijaz only to be blocked by French consuls.[41] Finally, having settled in Damascus, 'Abd al-Qadir made the pilgrimage via Cairo in 1863, staying on for a year and half in Mecca, Ta'if and Medina (**Pl. 1**).[42]

'Abd al Qadir's Hajj followed his protection of Christians in Damascus during the Mount Lebanon violence (1860), which made him something of a French hero. But he remained for many the object of deep mistrust. In 1881, when he approached the French government to raise funds in Algeria to repair the Zubayda aqueduct supplying Mecca, he was blocked by both the Ministry of Foreign Affairs and the Algerian Governor General's office.[43]

'Abd al-Qadir's case is representative of hardened French attitudes at the end of the 19th century. During this period, 'black legends' about Islam proliferated, such as that told about the Sanusiyya Sufi order, which emerged in French thought as a shadowy menace behind every setback France suffered in the Sahara.[44] Worth mentioning in this respect is an 1894 popularization of this conspiratorial view of Islam, the novel *L'Invasion noire* (The Black Invasion) written by a French army officer.[45] It tells the story of the conquest of Europe by a Muslim army that had originated in West Africa and crossed to Mecca, where, during the rites of the Hajj (and pursued by a French balloon), it was fully radicalized (**Pl. 2**). It then marched on Europe. The climax of the novel is both outlandish and chilling. Unable to stop the army of three million by conventional means, the French used poison gas to wipe out the invaders on a vast killing field outside of Paris.

Parts of these black legends expressed worries about the pan-Islamic ideology of Sultan Abdülhamid II (r. 1876–1909) and others in the Ottoman Empire. After losing Tunisia and

Egypt to European colonialism, he used Islam to consolidate his rule, placing himself as 'the *religious* leader of the Muslim world in its would-be unity', as the historian Kemal Karpat wrote.[46] This implied Istanbul's claims on Muslim allegiances throughout the world, claims that overlapped with those made by France and other colonial powers. Moreover, the pan-Islamic movement in general stoked fears that the sort of political hold of Islam that Volney had described might serve to foment anti-western revolts around the world.[47] A French report configured the political tides in the following terms: 'It is clear that Islamic groups around the world are beginning to acquire a conscious personality and show sudden activity, an activity that contrasts sharply with the inertia that they appear to have delighted in until now'.[48] This rising effervescence was contrary to the image of the 'Good Muslim'. In as much as the Hajj brought Algerians into contact with the people and ideas of the Ottoman Empire and beyond, it was to be singled out as a special threat. Thus, in a general order of 1880, Algeria's Governor General wrote that the Hajj was an occasion when the 'native's fanaticism is overexcited'. He continued, 'without forbidding in principle the pilgrimage to Mecca, we should try to limit it as much as possible'.[49] The goal then was to police the Hajj, which had been reconfigured as a political menace. In 1892 and 1894 came the first fully systematic and effective regulations of the Algerian Hajj. A long series of complicated measures had to be fulfilled before aspirant pilgrims received a travel permit.[50]

Strict regulation combined with outright prohibitions. In 1875, Algerians were first forbidden from making the Hajj, and unlike earlier bans, this one was backed by a robust control of Algeria's frontiers. The interdiction was extended repeatedly up until World War I. In the period between 1875 and 1915, France refused the Hajj to its North African Muslim subjects on 22 occasions, or roughly every other year. Administrators justified these prohibitions in terms of public health. Cholera posed a major threat to the world throughout the 19th century, and the pilgrimage was a significant vector for the global spread of the disease.[51] Cholera also presented an opportunity to French colonial planners, who used it as a pretext to stop the Hajj out of political concerns.

The Algerian Hajj through the World Wars

Although it remained wedded to the 'Good Muslim'/'Bad Muslim' understanding, policy in the 20th century changed significantly. The strict control of the Hajj led to a steep decline in the number of Algerians arriving at Mecca each year. In 1906, for example, there were only 1,304 Algerians and Tunisians combined who made the Hajj, numbers that were many times less than when the Hajj had been permitted in the previous decade.[52] This prompted negative comments from many circles. Even the French Inspector of Hygiene Services decried the health measures as 'draconian'.[53] The indignities experienced by pilgrims were also denounced. In 1913, for example, pilgrims from Constantine complained bitterly to the prefect that they were forced to make the train trip to the port at Bône in cattle cars.[54] Change came in 1916, when the French government lifted a wartime prohibition to organize a

Plate 2 'The balloon above the Great Mosque at Mecca' from *La Guerre au XXe siècle: l'invasion noire* (1913)

special trip for Algerian dignitaries. The occasion was to recognize the Sharif of Mecca, Hussein ibn 'Ali, joining the allied war effort.[55] For the first time in over a century, French leaders saw Muslims as allies rather than enemies. Thus, the French Ministry of Foreign Affairs paid to have 600 pilgrims from France's North African territories travel on the ocean liner *Orénoque* to Jedda. Some worried that these dignitaries would be exposed to anti-colonial propaganda, like the lectures Rashid Rida delivered that year.[56] However, they were comforted when the sharif expelled Rida and welcomed the North African dignitaries by having the French national anthem played in a concert, in what was likely the only time in history that people heard 'La Marseillaise' in the holy places.[57] In sum, a clear vision of the 'Good Muslim' returning from the pilgrimage took form in the 1916 Hajj.

In the early 1920s, a bitter fight pitted Hussein ibn 'Ali against the Saudis for control of the Hijaz, and very few pilgrims assembled during the month of Dhu al-Hijja, the month of pilgrimage. The Algerian contingent was infinitesimal.[58] In 1923, for example, only a few Algerians, who were workers in France, made the Hajj. In 1926, sources show that there may have been no more than three Algerian candidates for pilgrimage.[59] This was an embarrassment for some, and a resurgence of colonial support appeared. This echoed the idea of rapprochement informing policy a century earlier. Thus, particular profiles of colonial subjects were slated for preference, such as military veterans and influential dignitaries. Moreover, there was the idea that France needed to show itself to the emerging force of Muslim public opinion. As the head of the French military mission in the Hijaz wrote, the pilgrimage represented the 'Estates

general of Islam', a propaganda opportunity not to be missed.[60]

In the interwar years, efforts shifted from repressing 'Bad Muslims' to producing 'Good Muslims'. This shift was led by the Ministry of Foreign Affairs, which understood the link between the pilgrimage and good relations with the new Saudi leaders of the Hijaz, but it was seconded by the French Resident Generals in Tunisia and Morocco, along with the Governor Generals in Algeria. There were two ways French authorities tried to cultivate the 'Good Muslim' at this time. First, it was thought that Algerian pilgrims would see poverty and political oppression in other Muslim countries, and they would make favourable comparisons to their condition. In all, the French liked to represent the Hajj as a descent towards poverty, despotism, illness, crowds, poor food, and so forth. The return to Algeria was, in this view, a return to a promised land, a land of prosperity, justice, hearth and home. The economic crisis suffered in the Hijaz in the late 1920s and early 1930s facilitated this version of events, but it ignored the fact that Algerians too endured a particularly harsh crisis in the interwar years.[61] Moreover, it counted on a radical inversion of the typical view of the Hajj as an ascent towards spiritual perfection and instead configured it as something of a bad vacation.

But if it was a bad holiday, the second aspect of policy took pains to ensure that France would not be held to blame. Thus, the administration organized specially outfitted pilgrimage ships each year. Previously the government had organized ship inspections to ensure that basic sanitary standards were met, but now there was a robust effort to ensure that the French flag flew proudly above the pilgrimage. This began in 1921 when a committee headed by the rector of the Paris mosque was charged to manage the Hajj in consultation with an inter-ministerial council. It was named the *Société des Habous des Lieux Saints de l'Islam* and oversaw a newly established hostel in the holy places. With minimal resources, however, its efforts failed. When its first real test came with the organization of the 1928 pilgrimage, there were botched contract negotiations, a riot on board one ship and the financial collapse of another company that left pilgrims stranded in Jedda.[62] As a result, France assumed direct responsibility. It coordinated diplomatic affairs, oversaw medical care, ensured safety and awarded a transportation concession to a private bidder, based on the provider's quality of service and safety record.

This chapter got off to a disastrous start when in 1930 a deadly fire swept through the *Asie*, killing more than 600. But soon enough, annual maritime convoys transporting hundreds of pilgrims from France's colonies were making the journey each year. The departure from the North African ports became an annual rite still remembered today, with a busy scene of pilgrims, family and friends assembled to bid farewell. 'Abd al-Qader Ammam, who travelled on the *Floria* to make a 1936 pilgrimage, described the scene at Oran:

On the day of departure, beginning in the morning, docks that are usually relatively quiet swarm with people. A human wave unfurls through the artery leading to the port. Vehicles full of travellers go up and down the route. Countless carts carry heaps of luggage. Cars come and go constantly. The hum of

their engines is never ending.… Horse hooves echo on the pavement … the drivers' whips crackle.… Only joy, only elation! Emotion is painted on everyone's face.[63]

This was precisely the scene that colonial officials liked to see, where they showcased a colonial pilgrimage that was safe, comfortable and efficient. The official government agent on the 1940 ship called the trip 'a veritable masterpiece of propaganda' and reported:

Under the protection of France, pilgrims accomplished the wondrous journey that every Muslim ardently wishes to make. Carried by a beautiful ship, sailing on a sea that was almost always calm and entirely under the power of our flag, surrounded by care and showered with honours, the Muslims of Africa experienced, with the joy of such a cruise, the pride of belonging to the powerful and protective French Empire.[64]

The convoy continued well after World War II, and the French tried to extract as much favourable publicity from it as possible. However, this full organization of the Hajj was problematic. When the decision was first made to favour the pilgrimage, one commentator expressed his opposition frankly, 'Let us not reislamicize Algeria'.[65] And in 1949, when the government devoted 58 million francs to subsidize transportation expenses, European settlers demanded a similar fund to make the pilgrimage to the 'Saintly Places of Christianity' (ironically adapting the French term for Hajj, *Pèlerinage aux Lieux Saints de l'Islam*).[66] There were also gaffes made by administrators, like in 1952 when the dignitaries marking the departure of the *Athos II* from Algiers were invited to a *'champagne d'honneur'*.[67]

But the most important criticisms of France's pilgrimage policy came from Algerians themselves. The Hajj had served anti-colonial projects since the 19th century. For example, the pilgrimage 'Abd al-Qadir made with his father contributed to the cultural capital he later needed to attract and retain a popular following in the war against France. In the 20th century, Islamic reformers used the pilgrimage to establish a prestigious intellectual genealogy for their movements and develop the networks that would spread their message. This was particularly true for the most important reform movement, the Association of Algerian Muslim 'Ulama' (*Jam'iyyat al-'ulama' al-muslimin al-jaza'iriyyin*), known by the French acronym AUMA. The organization claimed a monopoly on the definition of the true religion for Algerian Muslims, a new orthodoxy based on Salafi principles, or a restoration of the original values of Islam responsible for the vitality and greatness of the Rashidun caliphs.[68] This struggle brought the AUMA into conflict with many powerful forces inside and outside of the colonial administration. The group's leader, 'Abd al-Hamid ibn Badis, had left his hometown of Constantine as a young man in 1912 to make the Hajj, staying for a year and half in the East. Here he complemented his previous education at Zaytuna University in Tunis with studies in Medina and Cairo, where he came into contact with the intellectual effervescence sparked by reformers like Muhammad 'Abduh and Rashid Rida.[69] When Badis returned and argued that orthodox Islam was the only way Algerians might restore a social order crumbling under colonialism, he made his case backed by the intellectual credentials earned in the East, eventually earning the sobriquet

'al-Ustad al-Imam' (The Master Guide) from his followers, a title he shared with 'Abduh.[70] In the 1930s the Hajj served as an occasion to publicize the AUMA's mission and Badis regularly saw pilgrims off or welcomed them home (generally with sober receptions that showcased the movement's values).[71] These were also an occasion to criticize the colonial administration's handling of the pilgrimage, and its very claim to authority over the Hajj. In 1905 the national assembly in Paris passed the Law of Separation, the founding law of French *laïcité* (secularism) by which the state disinvested itself from the religious sphere. This law transformed relations between church and state in the metropole, but it was not fully applied in Algeria even though a 1907 decree had given specific orders for it to be done so.[72] Instead, the state maintained firm control over Islamic institutions, much to the chagrin of the AUMA which wished to claim this field for itself. The AUMA was joined by diverse groupings of Algerian nationalists and reformers who protested against colonial control of the pilgrimage. In 1949 Lamine Belhadi, a prominent figure in the nationalist movement of Messali Hadj, led a debate in the Algerian Assembly focused on the 1905 law and the Hajj. 'We demand the full application of the law of separation of the church and state', he said. 'This means the liberty of all Algerians to accomplish with dignity one [of the most important] religious obligations of Islam'.[73] Finally, others in this period used the Hajj as an occasion to assert positive expressions of an Islamic identity in opposition to French-sponsored social ideals. For example in 1948 Malek Bennabi published the novel *Lebbeik*, which told the story of a down and out alcoholic who experienced a moral rebirth when he left Algeria as a pilgrim, eventually resettling in the holy places as a sort of *hijra*, or flight from oppression in imitation of the Prophet's flight from Mecca in 622.[74]

The Algerian war, 1954–62

The outbreak of war on 1 November 1954 took the colonial Hajj into its final chapter. While the pilgrimage went ahead during the first years of the conflict, insecurity forced the French to downscale their role significantly. In 1957, for example, there were only 107 Algerians among the 1 million who had assembled at 'Arafat. Rather than hearing 'La Marseillaise' this year, they joined in prayer for the Algerian *mujahidin*.[75] For their part, the *Front de Liberation National* (FLN) used the Hajj to maximum effect in their war with France. When Saudi Arabia and France broke off diplomatic relations after the 1956 Suez crisis, the FLN had a free hand in the Hijaz, and Saudi authorities provided them with logistical support, including the gift of an airplane.[76] In 1959, the nationalist leader Ferhat 'Abbas was received by the Saudi king who gave him a cheque for 10 million francs to aid the struggle.[77] Others joined in. When Air France flights carrying Algerian pilgrims on the state-sponsored flights to Jedda landed to refuel in Tripoli, Libya, the local police berated passengers for squandering money that could have been used to support the revolution.[78] The FLN collected funds from among pilgrims, and used the Hajj to rally world opinion, giving public speeches and distributing literature in the Hijaz.[79] This work succeeded. After debriefing returning pilgrims in 1959 one French

administrator lamented, 'long considered as a nation-protector [of Islam], our country has become the no. 1 enemy of the Muslim world'.[80] The FLN also used the Hajj to assert their sovereignty over Algerians by serving as the conservator for the effects of people who died making the pilgrimage.[81] Finally, the FLN established itself as the authority for requesting a visa, with a clandestine network that smuggled Algerian applications to Saudi diplomats in Switzerland.[82]

Conclusion

This history of the colonial Hajj shows how Islamic pilgrimage became a central part of the French strategy to rule Algeria. French policies towards the Hajj shifted considerably between 1830 and 1962, oscillating from repression and interdiction to direct state assistance to facilitate the pilgrimage and make it comfortable and safe. What remained stable was the conceptual model by which French authorities understood the relationship between Islam and politics. The Hajj represented an opportunity to produce the ideal Muslim colonial subject by either repressing the 'Bad Muslim' or cultivating the 'Good Muslim'. Both of these figures, which confined Algerian Muslims to the role of *homo religiosus*, served as a basis through which France hoped to extend an order based on violence, massive social inequalities and injustices.

Notes

1 Faroqhi 1994.
2 Brower 2009.
3 Kateb 2001: 47, 67.
4 Martin 1937: 171–98.
5 Bugeaud in Germain 1955: 31, 40.
6 Létang in Marçot 2009: 538.
7 Trumbull 2009.
8 Randon in Frémeaux 1976: 47.
9 Ministre de la Guerre to Ministre des Affaires étrangères (hereafter MG and MAE), 20 March 1830, Alg 5, Archives du Ministre des affaires étrangères.
10 Ageron 1968; Shinar 1980: 211–29.
11 Charles-Roux 1937, vol. 2: 113–38.
12 Herold 1962: 75.
13 The *mahmal* is a fabric-covered palanquin carried on a camel that was sent every year with the official Hajj caravan. See Porter in this volume.
14 Jabarti 1975: 60–1; Jomier 1953: 138–9.
15 Abir 1971: 191.
16 Cherfils 2005: 24.
17 Abir 1971: 192.
18 Jabarti 1975: 101.
19 Laurens 1989: 288.
20 Laurens 2006: 515–31.
21 Mamdani 2004.
22 Laurens 1987.
23 Volney 1798, II: 235–6.
24 Volney 1798, II: 236.
25 Oulebsir 2004: 87–91.
26 Devoulx 1870: 3.
27 Bernard 1882: 335.
28 Eisenstein 2006, IV: 112–13.
29 Richard 1860: xi.
30 Ageron 1968: 296.
31 Bussy 1833: 28.
32 Boyer 1977: 279.
33 MG to Valée, 13 December 1837, #7288. Archives nationales d'Outre mer (hereafter ANOM) F80 1636.
34 Boyer 1977: 280.

35 MG, 5 December 1844, #1599. ANOM F80 1636.
36 Brower 2011: 45.
37 Benzahra to Cambon, 9 April 1895. ANOM 1h85. The 1893 *fatwa* is in ANOM 22h35.
38 Azan 1925: 238, 245.
39 'Abd al-Qadir 1995: 117.
40 Bellemare 1863: 19–24.
41 'Abd al-Qadir 1978: 327.
42 'Abd al-Qadir 1964: 671–717; Graïa 1976: 85.
43 See correspondence in ANOM 1h84.
44 Triaud 1995.
45 Danrit (pseudo.). 1894.
46 Karpat 2001. Original italics.
47 Aydin 2007.
48 'Revue de la presse musulmane pendant le mois d'aout 1906'. ANOM 1affpol/923/1.
49 Circular of 6 July 1880. ANOM 16h84.
50 Regulations explained in Escande 1999: 277–96; Chantre 2009: 202–27.
51 Duguet 1932.
52 Bertrand to MAE, 11 June 1906. ANOM 16h83.
53 Inspecteur général services d'hygine to Préfet, 27 November 1913. ANOM 16h89.
54 Préfet to Gouverneur General, 25 October 1913. ANOM 16h89.
55 Le Pautremat 2006: 17–31.
56 Temimi 1996: 753–94.
57 Brémond 1931: 53.
58 Office international d'hygiène publique, 22 October 1928. ANOM 16h85.
59 Anonymous 'Pèlerinage à la Mecque', n.d. ANOM 16h85.
60 Catroux to MAE, n.d. [1919]. ANOM 16h91.
61 Ammam 1934: 159.
62 Renseignements, 6 August 1928; and Résident Général au Maroc to Gouverner général de l'Algérie, 3 June 1928 #3416cc. Both in ANOM 16h92.
63 Ammam 1934: 9.
64 'Note sur le pèlerinage nord africain aux lieux saints de l'islam en 1940'. ANOM 16h101.
65 Commission interministérielle des Affaires musulmanes. 26 October 1916. ANOM B3 168.
66 *Journal officiel de l'Algérie*, debates of the Algerian Assembly, 21 June 1949. Centre des Archives nationales de l'Algérie (hereafter CANA) IBA/CUL-056.
67 Letter of Scelles-Millie to *Journal d'Alger* 6 aug 1952; and Service des liaisons nord africaines, 7 August 1952. CANA IBA/CUL-056.
68 Shinar 2004 (*EI*); see also Colonna 1995; McDougall 2006.
69 Merad 1971: 26–30.
70 Merad 1971: 50.
71 McDougall 2006: 125.
72 De Janssens 1951: 305–39.
73 *Journal officiel de l'Algérie*, debate 21 June 1949. CANA IBA/CUL-056.
74 Bennabi 1948.
75 Préfet d'Oran, Cabinet, SLNA, 'Pèlerinage au Lieux saints de l'islam en 1957', 10 October 1957. #1533/na. ANOM 5i207.
76 Wazara al-Sh'un l-Kharjiyya, Maktab al-Hukuma l-Jaza'iriya bi al-Mamlaka al-'Arabiyya al-Sa'udiyya, Monthly Report: August 1960, 3 September 1960. #543. CANA GPRA-MAE Boite 110.1.2.
77 'Rapport sur le pèlerinage aux LSI en 1959', 14 October 1959, #170. ANOM 4i85.
78 'Rapport sur le pèlerinage aux LSI en 1959', 14 October 1959, #170. ANOM 4i85.
79 'Rapport sur l'activité de nos bureaux dans les pays arabes' [June 1960]. CANA GPRA-MAE Boite 45.
80 Sous préfecture de Blida to Préfet d'Alger, 10 July 1959 #737. ANOM 4i85.
81 Wazara al-Sh'un l-Kharjiyya, Report: August 1960, 3 September 1960 #543. CANA GPRA-MAE Boite 110.1.2.
82 These visa applications can be found in CANA GPRA-MAE Boite 91.

Chapter 15
The Hajj and the Raj
From Thomas Cook to Bombay's Protector of Pilgrims

John Slight

Introduction

From the late 19th to the mid-20th century, the British Empire was an overwhelmingly Muslim empire, a fact often overlooked by many scholars of imperial history. By the later decades of the 19th century, the British Empire contained more Muslim subjects than any other power, including the Ottoman Empire. British interactions with their Muslim subjects encompassed a variety of areas related to religious practice. One of the most important of these was the Hajj, the fifth pillar of Islam. As a testament to the importance the British attached to the Hajj, the colonial archives in India contain thousands upon thousands of pages of notes, memos and various other documents that deal with the pilgrimage.[1]

Every year, thousands of British colonial subjects, the majority of them Indian, made the long journey across the Arabian Sea to the Hijaz for the Hajj. They outnumbered pilgrims from anywhere else in the world during the colonial period. Robert Irwin has insightfully argued that 'by the late 19th century so many *hajji*s came from British imperial possessions, and British officials in the Foreign Office and India were so heavily involved in administering and monitoring the Hajj, that it is only a slight exaggeration to describe the Hajj as it was then as a ritual of the British Empire, comparable to durbars and receptions at the British embassies on the Queen's birthday'.[2]

Many studies of the Hajj during the colonial period focus on how empires such as those of the British, Dutch, French and Russians were involved with the ritual from sanitary and security perspectives. Consequently, this chapter seeks to elucidate some understudied areas of Britain's relationship with the Hajj from India. It begins with an outline of the Hajj during the pre-colonial period, in order to contextualize the scale of change to the pilgrimage from South Asia during the colonial period. It then examines the central role of the so-called 'pauper' pilgrims, Thomas Cook's brief involvement with the Hajj from 1886 to 1893, and the vital part played by Muslim employees in Britain's Hajj administrations, especially in Jedda and Bombay. Finally, this chapter will analyse Britain's administration of the Hajj from the port city of Bombay, the main departure point for Indian pilgrims. In many ways, the colonial Hajj administration from Bombay was shaped and run by Britain's Muslim employees.

The pre-colonial period

What was the experience of travelling to the Hajj for those who journeyed from South Asia across the Indian Ocean before the onset of British rule over the sub-continent from the late 18th century? In the 16th century, the Portuguese grip on the ocean's seaborne traffic meant indigenous ships had to get passes from the Portuguese for safe passage to Arabia. Mughal court historian Abu al-Fazl referred to the Portuguese resentfully as a 'stumbling block' to South Asian pilgrims' travels.[3] Piracy was another perennial problem, and Mughal Emperor Akbar (r. 1556–1605) in 1595 forced European trading companies to assist pilgrims by providing armed naval escorts for pilgrim ships.[4] The number of South Asian pilgrims rose due to Mughal patronage. From around 1600–1800, there were approximately 15,000 pilgrims every year out of a total South Asian Muslim population of 22.5

million.[5] Mughal emperors sponsored the pilgrimage to 'stand out as defenders of Islam'.[6] This was similar to other early modern Islamic empires, such as the Ottomans, who 'saw it as their duty to ensure that as many of their subjects as possible could go on pilgrimage'.[7] For those pilgrims lucky enough to be sponsored by the Mughals, their Hajj experience was undertaken, according to one late 16th-century chronicler, 'at great public expense, with gold and goods and rich presents'.[8]

This sponsorship began after Emperor Akbar conquered Gujarat in 1573, which meant that Surat, the South Asian gateway to Mecca, fell under Mughal rule.[9] An imperial edict by Akbar proclaimed that 'the travelling expenses of anybody, who might intend to perform the pilgrimage to the sacred places, should be paid'.[10] The Mughal Hajj caravan left Agra in 1576 with a 600,000 rupees donation for the holy places. Members of the Mughal royal household, which made up part of the caravan, were delayed in Surat until October 1576 while a laisser-passer was secured from the Portuguese so they could cross the Arabian Sea unhindered. In 1577, another caravan left for the Hijaz with 500,000 rupees, and 100,000 rupees for the Sharif of Mecca.[11]

These gargantuan amounts of money caused many 'destitutes' from across the Muslim world to flock to the Hijaz to share in the alms bonus. This trend caused considerable consternation among the Ottoman authorities in the Hijaz. Akbar apparently received many fulsome letters of thanks from pilgrims for his donations.[12] Mughal involvement with the Hajj drew Ottoman ire, viewed as a threat to their role as custodians of the two holy cities of Mecca and Medina. Permission letters from Sultan Murad III (r. 1574–95) and the Governor of Egypt to the Sharif of Mecca ordered that Mughal subjects should return home directly after performing the Hajj.[13] This affected the party of women from the Mughal royal court mentioned earlier, and their large number of retainer-pilgrims, who were accused of indulging in activities contrary to shari'a law. After the return of this party of pilgrims in 1582, Akbar broke off relations with the Hijaz and the Ottomans. The loss of the huge Mughal charitable donations through corruption also contributed towards Akbar's shift in policy towards the Hajj. He regarded Meccans (and his own emissaries) as corrupt. No more Hajj caravans were sent during his reign after 1580.[14] Nevertheless, many destitute Indian pilgrims remained in Mecca 'living in huts in the vicinity of the noble sanctuary, and in the Grand Mosque at night'.[15] Jedda's governor was ordered by the Ottoman sultan to destroy the huts and expel these pilgrims.[16] The issue of destitute pilgrims that plagued British colonial and consular officials had its roots, albeit in a very different context, in the early modern period.

Mughal Emperor Jahangir (r. 1605–27) and his family reinstituted paying for pilgrims' journeys to the Hijaz. For example, in 1612 a ship with 1,500 pilgrims sailed to Jedda under the patronage of Jahangir's mother, and the empress sent 1,700 pilgrims on Hajj in 1619. At the same time, high-level Mughal officials, prominent notables and landowners went on the Hajj, accompanied by large retinues of servants, which were mini Hajj-caravans in themselves. Trade and donations to the holy cities continued. In 1622,

200,000 rupees were sent for trade and to provide alms for poor pilgrims at Mecca and Medina. Lavish gifts were also sent by Mughal notables, such as Mufti Ahmed Sa'id in 1650, who dispatched a diamond studded candlestick and a 100 carat diamond. Emperor Aurangzeb (r. 1658–1707), known as zinda pir (a living saint), was also prolific in his gifts to the holy cities, religious scholars, and 'professional' pilgrims who went on Hajj and ziyara (visit) to Muhammad's tomb in Medina on his behalf. The Sharif of Mecca's ambassadors travelled to India in 1686, 1690 and 1693 to solicit more donations from Aurangzeb. The emperor reinstituted the annual Hajj caravan, the ganj-i-sarai, to Jedda, with the Amir al-Hajj, on a more formal basis, and paid for the expenses of poor pilgrims.[17] As Mughal power waned from the mid-18th century, these links with the Hajj became circumscribed.

Changes to the Hajj experience in the early 19th century

The violent expansion of British control over India led to an accompanying increase in the British presence across the Indian Ocean and the seas connected to this great expanse of water. The appointment of British Consul and Agent Alexander Ogilvie to the Red Sea port of Jedda in 1838 was due to a desire to promote trade links with India, and to protect British maritime interests in the region, which increased after the occupation of Aden in 1839. The Hajj remained a feature of the Hijaz that held only a fleeting interest for British officials. For example, the presence of Indian destitute pilgrims in Jedda in 1853 prompted the consul, George Cole, to ask his superiors how to deal with people who were now British subjects. The response was unequivocal: the Government of India felt it had 'no right to prevent any person who decides to do so from proceeding on pilgrimage'.[18]

In this period, technological advances had a massive impact on the Hajj. The first steamship voyage from Bombay to Suez in 1830, backed by the government of Bombay, was accomplished in only 21 days. The journey used to take many weeks.[19] European shipping companies began buying steamships from the 1840s, and quickly monopolized the pilgrim traffic in the Indian Ocean, although some Muslim firms remained involved.[20] Crucially, steamships made pilgrims' voyages much more affordable to a broader socio-economic spectrum of Muslims.[21] Before the innovation of steamers, poorer Muslims who performed the Hajj generally did so as a part of a contingent of servants to richer hajjis or as recipients of Mughal patronage. The number of pilgrims crossing the Indian Ocean annually increased dramatically as the 19th century continued. This phenomenon was remarked upon by many British officials. For example, in an 1867 House of Commons debate, Sir Stafford Northcote, Secretary of State for India, said he was 'astonished … to see how frequent and close are the communications between India and the eastern side of the Red Sea … Indians are not indifferent to what is passing on the eastern side'.[22] In Northcote's opinion, pilgrims to Mecca were the most important feature of these connections, 'Hundreds and thousands of our subjects go to Mecca year by year, and on their way they gather reports of what is passing in the countries bordering on the Red Sea'.[23] However, many Indians were only able to afford a one-way

passage, they were called 'pauper' pilgrims and will be discussed later. More ominously, this revolution in transport also contributed to the spread of disease.

Hajj, cholera and quarantine

The 1865 cholera epidemic in Arabia was the main catalyst for a more active European (and British) involvement with the pilgrimage. The disease killed 15,000 out of 90,000 pilgrims in Arabia and spread to Europe.[24] After an extensive investigation, Britain's Cholera Commissioners reported that cholera epidemics invariably arose in India, and that the annual sea-borne passage of pilgrims across the Arabian Sea was a significant route by which the disease spread to the Middle East, North Africa and Europe.[25] An international sanitary conference was convened in Istanbul in 1866, which concluded that the best way to protect Europe from cholera was to prevent the disease leaving India. Quarantine measures used by British officials for Hindu pilgrimages would be replicated in the Red Sea, and applied to pilgrim traffic in particular.[26] In Mecca itself, the Ottomans would also institute sanitation measures. European officials were worried about overcrowding on pilgrim ships, and how the shorter journey time across the ocean meant cholera could spread much more quickly. Despite India being the generally agreed source of cholera, Britain was opposed to any sanitary regulation of the Hajj, as it was concerned that any such regulations would be vulnerable to misinterpretation by poorer Muslims, who would view them as interfering with religious practice.

The quarantine measures were widely resented by pilgrims. In 1894, Ali Beg, a Deputy Collector from Manipur, complained of his experience on Kameran Island in the Red Sea: 'the quarantine prohibition is trying us much and is especially troublesome for those who are active and men of work'.[27] His lengthy enforced stay on Kameran led him to pen some poetry as his ship finally left for the Hijaz:

> Of Kameran they speak so bad
> Disgusted as much as they are sad
> The brackish water of its shore
> No tongue may taste it any more
> Oh Kamran thou didst take our peace
> And every comfort did thou cease
> So did thou kindle glowing fire
> As every heart is full of ire
> What raised thy value so much more
> Its nearness to the Arabian shore
> Now let us thank God that He
> Has by His favour made us free.[28]

In 1909, Salar Jung, Cambridge alumnus and a barrister from Hyderabad, wrote in his Hajj narrative about his ship's ten-day quarantine in the Red Sea, 'Nobody exactly knows who is to blame for these haughty commands; but the pilgrims must put up with the inevitable. European powers treat the poor pilgrims most mercilessly, under the fallacious belief that they are taking sanitary precautions for the safety of Europe. We feel sure that similar treatment would never be tolerated by any non-Moslem people.'[29] Barbara Metcalf has insightfully argued that some South Asian Hajj accounts show how their authors internalized British views of governance; the experiences of Ottoman supervised quarantine, Hijazi customs officers and other local officials led these authors to identify with British imperial administration instead of Hijazi administration.[30] Because there have been many detailed studies on quarantine and sanitation in the relation to the Hajj, this chapter will now move on to consider several understudied aspects of Britain's relationship with the pilgrimage in this period.

'Pauper' pilgrims

One key characteristic of the Hajj in the Indian Ocean in this period was so called Indian pauper pilgrims, *miskeen* in Arabic. Their combination of piety and poverty aroused the condescension, consternation and pity of colonial officials. They often only had enough money for a one-way ticket to Arabia, and became stranded there after they had completed the Hajj rituals. This group was noticed by Richard Burton, the Victorian explorer who performed the Hajj disguised as an Afghan doctor in 1853. Burton thought these poor Muslims were motivated to go on Hajj with hardly any money in 'a fit of religious enthusiasm, likest to insanity'.[31] This derogatory attitude towards poor Indian pilgrims extended to the explorer's belief that the British Consul in Jedda should intervene to prevent poor Indian pilgrims from arriving in the Hijaz.[32]

The popularity of Burton's *Personal Narrative of a Pilgrimage to Al-Madinah and Meccah* when it was published in 1855 did not, however, translate into any change in official colonial policy towards poor Indian pilgrims. It was only in 1291/1875–6 that the phenomenon caught the attention of colonial and consular officials. That year, the British Consul in Jedda demanded that his superiors in India should address the issue. George Beyts thought it 'very undesirable … if only for the sake of British prestige, leaving humanity aside, that large numbers of human beings should be suffered to die from want of food, water, and transport back to their countries within sight of the British Consulate, or as in fact with its very flag moving over them'.[33] Beyts believed there were so many destitute Indian pilgrims in the Hijaz outside the front door of the British Consulate because they had been sent on Hajj by wealthier Muslims, who paid for their one-way ticket as a way of gaining spiritual reward. The authorities in India ordered a lengthy investigation into this, which led local British officials across India to ask a variety of Muslim officials who were their colleagues as well as local Muslim community leaders about the Hajj. These documents form a remarkable corpus of information about the Hajj from India during this period. Overall, British officials tasked with consulting with Muslims about this aspect of the Hajj, aside from proving Beyts' theory incorrect, displayed a marked reluctance to recommend any regulations that would prevent poor Indian Muslims going on Hajj, because of the negative impact this would have on broader Anglo-Muslim relations in India.

The results of these enquiries across India about poor pilgrims and the Hajj reflected a wider concern among British colonial officials about upholding their policy of non-interference with religious practices which was enshrined in Queen Victoria's 1858 proclamation to Indians after the 1857 Rebellion. During their enquiries, local officials frequently found strong opposition to any idea that

the colonial government should prevent poor Muslims going on Hajj. The government of India took a laissez-faire attitude: government repatriation of destitute pilgrims was rejected because it would encourage more poor pilgrims to go on Hajj.[34] Officials placed a huge value on Muslim opinion, which was critical in reinforcing Britain's policy of non-intervention in this aspect of the pilgrimage. Gauging Muslim opinion on potential changes to government policy regarding something as important as the Hajj was seen as vital by colonial officials, a stance which continued until the end of British rule in 1947. However, it is important to remember that the Muslim opinion presented in the colonial records was, unsurprisingly, highly unrepresentative. Women were not consulted by the British, due to the obvious difficulties of doing so. The Muslim officials and community leaders consulted were generally drawn from the wealthier and higher educated sections of Indian Muslim society. Their closeness to the local British officials who undertook the exercise undoubtedly informed how they couched their views on the Hajj to the British. In light of this, local Muslim notables were asked to convene meetings at mosques where a wider cross-section of the community was consulted. However, the socio-economic profile of these group meetings was manipulated by the British as evidence of what they saw as the ill-considered opinions of poor and ignorant Muslims. Furthermore, as these reports came in from across the Raj, regional prejudices held by the British were reinforced; for example, the opinions of Mappillas and Pathans were dismissed due to their supposed fanaticism, and those of rural Bengali peasants castigated due to their supposed ignorance on religious matters.

The responses of some Muslims to the consultation conflicted with the idea that the pilgrimage rendered all Muslims equal. Throughout these documents, those Muslims consulted drew a clear distinction between themselves and Muslims who were poor and largely uneducated. Several thought it 'improper' that pilgrims begged to fund their travels. Others believed that the Qur'an prohibited the poor from going on Hajj. Muslims elites invoked the spectre of potential Muslim unrest if the colonial government introduced any travel restrictions for poorer pilgrims, and stressed that any such measures would be seen by uneducated Muslims as an interference with their Islamic faith.[35] Consequently, then, it was not just colonial officials who could manipulate the socio-economic stratification of India's Muslim population to buttress arguments for maintaining the status quo. One gentleman consulted, Maulvi Hamid Bukht Mozumdar, thought cautioning poor Muslims against going on Hajj would have no effect. His father had done so many times, and was ignored.[36] The desire to perform Hajj trumped worldly matters of finance. The destitute pilgrim was a potent image of the British Empire's inability, and unwillingness, to control these religious travellers.

Records of pilgrim numbers show the scale of the destitute pilgrim issue throughout the colonial period. To give one example, in 1885, of the 53,000 arrivals by sea to Jedda, 8,300 were from India, and of these, 2,600 were classed as destitute (that is, unable to afford a passage back to India). Later, in 1887, there were 10,324 arrivals by sea from India, of which 4,955 were destitute.[37] The Indian 'pauper' pilgrim was a seemingly permanent feature of the Hajj from India during this period. The issue remained intractable, to the consternation of British officials who despairingly compared the situation to pilgrims from other Muslim areas under European rule, such as the Dutch East Indies, and also British Malaya. Both territories required pilgrims to provide money for their return passage to prevent destitution.

Thomas Cook

A singular development in the Raj's association with the Hajj was when Thomas Cook was appointed as the official travel agent for the Hajj from 1886 to 1893. The difficulties pilgrims faced on voyages across the Indian Ocean prompted the government of India to search for solutions, while simultaneously trying to remain at a distance from the issue. Engaging a private company was one way of doing this.[38] This novel experiment in attempting to manage the transportation of pilgrims proved to be short lived. The company could not make a profit when most of its customers were poor pilgrims.

Thomas Cook's connection with the Hajj was precipitated by several scandals related to voyages on pilgrim ships. The ill-fated voyage of the steamship *Jeddah* was used by Joseph Conrad as a template for a scene in his novel *Lord Jim*.[39] In August 1880, the ship sailed from Penang, in British Malaya, and sprang a leak near the Gulf of Aden. The *Jeddah*'s European officers abandoned the ship and its pilgrim passengers. However, the pilgrims saved the ship and it was towed into Aden. This prompted a storm of outrage at the conditions on pilgrim ships and various official enquiries.[40]

Similar problems had occurred on pilgrim ships that sailed from India.[41] The Indian Viceroy approached Thomas Cook's son in 1885, requesting that the firm reform the transportation arrangements for the Hajj from India.[42] Thomas Cook would be the sole travel agent for the Hajj, and would have control over the Pilgrim Department in Bombay. Cook would arrange with railway and steamship companies for pilgrims' travel and publish fare prices. The government would cover any losses the firm incurred. Cook's son, John Mason Cook, said, 'I know this business is surrounded with more difficulties and prejudices than anything I have hitherto undertaken'.[43] The first page of an 1886 report by Cook's employees on conditions in Jedda related to the pilgrimage gave an indication of the scale of the task facing the company; during a conversation with boatmen in Jedda harbour, accompanied by the British Consul Thomas Jago, they were told that 'although some of the pilgrims are overcharged it does not amount to very much and it is reckoned that nearly a fourth of the Indian pilgrims are paupers or declare themselves as such and have to be landed for nothing or as much as the boatmen can squeeze out of them'.[44] His firm had to deal with the thousands of poor pilgrims who flocked to Bombay every year, who faced unscrupulous pilgrim brokers, interminable waits for steamships, over-priced accommodation, and over-crowded ships. The travails faced by Cook showed how the pilgrimage in this period had become an overwhelmingly non-elite activity.

Cook's management of pilgrim transportation faced significant criticism. For example, the Bombay newspaper *Mauj-i-Nerbudda* contained a critical article which described how the firm over-sold tickets for ships (**Pl. 1**). The eyewitness reporter wrote of crying children who had been left behind as their parents had departed for the Hijaz.[45] Other claims were harder to refute in another case, when 23 men with tickets were not allowed to board a ship due to lack of space.[46] The Government of India distanced itself from Cook, stating it had no 'direct concern' with pilgrim traffic.[47] Cook swiftly realized that the pilgrim business was unprofitable because his customers were mostly poor. The government refused to pay for Cook's losses, and the contract was terminated in 1893.[48] The brief association Thomas Cook had with the Hajj was evocative, but signalled the limits of British attempts to reform pilgrims' travels.

British attitudes and responses to indigent pilgrims were shaped by a desire to ameliorate the issue due to their negative impact on the British Empire's prestige in Arabia. This occurred within a wider context of intense imperial rivalry among the Ottoman, British, Dutch and French empires around the issue of the Hajj, which in turn was part of a larger competition for power and resources that extended far beyond Arabia.[49] Indeed, Britain's Hajj bureaucracies developed alongside concurrent administrative efforts in other empires that had a stake in the pilgrimage. For the British, this seemingly inexorable impetus for greater engagement with the Hajj sat uneasily with a concurrent wish to uphold non-interference in their subjects' religious practices, a stance that was heavily influenced by Muslim opinion solicited by the authorities. The interpretations by British officials of a tiny section of Indian Muslim views on the Hajj, derived from highly selective consultation processes, were central in driving colonial inaction on Hajj-related issues. One vital aspect which emerged from Britain's consideration of destitute pilgrims was the acute need for greater Muslim involvement in Britain's nascent Hajj bureaucracies.

Muslim employees

The first set of Muslim employees employed by the British to engage with the Hajj arose partly from suggestions from the respondents involved in the consultation of Muslim notables referred to above.[50] However, an equally important stimulus to this trend was the necessity of having a Muslim employee with medical experience who could travel freely to the holy places to report on sanitary matters, and who could assess the impact of the quarantine stations in the Red Sea which had been established in 1877 as part of the wider efforts to arrest the spread of epidemic diseases. The first person to fulfil this role was Assistant Surgeon Dr Abdur Razzack, who was sent on Hajj every year from 1878–82 by his British employers in India.[51] His employment as the first Indian Muslim Vice-Consul at the British Consulate in Jedda was formalized in 1882. Once ensconced in his new position, Dr Razzack began to repeatedly argue for further imperial intervention in the administration of the Hajj, in India and the Hijaz. This stood in stark contrast to his colleagues, those British officials who echoed the official policy of the Raj towards the Hajj: non-interference. It was Muslim

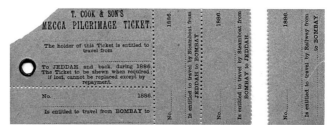

Plate 1 Mecca pilgrimage ticket issued by Thomas Cook and Sons, 1886. Thomas Cook Archive, Peterborough

employees within the colonial bureaucracy like Dr Razzack who tended to formulate and suggest measures related to the administration of the Hajj. Indeed, they were of vital importance to Britain's ability to interact with various aspects of the Hajj, a fact attested to by officials in India who recognized that Dr Razzack had the greatest knowledge of conditions in the Hijaz for pilgrims.[52] Britain would have been unable to have any involvement with the Hajj were it not for Muslims such as Dr Razzack.

The doctor's murder in 1895 by Bedouin tribesmen while out walking with the British Consul in Jedda, W.S. Richards, underscored his importance to Britain's engagement with the pilgrimage. In Richards' words, Dr Razzack's death, was an 'irreparable loss…. He was well educated, with a keen intelligence, an upright, straight forward, fearless character. After thirteen years residence here no one was more respected in Jedda.'[53] Razzack proved that Muslim employees were a vital component of Britain's dealings with the pilgrimage.

Dr Razzack's immediate successor as Vice-Consul, Dr Mohammed Hussein, was also highly valued by his employers, and played an important part in shaping British understanding of the Hajj. In his 1896–7 Hajj report, he noted how improvements in transportation had enabled more pilgrim guides to travel to India and popularize the Hajj, a trend also noted by Muslim officials in Bombay.[54] During the celebrations in Jedda for Queen Victoria's Diamond Jubilee in 1897, Dr Hussein, along with Indian merchants who had settled in Jedda, established the 'Jubilee Indian Pilgrims Relief Fund'.[55] Queen-Empress Victoria's Diamond Jubilee served to institutionalize Britain's first foray into the relief and repatriation of destitute pilgrims.

These Muslim employees served as crucial intermediaries between British officials and their pilgrim-subjects. Despite their position in the imperial and consular bureaucratic hierarchy, men such as Razzack and Hussein held significant influence over Britain's pilgrimage policies and activities related to the Hajj.[56] The considerable degree of agency that Muslim employees possessed will be underscored in the final section, which examines the workings of Britain's colonial Hajj administration from Bombay.

The Hajj from Edwardian Bombay

Bombay was the main port of departure for pilgrims from across India and Central Asia during the colonial period.[57] The city authorities and Muslim community worked together to manage the enormous annual influx of pilgrims to the port. Significantly, the majority of the staff in Bombay's Hajj bureaucracy was Muslim. An elaborate administrative apparatus was in place by 1914, with a

dedicated Protector of Pilgrims in charge of a Pilgrim Department. This was complemented by government-run pilgrim hostels as well as hostels owned by private Muslim citizens, in addition to the vital involvement of the city's wider Muslim community. Although the authorities encouraged such private initiatives, significant amounts of public funds were invested in pilgrimage administration in Bombay and beyond. In 1912, Bombay sanctioned 11,000 rupees per annum as well as a one-off grant of 30,000 rupees to Karachi when it was opened to pilgrim traffic.[58]

At the head of this enterprise was the Protector of Pilgrims, a position established in 1887. The Protector, a Muslim, reported to Bombay's Police Commissioner, and was in charge of the city's Pilgrim Department, staffed by Muslims. Bombay's official involvement with the pilgrimage was an overwhelmingly Muslim enterprise, on a vast scale. Thousands of pilgrims sailed for Arabia from Bombay each year; in 1909, there were 21,000 in total, out of which 13,000 arrived over seventeen days.[59] The Protector's duties were wide-ranging. He visited every vessel that returned from Jedda in order to consult with ship's captains and doctors about health matters, received complaints from pilgrims, visited hostels where destitute pilgrims lodged and arranged repatriation to their homes in the interior. He also answered enquiries from people who wanted news of lost relatives who had gone on Hajj. Moreover, he answered queries from pilgrims that covered a variety of areas such as questions about sailing dates, shipping companies, passage rates, return tickets, passports and other related matters.[60]

In 1912, Bombay's Pilgrim Department consisted of a head clerk, three assistants, an interpreter and a female superintendent. The head clerk dealt with correspondence and was the Protector's main aide. The first assistant kept accounts of the estates of pilgrims who had died while on Hajj. The second assistant responded to pilgrims' letters. The interpreter reported on what was happening in the pilgrim hostels. These were free for pilgrims to stay in for 15 days. Three were government owned; the rest were privately owned. The female superintendent 'attended to the comforts and well-being of all female pilgrims'.[61] The department distributed free copies of the *Bab-e Mecca* ('Gateway to Mecca'), an informational handbook for pilgrims. Muslim policemen were employed at railway stations to escort pilgrims to hostels, and guarded these establishments from illegal pilgrim brokers. Others policed the thousands of pilgrims who had to pass through the disinfection shed on the wharves.[62]

Bombay was a central hub in a web of connections related to the Hajj which encompassed the maritime space of the Indian Ocean, and simultaneously reached into the Indian interior. Bombay's Pilgrim Department was contacted by a variety of local administrations and community organizations for assistance. An Islamic society in Karachi first proposed opening their port city to pilgrim traffic in 1911 to ease the number of pilgrims who passed through Bombay. The idea was enthusiastically taken up by officials.[63] However, Karachi's officials were concerned that their city would be flooded by destitute pilgrims.[64] The outbreak of war in 1914 scotched the plan.

One group that concerned Bombay's Pilgrim Department was pilgrim guides, *mutawwafin* in Arabic. Most guides were Bengalis who lived in Arabia, and travelled to India each year to preach the importance of performing the Hajj to Indian Muslims. Official enquiries in 1909 and 1910 revealed that these men would travel from village to village 'with tales of cheap passages and an easy journey'.[65] They preached at village mosques and saints' tombs about the obligatory nature of pilgrimage. A British official noted that the guides neglected to mention the condition on the obligation to perform the Hajj in the Qur'an, that any potential pilgrims should only go if they have sufficient money to do so, although the phrase in question, *istata'a ilayhi sabilan*, while it has various translations, means 'able' in a more general sense than just having the financial capability to do so.[66] There was a general view among British officials who had some involvement with the Hajj that the extortionate practices of these guides in India and Arabia were responsible for the many cases of destitute pilgrims.[67] The Protector of Pilgrims warned local officials across India to watch out for these guides. They were monitored when they arrived in Bombay and during their travels.[68] Up until World War One, when travel controls were tightened, the authorities were unable to prevent this annual flow of guides between Arabia and India. Guides played a vital role in pilgrims' journeys to the Hijaz, and were key figures in popularising the pilgrimage among a broad swathe of Indian Muslims.

There was a substantial degree of co-operation between Bombay's wealthier Muslim citizens and the authorities. This was unsurprising given that most officials involved in the port's Hajj bureaucracy were Muslims. In 1912, for example, Mirza Mohamed Shirazi donated a sum which enabled 800 destitute pilgrims to be shipped from Jedda to Bombay, a gesture publicly acknowledged by the Government of India. Shirazi's reply underscored how his duty as a Muslim was the primary reason for his generosity: 'what little I have done is in obedience to a call to duty to my co-religionists'.[69] Shah Jahan, the Begum of Bhopal, who had performed the Hajj, funded repatriation efforts, sending 2,400 rupees a year from 1909–12, which enabled hundreds of pilgrims to return to their homes by train.[70] The colonial government's involvement with Bombay's Hajj administration was ultimately driven by pragmatism as opposed to altruism. Nevertheless, this picture of the Hajj from Bombay, the Indian Ocean's premier port, demonstrates the dominance of Muslims, within and outside of the colonial bureaucracy in the management of the Hajj.

Conclusion

Britain became involved in the Hajj in the 1860s in an attempt to halt the spread of cholera, and began an extraordinary association with this religious ritual that lasted for nearly a century. Despite the deeper knowledge the British gained of the Hajj, this chapter has argued for the importance of three key themes that pervaded this aspect of the interactions between British imperialism and Islam: Britain's haphazard and ultimately ineffective attempts to 'control' pilgrims, constrained as they were by the vagaries of colonial policies, doctrines and prejudices; the crucial role played by the Muslim employees of the 'largest Mohamedan power' in facilitating the Hajj experience for their fellow

believers; and the predominantly non-elite nature of the Hajj from the Raj in this period.

Notes

1 For a further example of the extent of British documentation on the Hajj, see Rush 1993.
2 Irwin 2012: 204.
3 Quoted in Digby 2004: 160.
4 Farooqi 1989: 153.
5 Pearson 1994: 52, 58.
6 Farooqi 1989: 113.
7 Pearson 1994: 24.
8 Quoted in Digby 2004: 161.
9 Farooqi 1989: 113.
10 Farooqi 1989: 114–15.
11 Farooqi 1989: 114–15.
12 Farooqi 1989: 114–15.
13 Digby 2004: 162.
14 Farooqi 1989: 116.
15 Farooqi 1989: 118–19.
16 Farooqi 1989: 118–19.
17 Farooqi 1989: 120–6.
18 5 May 1854, Secretary, Foreign Department, Government of India, to H.L. Anderson, Secretary Government of Bombay, in Political, External Affairs – A, 5/5/54, National Archives of India, Delhi (NAI).
19 Low 2008: 273.
20 Ochsenwald 1984: 201. Miller 2006: 98.
21 Bayly 2004: 354–5.
22 Column 372, House of Commons Debate on East India, Troops and Vessels (Abyssinian Expedition) considered in Committee, 28 November 1867, *Hansard*, vol. 190, Columns 359–407.
23 Column 372, House of Commons Debate on East India, Troops and Vessels (Abyssinian Expedition) considered in Committee, 28 November 1867, *Hansard*, vol. 190, Columns 359–407.
24 Peters 1994a: 301.
25 British Cholera Commissioners to Lord Stanley, 3 October 1866, 2, PC 1/2672, National Archives, London (TNA).
26 Maclean 2008.
27 Ali Beg 1896: 48.
28 Ali Beg 1896: 70–1.
29 Salar Jung 1912: 15–16.
30 See Metcalf 1990.
31 Burton 1855–6, II: 185–6.
32 Burton 1855–6, II: 185–6.
33 Capt. G. Beyts, Consul Jedda, to Earl of Derby, Secretary of State for Foreign Affairs, 1 December 1876; Foreign Department, General – A, 1877, No. 125–192, NAI.
34 Government of India to Secretary of State for India, 2 July 1877, Foreign Department, General – A, 1877, No. 125–192, NAI. See also Özcan 1997.
35 See the large collection of letters from Muslim notables and leaders to British officials in Foreign Department, General – A, 1877, No. 125–192, NAI.
36 Moulvi Hamid Bukht Mozumdar, Deputy Collector, Sylhet to Deputy Commissioner of Sylhet, 25 November 1876, Foreign Department, General – A, 1877, No. 125 – 192, NAI.
37 Dr Abdur Razzack, Report on the 1887 Hajj, 15 February 1888, FO 195/1610, TNA in Rush 1993, vol. 3: 761, 783–5.
38 Low 2007: 65–71; Irwin 2012: 198–201.
39 Stape 1996: 65; White 1996: 192–3; See also Sherry 1966.
40 Irwin 2012: 199. Conrad 1900: 7.
41 *The Times of India*, 31 October 1885, 5.
42 Low 2007: 65–71. Harrison 1994: 132–3.
43 Low 2007: 69, quoting Rae 1891: 211–12.
44 'Report of information obtained in Jedda regarding the Mecca pilgrimage', October 1886, p.1, Thomas Cook Archive, Peterborough.
45 Extract from Vernacular Newspapers, 31 July 1888, General Department, 1885, vol. 124, File 138, Maharashtra State Archives, Mumbai (MSA).
46 Memo by Commissioner of Police with report on allegations in extract from *Akbar-i-Churiar*, 18 October 1888, General Department, 1885, vol. 124, File 138, MSA.
47 Secretary, Political Department, Government of India to Agent for Thomas Cook in India, 10 December 1884, General Department, 1885, vol. 124, File 82, MSA.
48 Harrison 1994: 133.
49 See Tagliacozzo 2013.
50 Moulvie Abdool Luteef, Khan Bahadoor, Deputy Magistrate of 24 Pergunnahs, Alipore, to R.H. Wilson, Magistrate, 24 Pergunnahs, Alipore, 14 February 1876, Foreign Department, General – A, 1877, No. 125–192, NAI.
51 Government of India, Calcutta, to Secretary of State for India, London 15th June 1880, Foreign Department, Secret, June 1881, No. 425–6, NAI.
52 Note by W.J.S., 17 March 1890, Foreign Department, External – A, August 1890, No. 149–152, NAI.
53 W.S. Richards, Consul Jedda, to Secretary, Foreign Department, Government of India, 17 June 1895, Foreign Department, Secret – E, September 1895, No. 44–64, NAI.
54 Jedda Vice-Consul Dr Mohamed Hussein, Report on the Mecca Pilgrimage 1896–7, 1–2, Foreign Department, External – A, March 1898, No. 206–215, NAI.
55 George Devey, Consul Jedda, to Ambassador, Constantinople, 25 June 1897, FO 195/1987, TNA.
56 Slight 2012.
57 For accounts of pilgrims' journeys from Bombay in Urdu travelogues, see Green 2011.
58 Government of Bombay Resolution, 26 April 1912, General Department, 1912, vol. 130, File 916, MSA.
59 Protector of Pilgrims, Report on Pilgrim Season ending 30 November 1909, 9 April 1910, General Department, 1910, vol. 134, File 615, MSA; Protector of Pilgrims, Report on Pilgrim Season 1910, 10 May 1911, General Department, 1911, vol.158, File 992, MSA; Moulvi Abdulla Ahmed, Protector of Pilgrims Bombay to Commissioner of Police, Report of Pilgrim Season 1911, 10 June 1912, General Department, 1912, vol. 131, File 992, MSA; Protector of Pilgrims Bombay to Commissioner of Police, 28 April 1913, General Department, 1913, vol.141, File 992, MSA.
60 Protector of Pilgrims, Report on Pilgrim Season 1910, 10 May 1911, General Department, 1911, vol.158, File 992, MSA.
61 Protector of Pilgrims, Report on Pilgrim Season 1910, 10 May 1911, General Department, 1911, vol.158, File 992, MSA; Protector of Pilgrims, Report on Pilgrim Season season ending 30 November 1909, 9 April 1910, General Department, 1910, vol.134, File 615, MSA.
62 Protector of Pilgrims, Report on Pilgrim Season season ending 30 November 1909, 9 April 1910, General Department, 1910, vol. 134, File 615, MSA.
63 Karachi was opened to pilgrim traffic in 1897 and 1900–1 due to plague in Bombay.
64 Lawrence, Collector of Karachi to Commissioner, Sindh, 27 October 1910, General Department, 1912, vol. 130, File 916, MSA.
65 Lawrence, Collector of Karachi to Commissioner, Sindh, 27 October 1910, General Department, 1912, vol. 130, File 916, MSA.
66 S.M. Edwardes, Commissioner of Police, Bombay, to Collector of Customs, Bombay, 21 September 1910, General Department, 1912, vol. 130, File 916, MSA. See also Moulvi Abdulla Ahmed, Protector of Pilgrims, Bombay to Commissioner of Police, Bombay, Report of Pilgrim Season 1911, 10 June 1912, General Department, 1912, vol. 131, File 992, MSA. I am grateful to the peer reviewer for clarity on this phrase in the Qur'an regarding Hajj.
67 Protector of Pilgrims to Commissioner of Police, Bombay, 8 July 1909, General Department, 1910, vol. 134, File 615, MSA.
68 Protector of Pilgrims, Report on Pilgrim season 1910, 10 May 1911, General Department, 1911, vol. 158, File 992, MSA.
69 Secretary, Government of Bombay to Mirza Mahomed Shirazi, 6 May 1912; Mirza Mahomed Shirazi to Secretary, Government of Bombay, 28 May 1912, General Department, 1912, vol. 130, File 691, MSA.
70 Edwardes, President of Hajj Committee, Bombay to Secretary, Government of Bombay, 28 February 1912; M.F. O'Dwyer, Agent to Governor-General of Central India, Indore, to Secretary, Government of Bombay, 22 April 1912, General Department, 1912, vol. 133, File 682, MSA.

Chapter 16
Pilgrim Pioneers
Britons on Hajj before 1940

William Facey

This article aims to provide a brisk overview of early Britons known to have performed the pilgrimage to Mecca, from the first recorded one in 1685–6, to the first known woman convert to have done so in 1933.[1] These ten travellers form a cavalcade of very disparate characters spanning the entire religious spectrum from complete unbelievers to the genuinely devout.

It might be asked: why stop at 1940? The reason is that the 1930s, the decade that saw the signing of the first oil concession and the discovery of oil in commercial quantities, marked the close of the pre-modern era in the lands that today comprise the Kingdom of Saudi Arabia. These journeys all took place before Saudi Arabia made the transition to rapid modernization, one result of which was the institution in the 1950s by King 'Abd al-'Aziz of the first projects to extend and upgrade the cities of the Muslim holy places, a process culminating in the total transformation in recent years of pilgrim travel, of the cities of Mecca and Medina, and of the Hajj experience itself. The accounts presented here therefore constitute an invaluable record of the holy cities and the pilgrimage in former times, while those from the early 20th century additionally record the first harbingers of modernization such as the Hijaz Railway, motor transport and the early enforcement of law and order.

In considering these ten travellers, an obvious starting point is their essential Britishness. Most went to the Hijaz during the great age of British exploration in the 19th and early 20th centuries. Penetrating the unknown was a national pastime, and forbidden cities behind the veil of Arabia presented a tantalizing challenge. They were an affront to the presumption that an Englishman, at the height of empire, could go anywhere he liked. Little wonder then that most of the ten – everyone from Joseph Pitts to Lady Evelyn Cobbold, with the exception of Lord Headley – was a full- or part-time explorer. There is simply no getting away from the fact that the desire to get into Mecca and Medina and to write about them lay at the root of their adoption of Islam.

This gives rise to a related issue of sincerity. Necessarily we are confined to those who took the trouble to record and publish their experiences. For a Muslim, the pure intention to perform Hajj is a vital element of it, which is declared at the outset. The very fact that these people travelled with an ulterior motive – to write about their journeys – already in a way waters down any claim they might have to be truly pious pilgrims. There were undoubtedly many other British converts over the centuries who had performed Hajj for its own sake, with no thought of writing about it, but solely in order to focus on and fulfil their religious obligations – for example Pitts's Irishman in the 1680s (see note 7) and the Bristol-born Hajji Williamson in the 1890s.[2] These people's journeys are mostly lost to history; but it is perhaps among their number that the genuinely pious pilgrims are to be sought.

Then there is the question of literary merit. Travellers in Arabia fall into two quite distinct categories: world-famous stars of exploration, and those who have fallen into almost complete obscurity. But we should resist a prejudice that the celebrities' accounts are necessarily the best, either in terms of literary quality or as records of travel and exploration. John Lewis Burckhardt, Richard Burton and Harry St J. B.

Philby were explorers of world renown whose books are essential reading. Up against them are five writers who are now largely forgotten. Their books soon went out of print, but three or four of them undeniably vie with the works of the famous three as travel literature.

These considerations present us with some criteria against which to judge our ten *hajjis*: their sincerity of belief, their contribution to Western knowledge of Islam and its holy places, and how they rank as writers of travel and exploration.

Islam among the British

Long before European empires came to dominate the Middle East, Britain was brought face to face with Islam first through the Crusades, when there were many converts both ways, and again later through the activities of the Barbary corsairs of North Africa. For three centuries after 1500, Muslim ships based in North African ports captured thousands of vessels and enslaved hundreds of thousands of Christians. It is reckoned that a million or more European Christians, mostly Italian, French, Spanish, Dutch and English, were enslaved in this way between 1500 and 1800. They were captured for ransom, but many abandoned Christianity, became Muslims and changed their names. Other Europeans 'turned Turk' to escape the Protestant–Catholic wars in Europe, or simply because life in the Ottoman Mediterranean was so much more agreeable, and offered opportunities unavailable at home.[3]

By the 18th century, Voltaire could remark on 'the singular fact that there are so many Spanish, French and English renegades whom one may find in all the cities of Morocco'. The French occupation of Egypt in 1799 and the aftermath of the Napoleonic wars produced hundreds more, many of whom flocked to the service of Muhammad 'Ali Pasha of Egypt. Notable among them was the valiant Thomas Keith of Edinburgh who, as Ibrahim Agha, briefly became governor of Medina in 1815.[4] Then, from the 18th and 19th centuries, as Britain extended its empire into Muslim lands, many more Britons were attracted to Islam, first in India and then in Egypt.

Thus overseas, since the Crusades, it has been much less unusual to be British-born and Muslim than one might think. However, it is one thing to be a British convert living abroad, and quite another for educated Britons voluntarily to convert at home for intellectual reasons, going against the grain of a Christian society. It is not until the second half of the 19th century that such middle- and upper-class converts began to feature.

All the pilgrims dealt with here, except for Pitts and Burckhardt, coincided with this phase in the development of British Islam. Although their pilgrimages seemed exotic and strange to the public at the time, as converts they were far from alone. There were plenty of others, then as now including members of the upper echelons of society. Among them were William Henry Quilliam, a solicitor from the Isle of Man who in the 1880s set up the first mosque in Liverpool; the brilliant and eccentric Lord Stanley of Alderley; the renowned Qur'an translator, Muhammad Marmaduke Pickthall; Sir Abdullah Archibald Hamilton; Sir Jalaluddin Lauder Brunton; Lord Hothfield; and the fox-hunting Mrs Aisha Fitzwilliam.[5]

By this time, the idea of Englishness was becoming rooted more in language and culture than in religious affiliation. Faith had begun its retreat from the public sphere, and was becoming increasingly a matter of personal choice. One could select one's religion, as a matter of personal preference, from the buffet of faiths on offer, some of them newly invented, such as Mormonism, Baha'ism, Christian Science, the teachings of Gurdjieff and Ouspensky, and so forth. To adopt another faith was no longer to challenge one's English identity. British converts to Islam at this time have to be viewed in the context of this eclectic, personal and private European attitude to religious belief. It would not have occurred to them to advocate the public dimensions of their Muslim faith at home by, for example, adopting norms of Muslim dress and identity, nor did they evince much self-consciousness of belonging to a broader Muslim community.

Joseph Pitts of Exeter, 1685–6

Joseph Pitts of Exeter (*c.* 1663–*c.* 1739) is conventionally reckoned to be the first Englishman to perform the Hajj.[6] This is most probably not the case, and can be claimed only because so few of the many converts in the 16th and 17th centuries took the trouble to write about their lives as Muslims. Pitts himself met, among others, a very committed Irish convert in Mecca.[7] What can be said for certain is that Pitts's book is the earliest eyewitness account in English of the Hajj, as well as of Mecca and Medina. His book, *A Faithful Account of the Religion and Manners of the Mahometans*, was first published in 1704, with a fuller edition in 1731, and is a rich and fascinating memoir of his captivity and travels, as well as of Muslim ritual and daily life in North Africa and Arabia.[8] It is the first insider's description in English of Muslim society, which makes it uniquely important.

Born in Exeter around 1663, Pitts had a basic education before going to sea as a boy. On his very first voyage in 1678, his small fishing boat was captured off Spain by an Algerian corsair vessel, whose Muslim captain turned out to be a Dutchman and the first mate an Englishman. Nothing of what subsequently befell Pitts did he choose to undergo, and this sets him apart from all our other *hajjis*. Sold twice as a slave in Algiers to cruel masters, Pitts underwent forced conversion to Islam. Sold on again, he accompanied his kindly third master on pilgrimage to Mecca in 1685 or 1686. Having arrived in Jedda by dhow from Suez, the pair spent about four months in Mecca before going on to Medina. As an English slave, Pitts's identity was never any secret.

One of the recurring themes in his book is his admiration of Muslim devoutness and punctilious adherence to their rules and rituals, which he holds up as an example to Christians, while his moving descriptions of the pilgrims' emotions as they performed the Hajj ceremonies foreshadow many similar accounts in later travellers. He says, for example, 'I profess, I could not choose but admire to see those poor Creatures so extraordinary *devout*, and *affectionate* … and with what *Awe*, and *Trembling*, they were possess'd; insomuch, that I could scarce forbear shedding of *Tears*, to see their Zeal'.[9] And later at the Standing at 'Arafat:

> It was a Sight, indeed, able to pierce one's Heart, to behold so many Thousands in their Garments of *Humility* and

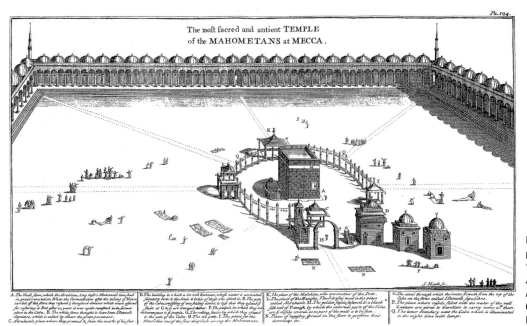

The moſt ſacred and antient TEMPLE
of the MAHOMETANS at MECCA.

Pₑ.124.

A.*The black ſtone, which the Arabians, long before Mahomet's time, had* | D.*The building in which is the well Zemzem, whoſe water is accounted* | K.*The place of the Malekies, who are another of the Sects.* | O.*The canal through which the water floweth from the top of the*
in great veneration. When the Carmathians after the taking of Mecca | *ſalutary look to the ſouls & bodies of thoſe who drink it.* E.*The gate* | L.*The place of the Hanifees. The Schafies meet in the place* | *Cabe on the ſtone called I.Damagh, ſepulchres.*
carried off this ſtone they refuſed a thouſand deniers which were offered | *of the Cabe, conſiſting of two folding doors; to look their they aſcend f* | *called Abrahams.* M.*The golden ſeſtoon faſtened to a black* | P.*The place where veſſels filled with the water of the well*
for reſtoring it. But after 22 years it was again reſtified in its former | *floor at G, & is arranged thither.* F.*The pulpit, in which they make* | *ſilk vail of Damagh, by which the external parts of the Cabe* | *Zemzem are given to travellers to carry home to them.*
place in the Cabe. B.*The white fence thought to have been Iſmaels* | *Mahometans or ſo people.* G.*The rolling ſtairs by which they aſcend* | *are & richly covered, as no part of the walls is to be ſeen.* | Q.*The inner boundary near the Cabe which is illuminated*
ſepulchre; which is called by others the pious pavement. | *to the gate of the Cabe.* H.*The old gate.* I.*The place for the* | N.*Pieces of tapeſtry ſpread on the floor to perform their* | *in the night time with lamps.*
C.*Abraham's place where they pretend to ſhew the marks of his feet.* | *Hanbelites one of the four chief ſects among the Mahometans.* | *devotions &c.* |

J. Mynde, ſc.

Plate 1 Joseph Pitts's pull-out plan of the Ka'ba from the 1731 edition of *A Faithful Account of the Religion and Manners of the Mahometans* (courtesy of Arabian Publishing)

Mortification, with their *naked Heads* and *Cheeks watered with Tears*; and to hear their grievous *Sighs* and *Sobs*, begging earnestly for the *Remission of their Sins*, and promising *Newness of Life*.... It is a matter of sorrowful Reflection, to compare the *Indifference* of many *Christians*, with this *Zeal* of those ... *Mahometans*.[10]

Having become a *hajji*, and having been granted his freedom, Pitts spent several years as a soldier in Algiers before venturing on a daring escape while serving at sea. After a gruelling journey through much of Italy and Germany on foot, he finally reached Exeter seventeen years after he had left. Reunited with his father and his country, he rediscovered his Englishness and returned to Christianity.

Pitts was profoundly affected by his relationship with his childless third master, who treated him like a son and intended to leave him all his worldly goods. He was confident that, had he stayed, he would have done well in North African society. He was sorely tempted to stay on, and he writes affectingly about his mental torment. However, in Pitts's time, unlike today, there was no way of combining being English with being a Muslim. One could not identify oneself as both English and non-Christian and expect to escape ostracism, or worse. The internal struggle between his two identities runs through his narrative, and this simple fact of his identity conflict proves how attracted he was to some aspects of Islam. If he had just been pretending to be a Muslim, he would never have suffered such inner agonies. He frequently protests, in a nod to his critical readership, that he was never a real Muslim at heart. But, in reality, he felt enough of a Muslim to be tortured by the idea that he had betrayed his Englishness. The remarkable thing about his account is that he is honest enough, and brave enough, to present himself as so torn.

Pitts was a man of genuine piety who found much to admire in Islam even though, ultimately, he was unable to relinquish his Englishness. He scores full marks for his contribution to the knowledge of Islam and the Muslim holy places in the English-speaking world of his time. He had never set out to be an explorer and lacked the education and background to be a great writer of travel, but his narrative, in its West Country style, is honest, sincere and compelling.

John Lewis Burckhardt, 1814

For our next *hajji* we have to move on more than a century to 1814. John Lewis Burckhardt (1784–1817) was in fact born Johann Ludwig Burckhardt into a wealthy and cultivated German Swiss family. However, Britain can take much of the credit for him as he was a huge Anglophile who, from his arrival in London at the age of twenty-one, devoted himself to exploration under the aegis of the Association for Promoting the Discovery of the Interior of Africa. His writings, all in English, were published posthumously and established him as one of the all-time great explorers.[11]

He arrived in London with an introduction to the renowned Sir Joseph Banks, one of whose dreams was the discovery of the true course of the Niger. Burckhardt was hooked, and put himself forward for the task. Already fluent in German, French and English, he set about learning Arabic to further a plan to travel from Egypt with a returning Hajj caravan across the Sahara to the Niger. In 1809, he set off for Syria to acclimatize himself to Arab culture. A tall, strapping young man with great fixity of purpose and a zeal for thorough preparation, he spent two years in Aleppo living as an urban Arab, perfecting his Arabic and studying the Qur'an and Islamic law. He also found time to travel widely, and one of his achievements was the modern rediscovery by a European of the fabled rock-hewn city of Petra.

By this time he had taken on a new identity, as Sheikh Ibrahim bin 'Abdullah al-Barakat, respected doctor of Islamic law. The question is: was this new identity a disguise, or did it represent a genuine conversion? It has never been resolved, and his family always denied he had really converted. However, Burckhardt lived as a devout Muslim, was accepted as a Muslim by all around him, and was buried according to his wishes in a Muslim grave in Cairo. Though he never had the chance to be tested by a return to Europe, on balance we should probably accept that he was, to all

124 | The Hajj: Collected Essays

intents and purposes, a Muslim, even though his adoption of Islam might initially have been motivated by his ambitions to explore Muslim lands.

In 1812, Burckhardt went to Cairo intending to join a caravan to Fezzan in Libya. It was delayed and, hating to remain idly in Cairo, he sailed down the Nile to explore Nubia. Then, finding it impossible to penetrate westwards, he changed direction and, in the character of a poor Syrian merchant, made a journey to Sawakin on the Red Sea. He then decided to cross the Red Sea and perform the Hajj.

He spent three months in Mecca, mapping the city and gathering information from a wide variety of informants. He so exhaustively described the rites of the Hajj, the Ka'ba, the Haram (Sacred Mosque), the history of Mecca and the surrounding holy places, as well as the customs and dress of the various classes of Meccan society, that he left little for later travellers to contribute on these topics. Sadly, his three months in Medina were spoiled by illness and he had to return to Cairo, where in 1817, worn out by disease and hardship, he died.

Burckhardt was a modest and self-effacing man, to whom objective observation was all. Unlike other travellers, notably Pitts, Burton and Keane, he leaves himself out of his story when he can. Thus, his careful accounts of travel in Syria, Arabia, Egypt and Nubia are classics of exploration literature, rather than travel writing in the modern sense. There can be little doubt that his Muslim faith was sincere, and his contribution to Western knowledge of Islam and Mecca was unsurpassed in its day.

Sir Richard Burton, 1853

Perhaps the most famous of all British travellers to Arabia, Richard Burton (1821–90), set off on the pilgrimage in 1853. His knighthood and career as explorer of Africa, orientalist, translator of the *Arabian Nights*, cartographer and diplomat lay far in the future.[12]

At thirty-two, rash, extrovert, hot-tempered 'Ruffian Dick', during his career in the East India Company Army had gained a reputation for exotic pursuits, phenomenal linguistic ability, undercover travel involving disguise as a Muslim, impetuous duelling and a 'demonic ferocity as a fighter'.[13] He had also reached a stage in his life when he felt he must do something spectacular to win the official recognition he craved. When, therefore, the Royal Geographical Society approved his proposal to enter Arabia, he set about elaborate preparations in India, even undergoing circumcision to reduce the risk of discovery.

Burton originally intended to use Mecca merely as a jumping-off place to cross the Arabian Desert, explore the as-yet-unknown Eastern Province, take a quick look at that great blank on the map, the Empty Quarter, investigate the possibility of opening up a market for Arabian horses in India, and settle the vexing question of the hydrology of the Hijaz. Thwarted in almost all these aims, instead he produced one of the greatest travel books ever written, *A Personal Narrative of a Pilgrimage to al-Madinah and Meccah*. The word 'Personal' in the title is no misnomer. Unlike Burckhardt, whom he greatly admired, Burton reveals a great deal about himself.

To get to Mecca, Burton disguised himself as an Afghan doctor and dervish – a Sufi holy man. At Suez he booked passage on a dhow for Yanbu', going from there on camelback to Medina. After a month, he joined the pilgrim caravan from Damascus. He was excited by the prospect of following the inland route from Medina to Mecca, for no European had taken it since Ludovico di Varthema, 350 years earlier. Unfortunately, the caravan travelled at night in order to avoid the summer sun, and Burton was able to make only the most cursory of observations. Just before reaching Mecca, caught in a narrow pass, the caravan was attacked by robbers. Several pilgrims lost their lives, and the camel in front of Burton was shot through the heart. The pilgrims entered Mecca later the same night, and Burton had to wait until the next morning for his first sight of the Sacred Mosque and the Ka'ba. This was the climax of his journey:

> There at last it lay, the bourn of my long and weary Pilgrimage, realising the plans and hopes of many and many a year. The mirage medium of Fancy invested the huge catafalque and its gloomy pall with peculiar charms.… The view was strange, unique – and how few have looked upon the celebrated shrine! I may truly say that, of all the worshippers who clung weeping to the curtain, or who pressed their beating hearts to the stone, none felt for the moment a deeper emotion than did the Haji from the far-north.[14]

Deeply moved by the devotion of the pilgrims, Burton describes in detail the actions and prayers which accompany the various Hajj rites, and even managed to enter the Ka'ba. A skilled observer and gifted anthropologist, he visited all the places of interest in the country around Mecca, made copious notes on the customs and dress of the Hijazis, and at last took passage from Jedda to Egypt to write what many judge to be the classic English account of the Hajj and the holy cities.

But Burton, a self-confessed impostor, gets no award for sincerity despite his oft-expressed preference for Islam over Christianity and his empathy with Muslims. And he gets fewer marks than he might have felt entitled to for his contribution to Western knowledge of Mecca, because Burckhardt had beaten him to it on this score. Burton's description of Medina is nonetheless extremely valuable, and his book as a whole is an outstanding literary classic.

Herman Bicknell, 1862

Up until now, European travellers on pilgrimage had dressed as natives of one Muslim society or another, even when, like Pitts and Burckhardt, they were not trying to conceal their European origin. Pitts's and Burckhardt's adopted form of dress was necessitated by a natural need to fit into their social surroundings, not by questionable motives of concealment. In contrast, Burton and others made much of the dangers of being known as a foreigner. Burton felt that foreign converts, or, as he put it, 'new Muslims', however genuine, were as at risk in travelling through Arabia as any foreign infidel.[15] There is no way of knowing, but Burton may have felt that to downplay this danger would have spoiled a good tale. If he had gone not disguised as an Afghan dervish but openly as an English convert, and nothing untoward had happened, his story would have been a good deal less spicy. As it was, in choosing

his Afghan masquerade in preference to conversion, feigned or otherwise, he succeeded in concealing his origins and instead ran a very real danger of being unmasked as an impostor.

Enter an Englishman intent on proving that Burton was wrong about the necessity of disguise, provided one's sincerity as a Muslim was beyond doubt. In 1862, Herman Bicknell (1830–75) became the first European to embark on the pilgrimage in his own clothes – though of course he had to adopt the pilgrim garb before reaching Mecca. Unfortunately, although he must have had some intriguing encounters dressed as he was in trousers and boiled shirt, the only account of his Hajj is in a letter he wrote to *The Times* of 25 August 1862.[16] But he is important in any survey of Western visitors to Mecca for he is the earliest representative of the increasing number of educated Europeans who embraced Islam in the latter half of the 19th century.

Bicknell was from a wealthy and well-connected family in Surrey. He had a cosmopolitan education and became a surgeon in the Indian Army. He then devoted himself to a life of travel and exploration, mountaineering and the study of oriental languages. In early 1862 he started from London as an English Muslim and went to Cairo for a few months of acclimatization to Muslim ways. Was this a sincere conversion? There is no mention of circumcision, but it seems to be true that his wealthy father disinherited him for renouncing Christianity, which implies the conversion was, at least at the time, genuine. In May 1862 he joined a steamer at Suez for the annual pilgrimage to Mecca. This supposedly dangerous venture passed entirely without incident. In his letter to *The Times* he wrote:

> In penning these lines I am anxious to encourage other Englishmen, especially those from India, to perform the pilgrimage, without being deterred by exaggerated reports concerning the perils of the enterprise. It must, however, be understood that it is absolutely indispensable to be a Mussulman (at least externally) and to have an Arabic name. Neither the Koran nor the Sultan enjoins the killing of intrusive Jews or Christians.
>
> Signed: Haji Muhammad Abd ul Wahid[17]

Bicknell died suddenly at the age of forty-five, and was buried at Ramsgate. By then he seems no longer to have been a Muslim; he was described by a former fellow officer as a Catholic in the West and a Mohammedan in the East, who 'lacked fixed principles, and was of an emotional and experimental nature'.[18] On that basis, Bicknell perhaps deserves little credit for deep sincerity, though he does merit a special mention for testing the Muslim attitude to genuine converts by going on Hajj openly in his national dress.

John Fryer Thomas Keane, 1877–8

With John Keane (1854–1937) we have perhaps our first truly modern traveller.[19] Born in 1854, he was the eldest son of the Anglican rector of Whitby, the Yorkshire port. He was a wayward boy and came to lead a picaresque life of wild adventure all over the globe, largely as a merchant seaman, journalist and explorer. He was the classic rolling stone, frequently penniless to the point of destitution, with a touch of the scoundrel, a sympathy for the underdog, a Burtonesque disregard for his own safety, and a genius for self-sabotage.

One thing that is clear from his other books is that, like many parsons' sons then as now, he had little time for organized religion. He was perhaps not actually an atheist, but he says some fairly derogatory things about Christians in his later writings. He had not planned to attend the Hajj, and it was sheer traveller's opportunism that brought him to Mecca and Medina. In 1877, the steamer he was on just happened to stop at Jedda, and somehow he managed to attach himself to the retinue of an Indian grandee performing the pilgrimage.

Jack Keane had a way with words and his two books about his six months in the Hijaz are a rollicking good read. He is a modern travel writer in that, unlike explorers such as Burckhardt, he makes his own adventures, personality and opinions an essential part of his story.

He arrived on the scene when the impact of Western technology on Arabia was beginning to accelerate. European steamships had been calling at Jedda for some time, the opening of the Suez Canal in 1869 had made the Hijaz more accessible, and the British were becoming involved in the welfare of Indian pilgrims and the prevention of disease. Furthermore, his visit antedated the first photographs of Mecca, by Muhammad Sadiq, by just four years. And in a review of his books in the *Graphic Magazine* of March 1882, there appeared a huge engraving of Mecca taken from one of Sadiq's photos.

Having lived in India and served with Muslim sailors, Keane was used to Muslims and could speak Hindustani, but little Arabic. A working man among working men, he is important as his story shines a light on the lower classes in the Hijaz. He suffered indignities and ordeals of the kind not experienced by grander travellers, such as being stoned in Mecca, and being stabbed in the leg en route to Medina, from which he very nearly died. Here he is in irreverent vein on the motley stream of humanity in Mecca:

> After a week or ten days I found I could walk about the crowded bazaars without attracting notice, my fair complexion exciting no curiosity among the chequered masses, nor my ignorance of Arabic giving me any inconvenience where so many nationalities were gathered.… Nor does the style of your get-up make any difference, except that it is advisable not to be too 'swell' in order to avoid attracting beggars, but otherwise the Archbishop of Canterbury doing the *tawaf* in his mitre and robes would not occasion a passing remark, and would be placed nowhere by twenty much more wondrously attired figures.[20]

However, even scoundrels and sceptics are not immune to the impact of the Haram, and Keane was genuinely affected by the displays of piety and devotion.

Keane emigrated to Australia in 1890 and spent the rest of his life as a sugar-cane cutter, explorer, newspaper editor, farmer, inventor, horse trainer and private detective. He was made of tough stuff, and lived until 1937. He had lived as an adventurer, and his Hajj must be seen in that light. As an impostor, he scores nil for sincerity. But his books provide such insight into life in the holy cities, and are written with such verve and observation, that they rate highly as travel literature.[21]

Arthur J. B. Wavell, 1908

Arthur Wavell (1882–1916), a cousin of Field Marshal Lord Wavell, was born in London, and educated at Winchester and Sandhurst. He served with distinction in the Boer War and travelled widely in southern Africa on intelligence missions before resigning his commission in 1906 and settling in East Africa, where he started a sisal plantation. It was here, among the labourers, that his interest in Islam was kindled. He studied the religion, and learnt Arabic and Swahili in Mombasa. From this grew a burning ambition to explore Arabia.[22]

In 1908, Wavell left London disguised as a Zanzibari Muslim, accompanied by a Swahili and a Syrian Arab. He had prepared himself thoroughly and steeped himself in Muslim culture and ritual, but he was not a genuine convert to Islam. In his book he is quite open about his 'deception', as he calls it, and he would have agreed with Burton on the necessity for Westerners to go in disguise however convincing their Muslim credentials might be.[23] The trio set out for Damascus, where they boarded the newly opened Hijaz Railway for Medina. Thus, Wavell's journey took place just as another technological leap forward was making the Hijaz more accessible. He was one of the first Westerners to travel on the railway, which was newly open that very year, slashing the journey time between Damascus and Medina from thirty days to four. Wavell's military career might suggest some ulterior intelligence motive for the timing of his enterprise. However, other British military men had already investigated it, so he was probably innocent of that charge and it is more likely that he intended this journey merely as preparation for farther-flung Arabian explorations.

The threesome duly arrived at Medina, under siege then by Bedouin tribes angry at the opening of the Railway, which had undermined their time-honoured protection racket of taking money from the Ottoman government in exchange for not preying on the pilgrim caravans. The three offered to join in the Ottoman defence of the city, but were turned down on account of their pilgrim status. They then joined a caravan to Yanbuʿ, and caught a steamer for Jedda.

There, donning pilgrim garb and setting out for Mecca on camels, they joined a steady stream of humanity flowing up into the hills. Wavell gives a full and lively description of the Hajj. His account, though an excellent read, is detached; he seems not to get swept up by the emotion of the occasion. But his style is full of energy and humour, and also of impressive depth and background for a person of only twenty-six.

Wavell subsequently visited the Yemen in 1910, but the outbreak of World War I found him back at his plantation in East Africa. He joined up again, and was killed in a German ambush in 1916. He had a genuine interest in Islam but his 'conversion' was motivated by a desire to explore Arabia. His book is a valuable contribution to Western knowledge of the Hijaz at a crucial moment as it was being opened up by the railway, and has considerable literary merit.

Lord Headley, 1923

Rowland George Allanson Allanson-Winn (1855–1935), as he was known from birth before succeeding to his title as Lord Headley and several thousand acres in Ireland, wrote no book about his pilgrimage in 1923, but he did write one in 1914 entitled *A Western Awakening to Islam* as a riposte to his Christian critics. His conversion in 1913 owed much to the influence of Khwaja Kamal ud-Din (1870–1932), from Lahore, who had recently reopened the Woking mosque as a mission of the Ahmadiyya sect. Headley then assumed the name Sheikh Saif al-Rahman Rahmatullah al-Farooq.[24]

Headley believed that Islam could curb the drift towards atheism in Britain. By converting to Islam, he maintained, he had not ceased to be a Christian; on the contrary, it made him a better Christian. In judging Islam to contain the best of Christian morality while dispensing with superstition and a hierarchical priesthood, Headley sought a simple faith that promoted charity, tolerance and brotherhood. He believed, like his contemporary Marmaduke Pickthall, in the centrality of morality to faith; that by pursuing a moral life and correct conduct, a person could almost be a Muslim without knowing it.[25]

Headley went with Khwaja Kamal ud-Din on a much-publicized Hajj in 1923. His pilgrimage was important because he was perhaps the first unassailably genuine English Muslim on record to perform the Hajj for its own sake, with no ulterior motive whatsoever.

A prominent civil engineer with a gift for mathematics, who had been boxing champion at Cambridge, the jovial Headley was well known during his life for his promotion of Islam. But his association with the Ahmadiyya fraternity prevented him from being taken seriously by mainstream Muslims. And his various eccentricities, such as a belief in spiritualism and a campaign against stewed tea as a cause of insanity, prevented his being taken entirely seriously by the British public, who regarded him as an amiable naive prone to tilting at windmills. He died in 1935 at the age of eighty.

Headley conformed to the European perception of faith as a matter of personal and private choice. Despite his total personal sincerity and his public efforts to promote Islam, he never tried to convert other members of his family.

Eldon Rutter, 1925

Eldon Rutter is a Will-o'-the Wisp, the disappearing man of Arabian travel. He emerged from obscurity, went to Mecca and Medina in 1925, and wrote a highly acclaimed book, *The Holy Cities of Arabia*. Later he made at least two other Middle Eastern journeys, and by the mid-1930s had sunk once more into obscurity. He was born probably in London around 1895. Where and when he died are a mystery, although he was still alive in the 1950s.[26]

Rutter became interested in Arabian travellers as a boy, and in Islam while he was working in Malaya after World War I, in which he fought against the Turks. When he left Egypt to go to Mecca he was clearly highly prepared. He had a gift for languages, managing to pass himself off as a Syrian merchant named Ahmad Salah al-Din. Thus he was in disguise, though he himself says this was only because he believed, like Burton, that he would be safer if he was not seen to be a Westerner. Eventually he was actually recognized in Mecca by a Syrian friend and unmasked, but interestingly this did him no harm, as he had put on an entirely convincing display as a Muslim and was universally

accepted as such. From then on he was out in the open, no longer disguised but still in Arab dress, as Salah al-Din al-Inkilizi – Saladin the Englishman. Bicknell would have felt vindicated.

In choosing 1925 as the year to go on the Hajj, Rutter arrived at a critical juncture in the history of the Hijaz. 'Abd al-'Aziz Ibn Sa'ud, Sultan of Najd (King 'Abd al-'Aziz as he was to become), was just then in the process of taking over the Hijaz from King 'Ali, son of Sharif Hussein of Mecca. As Rutter puts it, he arrived as the two poorest countries in the world were at each other's throats. Ta'if and Mecca had been taken by the stern and terrifying Ikhwan warriors, and Jedda and Medina were under siege. Rutter was unable to enter Jedda by sea, so instead took a steamer to Massawa, and a dhow to Qahma on the Tihama coast. From there, taking care to adhere to strict Wahhabi rules, he went by camel to Mecca, following a route breaking new ground in terms of European exploration.

The Holy Cities of Arabia is a remarkable and intensely readable book – an atmospheric and vivid portrait of Mecca and its people with dialogue skilfully presented in an Arabic idiom – and especially noteworthy for the several meetings that Rutter reports with Ibn Sa'ud himself. It is one of the very best books written by a foreigner about Saudi Arabia and rates, among the few who have read it, as a masterpiece of travel writing that has suffered unjust neglect.

Was Rutter a true convert? He is a good example of how difficult it can be to judge. He had spent many months in Egypt preparing and studying Islam, and seems to have been totally at home with Arabic and Muslim ways. He is capable of being deeply moved, for example by his first sight of the Ka'ba. In only two passages does he afford a glimpse of his real beliefs, presenting himself as, like Muslims, a devotee of the One God, apparently along the lines of Unitarian Christianity and in contradistinction to trinitarianism. Thus he was perhaps a Westerner of his time in viewing the major monotheisms as alternative and equally valid routes to the same divine essence, who could accept Islam on those terms.[27] Elsewhere, however, his book is dispassionate and displays little of the rapture of the true *hajji*. According to Philby, he lapsed after his Arabian journeys,[28] and there is no evidence that he died a Muslim, though that is not to gainsay his possible sincerity at the time of his journey.

Harry St J.B. Philby, 1931

'Greatest of Arabian explorers'. So reads the inscription on Harry St John Philby's (1885–1960) Muslim grave in Beirut. Few would quibble with that verdict, though he is perhaps best remembered these days as father of the British double agent, Kim Philby.[29] After Cambridge, which he left as a convinced atheist and anti-imperialist, Philby began his career as a servant of empire in the Indian Civil Service. Posted to British-occupied Mesopotamia (later Iraq) in 1915, he was chosen by Sir Percy Cox to undertake a diplomatic mission to Riyadh. There, in 1917, he met 'Abd al-'Aziz Ibn Sa'ud for the first time and made his first crossing of Arabia. It was the start of a lifelong friendship with the king, whom he fervently admired, and of a love affair with Saudi Arabia that would develop into a difficult marriage.[30]

In 1925, Philby resigned from government service and settled in Jedda, going into business. He wanted to devote the rest of his life to Arabia and its exploration, and fretted that business and travel opportunities were barred to him as a non-Muslim. Conversion was clearly the gateway to realizing his ambitions. In 1930 he took the step, with the king's encouragement, and was immediately escorted to Mecca to make his first 'Umra, or Lesser Pilgrimage.[31]

It is inescapable that he became a Muslim more from convenience than conviction. He confided as much to other Englishmen. Someone once remarked that the great advantage of being an atheist is that you can choose any religion you like according to circumstance, and this more or less fits Philby's case. But it is probably too harsh to say that, once he had taken the step, he was an unsatisfactory Muslim. After all, many of those born into Islam may not always live up to their religious obligations, but they are not thereby disqualified. Stricter judgements, it seems, apply to converts, and accordingly most Arabs and Europeans regarded him as a Muslim in the Western manner, who practised Islamic rules when among Arabs and dropped them when among his own people. But when in Arabia, Philby certainly lived as a devout Muslim. To become a Muslim is to join a community, with its daily rituals and obligations and idioms of everyday life, as much as it is a matter of personal belief. One cannot deny that Philby fulfilled these practical criteria, taking the name 'Abdullah and even attending the Hajj every year for the first ten years or so. And he maintained his membership to the end of his life, dying a Muslim and being buried in a Muslim grave. Whether or not his faith was totally sincere on a spiritual level is another matter.

Philby performed his first full Hajj in April 1931, as described in his book, *A Pilgrim in Arabia*.[32] The Great Depression had slashed pilgrim numbers and revenues, and government coffers were empty. Philby's description of the Hajj is valuable for that alone, but he never rises to the heights of other authors in catching the atmosphere of spiritual exaltation.

By converting, Philby effectively became a member of King 'Abd al-'Aziz's court. Soon after, the king gave him permission for his crossing of the Empty Quarter in 1932, so kick-starting his new life as explorer of Arabia. His many subsequent books and articles on Saudi Arabia are a goldmine of information on every aspect of its people, history and geography. Though they can be somewhat ponderous and archaic in style and no one would claim that they make easy reading, they stand alone as a basic resource for all those interested in Saudi Arabia's formative years.

Hot-tempered and contrarian, Philby was a man of wild contradictions. His guiding principle was to speak his mind whatever the cost. Once, during a conversation at a noisy party, he was heard to declare, 'I didn't hear what you said, but I entirely disagree with you' – an utterance epitomizing his combative nature. He was a patriotic Briton who was interned during World War II as a danger to his country; a socialist who wanted to appease Mussolini and Hitler, and who attached himself to a king; a pacifist who imported arms; a rebel against the British Establishment who was devoted to the Athenaeum and the cricket results, and who

claimed never ever to cheat at *The Times* crossword. The paradoxes in his personality were exemplified by his double life. He had a wife and family in England and, as a Muslim, another in Saudi Arabia. Even in his beloved adopted country, his outspoken criticisms of extravagance and financial irresponsibility, bravely telling truth to power, led to his being asked to leave the country after the death of King 'Abd al-'Aziz in 1953.

Lady Evelyn Cobbold, 1933

Lady Evelyn Cobbold (1867–1963) was, so far as this writer has been able to establish, the first British-born female Muslim convert to have recorded her pilgrimage to Mecca. Performing the Hajj in 1933 as a wealthy 65-year-old divorcee, she published her account of it, *Pilgrimage to Mecca*, in 1934.[33] After a brief celebrity, her Hajj was soon forgotten, and it was not until 2008, when her book was reprinted with a biographical introduction, that her memory was revived.

She cut an extraordinary figure. Mayfair socialite, owner of an estate in the Scottish highlands and accomplished deerstalker and angler, not to mention mother and gardener, she was surely unique in being also a Muslim and an Arabic speaker. It was a childhood of winters spent in North Africa and a chance meeting with the Pope that led her to declare that she had always been 'unconsciously … a little Moslem at heart' and that Islam was 'the religion of common sense'.[34] Thus, unusually, there seems never to have been a specific moment of conversion, nor any public declaration of it.

Her many connections included T.E. Lawrence and Marmaduke Pickthall, and she got to know Philby and his wife Dora by inviting herself to stay at their house in Jedda when she arrived to perform her Hajj. Unlike every other book discussed in this article, hers is as much a record of an interior experience of Muslim faith as a conventional travelogue, and it is as remarkable for its promotion of Islam as it is for its sympathy and vividness. It also provides the first description by an English writer of the life of the women's quarters of the households in which she stayed. Though her book is by no means the best-written of these English accounts, it has the great virtue of sincerity. Furthermore, it is important in describing the Hajj at its all-time nadir in terms of numbers: just 20,000 pilgrims from abroad, and perhaps 50,000 in total, at 'Arafat. Luckily for the languishing infant Kingdom of Saudi Arabia, officially proclaimed just the year before, economic salvation was in the offing: at that very moment in 1933 Philby was arranging the negotiations for American oil companies to gain the Saudi oil concession – with all the consequences we see today.

Like Lord Headley, Cobbold made no attempt to convert her children or other members of her family, nor is there much evidence of Islam in her daily life back home. It could be argued that in this sense she, and others like her, missed one of the essential aspects of being a Muslim: participation in a community identified by public acts, rituals and symbols. There can be no doubt, nonetheless, of the genuineness of her belief, in a European sense, and the fact that she retained it sincerely until her death sets her apart from the other *hajji*s considered here, with the exception of Headley and probably Burckhardt.

Evelyn Cobbold lived on for another thirty years. She died in January 1963, one of the coldest months of the century, and was buried as a Muslim, as she had stipulated, on a remote hillside on her Glencarron estate in Wester Ross. Her splendidly Islamo-Caledonian interment symbolized her two worlds; a piper, so frozen that he was scarcely able to walk let alone perform, played *MacCrimmon's Lament*, and the equally refrigerated imam of the Woking mosque, who had made a heroic journey to the north by train, recited the *surat al-Nour* ('Light') from the Qur'an loudly in Arabic. A verse from the same *sura* adorns the flat slab on her grave, over which the deer now wander, according to her wishes.

Conclusion

To revert to the criteria with which this survey began, the burning question for Muslim and non-Muslim readers alike is the extent to which these foreign converts can be regarded as sincere. Those born into Islam, and in particular Saudi Arabians, are naturally concerned to know whether their holy places have been defiled by infidels posing as Muslims. Burton, the self-confessed impostor, was suspected at the last by his Meccan servant Muhammad, who declared bitterly to his fellow-servant Sheikh Nur, 'Now I understand…. Your master is a Sahib from India, he hath laughed at our beards',[35] so illustrating the deep anxiety felt about allowing Westerners into the sacred precincts. For the rest of these travellers, there has perhaps been a tendency in the literature about them to give them the benefit of the doubt, and to accept claims to conversion at face value without looking more deeply into the complexities of motive and what Michael Wolfe calls 'the malleability of identity',[36] and without taking into account the personal nature of religious belief in the West and its resulting mutability.

It is hoped that this article provides some means of assessing those claims. In brief, it is clear that Burton was an impostor, while Headley and Cobbold, if open to criticism, were completely genuine. Between those extremes, Pitts was pious by nature and found much to admire in Islam, but was ultimately unable to surrender his Englishness and thus his Christianity; Burckhardt was probably sincere but was never tested by a return to Europe; Rutter, at least at the time of his journey, was a theist able to absorb Islam into his belief system; Bicknell, Keane and Wavell passed themselves off as Muslims from ulterior motives, to serve a temporary project; Philby, a chameleon by nature, was able to do the same, but on a permanent basis.

Another feature to emerge from this consideration of the ten British Mecca travellers is that what might be termed the English Hajj corpus emerges as a peculiarly appetizing and fascinating branch of literature in its own right. Though very disparate in character, style, narrative treatment and point of view, when taken together these accounts form a genre that richly deserves continued study and enjoyment. And among them is a largely forgotten literary gem, Eldon Rutter's *The Holy Cities of Arabia*, a work to rank with any of the classics of English travel writing in the inter-war years by the likes of Robert Byron, Graham Greene and Evelyn Waugh.

Notes

1 This article is based on a lecture given by the author at the British Museum on 10 February 2012.
2 Stanton-Hope 1951: 135–61.
3 Cobbold 2008: 64–7; Auchterlonie 2012: 1–96.
4 Facey 1997: 64.
5 Bawany 1961; Facey 2011: 171.
6 Auchterlonie 2012 gives a full account of Pitts's life and pilgrimage, on which this brief account is based.
7 Auchterlonie 2012: 206–7, 210.
8 The 1731 edition of Pitts's book is reprinted in full in Auchterlonie 2012.
9 Auchterlonie 2012: 186.
10 Auchterlonie 2012: 197–8.
11 A full biography of Burckhardt is given in Sim 1969. See Burckhardt 1829 for his travels in the Hijaz.
12 See Burton 1893 for his travels in the Hijaz. Burton remains a perennial subject of biographers. See also Lunde 1974.
13 Wright 1906, I: 119–20.
14 Burton 1893, II: 160–1.
15 Burton 1893, I: 23.
16 Bicknell 1862. Bicknell's letter to *The Times* is reprinted in full, though with an inaccurate signature ('El Haj Abd al Wahid') in Burton 1893, vol. 2: 409–14. More about Bicknell appears in Ralli 1909: 200–3.
17 *The Times*, 25 August 1862.
18 Ralli 1909: 203.
19 For what is known about Keane's life, see Keane 2006: 7–36.
20 Keane 2006: 20.
21 Keane's two books on his travels in the Hijaz, *Six Months in Meccah* (1881) and *My Journey to Medinah* (1881), are reprinted in facsimile in Keane 2006.
22 For his account of his Arabian travels, see Wavell 1912. For more information on Wavell's life, see the introduction to Wavell 1918.
23 Wavell 1912: 177–9.
24 For more information on Headley's life, see Tomes 2012.
25 Cobbold 2008: 69–70.
26 Details of Rutter's life are taken from the introduction to the forthcoming reprint of *The Holy Cities of Arabia* (Rutter 2014); see Michael Wolfe in this volume.
27 Rutter 1928, II: 133, 148–9.
28 Philby 1948: 257–8.
29 For Philby's life, see Monroe 1973; Craig 2012.
30 '...fallen in love with Arabia', Philby 1948: 279.
31 Philby 1948: 278–82.
32 Philby 1943 and 1946.
33 For her biography, followed by a full reprint of *Pilgrimage to Mecca*, see Cobbold 2008: 1–80; a condensed version appears in Facey 2011.
34 Cobbold 2008: 89.
35 Burton 1893, II: 271.
36 Wolfe 1997: 246.

Chapter 17
Eldon Rutter and the Modern Hajj Narrative

Michael Wolfe

This chapter takes the measure of one early 20th-century British traveller's journey to Mecca and Medina and the masterful two volumes he wrote about the Hajj. An initial glance backward at the motivations of a related group of earlier Hajj authors may help readers understand what is important about the man and his work.

On the short shelf of accounts by Western travellers who wrote well about the Hajj, Eldon Rutter's contribution ends one phase and starts another. The phase it ends reaches back four centuries and includes works by a number of non-Muslim authors who performed the pilgrimage, mostly in disguise, and who reported on their experience in European languages to an increasingly interested non-Muslim audience. These works begin with an account by the rough and tumble Italian *renegado* Ludovico di Varthema (in Mecca 1503); followed by an astute, anonymous account collected in Hakluyt (*c.* 1575), the confessional memoir of Joseph Pitts (*c.* 1685), a teenage sailor enslaved for fifteen years in Algiers; then a two-volume work by the Spanish sophisticate Ali Bey al-Abbasi (1807); another two-volume set by Sir Joseph Banks's Swiss-bred informant J.L. Burckhardt (1814); we can add one in 1853 by the ambitious Victorian outsider Richard Burton; another by the good humoured John F. Keene (1877–8); and a handful of others, including the last of the line, a 1908 adventure by Arthur Wavell.[1]

With the exception of the enslaved Pitts and possibly al-Abbasi, these authors may all be defined as masqueraders and impersonators. At a minimum, they have three things in common: most acted on occasion as spies and informants, most exercised a penchant for disguise, and all addressed a certain audience of readers who knew almost nothing of the topic, required reminding, needed extensive detail, close observation, anecdotal evidence, history, ethnology, sociology, economics, and all the help they could get to understand the people, faith and cultures of lands which, in many cases, their governments were then invading, conquering, administering or ruling, including, for a few centuries, virtually the entire Middle East, India, Africa and the South China Sea.

For the older European impersonators and masqueraders, up to and including Richard Burton (1821–90), the notion of Mecca as forbidden was an unquestioned given. This taboo, whether at the entry gate or branded into Western consciousness, defined and partly energized their exploits. It supplied suspense and tension to their tales. Historically impregnable to proselytism and conquest, Mecca and the Hajj pilgrimage represented a cultural 'Everest' in the masquerader's narrative; a life threatening, nearly unassailable peak where the oxygen is thin and only would-be heroes dared to venture. To penetrate and exit safely was at times received back home as a symbolic conquest. Three hundred and fifty years after di Varthema, when news reached London that Richard Burton had entered Mecca, he became a household name, although he only spent eleven days there.

This trope of an impenetrable Mecca was never more than partly true. Even for the earliest masqueraders, entering Mecca depended more on good planning than on daring. In 1503, Ludovico di Varthema, determined to see

Plate 1 An advertisement board at the time of publication of Eldon Rutter's *The Holy Cities of Arabia* (1928). This portrait of Rutter appeared on the jacket of the first edition (by courtesy of Eldon Rutter's literary executor)

the Hajj first hand, befriended a group of like-minded European *renegados* who, becoming nominal Muslims, had hired themselves as guards with the prosperous, bustling Damascus-to-Medina caravan. Joining their company, Varthema entered the city without a hitch as a paid official. His camouflage, in a sense, was the Hajj itself. Burton's later, more elaborate masquerades do not accurately indicate how hard or simple it may have been to trespass into Mecca. He asks his readers to see his disguises as mortal necessities, but they seem more truly a narrative device foregrounding the imperial hero's talents, especially his skill as a cultural chameleon. Presented as a requirement of safe travel, these subterfuges seem in reality to be personae undertaken to entertain the audience and to serve the interests of the performer. The performance was what counted, to author and reader alike. Indeed, nearly all the readable books by European pilgrims in disguise treat entering Mecca and performing the Hajj as an adventurer's personal best, an imperial exploit. Like a forbidding mountain or a desert, it is there to be climbed, to be crossed, described, packaged and delivered. It is a backdrop for traveller's bravura in the theatre of empire.

Later impersonators do not drop these subterfuges. Some accounts do make one wonder how necessary all the posturing was. When the young ex-soldier Arthur Wavell (1882–1916) arrived in Mecca, fifty years after Burton, he encountered no suspicion whatever. A shaved head, an Arab robe, reasonable command of Arabic and a passing acquaintance with Muslim manners were all that were required for safe passage – 'safe' here meaning that they were never unmasked. As for heroics and Burtonesque gunplay, when a battle ensues along the Medina railway and Wavell attempts to join the fray, he and his companions are asked to stand down, not because his loyalty or costume is suspect, but because he is a pilgrim, an agent of peace not of empire, for whom firing a rifle is inappropriate. This is a different figure than the British marksman in Muslim garb that Burton presents along the pilgrim way. With Wavell,

there are no cloak and dagger trappings either. Though he was almost certainly riding the new Ottoman-funded railway from Damascus with an assignment to report back to London, he makes nothing of this intrigue in his book.

The last of the European impersonators, Wavell wore his disguise more easily than his predecessors did. He also paid more attention to how the Hajj experience touched the Muslim pilgrims he travelled with. Through his valet and sidekick Masaudi and the Syrian Hajji ʿAbd al-Wahid, Wavell was able to convey the spiritual character of Mecca and the impact of the Hajj, not on trespassers in false beards reporting back to Whitehall, but on actual Muslims undertaking the central spiritual event of their lives. Now and then in their company Wavell even sheds his own ironical commentary for a more visionary view. 'Makka', he writes insightfully, 'is a place hardly belonging to this world, overshadowed like the Tabernacle of old by an almost tangible presence of the deity'.[2]

The publication in 1927 of Eldon Rutter's 500-page adventure, *The Holy Cities of Arabia* (**Pl. 1**) inaugurated a fresh stream of writing by modern Western Muslims, some of them converts, like the Austrian polymath Muhammad Asad (in Mecca 1927) and the American civil rights activist Malcolm X (1964), others Muslims born and raised, including the Iranian author Jalal Al-e Ahmad (1964) and the Moroccan American anthropologist Abdullah Hamoudi (in Mecca 1999). Like Wavell, Rutter intended to travel to Mecca with a born Muslim. In Rutter's case, however, his would-be companion, a young Meccan named Nur al-Din Sharqawi, dies at the outset (on page one) as the two friends are preparing their journey in Cairo. Rutter is left standing at the Suez railhead with a barometer, a compass and no guide. So begins one of the more hair-raising journeys on record, as a modern Englishman of twenty-five wends his way toward an Arabia engulfed by bloody civil war.

At the time when Rutter set out, the Red Sea ports and Hijazi roads as well as Mecca and Medina were bristling with hostile armies led by two warring princes, Sharif ʿAli, the all but defeated regional Hashemite ruler, and the triumphant besieging Najdi insurgent, ʿAbd al-ʿAziz ibn Saʿud. For the year 1925, in addition to marking the end of a certain type of Hajj travel writing, was also the year when a rising power, 600 miles to the east, finally put an end to seven centuries of Meccan rule by its generations of locally born Sharifs. The ensuing upheaval was widespread and, for bystanders, possibly fatal. In response, rather than place thousands of pilgrims in harm's way, the Egyptian religious authorities had recently issued a ruling releasing Muslims from their obligation to perform the Hajj. In the previous century, Rutter's two great predecessors, Burckhardt and Burton, had found safety in numbers. There were no numbers for Rutter to hide among in 1925. 'Usually', he notes, 'some 15,000 Egyptians go to Mecca annually'. That year there were none.

Being British, Rutter is often lumped together with the religious impersonators who went before him. This assertion, while not well founded, nonetheless raises interesting questions. On paper, Rutter seems to have been so at home in Islam's heartland and so well informed about Islam and Muslim cultures, that we may wonder how he

came to such a thorough engagement with the religion. Likewise, we might ask how this relationship fared in the decades after his return to England. Did he remain a practising Muslim in later life? Did he join a Muslim community in England? What, if any, subsequent path did he pursue as a British Muslim or professional Arabist?

The historical record is all but mute on these matters. What we know about Rutter before 1925 will fit into a single paragraph.[3]

Eldon Rutter was born in London in the 1890s in impecunious circumstances. He may have been raised there or in the south, perhaps in Devon. Sir Percy Cox, the British Indian Army officer and Middle East colonial administrator, reviewing Rutter's book in 1927,[4] presents the portrait of a boy 'hailing from one of our southern counties' who was smitten by the attraction to all things Arabian, which was still such a part of the British imagination. We know nothing of his education, only that his passion for matters Middle Eastern was interrupted by the World War I, when he served as a trooper. Apparently, Rutter emerged with his dreams intact for in 1919 he accepted a post in the Malay states that allowed him to master the Arabic language among immigrant Yemeni merchants. He returned to England in 1924 and soon travelled to Egypt to begin to carry out, so Cox asserts, a long-held plan to perform the Hajj and write about it.

After Rutter's return and the publication of his Hajj books in 1927, we hear of three lectures he offered at the Royal Asiatic Society in 1929, 1930 and 1933. In addition, there are two accounts of a journey from Damascus to Hail published in British journals.[5] We know very little about him after the mid-1930s. At a lecture entitled 'Slavery in Arabia', delivered to the Royal Central Asiatic Society in March 1933, the chairman of the event, Lord Frederick Lugard, the British soldier, mercenary and colonial administrator, introduced Rutter as 'one of the greatest living authorities on present day conditions' in Saudi Arabia.[6] Rutter was married in a church around that time, to a woman from Devon. He was still alive in the mid to late 1950s. As for faith, we are left to guess the long-term religious disposition of this gifted author, traveller and linguist.

Reading his two Hajj volumes in a vacuum, one would have no reason to doubt that Rutter was a believing Muslim at the time of his journey. Though some may see evidence of irreligiousness in Rutter's passion for adventure or in his desire to make a name for himself, neither motivation precludes his having been a believing Muslim. We find similar motives in such great, and unquestioned, Hajj author-travellers as Ibn Battuta, Ibn Jubayr and Malcolm X. Only when one takes into account the doubtful character of other reports by Europeans and Britons before him, do questions of personal authenticity arise. It is the Hajj books of Burckhardt, Burton, Keane, Wavell and a few others, all European and mostly imperial British informants performing the Hajj in self-styled masquerade, that by association call Rutter's good faith into question.

Nothing on record supports this. Neither a connection to a government nor a military sponsor has come to light. Nor does any remark in his 500 pages suggest that Rutter's motives were insincere or even very self-serving. Edward

Thompson, reviewing the book for Americans in the *Saturday Review* in 1929, described Rutter in passing as 'a professing Muslim'.[7] Sixty years later, a reader as careful as F.E. Peters, quoting Rutter in his history of the Hajj, accepts him as a British convert travelling disguised as a Syrian.[8] The disguise has given some readers pause, especially scholars sensitized by post-modern literary analysis. Here I would argue against construing Rutter's costume as an imposture. His garments and alias on reaching war-torn Arabia are better understood as a protective disguise in an unstable region, than as a gesture of imperial hauteur in the style of Sir Richard Burton or as a mask to hide behind while providing valuable information to British intelligence.

Throughout his book, Rutter presents himself as British on the one hand and as a practising Muslim on the other, without contradiction or need for explanation. No Arab or Muslim who crossed his path in 1925 seems to have questioned his faith or its practice. Through thick and thin, the pilgrim we meet as we read on is plainly determined (like Ibn Battuta at about the same age) to reach Mecca, perform the Hajj rites and write well about it.

Familiar with war and hard travel, Rutter is energetic, credible and accomplished on the page. His chiseled sentences, which rarely contain unnecessary words, stack up like brush strokes in his descriptive paragraphs. His word-for-word rendering of Arabic dialogue, its idioms and syntax, is completely original in the literature, giving readers a consistent feel for the timeless and peculiar ring of a tradition-laden language at work in a rough-and-tumble society. These deftly rendered exchanges create a remarkable verbal italic, setting off the book's conversational passages from the modernist English of its narration. They have the effect of raising speech to poetry in places, rather than reducing verbal exchanges with Arabs to burlesque, as Burton often does.

At the start of his account, Rutter slyly undercuts his predecessors' usual emphasis on a Western pilgrim's disguise: 'I was', he writes in passing, 'dressed in the style of an Egyptian *effendi*; that is to say I wore a European suit of clothes with a *tarbush* [fez] as headgear'. When asked by a tout if he is a *hajji*, Rutter says, 'Yes'. When, on landing in Arabia he changes to the local dress, he makes nothing of it.[9] Even on the deserted, embattled Hajj roads of 1925, Rutter demonstrates how for centuries a single traveller might be peaceably absorbed into the pilgrim stream simply by moving toward his destination. Despite a near absence of traffic, circumstances soon throw him together with a prosperous Meccan trader, the trader's son and two Meccan guides – cicerones in a bad year in a backwater, on the lookout for any business they can find. Rutter's biting but good-humoured portrait of these two *muttawifs* on the make, mealy mouthed, self-involved, hair-trigger, exasperating yet ultimately harmless, is an insightful depiction of the challenges facing the pilgrim in need of a guide at anytime, anywhere. Chaucer would recognize these two.[10] Rutter's merciless sketch of them never crosses from satire into caricature.

To those more deserving, regardless of their station, Rutter brings empathy. His sketch of four Abyssinian pilgrims whom he met on a Red Sea dhow is an early

example. Where a more egoistic writer might have taken centre stage, Rutter steps aside in a sentence:

> Clambering aboard, I assisted in stowing our baggage on the deck, where I found four Abyssinians already installed. These four, who were Gallas, I found to be of a very gentle yielding temper. All day they spoke among themselves in murmurs, or haltingly read passages from several tattered Arabic devotional books. Everything they did was done gently. They slept, prayed, and starved in an undertone, as it were. For food they had divers little sacks containing lumps of rock-like *durra* bread. This they gnawed painstakingly, and they drank water. Apparently they found this diet too rich, as they fasted every second day.

Rutter gives us the last pure adventure writing devoted to the journey of the Hajj. Only a few decades later, the Saudi administration would begin managing the intake and control travel and pilgrim identity in much the same way as any modern bureaucratic state. The officials Rutter meets as he approaches Mecca in 1925 have very different concerns from their more modern counterparts. These rough sheriffs in the employ of Ibn Saʻud are not so much interested in codifying him as in determining whether he eschews tobacco and behaves according to their strict Wahhabi standards. Luckily, paperwork counts for little in the new Saudi Hijaz. Even before he lands there, while still crossing the Red Sea, Rutter lightly informs us that his English passport and other travel papers as well as a compass and aneroid barometer have been carried overboard and lost. So much for visas, intake control, paper, transit letters and monitoring at every step the identity of the pilgrim in 1925. That is all in the future.

Nor is Rutter, although vulnerable, in thrall to the protection of his guides. When they try to gouge him for more money than contracted, he leaves them, disgusted, and sets out on his own: amazing fellow. Of course on the Hajj one is never alone, even in the vacuum of 1925. Only a little later, in the tiny village of Birk, several households quarrel pleasantly over who will house and feed him for the night. There are banquets and moonlit evenings reclining on rope couches smoking illegal tobacco and conversing under the stars.

Later, Rutter sheds a second collection of wayfaring acquaintances because, he writes, 'I had found the younger of the Indian merchants too inquisitive for my liking. I decided to let them proceed on their way without me.'[11] This merchant had seen Rutter writing in his notebook. He opts to proceed without companions rather than be mistaken for a spy. He is not alone for long. Again the Mecca-bound network of the pilgrimage offers companions. The very next day, he crosses paths with two Meccan merchants and their caravan of twenty camels. They are going his way and he joins them.

From the shapes of thatched huts to the size of the local wheat grain ('small as canary seed'), from the rites of Hajj to the form of a water ewer, Rutter is interested in everything, and he assumes that the reader will be too. Then, to make sure you are, he writes with a spirited accuracy about it.

In addition to his language skills, his ingenuity as a traveller, his dry sense of humour and readiness to take risks, the great pleasure of reading Rutter is that he is not obsessed with keeping his masquerade in place or with vaunting his cross-cultural mastery. He may be a British subject travelling at a time of upheaval. He may ultimately report what he sees to his countrymen, but he gives you the sense throughout that he belongs where he is, among Muslims, among Arabs, among pilgrims, despite being in the presence of great danger. Refreshingly, after Varthema and others, the danger he faces is not the danger of being unmasked as an imposter or a religious hypocrite, but rather the more straightforward risks of war, with which he is familiar by profession. The other danger is being taken for a spy. Rutter's one consistent deception is his secret note-taking, in a society suspicious of strangers who write things down. Spies take notes, and being marked as an English spy might make the accusation worse in light of British interest in the region. At deception Rutter is, smartly, a minimalist. He volunteers nothing. When asked, he calls himself a Syrian who has lived for many years in Egypt. The reply explains his skin, his direction of travel from Cairo and Suez, and his probably curious accent.

Any travel writer worth reading should be able to pose the hard questions. Within the limits of his genre, Rutter addresses directly the burning topics of the day, especially those concerning ʻAbd al-ʻAziz Ibn Saʻud and his young regime. The record of his encounters with the new Najdi ruler is as good as anything we have. And it is the earliest, set down in a transitional time when so much was at stake concerning Muslim tradition, cultural practice, the two holy cities of Mecca and Medina, the sacred Hajj, the future of the caliphate after the collapse of Ottoman Turkey, question upon question. All this is still in Rutter's time a matter of philosophy, theology and style. Oil's powerful, determining forces will only start operating later. Ten years must pass before St John Philby, Ibn Saʻud and the Americans conclude the financial deal of the century and lay the ground for a total transformation of one of the poorest economies on earth. Rutter's task in 1925 was to examine the Saudi-Wahhabi style. He reported well on its character, its spirit, its contradictions, and its effect on the local inhabitants of the Hijaz in the early months of the Najdi conquest. Unlike Philby and Lady Evelyn Cobbold a decade later, he did not find it necessary to come down firmly on the new side or the old. Instead, he registered what was happening through personal encounter and even-handed observation.

Scholars and readers occasionally wonder aloud if Muslims can report honestly and penetratingly about the Hajj, or whether some element of partiality does not prevent them from candour and from asking tough questions. Concerning this matter, the quality of Eldon Rutter's writing and the breadth of his observations make a persuasive case for the advantages to the reader of an author who *is* a Muslim. When reporting on Mecca – a city forbidden to outsiders – and on the Hajj – a set of rites intended solely for Muslims – it is virtually impossible for an imposter not to be preoccupied with his costume or disguise, and hard for him to report, beyond physical description, on rites that, while they are taking place in space and time, are likewise taking place internally, personally – if you happen to be a practising Muslim.

As with any writing, there is also the issue of what survives the passage of time, what proves useful and

attractive, transferring cleanly to the future and what winds up being useless or distasteful. Though in his day, Burton's observations and even his tortured English entertained and informed a society that nurtured him, one can imagine a time when, his unique scholarship on Medina excepted, the books he wrote about the Hajj may no longer be prized. His syntax and egotism aside, a comparison between Burton and Rutter makes plain certain shadings of pretence. A Muslim Englishman like Rutter pretending to be a Syrian in the Hijaz, in a year when a Briton would be unwelcome on the roads, may best be seen as simple self-defence, whereas a traveller in Burton's mould pretending to be a Muslim to gain entry into Mecca is engaged in a deeper deception. And while John Lewis Burckhardt (1784–1817), fifty years earlier, may (or may not) have pretended to the faith, he carried off his travel and his writing with a thoroughness, modesty, dedication and respect for the people he lived among that render his work of lasting value and interest. This may not be often said of Burton. There are shadings of imposture, too.

At the start of his journey, Eldon Rutter intended to travel with a Muslim. When his travelling companion died and Rutter set out alone, he was still with a Muslim: one named Eldon Rutter. The account of his journey marks the end of an outside adventurer tradition and the start of a continuing line of Western-inflected books by Muslims reporting on the Hajj.

Notes

1 For a list of principal narratives by pilgrims who wrote accounts of their Hajj, see Porter 2012a: 282–3.
2 Wavell 1912: 126.
3 It is a shame that a book as fine as this, detailing one of the longest stays in Mecca in the Western record, nine full months in two stages, has remained out of print so long. The great British Arabist, H.A.R. Gibb, reviewing the two volumes in 1929, rates them as 'possibly the best Introduction to Arabia ever written'. As I write, however, Rutter's Hajj narrative is being prepared for publication by Arabian Publishing (London) and edited by Sharon C. Sharpe. An accompanying introduction based on extensive research ought to shed new light on Rutter's life.
4 Cox 1929: 460–3.
5 Rutter 1931: xviii, 1; Rutter 1932: 4, 80.
6 Rutter 1933: 315.
7 Thompson: 1929: 286.
8 Peters 1994a: 353.
9 Rutter 1928, I: 2.
10 Rutter 1928, I: 12–44.
11 Rutter 1928, I: 74.

Chapter 18
Architectural 'Influence' and the Hajj

Jonathan M. Bloom

'The effect of the pilgrimage on communications and commerce, on ideas and institutions, has not been adequately explored; it may never be, since much of it will, in the nature of things, have gone unrecorded. There can be no doubt that this institution – the most important agency of voluntary, personal mobility before the age of the great European discoveries – must have had profound effects on all the communities from which the pilgrims came, through which they travelled, and to which they returned.'[1]

The idea of 'Influence'

Historians of art often cite the vague concept of 'influence' to explain how visual concepts and ideas were carried from place to place. This is particularly true in the study of medieval Islamic architecture, where plans such as the hypostyle mosque and forms such as the *muqarnas* are known to have been disseminated relatively quickly over a vast area stretching from the Atlantic coasts of North Africa and the Iberian Peninsula to Central Asia and the Indian Ocean. Historians regularly invoke the fuzzy concept of 'influence', as in the 'Umayyad influence' or 'Abbasid influence' supposedly present in the buildings of tenth-century Spain or ninth-century Egypt. The British art historian Michael Baxandall (1933–2008), however, cautioned that any discussion of 'influence' is wrongly conceived at the outset, for it reverses the appropriate roles of the agent and the client.[2] Umayyad or Abbasid buildings could not have exerted any 'influence' on other traditions; rather, builders in the 'target' regions adapted, misunderstood, copied, addressed, paraphrased, emulated, parodied, distorted, referred to, drew on, resorted to, appropriated from, reacted to, differentiated themselves from, engaged in a meditation on, responded to, or even ignored Umayyad or Abbasid buildings and forms.[3] This simple point serves to put the emphasis on the builders and their decisions and not on the buildings they copied.

Furthermore, many historians seem to assume implicitly that medieval builders and patrons were perfectly informed about the worldwide state of Islamic architecture at any particular moment, benefitting from a deep knowledge of all earlier buildings erected between the Atlantic and the Indus, and between the Sahara and the steppes of Central Asia. For example, 'Abd al-Rahman I (r. 731–88), the Umayyad prince who barely escaped the Abbasids' massacre of his family in 750 to establish an Umayyad amirate in the Iberian peninsula, is often said to have had in mind the Umayyad architecture of his native Syria when in 785 he commissioned the mosque of Córdoba. It is difficult to imagine, however, that the 54-year old prince, after a lifetime of campaigning in al-Andalus, would have retained an accurate memory of buildings he might possibly have seen in his youth, especially since he seems to have shown absolutely no interest in architecture during the intervening years.

In general, medieval builders and patrons had little means of knowing and sharing their architectural knowledge beyond their immediate surroundings, particularly at a time when graphic systems of architectural representation were neither common nor particularly sophisticated.[4] In an age before builders used plans and drawings on paper to ensure that their designs were followed closely, builders normally relied on personal experience and

familiarity with local materials and techniques. For that reason, many of the buildings in a particular region often share features because the same workmen, or their children, or their relatives worked on the same projects. To take an example from medieval Tunisia, it seems no accident that the mosque of Sidi 'Uqba in Kairouan and the Zaytuna mosque in Tunis are relatively similar in plan and elevation, for both were built during the ninth century when the region was under Aghlabid rule. The mosque at Mahdia, which the Fatimids built in the early tenth century after they defeated the Aghlabids in the region, is also based on the plan of the mosque at Kairouan, and shows how consistently builders returned to local models despite political changes.[5]

On the other hand, discontinuities in local styles can reveal how artisans and patrons travelled from one place to another, bringing ideas with them. For example, Ahmad ibn Tulun, the ninth-century governor of Egypt who was formerly in service to the Abbasids at Samarra, ordered his mosque in Cairo to be built in the Abbasid style of Iraq rather than the local idiom, represented by the earlier mosque of 'Amr.[6] One should hardly call this adoption of foreign ideas an example of 'Samarran' influence; rather, for some reason the governor deliberately chose not to follow local conventions, instead emulating the materials and style of building used at the Abbasid capital. Similarly, the unusual design and masonry construction of the great Fatimid gates of Cairo – which have little to do with earlier buildings in Egypt – seems to have close affinities to the military architecture of northern Syria. Indeed a Mamluk source states that the walls and gates of Cairo were designed and built by men from northern Syria who came to Cairo at this time.[7] But apart from these and a few other examples, the mechanisms by which such transfers took place in the history of Islamic architecture remain largely unstudied.

This situation is very different for the study of medieval Christian architecture. For example, it has long been known that Christian pilgrims to Jerusalem, Rome and Santiago de Compostela were instrumental in the spread of architectural forms along pilgrimage routes in Europe. In a pair of seminal articles published in the 1940s, the German-American architectural historian Richard Krautheimer (1897–1994) showed how pilgrims from all over Europe 'copied' the Church of the Holy Sepulchre when they returned from their pilgrimage to Jerusalem by erecting buildings that were round, that had a specific number and organization of supports, or that were simply named in honour of the burial place of Christ.[8] Similarly, Carolingian builders in northern Europe in the ninth century 'copied' the early Christian churches of Rome to express their reverence for the holy city.[9] Following a somewhat different course, the American art historian Arthur Kingsley Porter (1883–1933) explored the role of the pilgrimage roads to Santiago de Compostela in north-western Spain for the diffusion of a particular form of church and its decoration with sculpture across southern Europe in the Romanesque period.[10]

The Hajj and the transmission of architectural ideas
Considering that Christian pilgrimage in the Middle Ages was entirely voluntary while the pilgrimage to Mecca has been one of the pillars of Islam since its revelation in the seventh century, the impact of the pilgrimage to Mecca on the transmission of artistic ideas would appear to be a promising field of inquiry, although it has rarely, if ever, been considered.[11] It is well known for example, that the pilgrimage to Mecca served as an opportunity for scholars to exchange books and merchants to exchange goods. Indeed, one of the foci of the *Hajj: journey to the heart of Islam* exhibition in London was the pilgrims' experience of pilgrimage, which was represented in the exhibition by the physical objects pilgrims brought back as mementos or souvenirs. These ranged from Chinese blue-and-white porcelain bottles of Zamzam water to prayer beads and a host of religious items, some of them bordering on kitsch.[12] Nevertheless, whatever their artistic quality, they served to activate pilgrims' memories of their physical and spiritual journeys.

While we can interrogate contemporary pilgrims about their visual memories, it is much more difficult for us today to recreate and understand the kinds of visual memories people brought back from the pilgrimage centuries ago in the way that Krautheimer did for the pilgrimage to Jerusalem. First, the Ka'ba, which Muslims believe is the *bayt allah*, or house that the prophet Ibrahim erected for God, is unique and cannot be replicated in the same way that medieval Christians made 'copies' of the Church of the Holy Sepulchre to remind them of the place of Christ's burial. That said, we know that at various times Muslims who were unable or unwilling to make the arduous Hajj to Mecca made supererogatory pilgrimages to such sites as Medina, Jerusalem, Kairouan in North Africa, Najaf and Kerbala in Iraq, and Mashhad and Qum in Iran, which they believed were partially equivalent to the pilgrimage to Mecca.[13] Furthermore, the nature of pilgrimage in Islam is different from that of Christianity, which is based on the desire to venerate the places where Christ lived and died, where saints lived and died, and to do penance for one's sins.

Second, unlike Christian pilgrims to Jerusalem and Rome, only a very few medieval Muslims, such as the Persian traveller Nasir-i Khusraw in the 11th century and the Andalusian Ibn Jubayr in the 12th century, left accounts of their journeys that describe what they saw in the holy cities of Arabia. Nasir-i Khusraw, for example, left Cairo in May 1050, travelling via Aswan, 'Aidhab and Jedda, and arrived in Mecca in November of that year.[14] His extensive description of the Haram enclosure at Mecca is one of the most valuable sources for the period, perhaps because Nasir actually made four pilgrimages to the holy city during the period when it was controlled by the Fatimid caliphs of Egypt. He notes, for example that the 'Baghdad [i.e. Abbasid] caliphs had built many beautiful structures, but when we arrived some had fallen to ruin and others had been expropriated for private use'.[15] Ibn Jubayr arrived in Mecca over a century later in August 1183 and stayed there until April of the following year.[16] His description of the Haram is even more extensive than that of Nasir-i Khusraw, and he gives such precious details as the means by which the *kiswa*, the covering of the Ka'ba, which was made of green cloth at that time, was actually attached to the Ka'ba by means of iron rings and hemp ropes.[17] Hugh Kennedy focused on these two works in his contribution to the catalogue accompanying the British Museum exhibition.[18]

Plate 1 Bu Fatata mosque, Sousse (plan after Creswell: 1940)

Third, it is extremely difficult to correlate the few descriptions of travellers to Mecca with actual buildings since the Masjid al-Haram has been repeatedly enlarged and embellished over the centuries. The visual form of the Masjid al-Haram, the grand mosque that surrounds the Kaʻba, in the medieval period can be reconstructed only with great difficulty and a great deal of uncertainty.[19] Many aspects we unthinkingly imagine as unchanging have varied greatly over time. A most obvious example is the *kiswa* of the Kaʻba, which in modern times has been invariably black with gold embroidery, but Nasir-i Khusraw says that the *kiswa* was white, while Ibn Jubayr says it was green. Other sources tell us that at times it was striped or made of red silk brocade.[20] Moreover, the buildings pilgrims see today are not at all the ones they saw in the past, as properties were acquired and cleared, and arcades and other structures were added and expanded to accommodate the increasing numbers of pilgrims visiting the holy site.

We know the basic outlines of the process of expansion although we may not know all the details. What Mamluk pilgrims saw, for example, was very different to what Nasir-i Khusraw and Ibn Jubayr saw, and the Mamluk aspect was very different from the Ottoman one, as buildings were repeatedly expanded and enlarged and redecorated in the current style.[21] For example, we know that the Mamluk minarets were replaced by ones in the Ottoman style when sultans Selim II and Murad IV rebuilt parts of the building in 1570 and 1629, respectively. The Ottoman minarets were in turn replaced in the 20th century (1955–7 and 1982–8) by those in a modern hybrid style.[22] This process continues to the present day and there is no end in sight. Thus, although we can posit that the Kaʻba and its surrounding structures, the Masjid al-Haram, have been the most visually significant buildings in the Islamic lands over the course of some 14 centuries, we know relatively little about them and

we have to be very careful trying to imagine what they might have looked like in the past.

This is particularly true because representations of the Haram do not appear before the early 13th century. To my knowledge, the earliest representation of the Haram at Mecca is a stone stele from Mosul in the Baghdad Museum (see p. 163, **Pl. 5**), which was originally thought to date from the early 12th century but has recently been redated to the early 13th century on the basis of the name of the carver, which also appears on several dated tombstones from Mecca.[23] The artist presumably based his representation on those he knew from pilgrimage certificates, which began to be illustrated in the late 12th century, around the time of Ibn Jubayr, although no early examples of such certificates with representations of the Haram survive.[24] The Baghdad stele shows the Kaʻba with the Black Stone, all covered by the *kiswa* with a *tiraz* (inscription) band. It is surrounded by the arcades of Masjid al-Haram, which has minarets in three corners. We know from Ibn Jubayr that there were already seven minarets attached to the building, but it seems that the space available on the stone did not allow the sculptor to show them.[25] The sculptor has also shown several *minbars* (pulpits) and domed structures in the space around the Kaʻba, but the representation is not specific enough to identify them further.

These additional structures reappear in representations of the Kaʻba on later pilgrimage certificates, such as one in the British Library dated 1433, and depictions of the Masjid al-Haram become increasingly common and topographically accurate in the Ottoman period.[26] Unfortunately, the increased representation of the physical appearance of the Masjid al-Haram in the 15th century comes too late for the purposes of this essay, which concerns the early centuries of Islam.

All of these reasons – the uniqueness of the Kaʻba and the paucity of descriptions and representations – make it extremely difficult to reconstruct the impact of the pilgrimage to Mecca on the architectural history of the Islamic lands. Since so little is known about the physical aspect of the Haram al-Sharif in medieval times, it makes little sense to approach the problem the way that Krautheimer did by comparing the model and the copies. Instead, in the following pages I propose to approach it from a different perspective by exploring several discontinuities in the transmission of architectural ideas in the medieval Islamic lands that indicate that they might have resulted from the pilgrimage to Mecca. The limited space available permits me to only mention a few examples, but I hope that these will inspire other scholars to explore the subject further.

Three examples

Over the course of several decades studying the history of Islamic architecture, I have been struck by a few cases where the 'normal' processes of architectural transmission discussed earlier in this essay do not seem to apply, that is, where architectural ideas seem to leap across space and time, travelling in unexpected ways and appearing in unexpected places. These leaps suggest that the Hajj, which regularly brought Muslims from all over the *Dar al-Islam* (the regions of Islam) together in one place, might have been

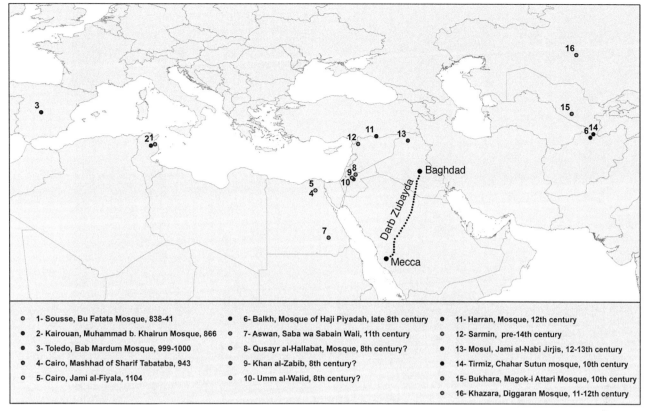

⊚	1- Sousse, Bu Fatata Mosque, 838-41	● 6- Balkh, Mosque of Haji Piyadah, late 8th century	⊚ 11- Harran, Mosque, 12th century
●	2- Kairouan, Muhammad b. Khairun Mosque, 866	⊚ 7- Aswan, Saba wa Sabain Wali, 11th century	⊚ 12- Sarmin, pre-14th century
●	3- Toledo, Bab Mardum Mosque, 999-1000	● 8- Qusayr al-Hallabat, Mosque, 8th century?	● 13- Mosul, Jami al-Nabi Jirjis, 12-13th century
●	4- Cairo, Mashhad of Sharif Tabataba, 943	⊚ 9- Khan al-Zabib, 8th century?	● 14- Tirmiz, Chahar Sutun mosque, 10th century
●	5- Cairo, Jami al-Fiyala, 1104	⊚ 10- Umm al-Walid, 8th century?	⊚ 15- Bukhara, Magok-i Attari Mosque, 10th century
			⊚ 16- Khazara, Diggaran Mosque, 11-12th century

Plate 2 Map showing location of early nine bay mosques (map: author)

responsible in some way for the dissemination of architectural ideas across the Islamic lands.

The first of my examples is the nine-bay mosque (**Pl. 1**). Historians of Islamic architecture have long noted that in addition to the large hypostyle (multicolumned) congregational mosque with an integral courtyard that spread in the early years of Islam, another type of mosque plan was used for smaller, neighbourhood mosques. It is characterized by a roughly square plan with four interior columns or piers that create nine bays which can be covered by vaults, domes or even a flat timber roof.[27] Over the course of the ninth and tenth centuries, the nine-bay mosque appears in virtually all areas of the Islamic lands from Spain to Afghanistan and Central Asia. Two of the classic examples are found in Tunisia: one the mosque of Bu Fatata at Sousse (838–41) and the other the mosque of Muhammad ibn Khairun (the Mosque of the Three Doors) at Kairouan (866), but it hardly seems likely that the plan is a North African invention.[28] Another example is the well-known mosque of Bab Mardum at Toledo in al-Andalus, which is dated to 390/999–1000.[29] K.A.C. Creswell found the remains of an early example in Egypt, the *mashhad* of the Sharif Tabataba, which he dated to 943.[30] The late Oleg Grabar once hypothesized that another example was the somewhat later Jami' al-Fiyala in Cairo, mentioned as having nine domes by the Mamluk historian and topographer al-Maqrizi.[31] Perhaps the earliest example known is the mosque of Haji Piyadah at Balkh in Afghanistan, which has long been dated to the ninth century. Recently, however, Chahryar Adle has convincingly redated this mosque to the very end of the eighth century under the patronage of the Barmakid vizier to the Abbasid caliph in Baghdad.[32]

As there were virtually no examples of this mosque type known from the central Arab lands, scholars were hard pressed to explain how the same plan appeared almost simultaneously at the opposite ends of the Muslim world. However, the discovery of at least six instances of this plan along the Darb Zubayda, the pilgrimage road linking Iraq and the Hijaz which was augmented under the patronage of Zubayda (d. 831), wife of the Caliph Harun al-Rashid, suggests that the quick and broad dissemination of the plan might have been helped by its use along the pilgrimage roads as an efficient means of designing and roofing a small mosque.[33] Like Bernard O'Kane, I do not believe that this particular type of mosque had a 'honorific connotation' as Geoffrey King had proposed.[34] The plan may have had its origins in pre-Islamic architecture and may have been adopted because it could be applied in a variety of circumstances using a variety of materials, but the rapid dissemination of the form in the early centuries of Islam (**Pl. 2**) is best explained by imagining that people everywhere believed it was a practical and efficient means of building a small mosque, perhaps having encountered this type of building on the way to and from Mecca.

My second example is the minaret, the quintessentially Islamic slender tower attached to a mosque and understood to be the place from which the *muezzin* calls the faithful to worship. Many years ago, I was struck by the similarities between an unusual type of minaret characterized by square bases, tapering cylindrical shafts and domed lanterns which is found in several towns and villages of Upper Egypt (**Pl. 3**) and the minarets of Hadramawt in the Yemen (**Pl. 4**). I hypothesized that both types shared features of the now-lost minarets of Mecca that Ibn Jubayr had seen before they were replaced in the Mamluk period.[35] He said that there

Plate 3 Minaret of Abu'l-Hajjaj, Luxor (photo: author)

Plate 4 Minaret in Shibam, Hadramawt (photo: author)

was one minaret at each of the four corners of the Haram and one each at the Dar al-Nadwa, the Bab al-Safa and the Bab Ibrahim.[36] According to Ibn Jubayr:

> The minarets also have singular forms, for the (lower) half is angulated at the four sides, by means of finely sculptured stones, remarkably set, and surrounded by a wooden lattice of rare workmanship. Above the lattice there rises into the air a spire that seems as the work of a turner, wholly dressed with baked bricks fitting the one into the other with an art that draws the gaze for its beauty. At the top of this spire is a globe also encircled by a wooden lattice of exactly the same pattern as the other. All these minarets have a distinct form, not one resembling the other; but all are of the type described, the lower half being angulated, and the upper columned.[37]

During the Fatimid period when the Upper Egyptian towers were built, the pilgrimage route from North Africa and Egypt went not across Sinai but through Upper Egypt and across the Eastern Desert to ports such as Qusair and 'Aidhab on the Red Sea coast, whence pilgrims sailed to Jedda before proceeding to Mecca. Thus, in the Fatimid period, Upper Egypt was culturally much closer to the Hijaz than it had been or would be in other periods, and pilgrims may have been responsible for bringing architectural ideas directly from the Hijaz to this region.

It is also possible that the pilgrimage to Mecca also played an even broader role in the diffusion of the minaret in the medieval period. I have argued elsewhere that the idea of placing a single tower opposite the *qibla* (the

direction of Mecca) in a mosque was developed not in Arabia nor Syria during the early years of Islam, but in Iraq towards the end of its second century (i.e. around 800), not as a place for the call to prayer but as a marker of the congregational mosque.[38] During the ninth century only a few cities including Samarra, Damascus, Siraf, Cairo and Kairouan erected such towers for their mosques, suggesting that Muslims did not yet consider the tower to be an essential part of a mosque. By the 11th century, however, the number of mosques with minarets had grown exponentially throughout the Islamic lands, and this growth may have resulted from the conflation of the idea of a single tower opposite the *qibla* with the multiple towers that had long been associated with the holy shrines of Arabia.

As early as the Umayyad period a tall slender tower known as a *manara* (from which 'minaret' is derived), had been erected at each of the four corners of the Mosque of the Prophet in Medina. As the Abbasids expanded the Meccan sanctuary, it was gradually embellished with a similar complement of towers placed in the corners of the sanctuary enclosure.[39] For various reasons the Medina mosque lost one of its four towers and three additional towers were added to the Meccan sanctuary, bringing its total to seven. Ibn Jubayr indicates that one of them was over a portal while the other two were on the far walls of the two annexes to the sanctuary, a placement roughly equivalent to the idea of placing a tower opposite the *qibla* of a mosque erected

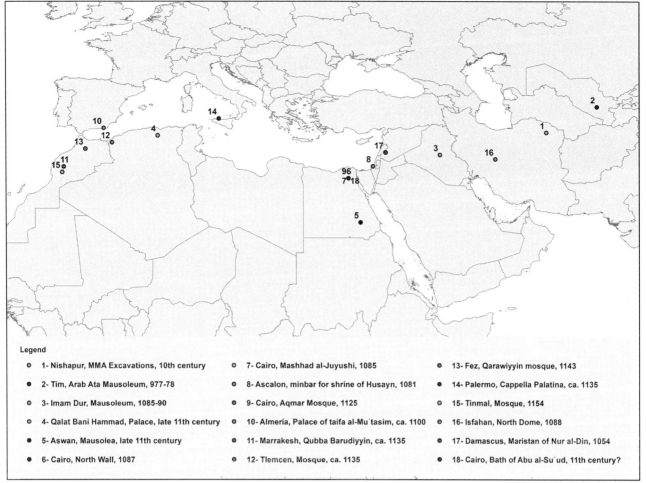

Legend

⊙ 1- Nishapur, MMA Excavations, 10th century	⊙ 7- Cairo, Mashhad al-Juyushi, 1085
● 2- Tim, Arab Ata Mausoleum, 977-78	⊙ 8- Ascalon, minbar for shrine of Husayn, 1081
⊙ 3- Imam Dur, Mausoleum, 1085-90	⊙ 9- Cairo, Aqmar Mosque, 1125
⊙ 4- Qalat Bani Hammad, Palace, late 11th century	⊙ 10- Almeria, Palace of taifa al-Muʿtasim, ca. 1100
● 5- Aswan, Mausolea, late 11th century	● 11- Marrakesh, Qubba Barudiyyin, ca. 1135
● 6- Cairo, North Wall, 1087	⊙ 12- Tlemcen, Mosque, ca. 1135

● 13- Fez, Qarawiyyin mosque, 1143
● 14- Palermo, Cappella Palatina, ca. 1135
⊙ 15- Tinmal, Mosque, 1154
⊙ 16- Isfahan, North Dome, 1088
⊙ 17- Damascus, Maristan of Nur al-Din, 1054
● 18- Cairo, Bath of Abu al-Suʿud, 11th century?

Plate 5 Map showing location of early *muqarnas* (map: author)

elsewhere. Whatever the particular histories and meanings these towers originally had, by around 1000 the single tower had come to signify a mosque and Islam, while multiple towers were especially associated with the holy cities of Mecca and Medina. The Fatimid Caliph al-Hakim unusually added two towers to the facade of the mosque he was building in Cairo in 1003, presumably a reference of some sort to the multiple towers of Mecca and Medina in whose affairs he was particularly interested at that time.[40] It is easy enough to imagine that pilgrims to Mecca and Medina would have identified the minarets they saw there with the towers attached to some of the mosques they knew from home. In this way, the mosque tower would have lost whatever specific meaning it had once had and gained through the medium of the pilgrimage a more general identification as the quintessential architectural symbol of Islam. Unlike Christianity or Buddhism, in which a class of people (priests) are charged with maintaining the relationships between architectural forms and specific meanings, in the history of Islamic architecture, the absence of clergy means that it is much more difficult for the society to maintain the relationship between form and meaning over space and time. As a consequence, meanings tend to devolve to their most common element, in this case, the tower as a symbol of Islam.

My third and final example of a possible role for the pilgrimage in the transmission of architectural ideas is the *muqarnas*, the quintessentially Islamic type of three-dimensional decoration usually likened to stalactites or honeycombs.[41] *Muqarnas* decoration is used to decorate concave interior surfaces such as squinches and vaults as well as convex exterior surfaces, where it is used to separate such elements as shafts and domes. Available evidence suggests that *muqarnas* first appeared in north-eastern Iran and Central Asia in the tenth century, for *muqarnas* elements were found in the excavations conducted by the Metropolitan Museum of Art, New York, at Nishapur in Iran and survive *in situ* in the Arab-Ata Mausoleum (977–8) at Tim, near Bukhara. The motif quickly spread throughout the Islamic lands (**Pl. 5**) and to such an extent that *muqarnas* elements were used virtually simultaneously at the shrine of Imam Dur (1085–90) in a tiny village north of Samarra in Iraq and at the Qalʿa of the Bani Hammad (late 11th century) in Algeria. While there is an enormous variation in the specific forms of *muqarnas*, the materials from which they are made, and the uses to which the motif was put, early examples have been found in Iran, Iraq, Syria, Egypt, Algeria, Morocco, Spain and even Norman Sicily, where the Cappella Palatina (1131–40) of King Roger II in Palermo is decorated with an exquisite wooden *muqarnas* ceiling.[42] In the east, *muqarnas* elements are used to separate the storeys on the shafts of the minaret of Jam (1194–5) in Afghanistan and the Qutb Minar (1199–1220) in Delhi (**Pl. 6**). Thus, within some two centuries, this completely new type of decoration came to be used from virtually one end of the increasingly fragmented Islamic lands to the other.

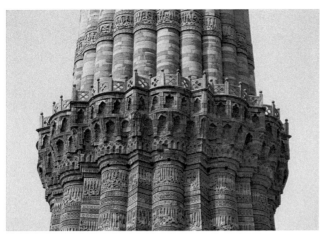

Plate 6 Detail of *muqarnas* on the Qutb Minar, Delhi (photo: author)

Ibn Jubayr also describes intricate stucco-work on a minaret at Mecca that may have been *muqarnas* decoration:

> Beside the Bab (Ibrahim), to the right of the entrant, is a minaret unlike those we have mentioned. It has a stuccoed lattice of oblong shape like *mihrab*s and surrounded by ornamented carving (*qarnasa*) of remarkable workmanship. By the Gate is a great dome, prominent in height, in which it approaches the minaret. Within are notable works of stucco and ornamental lattices, of which description fails.[43]

Does this description suggest that what we know as *muqarnas* were used in Mecca in the medieval period? It seems quite likely, since individuals from all over the Muslim world were likely to spend money on embellishing the shrine complex with the best materials and techniques they could find. If *muqarnas* decoration was considered prestigious, it is likely that someone ordered for them to be made for Mecca. We know, for example, that in 1155–6 Muhammad al-Jawad ibn 'Ali ibn Abi Mansur al-Isfahani, vizier to the ruler of Mosul, restored two of the towers of the Meccan sanctuary, presumably with elaborate brick decoration like that used in northern Iraq.[44] These must have been among the towers Ibn Jubayr saw when he visited a few years later.

I do not want to suggest that all *muqarnas* decoration was disseminated through Mecca, but rather that it may have been a means whereby the form was rapidly dispersed throughout the Muslim world. Surely local diffusion was accomplished by knowledgeable artisans moving from one place to another, but the broader spread of the motif could have been accomplished by people seeing something during their travels and trying to recreate it – whether more or less successfully – when they got home. Such a means of diffusion would also help explain the regional and local variants of *muqarnas*. In Cairo, for example, *muqarnas* decoration seems to have been brought from Syria by experts in the technique, while the simpler type used in Upper Egypt came from the Hijaz and was less sophisticated.[45]

While some authors have suggested that the *muqarnas* maintained a specific meaning everywhere it appeared, this is unlikely because, as with the case of the minaret, no universal authority could maintain the associations between forms and meanings in all Muslim lands between the Atlantic and the Indus. Indeed, at the time when the *muqarnas* spread rapidly, the Islamic lands were increasingly divided among many regional dynasties, making it

improbable that one political entity or religious approach could ensure the spread of a particular artistic form. The one activity, however, that brought – and still brings – all Muslims together is the pilgrimage to Mecca, and I trust that this brief essay has suggested some new and different ways of looking at how participation in the pilgrimage may have helped spread architectural forms across the medieval Muslim world.

Notes

1 Lewis 1960, III: 38.
2 Baxandall 1985: 58–62.
3 Baxandall 1985: 58–62.
4 Bloom 1993: 21–8.
5 Golvin, 1970–9, III: Ch. 2 207–19; Lézine 1965.
6 Creswell 1940, II: 332–56.
7 The information is first reported by the Mamluk historian al-Maqrizi (1364–1442); see Bloom 2007: 121–9.
8 Krautheimer 1942b.
9 Krautheimer 1942a.
10 Porter 1923.
11 Housley 1982–9: 654–61.
12 Porter 2012a. See Qaisra Khan in this volume.
13 For a recent example of this from Balkh, Afghanistan, see Adle 2011: 619–21. For examples from West Africa, see Sam Nixon's contribution to this volume.
14 Thackston 2001: 82–9.
15 Thackston 2001: 94–103.
16 Ibn Jubayr 1952: 75–188.
17 Ibn Jubayr 1952: 88.
18 Kennedy 2012: 110–32.
19 To my knowledge, there is no adequate architectural history in English of Masjid al-Haram at Mecca in the medieval period. I have dealt with some aspects of its expansion, particularly its minarets, see Bloom 1989: 49. A useful source remains Gaudefroy-Demombynes 1923.
20 Bloom and Blair 2011: 32–6.
21 Irwin 2012: 137–219.
22 On the Ottoman renovations, see Necipoğlu 2005: 173.
23 For a discussion of the stele and related carvings and pilgrimage scrolls, see Sheila Blair's essay in this volume. The stele was originally published in Strika 1976: 195–201; it has been redated by Maury 2010: 546–59. For a provocative discussion of representations of the Ka'ba, see Milstein 1999: 23–48. See Maury in this volume.
24 Sourdel and Sourdel-Thomine 1983: 167–223.
25 Ibn Jubayr 1952: 87.
26 Porter 2012a: 137, fig. 92. Many years ago, Richard Ettinghausen identified three different types of representations: topographical, painterly (i.e. illustrations in manuscripts) and symbolic. See Ettinghausen 1934: 111–37.
27 King 1989: 189–244; O'Kane 2005.
28 Creswell 1989: 351–3.
29 King 1972: 29–40; Ewert 1977: 287–354.
30 Creswell 1952–9, I: 11–15.
31 Fu'ad Sayyid 1998: 471–2.
32 Golombek 1969: 173–89; Adle 2011.
33 The most convenient listing and discussion of these mosques, with full bibliography, is to be found in O'Kane 2005: 191–4.
34 O'Kane 2005: 212; King 1977: 386.
35 Bloom 1984: 162–7.
36 Ibn Jubayr 1952: 87.
37 Ibn Jubayr 1952: 96.
38 Bloom 2013.
39 Bloom 2013: 45–53.
40 Bloom 1983: 23; Bloom 2007: 79.
41 Bloom and Blair 2009, III: 25–30.
42 Knipp 2011: 571–8.
43 Ibn Jubayr 1952: 102.
44 Bloom 2013: 170.
45 Bloom 1988: 21–8.

Chapter 19
Depictions of the Haramayn on Ottoman Tiles
Content and Context

Charlotte Maury

The Haramayn, or 'the two sanctuaries' of Mecca and Medina, were integrated into the Ottoman Empire from the time of Selim I (r. 1512–20) and remained for four centuries under the custody of his successors. From the 16th century onwards, images of Masjid al-Haram (the Holy Mosque of Mecca) and Masjid al-Nabawi (the Mosque of the Prophet in Medina) proliferated in Ottoman art and spread through a variety of media. They were painted on illustrated manuscripts dealing with the pilgrimage or with the history of the holy cities, on Hajj certificates, prayer books, ceramic tiles and, after the 17th century, on the walls of mosques and private houses from Egypt to Bosnia. They also appear on the verbal portrait of the Prophet Muhammad (*hilya*), on indicators of the direction of prayer (*qiblanama*), and on calligraphic panels bearing the sultan's emblem or *tughra*. Representations of the mosque of Mecca (Masjid al-Haram) also featured on embroidered textiles, and on carpets it was often reduced to the sole picture of the Ka'ba or the circumambulation area (*mataf*).[2]

This chapter will concentrate exclusively on depictions of the Haramayn that were painted on ceramic tiles. They form a well-established corpus that have attracted the interest of specialists of Islamic art mainly for their visual content. Kurt Erdmann was the first to draw up a list of single tiles and tiled panels bearing depictions of the Masjid al-Haram. He also classified them into four groups on the basis of their formal affinities.[3] Twelve years later, Sabih Erken dedicated an article to the same subject. Each piece was described in detail and the corpus divided into seven stylistic groups.[4] Since those two publications, which only take into account representations of the Masjid al-Haram and Mecca, more examples have been published. While there is a good knowledge of the pictures on the tiles and their formal and stylistic variations, their written elements have been scarcely reviewed and analysed. The same is true for their architectural context; the way they are integrated in architecture has not been sufficiently explored. The general assumption that some of them were pilgrimage ex-votos on behalf of pious individuals is also a recurrent explanation given to their production. By focusing here on all the written elements, from labels, mentions of donors and craftsmen, to Qur'anic quotations and mystical verses, and by analysing the spatial context for specimens still observable *in situ*, I would like to suggest other ideas and interpretations concerning their meanings and functions. Before addressing such issues an overview of the corpus and the main stylistic groups is offered, with special attention given to the dated specimens, and to those preserved in an architectural context or with a known provenance.

The corpus: groups, dates and locations

According to our investigations, single tiles and panels depicting the holy sanctuaries form a corpus of approximately sixty examples, including 19 tiles still preserved on monuments.[5] Depictions of the sanctuary of Mecca prevail and only eleven representations of the mosque at Medina have been identified so far. Depictions of Mecca and Medina were mainly produced during the 17th century when the two Anatolian cities of Iznik and Kütahya were competing centres of the ceramic industry and their

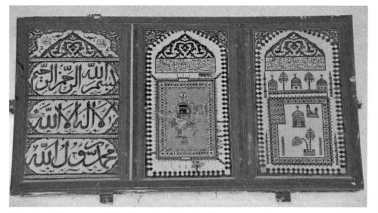

Plate 1a–b Mecca and Medina tiles, Handanija mosque, Prusac, Bosnia. Produced in Iznik or Kütahya, 17th century (photo: Mehmet Tütüncü)

products are difficult to differentiate. However, during the second half of the 17th century, Kütahya progressively gained prominence over Iznik and is thought to have produced the greater part of Ottoman ceramic architectural revetments. As for the few tiles dating back to the first half of the 18th century, they have all been assigned to the Tekfur Saray kilns even though Kütahya still remained an important centre of ceramic production. In addtion, it is not clear whether some 18th-century tiles made for monuments in Cairo are of Anatolian or North African manufacture. The latest example in the corpus is a Mecca panel mounted in the apse of the Great Mosque (Ulu Cami) of Kütahya, which was produced locally at the beginning of the 19th century.

As we shall see, a majority of depictions with a known provenance or those still in situ were made for monuments generally built before the 17th century.[6] Because tiles were produced during a period that witnessed a decrease in building activity, they were most often used in older monuments. Nevertheless, the large panels made in 1667 for the Harem of the Topkapi Palace were probably conceived as elements of the whole renovation programme of the area and it is only in the second quarter of the 18th century that panels belong to the original decorative programme of newly built monuments; such is the case for the panels depicting the city of Mecca and its surroundings included in the mosque of Hekimoğlu 'Ali Paşa (1734–5) in Istanbul, and in the Sabil-Kuttab of 'Abd al-Rahman Katkhuda (1744) in Cairo.

The oldest piece in the corpus is a rectangular tile depicting the Masjid al-Haram bearing the date 1640.[7] It belongs to an important group of tiles, all very similar in format and composition. The rendering of the monument, with a mixture of ground plan and elevation, makes use of the pictorial trope employed in Hajj certificates and illustrated manuscripts dealing with pilgrimage. Paintings that illustrate copies of the *Futuh al-haramayn*,[8] dating from the last quarter of the 16th century and later, are possible sources for those ceramic paintings. Characteristic of these ceramic depictions is the niche-like form created by a frieze of *lambrequin* motifs that surrounds the picture and an inscription band bearing a Qur'anic quotation that is placed under a polylobed pediment.

To this first group of tiles belong at least thirteen Mecca tiles and three Medina tiles.[9] Five tiles in this group are preserved in situ: a Mecca tile on the qibla wall of the Ağalar

mosque, in the third court of the Topkapi Palace and used from the 15th century by the sultan, his pages and their eunuchs;[10] a Mecca tile in the so-called 'Chamber of Adile Sultan', inside the Mausoleum of Ayyub al-Ansari in Istanbul;[11] a Medina tile mounted on the southern wall of the vaulted corridor of the south-eastern pillar of Hagia Sophia and donated by a certain Sha'ban (**Pl. 5**, left); two Mecca and Medina tiles mounted in a wooden frame on the qibla wall of the Handanija mosque, in Prusac (Bosnia), along with a third tile bearing the Sunni profession of faith (*shahada*) (**Pl. 1 a–b**).[12] Two other Mecca depictions, now in the collection of the Museum of Turkish and Islamic Art in Istanbul, were transferred to the museum from the Süleyman Subaşı and Neslişah Sultan mosques in the 20th century.[13]

The typical *mise en page* of these single tiles has been replicated on a Mecca tiled panel made in the beginning of Rajab 1053/September 1643 for Hagia Sophia. This panel (**Pl. 5**, right), which is composed of eight tiles, adjoins the abovementioned Medina tile. It possesses an additional lower register for a dedicatory inscription that gives the completion date and the name of the donor, Tabakzade Mehmet Beg. A dated Medina tile (1062/1651–2) is also related to the group but shows slight variations in the composition,[14] such as the replacement of the polylobed pediment and *lambrequin* motifs by a simple polylobed arch.[15] The tile, broken in two pieces, is divided between the Museum of Islamic Art in Berlin and the Museum of Turkish and Islamic art in Istanbul.

A second cluster of representations includes square tiles with sketchier drawings of the Masjid al-Haram. It is in this group that names of donors occur most frequently. Some tiles are characterized by four minarets arranged symmetrically on each side of the court (**Pl. 2**);[16] on others, all the minarets appear inside the court (**Pl. 7**).[17] The dated examples were made in the third quarter of the 17th century. One is inserted onto the tiled facade of the Rüstem Pasha mosque (1070/1659–60) and was endowed by Mehmet Etmekçizade.[18] Three others are kept in various museums: one in the Museum of Islamic art in Berlin dated 1073/1662–3;[19] one in the Museum of Islamic art in Cairo dated 1074/1663–4, donated by Mehmet Ağa and signed by Ahmed;[20] in the Museum of Bursa, dated 1085/1674–5 and donated by Yağcı Hasan.[21] Two undated tiles are given an architectural context. The first was formerly mounted on the qibla wall of the Murat 'Ali Paşa mosque in Niğde.[22] The second is still to

be seen next to the *mihrab* of the mosque of Solak Sinan Paşa in Istanbul.[23] A third tile, acquired by the David Collection in Copenhagen, was brought back from Egypt by Edme François Jomard and reputedly was part of the decoration of the Divan of the Janissaries in the citadel of Cairo (**Pl. 7**).[24] An undated tile, kept in the Sadberk Hanım Museum is the only Medina tile we know that is stylistically equivalent to the Mecca tiles within this second group.[25] It must also be mentioned that between the first and second group we find a unique pseudo-*mihrab* panel kept in the Museum of Islamic Art, Cairo, on which there is a depiction of the Masjid al-Haram.[26] The representation, which appears inside a niche (**Pl. 9**), has four minarets outside the court like some single tiles of the second group. It is also crowned by the polylobed pediment that is characteristic of the first group.

Other multilayered panels were produced in the second half of the 17th century for the Harem of the Topkapi Palace, more precisely for the mosque of the Black Eunuchs, the Oratory of the Queen Mother (Valide) which was adjacent to her bedroom, and the School of the Princes.[27] They were probably ordered from Kütahya workshops after a large fire broke out in 1666 in the Harem and had necessitated large-scale renovations. These panels represent the Mecca and Medina mosques as well as the plain and Mount of 'Arafat.[28] The Mecca panels are monumental versions of the flat representations seen on the first group of rectangular Mecca tiles and share with them a common source of inspiration. However, the architectural diagram is framed by floral designs and crowned by rows of hanging lamps and religious inscriptions. Medina panels are more detailed than the single tile versions, while 'Arafat panels have no equivalent in a smaller scale.

The three Mecca panels are dated 1077/1666–7 and signed in the name of a halberdier of the palace (*teberdar-ı hassa*), 'Ali Iskenderiye.[29] A fourth Mecca panel kept in the Museum of Islamic Art in Cairo and dated 1087/1676–7 is very similar to those made for the Harem, but it bears no signature.[30] A smaller Mecca panel composed of eight tiles and made in 1087/1676–7 is mounted on the *qibla* wall of the mosque of Hoca Şemseddin in Küre (Kastamonu province) (**Pl. 3**).[31] Its overall composition, with rows of hanging lamps at the top and sprays of flowers on both sides, is obviously inspired by the panels made for the imperial palace, but not its architectural depiction, which is formally related to a group of three undated panels kept in museums in Paris (**Pl. 6**), Athens and Istanbul.[32] The one currently held in the Museum of Turkish and Islamic Art comes from the Green Mosque of Bursa.[33] In the four panels, the Ka'ba is shown in perspective and not drawn in elevation; also the stations of the Sunni schools of Islamic law are not oriented towards the Ka'ba. With the exception of the Küre panel, a stylized mountain and a tent on the upper part evokes Mount 'Arafat and the encampments of pilgrims there, while the *mas'a* (the course between the hills of Safa and Marwa) and the green miles (*milayn al-akhdarayn*) which indicates the portion of the path between the Safa and Marwa hills where pilgrims must accelerate their pace while walking, are represented on the lower register.

Later plaques or panels produced in the first half of the 18th century mainly represent the Masjid al-Haram.[34] They

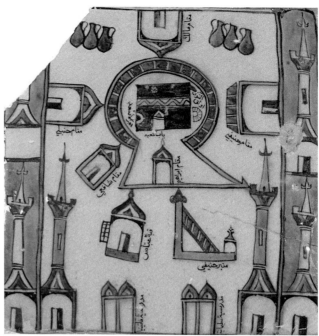

Plate 2 Mecca tile, 17th century, produced in Iznik or Kütahya, Musée du Louvre (inv. OA 3919/559) (photo: author)

are considered products of the Tekfur Saray workshops set up in Istanbul by Nevşehirli Damad Ibrahim Paşa, Grand Vizir between 1719 and 1730. They share the use of cavalier perspective,[35] including the design of the attractions located inside and outside the city of Mecca,[36] and encompassing the neighbouring plain of 'Arafat and the mountains that surround the holy city. Isolated architectural units are painted on a plain white or coloured background. A panel from the Cezeri Kasım Paşa mosque, Istanbul, is dated 15 Jumada al-Akhira 1138/18 February 1726,[37] and a single tile in the Museum of Islamic Art in Cairo is dated 1139/1726–7.[38] The panel located in the mosque of Hekimoğlu 'Ali Paşa is part of the original decoration of the mosque and can be dated from the construction of the monument to around 1734 or 1735. It is the most elaborate depiction of Mecca with regard to the rendering of the natural setting around Mecca and the use of perspective and shading technique. It reflects the growing influence of European pictorial modes in Ottoman paintings. A Medina tile in the Museum of Islamic Art in Cairo and dated 1141/1729 can also be added to this group.[39] It departs from earlier representations of the Prophet's Mosque. If not drawn using cavalier perspective, the quite realistic treatment of the grilles that surround the tomb of the Prophet Muhammad and other details testify to new trends in the visual arts during the first half of the 18th century.

Before the middle of the 18th century, a Mecca panel was also prepared for the original decoration of the Sabil-Kuttab sponsored by 'Abd al-Rahman Katkhuda in Cairo (1744), where it was mounted on its eastern wall (**Pl. 8**).[40] The Masjid al-Haram and important sites in and around the holy city are represented in a natural setting that reminds us of the composition of the Mecca panel made for the mosque of Hekimoğlu 'Ali Paşa in Istanbul. According to Prisse d'Avennes, similar panels existed in Cairo in the 19th century: in the Divan of the palace of Khorshid Pasha in Azbakiyya and in the sanctuary of the Takiyya of Ibrahim Gulshani.[41] The origin of these Egyptian panels is not clear

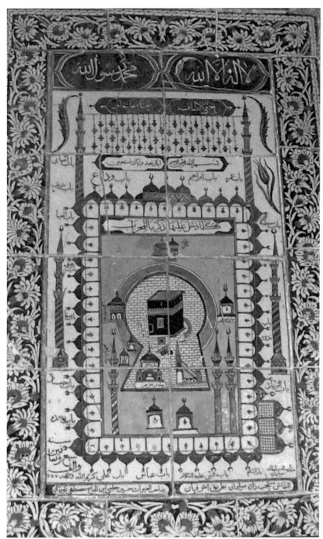

Plate 3 Mecca panel, Hoca Şemseddin mosque, Küre (Kastamonu). *Qibla* wall, to the left of the *mihrab*. Produced in Iznik or Kütahya, 1087/1676–7. Donated by Hüseyin ibn el-hac Mustafa and signed by Müstecebzade Süleyman (photo: Belgin Demirsar-Arlı)

architectural projection could still be employed in the 19th century. Comprised of four tiles, this Mecca panel could have been placed in the mosque during the restoration campaign of 1805.[46] Without any attempt at spatial depth, it nevertheless includes a representation of sacred places located in and around Mecca and traditionally visited by pilgrims.

Faith and memory: personalities behind the making

Only scant information exists about the individuals involved in the making of most of the tiles. In only a few cases can one find the donor's name or the craftsman's signature next to the pictures of the holy sanctuaries. It is even rarer to find the donor and the craftsman mentioned side by side. The addition of a donor's name had to be decided and fixed before firing after an agreement between the client and the craftsman. But a tile without the name of a patron could have been made independently from a commission. Without any obvious recipient, it could be acquired by any individual willing to buy it. But were anonymous depictions of Mecca or Medina always ordered, made for and bought by interested individuals? Could a tile or panel have been made at the request of the administration of the public building it was intended for rather than at the request of an individual?

The names of nine donors and five craftsmen are found among the sixty pieces of the corpus. The sponsor's name can be written freely inside the court of the Haram or in any other area. It can also fill in an empty rectangular panel or a horizontal cartouche.[47] Exceptionally, as in the Mecca panel of Hagia Sophia, an appropriate space is added under the depiction to host lines of text that give the name of the donor and the year the panel was made (**Pl. 5**, right). When both craftsman and donor are mentioned, the two names can be written in separate cartouches, as in the bottom of the panel of Küre (**Pl. 3**). It also happens that the artist's name is written in a frame while the name of the donor is written without formal emphasis within the representation of the sanctuary. This is the case, for example, on the tile dated 1074/1663–4 kept in the Museum of Islamic art in Cairo.[48] One must ask whether this differentiation indicates the relative importance of the people involved in the manufacture. At first glance, the frame places the craftsman at the fore, but at the same time it isolates him symbolically from the depiction. On the other hand, the donor's name, albeit not framed, features in a most prestigious position, that is 'inside' the holy precinct. On another tile recently sold in London, the donor's name, 'Abd Allah Muhammad, is written vertically, whereas all other texts on the tile remain horizontal. The donor's name has been placed just below the Bab al-Salam, which is the gate to the mosque through which pilgrims enter to begin the Hajj rituals. Thus, it is as if the donor was about to enter symbolically into the holy mosque.[49]

One word or more can precede the name of the donor: *sahib* (possessor, owner), *sahibuhu* (its possessor), *sahib al-khayrat* (possessor of good things), or *sahib al-khayrat wa al-hasanat* (possessor of good and beautiful things). The first two terms denoting ownership are widespread throughout the Islamic world. They could therefore indicate that the

and requires closer examination. By its style, the Mecca panel of the Sabil-Kuttab recalls the production of Tekfur Saray, but other tiles used in the monument in their appearance match the products of the workshops of Qallaline in the city of Tunis.[42] Moreover, by the time of the construction of the Sabil-Kuttab of 'Abd al-Rahman, the Tekfur Saray workshop had ceased its activity.[43] If depictions of Mecca employing cavalier perspective and including elements located outside the mosque are hallmarks of the 18th century, then this evolution could have begun earlier. An undated tile recently sold in London has the colours and quality typical of 17th or even 16th-century Iznik tiles, but shows the mosque and surrounding building in cavalier perspective.[44] A tile mounted on the southern face of a pillar in the Yeni Cami in Istanbul shows a box-like effect with the introduction of faint diagonals in the colonnades of the upper and lateral porticoes of the court, while sketchy mountains are already depicted all around the mosque. Erken attributes the tile to the Tekfur Saray workshops but its quality and colours are more in line with the sketchy tiles of the second half of the 17th century produced in Kütahya or Iznik.[45]

Finally, the latest tile of our corpus, mounted on the *qibla* wall of the Ulu Cami of Kütahya shows that flat

tiles in question were made for personal contemplation rather than for public use. However, this apparent mark of property also appears on a tile now in a public building, namely the tile mounted on the facade of the Rüstem Paşa mosque, in Istanbul.[50] Therefore, it is tempting to interpret it as an abbreviated version of the two longer formulas. Those longer versions are commonly used in Ottoman dedicatory inscriptions, which stress the charitable intention of the donor.

In four instances, the donor's name is devoid of any auxiliary information. In other cases, a title, or a professional and geographical affiliation accompanies the name and identifies the donor as belonging to the Muslim middle classes rather than the elite of the empire.[51] On the tile kept in Cairo,[52] a certain Mehmed or Muhammad is qualified by the common title of *ağa* used in many contexts for 'lord', or 'chief'. On the British Museum's tile (**Pl. 4**),[53] the donor bears the title *'efendi'* best translated as 'lord' or 'master'. Hüseyin, who endowed the panel of Küre, was a native of this small town and bore the distinctive title *'çelebi'*, which is also quite imprecise (**Pl. 3**).[54]

Hasan, the donor of the tile dated 1085/1674–5 kept in the Museum of Bursa, was an 'oil and butter dealer' as we learn from the word *yağcı*, which is written before his name.[55] His native Anatolian village in the district of Yenişehir is also specified after his name.[56] Mehmed, the donor of the tile located in the facade of the Rüstem Paşa mosque, bears the *nasab* or patronymic *Etmekçizade*, which means 'baker's son'.[57] We also learn from the dedicatory inscription of the Hagia Sophia panel that the donor, Tabakzade Mehmet Beg held the military position of *kethüda yeri* (an officer of the Janissary corps).[58] He also bore the *nisba* of *Iznikli*, 'of Iznik'. The fact that the donor or his family came from a city famous for its ceramic production is worth noting. His origins could have facilitated contacts with networks of potters and workshops, and may have enabled him to order the panel in his name and to ask for this unusual dedicatory inscription. Tabakzade Mehmet Beg is also known to have commissioned another tiled inscription for the mausoleum of Eşrefoğlu Rumi, in Iznik.[59] Tabakzade Mehmet Beg is not the only sponsor who came from an Iznik family. Osman ibn Ahmed, who donated the panel to the Cezeri Kasım Paşa mosque, was also a native of Iznik. His name and *nisba* are inscribed in a cartouche placed at the top of the representation of the Masjid al-Haram.

Unfortunately, names of donors are not accompanied by any information concerning the circumstances that motivated their pious gifts. The assumption that some of the tiles, whether 'personalized' or not, were necessarily made after the accomplishment of a pilgrimage is thus impossible to establish and verify. Among the mentions of individual donors, only one name is possibly preceded by the title *el-hac* (Arabic *al-hajj*) which is given to someone who has performed his pilgrimage and this is on the Medina tile of Hagia Sophia. But whether the name Şa'ban is preceded by *el-hac* or not,[60] it still does not prove that the Hagia Sophia tile was meant as a pilgrimage's ex-voto. In the case of Hüseyin, the donor of the Küre panel, he was the son of a certain *'el-hac* [*al-hajj*] Mustafa' who had apparently performed his pilgrimage. Would the pilgrimage of his

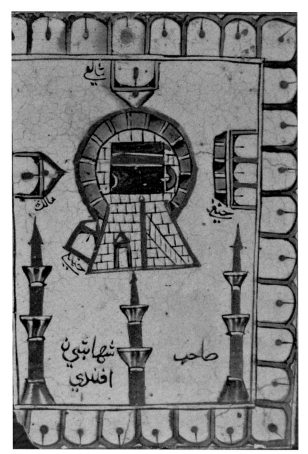

Plate 4 Mecca tile (incomplete) produced in Iznik or Kütahya, 17th century, British Museum, London (2009, 6039.1)

father have granted him enough prestige to order the panel? Was the panel a commemorative object for his father's pilgrimage and not his own? We will probably never know unless we find more information on Hüseyin ibn el-Hac Mustafa who must have been a local influential person. We know he ordered at least another tile for the same monument, which represents the sandals (*na'layn*) of the Prophet Muhammad.[61] Therefore, personal circumstances that propelled the making of the Mecca and Medina tiles remain unclear. These could have been quite diverse and not necessarily motivated by a donor's completion of the Hajj.

The donors' expectations are also seldom expressed, except for on the Medina tile and on the Mecca panel of Hagia Sophia. On the Medina tile the formula *ruhiçün fatiha* (recite a *fatiha* [the opening chapter of the Qur'an] for his soul) is written after the name of the donor. On the Mecca panel, in the right margin of the main inscription, a similar request is addressed to the reader, 'for the benevolent founder [recite] a *fatiha* and prayers'.[62] On the second line of the main inscription, the viewer is also asked to remember the owner through prayers (*du'a*), 'May the angelic scribes write his sins as good deeds. May anybody who remembers him pray for his soul'.[63] Through his donation of the tile panel, Tabakzade Mehmed expected to be remembered and to benefit from the recitation of prayers, securing salvation for his soul.

The third line of the same dedicatory inscription ends with this request: 'May God forgive its owner, its calligrapher and its reader'. The forgiveness of God is invoked not only for the persons involved in the making of the object, donor and scribe alike, but also for any person

Plate 5 Mecca tile panel (right) and Medina tile (left). Hagia Sophia, Istanbul, vaulted corridor of the southern pillar, to the right of the apse. Produced in Iznik or Kütahya, 1642 (Mecca tile panel), 17th century (Medina tile) (photo: author)

viewing the tile. The making of devotional tiles must have been considered a prestigious and meritorious act, and the extension of the spiritual benefit to the scribe or the maker of the tile could explain the presence of signatures by several craftsmen (five in total).

The role of those craftsmen is not always easy to define. Does the signature refer to the designer of the overall composition who gave the model to a person who reproduced it on ceramic? Was he rather a ceramic painter only? Was he painter and potter? Was he scribe and designer? As we shall see, the names are variously introduced and qualified and, as already mentioned, are always set in rectangular frames or horizontal cartouches.

The imprecise formula *amel-i* (work of) introduces the name Ahmed on the tile donated by Mehmed Aǧa in Cairo.[64] It also appears before the name of Muhammad al-Shami (Muhammad from Damascus) on a tile dated 1139/1726–2,[65] where it comes after a traditional expression of humility used in signatures throughout the Islamic world.[66] On a tile sold in Paris, *amel-i kaşi* (fabrication of the tile [by]) precedes the name of the craftsman.[67] The addition here of the word *kaşi* clearly implies that the individual mentioned took part in the fabrication of the tile. This term probably indicates the act of painting the design over the tile's surface, after the tile had been moulded and prepared by the same craftsman or, more probably, by someone specifically assigned to this preparatory step.

On a tile sold in London the name of Osman ibn Mehmed is preceded by *binayi resm-i* meaning 'the drawing of the monument is by'.[68] This written formula suggests that

Osman ibn Mehmed painted the image of the building on the tile. Müstecebzade Süleyman, the craftsman of the Küre panel (**Pl. 3**), is qualified in the inscription as 'the painter-designer' (*el-nakkaş*). As attested by documents in the Ottoman archives, painter-designers attached to the palace often provided designs and models for the ceramicists of Iznik who reproduced them on ceramic. However, painter-designers were versatile and could work on different media. They could execute paintings and illuminations on paper for luxurious manuscripts, wall paintings (*kalem işi*), paintings on wooden objects (*edirnekari*), and probably also painting on ceramic. In the case of the Küre panel, we can assume that the relatively elaborate composition of the panel necessitated a professional *nakkaş*, who collaborated with the ceramic workshop. His Sufi affiliation probably played an important role in his involvement. Müstecebzade Süleyman is indeed identified in the inscription as a member of the Eşrefiyye Sufi order by the expression *bi-tarik-i eşrefiyan* (on the path of the *eşrefi* Sufis) that is added to his name. The Eşrefiyye order was founded in the 15th century by Eşrefoǧlu Rumi, a member of the Qadiriyya order who came from Hama, in Syria, and settled in Iznik. His mausoleum became a place of pilgrimage and his *dergah* (convent) the centre of the order.[69]

The last of the five craftsmen is the only one to be known from his other works. 'Ali Iskenderiye, the imperial halberdier who signed the large Mecca panels made for the Harem of the Topkapi Palace, also designed two tiled inscriptions for the Chamber of the Sacred Relics and the Imperial Hall of the Topkapi Palace.[70] It is worth noting that he signed as a *teberdar* (halberdier) rather than as a *nakkaş* (painter-designer) even if he obviously worked in the palace as a designer-painter and calligrapher. He probably conceived the designs and provided the cartoons to the ceramic workshop. As in the case of the panel of Küre, the large scale and specific design of the panels of the Harem could have necessitated the contribution of a professional (or semi-professional) designer-painter who may have prepared the models at the court and received approval from the sultan, the queen mother or the chief of the eunuchs. Contrary to the four other signatures, the one of 'Ali Iskenderiye is more formal; not handwritten, it is designed in a large *nastaliq* script.

With the exception of 'Ali Iskenderiye, nothing is known about the other craftsmen and thus further research is needed to identify other works as well as understand the scope of their artistic activity, which could have been, in some cases, restricted to ceramic painting or could also include design and painting for different media.

Captions, verses of the Qur'an, mystical poetry and pious formulae

The pictures of the two sanctuaries often include captions that identify the main entrances to the two monuments and places linked to the rituals of the Hajj and the *ziyara* (visit) to the Prophet's tomb at Medina. As for images that are not limited to the depiction of the Mecca mosque but encompass the city itself and its natural surroundings, locations that are crucial to the performance of the Hajj such as the hills and ancient gates of Safa and Marwa as well as the plain of

'Arafat are also indicated outside the two sanctuaries. In addition, the sacred places traditionally visited inside and outside the holy city, such as the birthplaces of the Prophet Muhammad and of the first four caliphs and the Mount of Abu Qubays, are frequently identified. A complete absence of captions is rare but can occur, as in the case of the Mecca tile in the David Collection (**Pl. 7**) and the Medina tile in the Louvre. The number of captions often varies according to the degree of precision of the drawings. They are remarkably developed in the older group of Mecca tiles, in the large panels of the Harem in the Topkapi Palace, and in some Mecca tiles of the 18th century. Ottomanized names are often used and thus appropriate within an Ottoman cultural milieu.[71] Captions are meant to enhance the informative character of the depictions and help the viewer identify the places drawn; however, some inaccuracies can occasionally be detected.[72] We can imagine that those tiles were used to explain the rituals, as well as to familiarize the future pilgrim with the holy places and the rites that will be performed. By studying the image, the viewer could become mentally prepared before going on the Hajj or recollect past pilgrimages.

Pious formulae, Qur'anic quotations and Persian and Ottoman verses of mystical content also appear on top of or under the architectural depictions. They are generally inscribed 'outside' the buildings, in horizontal panels or cartouches. Less often, they are found inside the representation, written in the remaining space. Those inscriptions are often chosen for their connection with the image. Thus, the pilgrimage is the main theme of inscriptions selected for the Mecca tiles, while the Prophet Muhammad is the main subject on the Medina tiles. However, unspecific religious formulae were associated with either Medina or Mecca such as the canonical Sunni profession of faith or *shahada* ('There is no god but God, and Muhammad is His messenger'). It is freely written above the Medina mosque in the Hagia Sophia tile (**Pl. 5**, left) but inscribed in a frame below the tomb of the Prophet on the Medina panel of the Oratory of the Queen Mother. It is divided into two cartouches on top of the Mecca panel of Küre (**Pl. 3**) and appears inside the court of the Masjid al-Haram in the Mecca panel of the Sabil-Kuttab of 'Abd al-Rahman Katkhuda (**Pl. 8**).

An expanded version of the *shahada* also appears above the representation of the Masjid al-Haram in the mosque of the Black Eunuchs and in the School of the Princes: 'There is no god but God, the Just Sovereign, the Manifest, and Muhammad is His messenger, the faithful keeper of promises, the trustworthy'.[73] Another pious formula in Arabic, 'O He who conceals favour; He has delivered us from our fears',[74] is also coupled with the canonical *shahada* on the Küre panel (**Pl. 3**) and on a dated Medina tile.[75] Lastly, on the Mecca panel of Hagia Sophia the names of the first four caliphs (Abu Bakr, 'Umar, 'Uthman and 'Ali) are also inscribed, while the broken Medina tile bears the names of the caliphs and of the two grandsons of Muhammad, Hasan and Hussein.

Verses 96–7 of the third Qur'anic *sura* (chapter), has been often combined with the image of the Masjid al-Haram: 'the first house [of worship] to be established for people was the one at Mecca. It is a blessed place; a source of guidance for

people; there are clear signs in it; it is the place where Abraham stood to pray; whoever enters it is safe. Pilgrimage to the House is a duty owed to God by people who are able to undertake it. Those who reject this [should know that] God has no need of anyone.'[76] It appears on top of the Mecca tile kept in Berlin and dated 1073/1662–3,[77] as well as on top of the Mecca panel in the Ulu Cami of Kütahya.[78] It also occurs on all but one tile of the first group of rectangular Mecca tiles, below the polylobed pediment (**Pls 1, 5**). On two tiles of this group is another Qur'anic phrase evoking the Hajj; 'proclaim the pilgrimage to all people' (Q.22:27), which is written above the Bab Ibrahim, one of the numerous doors giving access to the court of the mosque.[79]

The verses Q.3:96–7 clearly assert the compulsory nature of the pilgrimage for every man who is physically and financially able to perform it. These verses were probably chosen to serve as a reminder to Muslims of this sacred duty. In some contexts, like in the Handanija mosque of Prusac or in the mausoleum of Eyüp, these verses could also have been invested with other connotations. The Bosnian town of Prusac was, and still is, renowned for the local pilgrimage to Ajvatovica, a place where the legendary Ajvaz Dedo (15th century) made water flow to Prusac through the nearby rocky mountains after forty days of prayer. The pilgrimage to Ajvatovica is often called 'the poor man's Ka'ba' or 'the little Hajj'.[80] Unfortunately, literary evidence for the existence of this pilgrimage does not go back beyond the 19th century and little is known about its early developments. But we assume that if the pilgrimage to Ajvatovica was already taking place in the 17th century, then it is possible that those tiles acted as a covert condemnation or marginalization of this pilgrimage, which may have been perceived as heterodox. Inside the prayer hall of the Handanija mosque – the point of departure of the Bosnian procession to the 'little Hajj' in the 19th and 20th centuries, and maybe also as early as the 17th century – the representation of Mecca and Medina could have represented a visual calling to an 'orthodox' order, an attempt to detract attention from the local and already popular pilgrimage. Likewise, something similar could have presided over the decision to commission the Mecca tile mounted in the mausoleum of Eyüp,[81] another popular site of pilgrimage for the people of Istanbul.

The verses Q.3:96–7 also form a verbal introduction to the image of the sanctuary itself, which offers in return a visual complement to the Qur'anic text. The place of Abraham or 'Maqam Ibrahim' commonly identified with the place where, according to Muslim tradition, Ibrahim, stood while he was building the Ka'ba with his son Isma'il (Ishmael), is always drawn and often labelled on the tiles. In addition, among the 'signs' of divine power (*ayat*) alluded to in the verses, one may include the well of Zamzam that miraculously gushed out from the desert to quench the thirst of Isma'il and Hagar. The monument erected above the well in the court of the Masjid al-Haram is a recurring element of the depictions. It is worth noting that the same verses were also selected for some elaborately illustrated pilgrimage certificates and positioned next to the image of the Mecca mosque. On a famous scroll executed for Maymuna ibn 'Abd Allah al Zardali in 1433, they are found above the image of

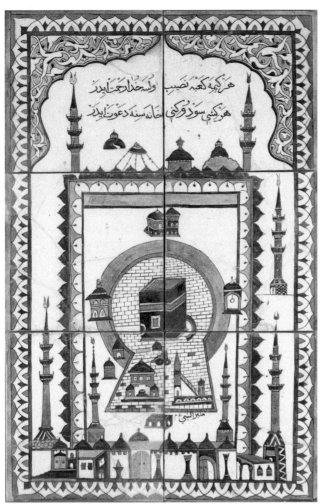

Plate 6 Mecca panel, produced in Kütahya (?), c. 1675. Musée du Louvre, Paris (inv. 0A 3919/558) (© RMN-Grand Palais (musée du Louvre) / Franck Raux)

Janissaries in the citadel of Cairo. The words are badly assembled on a tile dated 1139/1726–7 and kept in the Museum of Islamic Art in Cairo.[86] These lines are well known in Sufi circles and attributed to Jami (1414–92): 'To give his heart is the grandest pilgrimage/One heart is better than a thousand Ka'bas; The Ka'ba is the foundation of Ibrahim, son of Azar/the heart is the place where the divine glance lies'.[87] Here, the poet warns worshipers about performing their Hajj at the expense of their relatives and all the people that rely on their financial and personal support. Generosity and care are seen to be more valuable and meritorious than the performance of the pilgrimage. Moreover, the heart is held to be able to host the presence of God in a way that transcends the Ka'ba. In Sufi literature, the 'Ka'ba of the heart' is often contrasted with and considered superior to the 'Ka'ba of clay' (*kabe-i gel*), also called in a dismissive way the 'house built by humans' (*bayt al-khalq*).[88]

Absence of religious formulae and inscriptions related to the pilgrimage is found in a group of single tiles with sketchy views of the mosque, that were often endowed by named individuals. It is worth noting that the religious inscriptions on the large Mecca panels made for the Harem in the Topkapi Palace are the *shahada* and general pious formulae rather than the verses calling on Muslims to go on Hajj. This may have been done because members of the ruling family and employees of the palace would rarely visit the holy places because of their high status and dedication to the state. It is also on one of the large panels of the Harem where we find a rhyming line with official overtones at the bottom of the picture of Mecca. On the large Mecca panel of the School of the Princes, the designer 'Ali Iskenderiyye, an imperial halberdier familiar with the palace, wrote a verse in Ottoman Turkish that links the reigning sultan, Mehmed IV, with the representation of the holiest place in Islam: 'My God, for the sake of glory, this most noble Sovereign/My God, may his life be increased with prosperity and success!'[89] This address to God below the representation of his house on earth asking for the long life of the sultan could only be read by young members of the imperial family, some of them future sultans, as well as masters and professors who came here to teach them. Similar prayers and good wishes would often have been spoken aloud inside the palace to conform to official etiquette in the presence of the reigning sultan.

On the Medina tiles, Qur'anic verses concerned with Muhammad and his role as the messenger of God are chosen to complete the image of his burial place. On the Medina tile of Prusac, the following is written under the tympanum, 'Muhammad is not the father of any one of your men, he is God's messenger, and the seal of the prophets: God knows everything' (Q.33:40) (**Pl. 1a–b**). On the Medina tile dated 1141/1729 in the Museum of Islamic Art in Cairo,[90] the Qur'anic verse 'it was only as a mercy that We sent you [Prophet] to all people' (Q.21:107) is written inside a cusped cartouche.[91] This verse was possibly chosen because of its regular appearance on Ottoman *hilye* panels of the 18th century. Calligraphic panels featuring the verbal portrait of Muhammad and known as *hilye* developed in the second half of the 17th century and by the time the Cairo tile was made,

Mecca.[82] However, on a Hajj certificate made for Prince Mehmed, the son of Süleyman the Magnificent and Roxelana, they are placed in the right margin of the image.[83] In these cases, inscribing these verses on tiles and integrating them into their overall designs may have perpetuated an already established association between text and image.

Other Hajj-related motifs are expressed in the design through verses of Ottoman, Turkish or Persian poetry which replace Qur'anic quotations and religious formulae. In general, these poetic lines temper the injunction of performing the Hajj, stressing its spiritual value over its mandatory performance. A well-known verse attributed to the Ottoman poet Nahifi (1665–1738)[84] is associated with representations of the Masjid al-Haram: 'God forgives those for whom the Ka'ba is the fate/anyone invites to this house the one he loves'.[85] These verses occur on two identical panels: one kept in the Louvre (**Pl. 6**) in Paris, the other in the Benaki Museum in Athens. In this instance seeing the Ka'ba is presented as a matter of fortune and fate (*nasib*) rather than a strict religious duty. The visit to Mecca is compared to an invitation to the house of a loving owner. Indeed, pilgrims consider themselves to be guests in the House of God.

Persian poetic verses appear on the David Collection's Mecca tile (**Pl. 7**) which comes from the *Divan* of the

it had acquired an established form, and Q.21:107 had become one of its regular components. It appears most frequently at the bottom of the first part of the physical description of the Prophet written in a round frame and called in Turkish 'the belly' (göbek).[92] Some hilyes were also crowned by a painting of the Medina mosque, generally drawn in cavalier perspective, unlike the tile in Cairo. On the Cairo tile, the association of the Mosque of the Prophet with this verse could well have been inspired by its occurrence on hilyes.[93]

Other inscriptions are linked to the oral practice of uttering blessings upon the Prophet of Islam. 'God and His angels bless the Prophet – so, you who believe, bless him too and give him greetings of peace' (Q.33:56) is seen on the Medina tile in the Louvre. This passage from the Qur'an is the basis for the practice of uttering blessings at every mention of the name of the Prophet.[94] Examples of these blessing formulae are written in the framing band of the Medina tile divided between Berlin and Istanbul.[95] They are interrupted six times by the names of the first four caliphs and of the two grandsons of the Prophet, Hasan and Hussein, inscribed in a cusped medallion. On this tile, we find a hadith translated into Ottoman Turkish and taken from a compilation of Ebu Su'ud Efendi (1490–1574), the famous Ottoman jurist of the 16th century. Placed above the architectural depiction in a cusped cartouche framed by two minarets, the hadith specifies that the uttering of those 'honorable blessings' is equal to the utterance of hundred blessings.[96] The uttering of blessings to the Prophet lies at the heart of Muslim piety and is performed by the faithful on many occasions in daily life. Blessings, like the visit to the Prophet's Mosque, are also thought to facilitate the intercession of Muhammad before God. Therefore, on the divided Medina tile, the Turkish formula 'Ya Muhammed şefaat eyle' (O Muhammad, intercede!) is to be seen above the hadith in a smaller cartouche that also gives the date of completion of the tile. Interestingly, this cartouche interrupts the Arabic formula already mentioned: 'O He who conceals favour; He has delivered us from our fears'. By praising the magnanimity of God, it resonates with the appeal for the intercession of Muhammad.

The belief in divine magnanimity through the intercession of Muhammad is again echoed by a picture of the Medina mosque on a later tile kept in the Museum of Nevşehir and transferred there from the mosque of Nar Köyü.[97] This tile has not been taken into account in our corpus as its main motif is a calligraphic composition in the shape of a tughra (imperial emblem). The calligraphy was created by Ahmed III (r. 1703–30) on the popular hadith 'I intercede for those of my community who have committed grave sins'.[98] To the right of the tughra a bird's eye view of the Prophet's Mosque is drawn. Hope for intercession is otherwise written on a tile ordered by Huseyin Çelebi for the mosque of Küre, which in this case depicts the sandals of the Prophet and not his mosque.[99]

A final inscription to be mentioned is associated with the Medina mosque. It is the only poem we have been able to identify which is connected to Medina.[100] It evokes the life-giving effect of the winds of Medina. A literal translation reads: 'Sometimes the morning breeze of Medina,

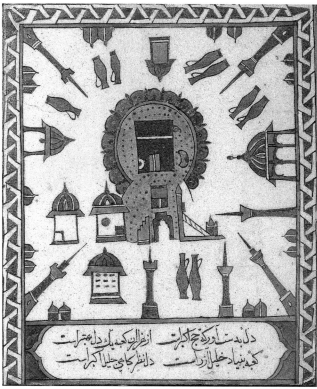

Plate 7 Mecca tile, produced in Iznik or Kütahya, 17th century. Reportedly from the Divan of the Janissaries in the citadel of Cairo. David Collection, Copenhagen (inv. 51/1979) (photo: Pernille Klemp)

sometimes the eastern breeze blows/As long as the [wind of] dawn blows, the eastern breeze is like the water of life for him'.[101] This verse must be an expression of the longing for Medina, a dominant theme of the numerous poems composed in honour of the Prophet. In these writings, the distance from Medina is often evoked by the image of a wind that reaches the remote poet and cures him temporarily from his pain.[102]

The spatial context

Among the nineteen examples of Mecca and Medina tiles preserved in situ, isolated Mecca tiles form the majority and only four Medina tiles and panels remain, always coupled with a depiction of Mecca. The monuments in which such tiles are present are public mosques with the exception of two educational structures that could serve as collective prayer halls: the School of the Princes in the Topkapi Palace where the children of the imperial family were given religious and non-religious education and the Sabil-Kuttab in Cairo which combined an elementary Qur'anic school with a public fountain. At a time when images of the two sanctuaries were mainly restricted to luxury manuscripts made for the most educated and privileged patrons, the ceramic versions were within reach of a wider audience and made accessible for any of the faithful entering the prayer hall. Some scholars consider these Ottoman tiles and panels found in prayer halls as heirs to the illustrated pilgrimage certificates that were displayed in public mosques.[103] From the 19th century onwards, the frequent hanging of oil paintings and later photographs of the sanctuaries accelerated the spread of images of Mecca and Medina in public as well as private contexts. This practice is still alive and it is therefore not uncommon to find an old Mecca tile or panel that portrays

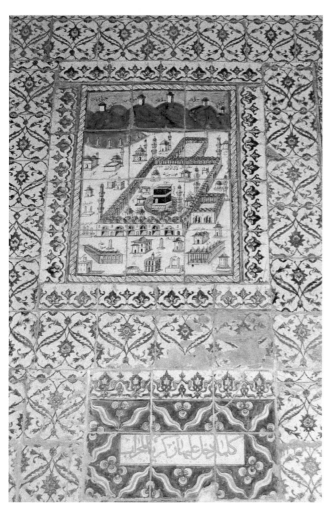

Plate 8 Mecca panel and pseudo-*mihrab* below. Sabil-Kuttab of 'Abd al-Rahman Katkhuda, Cairo. Produced in Tekfur Saray or North African workshop (?), *c*. 1744 (photo: Luitgard Mols)

the Mecca shrine as it appeared at the time of its production (mainly the 17th and first half of 18th century) adjacent to a contemporary photograph of the Masjid al-Haram. In such photographs, the recent evolution of the monument can be seen. For example, some structures that are drawn and labeled on the old tiles but have been destroyed in the 20th century have disappeared (e.g. the stations for the four Sunni legal schools or the domed chamber formerly used to keep the oil required for lighting the mosque lamps).

When they are preserved in mosques, the Mecca tiles and panels remain located on the *qibla* wall or on surfaces parallel to it. On the *qibla* wall, the representation is positioned in the vicinity of the *mihrab*, depending on the availability of space between the windows, the *minbar* (pulpit) or any other specific features. In the Ağalar mosque, the single Mecca tile has been inserted within the tile revetment of the *qibla* wall. The tile is not placed directly on the right side of the *mihrab* but on the portion of the wall running between its right window and corner. The lower level in this portion is occupied by a tiled vegetal composition set inside a niche. Two square tiles of the upper registers have been removed and replaced by the Ka'ba tile, which interrupts the top of the pointed arch.[104] In the Handanija mosque of Prusac, the three tiles are not mounted on the wall but set into a common wooden frame placed to the left of the *mihrab* (**Pl. 1**). In the mosque of the Black Eunuchs, it is the entire *mihrab* niche that is clad with a

large panel depicting the Haram at Mecca. In the mosque of Küre, the panel and other tiles of religious content are juxtaposed on the left side of the *mihrab* (**Pl. 3**). The Mecca panel of the mosque of Cezeri Kasım Paşa was once mounted between the *mihrab* and the *minbar*, sandwiched between two tiers of windows.[105]

When the *mihrab* area is magnified by a rectangular or rounded space, the representation is integrated into it. Thus, in the mosque of Hekimoğlu 'Ali Paşa, the Mecca panel appears on the eastern wall of the quadrangular area, and in the apse of the Great Mosque of Kütahya, the panel is mounted on the right side of the *mihrab*. If not mounted on the *qibla* wall, the Mecca tiles are fixed onto surfaces parallel to it, like the facade of the mosque of Rüstem Pasha and the southern face of a pillar inside the Yeni Cami.[106] In spaces that are not strictly oriented towards Mecca, panels are mounted on the most appropriate wall with regard to the sacred orientation. Therefore, the Mecca panel of the School of the Princes is on the southern wall while the Mecca panel of the Valide Oratory has been placed on the eastern wall, next to the south-eastern corner. In the Sabil-Kuttab, the Mecca panel is integrated into the tile revetment of the eastern wall in accordance with the local *qibla* (**Pl. 8**).

In the Sabil-Kuttab the panel is also placed above a now incomplete tiled panel that can be described as a 'pseudo-*mihrab*' in the sense that its form (a two-dimensional niche), iconography (a suspended lamp, today only partially visible) and its crowning inscription (the *mihrab* verse)[107] make it analogous to an architectural *mihrab* niche. The depiction of the Masjid al-Haram could also be integrated into the composition of pseudo-*mihrab* panels as shown by an example in the Museum of Islamic Art, Cairo (**Pl. 9**).[108] Here, the architectural diagram is featured in the centre of the false niche crowned by the *mihrab* verse. This composition may reflect the practice of mounting the Mecca tiles or panels directly inside the *mihrab*. As already mentioned, that was perhaps the case until the 1990s in the mosque of Solak Sinan Pasha in Istanbul. Furthermore, Tülay Ürün has recently argued that the Mecca panel now placed in the corridor of the south-eastern pillar of Hagia Sophia (**Pl. 5**, right) was originally mounted into the *mihrab* of the mosque. The removal of the ceramic panel would have happened during the restoration campaign of the Fossati brothers in the 19th century. The tiles were at that time replaced by an arched stucco panel imitating porphyry still on view, showing the same arched profile and dimensions as the tiled Mecca panel now placed in the vaulted corridor.[109]

In the panel of the Hoca Şemseddin mosque in Küre, the relationship between the *mihrab* and the representation of the Mecca mosque is also marked by the inclusion of the '*mihrab* verse' inside the court of the Masjid al-Haram (**Pl. 3**). The presence of this Qur'anic verse blurs the distinction between the *mihrab* and the Mecca panel and links it to the pseudo-*mihrab* tiles. Elsewhere, a Mecca panel could well have completely replaced the architectural niche, as in the case of the large-scale Mecca panels made for the Valide Oratory and in the School of the Princes, which are not mosques but could be used to perform collective or personal prayer. They form a new kind of pseudo-*mihrab*, devoid of any reference to

the architectural form of a niche, but that could, however, serve to identify the *qibla* wall in the absence of a *mihrab* niche.

It is also possible that individual prayers were sometimes performed in front of Mecca panels. Prisse d'Avennes makes mention of the practice in 19th-century Cairo of using a depiction of Mecca painted on ceramic like a prayer rug.[110] This remark may indicate that prayer was performed facing the Ka'ba image. In parallel, Ottoman prayer rugs with a representation of the Ka'ba or the circumambulation area (the *mataf*) have been produced but also condemned. An interdiction was issued in 1610 by the religious authorities of Kütahya that forbade the production of such carpets on the grounds that the representation should not be troden on. This prohibition would have soon resulted in the production of representation of the Ka'ba on ceramics.[111]

We now turn to the four tiles and panels depicting the mosque of Medina that still stand in an architectural context, namely in Hagia Sophia, the Handanija mosque in Prusac, the mosque of the Black Eunuchs and the Valide Oratory. In Hagia Sophia, the Medina tile is together with the Mecca panel (**Pl. 5**) but this association was most probably not intended as a first stage; firstly, because the Mecca panel may have been initially mounted in the *mihrab* niche, as already mentioned; and secondly, because the donor of the Mecca panel and the donor of the Medina tile are not the same person, and the probability of two separate and successive commissions is highly plausible. The dissimilarity in format, style and quality between the two objects also supports this assumption. However, if the Mecca panel was initially made for the *mihrab* of the mosque, then the question of the original location of the Medina tile remains unanswered.

In the case of the Handaniya mosque in Prusac (**Pl. 1**), the style, quality and dimensions of the two plaques are consistent enough to suggest that they were designed together, along with a third plaque containing the *shahada* on three horizontal registers. In this case, it is tempting to see the two architectural evocations as a visual paraphrase of the *shahada* written on the third plaque. The double assertion and split structure of the *shahada* is visually transposed by the juxtaposition of the two images. The proclamation of the uniqueness of God, which forms the first part of the *shahada*, is translated by the image of the Haram of Mecca that is the House of God on earth. The proclamation of the role of Muhammad as a divine messenger which forms the second part finds another form of expression as a depiction of the Prophet's Mosque in Medina. In the mosque of Solak Sinan Pasa in Istanbul, a different combination of images on both sides of the *mihrab* could have assumed the same symbolic function. Two square tiles are arranged here symmetrically depicting the Mecca mosque (on the left) and two sandals of the Prophet (on the right).

If we examine now the larger representations of Medina and Mecca in the Harem of the Topkapi Palace, we see that they do not appear side by side. Here, the unusual addition of a panel depicting the mount and plain of 'Arafat during the pilgrimage month enriches the evocation of the Haramayn and generates new visual interactions inside the monument. In the Valide Oratory, the Mecca and Medina panels are

Plate 9 Pseudo-*mihrab* panel, produced in Iznik or Kütahya, 17th century. Museum of Islamic Art, Cairo (inv. 6219) (photo: Arnaud de Boisselin)

facing each other and the panel representing the mount and the plain of 'Arafat adjoins the Mecca panel to the left. This arrangement conforms to the geographical reality as the plain of 'Arafat is situated immediately outside the city of Mecca. In the mosque of the Black Eunuchs, the three-fold pictorial ensemble is differently distributed. The Medina panel is set on the western wall of the mosque and faces the 'Arafat panel on the opposite wall, while the representation of Mecca is inserted into the niche of the *mihrab*. It is also interesting to note that the *kursi* (chair) of the imam of the mosque is often put in front of the Medina panel. This association probably underlines the link between Muhammad as the first imam of the nascent Islamic community and the function of an imam.

With their unusual scale, the panels made for the Harem also stand out from the rest of the corpus and suggest an imperial commission. When facing them, the viewer is literally immersed within the architectural composition and thus benefits from a closer view of the Haramayn. At the heart of the imperial palace, those impressive representations were probably seen as a proclamation of the privileged relationship between the Ottoman dynasty and the Haramayn as well as visual publicity for the title of 'Custodian of the Two Holy Sanctuaries' assumed by the sultans of the house of Osman since the time of Selim I. If no such representation exists today in the private apartments of the sultan, they are present in the Oratory of the Queen Mother (Valide). When the panels were made, the Valide Hatice Turhan Sultan, the mother of Mehmed IV, was a pivotal political figure of the time, like the

chief of the Black Eunuchs, also known as Darü's-saade Ağası. Since the reign of Murad III (1574–95), the latter was automatically nominated to the head of the administration of the two holy sanctuaries of Arabia.[112] He also used to launch the yearly departure of the convoy of imperial gifts sent to Mecca and Medina from Istanbul. Moreover, in the Ottoman period, the job of daily maintenance and cleaning of the Haramayn was entrusted to Black Eunuchs and their chief attendant chosen among those brought up in the imperial palace. Therefore, in addition to all the religious connotations already reviewed, the large panels made for the mosque of the Black Eunuchs reasserted the crucial involvement of the Black Eunuchs and their superior role in the maintenance and custody of the two holy sanctuaries.[113]

Conclusion

Inscriptions associated with Mecca and Medina tiles do not provide overt information on the circumstances surrounding their production. They sometimes provide the names of commissioners, patrons and craftsmen; however, they are not really helpful in understanding the objectives and motivations of the donors or those who commissioned them. In this respect, the hope for prayers for the soul of the donor is the sole indication we have found. When a donor's name occurs and points to an individual commission, the link between the order and the performance of the Hajj by the person who commissioned the tile to be made is impossible to deduce solely from the inscriptions. Moreover, the formal link between illustrated Hajj certificates and some of the tiles in the corpus may be misleading. Besides, anonymous examples predominate that are difficult to interpret. They could have been ordered by official or institutional bodies as well as individuals. The panels made for the Harem of the Topkapi Palace, the Hekimoğlu mosque or the Sabil-Kuttab were the result of an official order motivated by the renovation or the construction of the building itself rather than by the commemoration of the pilgrimage of an individual. In this case, they are inseparable from the whole architectural and decorative project. Nevertheless, most of the anonymous tiles and panels were added to buildings well after their completion.

The inscriptions also reveal a variety of messages that could be associated with the images of the two holy sanctuaries. On the Mecca tiles and panels, Qur'anic verses often stress the duty of the pilgrimage while poetic verses from well-known writers can convey other 'softer' conceptions of the Hajj. On the Medina tiles, the role of the Prophet, the practice of issuing blessings upon him and the hope for his intercession are intertwined. In their content, the Medina tiles are also linked to other artefacts made out of the devotion to the Prophet, such as tiles featuring the sandals of the Prophet or hilye panels. In some specific contexts, inscriptions may have delivered admonitory messages as in Prusac. They could also convey political claims as we find in the Harem of the Topkapi Palace. When inscriptions are missing, only the architectural evocations could have elicited one or another of these messages, albeit they are not overtly expressed. In this case, the image, which was connected to a rich network of abstract associations, would have assumed a rather open symbolic or allegorical function.

In addition to a dialogue between text and image, an interplay between space and image is also at work. The Mecca panels were mostly associated with the qibla wall and the direction of prayer. This spatial position stresses what is not necessarily expressed in words, that is, the role of the Ka'ba as a direction of prayer for the faithful. With an image, the idea of the sacred orientation is made more tangible and its formal appearance revealed. Like the mihrab niche, which since the beginning of Islam was an identifier of the qibla, tiles depicting the Ka'ba also acted as visual signs of the sacred orientation of prayer. The Mecca tiles and panels would have even sufficed in the absence of a mihrab niche, like in the Valide Oratory. Due to this common symbolic function of the mihrab and the image of the Ka'ba, some components of the mihrab can be transposed onto a Mecca panel, like the mihrab verse; a pseudo-mihrab panel can include a picture of the Haram of Mecca; and, at the end, an entire panel can cover the mihrab niche, a decorative choice that engages vision and sense of orientation together.

A dialogue between the Medina tiles and panels and their spatial context is more difficult to establish due to the rarity of the examples still in situ. Moreover, they always appear in conjunction with a depiction of Mecca so that the whole ensemble must be taken into consideration. In Prusac, a single Medina tile complements a Ka'ba tile and offers a visual expression to the Sunni profession of faith (shahada) written on a third accompanying tile. In the Valide Oratory and the mosque of the Black Eunuchs, the Medina and Mecca panels, along with a third panel depicting the mount and plain of 'Arafat, could have offered a permanent view of the holy sites that would never be visited by the members of the imperial family. An independent symbolic function of the Medina tiles and panels is, however, hard to determine. But the association of the kursi of the imam and the Medina panel inside the mosque of the Black Eunuchs suggests that the image of the Medina mosque could have created a visual link between the imam of the mosque and the first imam of Islam, the Prophet Muhammad.

Appendix

One can find below the current list of Mecca and Medina tiles or panels subdivided into groups. The correspondance is given with the groups previously defined by Erdmann and Erken.

I. Mecca tiles and panels

Group A (c. 1640)
Architectural diagram derived from a tradition of manuscript illustrations. Polylobed pediment and inscription band above the representation. Frieze of lambrequin forming a niche-like frame. Corresponds to Erdmann 1959, group A, nos 1 to 9 and Erken 1971, group I, 2 to 10 (figs 2–8): largest group.
1. Single tile dated 1640, current whereabouts unknown (see n. 7).
2. Single tile, Istanbul, Topkapi Palace, qibla wall of the Ağalar mosque (see n. 10).
3. Single tile, Prusac (Bosnia), qibla wall of the Handanija

mosque (1617), combined with a Medina tile and a tile bearing the *shahada* (see n. 12 and **Pl. 1a–b**).

4. Single tile, Istanbul, Mausoleum of Ayyub al-Ansari, 'Chamber of Adile Sultan' (see n. 11).
5. Single tile, Istanbul, Museum of Turkish and Islamic Art, inv. 828, from Süleyman Subaşı mosque (16th century) in the quarter of Eyüp (see n. 13).
6. Single tile, Istanbul, Museum of Turkish and Islamic Art, inv. 827, from Neslişah Sultan mosque (16th century) in the quarter of Edirnekapi (see n. 13 and database of www.discoverislamicart.org).
7. Single tile, Baltimore, Walters Art Gallery, inv. 48.1307.
8. Single tile, Istanbul, published recently as belonging to the Harem Collection, Topkapi Palace, inv. 8/1058;[114] previously published by Erken as belonging to the tile section in the Topkapi Palace, inv. 539; same inventory number mentioned by Erdmann.
9. Single tile, Istanbul, Topkapi Palace, Çinili kösk, inv. 541.
10. Single tile, Kuwait National Museum, inv. LNS 60 c.
11. Single tile, Paris, Louvre, inv. OA 3919/557 (formerly OA 3919/2-243).
12. Single tile, London, Victoria and Albert Museum, inv. 427-1900.
13. Single tile, Toronto, Aga Khan Museum, inv. 587.

Panel related to group A
14. Panel of eight tiles dated Rajab 1053/September 1643, donated by Tabakzade Mehmet Beg, southern wall of the vaulted corridor of the southern pillar of Hagia Sophia; combined with a Medina tile; possibly from the *mihrab* of Ayasofya (see n. 109 and **Pl. 5**).

Group B (c. 1663–75)
Simpler architectural diagram, fewer captions. Four minarets arranged symmetrically outside the courtyard. Courtyard delimited by a stylized portico (nos 15–19) or outlined with a simple line (nos 20–1). Corresponds to Erdmann 1959: group B: no 8–10, 12 and Erken 1971, group II, nos 1–5 (figs 13–16, 18).
15. Single tile dated 1074/1663–4, donated by Mehmet and signed by Ahmed, Cairo, Museum of Islamic Art, inv. 3251.
16. Single tile, formerly in the collection of Sabih Erken, current whereabouts unknown.
17. Single tile, Istanbul, *qibla* wall of Solak Sinan Paşa mosque (1548); combined with a tile showing the sandals of the Prophet; the two tiles were previously inside the *mihrab*; they were put on each side of the *mihrab* in the 1990s (see n. 23).
18. Single tile, Paris, Christie's, November 2006, acquired by Sadberk Hanım Museum, Istanbul, inv. 17645. P. 694, after the same model as tile no. 17.[115]
19. Single tile, British Museum, inv. 2009.6039 (**Pl. 4**); the tile seems incomplete and share some features with tiles nos 17 and 18. Donated by Şihabettin (for Shihab al-din) Efendi.
20. Single tile dated 1085/1674–5, donated by Yağcı Hasan, Bursa Museum (inventory number unknown).
21. Louvre Museum, inv. OA 3919/559 (formerly OA 4047/53), after the same model as tile no. 20 (**Pl. 2**).[116]

Panels related to group A or B
22. Pseudo-*mihrab* panel, Cairo, Museum of Islamic Art, inv. 6219 (**Pl. 9**); architectural diagram identical to group B in the centre of the niche and derived from the same model as no. 16; crowned by the polylobed pediment of the tiles of group A.
23. Panel of two tiles, formerly (?) in the *qibla* wall of Murat Pasa Cami in Niğde; according to Erdmann, similar in composition to no. 22.[117]

Group C (c. 1660–3)
Simple architectural diagram. All the minarets inside the court and turned inwardly. Variable frames. Corresponds to Erdmann 1959, group C, nos 1–4, and Erken 1971, group III, nos 1–3 (figs 22–4).
24. Single tile dated 1070/1659–60 and donated by Mehmet Etmekçizade, Istanbul, Rüstem Pasha mosque, facade wall.
25. Single tile dated 1073/1662–3, Museum of Islamic Art in Berlin (inv. 6220).
26. Single tile, brought back from Egypt by Edme François Jomard and reputedly from the Divan of the Janissaries in the citadel of Cairo, Copenhagen, David Collection, inv. 51/1979 (see n. 24 and **Pl. 7**).
27. Single tile, Bursa Museum, inventory number unknown.

Items related to group B or C
Representations on square format; arch portico around the court; minarets with variable positions, inside (nos 28–31) or outside (32–3) the portico.
28. Single tile, archives of Sami Güner, whereabouts unknown (see n. 17).
29. Single tile, signed Kamran (?), Paris, Drouot 1997 (see n. 17).
30. Single tile, London, Christie's, 2012 (see n. 17) (now in Kuala Lumpur, Islamic Arts Museum).
31. Single tile, on a mausoleum in the court of Koca Mustafa Cami, only mentioned by Erdmann (Erdmann 1969, C-5). We have not been able to check this information.
32. Single tile, formerly on the *qibla* wall of Murat 'Ali Paşa mosque in Niğde (see n. 22).
33. Single tile, Doha, Museum of Islamic Art, inv. 2013.161.[118]

Group D (c. 1667–76)
Multilayered panels. Architectural depiction without perspective. Corresponds to Erdmann 1959, group B, nos 1–3, 6, and Erken 1971, group V, nos 1–3 (figs 11–13)
34. Panel of 60 tiles, Istanbul, Topkapi Palace, mosque of the Black Eunuchs, dated 1077/1666–7, signed *teberdar-ı hassa* 'Ali Iskenderiye, combined with a Medina panel and 'Arafat panel.
35. Panel of more than 48 tiles,[119] Istanbul, Topkapi Palace, Oratory of the Queen Mother, dated 1077/1666–7 and signed *teberdar-ı hassa* 'Ali Iskenderiye, combined with a Medina panel and 'Arafat panel.
36. Panel of 66 tiles, Istanbul, Topkapi Palace, School of the Princes, dated 1077/1666–7 and signed *teberdar-ı hassa* 'Ali Iskenderiye.
37. Panel of 60 tiles, Cairo, Museum of Islamic Art, dated 1087/1676–7, inv. 16645 (cf. www.discoverislamicart.org).

Plate 10 Tile from a Mecca panel, produced in Iznik or Kütahya, 17th century, British Museum, London (1887,0617.29)

Group E
Smaller panels. The Ka'ba is shown in perspective. The architectural depiction can be linked to manuscript illustrations of the second half of the 17th century and beginning of 18th century. It corresponds to Erdmann 1959, group B, nos 4,5,11 and Erken 1971, group IV, nos 1–3 (figs 11–13).
38. Panel of 6 tiles, Athens, Benaki Museum, inv. 124.
39. Panel of 6 tiles, Paris, Louvre Museum, inv. OA 3919/558 (formerly OA 3919/2-242) (**Pl. 6**).
40. Panel of 6 tiles, Istanbul, Museum of Turkish and Islamic Art, inv. 830, from the Green Mosque in Bursa.

Panels bearing common features with panels of groups D and E
41. Panel of 8 tiles dated 1087/1676–7, *qibla* wall of Hoca Şemseddin mosque in Küre (Kastamonu province). Donated by Hüseyin Çelebi ibn el-Hac Mustafa Küreci and signed Müstecebzade Süleyman (**Pl. 3**).
42. Fragment of a panel of six or eight tiles, cf. London, British Museum, 1887,0617.29 (**Pl. 10**) and Louvre OA 4047/56-57 (formerly OA 4047/56–7).[120]

Group F
Tiles or panels representing the Haram and its surroundings with a bird's-eye view Numbers 43 to 46 have been assigned to the Tekfur Saray workshop by Erken. On each exemplar the architectural depiction is different. No common model. Corresponds to Erdmann 1959, group D, nos 1 to 4, and Erken 1971, group VII, nos 1–2, 4–5 (figs 27–8, 30–1).
43. Panel of six tiles dated 15 Jumada al-Akhira 1138/18 February 1726, till 2003 on the *qibla* wall of Cezeri Kasım Paşa mosque. Donated by Iznikli Osman ibn Muhammed (n. 37).
44. Single tile dated 1139/1726–7, signed Muhammad al-Shami. Cairo, Museum of Islamic Art, inv. 860.
45. Panel of 16 tiles, located in the mosque of Hekimoğlu 'Ali

Paşa, datable to the construction of the monument (1734–5).
46. Single tile, Bursa Museum, inventory number unknown.
47. Single tile, donated by Abdallah Muhammed and signed Osman ibn Muhammed, Christie's 2008, lot 406. Acquired by the Metropolitan Museum of Art, New York, inv. 2012.337 (see n. 44).

Exemplars showing the court of the Haram with a box-like effect
These two depictions are very different, the second being far more detailed (see n. 45).
48. Single tile, Istanbul, Yeni Cami.
49. Paris, Drouot 1980, lot 415.

Later panel with no perspective but including the surroundings of the Haram
50. Panel of 4 tiles, Kütahya, Ulu Cami, left to the *mihrab*.

Tiles or panels of possible provincial manufacture
The Haram is shown in a bird's-eye view. Those in Cairo may have been made in by North African craftsmen settled in Cairo in the 18th century (see n. 42).
51. Panel of 12 tiles, possibly Cairo, *qibla* wall of the Sabil-Kuttab of 'Abd al-Rahman Katkhuda in Cairo (1744).
52. Panel similar to no. 51, mentioned by Prisse d'Avennes in the Divan of the palace of Khorshid Pasha in Azbakiyya (see n. 41).
53. Panel similar to no. 51, mentioned by Prisse d'Avennes in the 'sanctuary' of the Takiyya of Ibrahim Gulshani. We have not been able to check this information.
54. Single tile, Tunis, prayer hall of the mosque of Hussein Ibn 'Ali erected between 1723 and 1727.[121]

II. Medina tiles and panels
Some of those Medina tiles are related to Mecca tiles of group A. They feature a polylobed pediment and inscription band (nos 2, 4, 5) or a frieze of *lambrequin* forming a niche-like frame (nos 4–5). Two are linked to the multilayered panels of the Harem. Five different models are identifiable for the architectural depiction (nos 1 to 3, nos 4–5, nos 6–8, nos 9–10 and no. 11).
1. Single tile dated 1062/1651–2, broken in two pieces and divided between the Museum of Islamic Art in Berlin and the Museum of Turkish and Islamic Art in Istanbul (see n. 14).
2. Single tile donated by Sha'ban, southern wall of the vaulted corridor of the southern pillar of Hagia Sophia, adjacent to a Mecca panel. The architectural depiction follows the same model as no. 1.
3. Lower part of a Medina tile, published in *La description de l'Egypte*, current whereabouts unknown (see n. 9). The architectural depiction follows the same model as no. 1.
4. Single tile, *qibla* wall of the Handanija mosque, Prusac (Bosnia), combined with a Mecca tile and a third tile with the *shahada*. The architectural depiction follows a model different from nos 1 to 3.
5. Single tile, Louvre Museum, inv. OA 3919/55 (formerly OA 3919/244). The architectural depiction follows the same model as no. 4.

6. Single tile, formerly in a private collection in Beirut, earlier in Nomico collection (see n. 15). The architectural depiction is drawn in reverse.

7. Panel of 2 tiles, Drouot 1976 (see n. 15). Donated by Muhammad ibn 'Ali. The architectural depiction follows the same model as no. 7.

8. Single tile, Istanbul, Sadberk Hanım Museum (inv. I.77), possibly coming from the collection of Henri René d'Allemagne (see n. 25). The architectural depiction follows the same model as no. 7.

9. Panel dated 1077/1666–7 and signed *teberdar-ı hassa* 'Ali Iskenderiye, Istanbul, Topkapi Palace, mosque of the Black Eunuchs, combined with a Mecca panel and 'Arafat panel.

10. Panel dated 1077/1666–7 and signed *teberdar-ı hassa* 'Ali Iskenderiye, Istanbul, Topkapi Palace, Oratory of the Queen Mother, combined with a Mecca panel and 'Arafat panel.

11. Single tile dated 1141/1729, Cairo, Museum of Islamic Art (see n. 39).

Notes

1 I wish to thank Faruk Bilici for his help in reading the Ottoman inscriptions quoted in the article. I am also grateful to Christiane Gruber, Venetia Porter and Liana Saif who took the time to carefully comment on this article and revise my English significantly.

2 For other articles dedicated to the representations of holy sites, see Fisher and Fisher 1982; Tanındı 1983; 'Ali 1996; 'Ali 1999; Witkam 2009. For representations of the two holy shrines in the Ottoman period, Maury 2010.

3 Erdmann 1959. Erdman publishes 31 pieces in groups A to D.

4 Erken 1971. Erken describes 31 examples and classifies them into groups I to VII. The lists of Erken and Erdmann are almost but not exactly identical.

5 Specimens regularly appear in the art market, which indicates that this number should be even higher.

6 Exceptions are the tiles of Mecca and Medina in the Handanija mosque of Prusac, Bosnia, built in 1617, and the Mecca tile located in the Yeni Cami, which was inaugurated in 1663.

7 Erdmann did not provide a photograph or make any mention of a date on this plaque, while Erken wrote that the date was inscribed next to a minaret on the top right corner.

8 Milstein 2006: 166–94.

9 For the Mecca tiles, see Erdmann 1959: group A, nos 2–8; Erken 1971, group I: nos 2–10; and Baltimore, Walters Art Gallery, inv. 48.1307; Kuwait National Museum, inv. LNS 60 c; a tile mounted in the so-called Chamber of Adile Sultan in the mausoleum of Eyüp. For the Medina tiles, see Louvre Museum, OA 3919/557 (formerly OA 3919/2-244); Hagia Sophia, vaulted corridor of the south eastern pillar; *qibla* wall of Handanija mosque, in Prusac (Bosnia); the lower part of a Medina tile published in the 19th century. See Commission des sciences et arts d'Egypte 1809–1822: Etat moderne, tome deuxième, pl. GG, fig. 14. The current whereabouts of this fragment is not known.

10 This mosque is now used for the library of the palace. It corresponds to the tile that Erken locates in the library of Ahmet I, see Erken 1971: 300, fig. 3.

11 Şen 1997: fig. 11. The author does not give the exact location of the tile inside the Chamber of Adile Sultan.

12 Andrejević 1989: 36–7, figs 11 and 13. This mosque was erected in 1617. Damaged during the war, it has been restored and the tiles set again on the *qibla* wall.

13 Ölçer 2002: 282.

14 Schnitzer and Schuckelt 1995: cat. 447; Abu Dhabi 2009: 362–3, cat 117.

15 Two other Medina tiles crowned by different polylobed arches are known to us: a Medina depiction spread over two square tiles sold

in Drouot 1976: lot 195; single tile in Beyrouth 1974: no. 100 (formerly Nomico collection). In these two specimens, the image is inverted and the tomb of the Prophet appears on the top right corner of the mosque.

16 Erdmann 1959: group B, nos 8–10, 12 and Erken 1971: group II, nos 1–4. We can add to their list: Christie's 2006, lot 210 (very close in design to the tile of Solak Sinan Paşa mosque); Christie's 2005: lot 52 (the minarets on the left and right sides are missing), acquired by the British Museum, inv. 2009.6039.1; Louvre Museum, inv. OA 3919/559 (formerly OA 4047/53 and close to the dated tile of Bursa; see **Pl. 2**).

17 Erdmann 1959: group C, nos 1–4, and Erken 1971: group III, nos 1–3. Three other tiles of square format can be added to the lists of Erdmann and Erken. One tile of unknown location, see archive of Sami Güner: http://www.samiguner.com/detay.php?category=__MAIN__&language=eng&find=search&searchKeys=1734&products=001734 (colours are reduced to blue and grey, minarets are vertically placed inside the court); Drouot 1997: lot 336 (a mountain outside the *haram* is depicted and the tile is signed); Christie's 2012: lot 243 (7 minarets vertically placed inside the court).

18 Erdmann 1959: no. C-4; Erken 1971: 311 and fig. 22.

19 Erdmann 1959: no. C-2; Erken 1971: 312 and fig. 23. Museum of Islamic Art in Berlin, inv. 6220.

20 Erdmann 1959: no. B-9; Erken 1971: 306–7 and fig. 15. Porter 2012a: 119, fig. 79.

21 Erdmann 1959: no. B-8 and ill. 4; Erken 1971: 306 and fig. 16.

22 Erdmann mentions two Mecca tiles in this mosque but does not illustrate them. Erken does not list them at all and they are not mentioned by Özkarcı 2001. We do not know their current whereabouts.

23 Erdmann 1959: no. B-10; Erken 1971: 308 and fig. 18. There is some confusion about the original position of this tile. According to Erdmann, it was placed next to the *mihrab*, above another tile featuring the sandals of the prophet Muhammad. But Erken describes the two tiles inside the *mihrab*. According to Demirsar-Arlı and Altun, the two tiles in question were positionned inside the *mihrab* until the 1990s, cf. Demirsar-Arlı and Altun 2008, p. 167.

24 The tile was published in Commission des sciences et arts d'Egypte 1809–22: Etat moderne, tome deuxième, pl. GG, fig. 13. It was then discussed in full in Jacquemart 1866: 245–9. Jacquemart also writes that the piece was brought from Cairo to France by Edme François Jomard, one of the authors of the *Description de l'Egypte*, see Jacquemart 1866: 251. In 1877, Prisse d'Avennes also states that the tile comes from the Divan of the Janissaries, see Prisse d'Avennes 2010: 183, fig. 46.

25 Inv. I.77. Like other Medina tiles, the image of the mosque is again drawn in reverse. The tile is very similar to a Medina tile formerly in the collection of Henri René d'Allemagne and could be the same object. The tile was on display inside one of the Oriental rooms of his house called 'vieux sérail', see d'Allemagne 1948, II: 181.

26 Inv. 6219.

27 Erdmann 1959: B-20, B-4 et B-11; Erken 1971: V-1 to 3.

28 Two 'Arafat panels are located in the mosque of the Black Eunuchs and in the Valide Oratory. A third one is located on the Golden Path, where it seems to have been reused after its removal from an unknown location. For those 'Arafat panels, see Carcaradec 1981: 174–84.

29 On 'Ali Iskenderiye and theses panels, see Bayraktar 1995.

30 Inv. 16645. See also database of http://www.discoverislamicart.org.

31 Erdmann 1959: B-11; Erken 1971: IV-1, fig. 19. The panel is published by Yaman 1996: 187–96.

32 Erken 1971: IV 2–3; Erdmann 1959: B 4–5. The specimen in the Louvre Museum was not listed by Erdman and Erken. Its inventory number is OA 3919/558 (ex OA 3919/2-242), see Paris 1977: 116–17, no. 210.

33 Ölçer 2002: 282.

34 Erdmann 1959: D 1–4; Erken 1971: VII 1,2,4,5.

35 This is a kind of oblique projection from a bird's-eye view, also called cavalier projection.

36 For example, birthplaces (*mawlid* but written *mawlud/mevlüd* according to a common Ottoman Turkish spelling of the word) of the Prophet, the first four caliphs, Fatima and Khadija; mosques like Masjid al-Khayf, Masjid Ibrahim and Masjid Muzdalifa.

Among the mountains: Jabal Mina, Thawr, Nur, al-Rahma, Abi Qubays and Mina.

37 Erken 1971: fig. 31. It was stolen from the mosque in August 2003 and later found. Since 2008, it is kept in the Museum of Pious Foundations in Ankara (Ankara Vakıf Eserleri Müzesi), inv. 6-2252.

38 Erken 1971: fig. 27. Inv. 860.

39 Inv. 3556. See also, El-Basha 1989: 232 and fig. 2; 'Ali 1999: 154–8 and fig. 37.

40 Prost 1916: 30–1.

41 Prisse d'Avennes 2010: 249. The panel of the Divan of the Palace of Khorshid Pasha is reproduced in pl. CXI. This panel was indeed very close to the panel of the Sabil-Kuttab and is often quoted as a reproduction of the panel of the Sabil-Kuttab itself.

42 We could examine a blue and white border tile kept in the Ariana Museum, Geneva (inv. 015168) similar in type to those of the Sabil-Kuttab. Its glaze and paste is close to the Qallaline products. In all cases, it can not be mistaken for a tile produced in Kütahya or the Tekfur Saray. Ülkü Bates also writes: 'I cannot attribute the tiles to a specific centre of production, although they must have been mass produced', in Bates 1989: 43, figs 16–20. Prost also considered that some tiles of the monument were products of local kilns set up by North African craftsmen in the Ottoman period; see Prost 1916: 31.

43 Sönmez 1997: 215–21.

44 Christie's 2008: lot 406. The colours of this tile are limited to red, cobalt blue, turquoise, black and grey and do not correspond to the palette of the Tekfur Saray production.

45 We think that this tile was made during or shortly after the erection of the mosque (1661–3). This box-like effect is known in illustrated manuscripts since the 16th century, see Maury 2010: 554–7, nn. 20–1. Another tile is known to us with a similar effect. It is far more detailed than the Yeni Cami tile and close in design to elements of the Tekfur Saray tile, see Drouot 1980: lot 415 (not in colour). It could date to the 18th century.

46 Şahin 1982: 127–8.

47 Erken 1971: figs 15, 22, 31 and Christie's 2008: lot 406.

48 Inv. 3251. See also, Erdmann 1959: no. B-9; Erken 1971: 306–7 and fig. 15.

49 For this tile, see n. 44.

50 Two other examples with apparent ownership's mark are a Mecca tile in the British Museum, inv. 2009.6039.1 and a Medina depiction spread over two square tiles sold in Drouot 1976: lot 195.

51 Atasoy and Raby 1989: 279.

52 Inv. 3251.

53 Inv. 2009.6039.1 (see n. 16).

54 His full name is Hüseyin Çelebi ibn el-Hac Mustafa Küreci. For all these titles see, Pakalın 1983, I: 21–2, 342–5, 505–6, for 'Ağa', 'çelebi' and 'efendi' entries.

55 Erken reads bahçeci but two dots are visible under the first letter. Erken 1971: 306.

56 an kariye karasal tabi'-i Yenişehir. Erdmann read Karasal but it could also be read Karısal. A village of this name still exists today in the district of Yenişehir, in the province of Bursa. Erdmann 1959: 195 (no. 8).

57 Erdmann 1959: no. C-2; Erken 1971: 312 and fig. 23.

58 The kethüda yeri, litterally 'place of the kethüda' was a member of the Janissary corps. He was an agent and delegate of the kul kethüda, a superior officer who assisted the Chief of the Janissaries (yeniçeri ağası), see Pakalın 1983, II: 252.

59 Otto-Dorn 1941: 47.

60 The reading is not absolutely certain. The dedicatory sentence has been read: El-hac Şa'ban ruhi içün fatiha. The beginning of the word 'el-hac' is truncated by a lacuna in the glaze; see Ürün 2012: 405.

61 Other tiles with pious formulas, names of the four caliphs and of the two grandsons of Muhammad are mounted of the same wall, but without any name of the donor. It is not clear whether Hüseyin ibn el-Hac Mustafa is responsible for them all; Yaman 1996: 191–3.

62 Sahibü'l hayr ruhiçün fatiha ma'a salavat.

63 Hayra yazsun şerrini anın kiramen kâtibin. Kim anarsa bir duadan iş bu hayrın sahibin. For this inscription, see also Otto-Dorn 1941: 125–6.

64 Erdmann 1959: no. B-8 and ill. 4; Erken 1971: 306 and fig. 16.

65 Museum of Islamic Art, Cairo, inv. 860.

66 amala al-faqir ila Allah al-ta'ala (made by the weak [servant] of God the most elevated).

67 The tile is not reproduced singly and not all of its inscriptions are legible. The name of the artist could be Kamran, see: Drouot 1997: lot 336.

68 For this tile, see n. 44.

69 The Sufi affiliation of Müstecbzade Süleyman hints that the panel may have been made in Iznik rather than in Kütahya and ordered on account of the connections between the donor and this order.

70 Bayraktar found his signature at the end of two Qur'anic-inscription bands (Throne verse). The first, located in the Chamber of the Holy Relics, on the wall opening to the Golden Path; the second, dated 1077/1666–7, at the end of the Qur'anic inscription band of the Hünkar Sofası. See Bayraktar 1995: 28–9.

71 Among them are: Turkish 'Altın oluk' for the golden gutter of the Ka'ba; 'bardak' for the bottles of Zamzam often represented in the court of the mosque; and Mina pazarı (market/bazaar) for the marketplace of Mina. See also n. 36.

72 For example, doors' names in the court of the mosque on a tile of the Aga Khan collection. See Paris 2007: cat. 73, n. 23. Sometimes legends follow mistakes made in the drawing, like in the panel of the Sabil-Kuttab of 'Abd al Rahman Katkhuda, where the Station of Abraham (Maqam Ibrahim) is not featured next to the entrance of the mataf but between the Shafi'i and Hanbali stations (**Pl. 8**).

73 La illah ila Allah, al malik al-Haq al-Mubin, Muhammad rasul Allah, sadiq al-wa'd al-amin.

74 Ya khaffiy al-altaf. Najina min mimma nakhaf.

75 Schnitzer and Schuckelt 1995: cat. 447.

76 Sometimes the last sentence of verse 97 is not written. All the translated Qur'anic verses in this article are derived from M.A.S. Abdel Haleem 2005.

77 Erdmann 1959: no. B-9; Erken 1971: 306–7 and fig. 15.

78 Erdmann 1959: no. C-6 and ill. 7; Erken 1971: 313 and fig. 26.

79 London, Victoria and Albert Museum, inv. 427-1900 and Kuwait, National Museum, inv. LNS 60C.

80 Clayer and Popovic 1995: 353–65.

81 Şen 1997: 348–56, fig. 11. The author does not give the exact location of the tile inside the Chamber of Adile Sultan.

82 British Museum, Inv. Add. Ms 27566, acquired from the Duke of Blacas, see Reinaud 1828: 310–24; Porter 2012b: 60–1, fig. 34.

83 Esin 1984: 178, ill. 1. They are written in cusped vertical cartouches. The end of the verse is visible in one cartouche while the first part has disappeared due to a missing section of the scroll.

84 Affiliated to the Mevlevi order, Nahifi mainly wrote on religious subjects. He was famous for the translation of the Masnavi of Jalal al-din Rumi and also conceived at the end of his life the inscription of the Tophane fountain in Istanbul. On Nahifi see, Uzun 2007.

85 Her Kime ka'be nasib olsa Hüda rahmet ider/ Her kişi sevdüğüni hanesine da'vet ider. We could not identify the specific work from which these verses come. They are also quoted by Evliya Çelebi in his famous travelogue before he began his description of the rites of the pilgrimage and the shape of the holy mosque, see Çelebi 1935: 687.

86 Inv. 860.

87 The work of Jami from which these two verses are taken is never mentioned. Sometimes they are also attributed to Rumi or even Sa'di.

88 On the value of pilgrimage in mystical traditions and this verse of Jami; see Tosun 2012: 136–47.

89 'Ilahi, Izzetin kakkiçün ol hakan-ı alişan/Ilahi, devlet ü iqbal ile ömrüni füzun olsun!'

90 Inv. 3556.

91 Prost 1916: 30–1.

92 The oldest examples are signed by Hafiz Osman (1642–98) and were made during the two last decades of the 17th century. See Taşkale 2006: 96–103.

93 Hilyehs with an image of Medina or of Medina and Mecca are attested from the 18th century onwards: see Taşkale 2006: 20, 104, 111, 126, 133, 141. In this book, the oldest dated hilyeh is signed by Seyyid Abdullah Efendi (1670–1731).

94 Schimmel 1985: 81–104. This verse is also associated with the depiction of the Prophet's Mosque on the Hajj certificate of Prince Mehmed, see Esin 1984: 185, ill. 9–10.

95 Schnitzer and Schuckelt 1995: cat. 447.

96 For bibliography, see n. 14.

97 Naza-Dönmez 1996.

98 *Shafa'ati li-ahl al-qaba'ir min ummati.* see, Naza-Dönmez 1996: 109–14. For this calligraphy composition on 18th-century Ottoman tiles, see Keskiner 2013.

99 Yaman 1996: 193. Precise formulation to be given. See Demirsar-Arlı 2013.

100 Drouot 1976: lot 195.

101 *geh nesimi Medeniden geh saba yeli eser; seher esdikçe saba yeli ana ab-i hayat.*

102 Schimmel 1985: 189–94.

103 For the most ancient illustrated Hajj certificates from the Ayyubid period, see Aksoy and Milstein 2000. For the Mamluk scroll of the British library, see Reinaud 1828, II: 310–24. For the description of an Ottoman Hajj certificate, see Esin 1984: 175–90. On the presence of those scrolls in mosques and the evidence that they had been hung, see Aksoy and Milstein 2000: 103–4.

104 In a similar fashion, on the symmetrical left portion of the wall, an identical composition has been disturbed to include two tiles representing a hanging lamp.

105 Erken 1971: fig. 27.

106 In the Yeni Valide, the single tile is protected from falling by metallic frame and bars. In the mosque of Rüstem Pasha, it is integrated in the ceramic revetment of the exterior wall under the entrance porch on the right side. This facade wall functions as a *qibla* wall for those who pray under the porch.

107 The *mihrab* verse (Q.3:37) is the verse most used for Ottoman *mihrab*s: 'Whenever Zachariah went in to see her in her sanctuary (*mihrab*)', see Sülün 2006: 255.

108 Inv. 6219.

109 Ürün 2012: 403–5.

110 Prisse d'Avennes 2010: 249.

111 Erken 1971: 297.

112 Ülkü Altındağ, 'Dârüssaâde', *Türkiye Diyanet Vakfı Islam Ansiklopedisi* 1994, IX: 1–3.

113 For the role of eunuchs in sacred sites, see Marmon 1995.

114 Istanbul 2008: 200, 254.

115 See Bilgi 2009: cat. 276, 434.

116 Till 2006 on deposit in Bayonne, Musée Bonnat, cf. Bayonne 2001: 8.

117 Erdmann, 1959: group B, no. 7. It is not mentionned by Erken.

118 Chekhab-Abudaya and Bresc 2013: 138. Information kindly given by Mounia Chekhab.

119 The upper register is cut by the wooden ceiling.

120 Published in Bayonne 2008, probably acquired by the French decorator Ambroise Baudry in Egypt.

121 Saadaoui 2001: fig. 59.

Chapter 20
Inscribing the Hajj

Sheila Blair

'The first House [of worship] to be established for people was the one at Mecca. It is a blessed place; a source of guidance for all people; there are clear signs in it; it is the place where Abraham stood to pray; whoever enters it is safe. Pilgrimage to the House is a duty owed to God by people who are able to undertake it. Those who reject this [should know that] God has no need of anyone (Q.3.96–7 (Al 'Imran)).[1]

These two verses describing the Ka'ba as the first house of worship where Ibrahim (Abraham) prayed and pilgrimage to it as a duty owed to God (Q.3:96–7), sometimes accompanied by the preceding or following verses, comprise the Qur'anic text most frequently associated with Mecca and the Hajj. Muslims make this association today: in the catalogue accompanying the splendid exhibition, *Hajj: journey to the heart of Islam*, Dr Muhammad Abdel Haleem opened his essay on the importance of the Hajj with this citation.[2] Muslims have made this connection since the beginning of Islam. These verses were already included in one of the earliest examples of graffiti to survive from Islamic times: a six-line text inscribed in August 735 on the walls of a ruined house in the village of Madina on the right bank of the Nile between Minya and Manfalus in Upper Egypt; the writer, Malik ibn Kathir, may have been commemorating his pilgrimage to the holy city.[3]

From these rather humble beginnings in the Umayyad period, these Qur'anic verses became canonical in inscriptions on the Haram surrounding the Ka'ba in Mecca. They are also found on objects associated with the Ka'ba including the *kiswa* (its covering), its doors and its fittings, such as keys and locks, as well as on many other objects associated with the Ka'ba such as pilgrimage certificates, tiles, manuals and popular religious texts. The text's strong associations with Mecca meant that it was also inscribed on buildings erected elsewhere in the Islamic lands to evoke the idea of sanctity and pilgrimage. This chapter traces the evidence for this, both written and visual, showing how the epigraphic use of this text developed over the centuries.

The Haram

The Abbasid caliphs had already monumentalized these verses on the Haram at Mecca by the mid-eighth century. According to the local ninth-century chronicler al-Azraqi, these verses were part of the large foundation inscription that records the order of the second caliph al-Mansur to enlarge the Haram.[4] The inscription was set over the Bab Bani Jumah, the major gateway on the south-west side of the Haram and replaced at the beginning of the tenth century by the Bab Ibrahim (**Pl. 1**). The text inscribed on the gateway is remarkably detailed. It says that al-Mansur ordered the Sacred Mosque to be widened, repaired and enlarged so that the new mosque was twice as large as the previous one. The inscription also records that the work was commissioned in Muharram 137/June–July 754 and finished in Dhu al-Hijja 140/April–May 758. It thus took almost four years to complete.

Placement and content underscore the official tenor and major significance of al-Mansur's inscription on the Bab Bani Jumah. The inscription was set over the most prominent entrance to the Haram. Virtually every visitor to the site might therefore see and even pass under it. Its content was

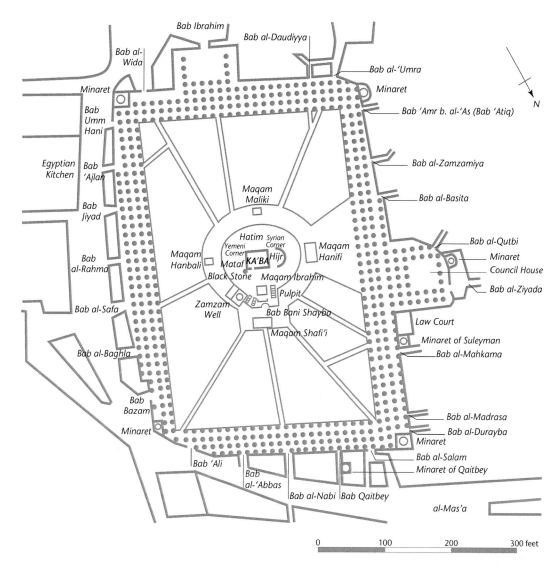

Plate 1 Plan of the Haram at Mecca (artwork by Matt Bigg, Surface 3 – after Eldon Rutter 1928)

carefully calculated as well, with the historical section preceded by two specifically chosen Qur'anic excerpts. The second was Q.3:96–7, the two verses about pilgrimage to Mecca. This Qur'anic text was preceded by the Prophetic Mission (Q.9:33), which says: 'It is He who has sent His Messenger with guidance and the religion of truth, to show that it is above all [other] religions, however much the idolaters may hate this'. The Umayyad Caliph 'Abd al-Malik (r. 685–705) had already adopted the first part of the Qur'anic verse with the Prophetic Mission in the margin on the obverse of his new epigraphic dinars issued from the year 77/696–7.[5] By selecting this verse for the front of the first epigraphic coins minted by Muslims in Syria, the caliph was making an official statement, for the rite of minting coins was considered to be one of the two signs of sovereignty. The numismatic text served not only to proclaim the new faith, but also to underscore the role of Umayyad rulers in disseminating it. Furthermore, coins – unlike religious buildings – would have been used by both Muslim and non-Muslims, so his message was broadcast widely. Caliph al-Mansur (r. 754–75), by opening his text at Mecca with this same verse that had been used on the earliest epigraphic coins, was thus affirming Abbasid connections to the official revelation of Islam and its first caliphal exponents, the Umayyads.

The materials and technique of al-Mansur's inscription on the Haram reinforce these Abbasid links to the Umayyads. The inscription was executed in mosaic, described by al-Azraqi who saw it *in situ*, as black letters on a gold ground.[6] The use of mosaic connects this Abbasid work to other formal inscriptions from the Umayyad period, notably the mosaics decorating the Dome of the Rock (**Pl. 2**)

Plate 2 Mosaic inscription on the interior of the Dome of the Rock, Jerusalem (photo: Jonathan M. Bloom and Sheila S. Blair)

Plate 3 Band (*hizam*) from the *kiswa* embroidered with Qur'an 3:95–7, c. 1900. Nasser D. Khalili Collection of Islamic Art (TXT 39A) (© Nour Foundation. Courtesy of the Khalili Family Trust)

and major mosques at Damascus, Medina and Jerusalem, all done in gold on a dark blue/green ground.[7] Al-Azraqi reported that the lettering at Mecca was done not in any dark colour, but specifically in black (*aswad*).[8] Black was, of course, the official colour adopted by the Abbasid rulers, who were known as *musawida* (the wearers/bearers of black) because they carried black banners decorated with black inscriptions set in gold bands.[9]

Moreover, the Abbasid inscription at Mecca was even more lavish than its Umayyad precedents, for it was done in the reverse of the earlier technique, with black letters on a gold ground. The Abbasid inscription thus required far more of the expensive gold cubes, made by sandwiching gold foil between pieces of glass. Such extravagant expenditure was all the more remarkable, as al-Mansur was a stickler for costs, renowned for his meanness. His nickname was Abu al-Dawaniq (the father of pennies), because he counted them all.[10]

Al-Mansur's desire to affiliate himself with – and even outdo – the Umayyads through the placement, content, materials and technique of his inscription on the major gateway to the Haram was especially potent at that particular moment in June–July 754, as he had just been proclaimed caliph. Having succeeded his brother Abu al-'Abbas al-Saffah (r. 749–54) the previous month, al-Mansur faced numerous rivals and challenges to the caliphate. The first part of al-Mansur's reign were 'years of struggle', as the new caliph grappled to assert his authority in face of major threats from Syrians, Abu Muslim and other discontents including the 'Alids.[11]

By enlarging the Haram and installing a prominent and shiny inscription to advertise that he had done so, al-Mansur achieved several goals. Most straightforwardly, he was affirming his piety. Known for his devotion, he was returning from the pilgrimage to Mecca in 754 when he received word of his brother's death and his own accession to the caliphate, and he was on pilgrimage there when he died in 775. More symbolically, by enlarging the Haram, al-Mansur was asserting his authority over the entire Muslim community as well as displaying Abbasid connections to Umayyad precedents, whose major rulers had served as his models.

Objects associated with the Hajj

Al-Mansur's inclusion of these Qur'anic verses about pilgrimage in his foundation inscription over the major gateway to the Haram set a standard that has been continued over the centuries on many objects connected with Mecca and the Hajj, especially those associated with the Ka'ba. The most important of these furnishings is the *kiswa*, the cloth covering God's House. Modern examples of the band known as the *hizam* (belt) are inscribed with this Qur'anic text about pilgrimage. One fragment from the turn of the 20th century (**Pl. 3**), for example, has Q.3:95–7 embroidered with gold and silver thread over padding against a ground of black and gold-coloured silk.[12] One of eight such panels is embroidered with Qur'anic verses that make up the *hizam*, and this section would have been hung on the north-east side of the Ka'ba, the one with the doorway. The embroidered band was set against a ground cloth of black brocade with chevrons inscribed with the *shahada*, or 'profession of faith', woven as part of the lampas ground.[13]

As the earliest surviving pieces from the *kiswa* date only from the 16th century, we must turn to textual descriptions and visual depictions to reconstruct what the *kiswa* looked like in earlier times. The first surviving report is the long, first-hand account by the Andalusian pilgrim Ibn 'Abd al-Rabbihi (d. 940). He described the Ka'ba as covered with curtains made of red silk brocade from Khurasan and decorated with circles inscribed with formulas praising and magnifying God and referring to His might and majesty.[14]

We get more evidence related to the *kiswa*'s inscriptions from the travelogue of the Persian pilgrim Nasir-i Khusraw, who visited the Haram almost a century and a half later in 1045. He described the *kiswa* as a white cloth divided vertically by two inscribed (*tiraz*) bands and decorated on each side with three *mihrabs*, a larger one in the centre flanked by two smaller ones.[15]

Nasir-i Khusraw did not specify the text used in these inscribed bands, but this was done by the Andalusian traveller Ibn Jubayr, who visited the shrine another century and a half later in 1183. He described the *kiswa* as made of green silk on cotton warps, with a band of red silk at the top, on which was inscribed the first half of Q.3:96 about the first house in Mecca. Ibn Jubayr added that the name of the Abbasid Caliph al-Nasir li-Din Allah, written three cubits high, encircled it all and that these coverings also had remarkable designs resembling handsome pulpits and inscriptions containing the name of God the most High and blessings for the caliph.[16] Later in his account, the traveller specified that the band with Q.3:96 was set on the side with the door that faces the venerated Maqam Ibrahim (Abraham's place of standing), while the inscriptions on the other sides had the name of the caliph and blessings for him. Around the inscription band were two reddish zones with small white roundels containing inscriptions in fine characters that included verses from the Qur'an as well as mentions of the caliphs.[17]

Plate 4 Schematic drawing from the centre of a pilgrimage scroll showing the Haram, Ka'ba and *kiswa* inscribed with Q 3:97 (after Aksoy and Milstein 2000, fig. 3, with permission of the author)

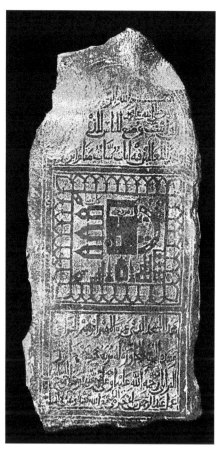

Plate 5 Drawing of a stone slab inscribed with a depiction of Mecca, early 13th century. Iraq Museum, Baghdad (no. 1149) (after Strika 1976)

Ibn Jubayr's 1183 description of the *kiswa* as inscribed with this verse about pilgrimage (Q.3:96) on the north-east or main facade of the Ka'ba is confirmed by contemporary representations of it on pilgrimage scrolls. These scrolls attest to the increasing number of pilgrims there in medieval times. The first surviving certificates, dating from the 11th century, had only large calligraphy, but at least from the late 12th century the written text was reduced to one, two or three lines squeezed in between larger schematic representations of the holy sites in four or five colours.[18] The central scene on these pictorial scrolls (**Pl. 4**) gives a detailed but conventionalized bird's-eye view of the Haram as an arcaded rectangle, with the Ka'ba in the centre surrounded by concentric rings of monuments and minarets in the corners. To the right is the wall (*hatim*); at the bottom is the Prophet's pulpit (*minbar*); and to the left are three domed structures that represent the Qubbat Zamzam, the Qubbat al-Sharrab (Dome of Drinking) and the Maqam Ibrahim. The depiction of the Ka'ba is equally detailed, showing it as a tall cube with the waterspout at the top right. The depiction illustrates the north-east facade of the building with the doorway; the band (*hizam*) above is inscribed with Q.3:97, saying that whoever enters it is safe.

This type of illustrated pilgrimage scroll continued to be made for centuries, with an increasing numbers of colours, as in the several examples illustrated in the catalogue accompanying the exhibition *Hajj: journey to the heart of Islam*.[19] And these certificates in turn served as the source for depictions in many other media including ceramic tiles,

pilgrimage manuals and biographies of the Prophet made in later centuries, all subjects of other essays in this volume.[20] But one other copy of a pilgrimage scroll also deserves mention, as it is the earliest and one of the most curious examples: a small (15 x 33cm) stone slab from the Maqam Ibrahim in Mosul (**Pl. 5**), now in the Iraq Museum in Baghdad (no. 1149).[21] The inscription at the bottom of the slab commemorates the foundation of a mosque and nearby tomb of Husna Khatun bint al-Qarabili/Qarayli by Amir Ibrahim al-Jarrahi.[22] The lowest line contains the signature of the stone carver, 'Abd al-Rahman ibn Abi Harami al-Makki. A member of a famous family of stone carvers active in Mecca between 1168 and 1220, al-Makki studied in Mecca, Damascus, Baghdad and Mosul before teaching and working in Mecca where he carved stones for the city's elite.[23] The stone can thus be dated to the early 13th century, and the depiction on it repeats exactly the same conventionalized view of the Haram used on the certificates, with the Ka'ba in the centre, covered by the *kiswa* inscribed with the same words from Q.3:97 that whoever enters it is safe. Above is the preceding Qur'anic text (3:96–beginning of 97) saying that the first house established for worship, the one in Mecca, was a blessed place with clear signs in it and the place where Ibrahim prayed. As Carin Juvin suggested, 'Abd al-Rahman ibn Abi Harami al-Makki may not only have carved stones but also calligraphed pilgrimage certificates.[24]

We do not know why the stone was commissioned for this foundation in Mosul, but there were close ties between

Mosul and Mecca. The stone was erected when the region around Irbil was in the hands of the local ruler Muzaffar al-Din Gökburi (d. 1233).[25] A member of an important seigneurial family, Gökburi astutely manoeuvred among the various rulers of Upper Mesopotamia, managing to control Irbil for over forty years (1190–1233). The pious Gökburi patronized charitable institutions in Irbil, including *madrasa*s (theological schools), *khanaqa*s (hospices for Sufis), hospitals and almshouses. He did so also in the Hijaz, commissioning a *madrasa* in Mecca as well as a basin at ʿArafat dated 594/1198 and inscribed by ʿAbd al-Rahman ibn Abi Harami, the same mason who carved the stone slab.[26] Amir Ibrahim al-Jarrahi might have accompanied Gökburi to Mecca and commissioned the slab there as a souvenir from the holy land. The Qurʾanic verse would have also been an apt choice, linking the local patron of the mosque and tomb, with his namesake, Ibrahim, the builder of the Kaʿba and founder of the Hajj.[27]

In addition to the *kiswa*, other Kaʿba fittings were also inscribed with Q.3:96. Nasir-i Khusraw specifically noted that the doors were inscribed with the first half of Q.3:96, the same text about the first house of worship at Mecca that Ibn Jubayr later reported on the *kiswa*.[28] It is no wonder that the Persian traveller mentioned these doors, for the set, which comprised two large teak valves decorated with circles and inscriptions in gold decorated (*munabbat*) with silver, was so fancy that it attracted the eye of many early travellers who left detailed descriptions of it.[29]

Nasir-i Khusraw also mentioned that the double door to the Kaʿba was closed with two sets of silver rings and a silver lock, and Q.3:96–7 soon became part of the standard decoration inscribed on keys to the Kaʿba. At least two dozen examples survive from medieval and early modern times, dating between the 12th and 17th century, most of which are preserved in the collection of the Topkapi Palace in Istanbul.[30] The keys fall into three chronological groups: a first group made during the last century of Abbasid power in Baghdad; a second group made during the first century and a half of Mamluk rule of Egypt and Syria; and a third group, the apogee of production, made during the century and half of Ottoman imperial grandeur.

On most of the examples belonging to the first two groups made for the Abbasids and the Mamluks the key text is

Plate 6 *Qibla* wall of the Tankiziyya Madrasa in Jerusalem, 1328–9 (after van Berchem 1920–2, pl. LXVIII)

Q.3:96–7, exactly the one that was inscribed on the Kaʿba speaking about God's house in Mecca as the place of Ibrahim's prayer and a place of safety for anyone who enters it, occasionally with parts of the preceding and following verses. The key made for the Abbasid Caliph al-Nasir li-din Allah in Rajab 576/November–December 1180, for example, has Q.3:96 and the first half of verse 97.[31] Another key made for the same patron 45 years later in 1224 is similar but slightly larger and correspondingly has room for the end of verse 97.[32] The choice of verse is underscored there by the foundation inscription, which mentions that the key was made for the noble house (*al-bayt al-sharif*), thus referring back to the Qurʾanic text about God's house (*bayt allah*).

The use of Q.3:96–7 seems to be associated particularly with examples commissioned by Abbasid caliphs and Mamluk sultans, but not on those made for local patrons. These verses are not found, for example, on the earliest key to survive – one made by a certain Ilyas ibn Yusuf ibn Ahmad al-Makki in 1160 – despite the fact that it is covered with inscriptions, most of them Qurʾanic.[33] These inscriptions identify the object as a key to God's Kaʿba (*miftah kaʿbatallah*) and include well-known Qurʾanic texts such as *Surat al-Fatiha* (Q.1) and *Surat al-Ikhlas* (Q.112) and the phrase from Q.61:13 about God's help and an imminent breakthrough, but not Q.3:96–7. This text is also missing on keys made later for non-royal patrons. The verses do not appear, for example, on an undated key made for Shaykh Ghanim al-Shaybi, whose family was in charge of the keys to the sanctuary.[34]

The pilgrimage text Q.3:96–7 also fell out of favour under the Ottomans. The first half of verse 97, about clear signs and the place where Ibrahim stood to pray, is still used on the earliest Ottoman example, a key made for Sultan Bayezid II in Rabiʿ I 915/1509 (June–July).[35] Although the Ottomans were beginning to expand their power at the time this key was made, sovereignty over the holy places was still in the hands, at least nominally, of the Mamluk sultans of Egypt. Hence, on this key Bayezid's only title is Sultan of Rum.[36] Once the Ottomans had gained sovereignty over the holy places after definitively defeating the Mamluk Sultan Qansawh al-Ghawri in 1516, the inscriptions on the keys change and Qurʾanic texts disappear. Sultan Süleyman, for example, made various embellishments to the Kaʿba, including repairs to the terrace and the gift of a massive gold gutter.[37] A lock (*qufl*) made at the end of the sultan's long reign in 973/1565–6 has an inscribed cartouche with a historical inscription, but no Qurʾanic text.[38]

Hajj verses in other places

The two verses about the Hajj (Q.3:96–7) thus become canonical in official inscriptions decorating the Haram, the Kaʿba, its fittings and associated objects made from Abbasid to Mamluk times. However, the strong association with Mecca meant that the verses were also used on buildings in other places to evoke the idea of sanctity and pilgrimage. One site was Jerusalem. The opening verse about the first house in Mecca was used, for example, in the large inscription at the top of the stunning marble revetment surrounding the *mihrab* in the Tankiziyya Madrasa, constructed in 728/1328–9 (**Pl. 6**).[39] The *madrasa*, part of a

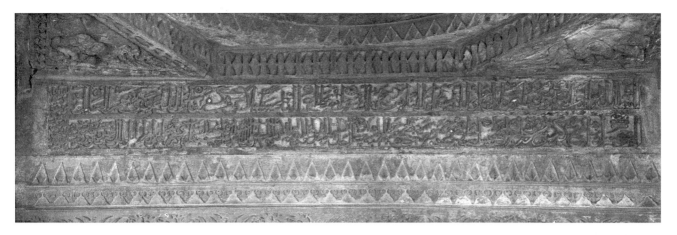

Plate 7a–b a (top): Lintel over the eastern doorway added by Iltutmish in the early 13th century to the Qutb mosque in Delhi (photo: Finbarr Flood); b (bottom): Eastern gateway added by Iltutmish in the early 13th century to the Qutb mosque in Delhi (photo: Jonathan M. Bloom and Sheila S. Blair)

complex including a bath, *Hadith* college and *khanaqa* which was located on the south side of the Tariq Bab Silsila, just beside the Haram Gate and partly over the west portico, was endowed by Amir Tankiz, virtual ruler of Syria for the Mamluk Sultan Muhammad ibn Qalawun. Like the Abbasid Caliph al-Mansur and the ruler of Mosul, Muzaffar al-Din Gökburi, this wealthy patron was known for his personal rectitude and founded a series of religious institutions as well as urban works in Damascus, Jerusalem and elsewhere.[40]

These verses about the Hajj also found resonance with the early Muslim rulers of Delhi, who used this text repeatedly on their constructions there. The verses occur several times on the additions made by Mu'izzi Sultan Iltutmish to the Qutb mosque in the early 13th century as part of his extensive campaign to triple the size of the mosque that had been constructed a generation earlier by

the founder of the dynasty, the *mamluk* (military slave) Qutb al-Din Aybak. The passage Q.3:96–7, which says that pilgrimage is a duty owed to God and dunning those who reject this idea, forms the opening line of text on the lintel that Iltutmish had inserted over the main eastern gateway to the mosque (**Pl. 7**).[41] The Qur'anic text is followed by a second line in Persian saying that Qutb al-Din Aybak had built the congregational mosque in 587/1191–2 and that the materials from 27 idol temples (*butkhana*) had been used in its construction. Although the inscription mentions Qutb al-Din, Horowitz showed that the lintel must have been added under Iltutmish for a variety of reasons ranging from the unusual choice of Persian, the titles in the text, its script and the wrong date given for the original foundation of the mosque (587 instead of 588).[42]

The same verses were also inscribed on the southern extension to the *qibla* screen added by Iltutmish in 626/1229–30.[43] The arch immediately to the south (left) of Qutb al-Din's original screen opens with the two verses about the first house of worship in Mecca (Q.3:96 and beginning of 97 up to the phrase that whoever enters it is safe).[44] The inscription continues down the left side of the arch with the following five verses (Q.3:98–102) addressed to believers to listen and not obstruct or deny God.

In dramatically expanding the Qutb mosque and decorating his additions with these inscriptions, the parvenu Iltutmish, newly triumphant successor to Qutb al-Din, was appropriating and superseding his master's authority. Iltutmish wanted to make the mosque a site of pilgrimage, an understandable goal since Delhi lies some 5500km east of Mecca, a long journey that would have been impossible for all but the heartiest of pilgrims.[45] But Iltutmish was also acting symbolically, for the ruler was using the mosque as a microcosm, a metonym of universal religious and political domination.[46] His larger goal was to make the entire city of Delhi a centre of pilgrimage, and in doing so he may have been deliberately emulating the Abbasid caliph al-Mansur, who had enlarged the Haram in a similar way and added the same verses there.

We know about Iltutmish's deliberate references to Mecca because the same text about the first house of worship and the duty of performing Hajj (Q.3:96 and the first half of 97) are prominently inscribed on another work carried out by Iltutmish at this time: the arch over the *mihrab* in the tomb of Sultan Ghari, Iltutmish's eldest son, who died in 629/1231–2.[47] The first mausoleum built in the Delhi sultanate, the

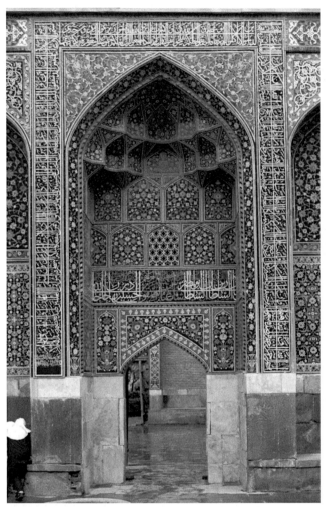

Plate 8 Doorway added by Shah 'Abbas in 1626 to the court of the dynasty shrine at Ardabil (photo: Jonathan M. Bloom and Sheila S. Blair)

the same city. A century later in 1311–12, 'Ala' al-Din Khalji added the great doorway known as the Alai Darvaza on the south side of the mosque. The text around the arched windows on the main facade includes Q.3:95–9, verses about Ibrahim's religion, the first house in Mecca and pilgrimage as a duty.[50] The text was part of a carefully chosen programme of inscriptions that repeatedly mention Mecca, including a Persian panegyric on the west side of the portal that describes the mosque as a 'second Ka'ba'.[51] The same verses about pilgrimage to Mecca (Q.3:96–7) are also repeated on the entrance to the tomb of Firuz Shah Tughluq (d. 1388) in the complex known as Hauz Khas, a *madrasa* that served as a centre for learning in medieval India.[52] And again contemporary panegyrists played on this metaphor of pilgrimage to the mosque and city. For the poet Amir Khusraw (d. 1325), the Qutb mosque was 'a world within a world' (*jahan dar jahan*).[53]

In addition to the Delhi sultans who wanted to turn their capital in a site of pilgrimage, the Safavids in Iran also used these verses at shrines, clearly intended to be sites of pilgrimage for the Shi'a. For example, Q.3:95–7 frame the west entrance portal to the courtyard in the Shrine of Sheikh Safi' at Ardabil (**Pl. 8**).[54] The inscription dated 1036/1626–7 commemorates the extensive work carried out at the shrine under Shah 'Abbas, including renovations to three major buildings there: the Jannat Saray, the large audience hall on the north which had been built by his grandfather Tahmasp; the Dar al-Huffaz (Hall of Qur'an Reciters), the rectangular reading and prayer hall on the west leading to the tomb of Shaykh Safi'; and the Chini-Khana (House of Porcelain), the octagonal hall to the west which was revamped to store the extraordinary collection of Chinese porcelains that 'Abbas donated to the shrine.[55] The Safavid shah carried out these renovations to the shrine to rejuvenate his legacy and promote his 'Alid connections. His aim is clear from the titles he bears in the band over the doorway: he is lauded as the most just, most noble sultan; the most courageous and magnificent emperor; he who has his foot on the necks of the Arabs and Persians; propagator of the School of Twelve Imams by the assistance of the Most Merciful [i.e. God]; he who eradicates infidelity and tyranny, raises the edifice of justice and beneficence, and lays the foundations of safety and security.

The Qur'anic verses surrounding the portal at Ardabil reinforce the role of Shah 'Abbas as propagator of Twelver Shi'ism. The text in the frame band begins with three verses from *surat Al 'Imran* (Q.3). It opens with Q.3:95 that God speaks the truth and urges believers to follow the religion of Ibrahim who had true faith; continues with verse 96 about the first house in Mecca; and ends with all of verse 97 that pilgrimage there is a duty owed to God. The text then jumps to Q.3:130–4, which states that believers should obey God so that they prosper and obtain mercy, for God loves those who do good. The band ends with Q.28:30, God's words to Moses from the right side of the valley from a tree on the blessed ground (*al-buq'a al-mubaraka*), the same verse evoked by Hasan Nizami's description of the Qutb mosque in Delhi.

Transforming a building into a place of pilgrimage seems to have been the primary reason for the use of the verses Q.3:96–7, but punning on the name Ibrahim could also be a

square tomb was the centre of a *madrasa* complex located several kilometres west of the Qutb mosque. The Qur'anic inscriptions on both the exterior and interior of the tomb focus on the requirements of faith, sanctuary and pilgrimage, and the choice of verses about pilgrimage to Mecca as a duty to God underscores the role of pilgrimage to the capital.

Local chroniclers reiterated this rhetoric about Delhi as a centre of pilgrimage. The contemporary panegyrist Juzjani (1193–c. 1270), for example, called the city the epicentre of Islamic lands, the rival to Baghdad, Constantinople, Egypt and Jerusalem, even the centre of the circle of Islam (*markaz-i da'ira-i islam*), the last an image evoking the idea of Mecca and one consonant with Iltutmish's erection of an antique iron pillar in the centre of the mosque as a symbolic pole or omphalos (*qutb*).[48] The first description of the Qutb mosque in the *Taj al-ma'athir*, written by Hasan Nizami during the reign of Iltutmish, calls it a *buq'a-yi mutabarrak* (blessed spot),[49] a phrase that not only recalled those used on earlier and contemporary mosques in the region but also one that recalls the site mentioned in Q.28:30 in which God addressed Moses from the right side of the valley from a tree on the blessed ground (*al-buq'a al-mubarraka*), saying, 'Moses, I am God, the Lord of the Worlds'.

The message about pilgrimage to Delhi encoded in the repeated use of verses Q.3:96–7 on buildings commissioned by Iltutmish resonated diachronically with later patrons in

subtext in the use of this particular text. The shrine known as Imamzada Isma'il at Kaj outside of Isfahan, renovated in 1593–4 during the reign of Shah 'Abbas, bears this text painted in white on a red ground around the interior of the tomb. As the Iranian epigrapher Lutfallah Hunarfar pointed out, the choice of verse was particularly suitable for a shrine built by someone called Ibrahim,[56] just as the verse was appropriate for Amir Ibrahim Jarrahi's plaque commemorating the construction of the Maqam Ibrahim in Mosul.

Conclusion

These two verses describing the Ka'ba as the first house of worship where Ibrahim prayed and pilgrimage to it as a duty owed to God (Q.3:96–7) have a long association with Mecca. The text, inscribed officially on the gateway to the Haram in the mid-eighth century to laud the Abbasids as successors to the Umayyads and rulers of the Muslim community, became canonical for the furnishings of the Ka'ba by the 11th century. It was inscribed on the *tiraz* band decorating the main facade of the structure and on the doors and keys to it, as well as pilgrimage certificates, themselves the source for commemorative stones, tiles and manuals. It was also used on buildings elsewhere to evoke the idea of sanctity and pilgrimage to a particular site and to connect a patron named Ibrahim with his namesake Ibrahim, builder of the Ka'ba and founder of the Hajj. No wonder then for many Muslims, both today and throughout past centuries, these verses are emblematic of the Hajj.

Notes

1 All Qur'anic translations are by M.A.S. Abdel Haleem 2005. Also available through Oxford Studies Online.
2 Porter 2012a: 30.
3 Van Berchem 1894–1903: no. 513; Combe, Sauvaget and Wiet 1931ff: no. 30. Somers Clarke discovered the text on the west wall of a ruined house in 1900 during excavations in the village. Written in simple kufic, with letters about 5cm high and 83cm in length, the text contained the *basmala*; these Qur'anic verses about pilgrimage (Q.3:89–92); and part of another Qur'anic verse (Q.41:40), saying 'Do whatever you want, God certainly sees everything you do', followed by the writer's signature and the date. Van Berchem, who reproduced the line with the signature, compared the style of script to that used in early Qur'an manuscripts.
4 El-Hawary and Wiet 1985: no. 1; Combe, Sauvaget and Wiet 1931ff: no. 40, citing al-Azraqi I: 59.
5 Blair 1992: 67; Bachrach 2010: 18. One dinar issued by the Umayyad Caliph 'Abd al-Malik in 698–9 is illustrated in Porter 2012a: 89, fig. 55.
6 Wustenfeld 1981, I: 311; al-Azraqi's exact words are *bi'l-fusayfisa' al-aswad fi fusayfisa' mudhahhab*; this was the source for Gaudefroy-Demombynes 1923: 145.
7 The inscription is best preserved at the Dome of the Rock, for which, see the long discussion by Marguerite van Berchem in Creswell 1969: 213–322.
8 Muslim authors used a range of colours to refer to black; see Morabia *EI²*.
9 Bosworth *EI²* and Bloom and Blair 2011: 32–6. As illustrated in this volume, such banners are depicted in the scene of the pilgrimage caravan from a copy of al-Hariri's *Maqamat* copied and illustrated by Yahya al-Wasiti in 1237, probably at Baghdad (Bibliothèque nationale de France, Paris, MS arabe 5847, fol. 94b; illustrated in Ettinghausen 1962: 119) and on pilgrimage scrolls, including one in the name of the Caliph al-Musta'sim (Turkish and Islamic Arts Museum, Istanbul, 4724; Aksoy and Milstein 2000: pl. 7; Paris 2010: fig. 5).

10 Kennedy 2004: 15–16.
11 Kennedy 1981: 57–73; see also his article in *EI²*.
12 Vernoit 1997: no. 9. The text contains the preceding verse (95) about Ibrahim's religion, verse 96 about the first house in Mecca, and the first five words of verse 97 about clear signs. The text about God's house (Q.3:96) is also used on modern textiles covering the interior of the Ka'ba, as the one in the exhibition from around 1935 (Porter 2012a: 257, fig. 195).
13 For other examples dating from the 16th century to the present in the collection of Topkapi Palace in Istanbul, see Tezcan 2007.
14 Shafi' 1922: 427. See also Sardi in this volume.
15 Nasir-i Khusraw/Dabir Siyaqi 2554: 133; Nasir-i Khusraw/Thackston 1986: 77–8.
16 Ibn Jubayr/Broadhurst 1952: 79, 87–8.
17 Ibn Jubayr/Broadhurst 1952: 185.
18 Aksoy and Milstein 2000. The earliest calligraphic scroll in the collection of the Turkish and Islamic Arts Museum is dated 476/1084, the earliest pictorial one 589/1193.
19 Porter 2012a: 33, fig. 8; 38, fig. 14; 136, fig. 92; and 197, fig. 146.
20 Porter 2012a: 33, fig. 8; 38, fig. 14; 45, fig. 20; 55–7, figs 27–8; and 117–19, figs 77–9.
21 Strika 1976; Paris 2010: 499, fig. 6.
22 The reading of the woman's *nisba* is unclear. Strike 1976 read Qarabili, but my colleague Mehmet Tütüncü pointed out to me that Qarayli was the name of an important Turkman tribe that settled in the region of Irbil and Mosul and that she might be a member of that tribe. He also noted that we have no other information about this mosque and tomb nor about the reason that the stone was moved to the Baghdad museum, so there are many unanswered questions about this stone. I thank him for his information on these points.
23 Juvin 2010: 499; Juvin 2013. Strika had dated the stone to the late 11th century based on his assumption that the patron was the penultimate Uqaylid ruler of Mosul (r. 1085–93), but the signature of the artisan and the style of script prove that it is actually more than a century later.
24 Juvin 2013.
25 Biography in Cahen *EI²*; the date of Gökburi's rule in Juvin 2010: 499 as 1190–1223 seems to be a misprint as Cahen gives his date of death as 1233 and says he ruled for 44 lunar years.
26 For Gökburi's works in Mecca, see Juvin 2010: 499 and 2013: n. 38; the inscription on his basin is also given in Combe, Sauvaget and Wiet 1933ff: nos. 3507–8.
27 On Ibrahim and his role in Islam, see Busse *EI²*, especially section 5. 'Builder of the Ka'ba, founder of the *Hajj*'.
28 Nasir-i Khusraw/Dabir-Siyaqi 2554: 131; Nasir-i Khusraw/Thackston 1986: 76. See also Kennedy's essay in Porter 2012a: 116–18.
29 Shafi' 1922: 425; Ibn Jubayr/Broadhurst 1952: 87 says that the door in his day had been donated by the Caliph al-Muqtafi in 1155.
30 The basic work is Sourdel-Thomine 1971; see also Allan 1982: nos 17–18, for two further examples once in the Nuhad al-Said collection and now in Doha (one is illustrated in Porter 2012a: 121, fig. 82), as is another example made for the Mamluk Sultan Sha'ban in 765/1364 and now in Cairo (Porter 2012a: 121, fig. 81).
31 Sourdel-Thomine 1971: no. 2.
32 Sourdel-Thomine 1971: no. 3.
33 Sourdel-Thomine 1971: no. 1. This text also does not seem to be used on a similar but undated key (no. 1 bis), most of whose inscriptions are illegible.
34 Sourdel-Thomine 1971: no. 5. The verses also do not appear on another anonymous bronze key of approximately the same date (no. 5bis). For Snouck Hurgronje's photograph of the children of the Bani Shayba family, see Porter 2012a: 120, fig. 80.
35 Sourdel-Thomine 1971: no. 14.
36 This is also the case on another key made for Bayezid at the same time; Sourdel-Thomine 1971: no. 15.
37 Gaudefroy-Demombynes R1971: 40.
38 Sourdel-Thomine 1971: no. 16.
39 Van Berchem 1920–2, I: no. 80; Dodd and Khairallah 1981, II: 29. On the building see Burgoyne 1987: no. 18.
40 The association of these verses with Jerusalem continued, for they were also used on a glazed tile, probably of the Ottoman period,

inserted on the portico of the Aqsa mosque; van Berchem 1920–2, II: 449.

41 Horowitz 1911–12: 13–14. This citation has engendered much misunderstanding and many mistakes. Hussain 1936: 113, no. CXVIII (99a) repeated Horowitz's citation of Q.3: 91–2, but Welch, Keshani and Bain 2002: 18 took the citation as referring to the new numbering system of the Qur'an as standardized in the Standard Egyptian edition, verses that referred to polytheists and numbered 85–6 in the older system used by Gustav Flügel and others in the 19th and early 20th century. Flood (2009: 158 and 2011: 129, n. 11) followed Welch, Keshani and Bain's citation (though he gave the numbers as Q.3:91–9, presumably just dropping the last digit 2 in 92) and interpretation, assuming also that the verses referred to disbelievers. The lintel is extremely difficult to photograph, and to my knowledge no one has published pictures of the inscription (Horowitz illustrated a rubbing only of the second line with the historical text.) Barry Flood kindly checked his photographs of the lintel for me, and indeed they show that Horowitz's citation refers to the verses using the old numbering system and corresponding to Q.3:96–7 in the new numbering system, as indicated in the index of Qur'anic inscriptions by Dodd and Khairallah (1981, II: 29). The problems point to the necessity of checking individual verses in Suras in which the numbering systems are so different.

42 Horowitz 1911–12: 13–14. Welch, Keshani and Bain 2002: 18 assumed, however, that that the inscription was part of the original mosque as set up by Qutb al-Din Aybak, but Flood (2009: 239 and 2011: 134–5) pointed out correctly that the inscription was likely to have been added by Iltutmish, as Horowitz had suggested.

43 Hussain 1936: 109, no. CXVIII (13b); Dodd and Khairallah 1981, II: 29–30; Welch, Keshani and Bain 2002: 28.

44 I do not have photographs of this inscription, and again there is some confusion about the exact text. I am relying on Welch, Keshani and Bain (2002: 28) who give Q.3:96–102 and discuss the content. Hussain (1936: 109, no. CXVIII, 13a; repeated in Dodd and Khairallah 1981, 2:29) says that the first part of the arch contains the same text as the third inscription on the tomb of Firuz Shah (his p. 74, no. LXXVI, 3) that is, Q.3:95–6, but only up to the phrase that whoever enters it is safe. This phrase, however, is part of verse 97 (not 96) in the Cairene numbering system, so I assume that his edition of the text had a slightly different numbering system here. This assumption seems to be confirmed by the evidence below from the tomb of Sultan Ghari, where he gives the same citation (Q.3:95–6), but photographs show that the inscription is Q.3:96–7 in the modern Standard Egyptian numbering system.

45 Pilgrimage from that region developed in great numbers only in the 19th century with the development of steam and rail travel; see the essays by Nile Green and others in this volume.

46 Flood 2009: 229.

47 Hussain 1936: 91, no. CIX (3); Dodd and Khairallah 1981, II: 29; Welch 1985: 259; Welch, Keshani and Bain 2002: 36–7. The first two sources give Q.3: 95–6, the latter two Q.3: 96–7. Photographs available on ArtStor show that the latter is correct.

48 Flood 2011: 133–6.

49 Flood 2009: 242 (n. 71), 246.

50 Hussain 1936: 100, no. CXVI (30); Dodd and Khairallah 1981, II: 29; Welch, Keshani and Bain 2002: 33.

51 Welch, Keshani and Bain 2002: 33.

52 Hussain 1936: 74, no. LXXVI(3); Welch 1996: 178.

53 Flood 2009: 229.

54 Tabataba'i 2525: 130–3; Rizvi 2010: 208.

55 Blair 2013: chapter 6 discusses the first part of the renovation; Rizvi 2011, chapter 5 discusses the other two.

56 Hunarfar 1330: 285–6.

Chapter 21
Weaving for the Hajj under the Mamluks

Maria Sardi

In the years of the Mamluk hegemony over Egypt and Syria (1250–1518), the holy cities of Mecca and Medina were put under the control of the Mamluk sultans. In order to legitimize their role as 'protectors of Sunni Islam' they showed remarkable concern for the organization of the annual Hajj to Mecca where they could best display their prominent role among other rulers of the Islamic lands. They reinstated the Egyptian Hajj route through Sinai, constructed several amenities, such as wells, cisterns, dams and caravanserais, on the pilgrims' route and enhanced the ceremony of the Hajj caravan's departure with great pomp and luxury.[1] The caravan departed annually from Cairo followed by hundreds of pilgrims and camels carrying the necessities for the trip. Alongside litters loaded with products for daily use, sumptuous woven items of religious and political importance commissioned by the royalty were carried in a ceremonial procession. Important among them were the coverings destined for the exterior and the interior of the Ka'ba, the curtain for its door, draperies for tombs of the prophets and fine silks covering the ceremonial *mahmal*, which was the centrepiece of the caravan.

In terms of the fabrics made for the Ka'ba, first to be discussed is the *kiswa*, the impressively large woven covering of the Ka'ba which was offered annually to the sanctuary at Mecca. The prerogative of the *kiswa*'s bestowal was reserved for the caliph up to the end of the Abbasid caliphate in Baghdad in 1258 and passed to the Egyptian rulers in 1263.[2] According to al-Fasi, Baybars (r. 1260–77) was the first Mamluk sultan who sent the covering of the Ka'ba to Mecca.[3] The name of the Mamluk sultan was inscribed on the Ka'ba's covering and thus his power symbolically spread into the Hijaz.[4] Although many other Muslim rulers had also wished to gain this prerogative, Sultan Qalawun (r. 1279–90) had already in 1282 coerced the Sharif of Mecca to promise him that the Mamluk *kiswa* would be the only one to cover the Ka'ba and that his standard would be placed at the head of the processions.[5] Yet, the political significance of this textile was so great that throughout the Mamluk era, several rulers attempted to abrogate this right, often leading to diplomatic conflicts.[6]

In 1438, the Timurid ruler Shahrukh (r. 1405–47) sent his ambassadors to Cairo to demand from Sultan Barsbay the right to send a *kiswa* to Mecca on behalf of the Turko-Mongol ruler, with the pretence that this request was made due to a vow made by the shah. The Mamluk sultan's reply was angry. He answered that if the shah wished to fulfill his vow he could then cut his covering in pieces and distribute it as alms to the poor of Mecca.[7] The significance given to the custom of the *kiswa*'s donation is further illustrated by the fact that the following year the same shah sent a second embassy with a similar request to Sultan Jaqmaq (r. 1438–53) who, unlike his predecessor, was less absolute. In opposition to the sultan's demands, both his *mamluks* and the populace attacked the shah's ambassadors and plundered all their possessions.[8] The following day the sultan punished his subjects, but the public reaction provides vivid testimony of the importance that the custom of offering the *kiswa* held among the Egyptians.

The Mamluk *kiswa* was mostly made of silk lined with other materials, obviously adhering to strict religious

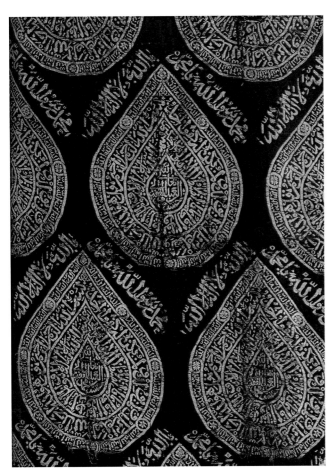

Plate 1 Mamluk *kiswa*, mid-14th century, Topkapi Palace Museum, Istanbul (inv. no. 13/1689)

restrictions. This was the case of the covering sent in 1327 by Sultan al-Nasir Muhammad (r. 1293–1340 with interruptions) which was made of black silk cloth lined with linen.[9] The overall covering generally consisted of several pieces embroidered with gold inscriptions. The inscriptions included Qur'anic verses and the name of the donor. Sources also record that since the 10th century medallions embroidered in white silk were also displayed on the part of the *kiswa* covering the facade of the Ka'ba, close to the door.[10] Material evidence for this kind of decoration may be provided by a still extant fragment of a Mamluk *kiswa* now in the Topkapi Palace Museum in Istanbul (**Pl. 1**). It is made of black silk embroidered with white pear-shaped medallions and is inscribed with Qur'an 3:18 (*Al Imran*) ('God bears witness that there is no god but Him, as do the angels, and those who have knowledge. He upholds justice. There is no god but Him, the Almighty, the All Wise') is read.[11] In the circumference of the medallions the word 'Allah' is repeated among eight petalled rosettes. In the core of the roundels the name of 'Hasan ibn Muhammad' is inscribed. It is apparently the name of the Mamluk Sultan Hasan (r. 1347–51, 1354–61) who was the patron of this textile.[12] According to the sources, the white decorative patterns were abandoned for three years (1413–16) under the reign of al-Mu'ayyad (r. 1412–21), although they were reintroduced in 1416–17. They remained in fashion for the following five years;[13] in 1418, al-Qalqashandi wrote that the *kiswa* of his time was made of 'black silk embroidered with a white inscription, in the weave itself'.[14] During the early years of

Sultan Barsbay's reign (r. 1422–38) the white medallions were replaced by black ones.[15] However, it seems that the decoration of both white and black roundels was completely abandoned in 865/1460–1.[16]

As for the actual place of the *kiswa*'s manufacture, sources are not very informative. Al-Fasi reports that during the years of al-Nasir Muhammad the noble covering was made in Ghulla, a village outside Cairo.[17] Al-Qalqashandi wrote in 1418: 'the *kiswa* is woven at the capital Cairo at Mashhad al-Husain'.[18] A few years later, under the reign of Sultan Barsbay (r. 1422–38), the noble fabric was still being woven in Cairo from where it was carried in a ceremonial procession upon the departure of the pilgrimage caravan to Mecca.[19] The ceremonial parade of the noble cover in the streets of Cairo and Fustat escorted by notables, high officials, magistrates, judges, Qur'an reciters, Sufis, preachers and imams is already recorded by al-Maqrizi in the year 1263.[20]

The esteem held for the Ka'ba's cover was such that a high official, bearing the prestigious title of the *nazir al-kiswa bi-dar al-tiraz* (controller of the *kiswa* in the state textile workshop), supervised its manufacture in the royal atelier. Furthermore, the fabric's exquisite quality and its impressive size were reflected in the elevated cost of its production. Therefore, in order to meet the expenses for its manufacture, Mamluk sultans had established several places as *waqf* (pious endowment). According to al-Fasi, Sultan al-Nasir Muhammad appropriated the income from the village of Ghulla mentioned above.[21] A few years later, in 1349, Sultan al-Malik Salih (r. 1351–4) was using the yield of one third of the borough of Baysus (Basus) in the district of Qalyub in Lower Egypt to cover the cost the *kiswa*.[22] However, the misappropriation of the *waqf* by its administrator during the first decade of the 15th century led to the reduction of the income and the manufacture of a less elaborate *kiswa* in 1415 financed by the ruler himself.[23] Later on, the replacement of the aforementioned official by the inspector of the army 'Abd al-Basit offered Sultan al Mu'ayyad Shaikh (r. 1412–21) the opportunity to send sumptuous coverings to Mecca. However, the maladministration during the late Mamluk period led the Ottoman sultans, who took over the right for the *kiswa*'s bestowal after 1517, to establish new *waqfs* for this purpose.[24]

Alongside the *kiswa*, the Mamluk sultans were also commissioning the manufacture of a curtain destined for the door of the Ka'ba and a covering for its interior which were both made in Cairo. The fabric covering the Ka'ba's entrance was called the 'the veil of Fatima', after the name of the Mamluk Sultana Fatima Shajarat al-Durr, who is believed to have been the first to send this fabric to Mecca.[25] Scarce as the descriptions of this curtain may be, we know that its colour varied. In fact, under the reign of Sultan Faraj (r. 1399–1405, 1406–12) two curtains of different colours are recorded by the Mamluk historian ibn-Taghribirdi (1410–70). The first one was black bearing a dedicatory inscription in yellow or white, whereas the second one, sent to Mecca in 1411, was white.[26] From a lesser known fabric now in Bursa, which has been recently published as a late Mamluk door curtain of the Ka'ba, we may get a real picture of what this fabric looked like on the eve of the Ottoman conquest of Egypt.[27] However, questions

referring to the presence of a simple Mamluk blazon of the *dawadar* instead of a tripartite one that would be the rule for a late Mamluk item and the absence of any Qur'anic inscriptions on a fabric destined for the Ka'ba still need to be further investigated and answered.

In terms of the Ka'ba's interior covering, it has been proposed that this was a personal offering by the Mamluk sultans made at their own expense.[28] Sultan al-Nasir Hassan (r. 1347–51, 1354–61) was the first Mamluk sultan who is recorded to have commissioned such a fabric in 1359.[29] Unlike the custom of the *kiswa*'s annual replacement, the interior covering was not removed on a regular basis. On the contrary, it seems more likely that being protected from weather conditions it was only replaced occasionally. This can be extrapolated from the fact that it was only after the floods of 1422 that the first Mamluk covering of the mid-14th century was actually replaced.[30]

It is unfortunate that the historical records fall short of describing this fabric. We only know that around 1349 it was embroidered with roundels bearing the *shahada* ('There is no god but God, Muhammad is the messenger of God'), while Qur'anic verses or the names of the Companions of the Prophet were inscribed at the edges.[31] Similarly decorated was the interior covering sent by Sultan Barsbay after the floods of 1422. It was made of red silk bearing the name of the donor alongside Qur'anic verses, the *shahada* and the names of the Prophet's companions.[32] Almost twenty years later after Barsbay's cover, a new one offered by Shahrukh was placed as an action of compromise between the Mamluk Sultan Jaqmaq (r. 1438–53) and Shahrukh.[33] This was the subterfuge contrived by the former to avoid the dispute with Shahrukh over the latter's request to send a covering for the Ka'ba to Mecca. Eventually, both interior coverings were replaced by the one sent by Jaqmaq himself in 1452.[34] Under the reign of Sultan Khushqadam (r. 1461–7), some sources record that a white covering embellished with black and golden medallions was sent to Mecca in 1460.[35] Based on this description, Maurice Gaudeffroy-Demombynes assumed that the interior *kiswa* bore the sultan's emblems as a way of achieving close contact with the shrine and ultimately receiving *baraka* (blessing).[36] The early surviving Ottoman fabrics of the 16th century once placed in the Ka'ba may serve as a material testimony to those made by the Mamluks. Their main decoration consists of the *shahada* repeated among chevrons bearing palmettes at their top; a combination of patterns of apparent Mamluk style.[37]

The Mamluks had the tendency to cover with textiles another holy shrine found in the vicinity of the Ka'ba. In 1448, a fabric was sent to Mecca for the covering of the *Hjjr* of Isma'il (Ishmael's chamber), the crescent-shaped area immediately adjacent to the Ka'ba. Since this was not customary at that time, the fabric was kept in the Ka'ba for more than one year before it was finally placed on the *Hjjr* in February 1450. It seems however that this custom was not continued.[38] In addition to the coverings destined for Mecca, exquisite draperies for the Prophet's Mosque in Medina were also commissioned by the Mamluks. As the chroniclers' descriptions of these fabrics are limited, we have to turn to the surviving Ottoman draperies with Mamluk influence or look to current research in order to gain an insight on the style of these hangings.[39]

Mamluk sultans were also the patrons for the coverings placed over several prophets' tombs. Most important among them was the covering made for the tomb of the prophet Ibrahim (Abraham), which we know was beautifully decorated with floral motifs during the reign of Sultan Qayit Bay (r. 1468–96).[40] Similarly, in February 1508 Sultan al-Ghawri commissioned the manufacture of an awning to cover the tomb of the same prophet in Hebron.[41] This fine silk, alongside the *kiswa* for the Ka'ba, were displayed on the streets of Cairo and ceremoniously escorted by lancers' corps and Mamluk officials with impressive pomp.[42] Chroniclers recount that there were hundreds of bearers who carried the exceptionally fine fabrics of that year which were displayed in several parts of the city to satisfy all viewers. The splendour of this parade was such that even al-Ghawri himself went down to the square below the Citadel to watch the ceremony.[43] A few years later in 1513 and 1515, seven silk fabrics for the sanctuaries of the prophets' tombs found in the Mamluk realm were commissioned by the same sultan. Prominent place among them once more was held for the fabric made for the tomb of Ibrahim. The fine covering was carried in procession around the streets of Cairo accompanied by tambourines, trumpets and whirling dervishes, whilst the chief steward of this shrine marched ahead of the displayed hangings.[44]

Fabrics of exquisite quality were also commissioned by the royal family to cover the *mahmal*, the empty ceremonial litter which accompanied the Mamluk pilgrimage caravan. The place held by the *mahmal* within the procession of the caravan was prominent, and upon its annual departure from Cairo, impressive festivals took place which the whole populace gathered to watch. The day of the *mahmal*'s parade in the streets of the capital was one of great festivity. The shops were decorated and the streets were strewn with fine fabrics while a band of seven drummers escorted the palanquin alongside the Mamluk corps of selected lancers.[45] Fine yellow silks were used as horse trappings for the troops of horsemen escorting the *mahmal* alongside manifold velvets and gold brocades that were decorating the saddles of the camels marching ahead.[46]

An important moment was also that of the return of the pilgrimage caravan back to Cairo and Syria. Bertrandon de la Brocquière, the Burgundian traveller who witnessed the return of a Hajj caravan to Damascus in 1432–3 talks of 'three thousand camels who took two days and nights before they had all entered the town', adding that the governor of Damascus and high officials 'went to meet the caravan out of respect to the Alcoran, which it bore … which was enveloped in a silken covering, painted over with Moorish inscriptions; and the camel that bore it was, in like manner, decorated all over with silk'.[47] However, scholars are not at all convinced that the Mamluk *mahmal* was actually carrying any copy of the Qur'an.[48]

According to al-Qalqashandi's description, which is definitely more accurate than that of de la Brocquière, the *mahmal* looked like an empty tent made of yellow silk carrying on its top a gilded silver spherical finial.[49] The choice of yellow for the *mahmal*'s silk was not accidental, as

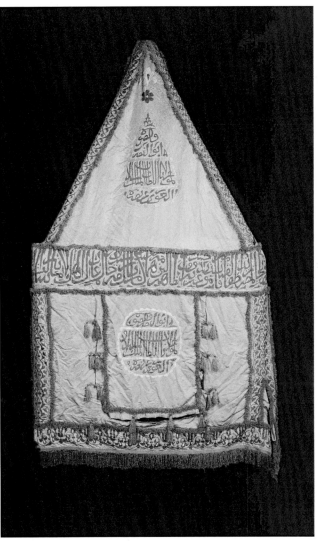

Plate 2 *Mahmal* of Sultan al-Ghawri, Topkapi Palace Museum, Istanbul (inv. no. 13/1689)

inscription which, although not Qur'anic, includes a text relating to the Hajj. It was transcribed by Jomier as follows:

> I asked God every day that we make it visiting the birthplace of Islam and contemplating the Ka'ba, unveiling His mercy,[55] and that we do the *tawaf* around it [the Ka'ba] and the *sa'i* (between Safa and Marwa) and that we accomplish our obligation and that the Lord of the Throne is satisfied by this and that we return to the one who has been entrusted absolute rule [Muhammad] and that the blessings of my Lord are upon him every day until the day of Resurrection.
>
> May this effort be blessed and may its [the *mahmal*'s] creator [have] happiness and well-being and everything that we need in our lives. May the vigilant guardian give you what you want.[56]

Although the appearance of the *mahmal* allegedly dates back to the reign of the Mamluk Sultana Shajarat al-Durr, the earliest historical reference to the Egyptian *mahmal* is connected to Sultan Baybars and goes back to 663/1264–5.[57] Various scholars have argued the actual origin of the *mahmal*.[58] However, I am interested here only in its political significance and symbolic value. The regular presence of this embellished palanquin in the pilgrimage caravan was a constant reminder of the Egyptian ruler despite his physical absence. It offered Mamluks the chance to demonstrate their wealth and power to the thousands of pilgrims attending the caravan. It was also a reminder of their role as the ultimate 'protectors of the Islamic world' at that time.

Moreover, there were also female connotations of the *mahmal*,[59] which were in one way or another connected with the pilgrimage of the sultans' wives. As Doris Abouseif remarks, due to the limited chances for a Sultana's public appearance, her departure for the pilgrimage was a unique opportunity for her to display through the decoration of her palanquin the sultan's magnificence and her own fine taste. Furthermore, it was one of the few chances to express her piety and thus make apparent the role of women in religious life.[60]

The importance of the pilgrimage made by the senior wife of the sultan and the magnificence of the ceremony accompanying her departure were also manifested in the exquisite fabrics displayed in her caravan. Mamluk chroniclers describe in detail the splendour of the royal litters (*mihaffat*) and their woven coverings.[61] We are informed for example by Ibn Iyas that the litter for Sultan Qayit Bay's wife was covered with 'brocaded material and attached to this were lozenges set with brilliant red rubies, pearls and turquoise'.[62] According to the same Mamluk source, the palanquin used some years later for the consort of Sultan al-Ghawri was made of:

> Red velvet of Kaffa embroidered with gold. Its brocaded bands worked with intertwined threads of pure Venetian gold. It was surmounted by five tufts decorated with pearls and rings of gold covered with cabochons of rubies of light red and turquoise. The textile covering the palanquin was decorated with a half-golden, half-silver band. Around the material of the litter (*mihaffa*) was a tinsel of gold and silver. And in front of the litter (*mihaffa*) were four torches wrapped with a fabric of gold brocade and tassels arranged in triangles.… It was estimated that this palanquin had cost more than twenty thousand dinars.[63]

The Sultana's palanquin was followed by four others covered with saddle cloths of red velvet, brocaded with gold

this was the official colour of the Mamluk sultans. Similarly made of yellow silk enriched with gold, was the Syrian *mahmal*, which according to al-Jazari cost 35,000 silver *dirhams* in 1404.[50] The surviving *mahmal* of Sultan al-Ghawri (r. 1501–16), housed now in the Topkapi Palace Museum, offers an illustrative example (**Pl. 2**). It is in the form of a wooden pyramid lying on a rectangular base. The base measures 1.60m by 1.10m and is 1.5m high. The total height of the palanquin, including the base, the pyramid and the wooden tuft at its top is 3.65m. It is completely covered with fabrics made of yellow silk lined with white linen.[51] It is decorated from the bottom to the top as follows: the three openings of the base's rectangular skeleton are covered by small curtains on which the tripartite epigraphic blazon of the sultan is stitched with appliqué letters of red fabric.[52] Likewise, on each of the four sides of the pyramid a tear-shaped medallion includes the sultan's titles and benedictory inscriptions.[53] The display of the sultan's name on the *mahmal* was apparently an old practice, since according to al-Maqrizi, the name of Sultan al-Zahir Barquq (r. 1382–99) was similarly displayed on a *mahmal* almost a century earlier.[54] The top and the bottom of the pyramid are embellished with fringes made of green silk. Divided on the three sides of the pyramid's base there is an Arabic

and silver. Twenty more palanquins made of coloured velvet were destined for members of her family and her guests.[64]

In the few instances when a sultan himself went on the pilgrimage, the luxury of the woven materials required was extravagant. This is best illustrated in an event recorded by Ibn Sasra who recounts the time when Sultan al-Ashraf Sha'ban (r. 1363 –77) decided to make his Hajj to Mecca in 778/1376–7, and he ordered the Syrian viceroy to manufacture hundreds of precious fabrics:

> A letter of the sultan reached him (the Viceroy of Damascus) saying that you shall make for the harem brocaded pieces and embroidery, and make, too, housings and robes which we will need for the Hijaz. He (the Viceroy) thereupon summoned the merchants and wealthy men of Damascus and levied money from them….One who supervised the work in vice regal palace told me that among all the work there were 700 pieces of brocade, each containing from 300 to 500 *mithqals*.[65] There were … slave girls – 300 of them; 1200 pairs of Yalbugawi *tiraz* were made,[66] likewise saddlecloths and saddle bags of brocaded satin – 120 saddlebags and 300 camel saddles…. He summoned the craftsmen and brought the gold and silver out of them and they worked. The vice regal palace became a workshop, and there was no room for anyone to place his foot because of the craftsmen; men making brocade, people sewing and others moulding gold, men working with furnaces, people packing and others weighing.[67]

To sum up, the Hajj was an event of great religious and political importance which Mamluk sultans recognized almost from the very beginning of their rule. Its religious significance is self-evident as the Hajj is one of the Five Pillars of Islam, obligatory for every Muslim. Politically, the control of the holy cities and that of the Hajj has been tightly associated with the leadership of the Islamic world. Therefore, the Mamluks hastened to link themselves to the Hajj in every possible way. Not only were they involved with building activities in the holy cities and along the Hajj route, but several Mamluk sultans and members of their families also performed the pilgrimage. Moreover, the Mamluk association with the Hajj was emphasized and best mirrored in the ceremonial processions of the pilgrimage caravans in the cities of Egypt and Syria. In these processions woven items of supreme quality imbued with various layers of meanings held a prominent place. The *kiswa* and the rest of the fabrics made for the Meccan sanctuary were the symbols of the Mamluk supremacy over the Hijaz. The name and the title of the Mamluk sultan embroidered on the covering of the Ka'ba was a constant reminder of the sultan's power to the thousands of believers visiting Mecca, securing meanwhile for him the divine blessing. Another reminder of the Mamluk religious superiority and political strength was the empty royal palanquin covered with fine silks bearing the name of the sultan which was carried with great pomp, alongside the hundreds of pilgrims, from the streets of Cairo to the city of Mecca. Similarly, royal litters with exquisite woven and bejewelled coverings, carrying members of the royal family, impressive housings and clothes, as well as gold brocaded saddlecloths and saddlebags for the camels escorting the caravan were also used with the aim to display the economic power and the political might of the Mamluk state. Hence we would be justified in proposing that the role of textiles in the Hajj processions during the Mamluk era

was neither utilitarian nor just decorative, it was above all political and symbolic.

Notes

1 Porter 2012a: 146. See 'Abd al-Malik's article in this volume.
2 Jomier 1952: 30.
3 Serjeant 1948: 106. It seems that the reference in Tezcan 2007: 229 about Sultan Hasan (d. 1361) being the first Mamluk who sent the *kiswa* to Mecca may refer to the interior covering of the Ka'ba.
4 Serjeant 1948: 106.
5 Quatremère 1840–5, II, 1: 52.
6 For a series of diplomatic manoeuvres between Mamluks and Mongols in the 14th century, which reveal the latter's attempt to extend their influence through the Hajj over the holy cities of Islam, see Melville 1992.
7 Popper 1957, XVIII: 120.
8 Popper 1957 XIX: 96–7.
9 Gaudefroy-Demombynes 1954: 14.
10 Unlike several other publications which use the term 'cups' to describe these patterns (e.g. Wüstenfeld 1857–61: II, 54 as cited and translated in Serjeant 1951: 79), I am adapting here the term 'circles' or even better 'medallions', which has also been proposed as better reading by Serjeant (Serjeant 1951: 79). The symbol of the 'cup' was a Mamluk coat of arm that could not have appeared on the *kiswa* prior to the mid-13th century. More than that, if the word 'cup' referred to a Mamluk blazon, then this could not have remained invariable, as each Mamluk sultan had his own blazon.
11 Translated by M.A.S. Abdel Haleem 2005.
12 I am indebted to Professor D. Abouseif for drawing my attention to this fabric and for her reading of the inscribed text.
13 Serjeant 1951: 79.
14 As quoted and translated in Serjeant 1948: 106.
15 Darrag 1961: 189.
16 Serjeant 1948: 106.
17 As quoted and translated in Serjeant 1948: 106.
18 Serjeant 1948: 106.
19 Darrag 1961: 70.
20 As quoted and translated in French in Jomier 1953: 35.
21 Serjeant 1948: 106.
22 Gaudefroy-Demombynes 1954: 17. According to other Arab sources the cost for the *kiswa* was covered by the revenues of Baisus and Sandabis; Gaudefroy-Demombynes 1918: 332. Tezcan mentions three villages established as *waqfs* by Sultan al-Nasir Hassan; Tezcan 2007: 229.
23 Darrag 1961: 188.
24 The Ottoman Sultan Süleyman bought and established as *waqfs* for the *kiswa*'s cost three more villages. Gaudefroy-Demombynes 1954: 14. However, Tezcan writes about four more villages added as *waqfs* by the same sultan; Tezcan 2007: 229.
25 Gaudefroy-Demombynes 1918: 334, n. 3.
26 Gaudefroy-Demombynes 1954: 20.
27 The fabric is now found in the Bursa Grand Mosque. For a detailed study of this curtain see Okumura 2012.
28 Darrag 1961: 190.
29 Darrag 1961: 190. However, Gaudefroy-Demombynes mentions that in 1422 Sultan Barsbay's fabric replaced that sent by al-Nasir ibn Qalawun a century earlier. He apparently refers to Sultan al-Nasir Muhammad who reigned for 1293–4, 1297–9 and 1310–40, but he provides no more information.
30 Darrag 1961: 190.
31 Gaudefroy-Demombynes 1918: 335.
32 Darrag 1961: 190.
33 Darrag 1961: 401.
34 Darrag 1961: 401.
35 Gaudefroy-Demombynes 1918: 337. I replaced here the term 'cups' originally used by Gaudefroy-Demombynes by that of 'medallions' for the reasons earlier stated in n. 10.
36 Gaudefroy-Demombynes 1918: 336. However, a Mamluk blazon of the 15th century should be a tripartite emblem bearing more than one symbols.
37 Tezcan 2007: 231, 227–38. For a Mamluk silk of similar style, see Walker 2000: 204, fig. 5.
38 Gaudefroy-Demombynes 1918: 337.

39 For the textile covers sent from Istanbul to Medina in the Ottoman era, see Ipek 2006. For a recent study on the *kiswa*s made for the Prophet's Mosque in Medina, see al-Mojan's article in this volume.

40 Newhall 1987: 241.

41 Petry 1993: 155.

42 Petry 1994: 161, 184.

43 Jomier 1953: 41.

44 Ibn-Iyas 1955: 315. Petry 1994: 162.

45 'Ankawi 1974: 165. See also Porter in this volume.

46 Johnson 2000: 124.

47 Brocquière 1807: 130–1.

48 Robinson 1931: 124. See also Porter in this volume.

49 Behrens-Abouseif 1997: 89.

50 Jomier 1953: 12.

51 Jomier 1953: 11, n. 3.

52 In the three horizontal bands of the medallion, one can read: 'Abu al-Nasr Qansawh' (on the upper band), 'Glory to our master, the Sultan, al-Malik' (on the middle band) and 'al-Ghawri, may his victory be glorious' (on the lower band); Jomier 1972: 184–5.

53 On two of the pyramids' sides the aforementioned text is inscribed within a tear-shaped medallion similarly divided in three horizontal bands. On the rest two sides the following text can be read on identical medallions: 'Abu al-Nasr Qansawh' (on the upper band), 'Glory to our master the sultan' (on the middle band), 'al-Malik, al-Ashraf' (on the lower band); Jomier 1972: 184–5.

54 Winter 1992: 409.

55 According to Jomier the term 'mercy' here refers to one of the names which were traditionally given to Mecca and which include this term; Jomier 1972: 186.

56 Jomier 1972: 185–7. Translated from Jomier's French translation by the author.

57 Robinson 1931: 120, n. 2.

58 For the various theories concerning the origin of this custom, see Gaudefroy-Demombynes 1923: 160–1; Robinson 1931; 120–2; Jomier 1953: 10–11; Behrens-Abouseif 1997: 90.

59 The *mahmal* was a kind of *hawdaj*, namely a palanquin with a dome at its top, in which women ride. For a further discussion on the female characteristics attributed to the *mahmal*, see Young 1993: 285–300.

60 Behrens-Abouseif 1997: 95–6.

61 For the Mamluk accounts of the pilgrimages to Mecca made by the sultans' senior wives, see Johnson 2000.

62 Johnson 2000: 121.

63 Ibn-Iyas 1955: 379–80.

64 Ibn-Iyas 1955: 379–80.

65 A *mithqal* is equivalent to about 4.25gm.

66 Following Brinner's explanation the Yalbugawi '*tiraz*' was a kind of brocade used for the decoration of a garment's border; Brinner 1963: 250.

67 Brinner 1963: 250.

Chapter 22
Dar al-Kiswa al-Sharifa
Administration and Production

Nahla Nassar

The textile factories of Egypt had been supplying some of the cloth for the drapes of the Ka'ba (*astar al-ka'ba* or *kiswa*) since the very beginning of Islam; according to some sources, the Prophet was the first to have used Egyptian *qubati* cloth for the purpose, followed by Abu Bakr, 'Umar and 'Uthman.[1] This continued into the Umayyad and Abbasid periods, and there are several accounts of the caliphs ordering the cloth, directly or through their agents, from the *tiraz* factories of Tanis, Tuna and Shata (all near Damietta) in Egypt.[2] When the Fatimids came to power in Egypt, they too dressed the Ka'ba with Egyptian-made cloth.

However, it was not until the Mamluk period, and the reign of Sultan Baybars (r. 1223–77), that Egypt assumed the role of providing the *kiswa*, occasionally facing competition from the rulers of the Yemen.[3] The cost of the *kiswa* was met by the Treasury (*bayt al-mal*) until 750/1349–50, when al-Salih Isma'il established a *waqf* (endowment) through which the revenue from three villages in Egypt was set aside to meet the cost of a yearly *kiswa* for the Ka'ba and one every five years for the Prophet's tomb and the *minbar* (pulpit). This remained the case until Sultan Süleyman the Magnificent (r. 1520–66) added seven more Egyptian villages to the *waqf* in 1540. Their income, in excess of 365,000 silver dirhams, was more than sufficient to cover the costs of the *kiswa* and the set of textiles sent to Mecca as well as a number of pieces for Medina, thus compensating for any shortfall in years of diminished return.[4] This *waqf* was dissolved in 1813 during Muhammad 'Ali Pasha's fiscal reforms. Subsequently, and up to 1962, the cost of providing the Meccan textiles was met by the Egyptian Treasury.[5]

The weaving of the *kiswa* seems to have been done at the mosque of Sayyidna al-Husayn during the Mamluk and early Ottoman periods, although there is mention of it being woven also at the *tiraz* factory in Alexandria.[6] By 1105/1693–4, it had moved to the Qasr al-Ablaq in the Citadel, and it was still being woven there in 1786 according to al-Jabarti.[7] During the French occupation (1798–1801), the *kiswa* was made in the private houses of some Cairene dignitaries.[8] In 1805, with the French out of Egypt and Muhammad 'Ali in power, the weaving of the *kiswa* moved back to the Citadel once more, until the Warshat al-Khurunfish was established in 1817. This was a large complex established by Muhammad 'Ali in the area of Bayn al-Surayn and the Christian Quarter, known as Khamis al-'Ads, contiguous to the al-Khurunfish Quarter. According to al-Jabarti, the project was begun on the advice of prominent European Christians, in order to bring together professional European craftsmen who had arrived in Egypt and other workers. A long time was spent in making the basic tools and machinery which were necessary, such as anvils, lathes for iron work, hammers, saws, work benches and the like. Each craft and trade had its own designated place as well as its own workers. The place contained looms and spinning wheels and all sorts of strange machines for weaving cotton, varieties of silk and brocades. Neighbourhood sheikhs were assembled towards the end of that year and instructed to gather 4000 young men from Cairo to work under the supervision of the craftsmen and learn the crafts. They received daily wages of one, two or three piastres, depending on their craft and what was appropriate for it, returning to their families at the end

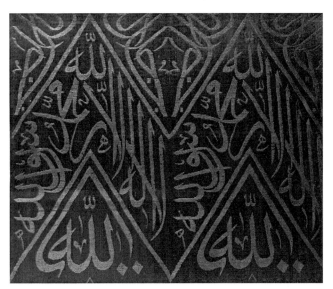

Plate 1 Photograph by Riyad Shehata of the *kamkh* cloth made at Dar al-Kiswa, from an album of photographs of its exhibits at the 1931 Agricultural and Industrial Fair, Cairo. Nasser D. Khalili Collection of Islamic Art (ARC.al 3.27) (© Nour Foundation. Courtesy of the Khalili Family Trust)

of the day. It was estimated that 10,000 youths might be needed once the place was complete, but the aforementioned number was all that was needed at that time. It was a huge workshop on which vast sums of money had been spent.[9]

'Ali Pasha Mubarak, writing around 1880 under the heading *shari' khamis al-'ads*, repeats some of what al-Jabarti had written and adds that the workshop still existed and was under government control (*'ala dhimmat al-miri*), but that parts of it had fallen into disrepair. It had become a workshop dedicated exclusively to the production of the *kiswa* of the noble Ka'ba.[10]

The workshop became known as the Department of the Noble Kiswa (*maslahat al-kiswa al-sharifa*). It was initially under the control of the Egyptian Ministry of Finance (*wizarat al-maliyya*) and, in 1919, the Ministry of Interior Affairs (*wizarat al-dakhiliyya*). The name changed to House of the Noble Kiswa (*dar al-kiswa al-sharifa*) in 1953, when the workshop became part of the Ministry of Religious Endowments (*wizarat al-awqaf*).[11]

The set of textiles sent annually from Egypt to Mecca consisted of the external drapes of the Ka'ba; a *sitara* – or

curtain for its door – known also as the *burqu'*; another for the internal door, the Bab al-Tawba; eight sections which made up the *hizam* or belt of the Ka'ba; four *kardashiyyat*, or square panels which were placed below the *hizam*; and finally a bag for its key. In addition, there were a *kiswa* for the Maqam Ibrahim; a *sitara* for the structure around it called the Maqsurat Ibrahim; and another for the *minbar* of al-Masjid al-Haram.[12] In 1940, Egypt stopped making the *kiswa* of the Maqam Ibrahim and the *sitara* of the Maqsura, as some which had been sent previously had not been used. The structure over the Maqam was replaced and the Maqsura demolished soon after, so the two textiles were no longer needed.[13] The *sitara* for the *minbar* was sent once every two years around this time.[14]

The workshop was equipped with all the facilities, machinery and personnel necessary for the production of the textiles and their embroidery. One section was responsible for spinning the yarn and dying it, and one for weaving it (*qism al-nawwala*). There was also a section for drawing and gilding the fine silver wire used in the embroidery (*al-mukhayyash*), and another for the embroidery work itself (*qism al-zarkasha*). At least one person was responsible for preparing the stencils used to transfer the patterns and inscriptions to be embroidered. At the head of the workshop was its Director, the *ma'mur al-kiswa al-sharifa*, and each section was overseen by its own head (*ra'is* or *usta-basha*). A supervisor (*mulahiz*) and a registrar or secretary (*amin al-makhzan*) made sure all was in order. The Dar al-Kiswa also had stables for the camels that carried the *mahmal*, where they were looked after by a keeper (*jammal*) and an assistant.[15]

Special looms were used to weave the black drapes for the external walls of the Ka'ba. These were made of a lampas-woven silk cloth, self-patterned with the *shahada* in zigzag bands (*qimash kamkh*; **Pl. 1**). In the 1880s, this was done on four looms, manned by 20 weavers.[16] Once woven, the bolts (*thawb*, pl. *athwab*) of cloth were handed over to a contractor – a *khaymi* or tent-maker – who was to cut them to measure, line them with white calico (*bafta*) and sew them into eight sections (*ahmal*; two for each wall). The number of bolts required for the *kiswa* varied, possibly due to changes in loom width. For example, the 1908 *kiswa* was made from 62 bolts, each 90cm wide; in 1961, with a width of 93cm, 52 bolts were

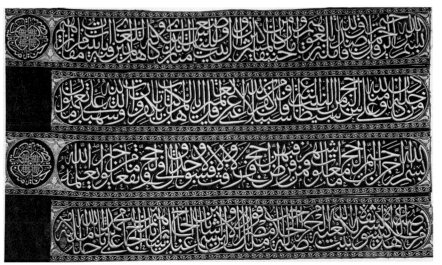

Plate 2 Photograph by Riyad Shehata of the last four sections of the *hizam* of the Ka'ba made in 1344/1925–6 in the name of King Fu'ad I. The dedication on the last line was designed by Mustafa al-Hariri in the style of 'Abdullah Zuhdi (d. 1878), who designed the calligraphy for the rest of the belt and whose signature cartouche appears at the end. Nasser D. Khalili Collection of Islamic Art (ARC.al 4.19) (© Nour Foundation. Courtesy of the Khalili Family Trust)

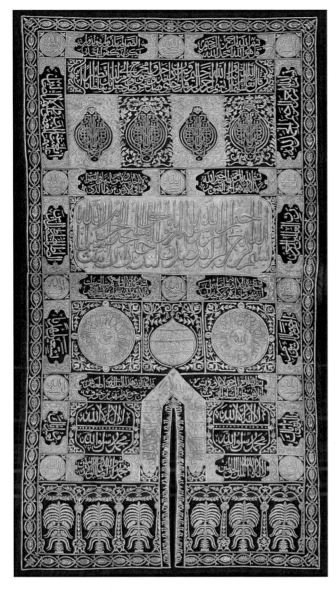

Plate 3 (left) *Burqu'* in the name of Sultan Abdülmecid I, dated 1266/1849–50. Nasser D. Khalili Collection of Islamic Art (TXT 307) (© Nour Foundation. Courtesy of the Khalili Family Trust)

Plate 4 (above) Detail showing half of a life-size pattern for *al-qa'im al-kabir*, or the section of the *burqu'* with the door opening, Egypt, late 19th century. Nasser D. Khalili Collection of Islamic Art (MSS 1128.6) (© Nour Foundation. Courtesy of the Khalili Family Trust)

used. The length in both cases is given as 14.8m or 26 *dhira' baladi*.[17] The bolts were sewn together with black silk and special straps made of cotton (*nawwar qutn*) were used to strengthen the seams. Loops or 'button holes' of leather were then fitted around the vertical edges of the eight sections of the *kiswa*. These were needed to attach one section to the next, after they were each draped over the walls of the Ka'ba and secured in place by ropes tied to the iron rings on its roof. Rings at the base of the Ka'ba were used in a similar way to secure the lower edge of the *kiswa*: 'Once all of this was done, the *kiswa* looked like a square black shirt'.[18]

The remaining textiles were all made of plain black, green or red silk, referred to as *atlas* and *atlas sasi*. Once embroidered, they too were given to the *khaymi* for lining with both calico and silk. The first of these to be listed in the official handover of documents is the *hizam*, an embroidered calligraphic band or belt that encircles the Ka'ba about two thirds of the way up (**Pl. 2**). It was made in eight sections attached to each of the eight *ahmal* mentioned above. Attached to two of the sections of the *kiswa* below the *hizam* were the four *kardashiyyat*.[19]

Edward Lane, who witnessed the procession of the *kiswa* in Cairo in February 1834, describes 'the four portions which form each one side of the *Kis'weh*' and the *hizam* which

'is in four pieces, which, when sewed together to the *Kis'weh*, form one continuous band, so as to surround the Ka'abeh entirely'.[20] It is not clear whether there was a change in practice in later years, or if the *kiswa* was already partially sewn by the time Lane saw it. In either case, the official documents for the *kiswa* of 1864 clearly describe it as consisting of eight *ahmal*, or sections, with one section of the *hizam* attached to each, as do those for 1894, 1904, 1905, 1909 and 1961.[21]

Following the *kiswa* and the *hizam* of the Ka'ba in the official lists was the curtain for its door. This was the largest and most elaborate of the embroidered pieces, measuring on average 5.75m in length by 3.5m in width. It is generally known as the *burqu'* (veil) but is almost always referred to as *burda* (mantle) on the pieces themselves. As it was too large to be embroidered as a single piece, its four sections were embroidered separately before being sewn together. At the top was *al-'ataba*, followed by *al-tiraz*, then *al-qa'im al-saghir* which included the dedication, and finally, *al-qa'im al-kabir* in which was the door opening (**Pl. 3**). It was fitted with six gilded silver buttons, 12 *shamsiyya*s – small circular pieces embroidered with a radiating design which were placed either side of the buttons – and a number of large and small tassels. Two styles of *burqu'* were made at Dar al-Kiswa, the most noticeable difference between them being in the decoration of the lowest section. Those made in the 19th century had a series of stylized palm trees within arches (**Pl. 4**); from around 1909 onwards, they were replaced by arabesque panels.[22]

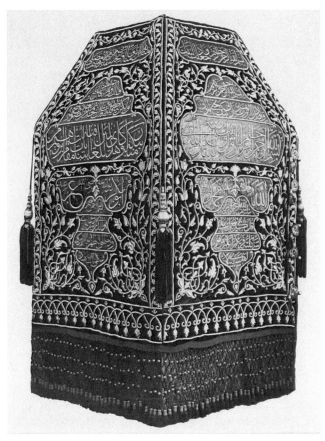

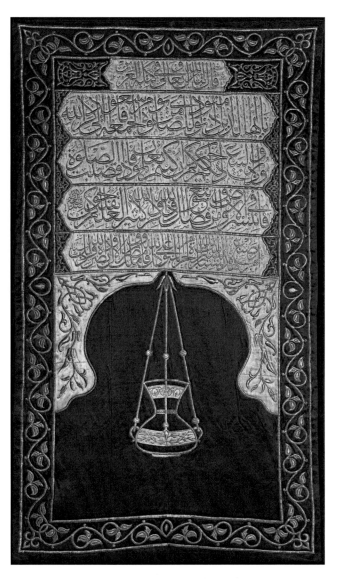

Plate 5 (above) Photograph by Riyad Shehata of sides 1 and 2 of the *kiswa* of the Maqam Ibrahim, made in the name of King Fu'ad I in 1344/1925–6. Nasser D. Khalili Collection of Islamic Art (ARC.pp 25) (© Nour Foundation. Courtesy of the Khalili Family Trust)

Plate 6 (right) *Sitara* for the *minbar* of the Masjid al-Haram, made in the name of King Faruq in 1365/1946. Nasser D. Khalili Collection of Islamic Art (TXT 503) (© Nour Foundation. Courtesy of the Khalili Family Trust)

The next item listed is the *kiswa* of the Maqam Ibrahim (**Pl. 5**). It consisted of four shaped sides and a small roof, sewn together to fit over the house-like metal structure placed over the Maqam.[23] Like the *burqu'*, it was fitted with gilded silver buttons, *shamsiyya*s, tassels, tasselled fringes and was occasionally embellished with sequins.[24] The bag for the keys of the Ka'ba was fitted with a braided metal-thread drawstring and two tassels. The final pieces to be listed are the *sitara*s for the Bab al-Tawba, Maqsurat Ibrahim and the *minbar*, the last two of which are known from very few examples, all dating from the 20th century (**Pl. 6**). In addition to the textiles, two different types of rope used to secure the *kiswa* to the Ka'ba were sent, as well as spare silk to repair any damage that may occur to the cloth during the course of the year, and two large copper containers filled with rose water for washing the Ka'ba. The Dar al-Kiswa was also responsible for making a new *kiswa* for the *mahmal* and the banners that accompanied it and the pilgrim caravan and undertook any required restorative work when old ones were being reused.[25]

During the Ottoman period, a lengthy dedication, giving the name of the current sultan and the date of presentation, occupied the seventh and eighth sections of the *hizam*. However, with the fall of the Ottoman Empire, the dedication took on a shorter form and was restricted to the

last section; between 1936 and 1961, the dedication on *hizam*s included the names of both the Egyptian and Saudi rulers.[26] The dedication on the *burqu'* was in the name of the Ottoman sultan until the middle of the 19th century, when the name of the *wali*, and later the Khedive, of Egypt was added. A standard formula was used. It began with the words 'this noble curtain was ordered by' (*amara bi-'amal hadhihi al-burda al-sharifa*) followed by the name of the reigning Ottoman sultan; the second part of the dedication informed that 'the noble curtain was renewed' (*jaddada hadhihi al-burda al-sharifa*) by his Egyptian contemporary.[27] The same formula was used in the dedications on the other textiles and, as with the *hizam*, the name of the Ottoman sultan was dropped after World War I.

The designs of the textiles made at Dar al-Kiswa changed little, with the exception of the lower section of the *burqu'* mentioned above. However, clever manipulations of the colour scheme and variations in the density of embroidery meant that hardly any two textiles of the same type looked alike. What is noticeable, however, is the marked improvement in the quality of the calligraphy which, after all, was the main decorative component on most of the textiles. This is especially true of pieces made in the second half of the 19th century when 'Abdullah Zuhdi was commissioned to design the inscriptions. Known as 'the

Plate 7 (left) Twenty-seven of the workers of Dar al-Kiswa, *c.* 1930–40. Nasser D. Khalili Collection of Islamic Art (ARC.pp 15) (© Nour Foundation. Courtesy of the Khalili Family Trust)

Plate 8 (above) Work at Dar al-Kiswa: transferring the patterns onto stretched fabric; undated anonymous photograph, *c.* 1930–40. Nasser D. Khalili Collection of Islamic Art (ARC.al 1.6) (© Nour Foundation. Courtesy of the Khalili Family Trust)

calligrapher of the two holy mosques' (*katib al-haramayn al-sharifayn*), he had risen to fame after he had designed the inscriptions for Sultan Abdülmecid's restoration work at the Prophet's Mosque in Medina, work which took him seven years to accomplish. He is also credited with designing the inscriptions on the gold rain spout of the Ka'ba (*mizab al-rahma*) which was presented by the same sultan in 1856–7. He later moved to Egypt, where he was well received by the Khedive Isma'il Pasha and commissioned to design the inscriptions for many buildings, as well as those for the *kiswa* of the Ka'ba (**Pl. 2**).[28] Another calligrapher who designed inscriptions for Dar al-Kiswa was Mustafa al-Hariri, a pupil of Zuhdi.[29] A third was Mustafa Ghazlan, calligrapher to King Fu'ad I, who designed the *kiswa* of 1937.[30]

In 1936, following a period of ten years during which Egypt did not supply the *kiswa*, production of both the *kamkh* and plain silk fabrics needed for the textiles moved to Sharikat al-Mahalla al-Kubra li'l-Ghazl wa'l-Nasij and later Sharikat Misr Halwan, which were equipped with modern, fast and efficient mechanical looms.[31] From then on, Dar al-Kiswa was only responsible for the embroidery.

More than a hundred weavers, artisans and embroiderers are known to have worked in Dar al-Kiswa at the beginning of the 20th century; of those, 47 were working in the embroidery section.[32] Twenty-nine embroiderers worked on the set of textiles for 1943,[33] by which time the *kiswa* of the Maqam Ibrahim and the *sitara* for the Maqsurat Ibrahim were no longer being made.[34] Twenty-six are known to have worked there in 1947 and 30 signed a contract in 1954.[35] Many were members of the same family – fathers, sons, uncles and cousins – having started there as young boys and remained until they retired (**Pl. 7**).

The embroidery work went through several stages. First, stencils were prepared by copying the designs to be embroidered onto paper; the outlines were then finely pricked with a pin. A number of such stencils are in the Nasser D. Khalili Collection of Islamic Art. They are all stamped *maslahat tashghil al-kiswa al-sharifa* with the date 1311/1893–4 and the name 'Abdallah Fayiq, *ma'mur maslahat al-kiswa al-sharifa*.[36] The stencils are signed 'drawn and pierced by Ahmad Effendi'. Most are on paper watermarked 'Gouvernement Egyptien'. Life-size tinted drawings of the patterns of the various *sitara*s were also made; on a set of eight in the Khalili Collection, yellow was used for areas to be embroidered in gold, and blue for silver (**Pl. 4**).[37] Hardly anything is known about the designers themselves, but one who held that position (*rassam*) in Dar al-Kiswa around 1937 was Hussein Muhammad al-Laythi.[38]

The fabric, silk satin of very high quality (*harir atlas*), was sometimes treated with a solution of no more than 2% starch. It was fixed by means of a paste to a thick canvas or calico backing, and then stretched very tight over wooden frames, and secured in place with nails (**Pl. 8**).[39] The designs were then transferred to the fabric by means of pouncing. This process, known as *tatrib* (from *turab*, fine dust), was done by the *usta-basha* and his assistant. In later years silk screens were used to transfer designs.[40]

The patterns were filled with a padding of cotton or linen threads, enough to build up the relief. In some cases – notably the inscriptions in the *tiraz* section of the *burqu'* and on the *hizam* – the relief exceeded 2.5cm. The padding threads were secured in place by stitches, done at regular intervals, with threads that were waxed for added strength. Occasionally, different coloured thread was used to pad or secure areas to be embroidered with silver and gold-plated wire. Often, forms cut out of card were placed below the padding or in areas which were not to be padded, namely

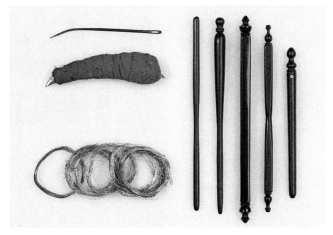

Plate 9 (left) Details showing *mukhayyash* work. Nasser D. Khalili Collection of Islamic Art (© Nour Foundation. Courtesy of the Khalili Family Trust)

Plate 10 (above) Some of the tools used for embroidery at Dar al-Kiswa, and eight coils of 'white' *mukhayyash*, each weighing 1 *mithqal*. Nasser D. Khalili Collection of Islamic Art (© Nour Foundation. Courtesy of the Khalili Family Trust)

secondary decorative patterns and small-scale inscriptions. The various layers of padding can be seen easily where the wires are damaged (**Pl. 9**). Once the padding was in place, the embroidery work could begin. The finely drawn wire, known as *mukhayyash*, was wrapped around special tools to keep it straight and tangle-free (**Pl. 10**). It was then looped, stretched over the padding and secured around the contours of the pattern with small stitches, again in a waxed thread (**Pls 9** and **11**). This way, the wire lay on top of the padding and did not go through the fabric, reducing the amount used, and therefore the cost, by almost half. In areas where the looped wires covered a relatively long stretch, they were secured further by small stitches, often applied in such a way so as to create secondary patterns within the wire embroidered areas. Patterns were also created by manipulating the direction in which the wires lay, and this is most evident in areas where the entire background was embroidered (**Pl. 9**).

The embroidery was done entirely in silver wire, most of it gold plated or gilded, respectively referred to as 'white' and 'yellow' in official documents. The grade of silver used is of extreme fineness, being 999 per 1000. Gold-plated wire is described as being 'plated with red *bunduqi*' – the purest type of gold.[41] Silver wire, plated with anything between 14 and 25 units of pure gold per thousand, and very occasionally, 5 per thousand, was used between 1918–20.[42] The wire was divided into coils; those in the Khalili Collection (**Pl. 10**) weigh around 4.67g each, which is equivalent to one *mithqal*, the unit of measure most often used for wire in official documents, and according to which

the workers were paid; on average, each worker used the equivalent of two or three *mithqal*s of wire per day (**Pl. 12**).[43] The wire had to be annealed at regular intervals during the course of work; the expenditures for the year 1899 include the cost of 'fuel used to heat the *mukhayyash*' and an additional payment made to the embroiderers for 'heating the *mukhayyash*'.[44]

A yearly contract was drawn up between the relevant ministry (as the first party) and the workers as a group (the second party). The severity of the terms of the contract, which were more in favour of the ministry than the workers themselves, was probably dictated by two factors: the intrinsic value of the materials with which they worked and the constraints of time, as the textiles had to be ready in time to be sent to Mecca with the *mahmal* (until 1953, and without it afterwards). The embroiderers were expected to complete the work to strict specifications and within a set timescale, in return for a specified wage; they were penalized if they failed to meet any of these requirements 'without any prior notice or warning'. There were also strict rules to be followed in handing over the wire to be worked with on a daily basis. The materials were given to each worker from the stores of the Dar al-Kiswa in the morning, in the presence of an inspector or supervisor (*mulahith*) and against a receipt (**Pl. 12**). If for any reason a worker did not use up all of the wire allocated to him on a particular day, the unused wire was handed over to the supervisor who placed it back in the store for safekeeping until the next morning, when it was given back to the worker before he received that day's allotted amount. Any scraps of wire also had to be returned: the weight of a finished textile had to be the same as the raw materials allocated to it. Penalties were paid if the weight of the former was less than the latter, as this implied that materials distributed had not been used or returned. Penalties were also paid if the textile weighed more than the raw materials, as this meant that more *mukhayyash* had been used than stipulated in the contract. In return, the ministry pledged to supply the raw materials and pay wages in 10

Plate 11 One of the workers from Dar al-Kiswa applying *mukhayyash*; the fine wire is wrapped around a tool similar to those in Pl. 10 (detail of an undated, anonymous photograph). Nasser D. Khalili Collection of Islamic Art (ARC.al 1.10) (© Nour Foundation. Courtesy of the Khalili Family Trust)

Plate 12 Page from a Dar al-Kiswa ledger, with a daily record of the amount of 'white' and 'yellow' *mukhayyash* used by the embroiderers working on section 4 of the *hizam*, during the period 2 February–3 March 1943. Nasser D. Khalili Collection of Islamic Art (ARC.lg 2) (© Nour Foundation. Courtesy of the Khalili Family Trust)

instalments. The wage per *mithqal* of *mukhayyash* worked was 250 *millim* in 1954, and that included the time taken to lay out and secure the padding underneath it.

The terms of the contract also stipulated that work should be done in Dar al-Kiswa, in the presence of the supervisor, and should follow the patterns that were agreed upon. If, in the opinion of the ministry or the supervisor, a worker had made mistakes by veering from the set design, be it in laying out the padding or the *mukhayyash*, or if the *mukhayyash* was not properly secured, then they had to undo the work, for which they were not paid. The decision of the ministry in this matter was final and not open to negotiation. They worked six days a week, and did not work on public or religious holidays. They were not allowed to strike or instigate others to strike. They had to start work at 8.00am sharp and were not permitted to be absent for more than one day without legitimate reason. If they failed to meet any of the above conditions, the ministry had the right to fire them.[45]

Work on the Meccan textiles took up about 10 months of every year (**Table 1**). For the rest of the year, Dar al-Kiswa embroidered robes of honour and uniforms worn by officials of the ranks of Bey and Pasha (until 1952, when these ranks were abolished) and for the clerics and the Egyptian

diplomatic corps, as well as making marks of rank for the army and police. They also embroidered covers for the tombs of saints and made decorative panels which were commissioned by the palace, given as diplomatic gifts or sold. In the 1930s, they embroidered a dress for Queen Nazli, wife of King Fu'ad I and mother of King Faruq, which took them two weeks of continuous work at a cost of 100 guineas per day. They also made a curtain for one of the doors in the palace of the daughter of the king of Brunei; 50 people worked on its embroidery.[46]

Maslahat al-Kiswa, as it was known then, took part in a number of local and international exhibitions and won several awards. Locally, it was awarded a certificate of merit and a gold medal at the Agricultural and Industrial Fair of 1926, and first prize at the same fair in 1931.[47] It received a 'Diplôme de Médaille d'Or' at the Exposition Internationale in Liége in 1930, and another at the Exposition Internationale des Arts et des Techniques in Paris in 1937.[48]

The final chapter in the history of Dar al-Kiswa began in 1962, when a ship called the *Mecca* arrived at the port in Jedda, carrying 1109 Egyptian pilgrims along with the *kiswa* of the Ka'ba, its *hizam*, its *burqu'* and the *sitara* for the Bab al-Tawba. However, the Saudi authorities regretfully declined to accept the *kiswa*, so it was sent back to Egypt

Table 1 Schedule of work for 1943, based on a daily log book from the Dar al-Kiswa (Nasser D. Khalili Collection of Islamic Art, ARC.lg 2)

Date	Item	Number of workers
2 February–3 May 1943	*hizam* 1	7 workers
	hizam 2	7 workers
	hizam 3	8 workers, some intermittently
	hizam 4	13 workers, but many only intermittently and some working on until 8 May
11 May–21 July 1943	*burqu' – qa'im kabir*	7 workers
	burqu' – 'ataba	7 workers; another listed but without any work details
	burqu' – qa'im saghir	5 workers; another 2 listed, but without any work details
	burqu' – tiraz	12 workers, but some intermittently
24 July–25 October 1943	*hizam* 5	5 workers
	hizam 6	5 workers
	hizam 7	17 workers, but many only intermittently or without any work details; work went on until 26 October
	hizam 8	8 workers, one working during the last month only
	sitarat al-tawba	5 workers
1 August–3 September 1943	*kardashiyyat*	17 workers, but intermittently, and some listed but without any work details
10–24 October 1943	key bag	11 workers, most intermittently
9–18 October 1943	*shamisyyat*	1 worker

and, by the time pilgrims were at 'Arafat, the returned *kiswa* was being displayed in the courtyard of the al-Azhar mosque, after which it was sent back to Dar al-Kiswa. It stayed in the stores there until 1972, when President Anwar al-Sadat offered it once more, but unsuccessfully. Egypt's very long association with the *kiswa* of the Ka'ba thus came to a very abrupt end.

Dar al-Kiswa continued with its embroidery work for some time, taking on small commissions and making decorative panels for mosques or for sale. The number of embroiderers dwindled; by the 1980s only a handful remained, many of the veterans having retired or passed away. It finally closed its doors in 1997. The *kiswa* is now made in Mecca, as it has been since 1962.[49]

Notes

1 Al-Daqn 1986: 27–8.
2 Hilmi 1994: 53–61; al-Daqn 1986: 29–36; see also Porter 2012a: 260, figs 200–1.
3 There were also attempts to send *kiswas* from Iraq and Iran, though not always successfully; see Hilmi 1994: 67–74; al-Mojan 2010: 184.
4 Rif'at 1925, I: 284–90 for the text of the *waqfiyya*, and al-Daqn 1986: 94–8 for a summary.
5 Al-Daqn 1986: 110; al-Mojan 2010: 196.
6 Hilmi 1994: 116.
7 Al-Jabarti 1994, II: 185 [II,111]; Hilmi 1994: 124–5.
8 Al-Jabarti 1994, II: 78 [III,49] for the house of Mustafa *katkhuda*; al-Jabarti 1994, III: 86 [III,55] for that of Ayyub Jawish; al-Jabarti 1994, III: 480 [III,318] for Ahmad Mahruqi and Bayt al-Mulla. See also Ahmad 1937, I: 259–60.
9 Al-Jabarti 1994, IV: 410–11 [IV,291–2].
10 Mubarak 1887–8, III: 27.
11 Al-Daqn 1986: 137; al-Mojan 2010: 263.
12 For examples, see al-Mojan 2010.
13 Al-Daqn 1986: 66; Hilmi 1994: 8, 26.
14 Hilmi 1994: 9–10.
15 Information based on four ledgers from Dar al-Kiswa now in the Nasser D. Khalili Collection of Islamic Art (unpublished).
16 Mubarak 1887–8: 22.
17 Rif'at 1925, I: 292; al-Daqn 1986: 155–7; al-Daqn 1986: 283, appendix 4.
18 Batanuni 1911: 136–7.
19 Porter 2012a: 259, fig. 199.
20 Lane 1836: 242–3.
21 Al-Mojan 2010: 430–1; Hilmi 1994: 93; Rif'at 1925, I: 6–7; al-Daqn 1986: 272–84. The *hizam* of eight sections (illustrated in Rif'at 1925, I: 110, in the name of Sultan Mehmed V) must date from 1909. Documents from Dar al-Kiswa now in the Nasser D. Khalili Collection of Islamic Art, with dates of 1939–43, also mention eight *ahmal* and eight *hizam* sections. The lengths of what are described as 'complete *hizams*' in the Topkapi Saray Museum (Tezcan 1996: 101–8) are far too short to encircle the Ka'ba completely.
22 For example al-Mojan 2010: 208, 212.
23 For the metal structure that used to be over the Maqam, see al-Mojan 2010: 128.
24 For one side of this cover, which is also embroidered with sequins, see Porter 2012a: 30–1, fig. 6.
25 The *mahmal* was not renewed annually, but every 20 years or so (Hilmi 1989: 89–90). In 1925, King Fu'ad I ordered a new *mahmal* to be made, as the previous one bore the name of 'Abbas Himli II (al-Daqn 1986: 147). Also see al-Mojan 2010: 111.
26 Al-Mojan 2010: 286–7, 300–1.
27 'Renewed' should not be understood to mean 'restored' or 'renovated'. *Jaddada* in this context means that the old curtain was replaced by a new one.
28 'Azb and Hasan 2010: 206–8; Ahmad 1937, I: 83–4, 265. For the inscription on the rain spout, see Rif'at 1925, I: 275–6; Ahmad 1937, I: 83. The first line of a presentation drawing of this inscription is in the Nasser D. Khalili Collection of Islamic Art; see Porter 2012a: 164–5, fig. 117.
29 Ahmad 1937, I: 269–71; Hilmi 1994: 133.
30 Hilmi 1994: 133; 'Azb and Hasan 2010: 327–34.
31 Al-Daqn 1986: 140. A ledger from Dar al-Kiswa now in the Nasser D. Khalili Collection of Islamic Art, ARC.lg4 (unpublished), mentions quantities of *qimash kamkh* bought from Sharikat Misr li-Nasij al-Harir, after which they were given to the *khaymi* to sew into *ahmal*.

32 With an additional 70 working in the preparation and weaving of silk; Batanuni 1911: 138. For a list of embroiderers between 1883–1928, see Hilmi 1989: 92–4 and al-Daqn 1986: 285–7.

33 Nasser D. Khalili Collection of Islamic Art, ARC.lg 2, a ledger from Dar al-Kiswa (unpublished).

34 See note 13 above.

35 Hilmi 1994: 127–8; al-Daqn 1986: 290.

36 'The Commissioner in charge of', or Director; 'Abd Allah Fayiq Isma'il Ibrahim was still in this position in 1904, as he is mentioned in the official handover document for the *kiswa* of that year; see Ahmad 1937, I: 279–80; he remained as Director until 1910; Hilmi 1994: 132–3.

37 The set comprises a pattern for each for the sections of the *burqu'*; one each for the *sitara*s of the Bab al-Tawba and the *minbar*; one for a side of the Maqam Ibrahim; and one for half of the *sitara* for the Maqsurat Ibrahim; Nasser D. Khalili Collection of Islamic Art, MSS 1128 (unpublished).

38 Ahmad 1937, I: 265, note 1; Hilmi 1994: 132.

39 For an early photograph of the *qism al-zarkasha*, see al-Mojan 2010: 262.

40 Hilmi 1989: 95–6; al-Mojan 2010: 263–4.

41 Hilmi 1994: 6, note 4; 38.

42 Nasser D. Khalili Collection of Islamic Art, ARC.lg1, a record of expenditures at Dar al-Kiswa during that period (unpublished).

43 Based on a ledger from Dar al-Kiswa in the Nasser D. Khalili Collection of Islamic Art, ARC.lg 2 (unpublished).

44 Rif'at 1925, II: 332.

45 Al-Daqn 1986: 114–6, 290–3 (for the contract of 1954).

46 Interview with Hajj Subhi Muhammad Salih, one of the last workers at Dar al-Kiswa, in *Akhbar el Yom*, 6 November 2010.

47 The medal awarded to Dar al-Kiswa in 1931 is now in the Nasser D. Khalili Collection of Islamic Art, together with two albums of photographs of pieces shown at the fair, taken by the royal photographer Riyad Shehata. Several albums were made at the time.

48 The two awards are now in the Nasser D. Khalili Collection of Islamic Art, ARC.ct 1, ARC.ct 2; see *Travel, Atlases, Maps and Natural History (catalogue of a sale held at Sotheby's, London, 10 May 2011*.

49 For *kiswa*s made in Mecca, see al-Mojan 2010: 348–413.

Chapter 23
The Textiles Made for the Prophet's Mosque at Medina
A Preliminary Study of their Origins, History and Style

Muhammad H. al-Mojan

Introduction

The subject of this essay is a group of textiles connected to the mosque of the Prophet Muhammad in Medina. These textiles known generically as *kiswa* include the covering of the chamber – the room surrounded by grilles which houses the Prophet Muhammad's tomb – the *hizam* (belt), the curtains placed on the door to the burial chamber, the coverings of the *minbar* (pulpit), the *mihrab* (the niche within the mosque which faces Mecca) and the gates of the Prophet's Mosque. Visitors to the mosque on *ziyara* will go to these specific locations as part of their devotions (**Pl. 1**).

Relying on descriptions in historical accounts and surviving textiles from the Mamluk period until the present day which are preserved in museums and private collections, this article explores the different types and styles of these textiles. This chapter starts, however, by setting the historical scene for their production.

The history of the *kiswa* of the Prophet's Chamber and its endowment

The Prophet's Chamber was originally one of the rooms in the house of the Prophet's wife 'Aisha and is approximately 15.50m². During the Mamluk period in the reign of Sultan al-Mansur Qalawun (r. 1279–90), a dome was placed over it.[1]

In the early Islamic period, the lawfulness of acquiring a covering over the chamber was a matter of debate amongst historians. Al-Samhudi (d. 1505), for example, relates several accounts from which he infers that it was lawful to do so. He mentions that originally jute was placed over its top.[2] In his book *al-Bayan*, Ibn Rushd (d. 1198) writes that eventually it did not suffice for it to be covered with jute.[3]

Plate 1 The Mamluk dome over the tomb chamber in the Prophet's Mosque at Medina (photo: author)

Furthermore, al-Samhudi confirms the lawfulness of placing a covering over the tomb chamber by analogy with the veneration expressed by bestowing a *kiswa* on the noble Ka'ba. He wrote: 'the covering of the Ka'ba is allowed because of the veneration [expressed] by it and we are instructed to venerate the Prophet – may God pray upon him and grant him peace – and the veneration of his tomb is part of the veneration [owed] to him'.[4] Al-Fasi (d. 1428) asserts that since it was permitted to acquire a *kiswa* for the Ka'ba then it should also be allowed to do the same for the Prophet's Mosque.[5]

The identity of who was the first to endow the tomb chamber with a *kiswa* is debated. The most common opinion is that the practice began in the Abbasid period.[6] Al-Samhudi reported: 'there isn't in the narration of Ibn Zabala (d. after 814) and Yahya – son of al-Hasan al-'Alawi and author of *Tarikh al-Madina* [*the History of Medina*] – any reference to the matter of the *kiswa* for the chamber, perhaps this is because it [the practice] began after their time. However, Ibn Zabala does mention the *kiswa* of the *minbar* and the placement of curtains on the gates to the mosque. He records that the *kiswa* of the Ka'ba passed through Medina where it was spread out at the back of the mosque before being taken to Mecca, and he [Ibn Zabala] did not mention a *kiswa* for the Prophet's Chamber.'[7] Al-Samhudi infers that since Ibn Zabala does not mention that the wife of Harun al-Rashid al-Khayzuran had ordered a *kiswa*, a fact mentioned by other historians, then there was no *kiswa* at that time. However, he then goes on to report that according to Razeen – who was quoting Muhamad ibn Isma'il – al-Khayzuran had ordered the *zananir* and the silk *shaba'ik*,[8] thus contradicting his own conclusion based on Ibn Zabala's account.[9]

A complete *kiswa* for the Prophet's Chamber is certainly known to have been made in the Fatimid period and according to Ibn al-Najjar (d. 1245), the first to clothe the chamber was al-Hussein ibn Abu al-Haija', son-in-law of al-Salih Tala'i' ibn Ruzzik, the vizier of al-'Adid (r. 1160–71), the last Fatimid caliph. He ordered a curtain to be made of white *dabiqi* (a type of silk cloth made in Dabiq, an Egyptian town) embroidered with yellow and red raw silk and that Qur'an 36 (*Yasin*) was inscribed on it. The caliph at that time was al-Mustadi' bi-Amr Allah (r. 1170–80).[10] Citing Ibn al-Najjar, al-Samhudi wrote:

> al-Hussein ibn Abu al-Haija' – son-in-law of al-Salih,[11] the vizier of the Egyptian kings – had a curtain made for it of white *dabiqi*, which had embroidery and decorative medallions of yellow and red silk. He also gave a belt (*zunnar – hizam*) made of red silk, and the belt was inscribed with *surat Yasin*. It is said that this curtain cost a great deal of money, and he wanted to hang it over the chamber but was stopped by Qasim ibn Muhanna the amir of the city who said 'not until we seek the permission of Imam al-Mustadi' bi-Amr Allah'. And so he sent to Iraq an order to obtain permission. The permission was granted and the curtain hung there for two years.[12]

That al-Hussein ibn Abu al-Haija' was the first to bestow a *kiswa* for the Prophet's Chamber is further confirmed by Ibn al-Najjar who wrote that 'Ibn Abu al-Haija' was the first to make a *kiswa* for the chamber during the caliphate of al-Mustadi' bi-Amr Allah who acceded in the year 566 [AH] and died in the year 575.[13]

As mentioned earlier, the amir of the city had refrained from hanging this complete *kiswa* until permission was obtained from the caliph in Baghdad.[14] Two years later, al-Mustadi' sent a curtain made of violet silk with white patterns around which the names of the caliphs Abu Bakr, 'Umar, 'Uthman and 'Ali were embroidered. Also included in the inscriptions was the name of Caliph al-Mustadi' bi-Amr Allah. This therefore replaced the older curtain[15] and citing Ibn al-Najjar, al-Samhudi explained:

> A curtain of violet silk arrived from the caliph; it is embroidered with white decorative medallions around which the names Abu Bakr, 'Umar, 'Uthman and 'Ali are also embroidered, and the name of Imam al-Mustadi' bi-Amr Allah on the *tiraz*. The *kiswa* of al-Hussein ibn Abu al-Haija' was removed and went to the cenotaph of 'Ali in Kufa, and this [the curtain of al-Mustadi'] was hung instead.[16]

When al-Nasir li-Din Allah (r. 1180–1225) became caliph, he sent a new *kiswa* made of black silk with patterns in white with inscriptions which was hung over the top of the *kiswa* of al-Mustadi'.[17] This is confirmed by Ibn al-Najjar and al-Samhudi.[18]

The Andalusian traveller Ibn Jubayr (d. 1217) described the *kiswa* of the Prophet's Chamber when he went to visit the Prophet's Mosque in 1183. He wrote:

> On the side between the north and the west corners is a place over which hangs a curtain … and it is [the chamber] covered with a finely cut marble of splendid quality.…The veils (that cover the *rawdah* [the exact site that holds the tomb of the Prophet and his companions]) fall as far as the line of the marble wainscot. They are of azure colour with a check of white quadrangular and octangular figures containing roundels and encircled by white dots. They present a handsome spectacle of novel design. In the upper part runs a band tending to white.[19]

A third black silk *kiswa* sent by the mother of the Abbasid Caliph al-Nasir li-Din Allah was similar to the ones before it.[20] These three *kiswa*s then stayed in place until the Mamluk period. Ibn al-Najar wrote: '*al-Jahha* the mother of the Caliph – al-Nasir li-Din Allah – went on Hajj,[21] and when she returned to Iraq she ordered a curtain to be made of black silk in the same style as the aforementioned [curtain]. It was completed and hung over this [the current] curtain. And so in these days three curtains lay on top of each other in the chamber.'[22]

The Mamluk Sultan al-Salih Isma'il ibn al-Nasir Muhammad ibn Qalawun purchased a village with expenses drawn from the treasury and established it as a *waqf* that would sponsor the production of the *kiswa* of the Ka'ba every year and the *kiswa* of the Prophet's Chamber in Medina and *minbar* every five years. All weaving activity was funded by the yield of the village.[23] According to Ibn al-Ji'an, the *waqf*s of the *kiswa* were distributed among three villages:[24] Baysus, al-Sardus and al-Zanfour, all together forming 955 acres, 40.5 of which were dedicated to the *waqf* with a yield of 7000 dinars.[25] Al-Maraghi (d. 1414), however, reports that *kiswa*s of the Prophet's Chamber and the *minbar* were endowed every six years rather than five.[26] He wrote: 'the *kiswa* of the chamber and also the *kiswa* of the Ka'ba are from the *waqf* of the village. The Ka'ba is endowed with a *kiswa* annually, whereas that of the *minbar* once every six years'.[27] Al-

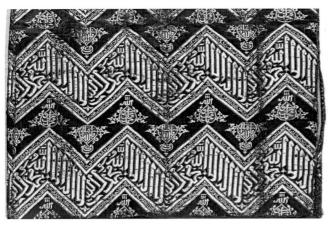

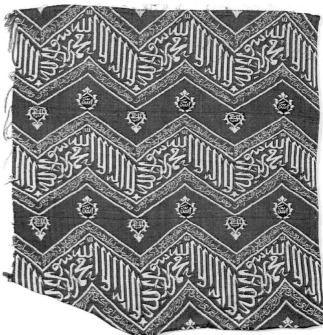

Plate 2 (above) Tunic (detail) made from green silk *kiswa*, 16th century, dimensions (complete) 80 x 63.5cm. Topkapi Palace Museum, Istanbul (inv no. 13/1658) (photo: author)

Plate 3 (right) Green silk *kiswa* fragment, 16th–17th century. Topkapi Palace Museum, Istanbul (inv. no 24/348) (photo: author)

Qalqashandi (d. 1418) reveals the main reason why the *kiswa*s of the chamber and the *minbar* were sent approximately every seven years and not annually as was the case with the *kiswa* of the Ka'ba. He wrote: 'the *kiswa* of the noble chamber is not renewed every year like the *kiswa* of the Ka'ba, but only when it wears out and it is then replaced with another one. This takes place only every seven years or thereabouts and this is because it is protected unlike the *kiswa* of the Ka'ba which suffers damage from long exposure to the sun.'[28]

During the first quarter of the 16th century, the *kiswa* for the Prophet's Chamber was sent irregularly; sometimes it was 10 years before a new one was dispatched. Its production became connected to the accession of a new sultan of Egypt. After reviewing the reports of al-Maraghi and al-Sakhawi, al-Samhudi confirmed: 'In our times ten years pass or thereabouts without it [the *kiswa* of the chamber] being produced. Indeed, whenever a new sultan came to power in Egypt, he would attend to sending a new *kiswa*.'[29]

The *kiswa* of the Prophet's Chamber and the curtains for its two doors are mentioned during the reign of the Mamluk Sultan al-Nasir Faraj ibn Barquq (r. 1399–1412). The *kiswa* was of black silk embroidered with white,[30] and according to al-Qalqashandi, the last to order its manufacture was al-Malik al-Zahir Barquq (r. 1382–9, 1390–9).

In 1408 the Prophet's Mosque was looted and the curtains of the gate of al-Nasir Faraj were stolen. Citing Ibn Hajar al-'Asqalani, al-Samhudi reports that when the amir of Medina, Jammaz ibn Hibba ibn Jammaz al-Jammazi, rebelled against the ruler of Hijaz, he entered the Prophet's Mosque, took the two curtains of the chamber's door and brought a ladder to take down the *kiswa* of the noble tomb chamber and the lamps hanging around it, but for some reason he could not manage to remove it and instead only removed the curtains of the chamber from the attendants' apartment.[31]

Al-Maraghi mentions that during the Mamluk period the *kiswa* of the Prophet's Chamber was made of black silk stitched with white. The inscriptions were made from

gold-plated silver wires.[32] Ibn Iyas notes that during the reign of the Mamluk Sultan al-Malik al-Ashraf Abu al-Nasr Inal al-'Ala'i (r. 1453–61) a complete *kiswa* was made for the Prophet's Chamber in Shawwal, 859/September–October 1455 and when it was completed, the *nathir al-khas* (the official or supervisor in charge of its production) showed it to the sultan.[33] In the 16th century, Ahmad al-'Abbasi wrote: 'the first to cover the *minbar* was 'Uthman ibn 'Affan – may God be pleased with him. But it was also said that it was Mu'awiya. In our times, a silk curtain is placed on the door of the chamber on a Friday, and also [silk curtains were placed on] the *mihrab* along with the *kiswa* of the noble chamber.'[34]

It should be noted that both during and after the Mamluk period, the *kiswa* of the chamber had been given its own *waqf* along with that of the Ka'ba and it acquired its own distinctive style. It was now made in black silk and decorated with patterns woven in white. Its *hizam* was embroidered with gilded silver wires.

The Mamluk *kiswa* of the Prophet's Chamber consisted of the main fabric, a belt and a pair of curtains for its doors. An important development in the manufacture of Islamic textiles is evident on this *kiswa*: the embroidery was now done with gold-plated silver wires. In the Ottoman period, Egypt was fully responsible for the weaving and transportation of the interior and exterior textiles of the Ka'ba, funded until 1706 by revenue from the *waqf*s established for the Haramayn (the sanctuaries of Mecca and Medina).[35] After this date, Istanbul took over the production of the textiles of the Prophet's Mosque.[36] Some of the calligraphy for these textiles were even designed by the sultans themselves.

The textiles for the Prophet's Chamber continued to be produced in Istanbul until Saudi rule.[37] In 1983, King Fahd ibn 'Abd al-'Aziz Al Sa'ud ordered the production of a *kiswa* for Medina for the first time in the *kiswa* factory at Mecca.[38]

The components of the *kiswa* of the Prophet's Chamber

The *kiswa* of the Prophet's Chamber consists of the main silk cloth (*thawb*), a belt (*hizam*), ten pieces of red silk which are

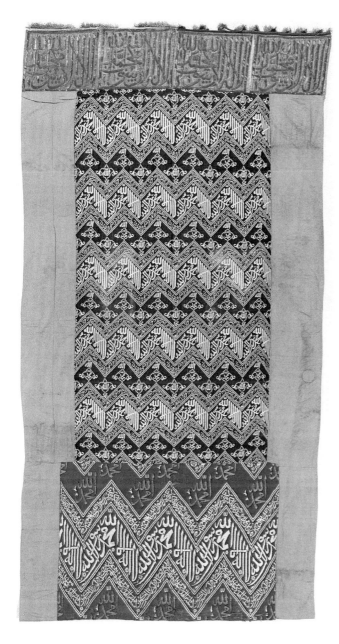

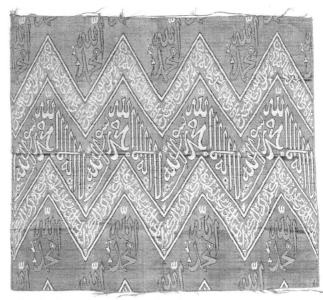

Plate 4 (left) Three pieces of silk fabric stitched together. The red *kiswa* is 16th century, 101 x 190cm. Topkapi Palace Museum, Istanbul (inv. no 24/798) (photo: author)

Plate 5 (above) Green silk *kiswa* fragment, 17th century. Topkapi Palace Museum, Istanbul (photo: author)

inscribed with Qur'anic verses, various pious expressions and the name of the ruler who commissioned it.

Thawb

The *thawb* consists of several pieces of silk which was produced over time in a range of different colours, black, green, red, white, or light brown. The pieces are sewn together making the *thawb* 40m in circumference and 10 m high. In style it is similar to that of the interior *kiswa* of the Ka'ba with zigzag designs which contain inscriptions and vegetal motifs.

An important example (**Pl. 2**) is a 16th-century piece of green silk with inscriptions and designs in white silk. Its design, as with the whole group, consists of zigzag bands two of which are wider than the others. In the wide band in *thuluth* script is the *shahada*: 'there is no god but God, Muhammad is the messenger of God'.[39] The second of the wider bands has pear-shaped medallions in red. Two inscriptions, 'Sufficient is God as witness' and 'Muhammad is the messenger of God', are inscribed within the medallions, with one word of each outside, alternating with each other. The wide bands are edged by narrow bands; the

first is inscribed with Qur'an 9:33 (*al-Tawba*): 'It is He who has sent His messenger with guidance and the religion of truth to manifest it to all religion, to show that it is above all [other] religions, however much the idolaters may hate this',[40] and in the second, the phrase 'May God, be He exalted, be pleased with Abu Bakr, 'Umar, 'Uthman, 'Ali and the rest of the Prophet's companions all together'.

Another example (**Pl. 3**) is made of green silk and dates to the late 16th to early 17th century. Its design consists of four zigzag bands of differing widths as before. On the wide bands is the *shahada* in *thuluth* script. Between the inscriptional bands are pear-shaped medallions inside each of which are two of the names of God: Allah, and *al-Baqi* 'the Everlasting'. The narrow bands are inscribed; the first with Qur'an 9:33 (*al-Tawba*) and the second with the phrase: 'May God, be He exalted, be pleased with Abu Bakr, 'Umar, 'Uthman, 'Ali and the rest of the Prophet's companions all together'.

Another example (**Pl. 4**) is a 16th-century piece of red silk with various pious expressions and patterns in white.[41] Its design also consists of four zigzag bands of differing widths. The inscriptions in white *thuluth* script consist of the *shahada*. In between the inscriptional bands are lobed medallions inscribed with the names Allah and Muhammad. These two bands are edged by two narrower ones: the first inscribed with Qur'an 108 (*al-Kawthar*), the other with Qur'an 112 (*al-Ikhlas*).

From the 17th century survives another piece of green silk, now faded (**Pl. 5**), and in similar style to the examples described above. The wide inscriptional band has, as before, the *shahada* in *thuluth* script while the words Allah and Muhammad alternate on the green ground. The narrow bands have Qur'an *suras* 33:40 (*Ahzab*) and 9 (*al-Tawba*) respectively. In a delightful feature, a carnation springs from the last letter of the word Muhammad.

An example from the 18th century[42] (**Pl. 6**) has six different texts inscribed in the bands:

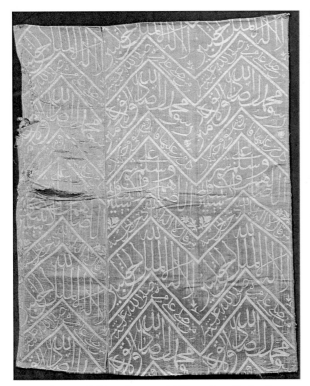

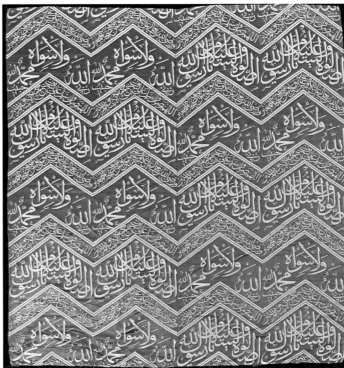

Plate 6 Green silk *kiswa* fragment, 18th century. Topkapi Palace Museum, Istanbul (inv. no 24/403) (photo: author)

Plate 7 Green silk *kiswa* fragment, 19th century. Topkapi Palace Museum, Istanbul (photo: author)

1. 'There is no god but God, The Sovereign, The Truth, The Evident'.
2. The *hadith* 'who prays on upon me once God will pray for him tenfold'.
3. 'Muhammad the Messenger of God [he who is] true to his promise and trustworthy'.
4. 'Everyone on earth perishes, all that remains is the face of your Lord'.
5. 'O God pray upon the noblest of prophets and messengers' (Q 55:26–7).
6. 'Whoever says there is no god but God shall enter paradise'.

As with the previous example, floral motifs appear, in this case tulips.

A 19th-century example is similar in style to the last and is distinguished by the careful execution and beauty of the calligraphy. It consists of a set of four bands containing inscriptions. Starting with the wide ones, the first is inscribed with the texts 'God is my Lord and only Him,

Muhammad beloved of God', and the second, 'O God pray upon the noblest of prophets and messengers'. As for the narrow bands, the first is inscribed with the text 'prayers and greetings upon you O Messenger of God', and the second with 'May God, exalted is He, be pleased with Abu Bakr, 'Umar, 'Uthman, and 'Ali and the rest of the Prophet's companions all together' (**Pl. 7**).

The *kiswa* for the Prophet's Chamber produced in the workshop at Mecca in the Saudi period is made of green silk.[43] It consists of three zigzag bands; the central one being the widest. The space above and below it is filled with medallions containing the inscriptions Qur'an 48:28–9 (*al-Fath*); the *shahada* and part of Qur'an 34:28 (*Saba*); and inside the round medallions is 'Muhammad is the Messenger of God' and 'May God pray upon him and grant him peace'.

The *hizam* or *nitaq*

The *hizam* (belt) of the Prophet's Chamber consists of ten pieces of red silk. Together, they measure 35.37m long and

Plate 8 (below) The opening part of a *hizam*, Mamluk, 16th century, 35 x 90cm. Topkapi Palace Museum, Istanbul (inv. no.13/1629) (photo: author)

Plate 9 (right) *Hizam* fragment, Ottoman, 18th century, 11.40 x 35cm. Topkapi Palace Museum, Istanbul (inv. no. 24/193)

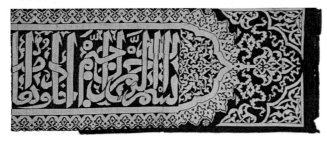

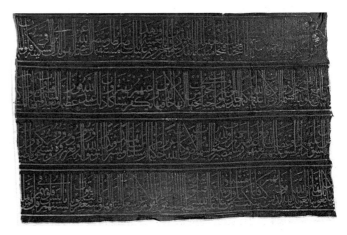

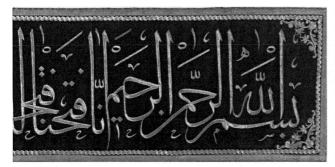

Plate 10 Opening part of *hizam*, Ottoman, from the reign of Sultan Abdülhamid I, 37 x 49cm. Topkapi Palace Museum, Istanbul (inv. no. 24/87) (photo: author)

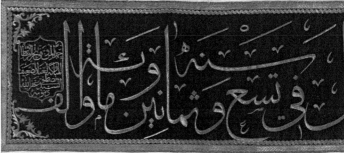

Plate 11 Closing part of *hizam*. Ottoman, from the reign of the Sultan Abdülhamid I. Topkapi Palace Museum, Istanbul (inv. no. 24/87) (photo: author)

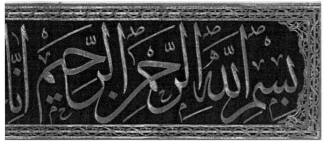

Plate 12 Opening part of *hizam*. Ottoman, dated 1229/1813–14, 35.10 x 51cm. With calligraphy designed by Sultan Mahmud II. Topkapi Palace Museum, Istanbul (inv. no. 24/86) (photo: author)

Plate 13 Closing part of *hizam*. Ottoman, from the reign of Sultan Mahmud II. Dated 1229/1813–14 with signature of the sultan. Topkapi Palace Museum, Istanbul (inv. no. 24/86) (photo: author)

are 95cm wide. They are inscribed with verses from Qur'an 48:1–10 (*al-Fath*).

The oldest surviving piece of the *hizam* (**Pl. 8**)[44] is made of red and off-white silk and belongs to the late Mamluk period, the beginning of the 16th century. It includes the *basmala* and the first part of Qur'an 15:48 (*al-Hijr*).

During the Ottoman period, the *hizam* of the Prophet's Chamber came to be known as *nitaq*. An 18th-century example (**Pl. 9**) is made of red silk embroidered with gold-plated silver wire, inscribed with the *basmala* and verses from Qur'an 48 (*al-Fath*).[45]

A *hizam* produced during the reign of the Ottoman Sultan Abdülhamid I (r. 1774–89) is dated to 1189/1775–6 (**Pl. 10**). It ends with the signature of the calligrapher Master Mustafa. A *hizam* of Sultan Mahmud II dated to 1229/1813–14 (**Pl. 11**) bears the signature of the calligrapher who is the sultan himself and states: 'inscribed by the Conqueror Mahmud ibn Abdülhamid Khan'. This is followed by the order for the making of the *nitaq* (**Pls 12, 13**).[46]

Other textiles made for the Prophet's Chamber

Also forming part of the *kiswa* of the Prophet's Chamber are five pieces of red silk that indicate the locations of the tombs of the Prophet and his companions and are inscribed with different pious expressions. One piece (**Pl. 14**) made during the reign of the Ottoman Sultan Mahmud II and dated 1228/1813, designates the tomb of the Prophet: 'this is the tomb of the Prophet, may God pray upon him and grant him peace'. Under it in a cartouche is the name of the sultan, who also designed the calligraphy.

Another piece of green silk embroidered in gold-plated silver wire was hung inside the chamber itself (**Pl. 15**). It was produced during the reign of Mahmud II and is also dated 1228/1813. It is inscribed with the phrase 'He is God, there is

no god but God, Muhammad is the messenger of God', and ends with the signature of the calligrapher and Sultan Mahmud ibn Abdülhamid Khan.

Also belonging to this group is an oval piece of black silk embroidered with gold-plated silver wire inscribed with Qur'an 33:40 (*Ahzab*) (**Pl. 16**).[47] It was placed at the oval opening through which greetings are offered to the Prophet Muhammad.

In the case of the *kiswa* produced under Saudi rule, there are examples from the reign of King Fahd ibn 'Abd al-'Aziz (r. 1982–2005). They are embroidered with gold-plated silver wire and are inscribed with the following texts: 'this is the tomb of Muhammad, may God pray upon him and grant him peace'; 'this is the tomb of Abu Bakr al-Siddiq, may God be pleased with him'; 'this is the tomb of 'Umar al-Faruq, may God be pleased with him'; 'God Most Mighty has told the truth, and Muhammad has told the truth'; and finally the text of the *shahada*. There is also another piece of red silk on which the making of the *kiswa* is recorded: 'this curtain was made and assembled at the beginning of Muharram … This *kiswa* was made in the holy city of Mecca'.

The curtains for the door of the Chamber

The door of the Prophet's Chamber had its own set of curtains. Two green silk curtains (**Pls 17, 18**)[48] from the time of the Ottoman Sultan Mahmud II (1789–1839) survive and on one of these his *tughra* is inscribed with his sobriquet, 'Adli, on the right. They are embroidered with gold-plated silver wire but in this instance the influence of the European baroque style is evident. They are framed with vegetal ornaments and the centre in both is decorated near the top with a lozenge from which long rays emanate with the inscription, 'Prayer and peace upon you O beloved one of God' and the signature of the sultan and calligrapher

Plate 14 Textile indicating the position of the Prophet's tomb dated 1228/1813. With calligraphy designed by Sultan Mahmud II. Topkapi Palace Museum, Istanbul (photo: author)

Plate 15 Textile indicating the position of the Prophet's tomb dated 1228/1813 with calligraphy designed by Sultan Mahmud II. Topkapi Palace Museum, Istanbul (photo: author)

Mahmud II. There are two roundels around which floral swags and decorative ribbons are embroidered. On the second (**Pl. 18**) is inscribed the *hadith* 'On earth roam angels who delivered to me greetings from my people'. In the centre of the curtains is the *tughra* of the sultan inside a wreath of vegetal designs, ribbons and two quivers filled with arrows.

The *kiswa* of the *minbar*

There seems to be general consensus amongst the historians that the caliph 'Uthman ibn 'Affan was the first to cover the *minbar* with a thin white flax cloth made in Egypt known as *qubati*,[49] as reported by Ibn al-Najjar, al-Maraghi, and al-Samhudi.[50] However, the 16th-century historian Ahmad al-'Abbasi suggests that the first may in fact have been Mu'awiya.[51]

The *minbar* continued to be covered with Egyptian flax cloth till the days of Ibn al-Zubayr (628–92) when Ibn Zabala reports that a woman stole this *kiswa* and as a result, the custom was stopped.[52] Citing Ibn al-Najjar, both al-Qalqashandi and al-Samhudi mention that throughout the Abbasid period the *kiswa* of the *minbar* was made of black silk. When they accumulated as the years went on, some were used as curtains for the gates of the Prophet's Mosque. These historians wrote:

Plate 16 Oval piece of black silk placed at the opening to the Prophet's Chamber, 104 x 61cm. Topkapi Palace Museum, Istanbul (inv. no. 21/123) (photo: author)

'to this day, the caliphs still send a *thawb* of black silk with a golden banner every year to cover the *minbar* … and when the [number of] the [older] *kiswa*s increased, they took them and placed them [as] curtains on the gates of the Haram [of the sanctuary of the Prophet's Mosque in Medina]'.[53]

Later, the Mamluks took over the production and transport of the covering of the *minbar*. Al-Qalqashandi, citing ibn al-Najjar, reported that 'the situation remained like this until the demise of the [Abbasid] caliphate in Baghdad and then the kings of the lands of Egypt took over the making of this and the *kiswa* of the Ka'ba'.[54] It is also in this period that the *kiswa* of the *minbar* acquired a distinctive style. Al-Maraghi wrote: 'the *kiswa* of the Prophet's Chamber is made of black silk woven with white silk. It has a *tiraz* inscription with gilded silver embroidered all around it. The *kiswa* of the *minbar* is [made with] white *taqsis*.'[55] Al-Fairuzabadi, writing in the 14th century, discusses the *kiswa* of the *minbar* in his book *Al-Maghanim al-mutaba*. He referenced the period in which it was sent, those undertaking its production, its two banners and their style. He wrote: 'a splendid and regal *kiswa* for the *minbar* is sent from the Egyptian lands every seven years or thereabouts. It is placed over the *minbar* on Fridays; and there are two banners with it made in the most exquisite weaving [style]. They are placed in front of the preacher at the sides of the *minbar* close to the door.'[56] Al-Samhudi writing later echoes al-Fairuzabadi's report that seven, ten, and more years pass before the *kiswa* for the *minbar* arrived.[57] Elsewhere, al-Samhudi mentions that 'on a Friday a curtain woven with black and white silk is placed on the door of the *minbar*'.[58] The historian Ahmad al-'Abbasi, reported that the *mihrab* also had a textile covering.[59]

In the Ottoman period, an important development in the production and the decoration of the *kiswa* and the banners of the Prophet's *minbar* took place. Al-Jaziri reported that 'Dawud Pasha … asked me, may God give him mercy, about the type of banners that were placed on the *minbar* of the Prophet, may God pray upon and greet him, and so I told him they were made of black and white silk and the tassels were of silk too, and so he replaced these with banners that were finely embroidered with silver wire.'[60]

An Ottoman *minbar* curtain (**Pl. 19**) was produced during the reign of Sultan Mehmed IV and is dated 1095/1683–4.[61] It is made of black, red and green silks with an outer frame divided into cartouches and roundels. The cartouches at the sides contain the *basmala* and Qur'an 2:255 (*al-Baqara*) and

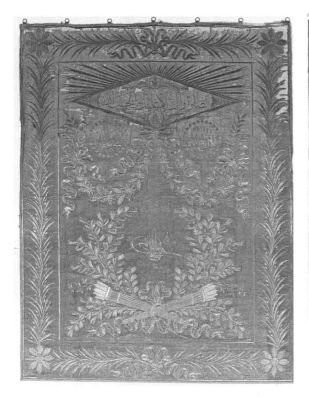

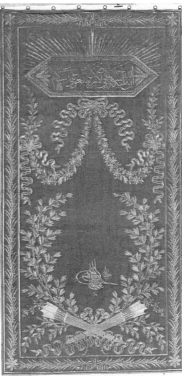

Plate 17 (far left) Curtain for the door of the Prophet's Chamber, Ottoman, from the reign of Sultan Mahmud II, 320 x 200cm. Topkapi Palace Museum, Istanbul (inv. no. 24/139) (photo: author)

Plate 18 Curtain for the door of the Prophet's Chamber, Ottoman, from the reign of Sultan Mahmud II, 393 x 200cm. Topkapi Palace Museum, Istanbul (inv. no. 24/143) (photo: author)

inside the roundels are the words God, Muhammad and the names of the Rashidun caliphs. There is a series of trefoils at the top of the curtain, and at the bottom are three lobed cartouches the outer one of which contains the following text: 'This curtain was commissioned in the days of the Great Sultan Mehmed', the middle one is inscribed 'and the Companions all together' which completes the content of the roundels on the sides. The top of the curtain contains two more elongated cartouches; Qur'an 33:56 (*Ahzab*) is inscribed in the upper one and the following *hadith* in the lower: 'The Messenger said: "between my *minbar* and tomb is a meadow from among the meadows of Paradise." ' The focal point of the textile is a *mihrab* arch with pillars on either side. The spandrels of the arch are filled with arabesque designs and from the top of the *mihrab* hangs a lantern on which is inscribed *al-Fattah* (The Opener, one of the 99 Names of God), in mirror script. A tear-shaped medallion flanked by a pair of candlesticks hangs from this lantern which contains the dedication: 'to our master Sultan Mehmed Khan, glorious be his victory, in the year 1095 [AH]'.

Another *minbar* curtain (**Pl. 20**), similar to the last from the reign of the Ottoman Sultan Ahmed III is dated to 1130/1717–18.[62] It is made of red, black and green silks with an outer frame of floral arabesques, an inner frame composed of elongated cartouches and roundels. In the cartouches is the *basmala* and Qur'an 62:9–11 (*Jumu'a*) and in the roundels the names of the Companions of the Prophet who are promised paradise. Unfortunately, considerable parts of the inscription have been lost. At the top of the curtain are a series of trefoils and an elongated cartouche which contains the *basmala* and Qur'an 33:45 (*Ahzab*). The cartouche in the central part of the curtain is inscribed with the same *hadith* as the previous example. The textile differs from the last in that the dedication roundel is aligned to the base of the candlesticks. This is inscribed at the top with: 'He asks for your intercession O Messenger of God'; and

continues: 'our master the conquering Sultan Ahmed Khan ibn Mehmed Khan, God support him with victory, ordered this blessed curtain'; and lower down 'this blessed and noble curtain was completed in the year 1130 [AH]'.

In summary, therefore it is possible to say that the caliph 'Uthman ibn 'Affan was the first to clothe the *minbar* with a *kiswa*, and that it was made of *qubati* cloth. The custom of providing a *kiswa* for the *minbar* continued until more recent times. An important development in its production occurred during the Ottoman period when the embroidery was done with gilded silver wire.

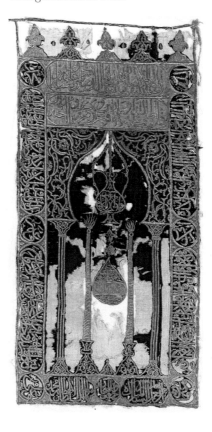

Plate 19 Curtain for the *minbar* of the Prophet, Ottoman, from the reign of Sultan Mehmed IV dated 1095/1683–4, 220 x 110cm. Topkapi Palace Museum, Istanbul (inv. no. 24/991) (photo: author)

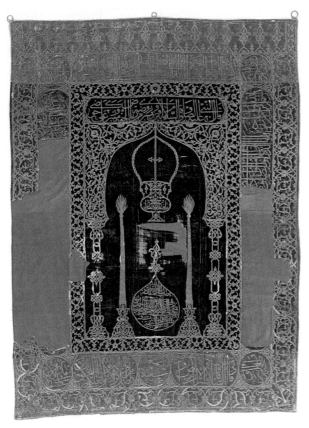

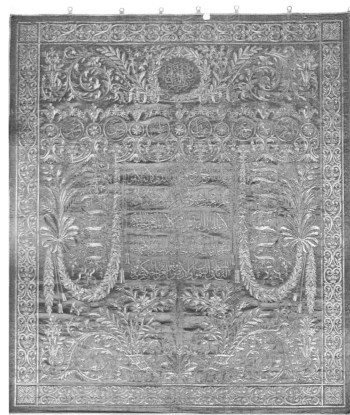

Plate 20 Curtain for the *minbar* of the Prophet, Ottoman, from the reign of Sultan Ahmed III, dated 1130/1717–18, 310 x 230cm. Topkapi Palace Museum, Istanbul (inv. no. 24/2088) (photo: author)

Plate 21 Curtain for the *mihrab* of the Prophet's Mosque, 19th century. The Public Library of King 'Abd al-'Aziz, Medina (photo: author)

The *kiswa* of the Prophet's *mihrab*

Writing in the 16th century, Ahmad al-'Abbasi reported that in addition to a covering for the *minbar*, there was also one for the *mihrab*.[63] Among the textiles of the Prophet's *mihrab* is a red silk curtain produced during the reign of Sultan Ahmed III and dated to 1131/1718–19.[64]

Another example dating to the 19th century (**Pl. 21**) is made of green silk embroidered with gold-plated silver wire.[65] The influence of the European baroque style is evident in the intricate vegetal motifs and the ribbons and tassels which overwhelm the inscriptions. At the top of the curtain is a wreath containing part of Qur'an 3:37 (*Al Imran*) which refers to the presence of *mihrab*s in mosques. There are also the names of the Rashidun caliphs in addition to the names of al-Hasan and al-Hussein, the grandsons of the Prophet Muhammad. The *basmala* and Qur'an 59:22–4 (*Hujurat*) are inscribed in the centre of the curtain.

The cover of the Holy Qur'an

The Qur'an of the Prophet's Mosque also had its own special textile. An example in the Topkapi Palace is made of red and green silk and dates to the reign of Sultan Ibrahim (r. 1640–8).[66] Its design is identical to that of the *mihrab* curtain of Sultan Ahmed III.

Curtains for the gates of the Prophet's Mosque

It was during the Abbasid period that the habit of hanging curtains on the gates of the Prophet's Mosque began as a way of utilizing the older *kiswa*s of the *minbar* which had accumulated over time. Ibn al-Najjar remarked: 'to this

day, the caliphs still send a *thawb* of black silk with a golden banner every year to cover the *minbar* ... and when the [number of] the [older] *kiswa*s increased, they took them and placed them [as] curtains on the gates of the Haram'.[67] Citing al-Maraghi, al-Samhudi explained that special curtains were eventually created for the gates. He wrote: 'the matter of sending the *kiswa* from Egypt was settled after the assassination of Caliph al-Mu'tasim, as al-Zain al-Maraghi said, and the gates today have their own textiles; and he adds that they only reveal them on important occasions such as on the arrival of the amir of the city'.[68] A number of these curtains are connected to al-Shami gate, the gate of Jibril and the principal gate of the main minaret.[69]

A curtain for the al-Hanafi gate (**Pl. 22**) made of green silk was placed there during the reign of Sultan Murad III (r. 1574–95).[70] A band of vegetal ornament decorates the top followed by the text of Qur'an 16:123 (*Nahl*) inside a large cartouche. The main design of the curtain is the *mihrab* arch supported by two pillars and with arabesque designs in the spandrels. Between two candlesticks, three lanterns hang from the *mihrab* under which there is a Qur'an stand inscribed with the following: 'Sultan Murad requests intercession O messenger of God, this is al-Hanafi gate'.

A curtain for the al-Shami gate (**Pl. 23**) of red silk[71] was made during the reign of the Ottoman Sultan Mehmed III (r. 1595–1603). A band of vegetal ornament decorates the top and the bottom and near the top is a large cartouche inscribed with Qur'an 33:45 (*Ahzab*). This curtain also has a *mihrab* in the centre but only one small lantern hanging from

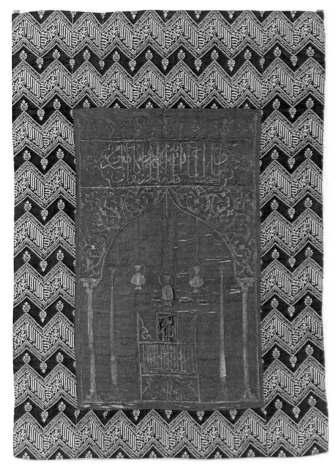

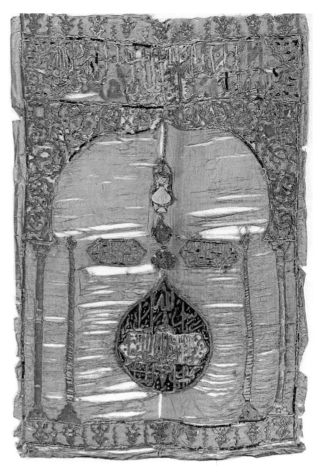

Plate 22 Curtain for al-Hanafi Gate, Ottoman, from the reign of Sultan Murad III, 140 x 87cm (panel). Topkapi Palace Museum, Istanbul (inv. no. 24/2001) (photo: author)

Plate 23 Curtain for al-Shami gate, Ottoman, reign of Sultan Mehmed III, 176 x 110cm. Topkapi Palace Museum, Istanbul (inv. no 24/241) (photo: author)

the *mihrab*. On each side is a cartouche, inside of which is the text 'God be pleased with Abu Bakr, 'Umar, 'Uthman, 'Ali, and the rest of the companions all together'. Between two candlesticks a small pear-shaped medallion under the lantern there is the inscription: 'Our master Sultan Mehmed asks for intercession O messenger of God, this is al-Shami gate'.

The cover for the courtyard of the Prophet's Mosque

The last textiles to be mentioned are the covers that were stretched over the courtyard of the Prophet's Mosque to protect worshippers from extreme heat. They were first commissioned in the Abbasid period by the Caliph Abu Ja'far al-Mansur in 140/757–8. They continued to be used until 145/762–3 when Muhammad ibn 'Abd Allah rebelled against the authority of the caliph. He ordered that they be cut into one cubit pieces and distributed among those fighting with him. They were not used during the Umayyad period, but were produced again during the reign of Harun al-Rashid.[72]

Conclusion

We have seen that the textiles of the Prophet's Mosque first began to be produced in the seventh century during the era of the Rashidun caliphs. The first to be produced was the *kiswa* for the *minbar* but the historical accounts are inconsistent regarding who was the first to endow it: 'Uthman ibn 'Affan, Mu'awiya ibn Abi Sufian or even Ibn al-Zubayr.

The *kiswa* of the Prophet's Chamber, however, we know was first presented by al-Khayzuran, the mother of the Abbasid Caliph Harun al-Rashid, and it was made of silk with an accompanying belt (*hizam*). The first complete *kiswa* for the chamber, however, was commissioned by Ibn Abu al-Haija', son-in-law of the Fatimid vizier al-Salih Tala'i' ibn Ruzzik during the reign of the Abbasid Caliph al-Mustadi' bi-Amr Allah.

In the Mamluk period, a *waqf* in a village in Egypt was dedicated by Sultan al-Salih Isma'il ibn al-Nasir Muhammad ibn Qalawun for the first time in history to fund the production of the *kiswa*. The *kiswa* of the Ka'ba was produced annually. Those of the chamber and *minbar* were made between five and seven years, and, eventually, were sent only to coincide with the accession of a new sultan. In the Abbasid period, *kiswa*s were placed on the gates of the Prophet's Mosque to make use of the old *kiswa*s of the *minbar* that had accumulated over time. However, under the Mamluks, special curtains were produced for the gates. In the 20th century, the *kiswa* of the chamber was made in the *kiswa* factory in Mecca where the *kiswa* for the Ka'ba was produced.

Many examples of textiles used in the Prophet's Chamber made for the *minbar*, the *mihrab* and the gates have been discovered, some of which are now being studied and published for the first time. This article has outlined the types of textiles that were produced and has illustrated their designs and stylistic development. Such an investigation has

been made possible through the survival of so many examples and historical accounts describing their manufacture. These beautiful textiles are testament to the reverence felt for the Prophet's Mosque, which after Mecca, is the holiest shrine in the Islamic world.

Notes

1 On the architecture of the Prophet's Chamber throughout the ages, see al-Samhudi 2001, II: 297–461; al-Shahri 1982: 321–34, 384–8; Hafiz 1984: 115–29; al-Jamil 2010: 34–44.
2 Ibn Rushd 1988, I: 409; al-Samhudi 2001, II: 349–50.
3 Ibn Rushd 1988, I: 409–10; al-Samhudi 2001, II: 350.
4 Ibn Rushd 1988, I: 409; al-Samhudi,2001, II: 349–50.
5 His full name is Khalil ibn Kaykaldi ibn 'Abd Allah al-'Ala'i al-Dimashqi, a theologian from Shafi'i school, see Brockelmann 1968, II: 68; Kahala [n.d.], IV: 126.
6 Al-Maraghi 1981: 66; al-Samhudi 2001, II: 348.
7 Ibn al-Najjar 2003, II: 376; al-Samhudi 2001, II: 350.
8 *Zananir* is plural of *zinnar*: that which is tied around the waist, it is also called *nitaq*. In the current context it refers specifically to a belt that is put on the *thawb* of the *kiswa* at the upper third part. The *zinnar* became referred to as *nitaq* in the Ottoman period and it is made with silk and the designs are embroidered with threads of gold plated silver or pure silver. See Ibn Manzur 2003, IV: 413–14, VIII: 601.
9 Al-Harbi 1981: 372; Ibn al-Najjar 2003, II: 364; al-Sakhawi 1993, I: 82; al-Samhudi 2001, II: 350–1. Al-Samhudi 2003, II: 349.
10 Ibn al-Najjar 2003, II: 394; al-Qalqashandi 1985, IV: 303; al-Maraghi 1981: 66.
11 Al-Salih Tala'i' ibn Ruzzik chancellor of the Fatimid Caliph al-'Adid. He was assassinated in 1160.
12 Ibn al-Najjar 2003, II: 394; al-Samhudi 2003, II: 348–9.
13 Ibn al-Najjar 2003, II: 394; al-Samhudi 2003, II: 349.
14 Ibn al-Najjar 2003, II: 394; al-Qalqashandi 1985, IV: 303; al-Maraghi 1981: 66; al-Samhudi 2003, II 349.
15 Al-Qalqashandi 1985, IV: 303.
16 Ibn al-Najjar 2003, II: 394; al-Samhudi 2003, II: 349.
17 Al-Qalqashandi 1985, IV: 303.
18 Ibn al-Najjar 2003, II: 394; al-Sakhawi 1993, I: 297; al-Samhudi 2003, II: 349.
19 Ibn Jubayr 1952: 168–9.
20 Al-Qalqashandi 1985, IV: 303; al-Samhudi 2003, II: 349.
21 Al-Jahha is a title given to Abbasid and Seljuk women. It was also given to the mother of the caliph and his wives.
22 Ibn al-Najjar 2003, II: 394.
23 On the *waqf* of the *kiswa* of Ka'ba and the Prophet's Chamber, see al-Fasi 1999, I: 123; al-Samhudi 2003, II: 350–1; Sabri Basha 2004, II: 714–19; Mu'thin 1981–2: 458–64; al-Daqn 1986: 94, 265–71; Tezcan 1996: 5–9.
24 Ibn al-Ji'an 1974: 9, 11, 77.
25 Ibn al-Ji'an 1974: 9.
26 Al-Maraghi 1981: 66; al-Samhudi 2003, II: 349; al-Barzanji [n.d.[: 206–12.
27 Al-Maraghi 1981: 66.
28 Al-Qalqashandi 1985, IV: 303.
29 Al-Samhudi 2003, II: 351.
30 Al-Qalqashandi 1985, IV: 303.
31 Al-Samhudi 2003, II: 354–5.
32 Al-Maraghi 1981: 66; al-Samhudi 2003, II: 349.
33 Ibn Iyas 1983, II: 330.
34 Al-'Abbasi [n.d.]: 137.
35 Al-Kurdi 1965, IV: 203; 'Attar 1977: 154; Mu'thin 1981–2: 190.
36 Ahmad 1937, I: 20–251; Mu'thin 1981–2: 190; al-Mojan 2006: 192; al-Mojan 2012: 45; al-Mojan 2012: 45.
37 On the curtains of the Chamber and the Prophet's Mosque, see Tezcan 1996: 111–62; Taha 2005: 134–51; Hamid 2011: 338–9, 363, 367 (figs 155–61).
38 Al-Mojan 2006: 406.
39 This group of textiles have also been studied by Selin Ipek. A number of them in the Topkapi Palace collections were re-used as tomb covers. Ipek 2006 (editor's note). **Plate 2** has been published in Tezcan 1996: 74; Atasoy 2001: 296; Ipek 2003: 27.
40 M.A.S. Abdel Haleem 2005 is used throughout this article for translation of verses from the Qur'an.
41 **Plate 4** is published in Tezcan 1996: 82.
42 **Plate 6** is published in İpek: 2005: 334.
43 'Abbas 1995: 117–18.
44 **Plate 8** is published in Tezcan 1996: 151.
45 **Plate 9** is published in Tezcan 1996: 153.
46 **Plate 13** is published in Tezcan 1996: 160.
47 **Plate 16** is published in Istanbul 2008: 175.
48 **Plates 17–18** are published in Tezcan 1996: 133, 135.
49 Al-Fairuzabadi, Istanbul, MS Faid Allah 1521 (fig. 204). Al-Shahri 1982: 108. *Qubati* is the plural of *qubtiya* which is a white flax cloth produced in Egypt. Flax was the material associated with affluent classes from which various garments and textiles are made. Its threads came in many colours. The Egyptians during the Islamic period adopted and developed methods of weaving flax that began in Ancient Egypt. See Ibn Sayda 1898–1903, IV: 71; Ibn Manzur 2003, VII: 468, XI: 406; Muhammad 1977: 32; Muhammad 1986: 75–83; al-'Ali 2003: 33, 97–8; Mu'thin 1981–2: 320–5.
50 Ibn al-Najjar 2003, II: 363; al-Maraghi 1981: 65–6; al-Samhudi 2003, II: 119.
51 Al-'Abbasi [n.d.]: 137.
52 Ibn Zabala 2003: 92; al-Samhudi 2003, II: 137, 350.
53 Al-Qalqashandi 1985, IV: 303–4; al-Samhudi 2003, II: 137.
54 Al-Qalqashandi 1985, IV: 303–4.
55 Al-Maraghi 1981: 66; al-Samhudi 2003, II, 349.
56 Al-Fairuzabadi 2002: 204; al-Samhudi 2003, II: 138.
57 Al-Samhudi 2003, II: 138.
58 Al-Samhudi 2003, II: 137.
59 Al-'Abbasi [n.d.]: 137.
60 Al-Jaziri 1983, I: 683–4.
61 **Plate 19** is published in Tezcan 1996: 119.
62 **Plate 20** is published in Tezcan 1996: 121.
63 Al-'Abbasi [n.d.]: 137.
64 The curtain is 335 x 255cm, Topkapi Palace Museum, inv. 24/271.
65 The curtain is kept in the Public Library of King 'Abd al-'Aziz in Medina. There is curtain of the same style in the Topkapi Palace Museum, inv. 24/165. See Tezcan 1996: 138–9 (fig. 55).
66 The curtain is 335 x 255cm, Topkapi Palace Museum, inv. 24/272.
67 Ibn al-Najjar 2003, II: 363; al-Samhudi 2003, II: 137, 350.
68 Al-Maraghi 1981: 66; al-Samhudi 2003, II: 137–8.
69 On the architecture of the minaret and its door, see al-Shahri 1982: 388.
70 **Plate 22** is published in Ipek 2006: 293.
71 **Plate 23** is published in Tezcan 1996: 115.
72 Ibn al-Najjar 2003, II: 224.

Chapter 24
The *Mahmal* Revisited

Venetia Porter

Introduction

The *mahmal* which departed annually to Mecca with the Hajj caravan was a highly charged political symbol. It is first attested in 1277 during the reign of the Mamluk Sultan Baybars, and it continued to be taken to Mecca until 1926, and was paraded in Cairo until 1952. At different times there were *mahmal*s going from Cairo, Damascus, Yemen, Timurid Persia, Hyderabad and Darfur.[1] The *mahmal*s from Cairo always escorted the holy textiles known generically as *kiswa* which had been made in Egypt since the early Islamic era.[2]

Much has been written in this volume and elsewhere about the *mahmal* tradition and its politics and a major source for the study of the subject continues to be Jomier's *Le Mahmal et la Caravanne Egyptienne* published in 1953.[3] The aim of this essay is to focus less on the history and more on the *mahmal* itself: its physical structure and how it has been depicted over time in paintings, manuscripts and tilework by Muslim artists, 19th- and early 20th-century Orientalist painters, in early photographs and in the contemporary wall paintings of the houses of Upper Egypt. Finally, the making of the cover of the *mahmal* will also be considered with an overview of the surviving *mahmal*s. By way of an introduction, however, the term *mahmal* itself needs to be considered and the theories surrounding its use and origin briefly reviewed.

The term '*mahmal*' and the origins of the *mahmal* tradition

The structure known as a *mahmal* consists of a wooden frame made to fit on top of a camel. It has a pointed top and over it a fabric tent is placed, thereby creating a small room. The fabric covering is generally referred to as *kiswat* or *sitr al-mahmal*, the 'robe' of the *mahmal*, as the robe of the Ka'ba is called *kiswat al-ka'ba*. There are references to two different kinds of *kiswa*s for the *mahmal* in the 19th century: a formal one and one for travel.

The word *mahmal* (*mahmil* or *mihmal*, pl. *mahamil*) is from the root *hml* ('carry'). Edward Lane, who saw a *mahmal* at first hand in 1825 and drew it (**Pl. 1**), described it as 'an instrument for carrying' and 'an ornamented *hawdaj*' (from *hadaj*, pl. *ahdaj*), the most common term for such a vehicle. Other terms for the *hawdaj* are *mihaffa*, *shibriya* and *shagduf*.[4] As Lane describes it, the *hawdaj* traditionally had a pair of panniers on either side of the camel in which two equal loads were borne. Within the small tent over the top, someone could sit in shelter and seclusion. Tabari (d. 923) mentions *mahamil* as a generic form of transport 'placed on mules to carry the wounded in battle', but as Jacques Jomier noted, there are early medieval references which firmly place the term *mahmal* within the context of the journey to the Hajj. These include the reference to 'a large *hawdaj* termed "*hajjaji*" … first made use of by El-Hajjaj Ibn Yoosef Eth-Thakafee: one of the *mahamil* of the pilgrims'.[5] Jomier also notes a reference to a Hamdanid princess who went on the Hajj from Mosul in 977 with a cortege of 400 *mahamil* which were all the same colour so that it was impossible to recognize the one that the princess was in. He also suggests that the term was being used to describe a vehicle or palanquin that was exceptionally grand. Al-Sam'ani

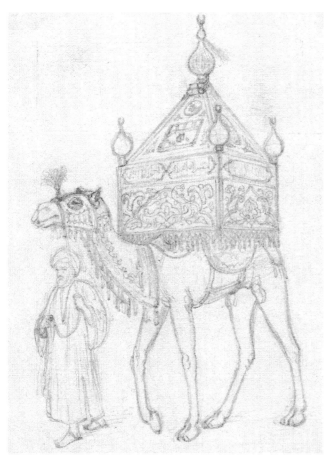

Plate 1 'Return of the *mahmal*', by Edward Lane. Pen drawing on paper, 1825. Griffiths Institute, Oxford

(d. 1167) in his *Kitab al-ansab* is very specific about the term *al-mahamili* and says it 'refers to the *mahmal* in which people are transported on camels as far as Mecca'.[6]

By the mid-12th century, the term *mahmal* therefore regularly appears within the clear context of the Hajj as a vehicle for transporting wealthy pilgrims. The question is, however, at what point did it cease to be a carrier of people on their way to the Hajj and become the large empty tented structure that is the focal point of the Hajj caravan, both in terms of its height and magnificence and as a symbol of religious authority?

There are various theories as to how it took on this role. One of these is that the tradition was derived from the palanquin that carried the Prophet's wife 'Aisha who, for encouragement, accompanied her husband on his battles. This followed an ancient practice in which girls of noble birth sat, beautifully apparelled, in palanquins lavishly decorated with ostrich feathers and shells. The structure which would have stood high above the warriors (as did the *mahmal*) acted therefore as the emblem of the tribe.[7] Other theories have suggested links to particular figures the first of whom is Queen Zubayda bint Ja'far (d. 831), wife of the caliph Harun al-Rashid (r. 708–809). Strongly associated with the pilgrimage, the route from Kufa to Mecca is named after her on account of her lavish spending on the care of pilgrims, most specifically the building of water facilities along the road and in Mecca itself.[8] She is said to have gone on Hajj herself at least five times and was apparently the first to travel in a palanquin described by al-Mas'udi as made of 'silver ebony and sandalwood adorned with clasps of gold

and silver and draped with sable and silk of blue, green, yellow and red'.[9] Another theory which took stronger hold is that the tradition was initiated by Shajarat al-Durr (d.1257), the first female Sultana and first of the Mamluks who ruled for a mere 80 days. This legend became popular in the 19th century with writers such as Lane and Christiaan Snouck Hurgronje suggesting that Baybars wished to emulate the rich regalia that characterized the Hajj procession of Shajarat al-Durr.[10]

The first clear reference to the ceremonial procession of the symbolic *mahmal* escorting the holy textiles dates to 1277, clearly expressed by Ibn Kathir: 'on 11 Shawwal 675 is celebrated the procession across the city [Cairo] of the *mahmal* escorting the exterior coverings of the Ka'ba'.[11] He does not describe it as an innovation, although the lavishness, formality and symbolism of the procession may have been noteworthy. Al-Suyuti (d. 1505) says that this is the first time the event occurred, but since he was writing several hundred years later this cannot be conclusive.

The *Maqamat* of al-Hariri and the *mahmal*

In the absence of any textual evidence,[12] the existence of a pre-existing tradition for the *mahmal* (i.e. before 1277) is asserted by Doris Behrens-Abouseif on the basis of the illustrations in the 31st *Maqama* entitled 'The encounter at Ramla' in the *Maqamat* (Assemblies) of al-Hariri, painted by Yahya al-Wasiti in 1237.[13] The text of the 31st *Maqama* and the double-page illustration in the Bibliothèque Nationale's version of the *Maqamat* (Arabe 5847) which accompanies the text need now to be considered as they are key in trying to reconstruct the history of the pre-Mamluk *mahmal*.

Abu Muhammad al-Qasim ibn 'Ali ibn Muhammad ibn 'Uthman ibn al-Hariri (b. 1054), poet and philologist, lived and studied in Basra. He began the *Maqamat* (Assemblies) in 1102 and by the time he died in 1122 they were already a classic and he boasted that he had authorized 700 copies to be made.[14] The success of the stories has been ascribed to the literary prowess of al-Hariri, the stories centre around two main characters: the narrator al-Harith and the roguish hero Abu Zayd.

In the 31st *Maqama*, al-Harith finds himself in Ramla, a town in Palestine 40km north-west of Jerusalem, expecting to do some trading. Here, he encounters the Hajj caravans making ready for the journey to Mecca.[15] The longing takes him to go on Hajj himself and he joins the convoy. Ramla is described in the second half of the tenth century by al-Muqaddasi as being 'rich in fruits, especially figs and palms, good water and all foodstuffs, it combined the advantages of town and country, those of a position in the plain with the proximity of hills and sea, of places of pilgrimage like Jerusalem and coast fortresses'. At the time that al-Hariri was writing in the early 12th century, Ramla had suffered a series of earthquakes and had been conquered by the Crusaders relatively recently in 1099 and was only retaken by Saladin following the Battle of Hattin in 1187. It is therefore unlikely that Muslim pilgrims would have stopped there at this time and al-Hariri is therefore most likely evoking an earlier era.[16]

The key moment in the story occurs at Juhfa, the *miqat* where the pilgrims from Syria assemble and where they

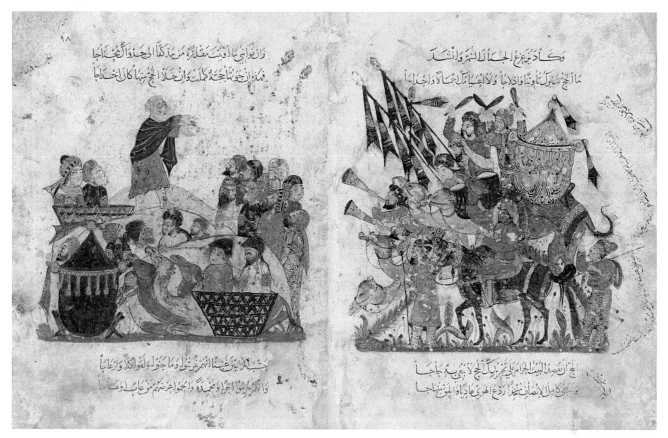

Plate 2 Pilgrims on Hajj, folios 94v–95r of the *Maqamat* of al-Hariri painted by Yahya al-Wasiti, 1237. Bibliothèque Nationale de France, Paris (Arabe 5847)

change into their *ihram* clothing.[17] 'No sooner had we made our animals kneel in the place, and laid down the saddle bags than there came among us down from the mountains a person, bare of skin'. This will turn out to be Abu Zayd but al-Harith does not discover this until later. Abu Zayd then calls out to the pilgrims, ascends a small hillock and starts a sermon on the meaning and benefits of the Hajj which begins as follows: *atakhalun an al-hajj huwa ikhtiyar al-rawahil wa qata' al-marahil wa itikhadh al-mahamil.* Amina Shah's translation of this passage, after that of Thomas Chenery, is as follows: 'O you company of pilgrims … do you comprehend what you are undertaking so boldly? Do you imagine that the Hajj is the choosing of saddle beasts, the traversing of stations?', and crucially now appears the word *mahamil* which Chenery and Shah translate as 'litters' ('and the taking of seats in litters').[18]

As disscussed above, by the 12th century the term *mahamil* was being used in connection with the transportation of people going on Hajj. Later on in the sermon, and expanding on his theme, Abu Zayd says: 'the Hajj is not your travelling by day and night, and your selecting camels and camel-litters' (*ajmalan wa ahdajan*). The *hawdaj* as we saw above was a vehicle of transport and, as explained by the editor of the *Maqamat*, the *hadaj* in this context is *markab min marakib al-nisa' ka'l mahaffa* ('a vehicle for carrying women like the *mahaffa*').[19] Is Hariri using the term *ahdaj* and *mahamil* interchangeably as Shah seems to suggest? Is he using *mahamil* in the sense that al-Sam'ani used it to carry people on Hajj or, could he in fact be referring to the taking of the ceremonial *mahmal?* In which case, why is he using the plural? Furthermore, painting around 1237, what was

al-Wasiti's understanding of the term? It is to al-Wasiti's illustration that we will now turn.

The double-page paintings (**Pl. 2**), are found on folios 94v and 95r. On 94v, there are four lines of text above and below the painting. The illustration is found half way through the story and includes part of Abu Zayd's sermon in verse. 'The Hajj is not your travelling by day and night, your selecting camels and camel litters [*wa la i'tiyamuka ajmalan wa ahdajan*], the Hajj is that you go to the holy house for the sake of Hajj, not that you accomplish your wants that way'. [20] The text around the sides in red is commentary on the vocabulary that occurs throughout the text.

The painting on folio 94v depicts the caravan en route, accompanied by musicians with drums and trumpets. We also see black flags: black being the dynastic colour of the Abbasids.[21] There is a turbaned man on horseback, possibly the Amir al-Hajj and two attendants on foot.[22] On the back of the camel is a large, gold painted pannier-like structure with a pyramid-shaped top. It has a finial at the top from which there is a gold and black pendant and around the middle there is a tasselled band. The scene echoes the exhilaration and pleasure of the journey as described by the narrator before they reach the *miqat* of Juhfa. On the left (fol. 95r) the camels and the pilgrims are on the ground, Abu Zayd is on the hillock and there are two groups of men in what look like open baskets, perhaps *ahdaj*. The *mahmal*, now black, is on the ground.

The resemblance of the *mahmal* on the right to the only known existing early *mahmal* which was commissioned by Sultan al-Ghawri and now in the Topkapi Palace is clear. It is made of yellow silk, yellow being the dynastic colour of

Plate 3 Pilgrims on Hajj fol. 117v of the *Maqamat* of al-Hariri 1242–58. Suleymaniye Library, Istanbul (Esad Efendi 2916) (courtesy of the Turkish Cultural Foundation)

what is clearly a *hawdaj*, a structure with open sides and in which people are sitting.[25]

It seems reasonable to conclude, therefore, as did Abousseif and Grabar, that al-Wasiti's painting is depicting a *mahmal* and that one can argue that this is what al-Wasiti understood by al-Hariri's term *mahamil*. Furthermore, it suggests that he may have seen them. What is less clear is why al-Wasiti depicts two *mahmals*, a gold and a black one, or if the change in colour reflects the change in mood as suggested by Anna Contadini, from joyful to reflective as the full implications of the Hajj are elaborated by Abu Zayd.[26]

These therefore are the earliest depictions of *mahmals* and their appearance in Abbasid period manuscripts strongly implies that after the fall of the Abbasids in Baghdad in 1258 and with the establishment of the Abbasid caliph in Cairo, the Mamluk Sultan Baybars is adopting a pre-existing tradition and form of *mahmal* to add great pomp and ceremony which would remain unchanged until its final abandonment in the 20th century.

After Baybars, other copies of the *Maqamat* which illustrate the 31st *Maqama* clearly show the *mahmals*. Two copies in the British Library were produced in early to mid-14th century in Syria. The first (Or. 9718) is signed by the calligrapher al-Ghazi (d. 1310). The caravan procession is a double-page illustration (fols 119v, 120r) with the *mahmal* on folio 119v. Unusually, it is painted blue but has the characteristic finial and seems unlikely to be anything other than a *mahmal*. The second (Or. 22114) (**Pl. 4**), is also a double-page composition (fols 102v, 103r) and dated by Hugo Buchtal to the mid-14th century. The *mahmal* on folio 102v (**Pl. 4**) is clear. It is triangular shaped with a yellow canopy

the Mamluks (see p. 172, **Pl. 2**).[23] It has finials at the top and on both sides of the central band. A question that should be asked is were al-Wasiti's structures intended for the transportation of people? This seems unlikely as there is a clear contrast between the '*mahmals*' and the open baskets on fol. 95r in which people, evidently men, are sitting. Most conclusive in this regard however is the illustration from the Suleymaniye library *Maqamat* datable to the reign of al-Musta'sim, the last Abbasid caliph (r. 1242–58) (**Pl. 3**).[24] On folio 117v, the Hajj caravan can be seen in two rows, on the top left a camel is carrying a yellow structure with a pyramid shaped top, a central band and finials, very similar to al-Wasiti's rendering, and to the right we note

Plate 4 Pilgrims on Hajj, folios 102v and 103r of the *Maqamat* of al-Hariri, mid-14th century. British Library, London (Or. Add.22114) (© The British Library Board)

decorated with star patterns and has a pendant hanging at the top of the finial.[27] The Bodleian *Maqamat* dated to 738/1337, whose patron was Amir Nasir al-Din Muhammad ibn Tarantay, an official at the Mamluk court, also includes an illustration of a *mahmal*.[28] What may have been the most lavish manuscript of them all (British Library, Or.add 72930) dated 723/1323, sadly remained unfinished. The spaces left indicate that the 31st *Maqama* would have contained one single and three double-page illustrations.[29]

Anis al-hujjaj and the *mahmal*

An interesting illustration of a *mahmal* appears in the depiction of a Hajj caravan from Egypt in one of the paintings in a 17th-century manuscript of *Anis al-hujjaj* (The Pilgrims' Companion) found in the Nasser D. Khalili Collection of Islamic Art (**Pl. 5**). The text was written by Safi ibn Vali who went on Hajj in 1087/1676–7 and this manuscript can be dated to 1677–80.[30] Clearly intended as a guide, the text starts with advice on how to choose the ship at Surat, details of the journey and the places he visited on the way and in Arabia itself, the other pilgrims he saw and the rituals of the Hajj.[31] At the top of folio 18r is the Egyptian Amir al-Hajj, who is named in red as 'Abdi Pasha and dressed in gold. Ahead of him is a camel bearing what is clearly a *mahmal* containing inside it a copy of the Qur'an on a stand. Above it is the text *mahmal/shabih muqaddamat hajj Misr* ('the likeness of a *mahmal* coming from Egypt'). This painting therefore clearly illustrates the text that describes the Egyptian caravan:

> One of the notable events that happened was that on Tuesday 6th of [Dhu'l Hijja], Barakat, Sharif of Mecca [32] came out riding on a horse with great pomp and show followed by five hundred cavalry and seven hundred infantry soldiers … *then a camel-litter covered with black silk and golden garment appeared* [author's italics]. A number of colourful flags surrounded it from both sides. It was followed by the Miri-i Hajj [Amir al-Hajj] with a big force and the standard bearer with different kinds of musical instruments which were customary with the suite of nobles of Rome.[33]

The painting depicts the *mahmal* as a rectangular structure painted black, with flags coming out of it. An interesting feature is that it is open with a Qur'an on its stand placed on the back of the camel. Safi ibn Vali does not mention the Qur'an in his text, and its appearance here highlights the debate about whether the *mahmal* was empty or whether a Qur'an was placed inside it. The anonymous observer of 1575 commented: 'it [the camel] carries a chest [*mahmal*] made in the likeness of the ark of the covenant (a frequent comparison) but without gold … within this is the Qur'an all written with great letters of gold bound between two tablets massey gold'.[34] John Lewis Burckhardt in his description of the Egyptian *mahmal* wrote in 1814:

> The *mahmal* … a high hollow wooden frame in the form of a cone, with a pyramidal top, covered with a fine silk brocade adorned with ostrich feathers and having a small book of prayers and charms placed in the midst of it, wrapped in a piece of silk … when on the road, it serves as the holy banner to the caravan, and on the return of the Egyptian caravan, the book of prayers is exposed in the mosque al-Hassanayn in Cairo where men and women of the lower classes go to kiss it to obtain

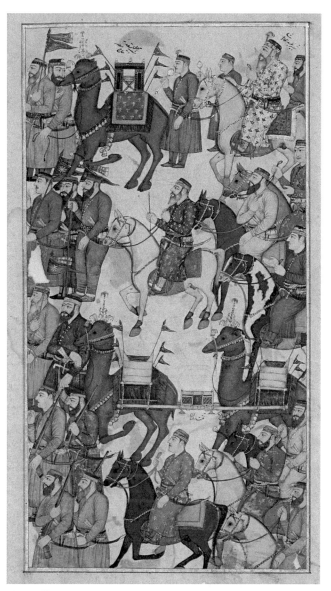

Plate 5 The Amir al-Hajj 'Abdi Pasha on his way from Mecca to Medina, fol. 18v of *Anis al-hujjaj*. Gujarat, *c.* 1677–80. Nasser D. Khalili Collection of Islamic Art (MSS 1025) (© Nour Foundation. Courtesy of the Khalili Family Trust)

blessings by rubbing foreheads against it. No copy of the Quran, nor anything but the book of prayers, is placed in the Cairo *mahmal*.[35]

Other sources, however, said it was completely empty.[36]

Illustrating the *mahmal*: 16th–20th century

Following the Ottoman capture of Egypt in 1517, the practice of sending the *mahmal* with the Hajj processions from Cairo continued. However, the official Ottoman Hajj caravan known as the *Sürre*, with its own *mahmal* departed from Damascus. Ceremonies took place in Istanbul before the Ottoman sultan and they included the parade of a camel bearing a *mahmal*. However, this was merely symbolic as the camel itself never left the capital.[37] A *mahmal* had gone from the Yemen in the 13th and 14th centuries, and with the conquest of the Yemen by the Ottomans in 1543 the practice was revived but only for about a century.[38] At the standing of 'Arafat, the key moment in the Hajj rituals, the representation of three *mahmal*s (Egyptian, Syrian and Yemeni) appear in manuscripts such as the *Futuh al-haramayn* and on a

Plate 6 (far left) Jabal 'Arafat, fol. 23b of *Futuh al-haramayn* by Muhyi al-Din Lari, late 16th century. Chester Beatty Library, Dublin (CBL Per 245)

Plate 7 (centre) Jabal 'Arafat, fol. 29r of *Futuh al-haramayn* by Muhyi al-Din Lari, Nasser D. Khalili Collection of Islamic Art (MSS 1038) (© Nour Foundation. Courtesy of the Khalili Family Trust)

Plate 8 (left) Tile panel, Harem, 17th–18th century. Topkapi Palace, Istanbul (photo: Bruce Wannell)

17th-century tile panel in the Topkapi Palace. In the Chester Beatty Library's Ottoman *Futuh*, dated 1003/1595 (**Pl. 6**) the *mahmal*s are lined up one above the other to the right of Mount 'Arafat and just below the site known as Adam's Kitchen.[39] On the Nasser D. Khalili Collection of Islamic Art's *Futuh*, dated 990/1582 (**Pl. 7**), the *mahmal*s are placed below Mount 'Arafat as they are in the tile panel in the Harem of the Topkapi Palace (**Pl. 8**).

From the 18th century onwards, illustrations of the *mahmal* appear in several different contexts. Sieur Lucas in 1744 captured the excitement at the sight of the *mahmal* procession; he writes:

> The procession was completed by a camel who carries a pavilion [*sic*] that the great lord sends to the tomb of Muhammad and which is made of magnificent rich embroidered fabric.... All the people who are at the windows or in their shops throw flowers as it passes and everyone tries to touch it. Those too far away attach an handkerchief to a rope so as to be able to reach it.[40]

Edward Lane, who also witnessed the departure to and the return from the Hajj in 1825, was fascinated by the *mahmal* procession, and as mentioned above, made several sketches of it.[41]

The paintings and drawings of 19th-century Orientalists vary in the degree of authenticity; some artists saw the *mahmal* and its procession with their own eyes, others relied on imagination.[42] Alfred Dehodencq (d. 1882) probably never actually witnessed the magnificent procession along the Red Sea which he painted in around 1853 (**Pl. 9**), as he was based mostly in Morocco and a number of places were probably conflated to create the landscape.[43] A particularly interesting painter in this respect is Konstantin Makovsky (d. 1915) who visited Cairo in 1873. He was keen to paint the *mahmal* procession and, as recounted by Mary (May) Thysen Amherst:

> He was very anxious to get a photograph of it as it passed through the streets. This was before the days of snapshots and the Kodak was not known. He consulted my father, and as my father was dining with the Khedive the following evening he promised to ask about it. Nothing could have been kinder than His Highness's reply. The procession was to be ordered to stop at a certain point where the photographer was to be ready with a plate and focus fixed and the photograph should be taken. Such a thing had never been heard of the great Mohamedan procession to be stopped by a Christian so that a photograph could be taken of it.[44]

Plate 9 Alfred Dehodencq, *Le Hajj*, mid-19th century, oil on canvas. Private collection (photo courtesy of Sotheby's)

Plate 10 Wood engraving by R. Brendamour 1893 after Konstantin Makovsky's *The Handing over of the Sacred Carpet in Cairo*, 1876. Nasser D. Khalili Collection of Islamic Art (ARC.pt 123) (© Nour Foundation. Courtesy of the Khalili Family Trust)

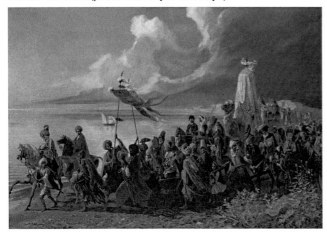

Makovsky completed a sketch which was the basis of the painting, now hanging in the National Museum of Armenia. A wood engraving of the painting was later done by R. Brendamour in 1893 (**Pl. 10**) and was included in a German periodical of 1893. The Khedive at this time was Isma'il (r. 1863–79) and the photographer in question is very likely to have been Sadiq Bey. A photograph of what is clearly a detail of the scene, where the same architectural features of the street can be seen, appears in his *Mash'al al-mahmal* published in 1881 (**Pl. 11**).

From the latter part of the 19th century and into the 20th century, it is in fact the photographic and film records where images of the *mahmal* are to be mostly found and we see photographers accompanying the Hajj, their photographs appearing in newspapers and magazines and turned into postcards.[45] These images particularly capture 'the ceremonial of departure', which the Europeans often called the departure of the 'Holy Carpet', mistakenly conflating the *kiswa* with the *mahmal*.[46] There are illustrations of the *mahmal* en route, across the desert, on the train to Suez and on the boat to Jedda. There are others depicting the arrival and parade at Mecca; the arrival at Medina, the standing of the *mahmal*s at 'Arafat and the return to Cairo. In addition, there are interesting late 19th- and 20th-century popular prints made in Germany (**Pl. 12**) and others by A.H. Zaki included in the *Cairo Punch* (**Pl. 13**).[47]

Surviving *mahmal*s

It is clear from the descriptions of surviving *mahmal*s and photographs that there were several different types of *mahmal* covers: the Egyptian *mahmal* cover was red or brownish-gold, while the Syrian one appears generally to have been green. In addition there was a travelling *mahmal* made of cotton produced in the *suq* of the tent-makers in Cairo and replaced every year.

Egyptian mahmals

Regarding surving late 19th- and 20th-century Egyptian *mahmal*s, the situation is complicated. There are three published examples,[48] in addition to photographic records of

Plate 11 Muhammad Sadiq Bey, *Mash'al al-mahmal*, Leiden University Library (courtesy of Leiden University Library)

others.[49] As they were so costly to make, they were constantly repaired and new panels were added to reflect a change in ruler. This makes them difficult to correlate with available photographic evidence. Their inscriptions and *tughra*s bear the names of both the Ottoman sultan and that of the Egyptian Khedive, in addition to verses from the Qur'an. Rif 'at Pasha mentions the manufacture of two covers for the *mahmal*. The first was made during the reign of the Khedive Tawfiq (r. 1879–92) and cost 1,571 Egyptian pounds.[50] He mentions in more detail the *kiswat al-mahmal* of 1310/1892, 'embroidered with silver and gold thread' made during the reign of 'Abbas Hilmi II (r. 1892–1914). He describes how the making of this *kiswat al-mahmal* was at the request of the Amir al-Hajj and that the associated large expense was ratified by the office of Majlis al-Nizar on 15 of Rabi' I 1310/6 October 1892 and sent to the Ministry of Finance for payment in July 1893. He goes on to list the costs of the materials and the calligrapher's fees.

Plate 12 'Al-Mahmal al-Sharif', popular print by Camille Burckhardt Wissenberg 1880–9. British Museum, London (2012,7020.86)

Plate 13 'The Egyptian and Syrian Mahmals and Mohammedan Pilgrims at 'Arafat', popular print in the *Cairo Punch*, early 20th century. British Museum, London (1948,1214,0.15)

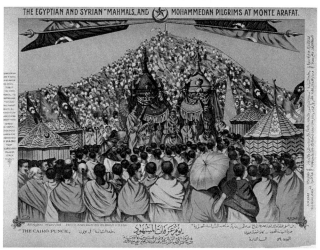

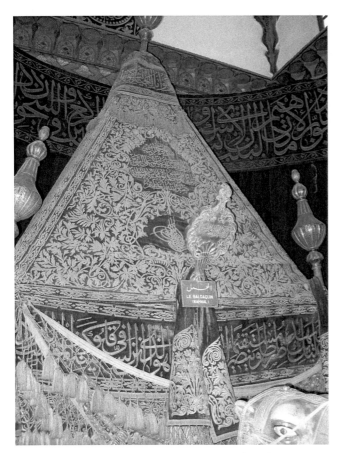

Plate 14 *Mahmal* in the Azem Palace, Damascus (detail) dated 1330/1821 (photo courtesy of Diana Darke)

The Khedive 'Abbas Hilmi went on Hajj in 1909 and there are photographs of the Hajj of this year taken by Muhammad al-Husayni, Muhammad 'Ali Sa'udi, Ibrahim Rif'at Pasha and Khedive 'Abbas Hilmi's anonymous photographer whose photographs were subsequently placed in an album.[51] It is likely that following the death of 'Abbas Hilmi the *mahmal* he was photographed with had acquired new panels made to reflect the rule of Fu'ad I who in 1922 was given the title Malik Misr. On the *mahmal* is also his title 'mawlana al-sultan' and the date 1336/1917. This is the *mahmal* now kept in the Cairo Geographical Society. The last known *mahmal* from the reign of King Fou'ad II (r. 1952–3) is kept in the Suez Museum. The practice of sending the *mahmal* was violently disapproved of by the Wahhabi rulers

of Saudi Arabia and 1926 was the last year in which it reached Mecca. It continued to be paraded in Cairo and on occasion reached Jedda but in 1952, with the deposition of the monarchy, and a *fatwa* issued by the Grand *mufti* of Egypt, the practice was proclaimed as idolatrous and completely discontinued.[52]

Syrian mahmals

The earliest published Syrian *mahmal* is dated to 1291/1874 from the reign of Sultan Abdülaziz. It is kept in the Topkapi Palace and is very likely to be the one depicted in the photographs by Felix Bonfils in Damascus.[53] Another important surviving Syrian example is in the Azem Palace in Damascus dated to 1330/1912 (**Pl. 14**). It is depicted in a painting made that year which is now in the Topkapi Palace,[54] and is very likely to have been the one photographed in Medina and included in the notebook of the *Sürre* captain in the Topkapi Palace collection written in 1917.[55] In his notebook, the captain describes his departure from Haydarpasha railway station, the journey to Damascus, the arrangements made for the departure of the *mahmal-i sheriff* in Damascus and the processions and prayers undertaken before the *mahmal* was put on the train at Kanawat station heading for Medina. At Medina, outside the station, there were ceremonies for receiving the *mahmal* and after ten days there, they returned to Istanbul without going to Mecca. By this time relations between the Ottoman sultan and the Sharif of Mecca had deteriorated dramatically and the last *mahmal* to be sent from Damascus was in 1918.[56]

In 1853 Richard Burton saw the Syrian *mahmal* and noted that 'on the line of March the Mahmil, stripped of its embroidered cover is carried on camel-back, a metre frame wood. Even the gilt silver balls and crescents are exchanged for similar articles in brass'.[57] Charles Doughty saw it in 1888 when he accompanied the Syrian caravan and evocatively describes the *mahmal* without its formal covering. He wrote: 'I might sometimes see heaving and rolling above all the heads of men and cattle in the midst of the journeying caravan, the naked frame of the sacred *mahmal* camel which resembles a bedstead and is after the fashion of a Beduish woman's camel-litter. It is clothed on high days with a glorious pall of green velvet, the Prophet's colour and the four posts are crowned with glancing knops of silver.'[58]

Plate 15 Photograph from *Pilgrims to Makkah* 1908 by Muhammad al-Husayni (plate 6), showing the *mahmal* on board the steamship to Jedda. Dominican Institute for Oriental Studies, Cairo

Plate 16 'The red castle', the *mahmal* on route between Medina and Mecca. Photograph from *Pilgrims to Makkah* 1908 by Muhammad al-Husayni (plate 38). Dominican Institute for Oriental Studies, Cairo

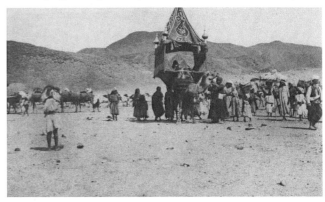

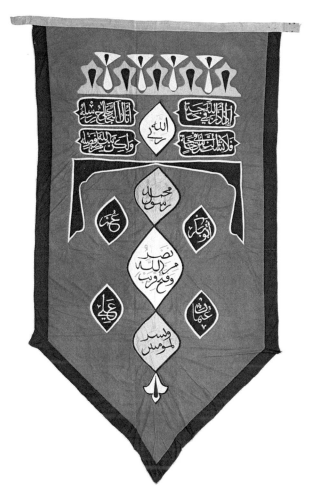
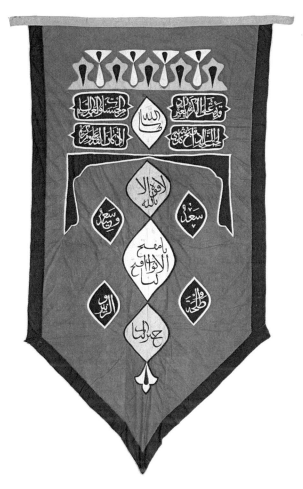

Plate 17 Hajj banner, 19th century. Department of Anthropology, NMNH, Smithsonian Institution (catalogue no. E158260) (photo by Donald E. Hurlber)

The travelling *mahmal* cover and the Smithsonian banner

When being paraded before its departure to Mecca, the *mahmal* was seen with its richly brocaded cover. However, once en route this was taken off and replaced with a travelling version. This covering can be seen in a number of photographs (**Pls 15, 16**) and may also be represented in the painting by Dehodencq of the caravan processing down the Red Sea (**Pl. 9**). This covering was replaced every year and was generally green. It was covered in appliqués and made in the tent-makers' market (*suq al-khayamin*). There was a clear association between the tent makers and the Dar al-Kiswa in Cairo where the holy textiles were made. There are references to the large textiles being cut and prepared by the *khayamin* and then brought over to Dar al-Kiswa for the embroidery.[59] There are no surviving travelling *mahmal* coverings to my knowledge. However, an important Hajj banner (**Pl. 17**), typical of the work of the *khayamin*, is in the Smithsonian and was purchased from the Turkish exhibit of the World's Columbian Exposition at the Chicago World Fair in 1893. The accession documents identified it as 'a Mecca flag – used in the pilgrimage processions [Hajj] to Mecca'.[60] Banners were traditionally carried along with the *mahmal*. They appear in a number of illustrations including al-Wasiti's painting, and Stephano Ussi's dramatic painting in the Dolmabahce Palace of the Egyptian *mahmal* caravan of 1874.[61] They were also carried by particular groups of pilgrims as indicated by the banner of North African Qadiri

Sufis in the Harvard Art Museum dated to 1094/1683.[62] Banners which resemble the Smithsonian banner are seen in a variety of 19th- and 20-century illustrations featuring the return of the *mahmal*, including postcards (**Pl. 18**). The style of the banner, its calligraphy and ornamentation can be related to other products of the *khayamiya*.[63] The texts inscribed on the Smithsonian banner (see below) are part of a large repertoire of inscriptions that include verses from the Qur'an, invocations to the Prophet Muhammad and his family and other verses.

The Smithsonian banner inscriptions[64]

Side A (**Pl. 17, left**):
In four cartouches:
Line 1. If God granted a need (*idha adhana Allah fi haja*), success will come to you in his own time (*ataka al-najah 'ala rusulihi*).
Line 2: so do not ask people when in need (*fala tas'al al-nas fi haja*) but rather ask God for his bounty (*wa lakin sal Allah min fadhlihi*).[65]
Central medallions from the top: God is my Lord (*Allah rabbi*), then in a line below: Muhammad is the messenger of God (*Muhammad rasul Allah*); Victory from God and a speedy success, and give good tidings to the faithful (*nasr min Allah wa fath qarib wa bashir al-mu'minin*, Q.61:13).
Interstices to the right and left are the names of the four Rightly Guided caliphs, Abu Bakr, 'Umar, 'Uthman and 'Ali.

Plate 18 Postcard. *Caire. L'Arrivée du Tapis Sacré*. Nasser D. Khalili Collection of Islamic Art (Arc. pc 12) (© Nour Foundation. Courtesy of the Khalili Family Trust)

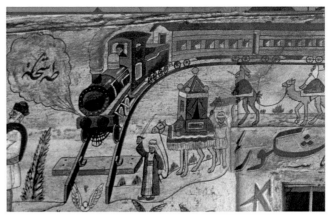

Plate 19 The *mahmal* procession en route to Mecca. Damietta, Talka road, Egypt *c*. 1970s (photo: Ann Parker)

Side B (**Pl. 17, right**):

In four cartouches:

Line 1: I visited the generous without provisions (*qadamtu 'ala al-karim bi-ghayr zad*), of righteous deeds and good actions (*min al-hasanat wa'l 'amal al-salim*).

Line 2: For the carrying of provisions is viler [than] anything (*li-hamal al-zad aqbah kul shay'*) if one is visiting the generous (*idha kana al-qudum 'ala al-karim*.[66]

Central medallions from the top: As God wills (*ma sha'a Allah*); there is no power except through God (*la quwwa illa billah*); Oh Opener of doors open for us [the way to] the best of people (*ya muftih al-abwab iftah lana khayr al-nas*, Q.6:44). Interstices to the right and left are the names Sa'd, Sa'id, Talha and Zubayr. These are four of the Companions of the Prophet who, with the four caliphs, make up eight of the ten *mubashirun al-jinna* for whom heaven is destined.

While these inscriptions do not in themselves make specific reference to the Hajj, it is interesting to note that they clearly match those on the travelling *mahmal* covers. The Qur'anic text 'Victory from God' (Q.61:13) and the names of the four companions are embroidered onto the side that is visible in the photograph of the *mahmal* on a boat taken in 1908 (**Pl. 15**).

The legacy of the *mahmal* tradition on wall paintings

As discussed above, the last of the *mahmal* processions in Cairo took place in 1952 but the strong association between the Hajj and the *mahmal* continued in the imagination of the painters who decorated the houses of returning pilgrims. These paintings, while not unique to Egypt are remarkable, firstly because of the clear links they demonstrate with the traditions of wall painting from Ancient Egypt, and secondly for the number of such paintings in existence and the skills of the painters. The subject repertoire includes the method of transport taken by the pilgrims such as boats and planes, the Ka'ba, the Hajj rituals and the celebrations of the homecoming. Amongst them can be found representations of the *mahmal* in a variety of forms.[67] While many of the extant paintings were done from the mid-1970s onwards, long after the *mahmal* tradition was no more, the presence of the *mahmal* in these paintings belongs in the collective memory of this glorious and ancient tradition.

Notes

1 Jomier 1953: 43 ff. Robinson 1931.
2 For a summary with further references, see Buhl and Jomier. 'Maḥmal'. *Encyclopaedia of Islam*, EI²; Porter 2012a: 257.
3 The translation of Jomier's book will be published by the Khalili Family Trust, forthcoming 2014.
4 Lane 1981: 433; Porter 2012a: 138, fig. 93; Lane 1955: 650; Wehr 1971: 187 (*mihaffa*); Cobbold 2008: 226–7 (she spells them Shagdoof and Shubreya); Barnes and Branfoot 2006: 103.
5 Lane 1836 (reprint 1981): 434; Lane 1955: 650; and hence '*mahamilu* a seller of *mahamil*'. Ibn Manzur 1990, 11: 178: Amongst its first uses cited by Ibn Manzur is the phrase: '*wahid mahamil al-hajjaj*' (one of the *mahamil* of the pilgrims, in other words a vehicle in which pilgrims were carried).
6 Jomier 1953: 22, n. 3, citing Tabari, al-Fasi, Sam'ani and others.
7 Jomier 1953: 21.
8 Kennedy in Porter 2012a: 95–6; Abbot 1946: 250 ff; al-Rashid 1980: 31 ff. 1; Behrens-Abouseif 1997: 91.
9 Behrens-Abouseif 1997: 91, citing al-Mas'udi/de Meynard *Muruj al-dhahab*, 1861–77, 8: 289.
10 Behrens-Abouseif 1997: 92. She suggests that another factor in the perpetuation of the legend is the historical accounts of the women from the Mamluk court going on Hajj.
11 Jomier 1953: 36, citing Ibn Kathir and al-Suyuti. Ibn Iyas gives the month as *rajab*. He says it was a memorable day, and that al-Zahir Baybars was the 'first among the kings in Egypt' to do this. He does not say that it became an annual event, but goes on to say that 'Baybars permitted pilgrims to go to Hajj in *rajab*, and this became known as *hajj rajabi* from then on, and it continued to occur every year after that, some years it happened, some years not'. (I am grateful to Nahla Nassar for this comment. She understands that the 'yearly occurence' refer to the *hajj rajabi*.). Ibn Iyas 1982, vol. I, part 1: 336.
12 Jomier was unable to find any references prior to the Ibn Kathir reference.
13 Behrens-Abouseif 1997: 89. Here she refers only to the gold *mahmal* as she only saw the illustration in Ettinghausen 1962: 119.
14 George 2012: 12; Margoliouth and Pellat. 'al-Hariri'. *Encyclopaedia of Islam (EI²)*.
15 The Leningrad *Maqamat* shows the tents of wealthy pilgrims (fol. 43v). This may be the earliest copy of the *Maqamat*. Grabar 1984: 11 (online http://warfare.uphero.com/Maqamat/StPetersburg-MsC-23.htm).
16 Honigmann. 'al-Ramla'. *Encyclopaedia of Islam (EI²)*. I am grateful to Andrew Petersen for confirming this.
17 There are five *miqat* around Mecca (see glossary).
18 Shah 1980: 140. It is Chenery's translation that Steingass (1898: 33) has used. In Chenery: 'the taking seat in litters'.
19 Al-Hariri 1965: 267.
20 Shah 1980: 141; Steingass 1898: 34; al-Hariri 1965: 267.
21 See Sheila Blair in this volume.
22 This is also suggested by Guthrie 1995: 45. David James 2013: 74–5

in his analysis of this manuscript discusses the illustrations to the 31st *Maqama* comparing them to other related *Maqamat* manuscripts.

23 See Sardi in this volume.

24 There is an inscription to this effect within the text. Grabar 1984: 12.

25 For the Arabic text see al-Hariri 1965: 265; Shah 1980: 140. The other Abbasid-period *Maqamat*, British Library Ms Or 1200, dated 654/1256, does not illustrate the *mahmal*, only Abu Zayd and the camel caravan on two double pages, fols 96r, 97v and fols 98v, 99r. James 2013: 25 and plate 4.5.

26 I am grateful to Anna Contadini for early advice on the illustrations of the *Maqamat*. I also discussed these with Bernard O'Kane and Alain Georges and I am grateful to them all for their insights.

27 Or.9718 has the date 1271/1855 in the colophon, the date of later additions. Al-Ghazi's death provides a *terminus post quem*. Grabar 1984: 13.

28 Grabar 1984: 15.

29 Grabar 1984: 14–15. The existing illustrations in Or.add 72930 are either quite crudely painted or consist of sketches 'with pouncing'.

30 Rogers 2010: 286; Porter 2012b: 30; Leach 1998: 124–5.

31 The text was translated by Ahsan Jan Qaisar whose family kindly made available the handwritten copy of the translation for use in the Hajj exhibition. There are extracts from it in Qaisar 1987. A project to publish the translation is in the planning stage.

32 This is Sharif Barakat bin Muhammad (1672–82).

33 This is from the translation of A.J. Qaisar (see n. 33).

34 Peters 1994a: 95.

35 Wolfe 1997: 185.

36 For Robinson's summary of the views see Robinson 1931: 124.

37 Mouradgea d'Hosson 1787 plate 46. For description, see d'Hosson 2001: 91–3; Porter 2012b: 26–7 and 172ff.

38 Jomier 1953: 57. Snouck Hurgronje gives the last date of the Yemeni *mahmal* as 1630 although Burckhardt notes one in 1640.

39 This is generally known as the house of Adam where Adam and Eve are believed to have come to live when they were cast out of Paradise. See Wolfe 1997: 100. During the Ottoman era, it acquired the title of 'Adam's kitchen' and is described in the text of the *Shawq-nama* as a 'resting place for the poor'. There is likely to have been a soup kitchen here, hence its name. Milstein 2001: 304.

40 Porter 2012a: 144–5; Lucas 1744: 138–9.

41 For the parading of the *kiswa* and the departure of the holy textiles and the *mahmal* to Mecca see Lane 1981: 475–81; for the return and further description see Lane 1981: 431–6.

42 There are a number of paintings showing the *mahmal*. These include Cooper Wylliams' parade in Cairo (1822); George Frederick in Cairo (1865); and Stefano Ussi en route (1874). I am grateful to Brionny Llewellyn and Nahla Nassar for all their help on this.

43 Sotheby's Orientalist sale 24 April 2012 lot 3.

44 Bolton 2009: 38.

45 An important archive of this material is in the Nasser D. Khalili Collection of Islamic Art. During the course of the years, there were several occasions when the *mahmal* was processed, when there were festivities and when it was photographed or illustrated. In the month preceding the Hajj it toured around as a form of advertising, see Jomier 1953: 62 ff.

46 For example Peters 1994a: 323.

47 Strasbourg 2011: 66ff and 120. According to Malou Schneider, author of 'Les Images Arabes de Wissenbrourg', this is one of a group of prints with Arab themes and inscriptions produced by Burckhardt probably in collaboration with Hassan Auvès in Cairo. Porter 2012b: 48–9.

48 a) Red *mahmal* in the Nasser D. Khalili Collection of Islamic Art bearing the names of Sultan Abdülaziz (r. 1861–76) and Khedive Isma'il (d. 1879). Porter 2012a: 141; b) Red *mahmal* in the Geographical Society in Cairo inscribed with the name of Ahmad Fu'ad I (r. 1917–36). Jomier 1953: 17c) A red *mahmal* from the reign of Fu'ad II (r. 1952–3) is in the museum at Suez. It was featured in Sabah al-Khayr no. 2862, 1431/2010: 72–3 (the Nasser D. Khalili Collection of Islamic Art archive, ARC.PT 25). The unpublished *mahmal*s in the Khalili Collection are in the course of study.

49 See Vrolik in this volume.

50 Rif'at 2009, I: 355ff. He mistakenly, says it was made in 1304/1887.

51 'Abbas Hilmi album, Mohammed Ali Foundation and Durham University Library; Kioumji 2009 (Sau'di); Pilgrims to Makkah 1908 (Al-Husayni); Rif'at Pasha 1925.

52 Jomier discusses the lead up to the end of the tradition from 1926 onwards; see Jomier 1953: 67 ff. Information on this can also be found in the *Records of the Hajj* for example the *mahmal* incident of 1926, see *Records of the Hajj* 1993, VI: 15–23.

53 Istanbul 2008: 221.

54 Istanbul 2008: facing page 7.

55 TKS 1331/1912 p. 238. The caption suggests that the location is Mecca. It is more likely to be Damascus on account of the *ablaq* architecture. The *Sürre* captain's book is illustrated and discussed in Imperial *Sürre*: 89 ff. There are other green *mahmal*s; these include ones in the Nasser D. Khalili Collection of Islamic Art and in the Collection of HE Sheikh Faisal bin Qassim Al Thani in Chekhab-Abudaya and Bresc 2013: 112.

56 Istanbul 2008: 90–5.

57 Burton 1855–6: 65, n. 3.

58 Doughty 1936, I: 101.

59 I am grateful to Nahla Nassar for this information which is based on her analysis of documents in the Nasser D. Khalili Collection of Islamic Art archive.

60 Casanowicz 1929, 148: 82, no. 32. I am extremely grateful to Felicia Pickering, Daisy Njoku and Sarah Johnson for their help in providing the information on the banner and to Donald Hurlbert for photographing the banner so beautifully. The negative numbers are NHB2013-00485 and NHB2013-00486.

61 For the image see www.artemisiaweb.forumfree.it.

62 Porter 2012a: 143; Denny 1974.

63 This is the subject of a major study by Sam Bowker. I am extremely grateful to him for generously sharing his current research with me.

64 I am extremely grateful to Liana Saif and Nahla Nassar for helping me to identify some of the texts.

65 This proverb is found in *Rabi' al-abrar* by al-Zamakhshari. See online http://www.alwaraq.net/Core/AlwaraqSrv/bookpage?book=169&session=ABBBVFAGFGFHAAWER&fkey=2&page=1&option=1, esp. p. 246.

66 Ibn Kathir (1998) uses this text in his account of AH 603, vol. 16: 751.

67 Parker 1995: 19, 59, 80, 91, 132, 147; Campo 1987.

Chapter 25
An Early Photograph of the Egyptian *Mahmal* in Mecca
Reflections on Intellectual Property and Modernity in the Work of C. Snouck Hurgronje

Arnoud Vrolijk

One of the most exquisite items in the British Museum exhibition *Hajj: journey to the heart of Islam* (2012) was a *mahmal*, the richly decorated ceremonial palanquin which traditionally headed the Egyptian pilgrims' caravan from Cairo to Mecca. This particular one was from the Nasser D. Khalili Collection of Islamic Art. It dates from the days of Sultan Abdülaziz (r. 1861–76) and his Egyptian viceroy Isma'il (r. 1863–79).[1] A slightly later one from the reign of Sultan Abdülhamid II (r. 1876–1909) and Khedive Tawfiq (r. 1879–92) caught the eye of three pioneers of photography in 19th-century Mecca: the Egyptian army engineer and surveyor Muhammad Sadiq Bey,[2] the Meccan physician 'Abd al-Ghaffar[3] and the Dutch Orientalist Christiaan Snouck Hurgronje.[4] In 1888, the young Snouck Hurgronje was the first to publish a lithographed image of this *mahmal* under his own name, based on a photograph that has recently come to light. By Snouck Hurgronje's own admission and as a result of subsequent research, it is known that he was not the author of many of the photographs he published. While exploring the history of this particular image in detail, this article is mainly concerned with how Snouck Hurgronje's attitude towards intellectual property corresponded with his overall ambition in the context of Dutch colonialism in Southeast Asia.

Let us start with some well-known facts. Under colonial law, freedom of religion was guaranteed, albeit grudgingly, to the Muslims of the Netherlands East Indies. This freedom included the right to perform the Hajj. In 1872, the Dutch opened a consulate in Jedda, to officially facilitate the transit of pilgrims and also to monitor the movements of so-called 'fanatic Muslims'. They were believed to be susceptible to the 'pan-Islamist' propaganda of the Ottomans, who tried to secure the spiritual and political allegiance of the entire Muslim world. This surveillance was subject to limitations, of course, because the Dutch civil servants could not follow them to Mecca and Medina, the holy places of Islam. The use of Muslim spics proved a failure. In the spring of 1884, consul J.A. Kruyt went on leave to the Netherlands where he met the young scholar Christiaan Snouck Hurgronje (1857–1936). In 1880, he had defended his doctoral thesis in Leiden on the pre-Islamic origins of the Hajj, *Het Mekkaansche Feest*. With Kruyt's recommendation, Snouck Hurgronje was awarded a grant of 1,500 guilders (roughly £130) from the Dutch government for research in the Arabian Peninsula. Together they travelled to Jedda where they landed on 28 August 1884. For the rest of the year Snouck Hurgronje stayed at the Dutch consulate as Kruyt's guest. He brought a camera to Jedda, which he used to photograph pilgrims and local figures in the courtyard of the consulate. Apparently having conceived the idea to travel onwards to Mecca, he converted to Islam in December 1884, adopting the name 'Abd al-Ghaffar, 'Servant of the All-Forgiving God'. A meeting in Jedda with the Ottoman governor of the Hijaz, Osman Nuri Pasha,[5] in whom he confided about his conversion to Islam, opened the door to Mecca. He arrived there on 22 February 1885. When his camera was sent on in April 1885 he started taking indoor photographs. In the meantime, he had made the acquaintance of a medical practitioner in Mecca, incidentally also named 'Abd al-Ghaffar, whom he described in his private correspondence

Plate 1 Albumen print of a photograph of Christiaan Snouck Hurgronje in Islamic dress, probably taken by his Meccan associate 'Abd al-Ghaffar, the doctor, April–August 1885. Leiden University Library (Or. 8952 L5: 18)

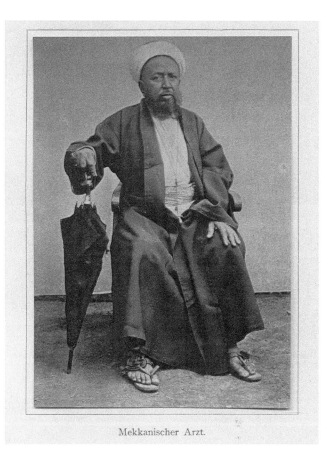

Mekkanischer Arzt.

Plate 2 'Mekkanischer Arzt' (Meccan doctor). Collotype illustration of Snouck Hurgronje's associate 'Abd al-Ghaffar in *Bilder-Atlas zu Mekka*, Haag 1888, pl. XIV

as 'a very liberal *hakim*' (doctor). His full name was al-Sayyid 'Abd al-Ghaffar ibn 'Abd al-Rahman al-Baghdadi. He had already experimented with photography and Snouck Hurgronje, feeling hesitant about making pictures out of doors, solicited his help.[6] The doctor also gave Snouck Hurgronje the free run of his studio, which was situated in the Jiyad quarter (**Pl. 1**).

Shortly before the beginning of the Hajj ceremonies of the year 1302/1885, however, the Dutch scholar's name came up in relation with the theft of pre-Islamic antiquities. The Ottoman governor summarily expelled him from Mecca in early August 1885. He would never witness the Hajj ceremonies himself. Snouck Hurgronje left his camera behind with the Meccan doctor and requested him to continue photographing. Having left Mecca in great haste, he asked for the assistance of Pieter Nicolaas van der Chijs, a Dutch honorary vice-consul and shipping agent in Jedda, to retrieve his possessions. Van der Chijs did so with meticulous care.

The *Bilder-Atlas* and *Bilder aus Mekka*

Once back in Leiden in October 1885, Christiaan Snouck Hurgronje started working on the report of his expedition, which led to the publication in 1888–9 of his two-volume German-language work *Mekka*.[7] As an accompaniment to this work he published a volume of plates: the *Bilder-Atlas zu Mekka*, which came out in 1888.[8] One year later, a second portfolio appeared under the title *Bilder aus Mekka* (1889).[9] Some of the photographs in the first volume of plates and all

photographs in the second were provided by 'Abd al-Ghaffar, the doctor. Snouck Hurgronje published the images under his own name, taking care to remove the doctor's signature from the photographs. Nevertheless, traces still remain.

The identity of 'Abd al-Ghaffar was only gradually revealed. In the introduction to the first volume of *Mekka*, dated May 1888, he was mentioned as 'an Arab trained by me in photography'.[10] Only in the preface to *Bilder aus Mekka*, dated March 1889, was he described as a physician. By this clue he could be identified as the man in plate XIV of the *Bilder-Atlas*, who appears in great detail in the text of the second volume of *Mekka*.[11] The collotype illustration shows him as a man in his fifties or early sixties with broad, strong hands (**Pl. 2**). The same portrait of the doctor appears together with a description of his activities in J.H. Monahan's translation of the second volume of *Mekka* (1931).[12] His name, however, was never made known to the public and could only be inferred from the signatures on the original photographs in the collections of Leiden University Library and elsewhere. These signatures read, 'Photograph of Sayyid 'Abd al-Ghaffar, physician in Mecca'.[13] Much more information became available in 1997, after the expiration of the official embargo on the letters from Snouck Hurgronje to his helper in Jedda, the Dutch vice-consul Van der Chijs.[14] A selection of these letters with special relevance for photography was edited by Jan Just Witkam in 2007 as an invaluable introduction to his Dutch translation of the second volume of *Mekka*.[15]

Plate 3 'Othman Pascha mit dem egyptischen Mahmal' (Osman [Nuri] Pasha with the Egyptian *mahmal*). Toned lithograph in *Bilder-Atlas zu Mekka*, Haag 1888, pl. V

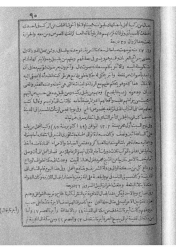

Plate 4 Muhammad Sadiq Pasha, illustration and description of the departure of the *mahmal* on 1 Muharram 1303, 10 October 1885. *Dalil al-hajj*, Bulaq 1313/1896, 95

The *mahmal* in Snouck Hurgronje's work

Snouck Hurgronje's *Mekka* is not about the Hajj, and it would be hard to find any book on Mecca where the pilgrimage is so conspicuously absent. The first volume is mostly about politics in Mecca in the course of history, where religion plays only a marginal role. The second volume, on 'contemporary life', is exclusively based on Snouck Hurgronje's personal observations. Needless to say, these observations did not cover the pilgrimage of 1302/1885 which he had been forced to miss. Therefore, the Egyptian *mahmal* occurs only as the symbol of political power it essentially was. Snouck Hurgronje was perfectly aware that the 'mysterious palanquin' symbolized the permanent influence of Egypt over her neighbour the Hijaz, not only before but also after the arrival of the Ottomans, with her generous donations of cash and corn to the officials and the pious foundations of Mecca and Medina.[16] Realizing the importance of the *mahmal*, Snouck Hurgronje made a fruitless effort to photograph it from the Austrian consulate in Jedda when it was paraded through the town on its way to Mecca on Sunday 14 September 1884.[17] Fortunately, Snouck Hurgronje eventually managed to find an alternative. Plate V of the *Bilder-Atlas* features a toned lithograph of governor Osman Nuri Pasha. He is standing in front of his own residence in Mecca (the so-called *Khassakiyya* or in Ottoman Turkish *Hasekiye*), holding the reins of a camel with the Egyptian *mahmal* on its back (**Pl. 3**). Was this illustration based on a photograph by 'Abd al-Ghaffar the doctor? Apparently not, for in 2003 the Saudi scholars Mi'raj ibn Nawab Mirza and 'Abd Allah ibn Salih Shawush noted in their magnificent illustrated atlas of Mecca that a photograph of the same scene also appears in a work entitled *Dalil al-hajj* (Guide to the Hajj).[18] It was published in 1896 by the Egyptian engineer-officer Muhammad Sadiq Bey.[19] He visited the holy places several times in an official capacity between 1861 and 1887, at least twice as *Amin al-Surra*, 'Guardian of the Purse' or treasurer of the pilgrims' caravan. He is commonly regarded as the first photographer ever in Mecca. A passage in the book in question gives us a detailed account of the event recorded in the photograph, the departure of the *mahmal* from Mecca on the first day of the year 1303/1885:

On Saturday 1 Muharram 1303, corresponding with 19 [actually 10] October 1885, the *mahmal* proceeded from the 'Ali Gate [of the Haram mosque] at two-thirty, while His Grace the Governor Osman Nuri Pasha was awaiting it in front of his residence. At his side were the military commander Ömer Pasha and a number of officers and amirs. When it approached him he took the reins of the camel and led the procession three times round in front of his residence. Then he surrendered the reins to the Amir [al-Hajj]. The *mahmal* pursued its way until it reached the encampment of the amir just off [the mausoleum of] Sheikh Mahmud. There it stopped for the night. I returned to Mecca for the Farewell Tawaf and also to bid farewell to His Grace the Governor and His Excellency the Sharif, and spent the night near the *mahmal* [**Pl. 4**].[20]

The *Dalil al-hajj*, however, is mostly a compilation of earlier books by the same author. This scene first occurred in Muhammad Sadiq's *Kawkab al-hajj fi safar al-mahmal bahran wa-sayrihi barran*, (The Star of the Hajj on the Sea Voyage of the *mahmal* and its Journey Overland).[21] The book was printed at the Egyptian Government Press in the first decade of Dhu al-Qa'da 1303 (1–10 August 1886). It covers the pilgrimage of 1302/1885, which the author joined as 'Guardian of the Purse'. Not owning a copy of the *Kawkab al-hajj* himself, Snouck Hurgronje borrowed it from vice-consul Van der Chijs in 1887 and characterized it as 'a little book in which, *in spite of all superficiality*, there are many valuable data on the geography and ethnography of Arabia' (author's italics).[22] Contrary to the later *Dalil*, however, the *Kawkab* contains no illustrations apart from some maps. This means that Muhammad Sadiq published the photograph of the *mahmal* only as late as 1896 and that Snouck Hurgronje did not know about its provenance when the *Bilder-Atlas* came out in 1888. Together with one other photograph it had been forwarded to him by Van der Chijs in December 1886. When it reached him on 10 February 1887 Snouck Hurgronje was very much surprised and assumed that it must have been made by 'Abd al-Ghaffar while he himself was staying in Jedda shortly before his involuntary departure for Europe.[23] Moreover, he must have been convinced of the provenance of the photograph by an undated letter from 'Abd al-Ghaffar in which he confirmed its despatch and described the scene in a few words.[24] If any

Plate 5 Albumen print of the departure of the *mahmal*, signed 'photograph of al-Sayyid 'Abd al-Ghaffar the doctor in Mecca'. Leiden University Library (Or. 12.288 L:4)

doubt remained it must have been expelled by 'Abd al-Ghaffar's familiar signature. The original photograph is preserved in Leiden University Library (**Pl. 5**).[25]

How did this confusion come about? Badr El-Hage, the historian of Arab photography, was the first to prove in 1997 that Muhammad Sadiq and 'Abd al-Ghaffar the doctor actually met during the Hajj of 1302/1885, basing himself on a key passage in the *Dalil*. In the afternoon of Monday 5 Dhu al-Hijja 1302 (14 September 1885), Muhammad Sadiq left the house of the Ottoman governor and set out for 'the house of one of the physicians who is called 'Abd al-Ghaffar Efendi al-Tabib (the doctor), because physicians are few in Mecca and the famous ones are Indians. This one practises medicine and photography.'[26] Apparently they got on very well together, for the Meccan doctor accompanied Muhammad Sadiq on his return voyage with the *mahmal* to Cairo and spent some time there to learn the manufacture of dentures (*sina'at al-asnan*) from a certain Dr Waller, the English dentist of the Khedivial family from 1860 until his death in 1897.[27] He received a diploma from Khedive Tawfiq on 3 May 1886 and returned to Mecca shortly afterwards.[28]

The fact that the two early Arab photographers were acquainted makes the question of the authorship of this particular photograph rather complicated. Did Muhammad Sadiq give a negative or a print to his friend 'Abd al-Ghaffar, who then signed it in his own name? Or was it the other way round? Did Muhammad Sadiq obtain a photograph from his Meccan friend, which he only dared publish years afterwards in 1896? A closer look at the picture can give us more clues. In fact, the photograph of the *mahmal* is not just a snapshot taken in a crowd of curious bystanders but a carefully created scene. The dignitaries, secular and spiritual, are arranged around and behind the central figure of the governor, who is holding the reins of the camel. They are trying hard, but not always successfully, to stand still and a servant who approaches with a tray of refreshments is obviously having a difficult time. The foreground is deliberately left free for the photographer. Thus, the

photograph is an official statement of power and of the importance of the ceremonial event, which was probably intended to symbolize Ottoman suzerainty over Egypt. How different had Snouck Hurgronje's own position been when he failed to photograph the passing *mahmal* the previous year in Jedda, doubtless because of the hustle and bustle of the crowd![29] No other outdoor photograph by 'Abd al-Ghaffar was taken in such an official setting. He appears to have taken his camera around quite unobtrusively among people who were going about their business without taking much notice either of him or his camera. After all, how could they have known what a camera was? As a matter of fact, the only person who could have arranged the official setting of the public ceremony was the Egyptian army officer Muhammad Sadiq Bey, who played a significant role in it. Theoretically, it is even possible that both men were present when the picture was taken, but Muhammad Sadiq's obvious authority would make him the creator.

The question is whether the Dutch scholar could have known this. In any case he greatly overrated the importance of the Meccan doctor, whom he apparently thought capable of bringing the whole *mahmal* caravan to a standstill. Also, if Snouck Hurgronje had read the 'superficial' *Kawkab al-hajj* more closely, he could have seen the passage where the scene of the picture was described in such detail. There is, however, another argument why Snouck Hurgronje should have realized that the photograph of the *mahmal* was not made by 'Abd al-Ghaffar. As mentioned above he received it on 10 February 1887. The undated letter which the doctor wrote to confirm its shipment also lists a number of other photographs of Ottoman government buildings of recent construction, such as the Gayretiye army barracks (formerly the fortress of Jabal Hindi, built under Selim III in 1806 but renovated and renamed by governor Osman Nuri Pasha), the clinic at Mina, the Hamidiye administration building and the police station and the Akarkun (also Karakun, from Turkish *karakol*). Most of these photographs would remain unpublished, but the latter two images appear in the

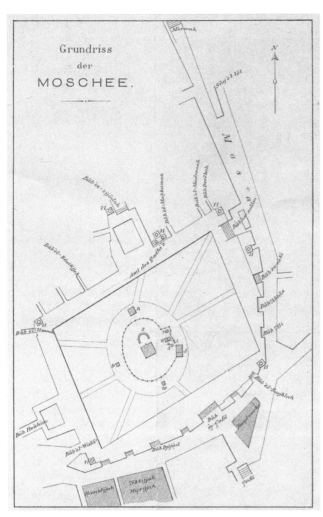

Plate 6 'Grundriss der Moschee' (Ground plan of the [Haram] mosque), in C. Snouck Hurgronje, *Mekka*, vol. 2, Haag 1889

Bilder-Atlas as plates IV and VI. Prints mounted on cardboard are preserved in the Leiden MSS Or. 26.403 and 26.404, some of them with German captions.[30] Apparently, not all photographs were sent at the same time; those of the Hamidiye and the police station reached Snouck Hurgronje as early as 19 March 1886, when 'Abd al-Ghaffar was still in Cairo.[31]

All these photographs, except for the one of the Hamidiye, show a reflection of the circular outline of the lens which is absent in Snouck Hurgronje's own photographs.[32] This technical peculiarity seems to rule out the use of his own camera. Indeed, Snouck Hurgronje was the first to notice this, for when writing to Van der Chijs on 19 March 1886, after receiving the first two of the set, he remarked that 'the photographs, though taken with a small camera, are rather well done'.[33] Apparently he never gave any thought to the question where this small camera came from, but it is more than likely that it belonged to Muhammad Sadiq Bey and that he was also responsible for the exposures.[34]

The first public appearance of a print of the *mahmal* photograph was on 5 March 1887, when Snouck Hurgronje gave a lecture before the Geographical Society of Berlin (Gesellschaft für Erdkunde).[35] The plate, bearing the German caption 'Das Mahmal in Mekka', is now much faded, but it is still visible that the image had to be retouched

so heavily that it proved unsuitable for publication,[36] hence the toned lithograph in the *Bilder-Atlas*.

Ground plan of the Haram

For the benefit of those who wished to acquaint themselves with the geography of Mecca, Snouck Hurgronje provided the second volume of *Mekka* with a map of the holy city and its surroundings, based on John Lewis Burckhardt's *Reisen in Arabien* (1830). Both the author and the title of the book are elaborately accounted for in the upper left corner of the map.[37] There is also a detailed ground plan of the Haram mosque and its immediate surroundings, 'Grundriss der Moschee' (**Pl. 6**). When comparing the ground plan with the information provided by the photograph of the *mahmal* (**Pl. 5**), it appears that the governor's mansion was situated on a square that was intersected by the Mas'a, the course between Safa and Marwa which is traditionally traversed by the pilgrims at a quickened pace. The photographer of the *mahmal* was probably standing in the middle of the square with his back to the police station. On the left-hand side of the photographer is the base of the south-easternmost minaret of the Haram and a little further down the street (the Mas'a) is Bab 'Ali, the gate of the Haram which is closest to the governor's palace and from which the *mahmal* had just exited the mosque. Snouck Hurgronje took this ground plan from Muhammad Sadiq's *Kawkab al-hajj*. Although the map was first published in 1886, it had been made more than five years earlier, when Muhammad Sadiq Bey visited the Arabian Peninsula during the pilgrimage of 1880 (**Pl. 7**).[38] Snouck Hurgronje obliterated the name of the author just as he had done with 'Abd al-Ghaffar, and in the process even removed the scale of the drawing (9mm to 20m). He did not actually publish it under his own name, but the only reference to its author was tucked away in a footnote in the first volume of *Mekka*.[39] This careless citation seems to be the rule in Snouck Hurgronje's treatment of Muhammad Sadiq, an author whom he characterized as 'a semi-European educated Egyptian'.[40] In the same manner, Snouck Hurgronje reused two views of the Haram mosque by Muhammad Sadiq as plates I and III in the *Bilder-Atlas*. The *Bilder-Atlas* itself, however, makes no mention of this, and the only references to the author are in the text of volume one of *Mekka*, where he is mentioned anonymously and erroneously as 'a Turkish officer', and in a footnote in the preface to the same volume (this time together with his name).[41]

Authorship

In terms of modern intellectual property this is hardly satisfactory. Snouck Hurgronje published a photograph under his own name which he believed to have been made by 'Abd al-Ghaffar, but which turned out to be the work of Muhammad Sadiq Bey. Historians of photography have come to Snouck Hurgronje's defence, claiming that in those days the misappropriation of photographs was still common practice and that they were treated as anonymous research data rather than the work of a creative author.[42] This may have been so in circles of photographers, amateur or professional, but among 19th-century academics there was a keen understanding of the notion of authorship and there were widely established systems of bibliographic reference.

In his foreword to the first volume of *Mekka*, Snouck Hurgronje lavished somewhat exaggerated praise on his fellow Dutchmen J.A. Kruyt and P.N. van der Chijs for their unwavering assistance to him during and after his expedition, assuring that 'their names should have been mentioned on the title page [of *Mekka*] instead of the preface'.[43] In the same manner, an illustration in plate XXV of the *Bilder-Atlas*, with a rather incongruous picture of two Levantine ladies, is duly credited – both in the caption and in the table of contents – to the Austrian orientalist Siegfried Langer (1857–82).[44] It therefore appears that Snouck Hurgronje did not hesitate to give the names of his European associates and colleagues, whatever their role, but imperfectly cited the 'semi-European educated' Muhammad Sadiq Bey and left out the name of his Meccan associate altogether.

The reason for this is not difficult to see, at least where 'Abd al-Ghaffar the doctor is concerned. In his correspondence with Van der Chijs, Snouck Hurgronje defined his own role in photography as that of the 'master' and 'Abd al-Ghaffar as the 'labourer'.[45] In the preface to *Bilder aus Mekka*, which covers only one page, Snouck Hurgronje found enough space to deny that his 'old student in photography' could ever be interested in scientific purposes, and that he would be 'exceedingly grateful to him if he could every now and then be prevailed upon to work in the desired direction'.[46] This implies that he regarded him as a useful sidekick but never as a creative individual who could – or should – take his own decisions. In his lecture before the Geographical Society of Berlin in 1887, he expressed himself in even more generic terms by claiming that 'the Arabs have no understanding of science at all'.[47]

However, Snouck Hurgronje took his treatment of 'Abd al-Ghaffar one step further. In a passage in *Mekka* which can only be described as a burlesque, the physician was ridiculed for his use of traditional medicine, his happy ignorance of the efficacy of the drugs he prescribed and his liberal use of the clyster. 'But what does it concern the Mekkans', so Snouck Hurgronje asked the modern European reader, 'that this eminent man has no notion of the functions of the body, nor of the effects of his own medicines? One fortunate result in a hundred attempts is enough to make their confidence unshakeable: the remaining 99 cases are put down to Allah'.[48] In fact, Snouck Hurgronje's description of Mecca and its inhabitants is permeated by an almost Waughian sense of humour, which he appears to have used as a rhetorical tool to emphasize the difference between modern Europeans and backward natives. However, his approach often leads to an obfuscation of the facts. How, for instance, are we to interpret the information that only one in every hundred treatments of patients is successful? Surely not, as statistical data on the efficacy of traditional medicine. Furthermore, Snouck Hurgronje's sense of humour hardly becomes a Muslim convert; for example, much later in 1909, he compared the presumed sterility of Islam in Mecca with the aridity of its climate.[49] This is not only a sneer to the Muslims in Mecca but also a facetious use of the Qur'an, where it is written that Ibrahim made his offspring live 'in an *uncultivated* valley, close to Your Sacred House' (i.e. the Ka'ba, Q.14:37).[50] The fact that Mecca and its sanctuary

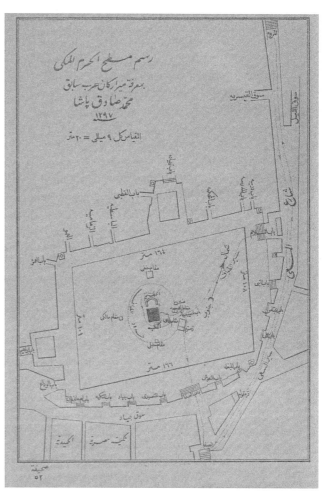

Plate 7 Survey of the Haram mosque and surroundings, made by Muhammad Sadiq Bey in 1297/1880 and first published in *Kawkab al-hajj*, Bulaq 1303/1886. This version with slight modifications appeared in *Dalil al-hajj*, Bulaq 1313/1896, opposite p. 52

thrived in spite of the infertility of the valley is a sign of God's bounty, not a symbol of intellectual poverty. Incidentally, by this expression Snouck Hurgronje subscribed to the environmental determinism of his day, which presupposed a direct relation between climatic conditions and culture.

Modernity

We are not here concerned with the moral aspects of Snouck Hurgronje's behaviour, but rather with the question of whether his treatment of 'Abd al-Ghaffar corresponds with the general purpose of his research. On this purpose he expressed himself in unequivocal terms during his Berlin lecture of 1887, 'It was my main goal to observe Muslim life *unrestrained by European influence*' (author's italics).[51] At the end of the first volume of *Mekka*, Snouck Hurgronje summarized the history of the holy city as 'nearly a millennium of strife between native chiefs … and foreign overlords.[52] This recalls the concept of history current then among Western scholars, who saw the history of the Orient as an endless series of events without development or purpose. By contrast, Western history is of a teleological nature: it progresses along a recognizable line of development towards a goal in the future. Again, the environmental 'barrenness' of the Hijaz appears to have played a role, not only in the work of Snouck Hurgronje but also other Orientalists of note such as

Richard Burton, Charles Doughty and William Robertson Smith. In his classic *Orientalism*, for instance, Edward Said remarked:

> Arabia has been an especially privileged place for the Orientalist, not only because Muslims treat Islam as Arabia's *genius loci*, but also because the Hejaz appears historically as barren and retarded as it is geographically; the Arabian desert is thus considered to be a locale about which one can make statements regarding the past in exactly the same form (and with the same content) that one makes them regarding the present. In the Hejaz you can speak about Muslims, modern Islam, and primitive Islam without bothering to make distinctions.[53]

Nevertheless, even Snouck Hurgronje conceded that the Ottoman Turks were unconsciously preparing the ground in the Arabian Peninsula for a shift towards modern culture. They were acting as an intermediary between East and West and he saw a role for them during the next century.[54] Even so, Snouck Hurgronje unleashed his abrasive sense of humour on the Turks, whom he reproached for 'having mastered the art of fashioning everything, money *and* reforms, out of mere paper'.[55]

If Snouck Hurgronje wanted to represent Mecca as a city untouched by modern civilisation, with only the Ottoman authorities in place to impose their half-hearted reform measures, it would make little sense to introduce a local doctor such as 'Abd al-Ghaffar as a pioneer of change and modernity. In an attempt to show that the Meccans did not regard medicine as an all-absorbing vocation as in the West, he characterized the doctor as acquainted with traditional handicrafts such as 'watchmaking and gun-mending, the distillation of fragrant oils, the gold or silver plating of trinkets, the manufacture of rattles, die stamping, and (this is a speciality of his) the smelting of gold and silver ores'.[56] Significantly, Snouck Hurgronje kept silent about 'Abd al-Ghaffar's early experiments with photography before his arrival, or of his initiative to follow a course in dentistry in Cairo, of which Snouck Hurgronje was perfectly aware, or, for that matter, that he provided 'Abd al-Ghaffar at the latter's own request with modern medical equipment to carry out eye surgery, hoping that the doctor 'wouldn't ruin too many eyes with it'.[57]

It was important for Snouck Hurgronje to represent Mecca as a stagnant society, where intellectual life was as barren as the surrounding valley. His basic tenet was that most pilgrims from the Netherlands East Indies came to Mecca like sheep and went back again like sheep. His advice was to target the resident colony of Indonesians in Mecca, which he considered as 'the heart of the religious life of the East-Indian Archipelago', taking part in 'pan-Islamic life and effort'.[58] They might be seditious and inflammable, but they were intellectually insignificant. They could either be neutralized, or persuaded by skilful handling to support the Dutch cause. How much more complicated would his position have been had he admitted that Indonesian Muslims could also be confronted with modernity in Mecca in the person of a versatile, inquisitive and liberal-minded local doctor? 'Abd al-Ghaffar stands out as an example, but Snouck Hurgronje's letters would deserve further scrutiny where other agents of modernity in Mecca are concerned. A

case in point is Shakir Efendi, a Hanafite cleric who indulged in gymnastic exercises and thought Meccan society to be very narrow minded. 'I have met several such people', Snouck Hurgronje admitted, but their voice remains unheard in *Mekka*.[59]

Most scholars agree that Snouck Hurgronje's *Mekka* is not only a scholarly work but also very much a political document. In 1889, it would set him on a new career in the Dutch East Indies as an advisor on Muslim and indigenous affairs. After 1906, he was called to the chair of Arabic at Leiden, where he was closely involved with the education of colonial civil servants. Throughout his distinguished career he acted as a tireless advocate of modernity in the East Indies under the supremacy of the Dutch. They would spread their message with the help of the indigenous aristocracy, whom he believed to be only superficially affected by the teachings of Islam.

As much a politician as a scholar, Snouck Hurgronje was able to change his opinion when the situation required so. He sensed the winds of change in the Arabian Peninsula which gathered into a storm from 1916 onwards. Through his contributions to the Dutch daily *De Telegraaf* he supported the Arab revolt and the emergence of the Saudi regime. Realizing that the Saudis had embraced the cause of modernity (or at least of technological progress), he was instrumental in arranging three official Saudi missions to the Netherlands between 1926 and 1935.[60] He died in 1936.

'Abd al-Ghaffar the doctor held on to the negatives and apparently continued making prints. His own photographs and, most notably, the exposures that Muhammad Sadiq made of the new Ottoman buildings in Mecca are to be found in album no. 90877 of the Yıldız Palace collections, now in Istanbul University. They are registered under the name of a certain Behcet Bey and dated 1306/1888–9. Other photographs bearing 'Abd al-Ghaffar's signatures are known to exist in the collections of the Royal Geographical Society in London.[61] And as recently as November 2012, a print of the *mahmal* photograph was auctioned in London as part of a set of twelve albumen prints ascribed to 'Abd al-Ghaffar.[62] All the same, the doctor appears to have devoted more and more of his time to his work as a dentist. He died around the year 1902, having established a family tradition of dentistry that continued until modern times.[63] The buildings in the photograph of the *mahmal* have disappeared long since, to make way for modern development.

Notes

1 Porter 2012a: 141.
2 On Muhammad Sadiq Bey (later Pasha, 1832–1902), see el-Hage 1997: 13–35; Mirza and Shawush 2006: 55–79; Sui 2006: 46–54.
3 On al-Sayyid 'Abd al-Ghaffar ibn 'Abd al-Rahman al-Baghdadi (c. 1902), see el-Hage 1997: 40–7; Mirza and Shawush 2003: 88–106; Sui 2006: 56–61.
4 General literature on C. Snouck Hurgronje (1857–1936) is too expansive to be mentioned here. On his contribution to photography in particular see Pesce 1986; el-Hage 1997: 40–7; Oostdam 1999; 17–24; Mirza and Shawush 2003: 84–8; Oostdam and Witkam 2004; Sui 2006: 43–4, 54–6; Witkam 2007c: 7–184; Van der Wall 2011.
5 On governor Osman Nuri Pasha (1840–1899), see Süreyya and Akbayar 1996, IV: 1298–9.

6 On 'Abd al-Ghaffar's early experiment with photography see Snouck Hurgronje to Van der Chijs, 11 April 1884 [i.e. 1885], MS Leiden University Library, Or. 8952 L 4: 16, edited in Witkam 2007c: 105. Please note that all Leiden University Library MSS mentioned below shall only be referred to by their 'Or'. classmarks.

7 Snouck Hurgronje 1888–9, published by Martinus Nijhoff, The Hague.

8 Snouck Hurgronje 1888, also published by Nijhoff..

9 Snouck Hurgronje 1889, published by E.J. Brill, Leiden.

10 Snouck Hurgronje 1888–9, I: xix: 'ein von mir in der Photographie unterrichteter Araber'.

11 Snouck Hurgronje 1888–9, II: 115–18.

12 Snouck Hurgronje 1931: opposite 93.

13 'Futughrafiyyat al-Sayyid 'Abd al-Ghaffar tabib bi-Makkka'.In the Leiden University Library collections his original photographs are mainly preserved in Or. 12.288 and Or. 18.097.

14 Or. 8952 L 4: 16–35. On the embargo see Witkam 2007c: 177.

15 Witkam 2007c: 7–184.

16 Snouck Hurgronje 1888–9, I: 83–5, 100, 105, 152–3, 157.

17 Witkam 2007c: 42.

18 Mirza and Shawush 2003: 86–7.

19 Sadiq 1896.

20 Sadiq 1896: 95.

21 Sadiq 1886: 34. A digital copy of the *Kawkab al-hajj* held at the Bavarian State Library, Munich, was kindly put at my disposal through EOD 'E-Books on Demand' (www.books2ebooks.eu).

22 Snouck 1931: 215, n. 113; Snouck Hurgronje to Van der Chijs, 19 (or 29?) June 1887, Or. 8952 L 4: 29.

23 Snouck Hurgronje to Van der Chijs, 10 Feb 1887, Or. 8952 L 4: 26, edited in Witkam 2007c: 154. His guess about the time was more or less correct, since the Hajj ceremonies of 1302/1885 took place immediately after his expulsion from Mecca, and during the pilgrimage of the following year (1303/1886) governor Osman Nuri pasha was no longer in function.

24 'Abd al-Ghaffar to Snouck Hurgronje, undated, Or. 18.097 S 32: 6, cited in German translation in Sui 2006: 58–9.

25 Or. 12.288 L: 4; reproduced in Porter 2012a: 205.

26 Sadiq 1896: 69; el-Hage 1997: 45–6; Mirza and Shawush 2003: 88–9.

27 Sadiq 1896: 69; el-Hage 1997: 45–6; Mirza and Shawush 2003: 88–9.

28 Mirza and Shawush 2003: 89; Snouck Hurgronje to Van der Chijs, 4 June 1886, Or. 8952 L 4: 23, edited in Witkam 2007c: 145.

29 Witkam 2007c: 42.

30 Egyptian *mahmal*: Or..26.404: 10; 'Akarkun' Police station: Or. 26.404: 12; Hamidiye Government building: Or. 26.403: 23, Or. 26.404: 9, 9a, 103, 103a; Clinic at Mina: Or. 26.404: 13, 13a, 68, 68a; Gayretiye barracks, facade: Or. 26.404: 8, 69; Gayretiye barracks with (Egyptian?) troops marching in front: Or. 26.404: 11, 11a.

31 Snouck Hurgronje to Van der Chijs, 19 March 1886, Or. 8952 L 4: 23, edited in Witkam 2007c: 143.

32 For the explanation of this technical phenomenon I am indebted to Herman Maes, senior conservator at the Nederlands Fotomuseum, Rotterdam, and my colleague Maartje van den Heuvel, curator of Photographic Collections at Leiden University Library.

33 Snouck Hurgronje to Van der Chijs, 19 March 1886, Or. 8952 L 4: 23, edited in Witkam 2007c: 143.

34 A set of 12 albumen prints attributed to Muhammad Sadiq Bey and featuring, among others, the Ottoman buildings and the *mahmal*, was auctioned by Christie's (London) in April 2008, sale 7571 lot 156, see www.christies.com.

35 Snouck Hurgronje 1887: 140–53.

36 Or. 26.404: 10.

37 Snouck Hurgronje 1888–9, II: 397: 'Grundriss von Mekka nach der in dem Werke "Burckhardt's Reisen in Arabien (Weimar 1830)" enthalt[enen] Karte mit Berichtigungen versehen von C. Snouck Hurgronje' ('Plan of Mecca after the map contained in the work "Burckhardt's Reisen in Arabien (Weimar 1830)," provided with corrections by C. Snouck Hurgronje').

38 Sadiq 1886: opposite 24. Muhammad Sadiq and the pilgrimage caravan of the year 1297 set out on 25 Shawwal 1297, 30 September 1880, and returned to Cairo on 26 Safar 1298, 27 or 28 January 1881. His report *Mash'al al-mahmal* was published later in 1298/1881, but it does not contain the ground plan made in 1880.

39 Snouck Hurgronje 1888–9, I: 13, n. 2.

40 Snouck Hurgronje 1931: 215; on Muhammad Sadiq's education at the École Polytechnique in Paris see Sui 2006: 47.

41 Snouck Hurgronje 1888–9, I: xix n. 1 (where plate III is mistakenly numbered II); for references to *Kawkab al-hajj* see Snouck Hurgronje 1931: 113 n., 215.

42 Sui 2006: 57; Van der Wall 2011: 40.

43 Snouck Hurgronje 1888–9, I: xxi.

44 Sui 2006: 57; Van der Wall 2011: 40.

45 Snouck Hurgronje to Van der Chijs, 29 April 1885, Or. 8952 L 4: 19, edited in Witkam 2007c: 110.

46 Snouck Hurgronje 1889: [preface]: 'Es handelt sich für meinen alten Schüler in der Photographie selbstverständlich gar nicht um die Forderung wissenschaftlicher Zwecke; ich bin ihm schon äusserst dankbar, wenn er sich ab und zu durch meine dringenden Bitten bestimmen lässt, in gewünschter Richtung zu arbeiten'.

47 Snouck Hurgronje 1887: 139: 'Für den Forschungstrieb haben die Araber ohnehin kein Verständnis'. In this context 'Arabs' are to be understood as the inhabitants of the Arabian Peninsula.

48 Snouck Hurgronje 1931: 93–5.

49 Snouck Hurgronje 1923–7: vol. IV/2 198, originally published in 1909.

50 Translation from M.A.S. Abdel Haleem 2005. In Arabic: *bi-wâdin ghayri dhî zar'in*.

51 Snouck Hurgronje 1887: 140: 'Mein Hauptzweck war die Beobachtung des durch europäischen Einfluss nicht gehemmten Lebens des Islāms'.

52 Snouck Hurgronje 1888–9, I: 186.

53 Said 1979: 235–6.

54 Snouck Hurgronje 1888–9, I: 189.

55 Snouck Hurgronje 1888–9, I: 172.

56 Snouck Hurgronje 1931: 106.

57 On 'Abd al-Ghaffar's early experiments with photography see Snouck Hurgronje to Van der Chijs, 11 April 1884 [i.e. 1885], Or. 8952 L 4: 16, edited in Witkam 2007c: 105; on dentistry see Snouck Hurgronje to Van der Chijs, 19 March 1886 and 4 June 1886, Or. 8952 L 4: 23, both edited in Witkam 2007c: 144–5; on eye surgery see Snouck Hurgronje to Van der Chijs, 30 April and 3 June 1887, Or. 8952 L 4: 28, and idem, 19 (or 29?) June 1887, Or. 8952 L 4: 29, all three edited in Witkam 2007c: 161–3.

58 Snouck Hurgronje 1931: 290–1.

59 'Dergelijke lieden heb ik verscheidene leeren kennen': Snouck Hurgronje to Van der Chijs, 29 April 1885, Or. 8952 L 4: 19, edited in Witkam 2007c: 110.

60 Oostdam and Witkam 2004: 129–56.

61 Dördüncü 2006: 54–9, 133–4, features numerous plates from Yıldız album no. 90789 in the chapters on Mecca and Medina; el-Hage 1997: 45.

62 Sotheby's 2012: 130–1, lot 265. With thanks to Richard Fattorini.

63 Mirza and Shawush 2003: 99–100.

Chapter 26
The Islamic Pilgrimage in the Manuscript Literatures of Southeast Asia

Jan Just Witkam

The sacred country far away

The Hajj, the Islamic pilgrimage, is a recurrent and varied theme in Islamic literatures, not only those of Southeast Asia. There is nothing remarkable in that, the pilgrimage being a duty incumbent upon the believer who has the means to perform that duty. It is one of the Five Pillars of Islam. The Islamic pilgrimage and the notion of the mythical holy land that for the believers in Southeast Asia lies in the far West, goes much further than that. One only needs to read the first canto of the Javanese mythological history, the *Serat Kondo ning Ringgit Purwa*, to see the Islamic details in the Javanese narrative:

> The beginning tells about Nabi Adam and *dewi kawah* in Mekah. Adam's son Kabil leaves Mekah, after having killed his brother Abil. He follows the Satan Idajil. The latter gave himself the nickname Manikmaya and pretended to have created the world. Kabil establishes himself in the land Kaci. He gets two children, Adabil and Daliyah. Kabil goes to Mekah. He wants to see his brother, Nabi Sis, but the latter's wife who happens to be pregnant tells him that he, Kabil, has been irrevocably exiled. Kabil answers that Sis's future child will become his son-in-law and that he will revolt against his father. Kabil wishes to return to Kaci but on the road his foot gets stuck in the ground. An angel comes and hits him with a whip. The angel blames for his misdeeds. Then Kabil sinks down in the earth and comes into Neraka, hell.[1]

And so a story unfolds, full of elements foretelling the drama that is being developed by the storyteller. The fact that the sacrifice of Isma'il (Ishmael) by his father Ibrahim (Abraham) is not mentioned anywhere, despite the fact that from the Arabian perspective this is the essence of the story of the adoption of the Ka'ba and the pilgrimage as a whole into Islam, does not mean that sacrifice is totally absent from this story. The story of Cain and Abel, Qabil and Habil in Islamic tradition, is also one of sacrifice and offering, of acceptance and rejection.[2] The two different stories have apparently been fused into one.

In the *Serat Kondo ning Ringgit Purwa*, Mecca – if that is the same as the 'Mekah' in the story – seems to be just the carpet on which a very Javanese story takes shape. Mecca and elements of Islamic prophetic lore, Cain and Abel, serve as background, but form no integral part of the story. That the story can easily do without these Arabian details is shown in the *Babad Tanah Jawi*, where the mythological beginnings of Javanese history are not placed in a location as specific as Mecca.[3] In the *Serat Kondo ning Ringgit Purwa* Mecca seems to be the additional detail of the far-away country, where history begins, a typical Southeast Asian Islamic perspective. Arabia in the beginning of history in the *Babad Tanah Jawi* is an element of legitimation. Wieringa quotes from the preamble of the major *Babad* the following lines which give an insight into the function of the double origins, Arabian and Javanese, being a talisman and a heirloom, and with these the text is given a position in which it is beyond doubt:

> As a reminder, in order not to forget,
> the genealogy from Arabia is needed
> and, verily, the Javanese one as well.
> The enumeration of the ancestors
> was from of old a talisman.

An heirloom in the form of a book
is what our king,
Pakubuwana the Fourth, desired,
wishing that the beginning of the noble
story should not be a bone of contention,
lest anyone be troubled.[4]

A conceptual perspective is possible here as well. In that view, the idea of pilgrimage to Mecca developed into a sort of higher consecration. As such it is, together with that other typically Muslim custom, circumcision, mentioned by Pigeaud in his description of Muslim popular performances on Java:

> One of the Javanese popular customs that can serve as an example of how the feeling for and the need of consecration has had a mediatory effect between Islam and paganism, is circumcision.… Also customs of genuine Muslim origin, such as the pilgrimage to Mecca, have for the traditional Javanese feeling of self-esteem obtained the value of a sort of higher consecration. The veneration of *hajji*s is sufficiently known, especially in former times and in traditional Muslim circles. Remarkable in this respect is the expression *munggah haji*, to become a *haji* (*munggah* also means to be elevated [in rank]) for: the conclusion of a Muslim marriage contract (the *ningkah*), as said of the groom.… If the word *haji* is really meant here in the sense of someone going on pilgrimage to Mecca, the expression should be understood as to obtain a higher form of consecration, as the *hajji*s do.[5]

The visiting of the graves of the *wali songgo*, the nine founding saints of Indonesian Islam is, so it is said, tantamount to the pilgrimage to Mecca. Touring the nine saints is a popular pastime for many Indonesians and much more feasible then to really go, at great cost and discomfort, to western Arabia. Bus tours are organized to accommodate pilgrims for an efficient trip to all nine locations. In the course of 1994, I personally participated in such trips, and I could observe that the purpose of the pilgrims was to visit graves. Those Indonesian visitors look for and obtain *shafa'a* (intercession) of the saints whose graves they visit, which they need on the Day of Judgment. The re-enactment of the Abrahamic sacrifice is not their prime concern. At best, the visit, the *ziyara*, to the grave of the Prophet Muhammad in Medina, following or preceding the pilgrimage to Mecca, but without being part of it, can be compared to the purpose of the pilgrims to the graves of Java's nine saints. This sense of consecration, which Pigeaud has already mentioned, and legitimation, which is mentioned in the beginning of the *Babad Tanah Jawi*, can also be seen in some of the considerations of 'Haji Muhammad' Suharto, the former president of Indonesia, when in 1991 he decided to perform the pilgrimage.[6]

The pilgrimage in law and spirit

In contrast to popular belief, religious fusions and transpositions and political considerations, the Arabic textbooks on Islamic law which are also used in Southeast Asia are clear and very concrete on the subject. They treat the pilgrimage at the end of the section on the *'ibadat*, the duties of man towards God. The pilgrimage is not described there in a literary or anthropological way, but the Muslim jurisprudents give a summary of the conditions that make the pilgrimage valid or invalid as a religious act (**Pl. 1**).[7] Nor

Plate 1 Notes about the criteria which make the Hajj and 'Umra valid actions according to Islamic law in a 19th-century manuscript from Java. Snouck Hurgronje collection, Leiden University Library (MS Leiden Or. 7173, f. 17a)

do they devote much space to it, certainly not in comparison to the lengthy discussions on ritual purity and ritual prayer. The pilgrimage was outside the possibilities of the majority of the believers anyway, certainly for those living on the periphery.[8] The jurisprudents write about the *ahkam al-hajj*, the juridical categories of the acts that together constitute the pilgrimage ritual. They mention the precise acts one has to perform, the exact formulas one has to say, and, to a certain extent, the emotions that the believer should have and display at particular moments during the days of the pilgrimage.

What participating in the pilgrimage does, or should do, to the inner feelings of the believer is not said in the books of Islamic law, nor is it very relevant to the jurisprudents. The Law of Islam deals with the outward part of acts and teaches the believer how to submit, how to be a Muslim and how God knows what is in the hearts.[9] It is the distinction between *muslim* and *mu'min*, between outward performance and inner conviction. In order to know more about the desired effects of the pilgrimage on the pilgrim's mindset one should study books on Islamic ethics and mysticism. Al-Ghazali, a contemporary of al-Ghazzi and also much studied in Southeast Asia, in his religious encyclopedia *Ihya' 'ulum al-din* treats the pilgrimage more from the inside, as is already evident from the title of the relevant chapter, *Kitab asrar al-hajj*, 'on the secrets of the pilgrimage'.[10] These 'secrets' (*asrar*) are distinctly different from the categories of law, the *ahkam*. Al-Ghazali approaches his subject from the

point of view of the *fada'il*, the virtues. He mentions the virtues of the pilgrimage, the virtues of Mecca in general and the House of God more in particular, the virtues of the Maqam Ibrahim, the virtue of Medina over other localities, and so forth. He does not exclude the acts that make the pilgrimage a lawfully valid act of religion, but he goes further than that by mentioning, at the end of his chapter on the pilgrimage, the inner acts of the pilgrim. He begins his final section as follows,

> The first thing about the pilgrimage is comprehension, by which I mean understanding the position of the pilgrimage in the religion. Then the desire for it, then the decision to go on pilgrimage, then cutting the bonds that withhold from doing it, then purchasing the ritual garb, then purchasing provisions, then hiring the riding animal, then the departure, then the journey through the desert, then taking up the ritual state of *ihram* at the limit of the holy area by acknowledging his service to God, then entering Mecca, then completing the aforementioned actions. In each of these things is a remembrance for him who remembers God, an example for him who takes the example, an exhortation for the truthful pupil, and a learning and an indication for the intelligent. Let us point to its possibilities till, when their gate is opened and their causes are known, to every pilgrim the secrets are unfolded, consisting of the necessary purity of heart, the inner cleanliness and his sure understanding.[11]

But regardless of how important the state of mind of the pilgrim may be, his precise acts, and to a lesser extent also his thoughts or feelings, are described and prescribed, in the guides of the genre *Manasik al-hajj*, 'the rituals of the pilgrimage'. In these the pilgrim finds detailed instructions and sometimes these works give even a small image of the Ka'ba with the names of its most important parts. They also treat, albeit to a lesser extent, the *ziyara*, the visit to the Prophet Muhammad's grave in Medina, which is, as already said, not part of the pilgrimage, but which few pilgrims are likely to neglect.

The journey

Coming, staying and leaving are the important moments for the pilgrim. The *Kisah Pelayaran Abdullah ke Negeri Judah* (The Story of the Journey of Abdullah to the City of Jedda), the travelogue of Abdullah Munshi (Abdullah bin Abdul Kadir, 1796–1854) from Singapore to Mecca,[12] is one of his lesser-known works. His Meccan travelogue is in fact an unfinished story as the author died in Mecca shortly after his arrival in Arabia, where he had gone in order to celebrate Ramadan and to perform the pilgrimage of the season of 1270/1854. The month of Ramadan in Mecca is a much longer and more intensive experience than the few days of pilgrimage and many who can afford it try to combine these two highlights of the Muslim ritual calendar during their stay. One of Abdullah's travel companions brought back his papers to Singapore and the text was published shortly afterwards. Abdullah Munshi's account therefore only treats his trip from Singapore to Mecca, and his very last words are contained in a short poem in which he describes his emotions upon entering the holy city:[13]

> As I entered into this exalted city
> I became oblivious to all the pleasures and joys of this world.
> It was as if I had acquired Heaven and all that it holds.

> I uttered a thousand prayers of thanks to the Most Exalted God.
> Thus I have forgotten all the hardships and torments along my journey
> For I have yearned and dreamed after the *Baitullah* for many months.[14]

H.C. Klinkert, the first translator of Abdullah Munshi's travelogue, tells the story, possibly on the authority of one of Abdullah's travel companions, that Abdullah was in fact poisoned in Mecca because he was drawing images of Jedda and writing down his impressions, but all we really know is that he suddenly fell ill and died.[15] It is true that Abdullah Munshi had drawn images when waiting in the harbour at Jedda to go ashore and had already attracted the attention of the Turkish authorities, so these acts could have been considered as espionage.[16]

Abdullah's journey was made by sea in sailing vessels, just before the revolutionary changes brought about in pilgrim transport by the international steamboat companies. His experiences must have been the same as those of many generations of pilgrims from Southeast Asia before him. That journey was an important event for the Southeast Asian pilgrim and the journey as a whole often gets more attention than the experiences of the pilgrimage ritual. Abdullah Munshi departed from Singapore on 29 Rabi' II 1270/29 January 1854, more than half a year ahead of the pilgrimage season. That was no superfluous luxury, as the progress of the voyage largely depended on favourable winds. Lack of wind, and also too much of it, is one of the themes in Abdullah's travelogue.

There are two problems of chronology in Abdullah Munshi's travelogue. First, there is the year of his departure from Singapore as expressed in the Islamic era. The Klinkert manuscript has ١٢٧٥, which reads as 1275, except by Klinkert in his translation and by Amin Sweeney in his edition. Klinkert follows ١٢٧٥ in his edition, or so it seems, and Raimy Ché-Ross translates it so, knowing however that this is a mistake (which he later on corrects, but for the wrong reason). Klinkert's translation has 1270, and Ahmad's edition has an unexplained 1273, which may just be a typographical error. The Islamic lunar year 1270 largely concurs with 1854, the year in which Abdullah Munshi died in Mecca. That Christian year is written by the copyist of Klinkert's edition in the Latin notation, because it refers to the Christian calendar. The solution for the problem '1270 or 1275' is simple if one reads the presumed 5 of the manuscript as a zero. The ٥ in ١٢٧٥ is nothing but a zero in the Indo-Persian number notation. So, Klinkert's edition had already the desired 1270, and in his translation Klinkert has understood this correctly. In the Indo-Persian writing style the number 5 is written very differently, as can be seen in the beginning of Abdullah Munshi's travelogue to Kelantan. There Klinkert's copyist writes the year 1253 in the Arabic numeral notation, and there the five is written in the Indo-Persian way: a vertical stroke with two small triangles pasted onto its left side.[17] It shows that the ٥ in ١٢٧٥ of the beginning of Abdullah's Meccan travelogue in the same volume and written by the same copyist is a zero. Sweeney in his edition passes the problem over in silence and just reads the 1270 which was intended by the copyists in the first place.[18]

Secondly, there is the problem of the day and the month of departure. Both Klinkert's manuscript and his edition give this as 29 Jumada I, for the year 1270. Abdullah rarely gives dates in his story. Rather he mentions the number of days during which he is aboard a ship or ashore. By counting these, Ché-Ross has made a timetable for the entire trip between Singapore and Mecca.[19] When Abdullah left Allepey on the south-west coast of India on 3 Jumada II (1270) (one of the few dates he does mention), he had already been underway for about a month. Therefore, the date of 29 Jumada I [1270] as the date of departure from Singapore must be a mistake, and Ché-Ross corrects it into 29 Rabi' II 1270, a month earlier. It is against the text of the manuscript and of the edition, but it is the only solution to the problem. So the journey lasted from 29 Rabi' II 1270 to the author's arrival in Mecca on approximately 19 Sha'ban 1270 (my counting of days slightly differs to that of Ché-Ross), that is a total of about 109 days (29 January – c. 17 May 1854). This long period includes several lengthy stays ashore: Allepey (5 days), Calicut (8 days), al-Mukha (13 days), al-Hudayda (7 days) and finally Jedda (9 days). The stay in Allepey was necessary in order to change to a larger pilgrim ship, the other stays ashore had apparently to do with business matters of the captain, and Jedda was the ship's final destination. Sweeney follows Ché-Ross' correction without, however, referring to it.[20]

Amin Sweeney's edition of Abdullah Munshi's travelogue to Mecca is, for the time being, the most comprehensive work on the Malay text.[21] It is not a critical edition in the Lachmannian sense of the word, but it has the advantage of synoptic tables with a selection of variant readings from Sweeney's three sources: MS W 215 in the National Library in Jakarta, the edition in *Cermin Mata* of 1858–9, and MS Klinkert 63 (the copy of the autograph) in the library of the University of Leiden. For reasons not further specified, Sweeney has decided to take the Jakarta manuscript as his basic textual witness.[22] One of the reasons of the existence of so many variants between Sweeney's three versions of the text may have been the fact that copyists and editors felt at freedom in their work with the orphaned travelogue that had never undergone its author's final editorial scrutiny.

It is evident how good an observer the author is, and how great his literary talents are. When they round Cape Comorin, the extreme southern point of the Indian subcontinent, the storm inspires him to pen a well-written account of danger and fear.[23] Descriptions of the frailty of a sailing vessel in the storm are topical and can already be savoured in Homer's works. Abdullah's account of the strength of the storm and the emotions of the ship's passengers stands out and shows his mastership over language. When the ship which the pilgrims had boarded in Allepey finally arrived at Jedda, its harbour had to be entered with great care because of the dangerous reefs. Only the *malim* (from Arabic: *mu'allim*, literally 'master'), the pilot, will be able to get the ship safely through:

> On the next day we saw Jedda before us. The ship, however, did not dare sail any closer. It was only then that both of the ship's land-based *Malim* from Hudaydah appeared. One of them scaled the back mast and one of them sat on the prow, while our *Malim* himself sat in the middle of the vessel.

Now the land-based *Malim* had been appointed to bring the ship safely into Jedda and he was paid forty *Ringgit* to do so. It was after this that we saw the path that lay before us: it was filled with coral reefs, so much so that the sea appeared green due to these corals, and there were only a few small channels through which we could navigate. It was through these channels that the ship made its way, with the *Malim* on the mast shouting to guide the *Malim* on the prow. The *Malim* on the prow would then reply, to which the ship's *Malim* responded … and he would in turn holler over to the helmsman in the bows. The *nakhoda* himself stood in trepidation. Everyone else was forbidden to speak. Each one of us was silently praying that we would be released from the danger of these reefs. Every now and again the coral would stick out and appear fortress-like around us. The sails were lowered, leaving only four on the mast. The water around us then felt as if it was being hurled … into the ship…. With His blessings, it took roughly three hours for our ship to pass through safely without any mishaps, by the end of which the *nakhoda* and everyone else on the ship broke out with gales of laughter in relief…. The cannon which were loaded beforehand were then fired three times in succession.[24]

But the pilgrims' joy is premature. Their tribulations are far from over, as they still have to pass the Turkish customs:

> It was the practice in the city of Jedda for a tax of a quarter *Ringgit* to be levied upon each individual, ignoring whatever baggage was taken ashore, save to pile them up in mounds at the place where the tax was collected. There were many policemen and people there, together with about twenty Turks, their scribes, and some soldiers standing bearing rifles.

> The place was then in absolute chaos and it resembled a war zone; all the goods were piled up in haphazard heaps and everyone scrambled around looking for their own belongings as they were not divided into any order. They were mixed up like hair tossed in vegetables!… Some were smashed, some were lost, some were switched around. Only God knows how frantic it was at that time, people were swarming about like ants, in the flash of a glance you would lose sight of your belongings, while coolies crowded about in their hundreds. They would haul a piece of baggage and place it in front of the tax collector, and if it took too long to open a chest, they would just simply smash it apart. Packages would have their ropes slashed and wrappings ripped apart in the roughest and most violent manner. All protestations fell upon deaf ears as they did whatever they pleased and they would order, 'Leave this thing and take that thing!' Some of us even had their clothing taxed! Some were only taxed on things that the tax officers pointed out. And that was final; one could not question them any further nor could one inquire what the procedures really are: we were totally uninformed about what the local conventions were.… My writing chests were ripped open and utterly ransacked; the inkwells were completely overturned and all my papers were splashed over with ink because too many people searched through them all at once. After we were freed from this peril, things that were lost remained lost and things that were broken remained broken. And thus each of us lugged our baggage away to our respective destinations.[25]

The emotions of being there

Another text on the pilgrimage, also in Malay but of a different nature from Abdullah Munshi's travelogue, is the *Syair Makah dan Madinah* (The Poem of Mecca and Medina) by Sheikh Daud.[26] From Wieringa's synopsis of this work it strikes the reader that the author of this *Syair* gives little space to the actual Abrahamic sacrifice, but that visiting

Plate 2 Description of the Ka'ba in Mecca with captions in Arabic. Illustration in an anonymous bilingual work (Arabic and Javanese) about *Manasik al-hajj*, possibly mid-19th century. Banten collection, Leiden University Library (MS Leiden Or. 5730, f. 22a)

Mecca, and to a lesser extent Medina as well, is a total experience for the pilgrim, which leaves him with many impressions. First the journey to Jedda is told, then the fixed moments in the ritual are detailed, some local geography is given, and both factual and legendary material is offered to the reader. It seems that Sheikh Daud, like Abdullah Munshi after him, had wanted to participate in Ramadan in Mecca as well. His style is much less sophisticated than that of Abdullah Munshi. When he enters the Ka'ba he says: 'Upon entering the Ka'ba sorrows disappear, it feels like entering Heaven'.[27] And to this he adds:

> If you have arrived in the Ka'ba, gentlemen,
> your tears are trickling like the rain.
> You recall your experiences,
> the many sins you have committed.
> Arriving in the Ka'ba the conscious heart harbours
> compassion,
> not remembering profits and losses,
> forgetting jealousy, greed and selfishness.[28]

Weeping is following the *sunna*, the exemplary behaviour, of the Prophet Muhammad. Tears are an old part of the prescribed show of emotions, not only when the pilgrim sees Medina from afar, but on other occasions as well. It is difficult to weep on command, also for Muslims, but al-Ghazali already has, not without humour, shown the believer how he can produce tears if they do not come spontaneously.[29] And in order to weep, Sheikh Daud prescribes his readers exactly what al-Ghazali says one should do in order to weep. That similarity gives once more force to the idea that much more than we think of the *Syair Makah dan Madinah* is based on Arabic sources, rather than on personal experiences. Not only is the story of Sheikh

Daud's pilgrimage the result of a total physical experience in the holy land of Western Arabia, but his written reminiscences are also the testimony of an extensive reading experience. On the water of the Zamzam source Sheikh Daud writes:

> Drinking the Zamzam water is very advantageous:
> former sins will be forgiven,
> life will be long and easy,
> learning and faith will increase.[30]

Medina is mentioned as well in the *Syair Makah dan Madinah*, and there the author follows, literally, the footsteps of the Prophet Muhammad, by drinking where the Prophet once spat:

> The Prophet once spat in there,
> until this moment one derives advantages from it,
> it is a pious act to drink it,
> the water is sweet and easy to fetch.[31]

Visiting the seven wells of Medina, from which the Prophet Muhammad had drunk, and where he performed his ritual ablutions, belongs to the recommended actions of the 'visitor'.[32] It is probable that Sheikh Daud has used an Arabic source for this as well.

Wieringa has gone to great pains to confirm the identification of the author of the original text of the *Syair Makah dan Madinah* as Sheikh Daud, a Minangkabau *guru*, and the year of his pilgrimage as somewhat before 1826. In the relevant literature there is mention of a reworking of the original text by Sheikh Isma'il bin Abdullah al-Khalidi at Mecca in 1250/1834–5, and this as well is analysed and placed in proper perspective by Wieringa.[33] The first half of Wieringa's article is factual and tells about the content of the *Syair*, the second half is a modern interpretation in which Wieringa treats the 'transformation of the intended function' of the text and that is where he occasionally goes astray. That the *Syair Makah dan Madinah* plays a role in a dispute between two Sufi orders, as Wieringa demonstrates, is possible, but to characterize Syaikh Daud's description of the holy cities of Mecca and Medina 'as a rhetorical performance designed to establish the poet's authority of possessing the right knowledge of Islam'[34] is not convincing because Sheikh Daud's adversary could equally have had recourse to Meccan *couleur locale* and certainly to the sources from which Sheikh Daud copied his personal emotions. The Meccan elements in the *Syair Makah dan Madinah* are not that specific and inimitable.

The modern anthropologist's attitude that religion is just a means in a perpetual struggle for power is rather an infertile approach. It is reductionist and it ignores the spiritual dimensions of the religious experience, even if these are expressed in a pious and naive way. To propose that exploiting this advantage that every *hajji* has over those who have stayed home as the all-pervading purpose of a work of literature is rather one-dimensional and it does little justice to Sheikh Daud's narrative. Maybe the exploration of Arabic examples, not only in the obvious sources such as al-Ghazali's encyclopedia, but also in the *Manasik* books, would give a more nuanced appreciation of Southeast Asian religious literature (**Pl. 2**). Arabic is a Southeast Asian language as well – which is often forgotten. It has a vast literature of its own, little known outside the region, and

hardly inventoried. Arabic is also the language of Islam in general, and many Muslim authors in Southeast Asia knew it well. They were heavily influenced by it and they used it extensively in vernacular texts for referring to Muslim concepts. Therefore their works are semantically much more layered than is often recognized in modern scholarship. I have shown this already in connection of the prescribed emotion of weeping, and to a lesser extent about the wells of Medina. Another example may illustrate this further. Wieringa translates the term *ibu negeri* (the 'mother-city') in the expression *Di dalam Makah ibu negeri* in the *Syair Makah dan Madinah*, as 'the world's capital',[35] which is rather free but not necessarily wrong, just with more to it. *Ibu negeri* is also the Malay translation of the Arabic *Umm al-Qura*, literally 'the mother of the villages', a much-used epithet of Mecca. It occurs twice in the Qur'an,[36] and M.H. Shakir translates it once as 'metropolis' and once as 'the mother city'.[37] And with that reference, which is immediately recognized by Muslim scholars anywhere, a hoard of connotations and associations comes about. Muslim scholars would recognize more references to Arabic sources in a work such as the *Syair Makah dan Madinah*. It would surprise me if not many more such Arabisms could be found in Malay texts of religious content. To identify and study these could give a deeper insight into the ideas and feelings of the pilgrims who not only have written about their personal experiences in the Holy Land of Islam, but also have excerpted their literary sources.

Nostalgia and death

That Mecca after a while can become the place from where one would wish to depart is clear from the epilogue of the Acehnese *Hikayat Makah Madinah* by an Acehnese scholar who calls himself Tuan Ahmad, and who is tentatively identified by Voorhoeve with Sayyid Ahmad, the author of the Malay *Kanz al-khafi*.[38] This *Kanz al-khafi* is basically a work on eschatology, and the ascription of its authorship to the author of the Acehnese *Hikayat Makah Madinah* is far from certain. Tuan Ahmad completed his *Hikayat*, a work in praise of Mecca and Medina, on 13 Rabi' I 1125/1713.[39] The Arabic source of the first part of this text has been identified by Voorhoeve as the *Risala fi fada'il Makka*, a pseudepigraphic text on the virtues of Mecca ascribed to al-Hasan al-Basri (d. 728), whose name in Southeast Asia is best known as an early chain in numerous Sufi *silsilas*, spiritual genealogies. His *Risala* has spread all over the Muslim world, and translations into Persian and Turkish are known to exist.[40] The short treatise is in the form of a letter, directed to a friend who is living in the Haram, Mecca's sacred territory, and who wishes to return to the Yemen. The author then sums up the virtues of Mecca which together should alter his friend's decision to leave the holy city. Tuan Ahmad's use of this text goes further. His book, of course, was to incite the readers to undertake the pilgrimage to the holy land. In the Achehnese version the letter of al-Hasan al-Basri is followed by various admonitions. The visiting of many other holy places besides Mecca and Medina is highly recommended. Among these the author mentions in the first place the tombs of four saints (*wali*): 'Abd al-Qadir (al-Jilani) in Baghdad, Ibn 'Alawan in Yemen, Sheikh 'Arabi in Mecca, and Muhammad Badawi [i.e. Ahmad al-Badawi] in Egypt'.[41]

The fact that this *Hikayat* is 'the oldest dated Achehnese text',[42] makes it special in its own right, but in this particular case more can be said.

To recognize Arabic literary examples is important for a fuller appreciation of the works of Muslim authors of Southeast Asia, but the truly remarkable element in Tuan Ahmad's *Hikayat* is not the text, but rather the epilogue, in which he writes, in a most personal style, about his nostalgia for Aceh, to where he longs to return. On the basis of the two most important manuscripts of the *Hikayat*, Voorhoeve has made a tentative edition of the latter part of the epilogue.[43] This takes the shape of a letter by the author 'to his family and relations in Aceh. He would rather return there, but because God did not comply with his wish he stays in Mecca, haunted by dreams of his Aceh home'.[44] The search for more personal elements in Tuan Ahmad's *Hikayat*, which Voorhoeve indicates as necessary, has still to be undertaken.[45]

As can be expected, some pilgrims never came back home. They died in Mecca or Medina of old age, weakness and certainly also as a result of the epidemics that raged in western Arabia. In the ideal case their estates would be described and relevant documents would be issued by the authorities. Such documents have mostly gone to the family archives of those left behind, but sometimes they have been preserved in public collections. Three such documents issued by the *qadi al-qudat wa mufti al-aqtar al-'arabiyya bi Makka al-Mukarrama*, the highest instance of the West-Arabian judiciary, are preserved and these describe the typical circumstances. Claimants are relatives of and sole heirs to certain pilgrims from Pasuruan, Eastern Java, who had died in Mecca. In all three cases the heritage consists of the value of the return ticket (*bilyet*) of the deceased. It was often all they possessed while travelling. These assets had been seized by the 'treasurer' in Mecca (*ma'mur bayt al-mal*), who is the defendant in the court case, pending the establishment of the identity of the heirs. The identity of the lawful heirs (the claimants) is established before the court and the defendant is ordered to deliver the heritage – the boat ticket – to the heirs. The three sentences in question are dated 25 Dhu al-Qa'da 1338 (1920), and the three pilgrims had died well before the pilgrim's season. They had come possibly to Mecca for Ramadan as well, as so many did.[46]

The pilgrims and their consuls

The foreign consuls in Jedda, who represented nations with a large Muslim population in their colonies (Britain, France, Russia and the Netherlands), had more than one task to perform.[47] The protection of their Muslim compatriots against the rapacity of the pilgrim guides was one, but at the same time they would monitor all those pilgrims who might become influenced by pan-Islamic ideas in the holy cities of Islam and might wish to bring these back to their country of departure. Mecca was seen by the colonial governments as a place where anti-colonialist and anti-Christian sentiments were fermenting. These consuls hardly ever had the specific knowledge of language and customs to do this, nor could

Plate 3 (above) Description of the Ka'ba in Mecca with captions in Javanese. Text of the intention (*niyya*) in Arabic. Illustration in a collection of notes about pilgrimage, from Java, possibly 19th century. Snouck Hurgronje collection, Leiden University Library (MS Leiden Or. 7173, ff. 45b–46a)

Plate 4 (right) Description of the Ka'ba in Mecca with captions in Arabic. Illustration in an anonymous collection of notes about pilgrimage, from Java, possibly 18th century. Snouck Hurgronje collection, Leiden University Library (MS Leiden Or. 7164, f. 181a)

they enter Mecca themselves since they were Christians. They therefore totally depended on the services of those Muslims who would offer themselves to provide useful knowledge of all sorts. An elaborate system of espionage and surveillance was set up for this purpose, and all consuls had informants in place. For the Dutch this was particularly important because the Netherlands had, since 1873, been involved in a war of attrition with the sultanate of Aceh, and Mecca was considered to be the place from where anti-Dutch sentiments were emanating to the colony.

In the course of the pilgrim season of 1884 a small group of mostly fragmentary manuscripts with texts in Arabic, with sometimes an interlinear Javanese translations on *Manasik al-hajj* came into the possession of the Dutch consul in Jedda, Johannes Adriaan Kruyt (1841–1927) (**Pl. 3**).[48] How he obtained these documents is not known. He may have

Plate 5 The mosques of Mecca (right) and of Medina as depicted in al-Jazuli's *Dala'il al-khayrat*. Part of the prayer book of Tuanku Imam Bonjol, dated Bandar Natar 1229 AH (1813–14). Leiden University Library (MS Leiden, Or. 1751, ff. 68b–69a)

received them as a gift, but it is more likely that they were confiscated, as the Dutch authorities were all the time in a state of alert against subversive writings. Kruyt handed the manuscripts over to Christiaan Snouck Hurgronje (1857–1936), who happened to be in Jedda preparing his own journey to Mecca, probably in order to allow him to give an impression of their content. Snouck Hurgronje kept the manuscripts among his books and after his death in 1936 they became the property of Leiden University Library. A few of these could be identified by short notes written in pencil by Snouck Hurgronje, who somewhat conspirationally mentions Consul Kruyt 'pilgrim X'. Such notes can be seen in several of the manuscripts in the Snouck Hurgronje collection in Leiden University Library.[49] If the Jedda provenance of these manuscripts had not been known, they would have simply been texts on *Manasik* from Java, of which there are thirteen in a dozen. Now they give an indication of the sort of books that were in the possession of the Javanese pilgrims or the *Jawa* residents of Mecca (**Pl. 4**).

Tuanku Imam Bonjol's prayer book

Associated with the pilgrimage, but mostly in popular imagination, is the prayer book that is said to have belonged to Tuanku Imam Bonjol (1772–1864).[50] According to the stories that have come with it, it was 'found' or rather captured, in Bonjol, West Sumatra, where the imam in 1837 fought his last stand against the Dutch-Indian army. That feat marked the end of the Padri Wars (1821–37), which were inspired by Wahhabi sentiments among returning pilgrims. It appears that Imam Bonjol himself had never performed the pilgrimage. The manuscript that is said to have been his personal prayer book is presently kept in the library of Leiden University, after it had been transferred there in 1864 from the Royal Academy in Delft. Its association with the imam has always remained somewhat obscure.[51] There are no signs of his ownership in the manuscript itself, but the

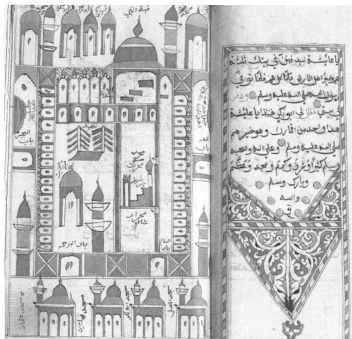

Plate 6 (left) Baqi' al-Gharqad, the cemetery of Medina, here with the graves of both the 'common people' and of the Prophet Muhammad and his first four caliphs. Religious imagery in the prayer book of Tuanku Imam Bonjol, dated Bandar Natar 1229 AH (1813–14). Leiden University Library (MS Leiden, Or. 1751, ff. 69b–70a)

Plate 7 (above) The Prophet's Mosque in Medina (on the left) and the description of the interior of the grave of the Prophet. Part of the prayer book of Tuanku Imam Bonjol, dated Bandar Natar 1229 AH (1813–14). Leiden University Library (MS Leiden, Or. 1751, ff. 182b–183a)

manuscript does not contradict his former ownership either. It was copied in 1813–14 (1229 AH) in Bandar Natar (Natal on Sumatra's west coast, not far from Bonjol). It is provided with numerous illustrations, many of a magical and eschatological nature, and also with several drawings that somehow show a connection with the pilgrimage or at least with the holy cities in Arabia.[52] About one third of the volume (pp. 327–501) is taken up by the text of the *Dala'il al-khayrat* of al-Jazuli. That is not a book on pilgrimage but on the devotion for the Prophet Muhammad, yet it is well known for its images, first of the Prophet's grave in Medina, and later of the mosques in Mecca and Medina (**Pl. 5**).[53] The latter two mosques are shown here (ff. 68b–69a), and the one in Medina once more, in an entirely different style of drawing (f. 183a).

The prayer book also shows (f. 69b) Medina's main cemetery, Baqi' al-Gharqad (**Pl. 6**), not in stylized drawings as the ones we see in Muhyi al-Din Lari's *Futuh al-haramayn* (a 16th-century Persian illustrated pilgrim's guide), but in an entirely different, typically Southeast Asian style, which is rather a collage of elements that the artist thought to be important. The Malay caption of the main part, the cemetery, reads *inilah kubur orang banyak* ('these are the graves of the ordinary people'). The illustrator has made the image fuller than reality permits by adding the two palms of Fatima, which actually belong to the iconography of the inner court of the Prophet's Mosque in Medina (*inilah rumput Fatimah*, where *rumput* must mean 'grass'), by adding a sort of enclosure of the Messenger of God (*inilah tirai rasul allah*,

where *tirai* means 'curtain'), with drawings of the graves of the four righteous caliphs ('Uthman, Abu Bakr, 'Ali and 'Umar, in that order), whereas in the foreground the grave of the Prophet Muhammad is displayed in a more colourful way (*qabr Rasul Allah*).[54] The only realistically drawn element in the drawing of Baqi' al-Gharqad is the somewhat crooked form of the road that leads through the graveyard.

The prayer book has many more images (**Pl. 7**), including a whole series of *muhr*s, magical seals (e.g. ff. 59b–60a), and *payong*s, ceremonial umbrellas, and banners (e.g. ff. 58b–59a), under which the believers can gather on the Day of Judgment. As a compilation the volume shows the great variety of forms used in Southeast Asian Islam, a mixture of piety and magic. If the provenance of the prayer book is genuine, that is if it has really been in the possession of Tuanku Imam Bonjol, who is said to have been deeply influenced by Wahhabism, its content does not confirm this at all. True, the prayer book, which was copied in 1813, precedes the Padri Wars. It might show today's reader that the simple Wahhabi message of *Tawhid*, unicity of God, would still allow for manifold manifestations, at least so far away from Arabia. A similar illustrated compilation from elsewhere in the Islamic world would be the Ottoman prayer book that goes by the collective title *En'am-ı Şerif*, but that falls outside the scope of the present subject.[55]

Conclusion

After a legendaric and a conceptual treatment of the Islamic pilgrimage from Southeast Asia in general (the sacred

country far away and the pilgrimage in law and spirit), I have followed the three stages of the long westbound journey of the pilgrim: first the journey itself as written by Abdullah Munshi, then the emotions of being there by the Minangkabau Sheikh Daud, and thirdly the themes of nostalgia as treated by the Acehnese author Tuan Ahmad, and of death as exemplified by death certificates of pilgrims from Pasuruan. All these are just examples and the total number of sources available must be much larger. Then follows a short treatment of the functions of the foreign consuls in Jedda, to whom we owe much information about the pilgrimage and also some authentic manuscript sources. The article closes with a short description of the Imam Bonjol's prayerbook. That illustrated manuscript from Sumatra with an important provenance has, strictly speaking, not much to do with the pilgrimage. However, with its numerous images it mixes ideas about eschatology with the devotion for the Prophet Muhammad and the intercession of the saints, and all this against a background of Islam's own Holy Land. A further analysis of the content of this prayer book can give a deeper insight into attitudes of Islamic piety in general and those of the pilgrims in particular. The vernacular Southeast Asian sources referred to in the article show a considerable influence of Arabic texts, not only about the pilgrimage itself but also, in a more general way, on Islamic law and ethics. It strikes the reader of these sources that the actual purpose of the pilgrimage, the re-enactment of the sacrifice by Ibrahim of his son Ismail, hardly plays a role of significance. It is the journey and the visiting of the holy places in Western Arabia that receives the most attention of the Southeast Asian pilgrim.

Notes

1 Translated by the author from G.A.J. Hazeu's abstract in Dutch, in MS Leiden Or. 6379 F(a), p. 1. For a description of the manuscript, see Pigeaud 1968: 356–63. On the narrative of the mythical beginnings of Javanese history, see Wieringa 1999: 244–63.

2 With Cain and Abel we are, in an Islamic context, in the realm of story telling, as they are not mentioned by name in the Qur'an, only in the *Hadith*, see Raven and Witkam 1988: s.v. Habil and s.v. Qabil. The short Qur'anic reference to them ('*Ibnay Adam*', Q. 5:27) tells the essence about the offerings.

3 Ras 1987: 7. See also the synoptic table of the beginning of the story in three other *Babad*s in Wieringa 1999: 253.

4 Wieringa 1999: 249.

5 Pigeaud 1938: 475 (§ 436). Another etymology is offered here as well, however.

6 For the political playing field for Suharto's pilgrimage, see Bianchi 2004: 72, 175–6.

7 See e.g. the *Kitab al-taqrib* by the Shafiʿ jurisprudent Abu Shujaʿ al-Isbahani, a compendium of the 12th century of which numerous manuscripts and printed editions exist, and which till today is in use in Southeast Asia. I refer to the text published in the margin of its commentary in al-Ghazzi 1952: 27–30. Voorhoeve 1957: 368 mentions manuscripts of this text and the cluster of commentaries and glosses that comes with it, from Aceh, from the Malay World and from Java, not only in Arabic, but also in Malay and Javanese.

8 MS Leiden Or. 5466 (3) is a Javanese translation of *al-Idah fil-fiqh*, a compendium in Arabic on Islamic law that exists only in manuscripts from Indonesia. Strangely, this particular manuscript completely omits the pilgrimage altogether (f. 110a). On the Arabic text, see Voorhoeve 1957: 121–2. For the full contents of MS Leiden Or. 5466, a collective volume on *dluang*, Javanese paper, see Pigeaud 1968: 321.

9 Qur'an 4:63, 8:70, 33:51, 48:18.

10 Al-Ghazali 1939, I: 246–79.

11 Minor textual differences in the passage quoted here can be observed in the edition of al-Ghazali 1996, I: 385–6, as compared to the 1939 edition.

12 This work is known under several different titles. This one is derived from the Malay text in the edition by Klinkert 1889: 87–107. Klinkert had prepared his edition of the Malay text at the same time when he published his Dutch translation, 'Verhaal eener pelgrimsreis van Singapoera naar Mekah door Abdoellah bin Abdil Kadir Moensji, gedaan in het jaar 1854', in Klinkert 1867. In Singapore, he had the author's autograph, which had come into the possession of the Protestant missionary Benjamin P. Keasberry (1811–75), copied for his edition. Klinkert's copy of that autograph is now the property of the Dutch Bible Society, MS Klinkert 63, which is on permanent loan in Leiden University Library. The manuscript bears the title *Kisah pelayaran Abdullah dari Singapura sampai ke-Mekah*, and that title may be the most authentic. The title of the edition by Kassim Ahmad, which is ultimately based on the Leiden manuscript, is also somewhat different (Ahmad 1960). Sweeney 2005: 273 has the title *Kisah Pelayaran Abdullah bin AbdulKadir Munsyi dari Singapura sampai ke Mekah*, which is not supported by any of the handwritten and printed versions which Sweeney used (Sweeney 2005: 305).

13 Ché-Ross 2000. Ché-Ross' study and translation is the first substantial scholarly contribution to the travelogue after Klinkert's translation 'Verhaal eener pelgrimsreis' of 1867.

14 Ché-Ross 2000: 200.

15 The short epilogue immediately following the lines of poetry mentions as Abdullah Munshi's cause of death *ta'un*, *taun*, which literally means 'plague', 'pestilence', but it can be any contagious desease. Ché-Ross translates it with 'cholera' (Klinkert 1889: 107; Klinkert's translation leaves it out but provides an epilogue of its own on p. 407; Ahmad 1960: 154; Ché-Ross 2000: 200).

16 Klinkert 1889: 408. He adds to this that it is regrettable that such a well-educated person as Abdullah, with many English missionaries among his acquaintances, never converted to Christianity and was now possibly killed by Islam. This is the sort of slur of which Klinkert's works abound. Another striking example of Klinkert's belittling attitude towards Abdullah Munshi is that in his translation he took away the word 'Mecca', which is in the manuscript, from the title of the travelogue and replaced it with Jedda. With the little poem at the very end of the text, Abdullah's journey arguably goes as far as Mecca. See also Putten 2006, but van der Putten does not treat Abdullah's final journey.

17 See the numbers in the two years, 1253 and 1270, in Klinkert 1889: 5, 87 respectively.

18 The year 1270 is mentioned in Sweeney 2005: 275, but the readings are omitted in his comparative tables.

19 Ché-Ross 2000: 206–8.

20 Instead Sweeney 2005: 299 acknowledges the help of Ian Proudfoot for clearing up the problem of the chronology of the travelogue.

21 Sweeney 2005.

22 Sweeney 2005: 258, where he says that MS Jakarta W 215 is nearest to the original. The lack in the edition of good photographs of the Jakarta manuscript prevents the reader from an evaluation of Sweeney's *modus operandi*.

23 Ché-Ross 2000: 187.

24 Ché-Ross 2000: 197.

25 Ché-Ross 2000: 198.

26 Wieringa 2002: 174–206.

27 Wieringa 2002: 177.

28 Wieringa 2002: 178.

29 Quasem 1979: 43–4, where weeping is the sixth external rule of Qur'an recitation. Abul Quasem's book is in fact the translation of Book 1/8 of the *Ihya' 'ulum al-din*. On the numerous varieties of weeping see also a much older authority, Ibn Abi al-Dunya (823–94) in his book *Kitab al-riqqa wa al-buka'*, of which several editions exist.

30 Wieringa 2002: 179.

31 Wieringa 2002: 181.

32 al-Ghazali 1977: 121, n. 4.

33 MSS Leiden Or. 3335, Or. 3336, Or. 3337, Or. 3338. Wieringa 2007: 271, 273–80.

34 Wieringa 2002: 192.

35 Wieringa 2002: 192, n. 61.

36 Qur'an 6:92, 42:7.

37 Translation put online by the University of Michigan: http://quod. lib.umich.edu/k/koran/ (last accessed on 11 February 2013).

38 Voorhoeve and Iskandar 1994: 175–6 (description of the manuscripts), 344–7 (illustrations of pages in either manuscript of the text with a tentative transliteration of the last part of the epilogue).

39 Voorhoeve 1952: 335–45, 337 (in particular) for a description of MS London, SOAS, No. 12914 A.

40 al-Basri 1980. Al-ʿAni treats the text as authentic and his edition is mainly based on MS Rampur, Reza Library No. 3609, which is dated 19 Shawwal 1054/1644.

41 Voorhoeve 1959: 337.

42 Voorhoeve 1959: 337.

43 Voorhoeve and Iskandar 1994: 344–7, concerning MS Leiden, Ethnographical Museum 163/48d, and MS London, SOAS, No. 12914 A.

44 Voorhoeve and Iskandar 1994: 345.

45 Voorhoeve and Iskandar 1994: 345.

46 MS Leiden Or. 14.365 a–c. See for more details of these three cases and for an illustration of one of the documents in Witkam 1989: 463–5.

47 Iran had a consulate in Jedda as well. One may assume that its double function was more or less the same as that of the consulates of the infidel nations, with this difference that Iran was a heterodox Muslim country.

48 Consul Kruyt had a truly encyclopedical approach. Apart from manuscripts he also collected textiles from the Hijaz which are now in the National Museum of Ethnography in Leiden. Samples of Hijazi minerals that come from him are now in the Museum Naturalis, also in Leiden. He also invited Christiaan Snouck Hurgronje to the Hijaz.

49 MSS Leiden Or. 7036, Or. 7173, Or. 7758, Or. 7778 (and possibly more) were once in the possession of Consul Kruyt. MS Leiden Or. 7177 was in the possession of Consul Joan Adriaan de Vicq (1857–99), who had been appointed in December 1884 to replace Consul Kruyt in Jedda and who gave the manuscript to Snouck Hurgronje in August 1885 upon the latter's return from Mecca.

50 He is one of the official heroes (*pahlawan*) of the Republik Indonesia. In almost each town a street is named after him and his portrait is on the 5000-rupia banknote.

51 Another manuscript in the Leiden library with a Bonjol provenance is Or. 5001, a collection of several shorter Javanese texts in Arabic script, with schematical drawings. According to a note in Dutch on the cover, the MS would originate from Bonjol from a Padri environment, see Pigeaud 1968: 252.

52 MS Leiden, Or. 1751, the pages of which are partly foliated, partly paginated. It has been extensively described twice, mostly on the basis of the detailed description that P. Voorhoeve inserted into the manuscript: Wieringa 1998, 111–14; Iskandar 1999, I: 29–31.

53 For the function of the illustrations and for the shifting illustration program in the manuscripts of the *Dalaʾil al-khayrat*, see Witkam 2007a: 67–82 (text), 295–300 (illustrations).

54 I am grateful to Dr Roger Tol, Jakarta, for helping me out with reading the captions on this page.

55 About this type of prayer book now, see Witkam 2010: 101–42, 108–33 (in particular).

Chapter 27
Ottoman-period Manuscripts from the Haramayn

Tim Stanley

The Haramayn – the holy cities of Mecca and Medina – were important locations of manuscript production during the four centuries of Ottoman rule over the two cities, which began in 1517, after the Ottoman conquest of Egypt, and ended with the surrender of Medina to Hashemite forces in January 1919. Yet, despite the length of time they remained under Ottoman rule, and the quantity of manuscripts produced there, no local style or styles seem to have developed in the two cities. In this, they differed from some other Ottoman centres of manuscript production, such as Shumen, now in Bulgaria,[1] or centres outside the empire, such as Shiraz in southern Iran.[2] This lack of stylistic uniformity is in tune with the diverse and, to a degree, transient character of the population. Believers were attracted to the two cities from all over the Muslim world by their immense prestige, but, at the same time, the inhospitable physical environment of the region, marked, for example, by a very limited water supply, tended to limit the number of permanent settlers.

The Haramayn were the focus for the Hajj and 'Umra, and for the commercial activities that went with them, which included the sale of books, particularly those of a religious character. The cities also attracted *mujawirun*, that is settlers who wished to live and die in proximity to the holy places, and, as we will see, they included people engaged in the production of fine manuscripts. Nevertheless, a stable tradition of training in calligraphy, illumination, binding and other aspects of luxury book production did not develop, and the evidence is that those who worked in the Haramayn on making fine manuscripts were trained elsewhere before settling in the two cities. The manuscripts they produced there were not, however, devoid of a local connection. Some, such as Hajj certificates, were directly connected to the pilgrimage, and they show a formal continuity over a very long period.[3] Even those that had a more general religious character may have enjoyed a certain cachet because they were copied in the Haramayn, and in the case of Qur'an manuscripts, a commercial advantage may have derived from their production in the very region where the text was revealed.

An anecdote recorded in the biographical dictionary of calligraphers compiled by Süleyman Sa'deddin Efendi and completed in 1202/1787–8 indicates how the prestige of the Haramayn affected the patronage of manuscripts at the highest level of Ottoman society. It also illustrates the transience of much book production there, as the scribe in question copied one manuscript in the Haramayn and then left. The anecdote relates to a copy of the Qur'an written by Şeyh Hamdullah (d. 1520) that had been donated to the Tomb of the Prophet. Two centuries after Hamdullah's death, towards the end of the reign of Sultan Ahmed III (r. 1703–30), this sovereign commissioned Mehmed Efendi (d. 1753), one of the most eminent Istanbul calligraphers of the period, to go to Medina to make a facsimile of the Qur'an manuscript by Şeyh Hamdullah. When Mehmed Efendi had performed the Hajj and completed his work on the manuscript, he returned to Istanbul, where a popular revolt had overthrown Ahmed III and replaced him with his nephew Mahmud I, to whom the calligrapher presented his facsimile.[4]

Plate 1 (far left) *Futuh al-haramayn* of Muhyi al-Din Lari, copied by Ghulam 'Ali, dated Mecca, 990/1582. Nasser D. Khalili Collection of Islamic Art (MSS 1038, fol. 42b) (© Nour Foundation. Courtesy of the Khalili Family Trust)

Plate 2 (left) *Futuh al-haramayn* of Muhyi al-Din Lari, copied by Ghulam 'Ali, dated Mecca, 990/1582. Nasser D. Khalili Collection of Islamic Art (MSS 1038, fol. 1b) (© Nour Foundation. Courtesy of the Khalili Family Trust)

Şeyh Hamdullah was seen as the founder of the distinctively Ottoman tradition of *naskh* and *thuluth* calligraphy, and the revival of this tradition in the second half of the 17th century, marked most notably by the career of its second great master, Hafiz Osman (d. 1698), had enhanced Seyh Hamdullah's status.[5] His high standing might of itself have explained the need for Mehmed Efendi's visit to Medina were it not for the existence of a substantial number of Qur'an manuscripts by Şeyh Hamdullah in the imperial palace in Istanbul. Among these, two were kept in the Emanet Hazinesi, or treasury of holy relics, until the palace became a museum in the 20th century, and they had probably been in the imperial residence since the reign of Hamdullah's patron, Sultan Bayezid II (r. 1481–1512).[6] Another had recently been transferred to the elegant new library erected by Ahmed III in the courtyard adjacent to the Emanet Hazinesi,[7] and Mahmud I later donated a fourth copy to the library he set up inside the Ayasofya mosque, just beyond the main gate of the Topkapi Palace.[8] Mehmed Efendi's mission to Medina was not, therefore, the result of a want of Qur'an manuscripts by Şeyh Hamdullah in the capital; we can presume that it was stimulated by the belief that a manuscript that had been at the Prophet's tomb for up to two centuries would be intrinsically superior to other copies by the same calligrapher.

Many other manuscripts with less august connections were produced in the Haramayn, and this is sometimes made explicit in the books themselves. This is the case with the most important surviving copy of the *Rihla* of Ibn Jubayr, in which the Spanish Muslim traveller describes his participation in the Hajj that occurred in 1184. The scribe who copied the manuscript reports in the colophon that he carried out this work in Mecca in 1470.[9] This book was written in a clear copyist's hand that has, however, no great claims to elegance, and in this it probably represents the great majority of manuscripts produced in the Haramayn, as elsewhere. Luxury manuscripts were also produced in the two cities on a smaller scale and were provided with illumination, fine bindings and sometimes illustrations. For example, Mecca was the place of production of at least 12 copies of the *Futuh al-haramayn* of Muhyi al-Din Lari, which was written in Persian verse and provides a guide to the holy sites of Haramayn and to the rituals performed there during the Hajj.[10]

One copy of Lari's work has a colophon (**Pl. 1**) that can be translated as follows:

> It attained completion in the month of Jumada al-Ukhra, in the city of Mecca, mighty and glorious – May God increase its glory and majesty! – by the hand of the needful and humble, the least of [His] slaves, Ghulam 'Ali – May He forgive him his sins and veil his shortcomings! Praise be to God, the Lord of the Worlds! Amen! *Anno* 990.[11]

This document establishes that the scribe, Ghulam 'Ali, completed the manuscript in Mecca in the month of Jumada al-Ukhra 990 – equivalent to the period from 23 June to 21 July 1582. Ghulam 'Ali's name suggests that his origins lay in Iran, and the sound *nasta'liq* hand in which he copied the manuscript certainly supports this assumption. The illumination in the manuscript is also in an Iranian style, even if it is a roughly executed version of it, which we may call provincial (**Pl. 2**). A more refined version was used on manuscripts produced at one or more centres in Iran in the 16th century, from where it was transferred to Mecca.[12] Such work reflects the special status of the Haramayn since this book is an 'Ottoman' manuscript, in the sense that it was made in a centre under Ottoman control, and yet it has distinctively non-Ottoman script, decoration and images executed by one or more people trained in an Iranian tradition.

This account of Ghulam 'Ali's manuscript presumes that its illumination was executed in the same place as the text,

Plate 3 Qur'an manuscript copied by Muhammad al-Shakir, probably in the Haramayn, dated 1231/1815–16. Nasser D. Khalili Collection of Islamic Art (QUR 11, fols 1b–2a) (© Nour Foundation. Courtesy of the Khalili Family Trust)

which does seem likely. Yet this was not necessarily the case in all instances. According to the colophon of an anonymous Ottoman-style copy of the Qur'an, the text was completed in the Mosque of the Prophet in Medina on 12 Shawwal 984/2 January 1577.[13] The sumptuous illumination of the manuscript, however, is a fine example of one of several modes of decoration applied to luxury manuscripts in Istanbul in the 16th century, and it seems very likely that, after the book was copied in Medina, and before it had been illuminated, it was taken to Istanbul, where the decoration was executed. There is a good chance, too, especially in view of its outstanding quality, that the manuscript was delivered to the imperial palace soon after it was copied and that it was kept there for two centuries. It was eventually donated to the Beylerbeyi mosque, situated on the Asian shore of the Bosphorus north of Istanbul. This mosque was originally commissioned by the mother of Sultan Abdülhamid I (r. 1774–89) and was completed in 1778, but was rebuilt by Abdülhamid's son Mahmud II soon after he came to the throne in 1809.[14] The manuscript may have been transferred to the mosque by either sultan.

We know that the Beylerbeyi copy of the Qur'an was copied in the Haramayn because this is stated in its colophon, and this is also the case with the manuscripts containing the *Rihla* of Ibn Jubayr and the *Futuh al-haramayn* of Muhyi al-Din Lari. There are, too, manuscripts that can be attributed to the two cities using other criteria. One is an early 19th-century copy of the Qur'an of a standard Ottoman type that reflects a more modest level of patronage than the Beylerbeyi copy.[15] Its colophon reads:

> It was written by the needful, humble and sinful Muhammad al-Shakir, one of the pupils of 'Umar al-Wasfi, [celebrated] as *Hâce-i Saraŷ-i Hümâyûn* – May his Lord be pleased with him! – Rest from copying out His illustrious Book – May God make it part of the provisions laid up for me until the Day of Menace! – occurred in the year 1231 since the migration (*hijra*) of him who possesses glory and splendour, and felicity and honour.[16]

This dates the manuscript in question to the Hijri year 1231/1815–16, although it does not state where it was copied.

The colophon shows, too, that the manuscript was written by a scribe trained in Istanbul, since both the scribe and his master are the subject of entries in the two main biographical dictionaries that cover the leading calligraphers active in Istanbul in the 19th century. These two publications are the *Hat ve Hattâtân* (Calligraphy and Calligraphers) of Habib Efendi, published in 1305/1887–8, and the *Son Hattatlar* (Last Calligraphers) of Mahmut Kemal İnal, published in 1955. The scribe's master called 'Umar al-Wasfi in the Arabic of the colophon was also known in Turkish as Laz Ömer Efendi. We are told that he was appointed as a teacher of calligraphy in the sultan's palace – which explains why his pupil gives him the title of *Hâce-i Saraŷ-i Hümâyûn*, 'master at the imperial palace' – and that he died in 1240/1824–5.[17] Of his pupil Muhammad al-Shakir, we are told that he was known as Baltacı Mehmed Şâkir Efendi in Turkish. He died in 1250/1834–5, ten years after his master, while resident in the Hijaz, which almost certainly means the Haramayn.[18] The date when Mehmed Şâkir moved to the Haramayn is not known, and so we cannot attribute his Qur'an manuscript to Mecca or Medina on this evidence alone. The stylistic features of the manuscript are contradictory, however, and this provides us with evidence of where it was produced.

The quality of the script is in line with the scribe's assertion that he was trained by a high-ranking master in Istanbul, for his hand is notable both for its internal consistency and its evident relationship to the grand tradition of Ottoman *naskh* and *thuluth* calligraphy that originated with Şeyh Hamdullah and was refined by Hafız Osman. At the same time, the scribe refrained from using the *âyet ber kenâr* format, that is, the method of presenting the Qur'anic text in which each page contains a discrete set of complete verses, so that the end of each page of text coincides with the end of a verse.[19] This format was popular with the scribes who produced Qur'an manuscripts in

Ottoman provincial centres in the 19th century, but it was avoided by masters trained in the great tradition. This was probably because, as Uğur Derman has phrased it, 'To fit the verses on each page exactly, the calligrapher must tightly space the letters on some lines of text and loosely space those on other lines. The *âyet ber kenar* format thus prevents the calligrapher from doing his best work, and for that reason the great masters did not use it.'[20] On the basis of the script and the format of the text, then, the manuscript could be attributed to Istanbul. The illumination of the manuscript points in another direction, however.

A small minority of Qur'an manuscripts produced in Istanbul in the period 1800–50 were decorated in a novel manner that reflected the Baroque style associated with the Ottoman court until the 1820s or the Empire style that succeeded it.[21] Other Qur'an manuscripts produced there in this period were more conservative in terms of their illumination, in general following the formats and motifs developed over the preceding three centuries. One major change seems to have occurred in this work, however, and that was the abandonment of the combination of blue and gold grounds in the decoration of the opening pages that had been predominant in earlier periods and the use in its place of decoration in two tons of gold, called *zer ender zer* in Ottoman Turkish.[22] The Qur'an manuscripts produced in provincial centres, however, show that there the use of the blue-and-gold style continued.[23]

This difference in illumination means that, for the period 1800–50, Ottoman provincial Qur'an manuscripts are marked by the use of both the blue-and-gold style of illumination and the *âyet ber kenâr* format for the text, while copies of the Qur'an made in Istanbul outside court circles and by members of the grand tradition of Ottoman calligraphy were characterized by the *zer ender zer* style and the running on of Qur'anic verses from page to page, that is, the avoidance of the *âyet ber kenâr* format. Baltacı Mehmed Şâkir Efendi was a member of the grand tradition, as we have seen, and he did indeed avoid the *âyet ber kenâr* format, but his Qur'an manuscript under consideration here (**Pl. 3**) was decorated in a fairly crude manner in a version of the blue-and-gold style. The most obvious solution for this apparent paradox is the one suggested by the information provided by Habib and İnal, namely, that the manuscript was produced *after* Mehmed Şâkir had moved to the Haramayn.

The attribution of the Mehmed Şâkir manuscript to the Haramayn, while not certain, does fit the pattern suggested by the *Futuh al-haramayn* manuscript discussed above. Both were decorated in a crude, provincial version of a style of illumination that was or had been current in a great metropolitan centre that lay outside the region. What made the Haramayn production distinctive is that the manuscripts made there were decorated in different styles, reflecting the holy cities' role as a magnet for all Muslims and not just a place of retreat for subjects of the Ottoman Empire.

Notes

1 Stanley 2000; Bayani, Stanley and Rogers 2009: 222–51.
2 Uluç 2006.
3 Compare Aksoy and Milstein 2000 with Porter 2012a: 5, 32, 39, 137.
4 Müstakim-zâde 1928: 419–20; Derman 1988.
5 Bayani, Contadini and Stanley 1999: 60–75.
6 Istanbul, Topkapi Palace Museum Library, mss E.H.71, 72; Serin 1992: 83, 118–19.
7 Topkapi Palace Museum Library, ms.A.5; Serin 1992: 89.
8 Istanbul, Türk ve İslam Eserleri Müzesi, ms.402; see Istanbul 2010: 368–73.
9 Leiden, University Library, ms.Or.320; Witkam 2007a: 157–8; Porter 2012a: 123, fig. 84.
10 Milstein 2006; Porter 2012a: 46–7.
11 Nasser D. Khalili Collection of Islamic Art, MSS 1038, folio 42b.
12 This style of illumination requires further investigation. Manuscripts with such decoration are often catalogued as Ottoman even though they have other features that are characteristically Safavid, most obviously their bindings (e.g. Sofia 1995, no. 9).
13 Türk ve İslam Eserleri Müzesi, ms. 161; Istanbul 2010: 412–13.
14 Goodwin 1971: 397–400; Kuban 2010: 629–30.
15 Nasser D. Khalili Collection of Islamic Art, ms.QUR 11; Bayani, Stanley and Rogers 2009: 194.
16 Bayani, Stanley and Rogers 2009: 287.
17 Habib 1305: 165; İnal 1955: 259–61.
18 Habib 1305: 167; İnal 1955: 202–3. He always signed his name in Arabic (Muhammad al-Shakir). In the sources he is referred to by the Turkish form of his name.
19 Déroche 2002: 106–7; Stanley 2004; Bayani, Stanley and Rogers 2009: 188–91.
20 Derman 1998: no. 45.
21 Bayani, Stanley and Rogers 2009: 208–21.
22 Bayani, Stanley and Rogers 2009: 161–87.
23 Bayani, Stanley and Rogers 2009: 188–207.

Chapter 28
Souvenirs and Gifts
Collecting Modern Hajj

Qaisra M. Khan

Introduction

Between January and April 2012 the British Museum staged *Hajj: journey to the heart of Islam,* a groundbreaking exhibition which told the story of a remarkable religious phenomenon – the annual pilgrimage to the sacred city of Mecca, the birthplace of Islam. This act of faith, known as the Hajj and laid down in the Qur'an, stipulates that at least once in their lives, if they are physically and financially able, Muslims must perform this act of worship. It takes place at a specific time of year, starting on the eighth day of the month of Dhu al-Hijja, the last month of the Hijri calendar, with a sequence of rituals which must be observed over five or six days, each of which has a particular meaning and resonance.

In developing the story of Hajj for the exhibition, we considered how we could translate this supremely pious act, which is both an intensely personal experience as well as a collective public act, through a wide range of fascinating and beautiful objects – historical and modern – collected from public and private institutions and collections from around the world. I worked on the exhibition for two years from 2010 to 2012 with lead curator Venetia Porter. As part of the experience, I went on Hajj myself.[2] Partly as a fact-finding exercise and for recording Hajj by taking photographs, notes, voice and video recordings, and also to purchase items for the British Museum. Above all, it was also my own spiritual pilgrimage; so my divine invitation came with additional responsibilities.[3]

The aim of this article is to attempt to trace the history of markets in Mecca and Medina and to comprehend their importance not only for the establishment of the Prophets' new community, but also as a legacy for future generations of visitors to the holy cities. I will also consider how modern-day souvenirs, using the British Museum's collection policy as a guide, display a need to buy and sell in the holy places and how this helps enhance our understanding of Hajj today.

Collecting for the British Museum

Collecting modern Hajj material was a unique exercise because we were not aware of any other collection in Britain holding these types of objects. The final objective was that they were to be displayed alongside objects of historical significance during the course of the exhibition.[4] Our curatorial predecessors have always acquired contemporary artefacts of material culture for the British Museum and so these modern acquisitions are vital if the Museum is to play a continuously dynamic role in the understanding of cultural identity and invention throughout history, whilst an awareness of contemporary cultures is also an important part of the Museum's engagement with the life of this country and with that of communities elsewhere.

In this chapter I will touch upon the nature of the acquisitions and the consideration of the particular context that the British Museum could provide for the material, and determine if the objects purchased from Mecca and Medina responded to a need to represent cultures of the Islamic world, especially in relation to the Hajj.

The historic markets of Mecca and Medina

From a young age the Prophet himself travelled alongside his uncle Abu Talib who was a merchant, accompanying him to trade markets, at times journeying as far as Syria. Indeed the Qur'an and the *Hadith* look positively on trade and commercial activity, for example the Qur'an often uses the language of commerce in illustrative metaphors in order to convey essential points of faith: 'They have bought error in exchange for guidance, so their trade reaps no profit, and they are not rightly guided' (Q.2:16). Elsewhere we read: 'Do not sell for a small price any pledge made in God's name: what God has [to give] is better for you, if you only knew' (Q.16:95). Numerous *hadiths* also frequently mention the superiority of the 'trustworthy merchant' and the importance of trade as a profession,[5] as this was the profession of the Prophet himself as well as that of his companions. 'Umar ibn al-Khattab, a close companion and second caliph of the Rashidun caliphate, is known to have preferred death to come to him in the markets, and encouraged people to trade so as not to become dependent on others.[6]

The term used for markets or marketplaces – *aswaq* (sing. *suq*) – occurs twice in the Qur'an and is used to suggest that the prophets were men, human beings, who bore similar characteristics to other humans, in that they too performed everyday activities including visiting the markets: 'They also say, 'What sort of messenger is this? He eats food and walks about in the marketplaces' (Q.25:7) and another verse tells that 'No messenger have we sent before you [Muhammad] who did not eat food and walk about in the marketplace' (Q.25:20).

Although some very large markets existed in Arabia before the advent of Islam in which Muhammad would probably have 'walked about', the Qur'an makes no reference to any specific market. The most notable market was the 'Ukaz market.[7] 'Ukaz was not only a trading market, but was also significant for being a gathering point for the major tribes of the region. Muhammad was known to have visited the market, which ceased to exist by the middle of the seventh century. This market was the most important of all the annual market fairs and took place just before the start of the annual pre-Islamic pilgrimage to 'Arafat within the designated 'Holy Months' and was situated to the south-east of Mecca near Ta'if. It was conveniently placed in the middle of the Incense Route of western Arabia and was known to be a market of great prosperity.[8] Of importance too were the markets of al-Hajar in al-Hira in southern Iraq, and Dumat al-Jandal in north-west Arabia.[9]

Markets of Medina

Medina, originally known as Yathrib, lies 350km north of Mecca, and became the home of the Prophet Muhammad after his emigration from Mecca in 622; it was thereafter the capital of the early Arab empire under the first Rashidun caliphs. According to W. Montgomery Watt, Medina emerged from a loose collection of scattered settlements, surrounded by groves of date palms and cultivated fields. Date palms were cultivated in large numbers before the time of Muhammad, and cereals were also grown. At a later date, oranges, lemons, pomegranates, bananas, peaches, apricots, figs and grapes were introduced.[10] Before the Prophet's arrival, the town was made up of a cluster of villages, in which there were four main markets, the most famous of which was the Banu Qaynuqa market. These markets were noted in some detail by 'Umar ibn Shabba and Ibn Zabala.[11]

All four markets were in the western part of what became known as Medina and their order from south to north was: al-Safasif, Muzahim, Qaynuqa and Ibn Zabala. Two out of the four (Qaynuqa and Zabala) were controlled by the Jews while Muzahim was controlled by 'Abd Allah ibn Ubayy, a close supporter of the Medinan Jews.

After the *hijra*, it was clear that many of the emigrants were not well off. Since most were not familiar with date farming, they were compelled to work as labourers for the people of Medina,[12] and as a result many went hungry.[13] Consequently, the Prophet needed to establish his position in Medina and changes were required to ensure the survival of the community.[14]

Shortly after the Prophet arrived, lands close to the market of Banu Qaynuqa were acquired by him. According to one report by 'Umar ibn Shabba,[15] when the Prophet wanted to make a market for Medina, he came to the market of Banu Qaynuqa and pitched a tent intending it to be the main market of Medina. Ka'b ibn al-Ashraf, an opponent of Muhammad, entered the market and cut the ropes of the tent, to which the Prophet responded that he would move it to another place that would be more offensive to him. The new market was then set up on ground in the Bani Sa'ida quarter. The Bani Sa'ida objected at first but gave their consent later. The new market was an open space so that a rider could put his saddle in the centre, go round the market in every direction and still see it.[16] Setting up this new market, which became the important Medina marketplace not far from the *suq* of Qaynuqa, the Prophet informed the Muslims: 'This is your market. Do not set up sections in it and do not impose taxes for it'.[17]

Attempts to erect buildings or to pitch tents in the market were prevented by the Prophet and then by 'Umar ibn al-Khattab. Under Mu'awiya I (r. 661–80), two houses were built in the market and taxes were levied. These houses were later demolished by the people of Medina as unlawful innovations on the grounds that 'the market is a charitable endowment' (*al-suq sadaqa*).[18]

The establishment of the market by the Prophet a short time after his arrival in Medina seems to have been of some importance. There is no indication of the intention of the Prophet, but the principle of establishing a new market without levying or paying taxes may suggest that the Prophet intended to establish the *suq* as *sadaqa*, as an opportunity for charity without profiting those in charge.

The needy were thus at the heart of this early Islamic economic world through the combined teachings regarding community cohesion and accessibility of the markets. The encouragement given to the merchants in the *Hadith* and the Qur'an makes clear that Islam did not begin by challenging wealth and social status, but encouraged the support of the community where the wealthy were expected to participate according to their incomes, which largely began in the markets.

Pilgrimage fairs: commerce and the Hajj

As previously seen with the 'Ukaz market, before Islam in Arabia there were several places of pilgrimage where fairs

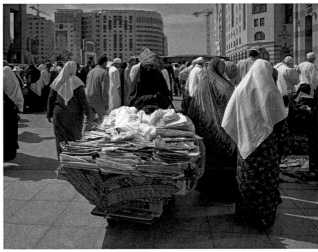

Plate 1 (above left) Bartering, Medina, Saudi Arabia (photo: Qaisra M. Khan, 2010)

Plate 2 (above) Local sellers in Medina, Saudi Arabia (photo: Qaisra M. Khan, 2010)

Plate 3 (left) Stalls of goods at Mount Uhud, Saudi Arabia (photo: Qaisra M. Khan, 2010)

also took place. Pilgrimage would be made to these places at certain times of the year, exempt from the usual obligations of tribal behaviour, and were considered free of violence, ensuring the safety of the goods and their owners.[19] The best known pagan festivals of Mecca were the Hajj and 'Umra performed by local Meccans and by visitors to the region, with a series of complex rituals. The main acts of Hajj were in fact centred around 'Arafat, a mountain plain some eleven miles east of Mecca; Mecca was not originally part of this pilgrimage.[20] And so the famous pilgrimage fairs associated with 'Arafat and Mina excluded the Meccan ritual which was joined to 'Arafat only at a later date by Muhammad.[21]

At the advent of Islam, trade was not forbidden to Muslims during the pilgrimage to Mecca, and the Qur'an states: 'The pilgrimage takes place during the prescribed months. There should be no indecent speech, misbehaviour, or quarrelling for anyone undertaking the pilgrimage – whatever good you do, God is well aware of it. Provide well for yourselves: the best provision is to be mindful of God – always be mindful of Me, you who have understanding' (Q.2:197), and elsewhere we read: 'but it is no offence to seek some bounty from your Lord' (Q.2:198).

Indeed, historically once the rituals of the Hajj were formally concluded after the standing (*wuquf*) at 'Arafat, a trade fair was held there from the 11th to the 13th of Dhu al-Hijja. While the fair served some pilgrims who merely replenished their supplies for the return journey, it was also the main setting for the international trade in luxury goods

which included silks, spices, coffee and pearls.[22] Merchandise was bought by pilgrims from all over the Islamic world and sold in order to fund the Hajj as well as gain from it, and so the Hajj played a major role in disseminating global crafts and learning.

Jedda, on the Red Sea coast, known as the port of Mecca, was also a significant trading post which was independent from Mecca largely because the lunar calendar made it difficult to synchronize trade during the Hajj with general maritime trade.[23] Despite this, the Hajj certainly generated significant commercial returns for Jedda.

As regards to the organization of the Hajj trade, Michael Miller notes that ships transporting pilgrims from the Indian coast could be heavily laden with textiles for the Red Sea markets whilst overland caravans from Damascus and Cairo required the Mamluks and Ottomans to spend great sums of money on grain, clothing and animals.[24]

Miller comments that practically everyone who was in a position to do so attempted to profit through trade during the pilgrimage season.[25] For example, Abderrahmane El Moudden writing in 1990 points to the necessity of the Hajj trade for Moroccan pilgrims, who might spend 15 to 18 months on their journey. The *rihla* (journey) texts for example, written by North African pilgrims (such as those written by ambassadors or those on diplomatic missions) between the 16th and 18th centuries give detailed descriptions of the economic possibilities of the route to the Hajj as pilgrims moved easily throughout large areas of the Muslim world. Because the journey was so long, everyday common practices were also important, and these *rihla* texts therefore served as 'market guides' showing how business and pilgrimage were intimately entwined.[26]

The population of Mecca has always lived largely off the Hajj. In the 20th century, the modern Saudi state took over responsibilities of the Hajj and even by World War II, the Hajj was still Saudi Arabia's principal source of revenue.

Gift giving, charity and the Hajj

In Muslim civil society charity and gift exchange frequently go hand in hand.[27] Islam's command to give charity (*sadaqa*) and alms (*zakat*) illustrates the importance of giving which draws upon the ideals of compassion, social justice, sharing and strengthening the community. The Qur'an emphasizes the ideal of generosity (Q.4:36 uses the word *ihsan* meaning 'compassion'; Q.2:215 mentions '*khayr*' meaning 'good') and it is in this broader sense that Muslims understand almsgiving and apply it to their daily life. This is seen most acutely in the Hajj where pilgrims, having taken a physical and spiritual step to fulfil their obligations to God, respond to this most profoundly. Al-Ghazali (1058–1111) writes:

> Giving out one's provisions during the Pilgrimage is a spending for the sake of God Most High. One dirham [spent for this purpose] has the value of seven hundred dirhams. Ibn 'Umar (may God be pleased with him) said, 'It is [a sign] of the nobility of a man to have [abundant] provisions in his journey.' And he used to say, 'The best pilgrim is the one who is most sincere in his intention, most pure in his spending and best in [degree of] certainty'.[28]

Indeed the place where charity is given or where money is spent is also significant: 'a dirham given in Mecca', according to a Shi'i tradition, 'merits a hundred-thousand-fold reward, in Medina ten-thousand-fold, in Kufa one-thousand-fold'.[29] Furthermore there is merit in specific types of alms: 'Of all that might be given as alms, water is pronounced to be best, and one who gives water to a thirsty Muslim will drink of the wine of Paradise'.[30] In Mecca, pilgrims and patrons have always considered the provision of water to be a paramount act of kindness. Another occasion for kindness is during Eid al-Adha (feast of the sacrifice), which begins on the tenth of the month of Dhu al-Hijja. This is a major part of the Hajj where the meat from the sacrifice is sent today from Mina to the poor around the world. On this day gifts are also exchanged.[31]

From a historical perspective, trade, gift-giving and charity are all concepts which are integral to Islam and particularly to the Hajj. Today, pilgrimage continues to be combined with the purchase of mementos and souvenirs, and Mecca is still full of bazaars and scattered shops filled with goods. Indeed, it is part of the Hajj experience to spare time to purchase gifts for friends and family. By virtue of being sold in Mecca these gifts have an added significance for pilgrims and their families. For those receiving gifts, the objects brought back often take a place of honour in a respected place in the house. A souvenir from Mecca or Medina, kept as a memento of this spiritual journey, which has required patience, strength and financial commitment, means that these will count amongst the most precious gifts ever bought.

I set as my objective the purchase of objects that might represent the current range of souvenirs available from Mecca and Medina. The sources of the modern material which were available for purchase on the Hajj can be categorized into four groups. The first comprises street stalls whose owners sold wares in large wheelbarrows after prayer time in the streets, leading out of the mosque or in the environs of the mosque grounds (**Pls 1, 2**), selling material such as clothing, prayer beads, children's toys, prayer mats

Plate 4 Street seller, Saudi Arabia (photo: Qaisra M. Khan, 2010)

and other items. These sellers, often unlicensed, were sometimes seen to pack up their wheelbarrows and flee at first sight of the local police. There were however, other elderly sellers who set up ad hoc stalls, especially in Medina, who sold trinkets and low value items (**Pls 3, 4**).

Fatima Sidiya, from the *Arab News*, reporting in 2009, noted that Bab Makkah (Mecca Gate) contains 'mini-shops selling various products that range from cloth to food to home accessories'.[32] This is reminiscent of the women seen selling their wares in the photographs (**Pls 1, 2, 4**). In Jedda, Sidiya notes that Egyptian women were selling cloth and kitchen utensils, Somali women sold henna, and East African women offered flat breads, while women from Chad and Mali sold handmade souvenirs, including fans, sweepers and wooden boxes. Interestingly, Sidiya also notes that the language used in the markets is a mixture of poorly pronounced Arabic words and grammar, with Asian or African accents, which certainly reflects Jedda's position as the gateway to Mecca and a bustling port.

Street shops form the second group (**Pls 5, 6**). Those that are set into the infrastructure of local buildings, largely serviced by South Asian workers, were packed full of trinkets and souvenirs much like the goods being sold out on the streets. There was very little evidence of locally made, or even non-mass produced goods, in either the street stalls or the shops, with most of the merchandise being made up of plastic everyday items, fabrics, clothing, toys and other generic items. These shops were particularly full (**Pls 7, 8**) after prayer times and often sold practical items as well as gifts.[33]

The only discernible exception to the lack of local or handcrafted products, were prayer beads made of local wood. These were inexpensive and were sometimes sold at initiatives begun by the Ministry of Social Affairs for local sellers. These small stalls were set up to provide specific goods such as *miswak* and prayer beads outside the mosque in Mecca, and were run by elderly men whose incomes depended on the initiative (**Pls 9, 10**).[34] *Miswak* is the name of a short stick made from the wood of the Salvadora persica tree which has traditionally been used to clean the teeth and deodorize the mouth all over the Arabian Peninsula. Even on his death bed the Prophet is said not to have given up the

Plates 5–6 Shops in Mecca during Hajj, Saudi Arabia (photo: Qaisra M. Khan, 2010)

use of it.[35] *Miswak* is one of the most popular products purchased in Mecca as its use was so highly recommended by the Prophet.[36]

The third group of shops are located in shopping malls. Pilgrims usually visit these malls for food and more expensive merchandise, such as perfumes, clothing, Qur'an recitations on CD and other 'luxury' items. Again, these are largely imported items with few exceptions. Another category of artefact available in the malls (and also in street shops) is gold. The gold markets in Mecca and Medina are famous and in the shopping malls and streets outside the mosques, gold is highly valued (**Pl. 11**).

In 2012 a report published by Reuters suggested that, unlike gem-set jewellery found in the Gulf, gold jewellery and artefacts in Mecca's markets are known for having very few additions making it easy to keep as a commodity,[37] and since the Saudi carat is inspected by government officials, the city's gold merchants declare the quality of their jewellery to be unsurpassed.[38] A Sudanese pilgrim, Ijlal Sulayman, who was interviewed stated: 'There is a difference in the price of gold between here and Sudan. Here, there are also different designs. Here you can choose from different designs, but in Sudan you have a limited choice. Here you have many options.' Whilst another pilgrim from Bangladesh had a spiritual purpose for purchasing, he said '[buying Saudi gold] is for two reasons: one is, it is good gold, honesty is there. Second, this is holy place for the Muslims, so we prefer purchasing gold from this holy place'.[39]

The fourth group comprises the markets of Mina and 'Arafat. In its series entitled *Hajj: The Greatest Trip on Earth*[40] aired on 3 February 2003, Channel 4 rightly noted that the Hajj is not just a spiritual journey, it is also big business. As we have seen previously, it always has been so. But the series also noted that wares from around the world were still being sold – they spoke of an African market and of goods from Azerbaijan, Iran, Turkey, Syria and Jordan. Although not always visible, the evidence of these markets is still especially apparent with the market traders from Central Asia.

Before their Hajj, Dagestani Muslims arrive in Jordan with carpets and silver items in order to pay for their trip to Mecca. The *Russia Journal* reporting in 2000 noted that

Plate 7 (below) In the market area after prayer time, Mecca, Saudi Arabia (photo: Qaisra M. Khan, 2010)

Plate 8 (right) Shops outside Masjid Al Quba, Saudi Arabia (photo: Qaisra M. Khan, 2010)

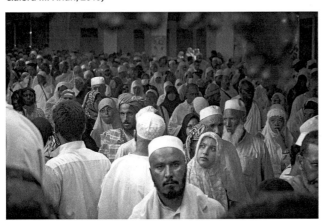

Plate 9 *Miswak* tradesman in his stall, Mecca, Saudi Arabia (photo: Qaisra M. Khan, 2010)

Plate 10 Individually packed *miswak*. Purchased in 2010, Saudi Arabia. British Museum, London (2011,6043.46)

Plate 11 A jewellery shop in the gold market, Mecca, Saudi Arabia (photo: Qaisra M. Khan, 2010)

Plate 12 Pilgrims en route from the Caucasus to Mecca, Amman, Jordan (photo: Filiberto Boncompagni, 2001)

roadside stalls covered with hand-woven carpets, silverware, crystals and other valuables were being sold to finance the Hajj.[41] Amman was the final stop from Central Asia, a journey which took them through Azerbaijan, Iran, Turkey and Syria. The report remarks that the Dagestanis' journey is of very little comfort, their transport buses do not contain seats, making the journey particularly arduous. The Jordanians purchase items from them, either seeking wares from distant places, or as an opportunity to help out a Muslim pilgrim. In another article from 2003, a correspondent for the newspaper *Dagestanskaya Pravda* reported how for Muslims travelling from Russia the journey is often prohibitively expensive and many try to recoup their expenditure while they are in Saudi Arabia.[42] For one couple, Ibragim and Aishat Magomedov, the Islamic injunction that trade is not prohibited is the only way they could fulfil their duty; equipped with rugs handwoven by their daughters, they sold them in order to secure their return. The irony however is that some pilgrims have become shrewd and learnt to exploit generosity. One story describes how a group of pilgrims rented out a warehouse somewhere along the pilgrimage route, making enormous amounts of profit by handling pilgrims' goods.[43] This is not without jeopardy however as pilgrims embarking on this activity often get caught by the Saudi officials.

A fascinating internet forum called 'A Rug Collector Meets the Hajj' (**Pls 12, 13**) run by Filiberto

Boncompagni,[44] discusses in detail the Central Asian market traders on their way to the Hajj, describing the goods sold. In response to one of his entries in 2001 a visitor to the forum notes:

> I've come across Hajj goods in both Morocco and Egypt. How does a lone South Caucasian rug end up high on the wall in a Marrakech shop? Well, that Moroccan shop owner of course took along some rugs when he went to Mecca – and traded for something exotic.… Many years later this memento was still on

Plate 13 Hajj flea market, selling goods to finance Hajj, Amman, Jordan (photo: Filiberto Boncompagni, 2001)

Plate 14 (left) A selection of objects purchased for the British Museum during Hajj through the Modern Museum Fund. Purchased in 2010, Saudi Arabia. British Museum, London

Plate 15 (above) Souvenirs displayed during the Hajj Exhibition, left (photo: British Museum, London, 2012)

The modern merchandise of Hajj

In 2011 the BBC reported that the annual occasion of the Hajj had become a lucrative business in recent years, proving a great financial asset to the economy of the oil-rich kingdom. Although the pilgrims themselves 'struggle to reconcile their spiritual needs with their wallets'.[46] Today, as has always been the case, travelling on Hajj has been an expensive affair and for some it is still a matter of saving up for a lifetime. The same article interviews a 53-year-old pilgrim from Tunisia who states, 'I spent up to $6,000 (£3,700) on my Hajj ... I thank God that he enabled me to save this amount of money but I'm sad I could not afford taking my wife and son with me'. These pilgrims bring with them millions of dollars into the Saudi economy, and for some the expenditure is not a difficulty. A Mauritian pilgrim named Ahmed Abdel Rahman commented that he did not find the shop owners opportunistic, 'But we help our brothers in Islam to make profit and make ends meet'.[47]

In November 2012, the *Saudi Arabia Gazette* stated that Saudi Arabia had raised approximately $16.5 billion from pilgrimage that year which hosted 12 million pilgrims.[48] This, they said, represented 3% of the country's gross domestic product (GDP). The revenue was generated from a variety of sources, including hotels, money exchange outlets,

the shop wall, and still Not For Sale. I've seen Berber women from the countryside give it long, hard looks. It shouldn't be surprising that some of those exotic motifs then appeared in their own weavings.[45]

This observation wonderfully summarizes the role of the Hajj and traders on their way to Mecca, as it has been across the centuries. The inspiration derived from styles and techniques used around the world come together in the Hajj as pilgrims from around the world seek and have sought new and unfamiliar items for use at home or to sell on again as 'exotic' mementos. The market traders eventually find their way to the Hajj where the remaining goods are sold at Mina and 'Arafat on the last few days of the Hajj, after the main rituals have been completed.

Plates 16–17 Modern textiles bought in Mecca and Medina Purchased in 2010, Saudi Arabia. British Museum, London (2011,6043.5 and 2011,6043.7)

retail shops, telecommunication and eateries serviced largely by expatriate workers who are hired temporarily during the season. The *Gazette* further reported that the average expense for each pilgrim was approximately $2,000–4,000 during their stay in the holy cities. In 2009 however, *Gulf News* reported that the annual revenue from organizing pilgrimage to Islamic holy places topped $30 billion,[49] which included purchases of gifts and spending amounting to approximately 7% of the country's GDP.[50] Thus, there is no doubt that the Hajj is indeed big business. With demand being higher than supply, in the same BBC interview, one of the Saudi real estate tycoons Muhammad Sa'id al-Jahni quantified that 35 years ago a metre of land in Mecca was worth 15 *rials* ($3), now it is 80,000 *rials* ($22,000).

'Blessed souvenirs'

Souvenirs, especially those sold in Mecca, as at any pilgrimage site, amount to a very profitable business. Although there are no official numbers, it can be estimated that revenue from souvenirs must amount to hundreds of millions of dollars every year. Ahmed Abdel Rahman was interviewed as he was buying gifts and souvenirs to take back to Mauritius stating that he felt a great spiritual relief when he spent his money in Mecca, 'These are blessed souvenirs'.[51]

The final section of the exhibition *Hajj: journey to the heart of Islam* displayed some of the objects purchased alongside historic souvenirs. In this section, we focused on how being a *hajji* or a *hajja* changes peoples' lives.[52] Their return is greeted with joy and celebrations as the experience was longed for, and the stay in the holy cities was a time for profound reflection and a renewal or reaffirmation of faith. In a chapter entitled 'Praying and Shopping' in his book *A Season in Mecca: Narrative of a Pilgrimage*, Abdellah Hammoudi writes: 'After the initial surprise, it was clear that for centuries pilgrims had divided their time between mosque and commerce'.[53]

Undertaking the journey and pilgrimage myself, I had to divide my time wisely between worship and shopping. I had to consider the types of objects that would benefit our modern collection and illustrate the importance and relevance of Hajj in modern times. I purchased approximately 60 to 70 objects. A selection of these were displayed in one case in the final part of the exhibition (**Pl. 15**), as a group of gathered objects that represent the volume of items brought home by pilgrims.[54]

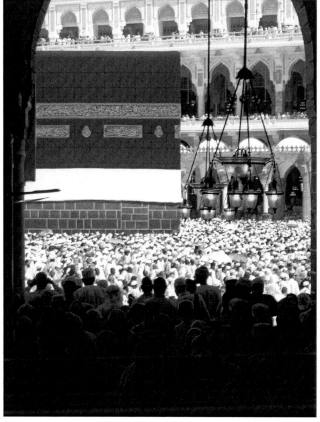

Plate 18 Admiring the Ka'ba, Mecca, Saudi Arabia (photo: Qaisra M. Khan, 2010)

There were two basic but important questions to consider when purchasing the objects: what kind of items should I buy? And what does it demonstrate to the visitor in London? There were many possible modern-day souvenirs that could be bought, such as Zamzam bottles, prayer rugs, prayer beads, religious texts, copies of the Qur'an, *miswak*, jewellery, Ka'ba-inspired textiles, architectural models and many others. But in order to consider their relevance, I approached collecting the material in two ways, firstly by their popularity and secondly by recognizable historical comparisons.[55]

For example, the Ka'ba is covered with embroidered verses from the Qur'an. Textiles inspired by these can be found in the markets and became the perfect souvenir items (**Pls 16, 17**).

The British Museum's routine visitor evaluation (which took place over the duration of the exhibition) raised many

Plate 19 (far left) Zamzam flask, purchased in 2010, Mecca, Saudi Arabia. British Museum, London (2011,6043.75)

Plate 20 (centre) Metal pilgrim flask owned by Sir Richard Burton. British Museum, London (OA+3740)

Plate 21 (left) A modern day plastic Zamzam container, acquired in Mali. Purchased in 2010. British Museum, London (2011,6044.1)[56]

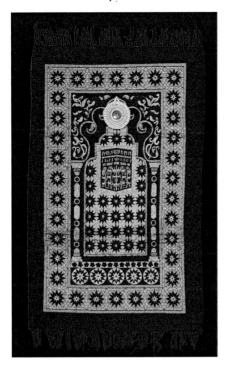

Plate 22 Modern day prayer rug with compass. Purchased in 2010, Medina, Saudi Arabia. British Museum, London (2011,6043.55)

Plate 23 Modern day prayer rug. Purchased in 2010, Medina, Saudi Arabia. British Museum, London (2011,6043.15)

Plate 24 A small modern day prayer rug Purchased In 2010, Medina, Saudi Arabia. British Museum, London (2011,6043.6)

interesting comments regarding the content of the exhibition and how visitors engaged with it.[57] One of the interviews conducted during the Hajj exhibition touched upon the importance of the textiles, which were a central feature of the exhibition. The interview shows how, for one visitor, being able to reflect back on one's own experiences and possessions was important to her understanding of the exhibition (**Interview 1**).

The textiles are an effective example therefore of the importance given to the most iconic visual elements of Hajj, the coverings of the Ka'ba. It is no surprise therefore that the availability of souvenir textiles which are reminiscent of the coverings, sometimes quite accurately so, were being purchased in good number by pilgrims, as a reminder of Mecca (**Pl. 18**).

During Hajj, pilgrims from all over the world were buying gifts, objects which would help to maintain a level of piety in the future life (**Pls 22–4, 27–8**); some were also being used whilst on the Hajj, and became infused with blessings (*baraka*) by the time they are taken home. Sometimes certain purchases were particularly distinct and used with great pride such as the gold plastic Zamzam flask (**Pl. 19**). Although the Hajj itself is a journey of minimal needs and humility, as illustrated by the garments worn, the wares

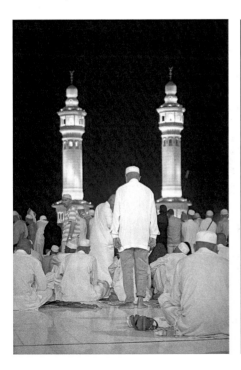

Plate 25 (far left) Men at prayer in the Masjid al-Haram, Mecca, Saudi Arabia (photo: Qaisra M. Khan, 2010)

Plate 26 (left) Eid clothing for children. Purchased in 2010, Mecca, Saudi Arabia. British Museum, London (2011,6043.3)

Interview 1 British-Pakistani, female, Muslim Sunni, 25–34

On your Hajj you saw the textiles…
I have a piece of the cloth at home. I was given it as a gift.

Tell me more about the piece you have
It was the covering, the door of the Ka'ba. And on the last day I was leaving.… And a friend of my mother who works there.… I just went along to say my goodbyes to her, because you never know if you're going to see anyone again and so I just went down to say my goodbyes. And she handed me this little envelope. And I was newlywed. And she goes, 'I'm not able to give you anything else, take this'. When I opened it … in fact before I even opened it I smelt it 'cause it's very highly perfumed with musk and I knew instantly what it was and it was a piece of the cloth that was taken.…And I cherish it. It's one of my most prized possessions and yet it's only a piece of cloth.

What significance does that piece of cloth hold for you? Is it spiritual, emotional..?
It's both. It's spiritual, it's emotional, it's a reminder, it's a piece – I guess for me – it's a piece of the house of God. What a great thing for a Muslim, really, to have a piece of that in my possession. You know, we come away with the water and some of us come away with a bit of sand or a bit of clay. So I guess it's just a little keep sake, isn't it.

How was it seeing the textiles in the museum today?
I think seeing them here, because you have a lot more of them here … Umm [pauses]. It's hard to describe in words if I'm honest. They're so beautiful and you want to go up close and touch them but out of respect, if I'm honest, I didn't [chuckles].

Interview 2 Female, UK, late 20s/early 30s, Muslim but not practising

How did you feel about the exhibition?
I'm so glad I came. I'm actually thinking I should come again maybe when it's not so busy.… It's something that you just have to digest and think about so I'm thinking I might come back and have a look over some things. I'm really intrigued about the hangings. Very interested in that. It's amazing to see it just so close.

What were you drawn to?
Just the trinkets and stuff. The souvenirs I thought were quite funny because my mum's got some things that other people brought back as presents. I thought that was quite cute. But I recognize certain things. My mum's got a counter and she's got one with a compass on it. And it just makes me remember that really because I always used to see her praying, making sure it's dead straight, you know, where it should be.… It's nice to see that because I've kind of lost contact with that. So it's nice to see those reminders, so yeah, [of] growing up.

Would you consider your visit an emotional or spiritual experience?
Yeah, I think so. It just makes me sort of connect a little bit more to my background and the way I was brought up, so yeah, I think so. Like I said, it's just reconnecting. It's just looking at these images makes me kind of feel … like it's a reminder and a stronger feeling.

being bought and sold tell a different story, as many pilgrims buy elaborate and expensive gifts to take home (**Pl. 26**).

Sometimes items purchased on Hajj were similar to those available in London. Although most of my fellow *hajjas* had to buy extra suitcases to accommodate their purchases, they certainly were not unusual pieces. The motivation for their purchases ran deeper than the uniqueness of the items or their material value. Many items were available in the UK but were much more significant for being purchased whilst on Hajj.

Other items, such as those relating to everyday life in Mecca, such as the gold-coloured aluminium kettle (**Pl. 29**), or the brass 'magic bowls' with stylized Qur'anic inscriptions in which Zamzam is poured and drunk from (**Pl. 30**), are useful for a practical knowledge of Hajj. Another interesting example here is the large coffin shroud which I purchased in Mecca, which is a green felt burial sheet decorated with Qur'anic verses with descriptions of the Ka'ba and the Prophet's Mosque in Medina. These sheets were being purchased by pilgrims in order to take home to be used as a burial shroud along with *ihram* garments, or sometimes they were given to those who had not been on the Hajj.[58] They were also often seen covering the bodies of pilgrims who had died on the Hajj and were being carried out of the mosques to the graveyards.[59] Fellow *hujjaj* were donating these to the families of the deceased who could not afford to buy them.

In another interview conducted with one of the visitors to the exhibition, an interest in the souvenirs was notable (**Interview 2**).

These types of comments illustrate the dilemma posed by my simple questions about the nature of the items purchased and their significance. I had begun with the objects I knew had obvious connections to the past, but on other occasions, I let the pilgrims be my guide as to what kind of souvenirs were valuable to them. The reactions to the material were not uniformly encouraging, however. Although very complimentary of the exhibition, Brian Sewell in the *Evening Standard* was 'appalled by the vulgarity of [one that is] a modern souvenir',[60] noting that in fact those who had been to Lourdes may have seen some similarity in the quality of souvenirs. Another visitor lamented what she perceived to be a dying art of craftsmanship in the Islamic word stating:

> The craftsmanship of past Muslims is incomparable. In his book about Delhi, Dalrymple mentions the last elderly calligrapher whose sons are now working as photographers because there is no demand for that art form. So he hasn't been able to pass on those skills. Very sad. I totally agree about Muslims not appreciating their own art and heritage but rather preferring plastic tat from China, usually. At the Hajj exhibition recently at the British Museum, their samples of what people brought back from Hajj was a load of cheap and tacky stuff.[61]

However, at a talk I gave in April 2013 regarding the engagement of Muslim audiences, a visitor to the Museum interestingly commented on the same objects and aptly summarized their importance in terms of the value of modern objects in their connection with the past, particularly in the case of the Hajj, 'You mentioned something very briefly about popular tradition as a sort of

Plate 27 Electronic counters acquired in Mecca and Medina. Purchased in 2010, Saudi Arabia. British Museum, London (2011,6043.66 (metal); 2011,6043.65 (finger))

Plate 28 Prayer beads acquired in Mecca and Medina. Purchased in 2010, Saudi Arabia. British Museum, London (2011,6043.60, 2011,6043.57)

link to the historical past. When I was at the Hajj exhibition there was a really interesting display right at the very end with a box of souvenirs brought back from Hajj. That kind of thing, I'm very interested to know … your take of the vernacular, popular, modern tradition within Islamic art and the way it links to the past.'[62]

In this way, the souvenirs bought from my own Hajj, despite being repetitive and (as far as I could tell) mainly produced in China and India, gave an insight into a living tradition which has not changed since the beginning of Islam (**Pls 20, 21**), i.e. a tradition which combines that which is commonplace and that which is sacred. So from this, modern-day souvenirs of the Hajj can be seen to support the fact that Hajj is not something of the past, but a phenomenon which is very much alive and material in today's world and although it is perceived that the holy places have only *just* become commercialized, we have seen that trade has in fact always been an important part of the pilgrim experience.

Conclusion
Early feedback on the scope of the exhibition highlighted that the rituals of the Hajj had the potential to be a very powerful section for respondents. Visitors wanted to learn

about the ritual details nearly as much as the spiritual fulfilment that is the focus of pilgrimage.

Although there may have been markets I missed on Hajj, or crafts being made and sold I was not able to witness, the material I purchased there will, I hope, build on the Museum's strengths to continue to collect categories of 'Islamic' material culture. The museum had not previously collected modern-day objects related to the Hajj and those purchased in this context, alongside material collected by Timothy Insoll in Bamako for the Museum, now represent a modern category of objects related to this ancient Muslim pilgrimage rite, demonstrating a spiritual as well as economic significance.

We have seen how these objects demonstrate the ways in which trade is conducted during the Hajj today, the kinds of objects pilgrims buy and sell from around the world, and how modern objects have taken on the roles of traditional objects. The collection documents change and continuity and sheds light on religious, spiritual and social human activity through the Hajj. From visitor reactions we know that these acquisitions have made a contribution to one or many areas of knowledge and public understanding of the Hajj. The British Museum's guidance notes on acquisitions procedure encapsulates this experience, stating that

Plate 29 Gold coloured aluminium kettle. Purchased in 2010, Mecca, Saudi Arabia. British Museum, London (2011,6043.72)

Plate 30 Brass magic bowls. Purchased in 2010, Mecca, Saudi Arabia. British Museum, London (2011,6043.38, 2011,6043.37)

'Material from the past allows the past to be reinterpreted, and inform the present, while material of the present mirrors our changing world, and forms a continuum with the past'.[63]

On a theological level we find the concept of God as the giver of gifts (kindness: *ni'ma*) and given Muhammad's concern with commercial affairs, it is perhaps not surprising that he is said to have been the first to appoint persons with jurisdiction over the markets for the betterment of the community. In Bukhari's *Sahih Muslim* we read, 'Abu Huraira reported Allah's Messenger (may peace be upon him) as saying: of the dinar you spend as a contribution in Allah's path, or to set free a slave, or as a *sadaqa* given to the needy, or to support your family, the one yielding the greatest reward is that which you spent on your family'.[64] In addition, a contemporary of the Prophet[65] is mentioned as frequenting the market of Medina, asking people to behave well there.[66] Watt sums this up by saying, 'The Qur'an has ample evidence of the importance of voluntary "contributions" in the plans for the young community at Medina. Men are commanded to believe in God and His messenger and contribute of their wealth. Their contributions are a loan they lend to God; he knows more than they do; he will repay them the double and more.'[67] The experience of my Hajj and of buying objects therefore made my interpretation of the exhibition much easier, as well as providing me with a deeper understanding of the spiritual significance, the emotion and meaning of the Hajj especially in relation to trade. But the Hajj exhibition and the tasks afforded me through this great exhibition also meant that my own Hajj became quite different to that of the other three million Muslims who performed the Hajj that year.

Notes

1 'Give not, thinking to gain greater' (Q.74: 6) is an alternative translation which expresses a warning against giving in the expectation of receiving. M.A.S. Abdel Haleem translates this verse as 'do not be overwhelmed and weaken' based on Mujahid's understanding of *manna* 'to weaken'. Unless stated otherwise, all translations of the Qur'an here are derived from M.A.S. Abdel Haleem 2005.

2 Chaperoned by my husband Nazar Zaidi, to whom I am grateful for his advice, patience and support in carrying cameras, taking photographs and helping me through my journey.

3 A Muslim tradition states that a person who embarks on the pilgrimage to Mecca has received a divine 'invitation' and thus must behave as a guest of God.

4 Thanks to Philip Attwood, Keeper of Coins and Medals and Chair of the British Museum's Modern Museum Group, for helping me to understand my acquisition objectives more clearly. Text provided by the 'British Museum's guidance notes on acquisitions procedure', 28 May 2009.

5 Rodinson 1974: 16.

6 Rodinson 1974: 17.

7 Amongst the goods being sold at 'Ukaz, specific reference has been made to Yemeni leather goods and raisins being traded there. See Crone 2004b: 156.

8 Shahid, ''Ukaz'. *Encyclopaedia of Islam (EI²)*.

9 Buckley. 'Markets'. Encyclopaedia of the Qur'an (*EQ*).

10 Watt, 'Al-Madina'. *Encyclopaedia of Islam (EI²)*.

11 Lecker 1986: 138.

12 Rodinson 1971: 151. Rodinson mentions here the story of 'Abd al-Rahman ibn 'Awf who presumably not wanting to work as a common labourer uses his commercial acumen to make a small purchase on credit and selling wares in small quantities at the markets, eventually earning enough to marry a woman of Medina.

13 Rodinson 1971: 151.

14 Rodinson 1971: 152.

15 Kister 1965: 273.

16 Kister 1965: 275.

17 Kister 1965: 273.

18 Bonner 2005: 406.

19 Including setting aside weapons and wearing special garments. See Hoyland 2010: 110, 161.

20 Peters 1994a: 32.

21 See Peter Webb in this volume.

22 Miller 2006: 198.

23 Miller 2006: 197.

24 Miller 2006: 197–8. See Dionisius Agius in this volume.

25 Miller 2006: 197–8.

26 El Moudden 1990: 74–5.

27 Lev gives the example of a tenth-century administrator who was known for his charity especially to the population of Mecca and Medina. Lev 2009: 248.

28 In his Book on the Secrets of Pilgrimage (*Kitab 'asrar al-hajj*) by al-Ghazali he encourages pilgrims to provide their own sustenance and not to depend on charity.

29 Weir and Zysow. 'Sadaka'. *Encyclopaedia of Islam (EI²)*.

30 Weir and Zysow. 'Sadaka'. *Encyclopaedia of Islam (EI²)*.

31 See Muhammad Abdel Haleem in this volume.

32 http://www.arabnews.com/node/328007.

33 For example, everyday items such as luggage, water carriers, scissors for *taqseer* or umbrellas for shade.

34 These stalls were built in order to keep these so-called 'hygienic' products from being sold from the ground.

35 Al-Bukhari: 'Expeditions' 730 (http://www.sahih-bukhari.com/Pages/results.php5).

36 After 2010, the *miswak* salesmen abandoned their stalls which had been provided by the Ministry of Social Affairs after electricity was cut in order to enable expansion works in neighbouring areas http://www.saudigazette.com.sa/index.cfm?method=home.regcon&contentid=2010092383774.

37 http://www.itnsource.com/en/shotlist//RTV/2012/10/23/RTV231012104/?v=1.

38 Interestingly the same article notes that despite the constant flow of customers, some gold traders said the Arab Spring had had a negative impact on their business, especially from Egyptians and Libyans, who are usually keen gold-buyers.

39 http://www.itnsource.com/en/shotlist//RTV/2012/10/23/RTV231012104/?v=1.

40 http://www.channel4.com/programmes/the-hajj-the-greatest-trip-on-earth.

41 http://www.russiajournal.com/node/2753.

42 http://iwpr.net/report-news/travails-dagestans-pilgrim-traders.

43 http://iwpr.net/report-news/travails-dagestans-pilgrim-traders.

44 This non-profit forum discusses Oriental rugs and textiles. http://www.turkotek.com/salon_00063/salon.html.

45 http://www.turkotek.com/salon_00063/s63t3.htm.

46 http://www.bbc.co.uk/news/world-middle-east-20067809.

47 http://www.bbc.co.uk/news/world-middle-east-20067809.

48 http://www.saudigazette.com.sa/index.cfm?method=home.regcon&contentid=20121109142213.

49 http://gulfnews.com/business/opinion/haj-vital-to-saudi-economy-1.533412.

50 http://www.saudigazette.com.sa/index.cfm?method=home.regcon&contentid=20121109142213.

51 http://www.bbc.co.uk/news/world-middle-east-20067809.

52 The terms given to male or female pilgrims who have completed Hajj.

53 Hammoudi 2006: 83.

54 The objects purchased were all being worn, used or bought in Mecca and Medina and often had some reminiscent characteristic of the holy cities. The objects purchased fit into six broad categories: 1. Clothing: including children's clothing for Eid celebrations, women's scarves and men's head coverings in various styles (including local styles) and *ihram* garments for men and for women; 2. Textiles: including prayer mats in different materials and styles, decorative textiles and wall hangings; 3. 'Souvenir' items: including models of Mecca, children's toys and gifts and decorative accessories; 4. 'Religious' items: including Qur'ans, prayer beads and Zamzam flasks; 5. 'Daily use' items: *miswak*, kettles, bowls,

cups; 6. 'Paper' items: including children's books, postcards and guides to Mecca and Medina. For more information on the Hajj collection acquired for the museum search on: http://www.britishmuseum.org/research/collection_online/search.aspx.

55 I assessed popularity by paying special attention to where certain groups of pilgrims were buying souvenirs and what they bought. Groups of African or Indian pilgrims would often shop at certain places and buy certain items such as children's clothing and toys.

56 As part of the research for the exhibition, in November 2010 Professor Timothy Insoll, Professor of Archaeology at the University of Manchester, travelled to Mali on the British Museum's behalf and purchased souvenir objects from Hajj souvenirs stalls adjacent to the Grand Mosque in Bamako, from Timbuktu Market and from the imam of the famous Djinguereber mosque in Timbuktu. The souvenirs purchased would have been bought in Mecca and Medina and resold in Mali. Amongst the most popular items are kohl, incense, perfumes, prayer rugs, Zamzam water and prayer beads.

57 Thanks to Stephanie Burns for providing the interviews and transcripts.

58 A pilgrim would always choose to be buried in the *ihram* garments, which may be instead of or in addition to a shroud.

59 For pilgrims it is a blessing to be buried amongst the earliest Muslims, especially in the al-Baqi' graveyard in Medina which is known to be the resting place of many of Muhammad's relatives and companions.

60 http://www.standard.co.uk/goingout/exhibitions/hajj--journey-to-the-heart-of-islam-british-museum--review-7439724.html.

61 Private email exchange.

62 Transcript.

63 From the 'British Museum's guidance notes on acquisitions procedure', 28 May 2009.

64 Muslim: Book 5, Chapter 12, Number 2181: Sahih Muslim.

65 This contemporary was the female *muhtasiba*, or market inspector Samra' bint Nuhayk al-Asadiyya who the Prophet employed to take jurisdiction over the market in Medina.

66 Buckley. 'Markets'. *Encyclopaedia of the Qur'an (EQ)*.

67 Watt 1956: 252.

Chapter 29
Organizing Hajj-going from Contemporary Britain
A Changing Industry, Pilgrim Markets and the Politics of Recognition[1]

Seán McLoughlin

Western scholarship on the Hajj, whether in Islamic, religious or pilgrimage studies, has mainly been the focus of generalized comment rather than specific and in-depth studies.[2] Important monographs do focus on its history, including the early modern period.[3] However, despite being perhaps the most high profile annual gathering of humanity, the late modern Hajj remains relatively under-researched.[4] This may be in part because of the exclusion of non-Muslims from the holy places, but also the more general closure of Saudi Arabia to detailed scrutiny by any outsiders. In edited collections and journal articles during the 1990s, anthropologists began to identify various aspects of Muslim experience of the Hajj worthy of further investigation.[5] However, apart from some fascinating memoirs,[6] few have illuminated its organization. Tourism and management scholars have very tentatively begun to explore the political economy of the Hajj and that of religious tourism in Saudi Arabia more generally,[7] while Robert Bianchi has produced a masterly survey of the pilgrimage's organization in non-Arab countries.[8] In this essay I contribute the first case study of the organization of Hajj-going in a contemporary Muslim diaspora: my focus here is on the UK.

Since the mid-2000s, on average, 23,000 pilgrims have travelled annually from Britain to complete the Hajj,[9] with around 100,000 also completing the 'Umra or minor pilgrimage. These figures are the highest for Muslims in Western Europe; indeed, 'London has become the Hajj capital of Europe'.[10] In what follows I will not be concerned with pilgrims' experiences of the religious rituals of Hajj, something I have written about elsewhere.[11] Rather, as a local case study of a global industry,[12] I begin by sketching the transformation of the late modern Hajj in Saudi Arabia, although an entirely original exposition of this context is beyond the scope of my research. Dwelling upon the Kingdom's key interventions to meet logistical, health and safety challenges, as well as to diversify its own economy, I assess the impact of recent industry restructuring on UK tour operators. Then, in greater detail, I explore two things. Firstly, I examine the popularity of the Hajj amongst British Muslims, identifying the economic and cultural dynamics of distinctive pilgrim markets, from the high to the low end. Secondly, in a Muslim diaspora context where Hajj-going is not supervised by the state, I examine the extent to which pilgrimage has been a focus for Muslim claims to public recognition in a secular, multi-faith society. This involves contextualizing the work of Muslim voluntary organizations and analysing the political contexts in which their interests seem to have converged with, and/or diverged from, government agendas since the 1990s.

My research draws upon original data collected mainly during late 2011. Transcripts of more than 100,000 words in total were produced following in-depth, semi-structured interviews of up to two hours' duration with 11 industry experts, all but two being of British Asian heritage with all but one being male.[13] They belong to four categories: 1) two tour operators approved by Saudi Arabia's Ministry of Hajj, one in London with a high end, multi-ethnic customer base,[14] and one in the north of England offering mainly British Indians a mid-range, good value service[15]; 2) three Hajj guides/imams, one British Arab based in London,[16]

one Irish convert from the English Midlands[17] and one British Pakistani in the north of England;[18] 3) the two Hajj pilgrim welfare organizations which claim national reach, one located in the Midlands and serving mainly British Pakistanis (three representatives interviewed),[19] and one in the north of England serving mainly British Indians;[20] and 4) two government officers, both based in London and incidentally of Muslim heritage, one British Pakistani working in central government,[21] and one British Bangladeshi employed in a local council's trading standards department.[22] The essay also draws in passing upon a survey – 'How was your Hajj?' – which ran on Bristol Online Surveys between November 2011 to March 2012,[23] and on archival research on parliamentary discussions concerning Hajj during the last decade or so.[24]

Organizing Hajj in contemporary Saudi Arabia: the Ministry of Hajj and UK tour operators

In late modernity, Hajj-going amongst Muslims worldwide is being very rapidly transformed. As Bianchi notes, the number of overseas pilgrims has mushroomed since the mid-1950s.[25] Before then such numbers rarely exceeded 100,000, whereas since the 1980s this figure has been 1,000,000 and rising, with more than 3,000,000 Muslims in total performing the Hajj in 2012.[26] Various global processes begin to explain this change, including inexpensive air travel, which since the mid-1970s especially has made time and distance no obstacle in sharp contrast to pilgrimages of the past. Bianchi argues that rising incomes are the most significant predictor of Hajj-going, but the end of colonialism and absence of world wars, as well as other major disruptions to the secure movement of people, have also been significant. In an effort to assert political legitimacy, many postcolonial Muslim states have sought to organize, promote and subsidize Hajj-going, too, while growing literacy, transnational Islamic organizations and new public spheres have all increased self-consciousness about religious 'orthodoxy'.[27] Of course, the modern pilgrimage is performed within the national boundaries of the oil-rich, absolute monarchy of Saudi Arabia, which has pumped huge budgets into the promotion of a puritanical 'Wahhabi' ideology, yet at the same time has had its own 'Islamic' credentials contested by critics.[28] In this context, pan-Islamising projects such as the Organization of Islamic Cooperation (OIC, established in 1969) have been a vehicle for the internationalization of the Hajj, and expending efforts to manage diplomatic relations surrounding its governance with much larger Muslim nations in Asia and Africa.

The huge numbers of Muslims attending the late modern Hajj have put immense pressure on the infrastructure of the holy places. Saudi petrodollars have funded ambitious developments which began with the expansion of al-Masjid al-Haram (the Grand Mosque) complex around the Ka'ba in 1957,[29] and subsequent work has included modern transport, medical and other facilities.[30] Nevertheless, recent decades have also witnessed various disasters resulting in the large-scale loss of human life. The severe heat, the prolonged duration of the Hajj rituals and the sheer number and proximity of people from diverse locations all intensifies

risks to health, especially among the elderly and infirm.[31] Thus, in 1988 the OIC decided to set a Hajj quota for each country at 1,000 pilgrims per million of total (Muslim) population.[32] Nevertheless, on several occasions between 1990 and 2006 hundreds of pilgrims died in fires and especially stampedes. While blaming pilgrim behaviour in part, the Saudis have embarked upon further major works to improve the safety and capacity of its infrastructure.[33] Moreover, with its own population growing faster than its economy, and youth unemployment rising, since the late 1990s especially, the late modern development of the Hajj has also reflected a context in which the Kingdom has sought to diversify the Saudi economy.[34] Tourism was identified as having specific potential in this regard,[35] but outside of pilgrimage, which is the country's third largest industry, Saudi Arabia does not encourage international tourism per se.[36] Thus, together with commercial partners, the Kingdom is aggressively increasing accommodation and related services in Mecca and new high-rise developments are transforming the landscape.[37] Not without controversy or protest, historic – and sometimes sacred – buildings from the Prophetic to the Ottoman eras have been almost entirely demolished. Critics draw attention to the longstanding iconoclasm of the Wahhabi movement since the 18th century and what seem to be curious double-standards vis-à-vis commercialization.[38] It is also unclear whether such growth is genuinely sustainable. In any case, what is certain is that, with fierce competition between multinationals for this prime real estate, costs in every part of the industry have been driven up, with the Mecca Chamber of Commerce estimating that $10 billion was spent on the Hajj in 2011.[39]

Since a hotel fire near the Grand Mosque caused further fatalities in 2006, the Ministry of Hajj has also revolutionized the way that pilgrims must organize their Hajj-going. In the absence of a Muslim state bureaucracy to manage the process, it was hitherto possible to organize pilgrimage from Western countries entirely independently in terms of travel, visa and accommodation arrangements. Professional tour operators began to appear in significant numbers in the UK only during the 1990s, so the normal pattern of Hajj-going often comprised individuals leading small groups. For instance, a Hajj guide from the Midlands interviewed for this project told how, even in the early 2000s, she and another pioneering woman regularly took a group of just 20 to 30 British Muslim converts on a 'walking Hajj'.[40] Pilgrims can still book flights to Jedda or Medina independently. However, they must now secure their accommodation and visas through a Ministry of Hajj approved tour operator. Thus, according to the north of England tour operator interviewed for this project, increasing attempts to regulate and discipline the Hajj in Saudi Arabia ensure that 'on the certain date, at a certain time, where we are, the Kingdom knows'.

Presently there are around 80 approved tour operators in the UK listed on the website of the Ministry of Hajj.[41] Such tour operators must now take a minimum of 150 pilgrims, with an initial upper limit being 450, and an option of applying for a higher band of 900 to 3000.[42] The Ministry used to accept tour operators with smaller numbers but now encourages mergers as it is keen to deal with fewer, more

established and larger companies. All tour operators must travel to Saudi Arabia to present their credentials months in advance of the Hajj and book a hotel, most likely leasing an entire establishment for the season.[43] Payments are staggered and the total amounts involved even at the mid to lower end of the market underline the scale of the capital investment now required; according to an imam accompanying another north of England tour operator, 'For one person in Mecca it is roughly £1,000 for a season for one bed. So there is a lot of money involved and there is also significant risk. Say, with the quota of 450 people, this means a minimum start-up cost for tour operators of half a million pounds.' Tour operators must also agree commercial contracts with a *mu'alim*[44] for the supply of transportation, tents and food in the Europa camp outside Mecca at Mina. Thus the north of England tour operator explained that even though he may return to Saudi Arabia with a group of pilgrims during the month of Ramadan, he will still need to visit one more time in the two months before Hajj. In particular, visas are released only after the holy month of fasting and this does put pressure on timescales especially if tour operators are not as organized and professionalized as they might be.[45] As the London-based trading standards officer interviewed for this project remarked, 'a lot of the time the tour operator wouldn't know they've got your visa until a week before you travel', with some pilgrims receiving passports, visas and flight tickets the night before or even at the airport (central government officer, London).[46]

Among the representatives of the UK Hajj industry interviewed for this research, there is widespread recognition of the great demands made upon Saudi Arabia by the pilgrimage,[47] the Midlands-based Hajj guide likening it to London hosting the Olympics every year. Her London-based tour operator also acknowledged that 'the services there, their systems, their procedures are getting more and more effective every year'. However, quite apart from the language barrier, the way of doing business in the Kingdom is quite different to the UK and the efficiency and work ethic of some Saudi nationals is questioned,[48] as the tour operator from the north of England elaborates:

> They do make it awkward … for days and days you go there, you sit there, they'll have a nice tea, coffee and they're eating this and that, you wait there all day, 'Bukra', 'Tomorrow', 'Tomorrow'.… [But] don't go with the demanding attitude like we do – my God, don't ever do that…. As long as you understand them and try to work their way, it becomes easy … you've got to overcome that and you've got to make sure you're one step ahead of them… The certain thing is, what we did last year, there will be something different next year. That's one of the reasons I go four time[s] a year.

Despite earning their living from the Hajj industry, like a majority of the other respondents, the two UK tour operators interviewed also registered significant concerns about the balance between necessary modernization of the Hajj and respect for Islamic heritage in Mecca. For the Hajj guide from the Midlands there is a sense of loss regarding the changing general ambience: what was once 'lovely … bustling … jovial' is now 'organized, and a bit starchy, and a bit less friendly and less memorable than it used to be'. The Abraj al-Bait complex of hotels, shopping malls and 600m

high clock tower, which now overshadows the Haram and the Ka'ba, is an obvious talking-point for those who worry that Las Vegas style development has compromised an aesthetic of sanctity; 'I tell you that a lot of people don't accept it. I've never been, I never asked their price because I don't want to take my *hajjis* there. I don't think that should be there' (tour operator, north of England). Even at the top end of the UK market, authenticity and religious ideologies of egalitarianism remain important; 'I'm always afraid of losing the spirit of Hajj … they had sofas last year in [the tents at] Mina. And I find it a bit frustrating … I don't want unnecessary luxury … the modernization can be detrimental because it may mean that Hajj is only for the wealthy' (tour operator, London).

Pilgrims, tour operators and distinctive UK Hajj markets

Records reveal that the average annual rate of Hajj-going from the UK was 121 pilgrims during 1961–5 and 4,482 during 1985–7,[49] with an average of around 23,000 in the period 2005–9.[50] Thus, simple calculations reveal that, while in the 30 years between 1961 and 1991 the Muslim population of Britain increased 18-fold from 55,000[51] to just less than 1 million,[52] Hajj-going during a similar period increased 37-fold. Between 1991 and 2011 the Muslim population of Britain nearly trebled to 2.7 million,[53] but during a similar period Hajj-going increased more than five-fold. Therefore, it can be said that Hajj-going has been popular in the UK diaspora since post-war immigration began to accelerate in the 1960s, the same point in time when the number of pilgrims going for Hajj began to mushroom more generally. However, UK Hajj-going has increased consistently at about twice the rate of Muslim population growth. How might this be explained?

Firstly, as the central government officer interviewed for this project explained: 'no quota has been given to the UK; if you apply on time you get your visa, there's no threshold'. As noted above, the Organization of Islamic Cooperation normally sets a Hajj quota of 1,000 pilgrims per million of total (Muslim) population for each sending country. However, Muslims who live as religious minorities are treated as a separate case,[54] with the quota either waived or set against more general population levels. If the Hajj quota for the UK was based on Britain's current Muslim population, it would limit the number of pilgrims to just 2–3,000 per year, some 10 times less than current levels. A quota based on the UK's total population would suggest a figure of 56,000 pilgrims, which has never been approached in terms of demand. Thus Muslims in Britain undoubtedly benefit from opportunities to go on the Hajj unavailable to most other Muslims. As Bianchi suggests, 'In wealthier nations such as Singapore, the United Kingdom, and South Africa, per capita Hajj rates are several times higher than the international average'.[55]

Secondly, British Muslims, generally speaking, do have the financial resources to go on the Hajj. Three-quarters of British Muslims are the offspring of economic migrants of Indo-Pakistani origin and, while Pakistanis/Kashmiris and Bangladeshis exhibit amongst the highest levels of relative deprivation in the country,[56] international labour migration

is still a marker of prosperity considering the development issues typical of homeland contexts.[57] Moreover, expectations of going on the Hajj have been transformed in the diaspora, just as they have become more democratized in terms of social class, gender and generation.[58] Only 35% of respondents to my online survey had grandparents who had been on the Hajj, a figure that will have been inflated by migration, too, as compared to homeland norms, because of economic migrants sponsoring their kin. In contrast, 80% had parents (more clearly the migrant generation) who had been on the Hajj, while 91% of respondents themselves (younger Muslims in their 20s, 30s and 40s) had always anticipated making the pilgrimage in their lifetime.

Thirdly, according to Islamic law, being physically able and having the necessary financial resources makes the Hajj incumbent upon Muslims. However, while the online survey suggested that 'religious duty' was the key factor in 53% of respondents determining when they made their pilgrimage, 'personal need or spiritual journey' was the most important factor for another 30%. Indeed, perhaps reflecting the intensity of individual as well as collective religious consciousness among a still expanding British Muslim youth demographic, there seems to have been a shift in both the custom and ideology of late modern Hajj-going in diaspora. Once an opportunity for older people to 'face al-akhira [the afterlife] with a clean sheet' (Hajj guide, the Midlands), Hajj is now increasingly seen as appropriate for the young not only because they have the financial resources or it is so physically arduous, but also because there is the possibility of piously choosing to remake one's character and self-identity in the here and now.[59]

Differences in the opportunities and resources to go on the Hajj, the sense of duty and desire of course reflect the more general diversity and divisions among Muslims in Britain, whether in terms of the complex and intersecting dynamics of social class and ethnicity, generation or religious orientation. It is also reflected in the different packages and experiences offered by Ministry of Hajj approved tour operators in the UK. Different pilgrim segments express distinctive economic and cultural logics as very brief case studies of one tour operator at the top and one tour operator in the middle of the Hajj marketplace will illustrate. Reflecting conversations with all the industry experts, as well as my own overall impressions of this and other research over nearly 20 years, I suggest that it is possible to identify two main segments in the UK Muslim pilgrimage market. At the top end of the market there is a relatively small but growing and significant 'new' middle class of upwardly mobile 'young' educated professionals in their 20s, 30s and 40s. They are increasingly cosmopolitan and reform-minded in terms of religion and, as a mirror to their own lifestyles, are typically attracted to highly professional tour operators. Thus, they are also most likely to organize their Hajj in a manner that mimics the purchase of 'mainstream' holiday packages using 'trip advisor' Hajj ratings websites for instance.[60] While there are of course overlaps, in general terms, this market can be contrasted with the established and much larger UK pilgrimage market, which in the mid-range may still be very well organized by experienced tour operators but reflect good value, as well as vestiges of a more informal economy often associated with migrant communities. Such tour operators typically serve a customer base that is less prosperous overall, or at least continues to be orientated to the organization of social and cultural life in terms of familiar networks of ethnicity and traditional Islam.

The London-based tour operator interviewed for this project was established in the late 1990s, after two organizers of university student pilgrimages across South Asian and Arab constituencies joined forces, having seen a clear business opportunity to provide a higher quality service which 'didn't cut any corners'. Committed to enabling pilgrims to minimize the very considerable stresses of performing Hajj, thus freeing them to concentrate on their spiritual journey, their aim is to make the pilgrimage 'as easy as possible', hence the motto: 'We will worry about your Hajj more than you will'. Before departure there are preparatory seminars,[61] ten experienced Hajj guides and helpers are on hand to escort the 200–300 pilgrims both in the UK and Saudi Arabia,[62] and two or three multi-lingual, ecumenically minded ulama (religious scholars) can also advise on the fiqh (jurisprudence) aspect of the Hajj across all madhahib (schools of law governing the detail of ritual behaviour amongst other things). In Mecca one mutawwaf (one who guides the pilgrim on the tawaf, the circumambulation of the Ka'ba) reportedly said of this tour operator's clients, 'If I want to see Hajj I look at your group'. By this he meant that they are especially multi-ethnic compared to other groups. However, in offering only four star and five star packages for an express (two-week) and more extended Hajj tour, which in 2011 cost between £4,000–5,000 per person including flights, most clients are middle-class British Muslims and their parents.

In contrast, the north of England tour operator interviewed for this project, a British Indian in his 60s from Gujarat, established his business in the early 1990s, following redundancy from the textiles industry. He also had previous experience of leading small groups for the Hajj and in 2011 took 395 pilgrims, mainly from a Gujarati Indian background, but anyone who is comfortable in Urdu, the lingua franca of the group, is welcome. The packages he offers are good value – 'Give them four, five star, I know the people who [are] from here, they won't be happy … not the price'. He describes the hotel used for several years until its demolition as 'nice enough, clean enough' and, all importantly, within a few minutes' walk of the Masjid al-Haram. In 2011, pilgrims paid £2,275–2,550 depending on whether they were four or two to a room and regardless of whether they travelled for five weeks or two. The tour operator is a fan of early departures for the holy places and dislikes taking professionals on express packages because they arrive too stressed, which in turn creates problems for him. He also contrasts the 'organized' Gujaratis who book very early with the 'last minute' Pakistanis. However, the biggest problem is food; 'I cannot satisfy them with the five star food or the Arabic food. They would not enjoy [it]'. Therefore, with the hotel's agreement and the appropriate immigration checks, he brings a chef from India.[63] Underlining the homeland orientation of this transnational operation, the 'alim who travels with him, is also

brought from India. More generally, he arranges one Hajj guide or helper to every 50 pilgrims, and while he does run a pre-Hajj seminar, this tour operator still prefers to brief his pilgrims face to face, being careful to manage their expectations: 'I explain to them it's not easy … I always paint the darkest picture possible. When he [sic] gets there he has no problem. He gets more than what I promised, but I don't promise what I can't produce.'

In the late 2000s British Muslims' spending on pilgrimages covered by Air Tours Organizers' Licensing (ATOL) was estimated by the Civil Aviation Authority (CAA) at £36 million.[64] For tour operators, there are therefore potentially lucrative profits with the General Secretary of the pilgrim welfare organization, The Association of British Hujjaj (ABH, see below), estimating in his interview that, especially with rising industry costs relating to greater regulation and commercialization in Saudi Arabia, as well as the related multiplication of middlemen, there is as much as £1000–1500 profit to be made per *hajji*.[65] Since the 1990s, low-cost airlines and wealthy Muslim entrepreneurs have also chartered flights to take advantage of the opportunity to transport pilgrims in their thousands from regional airports.[66] However, highlighting the unusual structure of the UK Hajj industry, the Civil Aviation Authority notes that only 12,000 (or 50–60%) of pilgrims make their bookings through approved tour operators such as the two discussed above. A significant number of British Muslim pilgrims arrange their Hajj through other channels.[67] As the central government officer elaborated, 'An ordinary pilgrim … will not walk into a travel agent [saying], "Look, I'm going for Hajj. This is my passport. How much are you going to charge me?"' While 'word of mouth' recommendations are of course important even at the top end of the market, and 'brand Islam' is increasingly marketized and mediatized for 'consumers' across very different Muslim public spheres,[68] at the lower end especially, the cultural logic of a large proportion of British Muslim Hajj organization is still very much rooted in the densely woven human relationships of mutual co-operation, honour and trust associated with networks of kinship, friendship and locality.[69] Like so many other aspects of social, economic, political and cultural life amongst British Muslims, Hajj-going is typically organized not individually but collectively as part of a larger group, with the lead often taken by a senior figure, such as a Sufi *pir* (spiritual guide), or family member.

While there may be only 80 Ministry of Hajj approved tour operators in the UK, the chief executive of the other UK pilgrim welfare organization, the Council of British Hajjis (CBH) explained that, given the pilgrim numbers agreed and paid for by tour operators in advance, 'Some will then appoint agents, sub-agents and smaller tour operators back home who aren't Ministry [of Hajj] approved because they can't meet the necessary quotas [on their own]'. Like the Association of British Hujjaj, the Council estimates that the total number of sub-agents selling Hajj packages in the UK is at least 200–50, with each of these operating various 'touts' at key points in the annual cycle such as during the month of Ramadan. Moreover, the London-based local council trading standards officer interviewed for this project speculated that

the decision of the Ministry of Hajj not to issue licenses to new operators has actually prompted the emergence of some 'rogue traders' given the profits to be made: 'a lot of people have missed the boat and so they are trying to find a different way of jumping on the bandwagon'. As well as the tout 'in the [high] street, [or] corner shop, who is a money exchanger [and] will sell this [Hajj packages] as additional business' (central government officer, London), at the very bottom of the pyramid of sub-agents are other 'members of the community'. These 'uncles' may include family and friends or imams. For instance, an intending pilgrim might very naturally ask their imam about going on the Hajj, and imams, who are rarely well paid, and employees of their mosque committees, may see the opportunity for a perk.[70] Indeed, they may be told by a sub-agent or operator, 'Your ticket will be free. You will be my guest. Bring your congregation with you' (central government officer, London). As an imam who accompanies a Ministry of Hajj approved tour operator in the north of England explained, 'those people who are living near me, they prefer to go where I am going, because they know me. I am going from 17 years. People trust me, that is why they want to trust [such and such a tour operator] … they don't know him'.

My argument here is that the informality of organizing the Hajj amongst a significant proportion of Muslims in Britain is best viewed as part of the continuing legacy of how the Hajj, and indeed so many other aspects of migrant and diasporic life in Britain, have been organized hitherto, especially amongst Pakistanis and Bangladeshis where the older generation may be relatively uneducated or even illiterate. Indeed, in excess of 80% of victims of what is now being called 'Hajj fraud' are over 65 (**Pl. 1**).[71] Unlike tour operators, who hold passports, visas (and tickets where flights are included), sub-agents and their touts are not Ministry of Hajj approved or ATOL registered. Thus, despite being the contact point for the consumer, they have no power over the delivery of services and rarely provide written contracts, receipts or accurate documentation. As the London-based trading standards officer reported, most complaints he receives are civil in nature, whether in terms of changes to verbal agreements regarding flights (delays, routes and stop-overs), misdescribed hotels or rooms or other services.[72] While such issues have been reported to trading standards departments in the UK in recent years, they are also often difficult to prosecute because of a lack of evidence or the amount of time that has elapsed since the alleged offence. Hajj fraud involves a range of industry problems including incompetence, dishonesty and outright deception. Amongst sub-agents and touts especially there is inevitably a lack of skills and knowledge of tour operators' responsibilities, while tour operators themselves can be unprofessional and disorganized concerning their liaison with the Ministry of Hajj. So, some will take pilgrims' money assuming that they can deliver, but there is no doubt that legitimate tour operators also over promise and raise pilgrims' expectations, both verbally and in terms of advertising, setting a relatively high price for low standards.[73]

In terms of outright deception, the case of Qibla Hajj Kafela Services in east London was well documented in the press during 2009.[74] As the trading standards officer

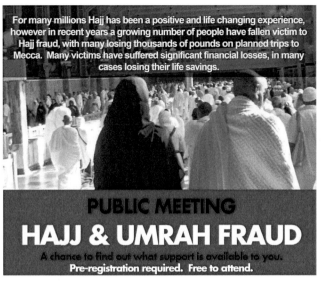

For many millions Hajj has been a positive and life changing experience, however in recent years a growing number of people have fallen victim to Hajj fraud, with many losing thousands of pounds on planned trips to Mecca. Many victims have suffered significant financial losses, in many cases losing their life savings.

PUBLIC MEETING

HAJJ & UMRAH FRAUD

A chance to find out what support is available to you.
Pre-registration required. Free to attend.

SATURDAY 21st JANUARY 2012
4pm-5pm

Wood Street Police Office
37 Wood Street
London
EC2P 2NQ

Register at: www.cbhuk.org
or call 0845 833 4145

 CBH UK

 CITY of LONDON POLICE

Plate 1 Hajj fraud now has a high public profile in the UK and sees pilgrim welfare organizations cooperate with the police and other agencies (poster courtesy of the Council of British Hajjis)

interviewed for this research explained, Mohammed Faruk Ahmed, having previously worked for a legitimate tour operator, began advertising his own Hajj packages which undercut the competition by £400–500 per pilgrim. He also claimed that he was Ministry of Hajj approved and had an ATOL licence when he did not. Eventually, legitimate traders reported him to the local trading standards department, prompting a visit to an office where he had only a single desk and filing cabinet. However, Ahmed absconded to Bangladesh with more than £500,000 and hundreds of passports only to be arrested and jailed on his return to the UK. A proactive response to this negative publicity was quickly demanded by Lutfur Rahman, the British Bengali leader of Tower Hamlets council, with trading standards representatives visiting all local mosques in a 'consultation bus' in order to raise awareness of the issues (trading standards officer, London).[75] Indicating significant social change and shaped by their socialization in Britain, many Muslims are now willing to assert their rights and challenge their experiences as consumers. However, older pilgrims especially are still reluctant to involve the authorities in investigating Hajj fraud, often for ostensibly religio-cultural reasons (central government officer, London).[76]

Pilgrim welfare, Muslim lobbying and changing contexts of public recognition

The prompt political response to the Tower Hamlets Hajj fraud case underlines the political leverage of large minority ethnic constituencies in particular locales of postcolonial Britain. However, successful lobbying on behalf of Muslim pilgrims in the UK began with a single Muslim voluntary organization in 1998 and was targeted then at national government given a primary concern with problems in Saudi Arabia. The Association of British Hujjaj (ABH) is a registered charity based in Birmingham, the city with the second largest Muslim population in the UK and one dominated by Pakistanis, the largest single Muslim ethnic group in the country.[77] At the time of writing this essay, the chairman of the Association is a middle-aged Pakistani/ Kashmiri businessman. The general secretary is a retired public servant, originally from Lahore. Formed in response to the various Hajj disasters of the 1990s, the chairman himself told of how, immediately after the 1997 tent fire at Mina which killed over 300 pilgrims and injured many more, he had been unable to determine the fate of various family members.[78] On other occasions, too, the general secretary and various local people had been unable to easily access help when they were affected by theft or death from natural causes in the holy places; it seemed that every year *hajji*s returned to Birmingham with tales of human tragedy. Thus, in a longstanding tradition of *khidmat* (voluntary religious service),[79] various businessmen and professionals in the city, together with a number of senior Muslim medical doctors and religious scholars, established the Association of British Hujjaj as a voluntary organization 'to help and protect these travellers suffering from hardship, difficulties and to prevent loss of innocent human lives due to accidents and contracting infectious diseases'.[80]

The pioneering objectives of the Association of British Hujjaj were therefore twofold: 1) to persuade the British government to better support its Muslim citizens on Hajj and 'Umra; and 2) to educate British Muslims about health and safety matters in Mecca and its environs. In terms of the former, Dr Syed Aziz Pasha of the Union of Muslim Organizations, UK and Eire (UMO), a Muslim umbrella organization founded in 1970, had called upon the Foreign Office to consider a UK Hajj mission during the early 1990s but to no avail.[81] However, when New Labour came to power in 1997, dependent on many votes from amongst the expanding Muslim populations of the UK's inner cities, a political context emerged that was more hospitable to the public recognition of Islam on a national scale.[82] The Association of British Hujjaj approached a fellow Pakistani/ Kashmiri, Baron Nazir Ahmed of Rotherham, who as a Labour councillor was raised to become the first Muslim male life peer in 1998, and it was he who provided the necessary 'bridging power' to government (**Pl. 2**). Together with Lord Ahmed, at a meeting in the House of Lords on 15 July 1999, the Association managed to convince Baroness Symons that there was a diplomatic advantage, both at home and abroad, to the UK being the first non-Muslim government in the West to establish a UK Hajj delegation.[83] However, while Lord Ahmed went on to lead the very first delegation in 2000, it was eventually decided by the Foreign Office that he would do so alongside another dignitary, general secretary of the Muslim Council of Britain (MCB, established 1997), (now Sir) Iqbal Sacranie, a Gujarati heritage businessman originally from Malawi.[84] Increasingly

privileged by New Labour in support of the effort to establish a new, professionalized British Muslim leadership as the main interlocutor with the state, yet representing a very different religio-ethnic segment of interests than the Association of British Hujjaj, at the time, the MCB was criticized for seeking to assume control of the work of existing Muslim organizations. Indeed, the general secretary of the Association of British Hujjaj, is on record suggesting that the whole British Hajj Delegation initiative had been 'hijacked' and 'politicized',[85] with the proposed delegation and its leadership increasingly dominated by MCB affiliates. When Lord Ahmed resigned his role, it was a member of the MCB's Board of Counsellors, and another new Labour peer, Lord Adam Patel of Blackburn, also of Gujarati heritage, who subsequently led the British Hajj Delegation from 2001, the year in which the MP for Blackburn, Jack Straw, became Foreign Secretary.

While the core concern of the British Hajj Delegation was medical,[86] it was also part of a wider Foreign Office strategic priority which saw domestic and foreign policy interests converge post 9/11. There was a desire to improve both British Muslim perceptions of UK government activities overseas and promote better relations with the Arab and Muslim world more generally.[87] In its heyday, this exercise in soft power was ritually performed when Foreign Secretary Straw launched the delegation annually in partnership with its leader and 'representative' of British Muslims, Lord Patel. In the company of various ambassadors and diplomats, this event was hosted at the home of the wider Muslim world in the UK, the Regent's Park Islamic Cultural Centre.[88] Even while in other arenas of policy 'old' Labour state multiculturalism faced stern criticism, this gathering communicated New Labour's communitarian vision for the UK as a multi-faith, participatory democracy where, as active citizens, British Muslims could take a role in UK diplomacy.[89] Moreover, while many of the medics of the British Hajj Delegation funded their own locum cover, the government was forced to defend criticism of the overall cost of the Delegation when it was clarified that the pilgrimages of other faiths were not being supported in a similar fashion.[90] Lord Ahmed retorted that the Delegation saved the National Health Service £1 million annually, while Sir Michael Jay, head of the diplomatic service, maintained that the Hajj was 'a unique event which merits special attention'.[91] Nevertheless, during the 2000s, the Foreign Office expenditure on the British Hajj Delegation increased every year from around £40,000 in 2004 to £110,000 by 2009.[92] A Hajj Advisory Group had also been established in 2001–2 with a view to encouraging British Muslims to independently support the British Hajj Delegation. However, despite the involvement of the Muslim Council of Britain, the Association of British Hujjaj and other organizations with close connections to diverse Muslim constituencies,[93] such finance was not forthcoming.[94] Thus, the Hajj Advisory Group was abolished in 2006,[95] the year that Jack Straw left the Foreign Office.

Tellingly, since its inception, there has been no mention at all of the British Hajj Delegation or Lord Patel on the website of the Association of British Hujjaj. In addition, since 2004, and always a few weeks before the official launch

Plate 2 Patron of the Association of British Hujjaj, Lord Ahmed of Rotherham, is inoculated at an event during Hajj Awareness Week (picture courtesy of the Association of British Hujjaj)

of the Delegation, the patron of the Association of British Hujjaj, Lord Ahmed, has hosted a complementary but parallel event, 'Hajj Awareness Week', from the House of Lords. There are also pre-Hajj camps and seminars organized by the Association in cities with significant Pakistani numbers, including Bradford, Manchester and Glasgow as well as Birmingham and London. Indeed, as a voluntary organization, the Association secured small pots of funding from the state to deliver key messages to these government-identified 'hard to reach' communities during the 2000s.[96] For instance, when, in 2001, an outbreak of the rare W135 strain of meningitis was traced to UK pilgrims or those who had been in close contact with them,[97] the Department of Health worked in partnership with both the Association of British Hujjaj and the Muslim Council of Britain to raise awareness of the issues, including new Ministry of Hajj immunization requirements.[98] Officers of the Association of British Hujjaj make regular contributions, too, in the British Pakistani diasporic public sphere,[99] including the Urdu press and newly burgeoning Islamic satellite television sector.[100] However, in my online survey, which has a bias towards younger Muslims who use social media, only 24% of respondents were aware of the existence of the Association. Similarly, the London-based trading standards officer argued that while the Association is clearly 'doing their bit for the Hajj … I don't think a lot of local [British Bangladeshi] pilgrims in Tower Hamlets are aware of what ABH are doing or whether they exist'.

While it would be right, therefore, to question whether the Association of British Hujjaj has comprehensive national coverage, my argument is that pilgrim welfare organizations reflect the general dynamics and limitations of established patterns of voluntary organizing amongst Muslims (and other religio-ethnic groups) in the UK. The Association is best understood as an expression of established (but far from unified) Pakistani Muslim networks and interests, and it is this constituency that it serves to a greater or lesser extent. Indeed, reinforcing my analysis in the previous section, the

chairman of the Association acknowledges that 'our people, due to lack of education, they do not take full precautions … unfortunately it's still a lot of people who are travelling with the *chacha lalas* [uncles]'. Hajj fraud is an increasingly important concern of the Association of British Hujjaj, with its home town trading standards department in Birmingham claiming that only four out of 40 Hajj and 'Umra tour operators and agents in the city were fully compliant with UK package tour regulations in 2012.[101] Estimating that only 10% of Hajj fraud is reported,[102] and well aware of the religio-cultural factors inhibiting this, the Association of British Hujjaj argues that it is the responsibility of central government to proactively benchmark and regulate the UK Hajj and 'Umra industry as distinct from the 'secular' travel and tourism industry. Indeed, following lobbying by the Association, their then local MP, Roger Godsiff, led a House of Commons debate on 25 March 2009 concerning 'Hajj Pilgrims (UK Tour Operators)'.[103] Reflecting the organization's view that the Department for Business, Enterprise and Regulatory Reform was taking a 'soft approach' to these issues in stressing only better consumer awareness, it was suggested that all travel agents should pay a bond to the Association of British Travel Agents with 'a number of small tour operators going out of business … a price worth paying' to protect a vulnerable community.

If the Association of British Hujjaj reflects the networks of British Pakistanis, the second and only other Hajj welfare organization of any significance in the UK, the Council of British Hajjis, is based in Bolton, Lancashire which, like other north-west locations, is a key UK node in Gujarati/ East African Asian Muslim networks.[104] While this means that the Council of British Hajjis also has links to another key British Indian political figure in Lord Patel, notably, the Council of British Hajjis is a British-born led initiative, too, and so reflects certain frustrations with an older generation of community leaders.[105] Nevertheless, like the leadership of the Association of British Hujjaj, the chief executive of the Council of British Hajjis, who is an information technology professional in his 30s, roots his narration of how the Council came about in his own pilgrimage experience. In 2005 he and his new bride performed the Hajj in style with a five star package, but the chief executive witnessed that many pilgrims were simply being 'dumped' by their tour operators in the holy places and told 'fend for yourself' – 'For them … the experience of going … to see the Ka'ba was a frustration, [one of] worry, panic'.[106] He describes being inspired to return to the UK and to try and make a difference. Indeed, his grandfather was a volunteer member of the Haj Committee of India (established in 1932), a legacy of the Raj that the Council of British Hajjis chief executive feels Britain can be proud of. Having subsequently attended a Muslim Council of Britain 'Health at Hajj' seminar in London during 2006, however, he was left wondering why so much accumulated knowledge was still not being communicated to British Muslims at the grassroots; 'Why weren't people being educated?' As a pilgrim himself, he reports never having heard of a UK-based pilgrim welfare organization. However, according to my online survey, only 23% of respondents had heard of the Council of British Hajjis (1% less than Association of British Hujjaj). This

suggests that, at present, it is no better known nationally. Each organization inevitably ends up doing quite similar work within its own networks because of their parallel ethno-denominational locations and constituencies.

Since holding their own 'Health at Hajj' seminar in Bolton during 2006, the volunteer young professionals of the Council of British Hajjis have delivered various events, including flu and meningitis vaccination clinics, in 30 locations around Lancashire, Yorkshire and beyond.[107] Echoing the *hadith* (saying or action attributed to the Prophet Muhammad), the chief executive's pithy message of 'trust in God but tie your camel' is also broadcast using the electronic media, though again in a diasporic public sphere distinct from the Association of British Hujjaj (for example, Iqra' TV, Islam Channel and BBC Asian Network). Moreover, unlike the Association, which imagines a more interventionist welfare state, the Council of British Hajjis emphasizes the need for Muslim self-regulation of the Hajj and 'Umra industry in the UK, a view which reflects both the position of the New Labour (1997–2010) and the Conservative/Liberal Democrat coalition (2010–) governments. In a secular, multi-faith society the central government officer interviewed for this project was clear that the UK state 'does not want to control religious pilgrimage … [it is] important that tour operators work together and have a national body'. Indeed, in the 2009 House of Commons debate mentioned above, New Labour reported on a Department for Business, Enterprise and Regulatory Reform 'compliance summit' (16 July 2008) organized to 'hear [from tour operators] their views on how they believe the sector can improve its reputation and achieve greater consumer confidence'.[108] While the Civil Aviation Authority subsequently reported increased Air Tours Organizers' Licensing and International Air Transport Association (IATA) registrations among UK tour operators, perhaps unusually for a watchdog, the Council of British Hajjis itself seized the opportunity to establish a national body and launched a British Hajj and 'Umrah Council.[109] This move exemplified the argument of the central government officer that, while tour operators – and indeed established Muslim representatives in Britain more generally – lack leadership, they are being 'shaken up' by a younger generation of 'can-do' activists with greater capacities in this regard.

In the wider context of austerity Britain, and a new emphasis on a 'small state' and the 'big society', in 2010, the new coalition government, despite petitioning from the Association of British Hujjaj, the Council of British Hajjis and others, withdrew its support for the British Hajj Delegation.[110] In public communications, consular ministers also seemed to adopt a more admonitory tone with pilgrims, urging them to heed Foreign Office travel advice and 'take responsibility for their own pre-travel preparations'.[111] Suggesting that British Muslim organizations no longer had the ear of government, in sharp contrast to the previous decade, the review of the British Hajj Delegation 'did not include consultations with community leaders but, rather, took an objective view.… The Foreign Office does not provide medical services at any other event involving large numbers of British nationals'.[112] In the context of economic deficits, and the envy which government resources directed

to Muslims have aroused,[113] a Tory establishment with fewer political reasons to court British Muslims decided that the Hajj was no longer 'unique' or deserving of 'special' support. Government argued that there had been a significant improvement in Saudi medical facilities and a related drop in demand for the medical services of the British Hajj Delegation although this was strongly contested by the Council of British Hajjis.[114] And yet, a new chapter in the story of the Delegation is already beginning, with its relaunch as a private British Muslim initiative by Lord Patel at the Islamic Cultural Centre on 29 September 2012.[115] On the new organization's website, and for the very first time, the logo of the Association of British Hujjaj sits alongside that of the Council of British Hajjis, as well as those of certain well-known Ministry of Hajj approved tour operators. It will be fascinating to see firstly whether, in the absence of financial support from the UK state, the new British Hajj Delegation can build leadership capacity and sustainable intra-Muslim alliances; secondly, what if any relationship it will have to attempt to establish a national body for tour operators; and thirdly to what extent any such developments will positively impact on the experiences of pilgrims.

Conclusion

In this chapter I have elaborated the first in-depth account of the organization of Hajj-going amongst late modern Muslim diasporas in the West. My study of the UK contributes a local case study to a developing literature on the global cultural and political economy of the pilgrimage. Three key arguments have been made. Firstly, by way of setting the wider context, I have suggested that restructuring of the late modern Hajj in Saudi Arabia is the outcome of twin processes. Greater regulation and commercialization would seem to be a response not only to the unprecedented demand for the pilgrimage on a global scale, but also the Kingdom's desire to diversify and liberalize its non-oil economy through religious tourism. While further research is needed in this regard, I have outlined how such transformations have been crucial in shaping the growth of large, increasingly professionalized private tour operators in the UK. For their part, such operators appreciate the great demands made upon Saudi Arabia in managing the late modern Hajj, though greater rationalization has not yet eliminated problems of efficiency and has provoked concerns about the balance between necessary modernization and care for Islamic heritage.

Secondly, the free market for Hajj-going in the UK reflects the fact that Muslim diasporas (and converts) in the West are relatively privileged as compared to their co-religionists worldwide. They typically have the opportunity, as well as the resources, to pursue both their duties and their personal desires in terms of the pilgrimage. This makes the industry here potentially very lucrative for tour operators. Nevertheless, I have suggested that in the UK they serve at least two distinctive market segments, one more 'cosmopolitan' and the other more 'traditional'. Each identifies quite different cultural-economic logics. The former segment mimics patterns of consumption in the mainstream 'premium' travel and tourism market and is attractive to a relatively small but growing British Muslim

middle-class. However, this vernacular iteration of Muslim modernity is also typically inflected with the pervasive values and aesthetics of an outward-looking, post-Islamist cultural turn which disaggregates individual self-identity from more inward-looking inheritances of homeland ethnicity. While opening up new and exciting sites of study for researchers, I argue that an examination of cosmopolitan Muslim consumer markets must be complemented and contextualized with studies of a more 'traditional' and less fashionable but no less important market segments. The fact is that the majority of tour operators serve intending *hajjis* still entwined not only with 'traditional' forms of received religious knowledge and authority but also ethnic networks of collective duty, trust and obligation. Thus, many of the 'choices' made within this larger constituency still reflect traces of earlier patterns of Hajj-going. Nevertheless, there is very rapid social change within this segment, too, something suggested by growing appeals to secular 'consumer' rights when confronted by Hajj fraud.

Finally, in an echo of developments under the British Raj in India,[116] and reflecting New Labour's balancing of neoliberal governance with more communitarian agendas, I have argued that the Hajj became a temporary focus for greater public recognition during the 2000s. Awareness of pilgrims' needs in Saudi Arabia and vis-à-vis the UK-based pilgrimage industry has emerged largely because of British Muslims' activism in civil society. Key umbrella organizations and pilgrim welfare organizations have undoubtedly taken advantage of political opportunity structures in late modern Britain, in particular, historically entrenched ideologies of multiculturalism and 'faith' relations. However, the pilgrim welfare lobby in the UK still reflects the finite capacities, as well as the divisions, of British Muslim voluntary organizations per se. Overall, they lack leadership capacity and independent resources, while also remaining divided in terms of ethnicity, denomination and generation, as well as their expectations of government. Thus, what was crucial in better recognition and regulation of Hajj-going in the UK during the 2000s was ultimately a changing political context. While seeking to show itself to be 'Muslim-friendly' abroad, at home the New Labour government needed to incorporate British Muslims, both to secure important inner city votes and to implement key policies associated with cohesion and security.

List of acronyms:

Organization of Islamic Cooperation – OIC
Ministry of Hajj – MOH
Air Tours Organizers' Licensing – ATOL
The Civil Aviation Authority – CAA
The Association of British Hujjaj – ABH
Union of Muslim Organizations – UMO
Muslim Council of Britain – MCB
Air Tours Organizers' Licensing – ATOL
International Air Transport Association – IATA
Islamic Cultural Centre – ICC
Council of British Hajjis – CBH
British Hajj Delegation – BHD
Islamic Cultural Centre – ICC

Notes

1 I would like to thank the *Hajj: journey to the heart of Islam* exhibition curator, Dr Venetia Porter, for inviting me to collect the data for this research as part of the grant awarded to the British Museum

by the Arts and Humanities Research Council (AHRC) and also the School of Philosophy, Religion and the History of Science at the University of Leeds for awarding me the sabbatical leave in 2012–13 which funded the writing up of this essay. I would also like to thank all the respondents who generously gave of their time, as well as research assistants, Dr Asma Mustafa and Mrs Rabiha Hannan, who between them conducted three of the 'Hajj industry' interviews on my behalf in London and Leicester respectively. Thanks also to British Museum curator, Ms Qaisra Khan, for her support during the research process, to Dr Jas Singh for his survey expertise, and to Dr Muzamil Khan for longstanding conversations about the Hajj and British Muslims, as well as access to his contacts in the north of England.

2 Roff 1985.

3 Pearson 1994; Peters 1994a.

4 On late modernity in general terms, see Baumann 1989; Giddens 1990; Ritzer 1993.

5 These topics have included travel and the religious imagination, the idea of sacred homelands, ritual transformations of identity and social change (Eickelman and Piscatori 1990; Fischer and Abedi 1990; Delaney 1990; Werbner 1998).

6 One of the most recent and significant memoirs published in English is that of the Moroccan-American Muslim anthropologist, Abdellah Hammoudi (2006). Except for his own account, the recollections of the 'Jet Age Hajj' in Wolfe 1997 are all pre-1990, including Jalal Al-e Ahmad and Malcolm X in 1964.

7 Woodward 2004; Sadi and Henderson 2005; Burns 2007; Haq and Jackson 2009; Henderson 2011.

8 Bianchi 2004.

9 The relevant annual figures for 2004–8 are as follows: 2004 (22,270); 2005 (27,910); 2006 (25,000); 2007 (21,715); 2008 (18,604). See http://www.publications.parliament.uk/pa/cm200809/cmhansrd/cm090226/text/90226. In 2009 the figure was 23,000, http://www.britishhajjdelegation.org.uk/about.php.

10 Bianchi 2004: 63.

11 McLoughlin 2009a; 2009b.

12 On globalization, see Appadurai 1990 and 1996. On the tailoring of the global to different local, national and regional contexts, which are themselves trans-locally linked, see Robertson 1995.

13 Approximately 75% of Muslims in Britain are of British Asian heritage.

14 Interview, 19 October 2011.

15 Interview, 3 December 2011.

16 Interview, 26 October 2011. Notably, British Arabs were generally more reluctant to participate in this research than their British Asian counterparts.

17 Interview, 26 October 2011.

18 Interview, 3 December 2011.

19 Interview, 23 October 2011.

20 Interview, 15 October 2011.

21 Interview, 20 October 2011.

22 Interview, 20 October 2011.

23 The survey collected 211 responses; https://www.survey.leeds.ac.uk/hajj.

24 A search for 'Hajj' at www.parliament.uk on 8 September 2012 produced 129 results.

25 Bianchi 2004: 50.

26 Bianchi 2004: 50.

27 Whether Muslim states entirely monopolize the organization of Hajj or simply regulate the work of private agents varies considerably country to country at a particular moment in time. See Bianchi 2004. On Islam and modernity in general see Turner 1994. On new Muslim public spheres, see Eickelman and Anderson 1999/2003.

28 On Wahhabism see DeLong-Bas 2008. On Saudi Arabia, see, for example, al-Rashid 2010.

29 Peters 1994a: 362.

30 Fischer and Abedi 1990: 169.

31 Gatrad and Sheikh 2005.

32 Bianchi 2004: 51; cf. http://www.hajinformation.com/main/m40.htm. However, this initiative was also a means of counteracting revolutionary Iran's political appropriation of Hajj following a major clash in 1987.

33 For an account from a Saudi government perspective, see http://www.kapl-hajj.org/.

34 Burns 2007: 219.

35 Sadi and Henderson 2005: 249, 256; cf. Park 1994; Burns 2007. In an effort to avert social unrest, the Saudis have also embarked upon a very ambitious programme of the 'Saudization' of its workforce, which has hitherto relied heavily on expatriates. For instance, in the mid-2000s only 16% of hotel staff was Saudi. Tourism was seen as having the potential to produce more private sector employment for Saudis.

36 Burns 2007: 229. In 2000 58% of international tourist arrivals in Saudi Arabia were for Hajj or 'Umra and 47% of international tourism expenditure in 2001 concerned Hajj or 'Umra. Other significant categories included 'visiting friends and relatives' and 'business/conferences'.

37 Henderson 2011: 541.

38 See, for example, *Guardian* (23 October 2012), which cites Saudi architect and activist, Sami Angawi, as well as UK-based Saudi, Irfan al-Alawi, http://www.islamic-heritage.org/.

39 http://www.bbc.co.uk/news/world-middle-east-20067809.

40 For an account of Hajj travelling overland from the UK in 1977, see Thomson 1994.

41 http://www.hajinformation.com/hajj_agents.php?id=53.

42 http://www.hajinformation.com/main/n4.htm. Within this bracket it is possible to apply to bring pilgrims in increments of 300.

43 Woodward 2004: 184, reports that outside Hajj and Ramadan periods, hotel occupancy is just 20%, with an overall annual average occupancy of around 60%.

44 Literally 'teacher' or one who shows a pilgrim how to perform Hajj. While the late modern *mu'alim* is effectively an agent, many have a longstanding family history of serving *hujjaj* (Woodward 2004).

45 As a time of spiritual reflection, this is also a key moment for many intending pilgrims to declare their intention to travel.

46 On 26 January 2004, Labour MP for Putney in London, Tony Colman, tabled 'Early day motion 481 British Citizens and Saudi Visas for Hajj' which details that while applications for Hajj visas 'must be accompanied by return airline tickets … there is no certainty that a visa will be granted … the substantial cost of a return fare to Saudi Arabia will be forfeited in the event of a refusal'. The motion called upon the Saudis to 'either abolish the requirement to buy a ticket in advance or refund the cost to the ticket to unsuccessful applicants'. See http://www.parliament.uk/edm/2003-04/481.

47 Henderson 2011: 546 quotes estimated public costs of US$3,967 million for 'the religious services sector' during the 2005–9 Saudi planning period.

48 Sadi and Henderson 2005 explain that progress on 'Saudization' has been slow because of a lack of training opportunities but also because the population has come to expect well-paid but undemanding public sector white collar positions.

49 Bianchi 2004: 279. This data is reported in an appendix and does not cover later periods despite his work being published in the last decade.

50 See n. 2 above.

51 Peach 2005: 23. No 'ethnicity' question was asked in the UK Census until 1991 and a 'religion' question was asked for the first time since 1851 in 2001.

52 Peach 2005: 23.

53 http://www.ons.gov.uk/ons/rel/census/2011-census/key-statistics-for-local-authorities-in-england-and-wales/rpt-religion.html.

54 Bianchi 2004: 53.

55 Bianchi 2004: 53. I have spoken to international Muslim students in Leeds who view their residency here as providing a great opportunity to perform Hajj given the competition for places at home. For example, Turkey's population is roughly 75 million and 99% Muslim, so its official quota is roughly around 75,000. See also, http://www.todayszaman.com/columnist-293279-iran-prime-culprit-for-slashed-hajj-quotas.html.

56 The majority of British Pakistanis actually hail from Pakistani-administered 'Azad' Kashmir.

57 For instance, the numbers from Pakistan performing Hajj has been low relative to population size, Park, 1994: 271.

58 McLoughlin 2009a, 2009b.

59 Interestingly, some young British Muslims are choosing to mark their marriage as a significant rite of passage by going on Hajj together. Moreover, while many pilgrims still incorporate a stopover in the holy places on a homeland visit, such ties are weakening amongst diasporic youth, with Islam providing one alternative space for 'homing desires': 'Instead of going on holiday somewhere else [i.e. Pakistan, India, Bangladesh], why not go on Hajj, or on 'Umra?' (imam and Hajj guide, north of England). McLoughlin 2009a, 2009c, 2010a.

60 See http://hajjratings.com/ and http://hajjbuddy.com/rate/. See Haq and Jackson 2009 for a very rare study of the experiences of Hujjaj, in this case middle class Pakistanis and Pakistani Australians.

61 I observed a London seminar organized by this tour operator on 9 October 2011 and conducted informal interviews with the tour operator, Hajj guides, a doctor and pilgrims.

62 The Ministry of Hajj requires tour operators to provide only one guide or helper for every 100 pilgrims, http://www.hajinformation.com/main/n4.htm.

63 For a discussion of foreign workers in the Saudi hospitality and tourism industry, see Sadi and Henderson 2005.

64 *Hajj: Pilgrimage to Mecca – essential information about fraud*, 15 October 2010, National Fraud Intelligence Bureau and City of London Police, http://www.fco.gov.uk/en/travel-and-living-abroad/your-trip/hajj-pilgrims; see also http://islamicmonitor.blogspot.co.uk/2008/11/launch-of-national-hajj-awareness.html.

65 *QNews* (1 April 2000) gives some insight into Hajj packages available in north-west London just over a decade ago, with prices then ranging from £1,400 to £1,750 for an average of five sharing over 2–3 weeks. It was cheaper travelling from Europe, with £830 buying a trip sleeping on the floor in flats away from Haram with another 150 people. No food (or flights) included. The article suggests that even then profits of £600 per pilgrim could be made.

66 See http://artsweb.bham.ac.uk/bmms/1996/03March96.html#Hajj from Britain, http://artsweb.bham.ac.uk/bmms/1997/04April97.html#Hajj and Eid news.

67 *Hajj: Pilgrimage to Mecca*, op cit.

68 Cf. Kılıçbay and Binark 2002 on Islamic consumer culture and lifestyles in Turkey with a focus on veiling, as well as Tarlo 2010 on British Muslim fashion.

69 Cf. Shaw 2000.

70 On mosques and imams, see McLoughlin 2005a; and for critical commentary on imams as Hajj touts, see the London edition of the *Daily Jang* (ABH religious scholar).

71 *Hajj: Pilgrimage to Mecca*, op. cit.

72 He reports having received 34 complaints in 2011. One complainant (letter, 3 August 2011) from E14 paid £2,200 per pilgrim for a separate room for his family party of five people. However, on arrival men were separated from women and he was directed to a bed in a room with six others which had one shared bathroom and was never cleaned; in his absence he was also evicted from one tent in Mina and moved to another: 'Please note many pilgrims suffer a lot because of such mismanagements but don't complain, reason being of their holiness for becoming *hajjis*'.

73 Where quality is compromised in terms of accommodation, food or transport, the impact on the elderly and frail with other illnesses such as diabetes and heart conditions can be especially deleterious. See Gatrad and Sheikh 2005.

74 http://news.bbc.co.uk/1/hi/uk/8144531.stm.

75 According to the 2011 Census the population of Tower Hamlets is 32% Bengali and 34.5% Muslim, the highest proportions respectively in the UK, http://www.ons.gov.uk/ons/guide-method/census/2011/index.html.

76 If having told everyone they know that they are going for Hajj and there is a problem some may perceive this as a curse or not being 'called' by God. Tour operators may also deploy emotional blackmail in religio-cultural terms, insisting that Hajj is a *jihad* (struggle) and that those who complain will not have their pilgrimage 'accepted' by Allah. There is also an established religio-cultural attitude that, having become a *hajji*, one does not speak of worldly things. Communities may reinforce such silence, too, especially if family are involved.

77 At the 2011 Census, 21.8% of Birmingham's population was Muslim, while 144, 627 Pakistanis represented 13.5% of the population, http://www.ons.gov.uk/ons/guide-method/census/2011/index.html.

78 Apparently the FCO was unsure of how many British Muslims were performing Hajj in 1997 because many held dual nationality, http://artsweb.bham.ac.uk/bmms/1997/04April97.html#Hajj and Eid news.

79 Cf. Werbner and Anwar 1991, Werbner 2002.

80 ABH 2010 annual report and financial statements, http://www.charitycommission.gov.uk/Showcharity/RegisterOfCharities/CharityWithoutPartB.aspx?RegisteredCharityNumber=1087426&SubsidiaryNumber=0.

81 See the blog of Dr Mozammel Haque, Media Advisor of the Islamic Cultural Centre (ICC). The ICC provided the secretariat for the Hajj Advisory Group (2002–6), http://islamicmonitor.blogspot.co.uk/2012/10/launch-of-british-hajj-delegation-2012.html.

82 McLoughlin 2002, 2005b. Following the Rushdie Affair the Tories did not concede any Muslims claims for public recognition as 'Muslims' and insisted that they speak with one voice. This led to the founding of the MCB.

83 *Independent on Sunday*, 17 October 1999. France and Germany were set to follow the UK's lead, http://collections.europarchive.org/tna/20080205132101/blogs.fco.gov.uk/blogs/the-hajj/.

84 Perhaps because of subsequent criticism (see following note), Sacranie is rarely mentioned in this regard, for example, http://islamicmonitor.blogspot.co.uk/2011/10/hajj-and-british-muslims-historical.html.

85 *QNews*, 1 March 2000. McLoughlin (2002, 2005b, 2010b, 2012) has argued that the vast majority of British Pakistanis have had nothing to do with the MCB, which traces its roots to the UK Action Committee on Islamic Affairs formed during the Rushdie Affair. The MCB has been dominated by an alliance of well organized activists with historical links to Jama'at-i Islami amongst middle-class Pakistanis and Deobandism among Gujeratis/East Africans like Sacranie and Patel. Despite representing probably the single largest constituency of British Muslims, even when the MCB's star fell in the mid-2000s, rival Pakistani organizations with historical links to Sufism and Barelwism such as the British Muslim Forum and the Sufi Muslim Council miserably failed in their bids to recover mainstream political influence, in part because of fragmented structures of religious authority.

86 Between 2000 and 2009 the British Hajj Delegation (BHD) included eight or nine volunteer British Muslim doctors, including eventually one or two women doctors, as well as a chief medical adviser. They were joined as part of the BHD by one or two counsellors and two or three FCO staff from the UK's consulate in Jedda. According to all the constituencies interviewed, the undoubted benefits of the BHD in Mecca and beyond were twofold: firstly, pilgrims no longer had to leave Mecca and make the long journey to Jedda to access consular services; secondly, unlike the doctors delivering medical services on behalf of Saudi Arabia, some of whom were from overseas, the BHD doctors were English-speaking and offered a home-visiting service to those too ill to travel (*Asian Image*, 11 October 2010).

87 This included UK universities, the British Council, the BBC World Service, and sat alongside military and political interventions in Afghanistan. See http://www.publications.parliament.uk/pa/cm200405/cmselect/cmfaff/36/36we06.htm.

88 The ICC was finally opened in 1977, following the UK government gifting a site in Regent's Park, London, to the Muslims of Great Britain and its empire during the 1940s. Subsequent funding for the building came from the Saudis and others, with several Muslim embassies acting as trustees, http://www.iccuk.org/index.php?article=1&. While never formally colonized, Britain has longstanding political and economic relations with Saudi Arabia.

89 McLoughlin 2005b, 2010b, 2012.

90 *The Independent*, 28 April 2003.

91 No special support is given to Hindus from the UK participating in the Kumbh Mela which has been 'trouble free' hitherto, http://www.publications.parliament.uk/pa/cm200001/cmhansrd/vo010118/text/10118.

92 *Asian Image*, 11 October 2010.

93 http://www.theyworkforyou.com/wrans/?id=2007-01-30b.112114. h&s=Hajj+delegation#g112114.r0.

94 In 2003–4 the total projected cost of the BHD of £65,000 was offset in part by sponsorship of £10,000 from Bombay Halwa Ltd and also £5,000 from GlaxoSmithKline, http://www.publications. parliament.uk/pa/cm200304/cmselect/cmfaff/745/745we10.htm.

95 http://www.theyworkforyou.com/wrans/?id=2009-02-24a.47.0&s =Hajj+delegation#g47.1.

96 See for instance, http://www.publications.parliament.uk/pa/ cm199900/cmhansrd/vo000707/text/00707w12.htm.

97 http://www.publications.parliament.uk/pa/cm200001/ cmhansrd/vo010503/text/10503w16.htm.

98 Interestingly, the leaflet, *Advice to British Hajjis* (2001/02), was sponsored in part by British Airways and Noon Products/Bombay Halwa Ltd. The previous year three women in Blackburn, Liverpool and Ilford had died from the same infection having returned from Hajj. See British Muslims Monthly Survey, http:// artsweb.bham.ac.uk/bmms/2000/04April00.asp.

99 Werbner 2009.

100 Channels include Noor TV (established 2006), Ummah Channel (established 2009) and Takbeer TV (established 2010). These are an especially significant means of reaching Muslim women, with the Midlands guide interviewed for this research complaining that they are too often treated as 'appendages' to Hajj travel groups, with knowledge rarely shared with them directly.

101 http://www.birminghammail.co.uk/news/local-news/watchdog-calls-on-government-to-stop-muslims-181285.

102 *Hajj: Pilgrimage to Mecca*, op. cit.

103 http://www.publications.parliament.uk/pa/cm200809/ cmhansrd/cm090325/halltext/90325h0004.htm. Godsiff was MP for Labour, Sparkbrook and Small Heath 1992–2010.

104 In Bolton 11.7% of the population was Muslim (32,385) in 2011, with around 15,000 of Indian heritage and 12,000 of Pakistani heritage, http://www.ons.gov.uk/ons/guide-method/census/2011/index. html.

105 Cf. Lewis 1997.

106 The institution of the *mutawwaf* has more or less vanished, which means that Muslims who do not necessarily know the *adab* (Islamic etiquette and manners) of the holy places are often left without guidance (ABH religious scholar).

107 http://www.the-cbh.org.uk/.

108 http://www.publications.parliament.uk/pa/ld200708/ldhansrd/ text/80630w0004.htm.

109 http://www.bhuc.org/. If the independent-minded north of England tour operator is anything to go by, the CBH may have its work cut out to win UK tour operators around to the idea of a trade organization: 'You don't get everybody in same frame of mind. I can't see that happening. I do my own thing. It keeps me free.' Moreover, following the Department for Business, Enterprise and Regulatory Reform summit, an Association of British Hajj and Umrah Agencies has also been established in East London, comprising 10 to 12 Ministry of Hajj approved members, which account for about 80% of the market amongst British Bangladeshis there and beyond (trading standards officer, London).

110 *Asian Image*, 11 October 2010.

111 https://www.gov.uk/government/news/travel-advice-for-hajj-pilgrims.

112 http://www.theyworkforyou.com/wrans/?id=2010-11-01d.19875.h &s=Hajj+delegation#g19875.q0.

113 Birt 2009.

114 'The number of people treated for minor ailments was 5,967 in 2007, 2,965 in 2008 and 254 in 2009', http://www.theyworkforyou. com/lords/?id=2010-11-11a.345.3&s=Hajj+delegation#g380.1. However, 'The advertisement of the delegation being there came out too late … people didn't know where the delegation was' (CBH chief executive).

115 http://www.britishhajjdelegation.org.uk/.

116 As other contributions to this volume illustrate, under the British Raj during the nineteenth century, Muslim public servants, including an assistant surgeon and female superintendent, accompanied Indian pilgrims and guidance was provided to them in the form of a handbook, *Bab-i Makkah*. In the context of a cholera epidemic during steam age globalisation, the Viceroy also asked travel agent, Thomas Cook, to reform the management of Hajj-going in British India.

Glossary

Ahl al-kitab: 'People of the book'. This is a Qur'anic term used to refer to Jews and Christians who in addition to Muslims were also believers in a revealed book.

Amir al-Hajj: the official leader of the Hajj caravan.

Amir al-Mu'minin: Commander of the Faithful, one of the titles of the caliphs.

'Arafat: the desert plain 15 miles east of Mecca. At its centre is the Mount of Mercy (*Jabal al-Rahma*). It is here that the vigil known as *wuquf* (standing) takes place from noon to sunset on the 9th Dhu al-Hijja. This is the high point of the Hajj. 'Arafat is where the Prophet Muhammad gave his Farewell Sermon in 632, the year of his death.

basmala: the phrase *bismillah al-rahman al-rahim*, the invocation 'in the name of God the Merciful the Compassionate'.

The Black Stone: the large stone set into the south-eastern corner of the Ka'ba about four feet from the ground.

burqu': veil; a term used along with *sitara* for the covering of the Ka'ba.

caliph: from Arabic *khalifa*, successor or follower. Title given to the leaders of the Muslim community following the death of the Prophet Muhammad in 632.

Dar al-Islam: the territories of Islam.

Dhu al-Hijja: the last lunar month of the Islamic calendar, during which the Hajj takes place.

du'a: prayers or supplications to God or revered figures in Islam.

Eid al-Adha: the feast of sacrifice. The festival which marks the formal end of the Hajj and continues for a further three days. It takes place on the 10th of the month of Dhu al-Hijja. For Hajj pilgrims the Eid occurs while they are at Mina.

The Five Pillars of Islam: five principles that are central to Muslim belief: *shahada*, the Profession of Faith: 'there is no god but God, Muhammad is the prophet of God'; *salat*, the five prayers that are performed daily; *zakat*, the giving of alms; *ramadan*, fasting during the 9th Islamic month; the Hajj, the pilgrimage to Mecca.

Hadith: the traditions which relate to the life, sayings and actions of the Prophet Muhammad. It refers to the complete body of traditions (The *Hadith*) or to single texts (a *hadith*).

Hajj: the pilgrimage to Mecca and one of the Five Pillars of Islam. It takes place between the 8th–12th of the month of Hajj, Dhu al-Hijja, the last month of the Muslim calendar. The term for a person who undertakes the Hajj is a *Hajj* or *Hajji* for a man and *Hajja* for a woman. The phrase *Hajj Mabrur*, 'congratulations on the Hajj' is said on a pilgrim's return.

Haram: sanctuary; refers to the entire sanctuary area at Mecca. At the centre is the Ka'ba which stands in an open space enclosed by porticoes. It also contains various other structures including the Maqam Ibrahim, the *hijr* and the Zamzam well (see separate entries). The area immediately surrounding the Ka'ba is known as al-Masjid al-Haram as it was once regarded as a mosque.

Al-Haramayn: the two sanctuaries. Refers to the Haram at Mecca and the Prophet's Mosque (al-Masjid al-Nabawi) at Medina.

hijr: an area of particular sanctity within the Haram on the north-western side of the Ka'ba. It is defined by a low

semi-circular wall known as *hatim* and is identified in Muslim tradition as the burial place of Isma'il and Hagar.

hijra: flight or emigration. Refers to the Prophet Muhammad's departure from Mecca in 622 and gives its name to the Muslim lunar calendar. 622 is year 1 of the Islamic (Hijra) calendar.

hilya: from the Arabic meaning adornment. In the Ottoman era, *hilye* also the physical description of the Prophet Muhammad which developed into a popular calligraphic form.

hizam: the belt embroidered with verses from the Qur'an which is attached to the *kiswa* and goes all around the Ka'ba.

ihram: the state of purification that is entered into in order to be able to perform Hajj or 'Umra. The term also applies to the clothes that are worn during these rituals. For men this is two pieces of seamless white cloth, one fixed round the waist and the other covering the top of the body. Women's *ihram* consists of a modest dress which can be any colour, although many choose white. The *ihram* is donned at the *miqat* which mark the boundaries of the sacred area around Mecca (see below).

imam: religious leader and one who leads the prayers.

isnad: chain of authorities.

iwan: a vaulted room with an arched opening at one end.

jahiliyya: state of ignorance; used to describe the pre-Islamic era.

jamarat: (sing. *jamra* meaning pile of stones). These are the three pillars in the valley of Mina close to Mecca which represent the three times that Satan attempted to tempt Ibrahim. On each occasion the angel Gabriel urged him to throw stones at Satan to demonstrate his refusal. Pilgrims throw 49 stones at the *jamarat* over several days which they will have collected at Muzdalifa. They are known as *jamrat al-'Aqaba* (at the narrow pass of al-'Aqaba, and the largest), *al-jamra al-wusta* (the middle one) and *al-jamra al-sughra* (the small one).

Ka'ba: the cube-shaped structure (from Arabic *ka'b*, cube), about 11m per side, with a flat roof and empty inside, positioned at the centre of the Haram. Muslims believe that it was first built by Adam and rebuilt by Ibrahim (Abraham) and his son Isma'il (Ishmael). It is the direction (*qibla*) that Muslims face in their prayers wherever they are in the world. Also known as *bayt Allah* (the House of God).

Khadim al-Haramayn: Servant or Custodian of the Two Holy Sanctuaries. A title first adopted by the Ottoman sultans and used by the rulers of the Kingdom of Saudi Arabia.

khanaqa: hospice for Sufis.

khan: caravanserai.

khor: harbour.

kiswa: garment or robe; the outer black cloth placed over the Ka'ba which is replaced every year during Hajj. Also used to describe the covering of the *mahmal* (see below).

madrasa: theological college.

mahmal (or **mihmal**): the fabric-covered palanquin carried on a camel which was sent every year with the official Hajj caravan to Mecca.

Manasik al-hajj: the rituals of Hajj.

Maqam Ibrahim: the station or standing place of Ibrahim, close to the Ka'ba within the Haram at Mecca.

According to Muslim tradition it is where Abraham stood in prayer or, where he stood when building the Ka'ba. In the Ottoman era a *kiswa* was made for it. Now it is covered with a brass structure.

markab: ship.

Marwa: see Safa.

Mas'a: see Safa.

mashhad: mausoleum of a revered person, saint or martyr.

mihrab: the niche within a mosque or shrine which indicates the direction (*qibla*) of Mecca.

Masjid al-Haram: see Haram.

Mina: a valley about 5km (3 miles) east of the Ka'ba at Mecca where pilgrims go to on 8th Dhu al-Hijja where they camp overnight before going to 'Arafat.

minbar: pulpit.

miqat: five stations in a radius bordering the sacred territory of Mecca where pilgrims purify themselves and put on the *ihram* before going on Hajj or 'Umra. Also known as *miqat makani* (fixed place). These are Dhu al-Hulayfa, close to Medina about 300km from Mecca; Juhfa, 190km to the north-west; Qarn al-Manazil, 90km to the east; Dhat Irq, 85km to the north-east and Yalamlan, 50km to the south-east.

mufti: a religious scholar capable of giving qualified judgments (*fatwas*) on matters of Islamic jurisprudence.

mujawirun (sing *mujawir*, Arabic meaning neighbouring): refers to people who settled in Mecca or Medina wishing to live and die in proximity to the holy places.

mukhayyash: finely drawn wire used for the embroidery of the *kiswa* and other sacred textiles.

muqarnas: honeycomb or stalactite vaulting made of individual niches and often used as a bridging element. A distinguishing feature of Islamic architecture.

mutawwaf: guide who helps the pilgrims perform the rituals of Hajj, often from a local Meccan family.

Muzdalifa: a plain about 5.5km from 'Arafat where pilgrims will pick up the stones needed to stone the *jamarat*.

nakhoda: sea captain or pilot.

naskh: copying; a rounded script predominantly used from the 12th century onwards.

qal'a: fort or citadel.

qibla: the direction of prayer towards the Ka'ba at Mecca.

qiblanama: an instrument which indicates the direction of Mecca.

rihla: journey; refers to a genre of travel literature which includes Hajj narratives.

Safa: one of two hills, the other being Marwa, within the Haram at Mecca about 1,350m long between which Isma'il's mother, Hagar, is said to have run in search of water. The running is known as *sa'i* and the area in which the activity takes place is *mas'a* (the place of hurrying).

sa'i: see Safa.

salat: see Five Pillars of Islam.

shahada: see Five Pillars of Islam.

shari'a: Islamic law.

sheikh: a tribal leader or elder.

Shi'a: party or faction. Refers to the 'party of 'Ali', the son-in-law of the Prophet Muhammad, 'Ali ibn Abi Talib. Shi'is believe that the leadership of the Muslim community passed from Muhammad through 'Ali to his descendants.

The major schism between Sunnis (see below) and Shi'a took place in 680 at the battle of Kerbela during which Husayn the third imam was martyred.

sitara: curtain; also known as *burqu'*, used to denote the curtains made for the interior and exterior doors of the Ka'ba.

Sufi: mystic or dervish who may belong to one of a number of orders known as *tariqa*.

Sunna: the largest branch of Islam. Refers to orthodox Muslims, known as Sunnis, who adhere to one of four schools of Islamic law, and who follow the tradition or practice (*sunna*) established by the Prophet Muhammad.

suq: market.

sura: chapter of the Qur'an.

Sürre: from the Arabic *surra*, meaning purse. The Hajj caravan to Mecca during the Ottoman era.

takiyya: hospice.

talbiyya: acclamation; prayer that is chanted when pilgrims begin the Hajj or 'Umra. '*Labbayk allahumma labbayk …*' ('Here I am, Lord, responding to Your call [to perform the Hajj]. Praise belongs to You, all good things come from You and sovereignty is yours alone').

tawaf: circumambulation; a key element of the Hajj rituals. Performed seven times around the Ka'ba anti-clockwise, starting from the eastern corner in which the Black Stone is embedded. The *tawaf al-wada'*, the farewell *tawaf*, is the last rite of Hajj.

thuluth: one third; a script characterized by its large size and rounded endings often used for architectural inscriptions.

tiraz: embroidery; inscribed fabrics made in state workshops, also the inscriptions used on such fabrics.

tughra: the elaborate monogram that represents the signature of the Ottoman sultan.

'ulama (sing. **'alim**): religious scholars.

umma: the community of Muslims.

'Umra: the 'minor' or 'lesser' pilgrimage which can be performed at any time of year and only involves the rituals of *tawaf* and *sa'i*.

wali: leader, also a man close to God.

waqf: property or land which yields an income that is endowed charitably in perpetuity to a pious institution.

wuquf: see 'Arafat.

Zamzam: the spring that emerged when Hagar was searching for water in the desert. It is believed to have appeared when Isma'il kicked his heel in the sand. The well is situated within the Haram at Mecca. Pilgrims will often take Zamzam water home with them as a souvenir of Hajj.

zawiya: a residential building used by Sufis.

ziyara: visit; often refers to visiting the tomb of the Prophet Muhammad at Medina, or to the ritual of visiting the graves of other revered figures such as those of the Shi'i imams.

Contributors

MUHAMMAD ABDEL HALEEM is Professor of Islamic Studies and Director of the Centre of Islamic Studies at SOAS, University of London. He is Editor in Chief of the *Journal of Qur'anic Studies* and a member of the *Building Bridges* Christian–Muslim seminars. His recent publications include: *The Qur'an: A New Translation* (2005) and *Understanding the Qur'an: Themes and Style* (1999). He has performed the Hajj several times.

SAMI SALEH 'ABD AL-MALIK is an archaeologist and Director in the Supreme Council of Antiquities in Egypt. He is Professor at Umm al-Qurra university in Mecca and works on the archaeology of the Sinai peninsula and the Hajj routes in particular on which he has published widely. These include *Abyar al-'Ala'i on the Egyptian Hajj Route in Sinai: A New Historical, Archaeological and Architectural Study in the Light of Recent Excavations* (Arabic) (2007).

DIONISIUS A. AGIUS is Fellow of the British Academy and Al Qasimi Professor of Arabic and Islamic Material Culture at the University of Exeter with expertise in maritime ethnography and the science of meaning. His publications include *Seafaring in the Arabian Gulf and Oman: The People of the Dhow* (2005) and *Classic Ships of Islam: From Mesopotamia to the Indian Ocean* (2008), which have both won awards.

ANDREW BLAIR is a PhD candidate in the Department of Archaeology at Durham University, co-supervised by the British Museum. His research explores the extent to which networks of interaction united an 'Indian Ocean world' during the medieval period, particularly through activities such as pilgrimage and trade.

SHEILA BLAIR shares the Norma Jean Calderwood University Professorship of Islamic and Asian Art at Boston College and the Hamad bin Khalifa Endowed Chair in Islamic Art at Virginia Commonwealth University with her husband and colleague Jonathan Bloom. Her publications include *Islamic Calligraphy* (2006) and *Text and Image in Medieval Persian Art* (2013). Along with Jonathan Bloom, she has also edited three volumes of the Hamad bin Khalifa Biennial Symposia on Islamic Art, *Rivers of Paradise* (2009), *And Diverse Are Their Hues* (2011) and *God is Beautiful* (2013).

JONATHAN M. BLOOM shares the Norma Jean Calderwood University Professorship of Islamic and Asian Art at Boston College and the Hamad bin Khalifa Endowed Chair of Islamic Art at Virginia Commonwealth University with his wife and colleague Sheila Blair. Among his recent publications are *Paper before Print* (2001), *Arts of the City Victorious: Islamic Art and Architecture in Fatimid North Africa and Egypt* (2007) and *The Minaret* (2013). Along with Sheila Blair, he has also edited three volumes of the Hamad bin Khalifa Biennial Symposia on Islamic Art, *Rivers of Paradise* (2009), *And Diverse Are Their Hues* (2011) and *God is Beautiful* (2013).

BENJAMIN CLAUDE BROWER teaches history at the University of Texas at Austin. His recent publications include *A Desert Named Peace: the Violence of France's Empire in the Algerian Sahara, 1844–1902* (2009).

WILLIAM FACEY has been involved with the Arabian Peninsula for forty years, as a museum consultant, historian and publisher. His particular research interests are Arab maritime history and lesser-known travellers in Arabia, with a focus on Western visitors to Mecca. Since 2002 he has been the owner and managing director of Arabian Publishing Ltd in London.

NILE GREEN is Professor of South Asian and Islamic History at UCLA and Director of the UCLA Program on Central Asia. His recent publications include *Bombay Islam: The Religious Economy of the West Indian Ocean, 1840–1915* (2011) and *Sufism: A Global History* (2012).

QAISRA M. KHAN was Project Curator for the 2012 British Museum exhibition *Hajj: journey to the heart of Islam*. Having completed a degree in law and an MPhil in Oriental studies, both from Cambridge University, she spent five years working in financial consulting after which she pursued a career in Islamic art. She is currently studying Islamic art history at SOAS, University of London and is Project Curator of the Faith and Islam gallery for the Zayed National Museum Project at the British Museum.

CHARLES LE QUESNE is an archaeologist with 25 years of experience working on research, conservation and development projects in North Africa. This has included conservation, survey and excavation projects in Old Cairo/Fustat, at Qusair on the Red Sea coast of Egypt and in central and south-western Libya. He is currently employed as principal cultural heritage consultant for ERM, an environmental consultancy. His publications include *Quseir: An Ottoman and Napoleonic Fortress on the Red Sea Coast of Egypt* (2007).

CHARLOTTE MAURY studied art history at the École du Louvre, at the University of Paris IV, and Turkish and Persian languages at the School of Oriental languages and civilisations (INALCO). Specializing in the Ottoman collections, since 2006 she has been working in the Department of Islamic Art at the Musée du Louvre. She co-curated the exhibition *Istanbul, Isfahan, Delhi: Three Empires of Islam* at the Sabanci Museum, Istanbul, in 2008 and *À la Cour du Grand Turc – Caftans du musée de Topkapi* at the Louvre in 2009.

SEÁN MCLOUGHLIN is a Senior Lecturer in the School of Philosophy, Religion and the History of Science at the University of Leeds. He works across the study of religion and ethnicity, with a special interest in Muslim diasporas in contemporary Britain. During 2013–14 he holds a British Academy Mid-Career Fellowship to write about various aspects of Hajj-going from the UK. This follows an AHRC-funded collaboration with the British Museum on its 2012 exhibition, *Hajj: journey to the heart of Islam*. His publications include *Diasporas: Concepts, Intersections, Identities*, co-edited with Kim Knott (2010).

MARCUS MILWRIGHT is Professor of Islamic art and archaeology in the Department of History in Art, University of Victoria, Canada. His publications include *The Fortress of the Raven: Karak in the Middle Islamic Period* (2008) and *An Introduction to Islamic Archaeology* (2010).

MUHAMMAD H. AL-MOJAN is an independent scholar who works on the history of Mecca and the textiles of Mecca and Medina. His publications include *The Honorable Kabah Architecture and Kiswah* (2010).

HARRY MUNT is a British Academy Postdoctoral Fellow at the Oriental Institute and Wolfson College, University of Oxford. His PhD was on Medina in the early centuries of Islam.

NAHLA NASSAR is Curator and Registrar of the Nasser D. Khalili Collection of Islamic Art. She is currently working on the publications of the Hajj-related material in the collection.

SAM NIXON is a Postdoctoral Researcher at the University of East Anglia and is currently researching and excavating medieval era sites in North and West Africa. His doctoral research (University College London) investigated the archaeology of early Islamic trans-Saharan trading towns in West Africa and focused around excavations at the ruins of Tadmekka in Mali. His monograph on the excavations will be completed in 2014.

ANDREW PETERSEN studied at St Andrews, Cardiff and Oxford universities. He is currently Director of Research in Islamic Archaeology at the University of Wales Trinity Saint David. He has carried out field work in East Africa, Iraq, Jordan, Oman, Palestine, Qatar, Turkmenistan and the United Arab Emirates. His recent publications include *The Medieval and Ottoman Hajj Route in Jordan: An Archaeological and Historical Study* (2012).

VENETIA PORTER is curator of Islamic and Modern Middle East art at the British Museum. She was the curator of the British Museum's 2012 exhibition *Hajj: journey to the heart of Islam* and editor of the accompanying catalogue and the *Art of Hajj* (2012). Her publications also include *Arabic and Persian Seals and Amulets in the British Museum* (2011).

LIANA SAIF is curator of the Hajj Legacy Project at the British Museum. She is also a post-doctoral researcher focusing on the intercultural exchange of esoteric ideas between the Islamic world and Europe in the Middle Ages and the Renaissance. Her book *Arabic Influences on Early Modern Occult Thought* will be published in 2014.

MARIA SARDI studied Islamic Art at SOAS, University of London and is completing her doctoral thesis titled *Mamluk Textiles in Context*. She has worked as a member of the curatorial team for the Benaki Museum, Athens, the textile collection of which she is currently researching.

JOHN SLIGHT is a Title A Fellow at St John's College, University of Cambridge. He has a PhD from Cambridge University, and was a researcher on the British Museum's

2012 exhibition *Hajj: journey to the heart of Islam*. His first book, *The British Empire and the Hajj, 1865–1956*, is forthcoming.

TIM STANLEY has been Senior Curator for the Middle Eastern collections at the Victoria and Albert Museum since 2002, working on gallery developments, touring exhibitions and an art and design prize. He is also a specialist on Islamic manuscript production and aspects of the decorative arts. His publications include *Palace and Mosque: Islamic Art from the Middle East* (2004).

MEHMET TÜTÜNCÜ is the chairman of the Research Centre for Turkish and Arabic World (SOTA). His recent publications include *Turkish Jerusalem (1516–1917): Ottoman Inscriptions from Jerusalem and other Palestinian Cities* (2006) and *Palestine (1069–1917): Inscriptions from al-Khalil (Hebron), Nabi Musa and other Palestinian Cities under Turkish Rule* (2008). He is currently working on the Ottoman heritage in Arabia, Mecca and Medina.

BRIAN ULRICH is an Assistant Professor of history at Shippensburg University in the United States, where he teaches courses in world history and aspects of Middle Eastern history from the rise of Islam to the present day. His current book project is on tribal identity in the early caliphate.

ARNOUD VROLIJK is curator of Oriental manuscripts and rare books at Leiden University Library. As an independent researcher he publishes on the history of the Leiden Oriental collections and Oriental studies in the Netherlands. His most recent monograph is *Arabic Studies in the Netherlands: A Short History in Portraits, 1580–1950*, together with Richard van Leeuwen (2013).

JANET C.E. WATSON studied at the University of Exeter and SOAS, University of London. She has held academic posts at the universities of Edinburgh, Durham and Salford, and visiting posts at the universities of Heidelberg (2003–4) and Oslo (2004–5). She took up the Leadership Chair for Language@Leeds at the University of Leeds on 1 May 2013. Her best-known work is on Yemeni Arabic dialects and her most recent publication is *The Structure of Mehri* (2012).

PETER WEBB is an AHRC-funded doctoral student at SOAS, University of London. His thesis analyses Arab origins and Muslim reconstructions of pre-Islamic history. With Saad al-Rashid, he has also co-written *Medieval Roads to Mecca* (2013), a literary and archaeological account of the Hajj during the first four centuries of Islam.

JAN JUST WITKAM is Emeritus Professor of Codicology and Paleography of the Islamic World at the University of Leiden. His publications include *Catalogue of Arabic Manuscripts in the Library of the University of Leiden and other Collections in the Netherlands* (1989) and a detailed study on Christiaan Snouck Hurgronje's stay in Mecca (2007). He is currently working on the manuscript collections of Dar al-Kutub in Cairo. He is the editor of the *Journal of Islamic Manuscripts*.

MICHAEL WOLFE is a poet, author and documentary film producer at Unity Productions Foundation. He is the author of many books of verse and prose including, *One Thousand Roads to Mecca* (2007) and *Cut These Words into My Stone: Ancient Greek Epitaphs in Translation* (2012).

Bibliography

'Abbas H. 1995. *Qissat al-tawsi'a al-kubra.* Jedda.

'Abbas I. 1988. *'Abd al-Hamid b. Yahya wa-ma tabaqqa min rasa'ilihi wa-rasa'il Salim b. Abi al-'Ala'.* Amman.

Al-Abbasi A.B. 1816. *Travels of Ali Bey: In Morocco, Tripoli, Cyprus, Egypt, Arabia, Syria, and Turkey between the Years 1803 and 1807.* London.

Al-'Abbasi, Ahmad ibn 'Abd al-Hamid/ed. M.T. al-Ansari and H. al-Jasir. [n.d.]. *'Umdat al-akhbar fi madinat al-mukhtar* (fourth edn). Medina.

Abbott N. 1946. *Two Queens of Baghdad: Mother and Wife of Harun al-Rashid.* Chicago.

'Abd al-Malik S.S. 2001. Une inscription du sultan mamelouk Kitbugha découverte à al-Qurrays (Sinaï central). In J.-M Mouton (ed.), *Le Sinaï de la conquête arabe à nos jours:* 51–8. Cairo.

'Abd al-Malik S.S. 2002. Al-Tahsinat al-harbiya al-baqiya bi-shibh al-jazira Sina' min al-'asr al-ayubi: dirasa athariya mi'mariya. MA dissertation. University of Cairo [unpublished].

'Abd al-Malik S.S. 2005. Darb al-Hajj al-misri hamzat wasl gharb al-'alam al-islami bi al-haramayn al-sharifayn: dirasa tarikhiya – athariya. In *Al-Nadwa al-kubra li makka al-mukarrama 'asimat al-thaqafa al-islamiya 1426 AH:* 70–250. Mecca.

'Abd al-Malik S.S. 2007. *Abyar al-'ala'i 'ala Darb al-Hajj al-misri fi Sina': dirasa tarikhiya, athariya mi'mariya jadida 'ala du' al-hafa'ir al-athariya.* Cairo.

'Abd al-Malik S.S. 2009. Al-Munsha'at al-ma'iya 'ala turuq al-hajj 'abr al-Qasim wa tukhumiha wa tariq al-hajj al-masri 'abr Sina': dirasa athariya- mi'mariya muqarina. In *Al-Qasim: tarikh wa hadara.* Riyadh.

'Abd al-Qadir, Ibn Muhyi al-Din/ed. M. Haqqi. 1964. *Tuhfat al-za'ir fi tarikh al-Jaza'ir wa-al-amir 'Abd al-Qadir.* Beirut.

'Abd al-Qadir, Ibn Muhyi al-Din. 1978. Lettres inédites de l'Emir. *Revue d'histoire maghrebine* 12: 327.

'Abd al-Qadir, Ibn Muhyi al-Din/transl. H. Benmansour. 1995. *L'Emir Abdelkader: autobiographie.* Paris.

Abdel Haleem M. (transl.). 2005. *The Qur'an.* Oxford.

Abir M. 1971. The 'Arab Rebellion' of Amir Ghalib of Mecca (1788–1813). *Middle Eastern Studies* 7/2: 185–200.

Al-'Absi, 'Antara ibn Shaddad [n.d.]. *Sirat 'Antara ibn Shaddad* (8 vols). Cairo.

Abu Dawud, Sulayman. 1999. *Sunan Abi Dawud.* Riyadh.

Abu Dhabi 2009: *Islam: Faith and Worship* (exhib. cat, Emirates Palace Abu Dhabi), Istanbul.

Abu al-Fida', Isma'il ibn 'Ali/Ed. J.T. Reinaud and S.Guyard 1840. *Kitab taqwim al-buldan.* Paris.

Abu Shamah, 'Abd al-Rahman ibn Isma'il. 1871. *Kitab al-rawdatayn fi akhbar al-dawlatayn* (2 vols). Cairo.

Abulafia D. 1997. The Impact of the Orient: Economic Interactions between East and West in the Medieval Mediterranean. In D.A. Agius and I.R. Netton (eds), *Across the Mediterranean Frontiers: Trade, Politics and Religion, 650–1450:* 1–40. Turnhout.

Abul Quasem M. 1979. *The Recitation and Interpretation of the Qur'an. Al-Ghazali's theory.* Bangi.

Adang C. 2005. The Prophet's Farewell Pilgrimage (*Hijjat al-wada'*): the True Story, According to Ibn Hazm. *Jerusalem Studies in Arabic and Islam* 30: 112–53.

Adle C. 2011. La Mosquée Hâji-Piyâdah/Nohgonbadân à Balkh (Afghanistan). Un chef-d'oeuvre de Fazl le Barmacide construit en 178–179/794–795. *Comptes-Rendus de l'Académie des Inscriptions et Belles-Lettres* 1: 565–625.

Ageron C.-R. 1968. *Les Algériens musulmans et la France (1871–1919).* Paris.

Agius D.A. 2005. *Seafaring in the Arabian Gulf and Oman: The People of the Dhow.* London.

Agius D.A. 2008. *Classic Ships of Islam: From Mesopotamia to the Indian Ocean.* Leiden.

Ahmad A.R. 1977. *Shibh jazirat Sina' fi al-'usur fi al-'usur al-wusta.* Cairo.

Ahmad K. 1960. *Kisah pelayaran Abdulla ka- Kelantan dan ka -Judah.* Kuala Lumpur.

Ahmad Y. 1937. *Al-Mahmal wa al-hajj.* Cairo.

Aksoy S. and R. Milstein 2000. A Collection of Thirteenth-Century Illustrated Hajj Certificates. In İ.C. Schick (ed.), *M. Uğur Derman 65th Birthday Festschrift:* 101–34. Istanbul.

Alexander J. 1997. Qalat Sai: the Most Southerly Ottoman Fortress in Africa. *Sudan and Nubia (The Sudan Archaeological Research Society Bulletin)* 1: 16–20.

'Ali A.R.M. 1996. *Al-Masjid al-haram bi Makka al-Mukarama wa rusumuhu fi al-fann al-islami*. Cairo.

'Ali A.R.M. 1999. *Al-Masjid al-Nabawi bi al-Madina al-Munawwara wa rusumuhu fi al-fann al-islami*. Cairo.

'Ali A.Y. 1975. *An English Interpretation of the Holy Qur'an. With Full Arabic Text*. Lahore [repr. 1977].

Ali Beg. M.I.1896. *A Pilgrimage to Mecca by Mirza Irfan Ali Beg Deputy Collector Manipur*. Benares.

Al-'Ali S.A. 2003. *Al-Mansujat wa al-albisa al-'arabiya fi al-'uhud al-islamiya*. Beirut.

Allan J.W. 1982. *Islamic Metalwork: the Nuhad es-Said Collection*. London.

Allemagne H.R. d'. 1948. *La maison d'un vieux collectionneur*. Paris.

Ames E. 1947. A Century of Russian Railroad Construction: 1837–1936. *American Slavic and East European Review* 6/3–4: 57–74.

Amin M.M. and L.'A Ibrahim. 1990. *Al-Mustalahat al-mi'mariya fi al-watha'iq al-mamlukiya*. Cairo.

Ammam A. 1934. *En Croyant … en curieux: Pèlerinage aux Lieux Saints de l'Islam*. Mostaganem.

Andrejević A.K. 1989. Turkish tiles and Pottery in Yugoslavia. In *First International Congress on Turkish Tiles and Ceramics*: 25–38. Istanbul.

Angraham M. *et al.* 1981. Al-Taqrir al-mabda'i 'an mash al-mantiqa al-shamaliya al-gharbiya. *Atlal* 5: 66–70.

'Ankawi A. 1974. The Pilgrimage to Mecca in Mamluk Times. *Arabian Studies* 1: 146–70.

Al-Ansari 'A. *et al.* 1999. *Al-muwasalat wa al-itisalat fi al-Mamlaka al-'Arabiya al-Sa'udiya khilal mi'at 'am*. Riyadh.

Appadurai A. 1990. Disjuncture and Difference in the Global Cultural Economy. *Theory Culture Society* 7: 295–310.

Appadurai A. 1996. *Modernity at Large: Cultural Dimensions of Globalization*. Minneapolis, MN.

Ashqar M.'A. 1999. *Tijarat al-tawabil fi Misr fi al-'asr al-mamluki*. (Silsilat tarikh al-misryeen, 137). Cairo.

Atasoy N. and J. Raby. 1989. *Iznik, the Pottery of Ottoman Turkey*. London.

Atasoy N., W.B. Denny, L. Mackie, and H. Tezcan 2001. *Ipek: The Crescent and The Rose: Imperial Ottoman Silks and Velvets*. London/ Istanbul.

'Attar A.'A. 1977. *Al-Ka'ba wa al-kiswa mundhu arba'at alf sana hatta al-yawm*. Beirut.

Auchterlonie P. 2012. *Encountering Islam. Joseph Pitts: an English Slave in 17th-century Algiers and Mecca*. London.

Al-'Ayashi, 'Abd Allah ibn Muhammad Abu Salim/ed. N.S. al-Qabisi. 1971. *Rihlat al-'Ayashi*. MA dissertation. University of 'Ain Shams [unpublished].

Al-'Ayashi, 'Abd Allah ibn Muhammad Abu Salim/ed. M. Hajji. 1977. *Rihlat al-'Ayashi ma' al-mawa'id*. Rabat.

Aydin C. 2007. *The Politics of Anti-Westernism in Asia: Visions of World Order in Pan-Islamic and Pan-Asian Thought*. New York.

Azan P. 1925. *L'Emir Abd El Kader, 1808–1883: du fanatisme musulman au patriotisme français*. Paris.

'Azb K. and Hasan M. 2010. *Diwan al-khatt al-'arabi fi Misr*. Alexandria.

Al-Azraqi, Muhammad ibn 'Abdallah/ed. R.S. Malhas.1983. *Akhbar Makkah* (2 vols), Beirut.

Bacharach J. 2010. Signs of Sovereignty: The *Shahada*, Qur'anic Verses, and the Coinage of 'Abd al-Malik. *Muqarnas* 27: 1–30.

Bagatti B. 1984. *Gli Scavi di Nazaret*. II. *Dal secolo XII ad oggi*. Jerusalem.

Al-Baghdadi, Abu al-Faraj Qudama ibn Ja'far ibn Ziyad/ed. T. Rifa'i 1987. *Al-Manzila al-khamisa min kitab al-khiraj wa san'at al-kitaba*. Mecca.

Al-Baghdadi, Abu al-Faraj Qudama ibn Ja'far ibn Ziyad.1988. *Nabth min kitab al-khiraj wa san'at al-kitaba*. Beirut.

Bakhit M.A. 1982. *The Ottoman Province of Damascus in the Sixteenth Century*. Beirut.

Bakr S. 'A. *Al-Ma'amih al-jughrafiya li durub al-hajj*. Jedda.

Al-Bakri, Abu 'Ubayd/ed. 'A.-A.Y. al-Ghunaym. 1977 (various edns 1945–52 and 1983). *Jazirat al-'Arab min kitab al-mamalik wa al-masalik*. Kuwait.

Al-Baladhuri, Ahmad ibn Yahya/ed. M.F. al-'Azm. 1997–2004 (also 1993). *Ansab al-ashraf* (25 vols). Damascus.

Bamdad M. 1363/1984. *Sharh-e Hal-e Rejal-e Iran Dar Qarn-e 12 va 13 va 14 Hijri*. Vols 2, 4 and 6. Tehran.

Barber B. 1992. *Jihad vs. McWorld*.

Barbir K.K. 1980 *Ottoman Rule in Damascus 1708–1758*. Princeton, NJ.

Al-Barzanji, Ja'far ibn Isma'il/ed. A.S. Salim. [n.d.]. *Nuzhat al-nazirin fi masjid sayyid al-awwalin wa al-akhirin*. Cairo.

Barzegar A. 1987. Mehdi Qoli Hedayat: A Conservative of the Late Qajar Era. *Iranian Studies* 20/1: 55–76.

El-Basha H. 1999. Ottoman Pictures of the Mosque of the Prophet in Madina as Historical and Documentary Sources. *Islamic Art* 3: 232.

Al-Basri, al-Hasan ibn Abu al-HasanYasar/ed. S.M. al-'Ani. 1980. *Fada'il Makka wa al-sakan fiha*. Kuwait.

Batanuni M.L. 1329/1911 (also 1995). *Al-Rihla al-hijaziya*. Cairo.

Bates Ü. 1989. Evolution of Tile Revetments in Ottoman Cairo. In *First International Congress on Turkish Tiles and Ceramics*: 39–58. Istanbul.

Baumann Z. 1989. *Modernity and the Holocaust*. Ithaca, NY.

Bawany E.F. 1961. *Islam – Our Choice: Impressions of Eminent Converts to Islam*. Karachi.

Baxandall M. 1985. *Patterns of Intention*. New Haven and London.

Bayani M., A. Contadini, T. Stanley and J.M. Rogers. 1999 and 2009. *The Decorated Word: Qur'ans of the 17th to 19th Centuries*. (The Nasser D. Khalili Collection of Islamic Art, 4, parts 1 and 2). London.

Bayly C.A. 2004. *The Birth of the Modern World, 1780–1914: Global Connections and Comparisons*. London.

Bayonne 2001: *Carreaux décoratifs de l'époque ottoman: la collection du musée Bonnat à Bayonne* (exhib. cat., musée Bonnat), ed. D. Delmas. Bayonne.

Bayraktar N. 1995. Osmanlılar Zamanında Saray ve Çevresi İçin Eser Veren Mısırlı İki Sanatçı. *İlgi* 81: 26–8.

Behrens-Abouseif D. 1997. The Mahmal Legend and the Pilgrimage of the Ladies of the Mamluk Court. *Mamluk Studies Review* 1: 87–96.

Bellemare A. 1863. *Abd-el-Kader, sa vie politique et militaire*. Paris.

Bennabi M. 1948. *Lebbeik (Pèlerinage de pauvres): Roman*. Algiers.

Berchem M. van 1894–1903. *Matériaux pour un Corpus Inscriptionum Arabicarum*: I: *Egypte*. (3 vols); II: *Syrie du Sud*. Cairo.

Bernard F. 1882. *Deuxième mission Flatters*. Algiers.

Bernard V.O. Callot and J.F. Salles. 1991. L'église d'al-Qousour, Failaka, État de Koweit. *Arabian Archaeology and Epigraphy* 2: 145–81.

Bianchi M. 1825. *Itinéraire de Constantinople à la Mecque. Recueil des Voyages et des Mémoires publiés par la Société de Geographie*. Paris.

Bianchi R.R. 2004. *Guests of God. Pilgrimage and Politics in the Islamic World*. Oxford.

Bilgi H. 2009. *Dance of Fire. Iznik Tiles and Ceramics in the Sadberk Hanim Museum and Ömer H. Koç Collections*. Istanbul.

Binbin A. Sh. *et al.* 2001. *Faharis al-khizana al-hasaniya: fihris makhtutat al-adab* (2 vols). Rabat.

Birch W. De Gray (transl.). 1875–84. *The Commentaries of the Great Alfonso Dalboquerque* (4 vols). London.

Birks J. 1978. *Across the Savannas to Mecca. The Overland Pilgrimage Route from West Africa*. London.

Birt Y. 2009. Promoting Virulent Envy? Reconsidering the UK's Terrorist Prevention Strategy. *Royal United Services Institute Journal* 154/4: 52–8.

Blair A., D. Kennet and S. al-Duwish. 2012. Investigating an Early Islamic Landscape on Kuwait Bay: The Archaeology of Historical Kadhima. *Proceedings of the Seminar for Arabian Studies* 42: 1–14.

Blair S. 1992. What is the Date of the Dome of the Rock? In J. Raby and J. Johns (eds), *Bayt al-Maqdis: 'Abd al-Malik's Jerusalem, Part 1* (Oxford Studies in Islamic Art, IX): 59–88. Oxford.

Blair S. 2013. *Text and Image in Medieval Persian Art*. Edinburgh.

Blankinship K.Y. 1994. *The End of the Jihad State: the Reign of Hisham ibn 'Abd al-Malik and the Collapse of the Umayyads*. Albany, NY.

Bloom J.M. 1983. The Mosque of al-Hakim in Cairo. *Muqarnas* 1: 15–36.

Bloom J.M. 1984. Five Fatimid Minarets in Upper Egypt. *Journal of the Society of Architectural Historians* 43: 162–7.

Bloom J.M. 1988. The Introduction of the Muqarnas into Egypt. *Muqarnas* 5: 21–8.

Bloom J.M. 1989. *Minaret: Symbol of Islam*. Oxford.

Bloom J.M. 1993. On the Transmission of Designs in Early Islamic Architecture. *Muqarnas* 10: 21–8.

Bloom J.M. 2007. *Arts of the City Victorious: Islamic Art and Architecture in Fatimid North Africa and Egypt*. New Haven and London.

Bloom J.M. and S. Blair (eds). 2009. *The Grove Encyclopedia of Islamic Art and Architecture* (3 vols). New York.

Bloom J.M. 2013. *The Minaret*. Edinburgh.

Bloom J.M. and S. Blair (eds). 2011. *And Diverse Are Their Hues: Color in Islamic Art and Architecture*. New Haven and London.

Bloom J.M. and S. Blair. 2011. Color in Islamic Art and Culture. In J.M. Bloom and S. Blair (eds), *And Diverse Are Their Hues: Color in Islamic Art and Culture*: 1–51. New Haven and London.

Bloss J.F.E. 1936. The Story of Suakin. *Sudan Notes and Records* 19/2: 271–300.

Blue L., J. Whitewright and R. Thomas. 2011. Ships and Ships' Fittings. In D. Peacock and L. Blue (eds), *Myos Hormos – Quseir Al-Qadim: Roman and Islamic Ports on the Red Sea, Volume 2, Finds from Excavations 1999–2003*: 179–209. Oxford.

Bolton R. 2009. *Russian Orientalism and Constantinople*. London.

Bonner M. 2005. Poverty and Economics in the Qur'an. *The Journal of Interdisciplinary History* 35/3: 391–406

Bosworth C.E. 'Musawida'. *Encyclopaedia of Islam (EI²)*.

Boubekeur A. and O. Roy (eds). 2012. *Whatever Happened to the Islamists? Salafis, Heavy Metal Muslims and the Lure of Consumerist Islam*. London.

Burgoyne M. 1987. *Mamluk Jerusalem: An Architectural Study*. London.

Bowring J. 1840. *Report on the commercial Statistics of Syria*. London.

Boyer P. 1977. L'Administration française et la règlementation du pèlerinage à la Mecque (1830–94). *Revue d'historie maghrébine* 9: 275–93.

Braun G. (ed.). 1572–1617. *Civitates orbis terrarum* (6 vols). Cologne.

Breen C., W. Forsythe, L. Smith, and M. Mallinson. 2011. Excavations at the Medieval Red Sea Port of Suakin, Sudan. *Azania* 46: 205–25.

Brémond E. 1931. *Le Hedjaz dans la guerre mondiale*. Paris.

Brockelmann C./transl. A. Faris and M. al-Ba'albaki. 1968. *Tarikh al-shuub al-islamiyah*. Vol. 2. Beirut.

Brocquière B. de la/transl. T. Johns. 1807. *The Travels of Bertrandon de la Brocquière to Palestine and his Return from Jerusalem Overland to France, during the Years 1432 and 1433*. London.

Brower B.C. 2009. *A Desert Named Peace: The Violence of France's Empire in the Algerian Sahara, 1844–1902*. New York.

Brower B.C. 2011. The Amir 'Abd Al-Qadir and the 'Good War' in Algeria, 1832–1847. *Studia Islamica* 45: 35–68.

Brower D. 1996. Russian Roads to Mecca: Religious Tolerance and Muslim Pilgrimage in the Russian Empire. *Slavic Review* 55/3: 567–84.

Brown R. 2000. The Distribution of Thirteenth- to Fifteenth-Century Glazed Wares in Transjordan: A Case Study from the Kerak Plateau. In L. Stager, J. Greene and M. Coogan (eds), *The Archaeology of Jordan and Beyond: Essays in Honor of James A. Sauer*: 84–9. Winona Lake, IN.

Brown R. 2006. Late Islamic Ceramic Sequences from el-Lejjun: Stratigraphic and Historical Contexts. In S. T. Parker (ed.), *The Roman Frontier in Central Jordan: Final Report of the Limes Arabicus Project, 1980–1989*. Vol. 2: 373–92. Washington DC.

Brünnow R.E. and Domaszewski A. 1905. *Die Provincia Arabia*. Strassbourg.

Bruyère B. 1966. *Fouilles de Clysma-Qolzoum (Suez) 1930–1932*. Cairo.

Buckley R.P. 'Markets'. *Encyclopaedia of the Qur'an*.

Buckton D. (ed.). 1994. *Byzantium: Treasures of Byzantine Art and Culture*. London.

Buhl Fr. and J. Jomier. 'Maḥmal'. *Encyclopaedia of Islam (EI²)*.

Al-Bukhari, Muhammad ibn Isma'il. 1999. *Sahih al-Bukhari*. Riyadh.

Bulliet R. 1979. *Conversion to Islam in the Medieval Period: An Essay in Quantitative History*. Cambridge, MA.

Burckhardt J.L. 1822. *Travels in Syria and the Holy Land*. London.

Burckhardt J.L. 1829. *Travels in Arabia, Comprehending an Account of those Territories in Hedjaz which the Mohammedans Regard as Sacred* (2 vols). London.

Burckhardt T. 1976. *Art of Islam: Language and Meaning*. London.

Burke C. 2007. 'Archaeological Texts and Contexts on the Red Sea: the Sheikh's House at Quseir al-Qadim'. PhD thesis. University of Chicago [unpublished].

Burns P. 2007. From Hajj to Hedonism: Paradoxes of Developing Tourism in Saudi Arabia. In R.F. Daher (ed.), *Tourism in the Middle East: Continuity, Change and Transformation*: 215–36. Clevedon, Buffalo and Toronto.

Burton R. 1855–6 (various edns 1893, 1937 and 1964). *Personal Narrative of a Pilgrimage to al-Madinah and Meccah*. (2 vols). London.

Burton R./transl. 'A.'A. al-Shaykh. 1994. *Rihlat Burton ila al-Misr wa al-Hijaz*. Cairo.

Busse H. 'Abraham'. *Encyclopaedia of Islam (EI³)*.

Bussy P.G. 1833. *De l'Établissement des Français dans la régence d'Alger*: Algiers.

Cahen C. 'Begteginids'. *Encyclopaedia of Islam (EI²)*.

Calder N. 1993. *Studies in Early Muslim Jurisprudence*. Oxford.

Campo J. Shrines and Talismans: Domestic Islam in the Prilgrimage Paintings of Egypt. *Journal of the American Academy of Religion* 55/2: 285–305.

Canaan T. 1927. *Mohammedan Saints and Sanctuaries in Palestine* (Luzac's Oriental Religions Series, 5). London.

Carcaradec M. de. 1981. Les Mahmils du palais de Topkapi. *Turcica* 13: 174–84.

Casanowicz I. M. 1929. Smithsonian Institution. Collections of Religious Ceremonial. *United States National Museum (USNM) Bulletin* 148.

Casson L. 1989. *The Periplus Maris Erythraei*. 1989. Princeton, NJ.

Çaycı A. 2010. *Ürdün'de Osmanlı Mimarisi*. Ankara.

Chantre L. 2009. Se rendre à La Mecque sous la Troisième République: Contrôle et organisation des déplacements des pèlerins du Maghreb et du Levant entre 1880 et 1939. *Cahiers de la Méditerranée* 78: 202–27.

Charles-Roux F./transl. E.W. Dickes. 1937. *Bonaparte: Governor of Egypt*. London.

Ché-Ross R. 2000. Munshi Abdullah's Voyage to Mecca. A Preliminary Introduction and Annotated Translation. *Indonesia and the Malay World* 28/81: 173–213.

Chekhab-Abudaya M. and C. Bresc. 2013. *Hajj: The Journey through Art* (exhib. cat., Museum of Islamic Art, Doha). Milan.

Cherfils C. 2005. *Bonaparte et l'Islam*. Studley.

Christie's 2005. *Islamic Art and Manuscripts*, sale catalogue (26 April). London.

Christie's 2006. *Mobilier et Objets d'Art*, sale catalogue (7 November). Paris.

Christie's 2008. *Arts of the Islamic and Indian Worlds*, sale catalogue (7 October). London.

Christie's 2012. *Art of the Islamic and Indian World*, sale catalogue (4 October), London.

Church S.K. 2005. Zheng He: An Investigation into the Possibility of 450-ft Treasure Ships. *Monumenta Serica* 53: 1–43.

Clawson P. 1993. Knitting Iran Together: The Land Transport Revolution, 1920–1940. *Iranian Studies* 26/3: 235–50.

Clayer N. and A. Popovic. 1995. Le culte d'Ajvatovica et son pèlerinage annuel. In H. Chambert-Loir and C. Guillot (eds), *Le culte des saints dans le Monde musulman*: 353–65. Paris.

Clédat J. 1921..Notes sur l'Ishtme de Suez (1). *Bulletin de l'Institut français d'archéologie orientale* 18.

Cobbold E. 2008. *Pilgrimage to Mecca*. London.

Colonna F. 1995. *Les Versets de l'Invincibilité: Permanence et changements religieux dans l'Algérie contemporaine*. Paris.

Combe E., Sauvaget J and G. Wiet (eds). 1931–91. *Répertoire chronologique d'épigraphie arabe* (18 vols). Cairo.

Commins D. 1990. *Islamic Reform: Politics and Social Change in Late Ottoman Syria*. Oxford and New York.

Commins D. 2012. *The Wahhabi Mission and Saudi Arabia*. London and New York.

Commission des sciences et arts d'Egypte. 1809–22. *Description de l'Égypte: ou Recueil des Observations et des recherches qui ont été faites en Égypte pendant l'expédition de l'armée française*. Paris.

Conrad J. 1900. *Lord Jim*. London.

Contadini A. (ed.) 2010. *Arab Painting: Text and Image in Illustrated Arabic Manuscripts*. Leiden.

Cook M. 1981. *Early Muslim Dogma: a Source-Critical Study*. Cambridge.

Cooper J.P. 2008. The Medieval Nile: Route, Navigation and Landscape in Islamic Egypt. PhD Thesis. University of Southampton [unpublished].

Cooper J.P. 2009. Egypt's Nile-Red Sea Canals: Chronology, Location, Seasonality and Function. In L. Blue, J. Cooper, R. Thomas and J. Whitewright (eds), *Connected Hinterlands. Proceedings of the Red Sea Project IV*: 195–210. Oxford.

Correa G. 1969. *Lendas da India* (4 vols). Lisbon.

Cox P.Z. 1929. An Englishman in Mecca. *The Geographical Journal* 73/5: 460–3.

Craig J. 2012. 'Harry St John Bridger Philby (1885–1960)'. *Dictionary of*

National Biography. (http://www.oxforddnb.com/templates/article. jsp?articleid=35504&back=,40699. (Accessed online 2 Feb. 2012).

Creswell K.A.C. 1940 (various edns 1952–9 and 1969). *Early Muslim Architecture*. Vol. 2. Oxford.

Creswell K.A.C. 1989. *A Short Account of Early Muslim Architecture*. Aldershot.

Crone P. 1987. *Meccan Trade*. Oxford.

Crone P. 2004a. *Medieval Islamic Political Thought*. Edinburgh.

Crone P. 2004b. *Meccan Trade and the Rise of Islam*. New Jersey.

Crone P. and M. Hinds. 1986. *God's Caliph: Religious Authority in the First Centuries of Islam*. Cambridge.

Cytryn-Silverman K. 2004. *The Road Inns (Khans) of Bilad al-Sham during the Mamluk Period (1260–1516): An Architectural and Historical Study*. Vol. 1. Jerusalem [repr. 2007, Oxford].

Dames M.L. (transl.). 1818–1921. *The Book of Duarte Barbosa* (2 vols). London.

Danrit (pseudo). 1894. *La Guerre au XXe siècle: l'invasion noire*. Paris.

Al-Daqn S.M. 1986. *Kiswat al-ka'ba al-mu'aththama 'abr al-tarikh*. Cairo.

Al-Dar'i, Ahmad ibn Muhammad ibn Nasir. 1902. *Al-Rihla al-nasiriya*. Fes.

Al-Dar'i, Muhammad ibn 'Abd al-Salam ibn 'Abd Allah al-Nasiri/ed. H. al-Jasir. 1983. *Mulakhkhas rihlatay ibn 'Abd al-Salam al-Dar'i*. Riyadh.

Darrag A. 1961. *L'Égypte sous le règne de Barsbay (825–841/1422–1438)*. Damas.

Darrag A.1975. 'Aidhab min al-thughur al-'arabiya al-mundathira. *Majallat al-mu'arikh al-'arabi* 7: 53–63.

Al-Dayel K. and S. al-Helwa. 1978. Preliminary Report on the Second Phase of the Darb Zubayda Reconnaissance 1397/1977. *Atlal* 2: 51–64.

Al-Dayel K., S. al-Helwa and N. MacKenzie. 1979. Preliminary Report on the Survey of the Darb Zubayda, Third Season 1978. *Atlal* 3: 43–54.

De Castanheda F.L. 1833 (also 1924–33). *História do descobrimento e conquista da India pelos Portugueses* (8 vols). Lisbon.

Delaney C. 1990. The Hajj: Sacred and Secular. *American Ethnologist* 17(3): 515–30.

DeLong-Bas N.J. 2008. *Wahhabi Islam: From Revival and Reform to Global Jihad*. Oxford/New York.

Demirsar-Arlı B. and Altun. 2008. *Anadolu Toprağının Hazinesi Çini. Osmanlı Dönemi*. Istanbul.

Demirsar-Arlı B. 2013. Depictions of 'nalin-i Şerif' on Ottoman Tiles. *The 14th International Congress of Turkish Art*. Ankara.

Denny W. 1974. A Group of Islamic Silk Banners. *Textile Museum Journal* 4/1: 67–82.

Derman, M.U. 1988. Üçüncü Ahmed'in yazdırdığı mushaf. *Türkiye İş Bankası Kültür ve Sanat Dergisi* 1: 70–4.

Derman M.U. 1998. *Letters in Gold: Ottoman Calligraphy from the Sakıp Sabancı Collection*. New York. NY.

Déroche F. 2002. The Ottoman Routes of a Tunisian Calligrapher's *tour de force*. In Z. Yasa Yaman (ed.), *Sanatta Etkileşim/Interaction in Art*: 106–9. Ankara.

Devisse J. 1988. Trade and Trade Routes in West Africa. In M. al Fasi (ed.), *General History of Africa*. Vol. 3: *Africa from the Seventh to the Eleventh Century*: 367–435. Berkeley, CA.

Devoulx A. 1870. *Les Édifices religieux de l'ancien Alger*. Algiers.

Al-Dhahabi, Muhammad ibn Ahmad/eds Sh. al-Arna'ut *et al.* 1981–8. *Siyar a'lam al-nubala'* (25 vols). Beirut.

Diem W. 1993. *Arabische Briefe aus dem 7.–10. Jahrhundert* (2 vols). Vienna.

Digby S. 2004. Bayazid Beg Turkman's Pilgrimage to Makka and Return to Gujarat: A Sixteenth-Century Narrative. *Iran* 42: 159–77.

Al-Dinawari, Abu Hanifa Ahmad/ed. 'I.M.al-H. 'Ali. 2001. *Al-Akhbar al-tiwal*. Beirut.

Al-Diyarbakri, Hussein ibn Muhammad ibn al-Hasan [n.d.]. *Ta'rikh al-khamees fi ahwal anfus nafees*. Beirut.

Dodd E.C. and Sh. Khairallah. 1981. *The Image of the Word* (2 vols). Beirut.

The Dominican Institute for Oriental Studies [n.d.]. *Pilgrims to Makkah 1908*. Cairo.

Donner F.M. 2010. Umayyad Efforts at Legitimation: the Umayyads' Silent Heritage. In A. Borrut and P. Cobb (eds), *Umayyad Legacies: Medieval Memories from Syria to Spain*: 187–211. Leiden.

Dördüncü M.B. 2006. *Mecca – Medina: the Yıldız Albums of Sultan Abdülhamid II*. Somerset, NJ.

Doughty C.M. 1936. *Travels in Arabia Deserta*. New York [repr. 1979. 2 vols, Cambridge].

Dozy R. 1881. *Supplément aux dictionnaires arabes*. Leiden.

Drouot 1976. *Objets d'art d'Orient et d'Extrême-Orient*, sale catalogue (14 December). Paris.

Drouot 1980. *Art d'Asie: antiques, art Orientaliste, art d'Orient*, sale catalogue (9–10 December). Paris.

Drouot 1997. *Art d'Islam et de l'Orient, tableaus Orientalistes*, sale catalogue (17–18 November). Paris.

Du Bois-Aymé J. 1822. Mémoire sur la ville de Quçeyr et ses environs et sur les peuples Nomades qui habitent cette partie de l'ancienne Trogolodytique. In *Description de l'Égypte. État Moderne*m. Vol.II: 383–400. Paris.

Dudoignon S.A. 2000. Un islam périphérique? Quelques réflexions sur la presse musulmane de Sibérie à la veille de la Première Guerre mondiale. *Cahiers du monde russe* 41/2–3: 297–339.

Duguet F. 1932. *Le Pèlerinage de la Mecque au point de vue religieux social et sanitaire*. Paris.

Al-Duwish S. 2005. *Kazima al-buhur: dirasa tarikhiya wa 'athariya limawqi' Kazima – muhafiza al-Jahra'*. Kuwait City.

Dykstra D. 1998. The French Occupation of Egypt, 1798–1801. In M.W. Daly (ed.), *The Cambridge History of Egypt* (vol. 2): 113–38. Cambridge.

Edib M./ed. T.X. Bianchi. 1840. *Itinéraire de Constantinople à la Mecque: extrait de l'ouvrage turc intitulé: Kitab menassik el-hadj (Livre des prières et des cérémonies relatives au pélerinage)*. Paris.

Eickelman D.F. and J. Piscatori (eds). 1990. *Muslim Travellers: Pilgrimage, Migration and the Religious Imagination*. Berkeley/Los Angeles, CA.

Eickelman D.F. and J.W. Anderson (eds). 2003. *New Media in the Muslim World: The Emerging Public Sphere*. Bloomington, IN.

Eisenstadt S. N. 2000. Multiple Modernities. *Daedalus* 129/1: 1–29.

Eisenstein H. 2006. 'Spider'. *The Encyclopaedia of the Qur'an*.

Elad A. 1992. Why did 'Abd al-Malik Build the Dome of the Rock? A Re-examination of the Muslim Sources. In J. Raby and J. Johns (eds), *Bayt al-Maqdis: 'Abd al-Malik's Jerusalem*: 33–58. Oxford.

Erdmann K. 1959. Ka'bah Fliesen. *Ars Orientalis* 3: 192–7.

Erken S. 1971. Türk Çiniliğinde Kâbe Tasvirleri. *Vakıflar* 9: 297–320.

Escande L. 1999. D'Alger à La Mecque: l'administration française et le contrôle du pèlerinage (1894–1962). *Revue d'histoire maghrébine* 26: 277–92.

Esin E. 1984. Un manuscrit illustré représentant les sanctuaires de la Mecque et Médine et le dôme du miradj à l'époque des sultans turcs Selim et Suleyman 1er (H. 982–74/1516–66). In A. Temimi and M. Mzali (eds), *Les provinces arabes et leurs sources documentaires à l'époque ottomane*: 175–89. Tunis.

Establet C. and J.-P. Pascual. 1996. Pèlerinage et commerce à l'époque ottomane: Les inventaires après décès de 135 pèlerins morts à Damas à l'aube du XVIIIe siècle. *Turcica* 28: 117–62.

Establet C. and J.-P. Pascual. 2001. Café et objets du café dans les inventaires de pèlerins musulmans vers 1700. In M. Tuchscherer (ed.), *Le commerce du café avant l'ère des plantations coloniales: Espaces, réseaux, sociétés (XVe–XIXe siècle)*. (Cahiers des Annales Islamologiques 20): 143–51. Cairo.

Ettinghausen R. 1934. Die bildliche Darstellung der Ka'ba im islamischen Kulturkreis. *Zeitschrift der Deutschen Morgenländischen Gesellschaft* 12/3: 111–37.

Ettinghausen R. 1962. *Arab Painting*. Geneva.

Euting J./transl. F.S. al-Sa'eed. 1999. *Rihla dakhil al-Jazira al-'Arabiya*. Riyadh.

Euting J. 2007. Exploration of the North Western Arabia: A Comparative Study in the Light of Recent Archaeological Surveys. In A.U. al-Zayla'i *et al.* (eds), *Studies on the History and Civilization of Arabia*. Riyadh.

Evliya Çelebi. 1935. *Seyahatname: Anadolu Suriye Hicaz (1671–1672)*. Istanbul.

Evliya Çelebi. 1996. *Seyhatnâme* (10 vols). Istanbul.

Ewert C. 1977. Die Moschee am Bab al-Mardum in Toledo, eine 'Kopie' der Moschee von Córdoba. *Madrider Mitteilungen* 18: 287–354.

Facey W. 1997. *Dir'iyyah and the First Saudi State*. London.

Facey W. 2004. The Red Sea: The Wind Regime and Location of Ports. In P. Lunde, and A. Porter (eds). *Trade and Travel in the Red Sea Region*: 7–18. Oxford.

Facey W. 2011. The First Englishwoman on the Hajj: Lady Evelyn Cobbold in 1933. In G. Maclean (ed.), *Britain and the Muslim World: Historical Perspectives*: 164–77. Newcastle upon Tyne.

Al-Fairuzabadi, Majd al-Din. 2002. *Al-Maghanim al-mutaba fi ma'alim taba*. Medina.

Al-Fakihi, Muhammad/ed. 'Abd al-Malik ibn 'Abd Allah ibn Dahish. 1994. *Akhbar makka* (6 vols). Beirut.

Farooqi N. 1989. *Mughal-Ottoman Relations: A Study of Political and Diplomatic Relations between Mughal India and the Ottoman Empire, 1556–1748*. Delhi.

Faroqhi S. 1994. *Pilgrims and Sultans: the Hajj under the Ottomans, 1517–1683*. London and New York.

Faruk Ş. 1981–2. Kütahya'da çinili eserler. In *Atatürk'ün Doğumunun 100. Yilna Armağan. Kütahya*: 127–8. İstanbul.

Al-Fasi, al-Hafiz Abu al-Tayyib Taqi al-Din al-Qurashi/ed. A. Fu'ad and M.M. al-Dhahabi. 1999. *Shifa' al-gharam bi akhbar al-balad al-haram*. Mecca.

Featherstone M. 2002. Islam Encountering Globalization: An Introduction. In A. Mohammadi (ed.), *Islam Encountering Globalization*: 1–13. London.

Ferize Ş. 1997. Eyüp Sultan Türbesi Çinileri Üzerine. *I Eyüp Sultan Sempozyumu*: 348–56.

Ferrand G. (transl.). 1922. *Voyage du marchand arabe Sulayman en Inde et en Chine, Written in 851, Followed with Comments by Abu Zayd Hasan (c. 916)*. Paris.

Fetzer J.S. and J.C. Sopher. 2005. *Muslims and the State in Britain, France, and Germany*. Cambridge.

Al-Fi'r M.F.'A. 1986. 'Al-Kitabat wa al-nuqush fi al-Hijaz fi al-'asrayn al-mamluki wa al-'uthmani min al-qarn al-thamin hatta al-qarn al-thani 'ashar al-hijri'. PhD Thesis. University of Umm al-Qura [unpublished].

Fischer M. and M. Abedi. 1990. *Debating Muslims: Cultural Dialogues in Postmodernity and Tradition*. Wisconsin.

Fisher C. and A. Fisher. 1982. Illustrations of Mecca and Medina in Islamic Manuscripts. In C. Fisher and A. Fisher (eds), *Islamic Art from Michigan Collection*: 40–7. Michigan.

Flecker M. 2000. A 9th-century Arab or Indian Shipwreck in Indonesian Waters. *International Journal of Nautical Archaeology* 29/2: 199–221.

Flood F.B. 2009. *Objects of Translation: Material Culture and Medieval 'Hindu-Muslim' Encounter*. Princeton, NJ.

Flood F.B. 2011. Appropriation as Inscription: Making History in the First Friday Mosque of Delhi. In R. Brillant and D. Kinney (eds), *Reuse Value: Spolia and Appropriation in Art and Architecture from Constantine to Sherrie Levine*: 121–48. Farnham.

Foster W. (ed.). 1967. *The Red Sea and Adjacent Countries at the Close of the Seventeenth Century*. Liechtenstein.

François V. 2002. Production et consommation de vaisselle à Damas à l'époque ottomane. *Bulletin d'Études Orientales* 53–4. *Supplément: études et travaux à la citadelle de Damas, 2000–2001: un premier bilan*: 157–70. Damascus.

Freitag U. 2011. The City and the Stranger: Jeddah in the Nineteenth Century. In U. Freitag, M. Fuhrmann, N. Lafi and F. Riedler (eds), *The City in the Ottoman Empire*: 218–27. Abingdon.

Frémeaux J. 1976. 'Les Bureaux Arabes dans la province d'Alger (1844–1856)'. PhD thesis. Université de Toulouse-le-Mirail [unpublished].

Frenkel M. and Lev Y. 2009. *Charity and Giving in Monotheistic Religions*. Berlin/New York.

Freyberger K.S. 1989. Das Tychaion von as-Snamain.Ein Vrobericht. *Damaszener Mitteilungen* 4: 87–108.

Freyberger K.S. 1990. Research on Roman Temples in Syrian, the Tychaion at es-Snamain: A Preliminary Report. In S. Kerner (ed.), *The Near East in Antiquity. German Contributions to the Archaeology of Jordan, Palestine Syria Lebanon and Egypt*. Vol. 1: 293–7. Amman.

Fu'ad Sayyid A. 1998. *La Capitale de l'Égypte jusqu'à l'époque fatimide: al-Qahira et al-Fustat, essai de reconstitution topographique*. Beirut.

Gachet J. 1998. Akkaz (Kuwait), A Site of the Partho-Sasanian Period: A Preliminary Report on the Three Seasons of Excavation (1993–1996). *Proceedings of the Seminar for Arabian Studies* 28: 69–81.

Garcin J.C. 1976. *Un centre musulman de la Haute Egypte mediévale* (3 parts). Cairo.

Gatrad A.R. and A. Sheikh. 2005. Hajj: Journey of a Lifetime. *British Medical Journal* 330: 133–7.

Gaudefroy-Demombynes M. 1918. Notes sur la Mekke at Medine. *Revue de l'Histoire des Religions* 77: 316–44.

Gaudefroy-Demombynes M. 1923 (repr. 1977). *Le Pèlerinage à la Mekke*. Paris.

Gaudefroy-Demombynes M. 1954. La voile de la Ka'ba. *Studia Islamica* 2: 5–21.

Gellner E. 1992. *Postmodernism, Reason and Religion*. London.

George A. 2012. Orality, Writing and the Image in the *Maqamat*: Arabic Illustrated Books in Context. *Art History* 35/1: 10–37.

Georgeon F. and I. Tamdoğan-Abel. 2004. *Abdürrechid Ibrahim: Un Tatar au Japon. Voyage en Asie (1908–1910.)* Paris.

Germain R. 1955. *La Politique indigène de Bugeaud*. Paris.

Ghabban A.I. 1988. 'Introduction à l'étude archéologique des deux routes Syrienne Egyptienne de Pèlerinage au nord ouest de l' Arabie Saoudite'. PhD thesis. Université de Provence Aix Marseille I [unpublished].

Ghabban A.I. 1990. Al-Abar al-sultaniya bi Wadi al-Zurayb bi al-Wajh. *Majallat al-'usur* 5/2: 257–83.

Ghabban A.I. 1991. Naqshan min shibh jazirat Sina' yu'arikhan li-'imarat al-sultan al-mamluki Qansawh al-Ghawri li-tariq al-hajj al-misri wa al-amakin al-muqaddasa fi al-Hijaz. *Manshurat markaz al-buhuth, kulliyat al-adab, jami 'at al-Malik Su'ud*.

Ghabban A.I. 1992. Naqsh ghair manshur bi baldat al-Muwailih mu'arrakh bi sanat 967/1560. In 'A.T. al-Ansari *et al.* (eds), *Dirasat fi al-athar*: 305–30. Riyadh.

Ghabban A.I. 1993a. *Al-Athar al-islamiya fi shamal gharb al-Mamlaka al-'Arabiya al-Sa'udiya*. Riyadh.

Ghabban A.I. 1993b. Shamal gharb al-Mamlaka al-'Arabiya al-Sa'udiya. In 'A.T. al-Ansari *et al.* (eds), *Dirasat fi al-athar*: 99–136. Riyadh.

Ghabban A.I. 1993c. Qira'a jadida li naqsh Qal'at al-Zurayb bi al-Wajh shamal gharb al-Mamlaka al-'Arabiya al-Sa'udiya. *Majallat jami'at al-malik Sa'ud* 5: 305–30.

Ghabban A.I. 1998. Al-Nuqush al-'uthmaniya al-baqiya 'ala 'ama'ir tariqay al-hajj al-shami wa al-misri fi shamal gharb al-Mamlaka al-'Arabiya al-Sa'udiya. In 'A. al-Tamimi (ed.), *A'mal al-mu'tamar al-thani li mudawanat al-athar al-'uthmaniya fi al-'alam*: 201–42. Zaghwan.

Ghabban A.I. 2011. *Les deux routes syrienne et égyptienne de pèlerinage au nord-ouest de l'Arabie Saoudite*. Cairo.

Ghalib 'A. 1988. *Mawsu'at al-'imara al-islamiya*. Beirut.

Ghawanmeh Y. 1982. *Al-Tarikh al-hadari li-sharqay al-Urdunn fi al-'asr al-mamluki*. Amman.

Ghawanmeh Y. 1984. *'Ayla' al-'Aqaba wa al-bahr al-ahmar wa ahamiyatuha al-tarikhiya wa al-istratijiya*. Irbid.

Al-Ghazali, Abu Hamid Muhammad/ed. M.M.'A. Sayda 1977. *Asrar al-hajj*. Beirut.

Al-Ghazali, Abu Hamid Muhammad/ed. Sh. al-Tahhan and 'A al-Minshawi 1996 (also 1939). *Ihya' 'ulum al-din*. Al-Mansura.

Al-Ghazzi, Ibn Qasim. 1952. *Fath al-qarib*. Cairo.

Al-Ghunaym Y.Y. 1998. *Al-Sayyidan: qabs min madi al-Kuwait*. Kuwait City.

Gibb H.A.R. 1929. The Holy Cities of Arabia by Eldon Rutter. *Bulletin of the School of Oriental and African Studies* 5: 625–6.

Gibb H.A.R. 1952. The Achievement of Saladin. *Bulletin of John Rylands University Library* 35: 44–60.

Giddens A. 1990. *The Consequences of Modernity*. Palo Alto, CA.

Glidden H.W. 1952. The Mamluk Origin of the Fortified Khan at al-'Aqabah. In G.C. Miles (ed.), *Archeologica Orientalia in Memoriam Ernst. Herzfeld*: 116–18. New York.

Goitein S.D. 1967. *A Mediterranean Society: The Jewish Communities of the Arab World as Portrayed in the Documents of the Cairo Geniza*. Los Angeles.

Goitein S.D. 1973. *Letters of Medieval Jewish Traders*. Princeton, NJ.

Golombek L. 1969. The Abbasid Mosque at Balkh. *Oriental Art* 15: 173–89.

Golvin L. 1970–9. *Essai sur l'architecture religieuse musulmane*. Paris.

Goodwin G. 1971. *A History of Ottoman Architecture*. London.

Grabar O. 1984. *The Illustrations of the Maqamat*. Chicago and London.

Graïa D. 1976. 'Les Hadjis Algeriens (1962–1972)'. PhD thesis. École des hautes études en sciences sociales [unpublished thesis].

Grant C.P. 1937. *The Syrian Desert: Caravans, Travel and Exploration*. London, New York and Bahrain [repr. 2003].

Green N. 2011. *Bombay Islam: The Religious Economy of the West Indian Ocean, 1840–1915*. New York.

Green N. 2012. *Sufism: a Global History*. Oxford.

Green N. 2013 (forthcoming). Forgotten Futures: Indian Muslims in the Trans-Islamic Turn to Japan. *Journal of Asian Studies* 72/3.

Greenlaw J.-P. 1995. *The Coral Buildings of Suakin: Islamic Architecture, Planning, Design and Domestic Arrangements in a Red Sea Port*. London and New York.

Grenier J.A. 1963. A Minnesota Railroad Man in the Far East, 1917–1918. *Minnesota History* 38/7: 310–32.

Grob E.M. 2010. *Documentary Arabic Private and Business Letters on Papyrus: Form and Function, Content and Context*. Berlin.

Guo L. 2004. *Commerce, Culture, and Community in a Red Sea Port in the Thirteenth Century: The Arabic Documents from Quseir* (Islamic History and Civilization: Studies and Texts, 52). Leiden and Boston.

Guthrie S.1995. *Arab Social Life in the Middle Ages*. London

Habib I. 1305/1887. *Hat ve Hattâtân*. Istanbul.

Hafiz 'A. 1984. *Fusul fi tarikh al-Madina al-Munawwara*. Jedda.

El-Hage B. 1997. *Saudi Arabia Caught in Time: 1861–1939*. Reading.

Hall S. 1996. Gramsci's Relevance for the Study of Race and Ethnicity. In D. Morely and K. Chen (eds), *Stuart Hall: Critical Dialogues in Cultural Studies*: 411–40. London.

Al-Hamawi,Yaqut/ed. Farid 'Abd al-'Aziz al-Jundi. [n.d.] (also 1977). *Mu'jam al-buldan*. Beirut.

Hamid Kh.M. 2011. *Wasf al-masjid al-nabawi*. Giza.

Hamilton B. 2006. Reynald of Chatillon (d. 1187). In A.V. Murray (ed.), *The Crusades: An Encyclopedia* (4 vols). Vol 4: 1027–8. Santa Barbara, CA.

Hammoudi A. 2006. *A Season in Mecca: Narrative of a Pilgrimage*. Cambridge.

Hantscho W./transl. K. al-'Asali. 2001. *Al-Makayeel wa al-awzan al-islamiya wa ma yu'adiluha fi al-nitham al-mitri*. Amman.

Haq F. and J. Jackson. 2009. Spiritual Journey to Hajj: Australian and Pakistani Experience and Expectations. *Journal of Management, Spirituality and Religion* 6/2: 141–56.

Al-Harbi, Abu Ishaq Ibrahim/ed. A. al-Jasir. 1969 (also 1981). *Kitab al-manasik wa-amakin turuq al-hajj wa-ma'alim al-Jazirah*. Riyadh.

Harden D.B. 1955. Glass from Sennar and Aidhab. In P.L. Shinnie (ed.), *Excavations at Soba*: 69–76. Khartoum.

Hariri, Abu Muhammad al-Qasim 1965. *Maqamat al-Hariri*. Beirut

Harrison M. 1994. *Public Health in British India: Anglo-Indian Preventative Medicine, 1859–1914*. Cambridge.

El-Hawary H.M. and G. Wiet./ed. N. Elisséeff. 1985. *Matériaux pour un Corpus Inscriptionum Arabicarum: IV: Arabie: Inscriptions et Monuments de la Mecque: Haram et Ka'ba*. Cairo.

Hawkins C.W. 1977. *The Dhow*. Lymington (Hampshire).

Hawting G.R. 1984. 'We Were Not Ordered with Entering it but Only with Circumambulating It': *Hadith* and *Fiqh* on Entering the Ka'ba. *Bulletin of the School of Oriental and African Studies* 47: 228–42.

Hawting G.R. 1993. The Hajj in the Second Civil War. In I.R. Netton (ed.), *Golden Roads: Migration, Pilgrimage and Travel in Mediaeval and Modern Islam*: 31–42. Richmond.

Hawting G.R. 2001. 'Ka'ba'. *The Encyclopaedia of the Qur'an*.

Hawting G.R. 2004. *The Development of Islamic Ritual*. Burlington, VT.

Headley Lord. 1914. *A Western Awakening to Islam*. London.

Hedayat M.Q. [n.d.]. *Safarnama-ye Tasharruf bih Makka-ye Mu'azzama*. Tehran.

Hedayat K.M. 2003. 'Mokber al-Saltana. i. Life and Work'. In *Encyclopaedia Iranica*.

Al-Helwa S., A.A. al-Shaikh and S.A. Murad. 1982. Preliminary Report on the Sixth Phase of the Darb Zubaydah Reconnaissance 1981 (1401). *Atlal* 6: 39–62.

Henderson J.C. 2011. Religious Tourism and Its Management: The Hajj in Saudi Arabia. *International Journal of Tourism Research* 13: 541–52.

Herold J.C. 1962. *Bonaparte in Egypt*. London.

Al-Hibri, 'Abd al-Rahman.1975. Menasik-ı Memalik I. *Tarih Enstitüsü Dergisi* 6: 112–18.

Al-Hijji Y.Y. 1984. *Rihlat al-Ghazir*. Madrid.

Hilmi I. 1989. Kiswat al-ka'ba al-sharifa. *Al-Funun al-Shaabia* 29: 73–114.

Hilmi I. 1994. *Kiswat al-ka'ba al-musharrafa wa funun al-hujjaj*. Cairo.

Al-Himyari, Nashwan/ed. 'Ali ibn Isma'il al-Mu'ayyad and Isma'il ibn Ahmad al-Jarafi. 1985. *Muluk Himyar wa Aqyal al-Yaman*. Beirut.

Holland T. 2012. *In the Shadow of the Sword*. London.

Honigmann. E. 'al-Ramla'. *Encyclopaedia of Islam* (*EI²*).

Horowitz J. 1911–12. The Inscriptions of Muhammad Ibn Sam, Qutubuddin Aibeg and Itltutmish. *Epigraphia Indo-Moslemica*: 12–34.

Hourani A. 2005. *A History of the Arab Peoples*. London.

Housley N. 1982–9. Pilgrimage, Western European. In J.R. Strayer (ed.), *Dictionary of the Middle Ages*: 9/654–61.

Hoyland R. 2001. *Arabia and the Arabs*. Oxford.

Hoyland R.G. 2006. New Documentary Texts and the Early Islamic State. *Bulletin of the School of Oriental and African Studies* 69: 395–416.

Hrbek I. and Devisse J. 1988. The Almoravids. In M. El Fasi (ed.), *General History of Africa*. Vol. III, *Africa from the Seventh to the Eleventh Century*: 336–66. Berkeley, CA.

Hugo V./ed. E. Barineau 1954. *Les Orientales*. Paris.

Humbert J.B. 1986. El Fedein-Mafraq. *Liber Annuus* 36: 354–8.

Hunarfar L. 1930. *Ganjina-yi athar-i tarikhi-yi Isfahan*. Isfahan.

Hussain M.A. 1936. *A Record of all the Qur'anic and Non-historical Epigraphs on the Protected Monuments in the Delhi Province*. Archeological Survey of India 1947. Calcutta.

Ibn al-Athir, 'Izz al-Din. 1978 (various edns 1867–71, and 1987). *Al-Kamil fi 'l-ta'rikh* (9 vols). Beirut.

Ibn al-Athir, 'Izz al-Din/transl. D.S. Richards. 2010. *The Chronicle of Ibn al-Athir for the Crusading Period from al-Kamil fi 'l-ta'rikh*. London.

Ibn Battuta, Muhammad ibn 'Abd Allah/ed. and transl. H.A.R. Gibb. 1929 (various edns 1958–2000, 2005). *Travels in Asia and Africa 1325–1354*. London.

Ibn Battuta, Abu 'Abd Allah Muhammad ibn 'Abd Allah/transl. C. Defrémery and B.R. Sanguinetti. 1968. *Voyages d'Ibn Battuta* (4 vols). Paris.

Ibn Battuta Abu 'Abd Allah Muhammad ibn 'Abd Allah/ed. J. Ramadi. 1981. *Rihalat Ibn Battuta*. Beirut.

Ibn Fahd, al-Najm 'Umar/ed. F.M. Shaltout. 1984. *Ithaf Umm al-Qura*, Mecca.

Ibn Fahd, al-Najm 'Umar/ed. S. Kh. Ibrahfim *et al*. 2005. *Bulugh al-qura fi thayl ithaf al-wura bi-akhbar Umm al-Qura*. Cairo.

Ibn al-Furat, Nasir al-Din Muhammad/ed. C. Zureiq *et al*. 1940–2. *Tarikh ibn al-Furat*. Beirut.

Ibn Habib, Muhammad/ed. I. Lichtenstadter. 1942. *Al-Muhabbar*. Hyderabad.

Ibn Habib, Muhammad/ed. Kh.A. Fariq. 1985. *Al-Munammaq*. Beirut.

Ibn Hajar, Ahmad ibn 'Ali. 1907–10.*Tahdhib al-tahdhib* (12 vols). Hyderabad.

Ibn Hanbal, Ahmad/ed. M. 'Abd al-Thani. 1993. *Musnad Ahmad Ibn Hanbal* (8 vols). Beirut.

Ibn Hawqal, Abu Qasim/ed. M.J. De Goeje. [n.d.] (also 1992). *Kitab surat al-ard*. Beirut.

Ibn Hazm, 'Ali ibn Ahmad/ed. A.-S. al-Karmi.1998. *Hijjat al-wada'*. Riyadh.

Ibn Hisham, 'Abd al-Malik/eds M. al-Saqqa *et al*. 1936. *Al-Sira al-nabawiya* (4 vols). Cairo.

Ibn Iyas, Muhammad ibn Ahmad. 1955–60/transl. G. Wiet. *Journal d'un bourgeois du Caire. Chronique d'Ibn Iyas* (2 vols). Paris.

Ibn Iyas, Muhammad ibn Ahmad/ed. M Musatafa. 1982 (also 1983). *Bada'i' al-zuhur fi waqa'i' al-duhur*. Cairo.

Ibn al-Jawzi, Abu al-Faraj/ed. Suhayl Zakkar. 1995. *Al-Muntazam* (13 vols). Beirut.

Ibn al-Ji'an, Sharaf al-Din Yahya ibn Shakir Ibn 'Abd al-Ghani. 1974. *Al-Tuhfa al-sunniya bi asma'al-bilad al-misriya*. Cairo.

Ibn Jubayr, Abu al-Hasan Muhammad ibn Ahmad. [n.d.]. *Rihlat Ibn Jubayr*. Beirut [repr. 1984. Beirut].

Ibn Jubayr/ed. M. Gaudefoy-Demombynes. 1949–51. *Ibn Jobair: Voyages* (2 vols). Paris.

Ibn Jubayr/transl. R.J.C. Broadhurst. 1952. *The Travels of Ibn Jubayr*. London [repr. 2004, New Delhi].

Ibn Kathir, Abu al-Fida'/eds Ahmad Abu Mulhim *et al*. [n.d.]. *Al-Bidaya wa-l-nihaya* (15 vols). Beirut.

Ibn Khayyat, Khalifa/ed. A.D. al-'Umari. 1985. *Ta'rikh* (third edn). Riyadh.

Ibn Khurdadhbih, 'Ubayd Allah ibn 'Abd Allah/ed. M.J. De Goeje. 1889. *Kitab al-masalik wa-'l-mamalik*. Leiden [n.d. reprint. Cairo].

Ibn Majah, Muhammad Ibn Yazid. 1999. *Sunan Ibn Majah*. Riyadh.

Ibn Manzur, Muhammad ibn Makram. 1990. *Lisan al-ʿarab* (15 vols). Beirut [repr. 2003. Cairo].

Ibn al-Mujawir,Yusif ibn Yaʿqub/ed. O. Löfgren. 1951–4. *Sifat bilad al-Yaman wa-Makka wa-baʾd al-Hijaz al-musamma tarikh al-mustabsir (Descriptio Arabiae Meridionalis)* (2 vols). Leiden.

Ibn al-Mujawir,Yusif ibn Yaʿqub/transl. G.R. Smith. 2007. *A Traveller in Thirteenth-Century Arabia: Ibn al-Mujawir's Tarikh al-Mustabsir*. London.

Ibn Munabbih, Wahb. 1997. *Kitab al-tijan fi muluk Himyar*. Cairo.

Ibn al-Najjar, al-Imam al-Hafiz Muhammad ibn Mahmoud/ed. ʿA. al-Mahdi. 2003. *Tarikh al-Madina al-Munawwara al-musamma al-durra al-thamina fi akhbar al-Madina*. Medina.

Ibn Qutayba, ʿAbd Allah ibn Muslim/ed. Th. ʾAkasha. 1958. *Al-Maʿarif*. Cairo.

Ibn Rushd, Muhammad ibn Ahmad. 1988. *Al-Bayan wa al-tahseel wa al-sharh wa al-tawhid wa al-taʿlil fi masaʾil al-mustakhraja*. Beirut.

Ibn Rusta, Abu ʿAli Ahmad ibn ʿUmar/ed. M.J. De Goeje. 1892. *Kitab al-aʿlaq al-nafisa*. Leiden.

Ibn Saʿd, Muhammad/eds E. Sachau *et al.* 1904–40. *Kitab al-tabaqat al-kabir* (9 vols). Leiden.

Ibn Sasra, Muhammad ibn Muhammad/ed. and transl. W.M.Brinner. 1963. *A Chronicle of Damascus, 1389–1397, by Muhammad ibn Muhammad ibn Sasra. The Unique Bodleian Library Manuscript of al-Durra al-Mudiʾa fi l-Dawla al-Zahiriya (Laud or. MS 112)*. Berkeley, CA and Los Angeles.

Ibn Sayda, Abu al-Hasan ʿAli ibn Ismaʿil al-Andalusi. 1898–1903. *Al-Mukhassas fi al-lugha*. Bulaq.

Ibn Shaddad, ʿIzz al-Din Muhammad/ed. A. Hatit. *Tarikh al-Malik al-Zahir*. Germany.

Ibn Taghribirdi, Jamal al-Din Abu al-Mahasin Yusif al-Atabaki/ed. W. Popper. 1908–36. *Al-Nujum al-zahira fi muluk Misr wa l-Qahira* (40 vols). Berkeley and Leiden [repr., ed. M.H. Shams al-Din. 1992. Beirut].

Ibrahim ʿA. 1910–13. *ʿAlem-i Islam ve Japonya'da Intişarı islamiyet* (2 vols). Istanbul.

Ibrahim ʿA. 1956. *Dirasat tarikhiya wa athariya fi wathaʾiq min ʿasr al-Ghawri*. PhD thesis. University of Cairo [unpublished].

Ibrahim ʿA. 1963. Min wathaʾiq Saint Catherine: thalath wathaʾiq fiqhiya. *Majallat kulliyat al-adab* 25/2: 95–133.

Ibrahim ʿA. 1979 Wathaʾiq al-waqf ʿala al-amakin al-muqaddasa. (*Dirasat fi tarikh al-jazira al-ʿarabiya*). Riyadh.

Al-Idrisi, Abu ʿAbd Allah Muhammad ibn Muhammad. [n.d.] (also 1994). *Nuzahat al-mushtaq fi ikhtiraq al-afaq*. Cairo.

Al-Idrisi/ed. R. Dozy and M.J. De Goeje. 1866. *Description de l'Afrique et de l'Espagne*. Leiden.

İnal M.K. 1955. *Son Hattatlar*. Istanbul.

Insoll T. 2002. The Archaeology of Post Medieval Timbuktu. *Sahara* 13: 7–22.

Insoll T. 2003. *The Archaeology of Islam in Sub-Saharan Africa*. Cambridge.

Ipek S. 2003. Kabe Kabe Örtülerinin İkinci Kullanımları (The Re-use of Kaʿba Covers). *Toplumsal Tarih*, V.114 (June): 22–7.

Ipek S. 2005. Osmanlı'da Sandukalara Örtü Örtme Geleneği ve Eyüp Sultan Haziresi'ndeki Taş Lahit (The Ottoman custom of covering sarcophagi and the stone sarcophagus in the tomb of Eyup Sultan). *Tarihi, Kültürü ve Sanatıyla Eyüp Sultan Sempozyumu IX (13–15 May 2005)*: 322–37

Ipek S. 2006. Ottoman Ravza-i Mutahhara Covers Sent from Istanbul to Medina with the Surre Processions. *Muqarnas* 23: 289–316.

Ipek S. 2008. Religious Fabrics in the Topkapi Palace Museum Sent to Mecca and Medina. In Istanbul 2008: 57–69.

Irwin R. 2012. Journey to Mecca: A History (Part 2). In V. Porter (ed.), *Hajj. Journey to the Heart of Islam*: 136–219. London.

Al-Isfahani, al-Hasan ibn ʿAbd Allah/ed. H. al-Jasir and S. al-ʿAli. 1968. *Bilad al-ʿarab*. Riyadh.

Iskandar T. 1999. *Catalogue of Malay, Minangkabau, and South Sumatran Manuscripts*. 2 vols. Leiden.

Issawi C. (ed.). 1966. *The Economic History of the Middle East, 1800–1914: A Book of Readings*. Chicago and London.

Issawi C. (ed.). 1988. *The Fertile Crescent, 1800–1914. A Documentary Economic History. Studies in Middle Eastern History*. New York and Oxford.

Al-Istakhri, Abu Ishaq Ibrahim ibn Muhammad/ed. M.J. De Goeje. 1927. *Kitab al-masalik wa al-mamalik*. Leiden.

Istanbul 2008: *Imperial Surre* (exhib. cat, Topkapi Palace Museum).

Istanbul 2010: *1400. Yılında Kurʾan-ı Kerim* (exhib. cat., Türk ve İslam Eserleri Müzesi), Istanbul.

Al-Jabarti, ʿAbd al-Rahman/ed. and transl. S. Moreh. 1975. *Al-Jabarti's Chronicle of the First Seven Months of the French Occupation of Égypt*. Leiden.

Al-Jabarti, ʿAbd al-Rahman/eds T. Phillip and M. Perlmann. 1994. *ʿAbd al-Rahman al-Jabarti's History of Egypt: ʿAjaʾib al-Athar fi'l-Tarajim wa'l-Akhbar* (4 vols). Stuttgart.

Jacquemart A. 1866. *Les merveilles de la céramique, Première partie Orient*. Paris.

Al-Jahiz, ʿAmr ibn Bahr/ed. ʾA.S.M. Harun. 1963–79. *Al-Rasaʾil* (4 vols). Cairo.

Al-Jahiz, ʿAmr ibn Bahr/ed. M.B. ʿUyun al-Sud. 1998. *Kitab al-hayawan* (4 vols). Beirut.

Jalal A.H.M.ʿA 2006. *Turuq wa marafiq al-hajj fi al-Hijaz fi al-ʿasr al-mamluki*. Jedda.

Al-Jamil M.F. 2010. *Buyut al-nabi salla Allah ʿalayhi wa sallam wa hujratiha wa sifat maʿishatahu fiha ʿbayt ʾaʿisha unmuthajan'* (5 vols). Riyadh.

Janssens G. B. de. 1951. L'Indépendance du culte musulman en Algérie. *Revue juridique et politique de l'Union française* 1: 305–39.

Jar Allah ibn Ibrahim. 1997. *Al-Istitan wa al-athar al-islamiya fi mintiqat al-Qasim*. Riyadh.

Al-Jasir H. 1975. Fi rihab al-haramayn min khilal kutub al-rihlat ila al-hajj 2. *Majallat al-ʿarab* 9/7–8: 494.

Al-Jasir H. 1976. Al-Muʿjam al-jughrafi li al-bilad al-ʿArabiya al-Saʿudiya. *Majallat al-ʿarab* 10/11–12: 934–45.

Al-Jasir H. 1977. Fi rihab al-haramayn min khilal kutub al-rihlat ila al-hajj 13. *Majallat al-ʿarab* 12/5–6: 425.

Al-Jasir H. 1978a. Fi rihab al-haramayn min khilal kutub al-rihlat ila al-hajj 15. *Majallat al-ʿarab* 12/7–8: 425.

Al-Jasir H. 1978b. Fi rihab al-haramayn min khilal al-rihlat ila al-hajj 16. *Majallat al-ʿarab* 12/11–12: 837–52.

Al-Jasir H. (ed.). 1984. *Muqatatafat min rihlat al-ʿAyashi maʿ al-mawaʾid*. (Silisilat fi rihab al-haramayn ashhar al-rihlat, 2). Riyadh.

Al-Jasir H. 1990. Ashhar rihlat al-hajj li bayt Allah al-haram. *Majallat al-haras al-watani* 94: 18–27.

Jaussen. R.R. and P.P. Savignac. 1997. *Mission Archéologique en Arabie (Mars–Mai 1907) de Jérusalem au Hedjaz Médain-Saleh* (3 vols). Cairo.

Al-Jawhari R. 1964. *Sinaʾ ard al-qamar*. Cairo.

Al-Jaziri, ʿAbd al-Qadir/ed. H. al-Jasir. 1983. *Al-Faraʾid al-munazzama fi akhbar al-hajj wa tariq makka al-muʿazzama*. Riyadh.

Johnson K. 2000. Royal Pilgrims: Mamluk Accounts of the Pilgrimages to Mecca of the Khawand al-Kubra (Senior Wife of the Sultan). *Studia Islamica* 91: 107–31.

Jomier J. 1951. Un Caravanserai sur la route des pèlerins de la Mecque. *Bulletin de la société d'études historiques et géographiques de l'Isthme de Suez* 2: 33–56.

Jomier J. 1953. *Le Mahmal et la caravane égyptienne des pèlerins de la Mecque (XIIIe–XXe siècles)*. Cairo.

Jomier J. 1972. Le mahmal du sultan Qansuh al-Ghuri (début xvie siècle). *Annales islamologiques* 11: 183–8.

Jones A. 2007. *The Qurʾan*. Cambridge.

Judd S. 2011. Muslim Persecution of Heretics during the Marwanid Period (64–132/684–750). *Al-Masaq* 23: 1–14.

Juvin C. 2010. Les stèles du cimetière d'al-Maʿla à la Mecque. In Paris 2010: *Routes d'Arabie: archéologie et histoire du royaume d'Arabie Saoudite* (exhib. cat., Paris), ed. A.I. al-Ghabban, B. André-Salvini, F. Demange, C. Juvin and M. Cotty: 490–9. Paris.

Juvin C. 2013. Calligraphy and Writing Activities in Mecca during the Medieval Period (Twelfth–Fifteenth Centuries). *Proceedings of the Seminar for Arabian Studies* 43: 153–66.

Kafesçioğlu C. 1999. 'In the Image of Rum': Ottoman Architectural Patronage in Sixteenth-Century Aleppo and Damascus. *Muqarnas* 16: 70–96.

Kahala ʿU.R. [n.d.]. *Muʿjam al-muʾallifeen*. Vol. 4. Beirut.

Kane E. 2012. Odessa as a Hajj Hub, 1880s–1910s. In J. Randolph and E. Avrutin (eds), *Russia in Motion: Essays on the Politics, Society, and Culture of Human Mobility, 1850-Present*: 107–25. Illinois.

Karpat K. 2001. *Politicization of Islam: Reconstructing Identity, State, Faith, and Community in the Late Ottoman State*. Oxford.

Kateb K. 2001. *Européens, 'Indigènes', et Juifs en Algérie (1830–1962)*. Paris.

Kawatoko M. 1993. Preliminary Survey of 'Aydhab and Badi sites. *Kush* 16: 203–24.

Kawatoko M. 1995. *A Port City Site on the Sinai Peninsula, al-Tur: The 11th Expedition in 1994 (a Summary Report)*. Tokyo.

Kawatoko M. 1996. *A Port City Site on the Sinai Peninsula, al-Tur: The 12th Expedition in 1995 (a Summary Report)*. Tokyo.

Kawatoko M. 1998. *A Port City Site on the Sinai Peninsula, al-Tur: The 13th Expedition in 1996 (a Summary Report)*. Tokyo.

Kawatoko M. 2003. *Archaeological Survey of the Raya/al-Tur Area on the Sinai Peninsula, Egypt, 2002*. Tokyo.

Kawatoko M. 2005. Multi-disciplinary Approaches to the Islamic Period in Egypt and the Red Sea Coast. *Antiquity* 79: 844–57.

Kazantzakis N./transl. C. Wildman. 1961. *Zorba the Greek*. London and Boston.

Keane J.F.T. 2006. *Six Months in the Hijaz: Journeys to Makkah and Madinah*. Manchester and Beirut.

Kemper M. 1998. *Sufis und Gelehrte in Tatarien und Baschkirien: Der islamische Diskurs unter russischer Herrschat*. Berlin.

Kennedy D. and H. Falhat. 2008. Castra Legionis: a Building Inscription for the Legionary Fortress at Udruh near Petra. *Journal of Roman Archaeology* 21: 150–69.

Kennedy H. 'Al-Mansur'. *Encyclopaedia of Islam (EI²)*.

Kennedy H. 1981. *The Early Abbasid Caliphate: A Political History*. London.

Kennedy H. 2004. *The Court of the Caliphs: The Rise and Fall of Islam's Greatest Dynasty*. London.

Kennedy H. 2012. Journey to Mecca: a History. In V. Porter (ed.), *Hajj: Journey to the Heart of Islam*: 68–135. London.

Kennet D. 2004. *Sasanian and Islamic Pottery from Ras al-Khaimah: Classification, Chronology and Analysis of Trade in the Western Indian Ocean*. London.

Kennet D. 2012. Archaeological History of the Northern Emirates in the Islamic Period: an Outline. In D. Potts and P. Hellyer (eds), *Fifty Years of Emirates Archaeology – Proceedings of the Second International Conference on the Archaeology of the UAE*: 190–201. Abu Dhabi.

Kennet D., A. Blair, B. Ulrich and S. al-Duwish 2011. The Kadhima Project: Investigating an Early Islamic Settlement and Landscape on Kuwait Bay. *Proceedings of the Seminar for Arabian Studies* 41: 161–72.

Keskiner B. 2013. Sultan Ahmed III's Calligraphy on Tekfursarayi Tiles. *International Congress of Turkish Art*. Ankara.

Khan G. 1993. *Bills, Letters and Deeds: Arabic Papyri of the 7th to 11th Centuries*. London.

Al-Khayyari, Ibrahim ibn 'Abd al-Rahman/ed. R. M. Samarra'i. 1980. *Tuhfat al-udaba' wa salwat al-ghuraba': rihlat al-Khayyari*. Baghdad.

Al-Khuza'i, Di'bil ibn 'Ali/ed. N. Abaza, 1997. *Wasaya al-muluk*, Damascus.

Kibrit, Muhammad ibn 'Abd Allah al-Musawi/ed. M.S. al-Tantawi. 1966. *Rihlat al-shita' wa al-sayf*. Beirut.

Kiel M. 2001. The Caravanseray and Civic Centre of Defterdar Murad Çelebi in Ma'arrat an-Nu'man and the Külliye of Yemen Fatih Sinan Pasha in Sa'sa. In N. Akin, A. Batur and S. Batur (eds), *7 Centuries of Ottoman Architecture 'A Supra National Heritage'*: 103–10. Istanbul.

Kılıçbay B. and Binark, M. 2002. Consumer Culture, Islam and the Politics of Lifestyle. *European Journal of Communication* 17: 495–511.

King G. 1972. The Mosque Bab Mardum in Toledo and the Influences Acting upon It. *Art and Archaeology Research Papers* 2: 29–40.

King G. 1997. A Nestorian Monastic Settlement on the Island of Sir Bani Yas, Abu Dhabi: a Preliminary Report. *Bulletin of the School of Oriental and African Studies* 60: 221–35.

King G.R.D. 1989. The Nine Bay Domed Mosque in Islam. *Madrider Mitteilungen* 30: 332–90.

Kioumji F. and R. Graham 2009. *A Photographer on the Hajj: The Travels of Muhammad 'Ali Effendi Sa'udi (1904/1908)*. Cairo and New York.

Kirmani H.Kh.'A./ed. R. Ja'fariyan 1386/2007. *Ruznama-ye Safar-e Hajj, 'Atabat-e 'Aliyat va Darbar-e Nasiri 1309–1312 Q, 1271–1273 SH*. Qum.

Kister M.J. 1956. The Market of the Prophet. *Journal of the Econmic and Social History of the Orient* 8: 272–6.

Klinkert H.C. 1867. Verhaal eener pelgrimsreis van Singapoera naar Mekah door Abdoellah bin Abdil Kadir Moensji, gedaan in het

jaar 1854. *Bijdragen tot de taal-, land- en volkenkunde van Nederlandsch-Indië* 14/4: 384–410.

Klinkert H.C. 1889. *Verhaal van de reis van Abdoellah naar Kalantan en van zijne reis naar Djeddah, in het Maleisch*. Leiden.

Klunzinger C. 1878. *Upper Egypt: Its People and Products. A Descriptive Account of the Manners, Customs, Superstitions and Occupations of the People of the Nile Valley*. New York.

Knipp D. 2011. Almoravid Sources for the Wooden Ceiling in the Nave of the Cappella Palatina in Palermo. In T. Dittelbach (ed.), *Die Cappella Palatina in Palermo: Geschichte, Kunst, Funktionen*: 571–8. Künzelsau.

Knudstad J. 1977. The Darb Zubaydah Project 1396/1976: A Preliminary Report on the First Phase. *Atlal* 1: 41–68.

Krätli G and G. Lydon. (eds) 2011. *The Trans-Saharan Book Trade: Arabic Literacy, Manuscript Culture, and Intellectual History in Islamic Africa*. Leiden.

Krautheimer R. 1942a. The Carolingian Revival of Early Christian Architecture. *The Art Bulletin* 24/1: 1–38.

Krautheimer R. 1942b. Introduction to an 'Iconography of Mediaeval Architecture. *Journal of the Warburg and Courtauld Institutes* 5: 1–33.

Kuban D. 2010. *Ottoman Architecture*. Woodbridge.

Al-Kurdi, Muhammad Tahir ibn 'Abd al-Qadir. 1965. *Al-Tarikh al-qawim li Makka wa baytil- Allah al-karim*. Mecca.

Al-Kurdi H. 1974. *Al-Qila' al-athariya fi al-Urdunn*. Amman.

Labadi S. And C. Long (eds). 2010. *Heritage and Globalisation*. London.

Labib S. 1970. Egyptian Commerical Policy in the Middle Ages. In M.A. Cook (ed.), *Studies in the Economic History of the Middle East*: 63–77. Oxford.

Landau J.M. 1971. *The Hejaz Railway and the Muslim Pilgrimage: a Case of Ottoman Political Propaganda*. Detroit, MI.

Lane E. 1836. (various edns 1837 and 1981). *An Account of the Manners and Customs of Modern Egyptians, Written in Egypt during the Years 1833–1835*. London.

Lane E.W. 1863–93. (various edns 1955, 8 vols; 1984, 2 Vols). *Arabic-English Lexicon, Derived from the Best and Most Copious Eastern Sources*. London.

Laurens H. 1987. *Les Origines intellectuelles de l'expédition d'Égypte; l'orientalisme islamisant en France (1698–1798)*. Istanbul.

Laurens H. 1989. *L'Expédition d'Égypte: 1798–1801*. Paris.

Laurens H. 1997. Les Indonesiens en Arabie Saoudite pour la foi et le travail. *Revue Européene des Migrations Internationales* 13/1: 125–47.

Laurens H. 2006. L'islam dans la pensée française, des Lumières à la IIIe République. In M. Arkoun (ed.), *Histoire de l'islam et des musulmans en France du Moyen Âge à nos jours*: 515–31. Paris.

Lazarus-Yafeh H. 1981. The Religious Dialectics of the Hadjdj. In H. Lazarus-Yafeh (ed.), *Some Religious Aspects of Islam*: 17–36, 136–42. Leiden.

Le Pautremat P. 2006. La Mission du lieutenant-colonel Brémond au Hedjaz, 1916–17. *Guerres mondiales et conflits contemporains* no. 221: 17–31.

Le Quesne C. 2007. *Quseir. An Ottoman and Napoleonic Fortress on the Red Sea Coast of Egypt*. (American Research Center in Egypt, 2). Cairo.

Le Strange G. 1890. *Palestine under the Moslems*. London.

Leach L. 1998. *Paintings from India* (The Nasser D. Khalili Collection of Islamic Art, 8). Oxford.

Lecker M. 1986. On the Markets of Medina (Yathrib) in Pre-Islamic and Early Islamic Times. *Jerusalem Studies in Arabic and Islam (JSAI)* 8: 133–45.

Lee M. *et al.* 1992. Mamluk Caravansarais in Galilee. *Levant* 24: 55–94.

Lev Y. 1999. *Saladin in Egypt*. Leiden.

Levtzion N. 1980. *Ancient Ghana and Mali (Revised Edition)*. New York, NJ.

Levtzion N. and J.F.P. Hopkins (eds). 2000. *Corpus of Early Arabic Sources for West African History*. Princeton, NJ.

Lewis B. 1960. 'Hadj'. In H.A.R. Gibb *et al. The Encyclopaedia of Islam (EI²)*.

Lewis N. 1938. *Sand and Sea in Arabia*. London.

Lewis P. 2007. *Young, British and Muslim*. London.

Lézine A. 1965. *Mahdiya: recherches d'archéologie islamiya*. (Archéologie Méditerranéenne, 1). Paris.

Licata G.B. 1885. L'Italia nel Mar Rosson. *Boll. Sez. Fiorentina della Soc. Africana d'Italia* March: 5.

Linschoten J.H. van. 1598. *Discours of voyages into ye Easte and West Indies*. London.

Liverani M. 2003. The Libyan Caravan Road in Herodotus IV. *Journal of the Economic and Social History of the Orient* 43: 496–520.

Lorimer J.G. 1908. *Gazetteer of the Persian Gulf, Oman and Central Arabia*. Vol. 1. *Geographical and Statistical*. Calcutta.

Low M.C. 2007. Empire of the Hajj: Pilgrims, Plagues and Pan-Islam under British Surveillance 1865–1926. MA dissertation, Georgia State University [unpublished].

Low M.C. 2008. Empire and the Hajj: Pilgrims, Plagues and Pan-Islam, 1865–1908. *International Journal of Middle Eastern Studies* 40: 269–90.

Lucas C. and E. Lash 2010. Contact as Catalyst: the Case for Coptic Influence in the Development of Arabic Negation. *Journal of Linguistics* 46: 379–413.

Lucas P. 1744. *Voyage du Sieur Lucas*. Vol. 2. Paris.

Lunde P. 1974. The Lure of Mecca. *Aramco World Magazine* November/December 1974: 14–15.

Lydon G. 2004. Inkwells of the Sahara: Reflections on the Production of Islamic Knowledge in Bilad Shinqit. In S. Reese (ed.), *The Transmission of Learning in Islamic Africa*: 39–71. Leiden.

Lydon G. 2009. *On Trans-Saharan Trails: Islamic Law, Trade Networks, and Cross-Cultural Exchange in Nineteenth-century Western Africa*. Cambridge.

MacKenzie N. and S. al-Helwa. 1980. Darb Zubaida – 1979: a Preliminary Report. *Atlal* 4: 37–50.

Maclean K. 2008. *Pilgrimage and Power: Kumbh Mela in Allahabad, 1765–1954*. Oxford.

McDonnell M.B. 1990. Patterns of Muslim Pilgrimage from Malaysia, 1885–1985. In F. Dale Eickelman and J. Piscatori (eds), *Muslim Travellers: Pilgrimage, Migration and the Religious Imagination*: 111–30. Berkeley, CA.

McDougall J. 2006. *History and the Culture of Nationalism in Algeria*. Cambridge.

McGrail S. 1981. *Rafts, Boats and Ships*. London.

McLoughlin S. 2002. Recognising Muslims: Religion, Ethnicity and Identity Politics in Britain. *Cahiers d'études sur la Méditerranée Orientale et le Monde Turco-Iranien* 33: 43–54.

McLoughlin S. 2005a. Mosques and the Public Space: Conflict and Cooperation in Bradford. *Journal of Ethnic and Migration Studies* 31/6: 1045–66.

McLoughlin S. 2005b. The State, New Muslim Leaderships and Islam as a resource for Public Engagement in Britain. In J. Cesari and S. McLoughlin (eds), *European Muslims and the Secular State*: 55–69. Aldershot.

McLoughlin S. 2009a. Contesting Muslim Pilgrimage: British-Pakistani Identities, Sacred Journeys to Makkah and Madinah and the Global Postmodern. In V.S. Kalra (ed.). *The Pakistani Diaspora*: 233–65. Karachi and Oxford.

McLoughlin S. 2009b. Holy Places, Contested Spaces: British-Pakistani Accounts of Pilgrimage to Makkah and Madinah. In R. Gale and P. Hopkins (eds), *Muslims in Britain: Identities, Places and Landscapes*: 132–49. Edinburgh.

McLoughlin S. 2009c. Religion and Diaspora. In J.R. Hinnells (eds), *The Routledge Companion to the Study of Religions*: 558–80. London and New York.

McLoughlin S. 2010a. Muslim Travellers: Homing Desire, the *Umma* and British-Pakistanis. In K. Knott and S. McLoughlin (eds), *Diasporas: Concepts, Identities, Intersections*: 223–9. London.

McLoughlin S. 2010b. From Race to Faith Relations, the Local to the National Level: The State and Muslim Organisations in Britain. In A. Kreienbrink and M. Bodenstein (eds), *Muslim Organisations and the State - European Perspectives*: 123–49. Nürnberg.

McLoughlin S. 2012. United Kingdom and Northern Ireland. In J. Nielsen (ed.), *Yearbook of Muslims in Europe 2011*. Leiden.

McMillan M.E. 2011. *The Meaning of Mecca: The Politics of Pilgrimage in Early Islam*. London.

Magnavita S. 2009. Sahelian Crossroads: Some Aspects on the Iron Age Sites of Kissi, Burkina Faso. In S. Magnavita, L. Koté, P. Breunig and O. Idé. (eds), *Crossroads: Cultural and Technological Developments in First Millenium BC/AD West Africa*: 79–104. Frankfurt.

Mahfouz N. 1947. *Midaq Alley*. Cairo.

Mahfouz N. 1957. *Al-Sukkariya*. Cairo.

Mallinson M., C. Breen, W. Forsythe, J. Phillips, and L. Smith. 2009.

Ottoman Suakin 1541–1865 AD – Lost and Found. In A. Peacock (ed.), *The Frontiers of the Ottoman World*: 469–92. Oxford.

Mamdani M. 2004. *Good Muslim, Bad Muslim: America, the Cold War, and the Roots of Terror*. New York.

Mangano G. 1909. Relazione Riassuntiva di un Viaggio di Studi nell 'A.O., India, Ceylon, Malacca, e Giava. *L'Agricoltura Coloniale* 4/5: 272–313.

Al-Maqrizi, Taqi al-Din Abu al-'Abbas Ahmad ibn 'Ali [n.d.] (various edns 1853 and 2002–4). *Al-Mawa'iz wa al-i'tibar bi-thikr al-khitat wa al-athar*. Beirut.

Al-Maqrizi Taqi al-Din Abu al-'Abbas Ahmad ibn 'Ali/ed. J. al-Shayyal. 1955. *Al-Tibr al-masbuk bi-dhikr man hajja min al-khulafa' wa al-muluk*. Cairo.

Al-Maqrizi Taqi al-Din Abu al-'Abbas Ahmad ibn 'Ali/ed. M.M. Ziyada. 1957–64 (also 1970–3). *Kitab al-suluk li-ma'rifat duwal al-muluk* (2 vols). Cairo.

Al-Maraghi, Zain al-Din Abi Bakr ibn al-Hussein al-'Uthmani/ed. M.'A al-Asma'i. 1981. *Tahqiq al-nusra bi talkhis ma 'alim dar al-hijra* (second edn). Medina.

Marçot J.-L. 2009. 'La belle utopie, La France, son avant-garde et l'Algérie (1830–1848)'. PhD thesis. École des Hautes Études en Sciences Sociales [unpublished].

Margariti R.E. 2002. 'Maritime Trade in Medieval Aden'. PhD thesis. Princeton University [unpublished].

Margariti R.E. 2007. *Aden and the Indian Ocean Trade: 150 Years in the Life of a Medieval Arabian Port*. Chapel Hill, NC.

Margoliouth D.S and Ch. Pellat. 'al-Hariri'. *Encyclopaedia of Islam* (*EI²*).

Marks S.G. 1991. *Road to Power: the Trans-Siberian Railroad and the Colonization of Asian Russia, 1850–1917*. Ithaca.

Marmon S. 1995. *Eunuchs and Sacred Boundaries in Islamic Societies*. New York.

Marsham A. 2009. *Rituals of Islamic Monarchy: Accession and Succession in the First Muslim Empire*. Edinburgh.

Marsham A. 2011. Public Execution in the Umayyad Period: Early Islamic Punitive Practice and its Late Antique Context. *Journal of Arabic and Islamic Studies* 11: 101–36.

Marsham A. 2012. The Pact (*amana*) between Mu'awiya ibn Abi Sufyan and 'Amr ibn al-'As (656 or 658 CE): 'Documents' and the Islamic Historical Tradition. *Journal of Semitic Studies* 57: 69–96.

Martikainen T. and F. Gauthier. 2013. *Religion in the Neoliberal Age: Political Economy and Modes of Governance*. Farnham.

Martin C. 1937. L'affaire doineau. *Revue africaine* 80: 171–98.

Masud M., A. Salvatore, M. van Bruinessen. 2009. *Islam and Modernity: Key Issues and Debates*. Edinburgh.

Al-Mas'udi, 'Ali ibn al-Husayn/ed. and transl. C.B. de Meynard and A.P. de Courteille. 1966–79 (various edns 1966–79 and 1983). *Muruj al-dhahab wa-ma'adin al-jawhar* (9 vols). Paris.

Maury C. 2010. Les représentations des deux sanctuaires à l'époque ottomane: du schéma topographique à la vue perspective. In al-Ghabban A.I. *et al.* (eds), *Routes d'Arabies. Archéologie et Histoire du Royaume d'Arabie Saoudite*: 547–58. Paris.

Al-Mawardi, 'Ali ibn Muhammad. 1909. *Al-Ahkam al-sultaniya wa-al-wilayat al-diniya*. Cairo.

Meinecke M. 1992. *Die mamluckishe Architecktur in Ägypten und Syrien (648/1250 bis 923/1517)* (2 vols). Glückstadt.

Meinecke M. 1996. *Patterns of Stylistic Changes in Islamic Architecture*. New York.

Melville C. 1992. 'The Year of the Elephant': Mamluk-Mongol rivalry in the Hejaz in the reign of Abu Sa'id (1317–1335). *Studia Iranica* 21/2: 197–214.

Merad M. 1971. *Ibn Badis. Commentateur du Coran*. Paris.

Metcalf B. 1990. The Pilgrimage Remembered: South Asian accounts of the Hajj. In D. Eickelmann and J. Piscatori (eds), *Muslim Travellers, Pilgrimage, Migration and the Religious Imagination:* 85–107. Berkeley, CA.

Meyine M. 2009. La sauvegarde des bibliothèques mauritaniennes: un défi majeur à relever (*L'exemple des Bibliothèques de Chinguetti*). Communication présentée au colloque international sur 'Carrefour Saharien: *la vue du nord*'. Tanger (Maroc) du 5 au 9 Juin 2009.

Miller M. 2006. Pilgrim's Progress: the Business of the Hajj. *Past and Present* 191: 189–228.

Milstein R. 1999. The Evolution of a Visual Motif: The Temple and the Ka'ba. *Jerusalem Studies in Arabic and Islam* 19: 23–48.

Milstein R. 2001. *Kitab Shawq-nama* – An Illustrated Tour of Holy Arabia. *Jerusalem Studies in Arabic and Islam* 25: 275–345.

Milstein R. 2006. Futuh-i Haramayn. Sixteenth illustrations of the Hajj Route. In D.J. Wassertein and A. Ayalon (eds), *Mamluks and Ottomans: Studies in Honour of Michael Winter*: 166–94. London.

Milwright M. 2008a. Imported Pottery in Ottoman Bilad al-Sham. *Turcica* 40: 121–52.

Milwright M. 2008b. *The Fortress of the Raven: Karak in the Middle Islamic Period (1100–1600)*. (Islamic History and Civilization. Studies and Texts, 72). Leiden.

Milwright M. 2010. *An Introduction to Islamic Archaeology*. Edinburgh.

Milwright M. 2011a. On the Date of Paul Kahle's Egyptian Shadow Puppets. *Muqarnas* 28: 43–68.

Milwright M. 2011b. An Arabic Description of the Activities of Antiquities Dealers in Late Ottoman Damascus. *Palestine Exploration Quarterly* 143/1: 8–18.

Mirza M.N. and A.S. Shawush. 1424/2003. *Al-Atlas al-musawwar li-Makka al-Mukarrama wa'l-masha'ir al-muqaddasa*. Riyadh.

Mitchell P.J. 2005. *African Connections. Archaeological Perspectives on Africa and the Wider World*. Walnut Creek, CA.

Al-Mizzi, Jamal al-Din/ed. B.'A. Ma'ruf. 1982–93. *Tahdhib al-kamal fi asma' al-rijal* (35 vols). Beirut.

Modood T. 2005. *Multicultural Politics: Racism, Ethnicity and Muslims in Britain*. Edinburgh.

Al-Mojan M.H. 2006. *Al-Ka'ba al-musharrafa 'imaratan wa kiswatan*. Jedda.

Al-Mojan M.H. 2010. *The Honorable Kabah Architecture and Kiswah*. Mecca.

Al-Mojan M.H. 2012. *Kiswat al-ka'ba al-musharrafa: jamal wa jalal*. Kuwait.

Monroe E. 1973. *Philby of Arabia*. London.

Montalboddo F. 1508. *Itinerarium portugallensium e Lusitania in Indiam*. Milano.

Morabia A. 'Lawn'. *Encyclopaedia of Islam (EI²)*.

Moraes Farias P.F. de. 2003. *Arabic Medieval Inscriptions from the Republic of Mali. Epigraphy, Chronicles and Songhay-Tuareg History*. Oxford.

Morgan C. and S. al-Helwa. 1981. Preliminary Report on the Fifth Phase of the Darb Zubayda Reconnaissance 1400/1980. *Atlal* 5: 81–108.

Moritz B. 1908. Ausflüge in der Arabia Petraea. *Mélange de la Faculté Orientale de Beyrouth* 3: 387–436.

Moritz B. 1911. Inscription à Ageroud. *BIE* 5/4.

Motzki H. 1991. The Musannaf of 'Abd al-Razzaq Al-San'ani as a Source of Authentic *Ahadith* of the First Century A.H.. *Journal of Near Eastern Studies* 50: 1–21.

El-Moudden A. 1990. The Ambivalence of Rihla. Muslim Travellers: Pilgrimage, Migration, and the Religious Imagination. *American Ethnologist* 20: 421–2.

Mouradgea d'Hosson I. 1787. *Tableau Général de l'Empire Ottoman*. Paris [repr. 2001. 7 vols. Istanbul].

Mouton J.-M, S. 'Abd el-Malik, O. Jaubert, and C. Piaton. 1996. La Route de Saladin (Tariq Sadr wa Ayla) au Sinai. *Annales Islamalogiques* 32: 41–70.

Mouton J. –M. 2000. *Le Sinaï médiéval 'Un espace stratégique de l'islam'*. Paris.

Mubarak, 'Ali Basha. 1305/1887 (also 2006). *Al-Khitat al-tawfiqiya al-jadida li-Misr al-Qahira*. Cairo.

Müderrisoğlu, F. 1993. *16 Yüzyılda Osmanlı İmparatorluğu'nda İnşa Edilen Menzil Külliyeleri*. PhD thesis. Hacettepe University [unpublished].

Muhammad S. 1966. *Muhafazat al-jumhuriya al-'arabiya al-muttahida wa athariha al-baqiya fi al-'asr al-islami*. Cairo.

Muhammad S. 1977. *Al-Nasij al-islami*. Cairo.

Muhammad S. 1985. *Al-'Imara al-islamiya 'ala mar al-'usur*. Jedda.

Muhammad S. 1986. *Al-Funun al-islamiya*. Cairo.

Al-Muqaddasi, Abu 'Abd Allah Muhammad/transl. B.A. Collins and M.H. al-Tai. 2001. *The Best Divisions for Knowledge of the Region*. Reading.

Al-Muqaddasi, Abu 'Abd Allah Muhammad/ed. M.J. De Goeje. [n.d.] (various edns 1877 and 1906). *Ahsan al-taqasim fi ma'rifat al-aqalim*. Beirut.

Al-Musawi M. J. 2009. *The Islamic Context of the Thousand and One Nights*. New York.

Muslim ibn al-Hajjaj. 1999. *Sahih Muslim*. Riyadh.

Müstakim-zâde Sülayman Sa'deddin/ed. 'I.M. Kemal. 1928. *Tuhfe-i hattâtin*. Istanbul.

Mu'thin 'A.'A. 1981–2. 'Kiswat al-ka'ba wa turuzuha al-fanniya munthu al-'asr al-'uthmani'. MA dissertation. University of Umm al-Qura [unpublished]

Al-Nabulsi, 'Abd al-Ghani ibn Isma'il/ed. A.'A. Haridi. *Al-Haqiqa wa al-majaz fi al-rihla ila Bilad al-Sham wa Misr wa al-Hijaz*. Cairo.

Nadler R. 1990. *Die Umayyadenkalifen im Spiegel ihrer zeitgenössischen Dichter*. Erlangen/Nürnberg.

Nakamura K. 1986. Early Japanese Pilgrims to Mecca. *Report of the Society for Near Eastern Studies in Japan* 12: 47–57.

Al-Naqar U. 1972. *The Pilgrimage Tradition in West Africa: an Historical Study with Special Reference to the Nineteenth Century*. Khartoum.

Al-Nasa'i, Ahmad ibn Shu'ayb. 1999. *Sunan al-Nasa'i*. Riyadh.

Nasir-i Khusraw/ed. M. Dabir-Siyaqi. 2004. *Safarnama*. Tehran.

Nasir-i Khusraw/transl. W.M. Thackston. 1986 (also 2001). *Book of Travels (Safarnama)*. New York.

Nasir-i Khusraw/ed. and transl. W.M. Thackston Jr. 2001. *Naser-e Khosraw's Book of Travels (Safarnama): A Parallel Persian–English Text*. Costa Mesa, CA.

Nawab 'A.M.Y. 1999. 'Al-Rihla fi al-maghrib al-aqsa masdar min masadir tarikh al-hijaz fi al-qarnayn al-hadi 'ashar wa al-thani 'ashar al-hijriyayn'. PhD thesis. University of Umm al-Qura

Naza-Dönmez E. 1996. Nevşehir Müzesi'nde Bulunan Medine Camii Tasvirli Bir Çini Levha. In *Prof. Dr. Şerare Yetkin Anısına Çini Yazıları*: 109–14. Istanbul.

Necipoğlu G. 2005. *The Age of Sinan: Architectural Culture in the Ottoman Empire*. Princeton, NJ.

Newhall A. 1987. The Patronage of the Mamluk Sultan Qait'bay, 872–901/1468–1496, PhD thesis, Harvard University [unpublished].

Nicholson J. 2005. *The Hejaz Railway*. London.

Nicolle D. 1989. Shipping in Islamic Art: Seventh through Sixteenth Century AD, *American Neptune* 49/3: 168–97.

Nixon S. 2009. Excavating Essouk-Tadmakka (Mali): New Archaeological Investigations of Early Islamic Trans-Saharan Trade. *Azania: Archaeological Research in Africa* 44: 217–55.

Nixon S. 2010. Before Timbuktu: The Great Trading Centre of Tadmakka. *Current World Archaeology* 39: 40–51.

Nixon S., Th. Rehren and M. F. Guerra. 2011. New Light on the Early Islamic West African Gold Trade: Coin Moulds from Tadmekka, Mali. *Antiquity* 85: 1353–68.

Noack C. 2000. Die sibirischen Bucharioten: Eine muslimische Minderheit unter russischer Herrschaft. *Cahiers du monde Russe* 41/2–3: 263–78.

Norris H. 1962. The History of Shinqit According to the Idaw 'Ali Tradition. *Bulletin de l'institut fondamental d'Afrique noire* T.XXIV: 39–413.

Norris H. 1975. *The Tuaregs: their Islamic Legacy and its Diffusion in the Sahel*. Warminster.

Al-Nuwayri l-Iskandarani. 1968–76. *Kitab al-ilmam bil-i'lam fi ma jarat bihi l-ahkam wa-l-umur al-muqdiya fi waq'at al-Iskandariya* (7 vols). Hyderabad.

Nye J.S. 2004. *Soft Power: The Means to Success in World Politics*. New York.

Ochsenwald W. 1984. *Religion, Society and the State in Arabia: the Hijaz under Ottoman Control, 1840–1908*. Athens, OH.

O'Kane B. 2005. The Origin, Development and Meaning of the Nine-Bay Plan in Islamic Architecture. In A. Daneshvari (ed.), *A Survey of Persian Art: Vol XVIII: From the End of the Sasanian Empire to the Present, Studies in Honor of Arthur Upham Pope*: 189–244. Costa Mesa, CA.

Okumura S. 2012. The Mamluk Kaaba Curtain in the Bursa Grand Mosque. In *Textile Society of America Symposium Proceedings*: 1–12. Washington DC.

Ölçer N. 2002. *Türk ve Islam Eserleri Müzesi*. Istanbul.

Oostdam D. 1999. Collecting Arabia: Christiaan Snouck Hurgronje and His Work. In F.C. van Leeuwen *et al.* (eds), *Dutch Envoys in Arabia 1880–1950: Photographic Impressions*: 17–24. Amsterdam.

Oostdam D. and J.J. Witkam. 2004. *West Arabian Encounters: Fifty Years of Dutch–Arabian Relations in Images (1885–1935)*. Leiden.

Otto-Dorn K. 1941. *Das islamische Iznik*. Berlin.

Oulebsir N. 2004. *Les usages du patrimoine: monuments, musées et politique coloniale en Algérie (1830–1930)*. (Éditions de la Maison des sciences de l'homme). Paris.

Özcan A. 1997. *Pan-Islamism: Indian Muslims, the Ottomans and Britain, 1877–1924*. Leiden.

Özgüven B. 2009. Palanka Forts and Construction Activity in the Late Ottoman Balkans. In A. Peacock (ed.), *The Frontiers of the Ottoman World: Fortifications, Trade Pilgrimage and Slavery*: 171–87. London.

Özkarcı M. 2001. *Niğde'de Türk Mimarisi*. Ankara.

Pakalin M.Z. 1983. *Osmanlı Tarih Deyimleri ve Terimleri Sözlüğü* (3 vols). Istanbul.

Paris 1977: *L'Islam dans les collections nationales* (exhib. cat., Grand Palais), ed. J-P. Roux. Paris.

Paris 2007: *Chefs d'oeuvre islamiques de l'Aga Khan Museum* (exhib. cat, Louvre), ed. S. Makariou, Paris.

Paris 2010: *Routes d'Arabie: Archéologie et histoire du Royaume d'Arabie Saoudite* (exhib. cat., Paris), ed. A.I. Ghabban, B. André-Salvini, F. Demange, C. Juvin and M. Cotty. Paris.

Park C. 1994. *Sacred Worlds: An Introduction to Geography and Religion*. London.

Park D.P. 2010. Prehistoric Timbuktu and its Hinterland. *Antiquity* 84: 1076–88.

Parker A. and A. Neal. 1995. *Hajj Paintings: Folk Art of the Great Pilgrimage*. Washington, DC.

Peach C. 2005. Britain's Muslim Population. In T. Abbas (ed.), *Muslim Britain: Communities under Pressure*: 18–30. London.

Peacock D. 2006. Introduction. In D. Peacock and L. Blue (eds), *Myos Hormos – Quseir al-Qadim. Roman and Islamic Ports on the Red Sea. Survey and Excavations 1999–2003*. Oxford.

Peacock D. and A. Peacock 2007. The Enigma of 'Aydhab: a Medieval Islamic Port on the Red Sea Coast. *The International Journal of Nautical Archaeology* 37/1: 32–48.

Peacock D. and L. Blue (eds). 2006. *Myos Hormos – Quseir al-Qadim. Roman and Islamic Ports on the Red Sea. Survey and Excavations 1999–2003*. Oxford.

Peacock D. and L. Blue. 2011. *Myos Hormos – Quseir Qadim: Roman and Islamic Ports on the Red Sea. Volume 2: Finds from the Excavations, 1999–2003*. (British Archaeological Reports International Series, 2286). Oxford.

Peake Pasha. 1958. *A History of Jordan and its Tribes*. Miami, FL.

Pearson M.N. 1994. *Pious Passengers: The Hajj in Earlier Times*. London.

Pesce A. 1986. *Makkah a Hundred Years ago: Or, C. Snouck Hurgronje's Remarkable Albums*. London.

Peters F.E. 1994a. *The Hajj: The Muslim Pilgrimage to Mecca and the Holy Places*. Princeton, NJ.

Peters F.E 1994b. *Mecca: A Literary History of the Muslim Holy Land*. Princeton, NJ.

Petersen A.D. 1994. The Archaeology of the Syrian and Iraqi Hajj Routes. *World Archaeology* 26/1: 47–56.

Petersen A.D. 2005. *The Towns of Palestine under Muslim Rule. AD 600–1600*. (BAR International Series). Oxford.

Petersen A.D. 2012. *The Medieval and Ottoman Hajj Route in Jordan: An Archaeological and Historical Study* (Levant Supplementary Series 12). Oxford and Oakville, CT.

Petry C. 1993. *Twilight of Majesty: the Reigns of the Mamluk Sultans al-Ashraf Qaytbay and Qansuh al-Ghawri in Egypt*. Seattle, WA.

Petry C. 1994. *Protectors or Praetorians? The Last Mamluk Sultans and Egypt's Waning as a Great Power*. Albany, NY.

Pharaon F. 1880. *Épisodes de la conquête: cathédrale et mosquée*. Paris.

Philby H. St J. B. 1946. *A Pilgrim in Arabia*. London.

Philby H. St J. B. 1948. *Arabian Days: An Autobiography*. London.

Piana M. 2010. From Montpèlerin to Arabulus al-Mustajadda: the Frankish-Mamluk Succession in Old Tripoli. In U. Vermeulen and K.D'Hulster (eds), *Egypt and Syria in the Fatimid, Ayyubid and Mamluk Eras VI*: 307–54. Leuven.

Pieta K., A.S. Shehab, J. Tirpak, M. Bielich, M. Bartik. 2009. Archaeological and Geophysical Survey in Deserted Early Islamic Village Al-Qusur (Failaka, Kuwait). *ArchaeoSciences* 33: 155–7.

Pigeaud Th. 1938. *Javaansche volksvertoningen. Bijdrage tot de beschrijving van land en volk*. Batavia.

Pigeaud Th. 1968. *Literature of Java*. Vol. 2. Leiden.

Pires T./ed. A. Cortesão. 1944. *The Suma Oriental of Tomé Pires* (2 vols). London.

Pococke R. 1743. *A Description of the East and Some Other Countries*. London.

Popper W. 1957. *History of Egypt 1382–1469 A. D. Translated from the Arabic Annals of Abul-Mahasin Ibn Taghri Birdi*. Vol. 18. Berkeley and Los Angeles, CA.

Porter A.K. 1923. *Romanesque Sculpture of the Pilgrimage Roads*. Boston.

Porter V. (ed.). 2012a. *Hajj: Journey to the Heart of Islam*. London.

Porter V. 2012b. *The Art of Hajj*. London.

Power T.C. 2010. *The Red Sea Region During the 'Long' Late Antiquity (AD 500–1000)*. PhD thesis. University of Oxford [unpublished].

Princep J. 1836. Note on the Nautical Instruments of the Arabs. *Journal of the Asiatic Society of Bengal* December 5: 784–94.

Pringle D. 1984. Italian Pottery from Late Mamluk Jerusalem: Some Notes on Late and Post-Medieval Italian Tradewares in the Levant. *Atti XVII. Convegno internazionale della ceramica. Temi liberi*. Abisola: 37–44.

Pringle D. 2005–6. The Castles of Ayla (al-'Aqaba) in the Crusader, Ayyubid and Mamluk Periods. In U. Vermeulen and Van Steenbergen (eds), *Egypt and Syria in the Fatimid, Ayyubid and Mamluk Eras*. Vol. 4: 333–54. Louvain.

Prisse d'Avennes É. 2010. *Arab Art*. Introduction by S. Blair and J. Bloom. Cologne.

Prost C. 1916. *Les Revêtements céramiques dans les monuments musulmans de l'Egypte*. Cairo.

Prussin L. 1986. *Hatumere: Islamic Design in West Africa*. Berkeley, CA.

Purchas S. 1905–7. *Hakluytus Posthumus or Purchas His Pilgrimes* (20 vols). Glasgow.

Putten J. van der. 2006. 'Abdullah Munsyi and the Missionaries. *Bijdragen tot de Taal-, Land- en Volkenkunde* 162/4: 407–40.

Al-Qadi W. 1992. Early Islamic State Letters: the Question of Authenticity. In A. Cameron and L.I. Conrad (eds), *The Byzantine and Early Islamic Near East, I: Problems in the Literary Source Material*: 215–75. Princeton, NJ.

Al-Qadi W. 1993. The Impact of the Qur'an on the Epistolography of 'Abd al-Hamid. In G.R. Hawting and A.K.A. Shareef (eds), *Approaches to the Qur'an*: 285–313. London.

Al-Qadi W. 1994. The Religious Foundation of Late Umayyad Ideology and Practice. In Agencia Española de Cooperación Internacional (eds), *Saber religioso y poder político en el islam*: 231–73. Madrid.

Qaisar A.J. 1987. From Port to Port: Life on Indian Ships in the Sixteenth and Seventeenth Centuries. In A. Das Gupta and M.N. Pearson (eds), *India and the Indian Ocean, 1500–1800*: 331–49. Calcutta.

Al-Qalqashandi, Abu al-'Abbas Ahmad ibn 'Ali [n.d.] (various edns 1913–19, 1985 and 1987). *Subh al-a'sha fi sina'at al-insha*. (Silsilat Turathana). Cairo.

Qasatili N. 1876. *Al-Rawdat al-ghanna' fi Dimashq al-fayha'*. Beirut.

Al-Qasimi M.S., J. al-Qasimi and K. al-'Azm/ed. Z. al-Qasimi 1960. *Dictionnaire des métiers damascains* (2 vols). Paris and Le Haye.

Quasem M.A. 1979. *The Recitation and Interpretation of the Qur'an. Al-Ghazali's Theory*. Bangi.

Quatremère É. 1840–5. *Histoire des Sultans Mamlouks de l'Égypte* (2 vols). Paris.

Al-Qurtubi, Muhammad ibn Ahmad/ed. Salim Mustafa al-Badri. 2000. *Al-Jami' li-ahkam al-Qur'an* (21 vols). Beirut.

Rabi' H.M. 1977. Bahr al-Hijaz fi al-'usur al-wusta. *Majallat kulliyat al-'ulum al-ijtima'iya* 1: 399–416.

Rae W.F. 1891. *The Business of Travel: A Fifty Year's Record of Progress*. London.

Al-Rajub A.M. and A.Q.M. al-Husan. 2010. Ottoman Islamic Architecture in Jordan. The Syrian Hajj Fort of al-Fudayn/ al-Mafraq as a Case Study. *Jordan Journal for History and Archaeology* 4: 45–68.

Ralli A. 1909. *Christians at Mecca*. London.

Al-Ramhurmuzi, Burzug ibn Shahriyar/ed. and transl. G.S.P. Freeman-Grenville. 1981. *The Book of the Wonders of India*. London and The Hague.

Al-Ramhurmuzi, Burzug ibn Shahriyar/ed. P.A. Van der Lith and transl. L. Marcel Devic. 1883–6. *Kitab 'aja'ib al-Hind*. Leiden.

Al-Rammal Gh.'A.M. 1980. 'Sira' al-muslimeen ma' al-burtughaliyeen fi al-bahr al-ahmar khilal al-qarn 10 AH'. MA dissertation. University of Umm al-Qura [unpublished].

Ramzi M. 1953. *Al-Qamus al-jughrafi lil-bilad al-misriya min 'ahd qudama'
ila sanat 1945*. Cairo.

Ras J.J. (ed.). 1987. *Babad Tanah Djawi. Javaanse Rijkskroniek. W.L. Olthofs
vertaling van de prozaversie van J.J. Meinsma lopende tot het jaar 1721*.
Dordrecht.

Al-Rashdan W.M. 2010. *Al-Qila' al-ayyubiya wa al-mamlukiya fi
al-Urdunn: dirasa mi'mariya wasfiya*. Riyadh.

Rashdan W. M. and T.B.M. Sha'ban. 2011. An Ottoman Foundation
Inscription in the Ottoman Fort Ma'an, Jordan. *Journal for History
and Archaeology* 5/1: 117–40.

Al-Rasheed M. 2010. *A History of Saudi Arabia* (second edn). Cambridge.

Al-Rashid S. 1978. Darb Zubaydah in the Abbasid Period: Historical
and Archaeological Aspects. *Proceedings of the Seminar for Arabian
Studies* 8: 33–45.

Al-Rashid S. 1979. Ancient Water Tanks on the Hajj Route from Iraq
to Mecca and their Parallels in Other Countries. *Atlal* 3: 55–62.

Al-Rashid S. 1980. *Darb Zubaydah: the Pilgrim Road from Kufa to Mecca*.
Riyadh.

Al-Rashid S. 1986. *Al-Rabadhah: Portrait of an Early Islamic Civilization in
Saudi Arabia*. Riyadh.

Al-Rashid S. *et al.* 2003. *Athar mantiqat Tabuk*. (Silsilat athar al-
Mamlaka al-'Arabiya al-Sa'udiya, 7). Riyadh.

Al-Rashid S. and P. Webb 2013. *Medieval Roads to Mecca*. London.

Raslan 'A.'A. 1401/1980–1. Al-Aznam: khanan wa burjan. *Majallat
al-bahth al-'ilmi wa al-turath al-islami* 4: 367–71.

Raven W. and J.J. Witkam 1988. *Concordance et Indices de la Tradition
Musulmane*. Vol. 8. Leiden.

Records of the Hajj 1993. *The Saudi Period (1926–1935)*. Vol. 6. *A
Documentary History of the Pilgrimage to Mecca* (10 vols) (Archive
Editions). Cambridge.

Regourd A. 2004. Trade on the Red Sea during the Ayyubid and the
Mamluk Periods: The Quseir Paper Manuscript Collection
1999–2003. *Proceedings of the Seminar for Arabian Studies* 34: 277–92.

Regourd A. 2011. Arabic Language Documents on Paper. In D.
Peacock and L. Blue (eds), *Myos Hormos – Quseir al-Qadim Roman and
Islamic Ports on the Red Sea*: 339–44. Oxford.

Reinaud J.T. 1828. Attestation de pèlerinage. *Description des monumens
musulmans du cabinet de M. le duc de Blacas*. Vol. 2: 310–24. Paris.

Remnev A. 2011. Colonization and 'Russification' in the Imperial
Geography of Asiatic Russia: From the Nineteenth to the Early
Twentieth Centuries. In U. Tomohiko (ed.), *Asiatic Russia: Imperial
Power in Regional and International Contexts*: 102–28. London.

Renaudot E. (transl.). 1733. *Ancient Accounts of India and China, by Two
Mohammedan Travellers Who Went to Those Parts in the 9th Century*
(*Silsilat al-tawarikh*). London.

Al-Resseeni I.M. 1992. The Water Resources Structures on the Syrian
and Egyptian Pilgrim Routes to Mecca and Medina. PhD thesis.
University of Leeds [unpublished].

Ribat N. 2001. *'Anasir tashkeel al-sura al-mamlukiya*. Kuwait.

Rice T.D. 1965. *Islamic Art*. London.

Richard C. 1860. *Les Mystères du peuple arabe* (second edn). Paris.

Ricklefs M.C. 2009. The Middle East Connection and Reform and
Revival Movements among the Putihan in 19th-Century Java. In
E. Tagliacozzo (ed.), *Southeast Asia and the Middle East: Islam,
Movement and the Longue Durée*: 111–34. Stanford, CA.

Rif'at I. 1925. *Mir'at al-haramayn* (2 vols). Cairo [repr. 2009].

Ritzer G. 1993. *The McDonaldization of Society*. Thousand Oaks, CA.

Rizq 'A.M.'A. 2000. *Mu'jam mustalahat al-'imara wa al-funun al-islamiya*.
Cairo.

Rizvi K. 2010. *The Safavid Dynastic Shrine: Architecture, Religion and Power
in Early Modern Iran*. London.

Robertson R. 1995. Globalization: Time-space and Homogeneity-
Heterogeneity. In M. Featherstone, S. Lash and R. Robertson
(eds). *Global Modernities*: 25–44. London.

Robinson A.E. 1931. The Mahmal of the Moslem Pilgrimage. *Journal
of the Royal Asiatic Society of Great Britain and Ireland* 1: 117–27.

Robinson C.F. 2005. *'Abd al-Malik*. Oxford.

Rodinson M. 1971. *Muhammad*. Harmondsworth.

Rodinson M. 1977. *Islam and Capitalism*. Harmondsworth.

Roff W.R. 1982. Sanitation and Security: The Imperial Powers and
the Nineteenth Century Hajj. In R. Serjeant and R. L. Bidwell
(eds), *Arabian Studies* 6: 143–60. New York.

Roff W.R. 1985. Pilgrimage and the History of Religions: Theoretical
Approaches to the Hajj. In R.C. Martin (ed.), *Approaches to Islam in
Religious Studies*: 78–86. Oxford.

Rogers M. 2010. *The Arts of Islam: Masterpieces from the Khalili Collection*.
London.

Rosen-Ayalon M. (ed.). 1984. *Richard Ettinghausen: Islamic Art and
Archaeology Collected Papers*. Berlin.

Rubin U. 1982. The Great Pilgrimage of Muhammad: Some Notes on
Sura IX. *Journal of Semitic Studies* 27: 241–60.

Rubin U. 1986. The Ka'ba: Aspects of its Ritual Functions and
Position in Pre-Islamic and Early Islamic Times. *Jerusalem Studies of
Arabic and Islam* 13: 97–131.

Al-Rumi, Yaqut ibn 'Abd Allah/ed. F.'A. al-Jundi. [n.d.]. *Kitab mu'jam
al-buldan* (5 vols). Beirut.

Rutter E. 1928. *The Holy Cities of Arabia* (2 vols). London.

Rutter E. 1931. Damascus to Hail. *Journal of the Central Asian Society*
18/1: 61–73.

Rutter E. 1932. A Journey to Hail. *The Geographical Journal* 80/4: 322–31.

Rutter E. 1933. Slavery in Arabia. *Journal of the Royal Central Asian
Society* 20/3: 315–32.

Rutter E./ed. S.C. Sharpe. (Forthcoming, 2014). *The Holy Cities of
Arabia*. London.

Saadaoui A. 2001. *Tunis, ville ottoman: trois siècles d'urbanisme et
d'architecture*. Tunis.

Sabiq, al-Sayyid. 1987. *Fiqh al-sunnah*. Beirut.

Sabri Basha A./transl. Mitwali A.F. and Al-S. A. al-Mursi. 1999.
Mir'at Jazirat al-'Arab. Cairo.

Sabri Basha A./transl. M. Makhlouf *et al.* 2004. *Mawsu'at mir'at
al-haramayn al-shareefayn wa jazirat al-'arab*. Cairo.

Sa'deddin M.S./ed. İ.M. Kemal. 1928. *Tuhfe-i hattâtîn*. Istanbul.

Sadi M.A. and J.C. Henderson. 2005. Local versus Foreign Workers in
the Hospitality and Tourism Industry: A Saudi Arabian
Perspective. *Cornell Hotel and Restaurant Administration Quarterly* 46:
247.

Sadiq M. 1298/1881. *Mash'al al-mahmal*. Cairo.

Sadiq M. 1303/1886. *Kawkab al-hajj fi safar al-mahmal bahran wa-sayrihi
barran*. Bulaq.

Sadiq M. 1313/1896. *Dalil al-hajj lil-waridin ila Makka min kull fajj*. Bulaq.

Sahadeo J. 2007. *Russian Colonial Society in Tashkent*. Bloomington, IN.

Şahin F. 1982. Kütahya'da Çinili eserler. In S. Erman, B. Mereyer *et al.*
(eds), *Atatürk'ün Doğumunun 100. Yılına Armağan*. Kütahya: 121–7.
Istanbul.

Said E. 1979. *Orientalism*. New York [repr. 1994].

Al-Sakhawi, Shams al-Din Muhammad ibn 'Abd al-Rahman/ed.
M.H. al-Faqi. 1993. *Al-Tuhfa al-latifa fi tarikh al-Madina al-sharifa*.
Beirut.

Al-Sakhawi, Shams al-Din Muhammad ibn 'Abd al-Rahman/ed.
H.M. al-Qattan. 2001. *Al-Buldaniyat*. Riyadh.

Salar Jung M. 1912. *A Pilgrimage to Mecca and the Near East*. Hyderabad.

Salim M.R. [n.d.]. *Al-Ashraf Qansawh al-Ghawri*. Cairo.

Saller S. 1957. *Excavations in Bethany (1949–1953)*. (Studium Biblicum
Franciscanum, 12). Jerusalem.

Al-Samhudi, Nour al-Din 'Ali ibn Ahmad/ed. Q. al-Samarra'i. 2001.
Wafa' al-wafa bi akhbar dar al-mustafa. Jedda.

Sauvaget J. 1935. Un relais du barîd mamelouk. In W. Marçais, R.
Tresse and L. Brunot (eds), *Mélanges Gaudefroy-Demombynes*: 41–8.
Cairo.

Sauvaget J. 1937. Les Caravansérails Syriens du Hadjdj de
Constantinople. *Ars Islamica* 4: 98–121.

Sauvaget J. 1939. Caravansérails Syriens du Moyen-Âge;
Caravansérails Ayyubides. *Ars Islamica* 6: 48–55.

Sauvaget J. 1940. Caravansérails Syriens du Moyen-Âge, II.
Caravansérails Mamelouks. *Ars Islamica* 7: 48–55.

Sauvaget J. 1941. *La Poste aux Chevaux dans l' Empire des Mameloukes*.
Paris.

Sauvaget J. 1946. *Historiens Arabes, Pages Choisies Traduites et présentées par
J. Sauvaget*. Paris.

Sauvaget J. 1968. Caravansérails Mamelouks. *Ars Islamica* 7: 3–19.

Schick İ.C. (ed.). 2000. *M. Uğur Derman 65th Birthday Festschrift*.
Istanbul.

Schimmel A. 1985. *And Muhammad is His Messenger. The Veneration of the
Prophet in Islamic Piety*. Chapel Hill, NC/London.

Schnitzer C. and H. Schuckelt. 1995. *Im Lichte des Halbmonds: das
Abendland und der türkische Orient*. Dresden.

Schoff W.H. 1912. *The Periplus of the Erythraean Sea*. New York.

Schumacher G. 1886 *Across the Jordan: Being an Exploration and Survey of Part of Hauran and Jaulan*. London.

Scott H., K. Mason, M. Marshall, GB Naval Intelligence. 1946. *Western Arabia and the Red Sea*. (Geographical Handbook Series). Oxford.

Şen F. 1997. Eyüp Sutlan Türbesi Çinileri. In *Eyüp Sutlan Sempozyumu 1*: 74–68. Istanbul.

Serin M. 1992. *Hattat Şeyh Hamdullah*, Istanbul.

Serjeant R.B. 1948 and 1951. Material for a History of Islamic Textiles up to the Mongol Conquest. *Ars Islamica* 13: 75–117 and 15–16: 29–85.

Serjeant R.B. 1962. Haram and Hawtah: The Sacred Enclaves in Arabia. In A. Badawi (ed.), *Mélanges Taha Husain*: 41–58. Cairo.

Shafi' M. 1922. A Description of the Two Sanctuaries of Islam by Ibn 'Abd Rabbihi. In T. Arnold and R.A. Nicholson (eds), *A Volume of Oriental Studies Presented to Edward G. Browne*: 416–38. Cambridge.

Shah A. 1980. *The Assemblies of Al-Hariri*. London.

Shahid I. 'Ukaz'. *Encyclopaedia of Islam (EI²)*.

Al-Shahri M.H. 1982. 'Imarat al-masjid al-nabawi fi al-'asr al-mamluki'. MA dissertation. University of Umm al-Qura [unpublished].

Shakir M.H. (transl.) 1983. *The Holy Qur'an*. http://quod.lib.umich. edu/k/koran/. (Accessed on 11 February 2013).

Al-Shami 'A. 1981. *Mudun Misr wa quraha 'inda Yaqut al-Hamawi*. 1981.

Shaw A. 2000. *Kinship and Continuity: Pakistani Families in Britain*. London.

Shaw S. 1962. *The Financial and Administrative Organization and Development of Ottoman Egypt, 1517–1798*. Princeton, NJ.

Sheehan P.D. 2010. *Babylon of Egypt: The Archaeology of Old Cairo and the Origins of the City*. Cairo.

Sherry N. 1966. *Conrad's Eastern World*. Cambridge.

Shinar P. 'Salafiyya', North Africa. *Encyclopaedia of Islam (EI²)*

Shinar P. 1980. 'Ulama', Marabouts and Government: An Overview of their Relationships in the French Colonial Magrib. *Israel Oriental Studies* 10: 211–29.

Al-Shqour R. 2005–6. *From Roman to Islamic Khan in Jordan: An Archaeological Look at structural Continuity in Defence Systems* (2 vols). Leuven.

Shuqair N. 1985. *Tarikh sina' al-qadim wa al-hadith wa jughrafiyataha*. Athens.

Sijpesteijn P. (Forthcoming). An Early Umayyad Papyrus Invitation for the Hajj. *Journal of Near Eastern Studies*.

Sim K. 1969. *Desert Traveller: The Life of Jean Louis Burckhardt*. London.

Sima A./ed. J.C.E. Watson and W. Arnold 2009. *Mehri-Texte aus der jemenitischen Sharqiyah: Transkribiert unter Mitwirkung von 'Askari Sa'id Hugayran*. Wiesbaden.

Al-Sindi Kh.M./transl. M.A. al-Khozai. 1999. *Dilmun Seals*. Bahrain.

Singer A. 2011. Charity in Islamic Societies. *English Historical Review* 518: 117–18.

Slight J.P. 2012. The British Empire and the Hajj, 1865–1956. PhD thesis. University of Cambridge [unpublished].

Snouck Hurgronje C. 1887. Herr Snouck Hurgronje ueber seine Reise nach Mekka: 5 März 1887. *Verhandlungen der Gesellschaft für Erdkunde zu Berlin* 14: 140–53.

Snouck Hurgronje C. 1888–9. *Mekka: Herausgegeben von 'Het Koninklijk Instituut voor de Taal-, Land- en Volkenkunde van Nederlandsch-Indië te 's-Gravenhage* (2 vols). Haag.

Snouck Hurgronje C. 1888. *Bilder-Atlas zu Mekka*. Haag.

Snouck Hurgronje C. 1889. *Bilder aus Mekka: Mit kurzem erläuterndem Texte*. Leiden.

Snouck Hurgronje C. 1923–7. De Hadji-politiek der Indische regeering. In C. Snouck Hurgronje, *Verspreide geschriften 4/2*: 175–98. Cologne.

Snouck Hurgronje C./transl. J.H. Monahan. 1931. *Mekka in the Latter Part of the 19th Century: Daily Life, Customs and Learning: The Moslims of the East-Indian-Archipelago*. Leiden.

Snouck Hurgronje C./transl. J.J. Witkam. 2007. *Mekka in de Tweede Helft van de Negentiende Eeuw. Schetsen uit het Dagelijks Leven*. Amsterdam.

Sofia 1995: *The Holy Qur'an through the Centuries* (exhib. cat., SS Clement and Methodius National Library), ed. A. Stoilova and Z. Ivanova, Sofia.

Sohrab/ed. H. von Mžik. 1930. *'Aja'ib al-aqalim al-sab'a ila nihayat al-'imara*. Leipzig.

Sönmez Z. 1997. Tekfur Saray Ware Tiles. In A. Altun (ed.), *The Story of Ottoman Tiles and Ceramics*: 215–21. Istanbul.

Sotheby's 2012. *Travel, Atlases, Maps and Natural History*, catalogue L12405 (15 November 2012). London.

Sourdel D. and J. Sourdel-Thomine. 1983. Une collection médiévale de certificats de pèlerinage à la Mekke conservés à Istanbul. Les actes de la période seljoukide et bouride (jusqu'à 549/1154). In J. Sourdel-Thomine (ed.), *Études Médiévales et Patrimonie Turc*: 167–223. Paris.

Sourdel-Thomine J. 1971. Clefs et serrures de la Ka'ba. *Revue des Études islamiques*, 29/1: 29–64.

Söylemezoğlu S.S./ed. A. Çaycı and B. Ürekli. 2013. *Hicaz Seyathamesi*. Istanbul.

Stanley H.E. J. (transl.). 1869. *Three Voyages of Vasco da Gama and his Viceroyalty. From the Lendas da India of Gaspar Correa*. London.

Stanley T. 2000. Shumen as a Centre of Qur'an Production in the 19th Century. In İ.C. Schick (ed.), *M. Uğur Derman 65th Birthday Festschrift*: 483–512. Istanbul.

Stanley T. 2004. Page-setting in Late Ottoman Qur'ans. *Manuscripta Orientalia* 10/1: 56–63.

Stanton-Hope W. E. 1951. *Arabian Adventurer: The Story of Hajji Williamson*. London.

Stape J.H. 1996. Lord Jim. In J.H. Stape (ed.), *The Cambridge Companion to Joseph Conrad*: 63–80. Cambridge.

Stausberg M. 2011. *Religion and Tourism: Crossroads, Destinations and Encounters*. Abingdon.

Strasbourg 2011. *Des mondes de papier. L'imagerie populaire de Wissembourg* (exhib. cat., Galerie Heitz, Palais Rohan). Strasbourg.

Strayer J.R. (ed.). 1982–9. *Dictionary of the Middle Ages*. New York.

Strika V. 1976. A Ka'bah Picture in the Iraq Museum. *Sumer* 32: 195–201.

Sui C.W. 2006. Die Pilgerfahrt zu den heiligen Stätten des Islam und die frühe Photographie. In A. Wieczorek and C.W. Sui (eds), *Ins heilige Land. Pilgerstätten von Jerusalem bis Mekka und Medina. Photographien aus dem 19. Jahrhundert aus der Sammlung des Forum Internationale Photographie der Reiss-Engelhorn-Museen Mannheim*: 40–63. Heidelberg.

Al-Sulayman 'A.H. 1973. *Al-'Alaqat al-masriya al-hijaziya zaman salatin al-mamalik*. Cairo.

Sülün M. 2006. *Sanat eserine vurulan Kur'an mührü: Sanat Eserinden Yansıyan Kur'an Mesajı*, Istanbul.

Süreyya M./ed. N. Akbayar et al. 1996. *Sicill-i Osmanî* (6 vols). Istanbul.

Surur M.J. 1960. *Dawlat al-Zahir Baybars fi Misr*. Cairo.

Al-Surur 'A. 2007. *Tariq al-hajj al-bahri bayna al-Nabaj wa-al-Ruqa'i*. Hafar al-Batin.

Al-Suyuti, Jalal al-Din 'Abd al-Rahman. [n.d.]. *Husn al-muhadara fi akhbar Misr wa al-Qahira*. Cairo.

Sweeney A. (ed.). 2005. *Karya lengkap Abdullah bin Abdul Kadir Munsyi*. In *Kisah pelayaran Abdullah ke Kelantan, Kisah pelayaran Abdullah ke Mekah*. Vol. 1: 255–330. Jakarta.

Al-Tabari, Muhammad ibn Jarir/ed. M.A. Ibrahim. [n.d.] (various edns 1879–1901 and 1965). *Tarikh al-rusul wa-l-muluk* (11 vols). Beirut.

Al-Tabari, Muhammad ibn Jarir/ed. S.J. al-'Attar. 1999. *Tafsir jami' al-bayan* (30 vols). Beirut.

Tabataba'i J.T. 1977. *Athar-i bastani-yi Azirbayjan*. Vol. 2. Tehran.

Tabrizi M.R.T. 1386/2007. *Hidayat al-Hujjaj: Safarnama-ye Makka*. Qom.

Taft M.L. 1911. *Strange Siberia along the Trans-Siberian Railway: a Journey from the Great Wall of China to the Skyscrapers of Manhattan*. Cincinnati, OH.

Tagliacozzo E. 2013. *The Longest Journey: Southeast Asians and the Pilgrimage to Mecca*. Oxford.

Taha 'U. 2005. *Al-Kawkab al-durri: hujrat buyut al-nabi 'alayhi al-salat wa al-salam*. Medina.

Tamari S. 1971. An Inscription of Qansuh al-Guri from 'Aqabat al-'Urqub. *Atti del l'Accadcmia Nazionale dei Lincei* 26: 173–87.

Tamari S. 1975. L' Iscrizione di 'Aqabat al-'Urqub nel Sinai e N'aum Shuqayer. *Annali del l'Istituto Universitario Orientale di Napoli* 35/2: 274–6.

Tamari S. 1982. Darb al-Hajj in Sinai: An Historical-Archaeological Study. *Malinc* 8/25: 505–16.

Tampoe M. 1989. *Maritime Trade between China and the West: An Archaeological Study of the Ceramics from Siraf (Persian Gulf), 8th to 15th Centuries AD.* Oxford.

Tanindi Z. 1983. Islam resminde kutsal kent ve yöre tasvirleri. *Journal of Turkish Studies* 7: 407–37.

Tarlo E. 2010. *Visibly Muslim: Fashion, Politics, Faith.* Oxford.

Taşkale F. 2006. *Hat sanatında hilye-i şerife: Hz. Muhammed'in özellikleri: Characteristics of the Prophet Muhammed.* Istanbul.

Tavakolian N. 2011. *The Fifth Pillar.* London.

Al-Tayyar M. 2001. Nuthum al-qiyas al-tooli wa al-masahiya al-islamiya. *Majallat dirasat tarikhiya* 22: 73–4.

Temimi A. 1996. Le Gouvernent du Cherif Hussein au Hedjaz et la mission politique et militaire française en Arabie (1916–1918). *Revue d'histoire maghrebine* 23/83–4: 753–94.

Tezcan H./transl. T.'U.T. Tabakoglu. 1996. *Astar al-haramayn al-sharifayn.* Istanbul.

Tezcan H. 2007. Ka'ba Covers from the Topkapi Palace Collection and their Inscriptions. In F. Suleman (ed.), *Word of God, Art of Man: the Qur'an and its Creative Expressions*: 227–38. Oxford.

Theophrastus/transl. A. Hort. 1916. *Enquiry into Plants* (2 vols). London and New York.

Thompson E. 1929. *Saturday Review of Literature.* 19 October 1929. 286.

Thomson A. 1994. *The Difficult Journey.* London.

Tibbetts G.R. 1981. *Arab Navigation in the Indian Ocean before the Coming of the Portuguese, trans. of Kitab al-fawa'id fi usul al-bahr wa l-qawa'id of Ahmad b. Majid,* London.

Al-Tirmidhi, Abu 'Isa Muhammad. 1999. *Jami' al-Tirmidhi.* Riyadh.

Tomalin V.V., V. Selvakumar, M.V. Nair, and P.K. Gopi. 2004. The Thaikkal-Kadakkarappally Boat: An Archaeological Example of Medieval Shipbuilding in the Western Indian Ocean. *The International Journal of Nautical Archaeology* 33/2: 253–63.

Tomes J. 2012. 'Rowland George Allanson Allanson-Winn (1855–1935)'. *Dictionary of National Biography.* http://www.oxforddnb.com/view/article/76887 (accessed online 2 February 2012).

Toowara S.M. 2005. *Ibn Abi Tahir Tayfur and Arabic Writerly Culture: A Ninth-Century Bookman in Baghdad.* London.

Torrey C.C. 1922. *The History of the Conquest of Egypt, North Africa and Spain: Futh Misr of Ibn 'Abd al-Hakam.* New Haven, CT.

Tosun N. 2012. Hajj from the Sufi Point of View. In A. Papas, T. Welsford, and T. Zarcone (eds), *Central Asian Pilgrims: Hajj Routes and Pious Visits between Central Asia and the Hijaz*: 136–47. Berlin.

Treadgold D.W. 1957. *The Great Siberian Migration: Government and Peasant in Resettlement from Emancipation to the First World War.* Princeton, NJ.

Triaud J.-L. 1995. *La Légende noire de la Sanûsiyya: Une confrérie musulmane saharienne sous le regard Français (1840–1930)* (2 vols). Paris.

Trumbull G. 2009. *An Empire of Facts: Colonial Power, Cultural Knowledge, and Islam in Algeria, 1870–1914.* Cambridge.

Turner B.S. 1994. *Orientalism, Postmodernism and Globalism.* London.

Tuscherer M. 1994. Approvisionnement des villes saintes d'Arabie et blé d'Egypte d'après des documents ottomns des années 1670. *Anatolia Moderna* 5: 79–99.

Tushingham A. D. 1985. *Excavations in Jerusalem, 1961–1967.* Vol. 1. Toronto.

Tütüncü M. 2006. *Turkish Jerusalem (1516–1917), Ottoman Inscriptions from Jerusalem and Other Palestinian Cities.* Haarlem.

Tütüncü M. 2008. *Palestine (1069–1917): Inscriptions from al-Khalil (Hebron), Nabi Musa and other Palestinian Cities under Turkish Rule.* Haarlem.

'Ujaimi H.M.'A. 1983. Qal 'at al-Muwailih: dirasa mi'mariya hadariya. MA dissertation. University of Umm al-Qura [unpublished].

'Ujaimi H.M.'A. 2001. *Qila' al-Aznam wa al-wajh wa daba bi al-mantiqa al-shamaliya al-gharbiya min al-Mamlika al-'Arabiya al-Sa'udiya: dirasa mi'marya.* Mecca.

'Ujaimi H.M.'A. 2007. Kal'a dhat-al-Hajj fi Tarik el Hajj Shami, *Annales Islamologique,* 41: 45–65.

Ulrich B. 2012. Kazimah Remembered: Historical Traditions of an Early Islamic Settlement by Kuwait Bay. *Proceedings of the Seminar for Arabian Studies* 42: 401–10.

Uluç L. 2006. *Turkish Governors, Shiraz Artisans, and Ottoman Collectors.* Istanbul.

Um N. 2012. Reflections on Red Sea Style: Beyond the Surface of Coastal Architecture. *Northeast African Studies* 12/1: 243–272.

'Umar I. 2009. *Al-Ghazali's Secrets of Pilgrimage.* Kuala Lumpur.

'Umar S.F.'A. 2001. *Imarat al-hajj fi Misr al-'uthmaniya.* (Silsilat tarikh al-misriyeen, 201). Cairo.

Al-'Umari, Shahab al-Din Ahmad ibn Yahya. 1988. *Masalik al-absar fi mamalik al-amsar.* Frankfurt.

Ürün T. 2012. Ayasofya Mihrabı ve mihrap çevresindeki yazılar. *Aya Sofya Müzesi Yıllığı (Annual of Haghia Sophia Museum)* 13: 403–5.

Al-'Utaybi S. 2005. *Tariq al-hajj al-Basri: dirasa tarikhiya lil-tariq wa-athariya li-manazilihi min Dariya ila Awtas.* Riyadh.

Uzun M. 2007. Nahifi. In *İslam Ansiklopedisi.* Vol. 32: 297–9. Istanbul.

Valentia G. 1994. *Voyages and Travels to India, Ceylon, the Red Sea, Abyssinia and Egypt in the Years 1802–1806* (4 vols). New Delhi.

Vantini G. 1975. *Oriental Sources Concerning Nubia.* Heidelberg and Warsaw.

Varthema L./transl. J. W. Jones. 1928. *The Itinerary of Ludovico di Varthema of Bologna from 1502–1508.* London.

Varthema L./transl. J.W. Jones and ed. G.P.Badger. 1863. *The Travels of Ludico di Varthema in Egypt, Syria, Arabia Deserta and Arabia Felix, in Persia, Ethiopia and India, A.D. 1503 to 1508.* London.

Vernoit S. 1997. *Occidentalism* (Nasser D. Khalili Collection of Islamic Art, 23). London.

Vertovec S. and R. Cohen (eds). 2002. *Conceiving Cosmopolitanism: Theory, Context and Practice.* Oxford.

Volney C.-F. 1798. *Travels through Egypt and Syria in the Years 1783, 1784 & 1785,* Vol. 2. New York.

von Soden W. 1959–81. *Akkadisches Handwörterbuch* (3 vols). Wiesbaden.

Voorhoeve P. Three Old Achehnese Manuscripts 1952. *Bulletin of the School of Oriental and African Studies* 14/2: 335–45.

Voorhoeve P. 1957. *Handlist of Arabic Manuscripts in the Library of the University of Leiden and Other Collections in the Netherlands.* Leiden.

Voorhoeve P. and T. Iskandar/transl. M. Durie. 1994. *Catalogue of Acehnese Manuscripts in the Library of Leiden University and Other Collections outside Aceh.* Leiden.

Vosmer T. 2005. The Development of Maritime Technology in the Western Indian Ocean, 2500 BC to Present, with Particular Reference to the Arabian Gulf. PhD Thesis, Curtin University of Technology [unpublished].

Wagstaff M. 2009. Evliya Çelebi, the Mani and the Fortress of Kefela. In A. Peacock (ed.), *The Frontiers of the Ottoman World: Fortifications, Trade Pilgrimage and Slavery*: 113–35. London.

Walker B.J. 2000. Rethinking Mamluk Textiles. *Mamluk Studies Review* 4: 167–217.

Wall D. van der. 2011. *Christiaan Snouck Hurgronje: The First Western Photographer in Mecca, 1884–1885.* Amsterdam.

Al-Waqidi, Muhammad ibn 'Umar/ed. J.M.B. Jones. 1966. *Kitab al-maghazi* (3 vols). London

Al-Washmi S.1994. *Al-Athar al-ijtima'iya wa al-iqtisadiya li-tariq al-hajj al-'iraqi 'ala mintaqat Qasim.* Beirut.

Watson J.C.E. 2012. *The Structure of Mehri.* Wiesbaden.

Watson J.C.E. and A. Bellem 2010. A Detective Story: Emphatics in Mehri. *PSAS* 40: 345–56.

Watson J.C.E. and A. Bellem. 2011. Glottalisation and Neutralisation in Yemeni Arabic and Mehri: An Acoustic Study. In Z.M. Hassan and B. Heselwood (eds), *Instrumental Studies in Arabic Phonetics*: 235–56. Amsterdam.

Watson J.C.E. and P. Rowlett. Forthcoming. Negation in Mehri, Stages in Jespersen's Cycle. In D. Eades (ed.), *Grammaticalization in Semitic.* Oxford.

Watt W.M. 1953. *Muhammad at Mecca.* Oxford.

Watt W.M. 1956. *Muhammad at Medina.* Oxford.

Watt W.M. and R.B. Winder. 'Al-Madina'. *Encyclopaedia of Islam (EI²).*

Wavell A.J.B. 1912. *A Modern Pilgrim in Mecca and a Siege in Sanaa.* London.

Wavell A.J.B. 1918. *A Modern Pilgrim in Mecca.* London.

Wehr H./ed. J.M. Cowan. 1971. *A Dictionary of Modern Written Arabic.* Wiesbaden.

Weir T.H. and Zysow A. 'Sadaka'. *Encyclopaedia of Islam (EI²).*

Welch A. 1985. Qur'an and Tomb: The Religious Epigraphs of two Early Sultanate Tombs in Delhi. In F.M. Asher and G.S. Gai (eds), *Indian Epigraphy: Its Bearing on the History of Art*: 257–67. Oxford.

Welch A. 1996. A Medieval Center of Learning in India: The Hauz Khas Madrasa in Delhi. *Muqarnas* 13: 165–90.

Welch A., H. Keshani and A. Bain. 2002. Epigraphs, Scripture, and Architecture in the Early Sultanate of Delhi. *Muqarnas* 19: 44–77.

Wellhausen J. 1897. *Reste arabischen Heidentums* (second edn). Berlin.

Werbner P. 1998. Langar: Pilgrimage, Sacred Exchange and Perpetual Sacrifice in a Sufi Saint's Lodge. In P. Werbner and H. Basu (eds), *Embodying Charisma: Modernity, Locality, and Performance of Emotion in Sufi Cults*: 95–116. London.

Werbner P. 2002. *Imagined Diasporas among Manchester Muslims*. Oxford.

Werbner P. 2009. Revisiting the UK Muslim Diasporic Public Sphere at a Time of Terror: From Local (Benign) Invisible Spaces to Seditious Conspiratorial Spaces and the 'Failure of Multiculturalism' Discourse. *South Asian Diaspora* 1/1: 19–45.

Werbner P. and M. Anwar (eds). 1991. *Black and Ethnic Leaderships in Britain: the Cultural Dimensions of Political Action*. London.

Western Arabia and the Dead Sea. 1946. Oxford.

Whalen N., A. Killick, N. James, G. Morsi, and M. Kaamal. 1981. Saudi Arabian Archaeological Reconnaissance 1980. *Atlal* 5/1a: 43–58.

Whitcomb D. 1996. The Darb Zubayda as a Settlement System in Arabia. *ARAM* 8: 25–32.

Whitcomb D. and J.H. Johnson. 1979. *Quseir al-Qadim: Preliminary Report, 1978*. Princeton, NJ [repr. 1978, Cairo].

Whitcomb D.S. and J.H. Johnson. 1982. *Quseir Al-Qadim 1980*. Malibu [repr. 1982, Princeton, NJ].

White A. 1996. Conrad and Imperialism. In J.H. Stape (ed.), *The Cambridge Companion to Joseph Conrad*: 179–202. Cambridge.

Wieringa E./ed. J. de Lijster-Streef and J.J. Witkam. 1998. *Catalogue of Malay and Minangkabau Manuscripts in the Library of Leiden University and other Collections in the Netherlands*. Vol. 1. Leiden.

Wieringa E. 1999. An Old Text Brought to Life Again. A Reconsideration of the 'Final Version' of the *Babad Tanah Jawi*. *Bijdragen tot de Taal-, Land- en Volkenkunde* 155/2: 244–63.

Wieringa E. 2002. A Tale of Two Cities and Two Modes of Reading. A Transformation of the Intended Function of the *Syair Makah dan Madinah*. *Die Welt des Islams* 42/2: 174–206.

Wieringa E. 2007. *Catalogue of Malay and Minangkabau Manuscripts in the Library of Leiden University and other Collections in the Netherlands*. Vol. 2. Leiden.

Wilkinson T. 1980. Darb Zubayda – 1979: The Water Resources. *Atlal* 4: 51–67.

Winter M. 1992. *Egyptian Society under Ottoman Rule, 1517–1798*. London.

Witkam J.J. 1989. *Catalogue of Arabic Manuscripts in the Library of the University of Leiden and other Collections in the Netherlands*. Leiden.

Witkam J.J. 2007a. The Battle of the Images. Mekka vs. Medina in the Iconography of the Manuscripts of al-Jazuli's Dala'il al-khayrat. In J. Pfeiffer and M. Kropp (eds), *Technical approaches to the Transmission and Edition of Oriental Manuscripts = Beiruter Texte und Studien*: 67–82 (text), 295–300 (illustrations). Beirut.

Witkam J.J. 2007b. *Inventory of the Oriental Manuscripts of the Library of the University of Leiden*. Vol. 1. Leiden.

Witkam J.J. 2007c. Introduction. In C. Snouck Hurgronje/transl. J.H. Monahan. *Mekka in the Latter Part of the 19th Century*: 7–84. Leiden and Boston.

Witkam J.J. 2009. Images of Mecca and Madinah in an Islamic Prayer Book. *Hadeeth al-Dar* 30: 27–32.

Witkam J.J. 2010. The Islamic Manuscripts in the McPherson Library, University of Victoria, Victoria, B.C. *Journal of Islamic Manuscripts* 1: 101–42.

Wolfe M. (ed.). 1997. *One Thousand Roads to Mecca: Ten Centuries of Travelers Writing about the Muslim Pilgrimage*. New York [repr. 2007. New York].

Woodward S.C. 2004. Faith and Tourism: Planning Tourism in Relation to Places of Worship. *Tourism and Hospitality Planning and Development* 1/2: 173–86.

Wright T. 1906 *The Life of Sir Richard Burton* (2 vols). London and New York.

Wüstenfeld F. 1857–61. *Die Chroniken der Stadt Mekka gesammelt und auf Kosten der Deutschen Morgenländischen Gesellschaft*. Leipzig.

Wüstenfeld F. (ed.). 1981. *Die Chroniken der Stadt Mekka* (4 vols). Hildesheim.

Yaman Z. 1996. Küre Hoca Şemseddin Camii'nde Kâbe Tasvirli Çini Pano. In *Prof. Dr. Şerare Yetkin Anısına Çini Yazıları*: 187–96. Istanbul.

Al-Ya'qubi, Ahmad ibn Abi Ya'qub. [n.d.] (also 1883). *Tarikh al-Ya'qubi* (2 vols). Beirut.

Al-Ya'qubi, Ahmad ibn Abi Ya'qub/ed. and transl. G. Wiet. 1937 (also 1892). *Kitab al-buldan (Les Pays)*. Cairo.

Young W. 1993. The Ka'ba, Gender and the Rites of pilgrimage. *International Journal of Middle East Studies* 25/2: 285–300.

Al-Yunayni, Qutb al-Din Muha ibn Musa ibn Muhammad. 1960. *Dhayl mir'at al-zaman*. Hyderabad.

Yusuf M. 1996. Sea Versus Land: Middle Eastern Transportation during the Muslim Era. *Der Islam* 73/1: 232–58.

Al-Zahiri, Ghars al-Din Khalin Ibn Shahin. 1997. *Zubdat kashf al-mamalik wa bayan al-turuq wa al-masalik*. Beirut.

Al-Zahrani D.B.Y. 1994. Al-Jar: mina' wa madina. In *Al-Hadara al-islamiya wa 'alam al-bahr*: 239–70. Cairo.

Zain N.Sh.M. 2000. Ahammiyat mawani' al-Sudan lil-tijara al-duwaliya 'abr al-bahr al-ahmar khilal al-'asr al-islami. *Majallat al-'aqiq* 29/15: 7–126.

Zaki 'A. 1960. *Qal'at Salah al-Din wa qila' islamiya mu'asira*. Cairo.

Zarcone T. 2000. Les confréries soufies en Sibérie (XIXe siècle et début du XXe siècle). *Cahiers du Monde Russe* 41/2–3: 279–96.

El-Zeini H. 1982. Notes on Some of the Old Mosques in Quseir, In Whitcomb and Johnson. *Quseir-al-Qadim: Preliminary Report, 1980*. 397–406. Princeton, NJ.

Al-Zubayri, Mus'ab/ed. E. Levi-Provençal. 1953. *Kitab nasab quraysh*. Cairo.

Index

(Page numbers in **bold** denote illustrations)